M000035706

WESTERN CULTURE AT THE AMERICAN CROSSROADS

AMERICAN IDEALS AND INSTITUTIONS SERIES

Robert P. George, series editor

Published in partnership with the James Madison Program in American Ideals and Institutions at Princeton University, this series is dedicated to the exploration of enduring questions of political thought and constitutional law; to the promotion of the canon of the Western intellectual tradition as it nourishes and informs contemporary politics; and to the application of foundational Western principles to modern social problems.

WESTERN CULTURE AT THE AMERICAN CROSSROADS

Conflicts Over the Nature of Science and Reason

ARTHUR PONTYNEN
ROD MILLER

WILMINGTON, DELAWARE

Library of Congress Cataloging-in-Publication Data

Pontynen, Arthur.
　　Western culture at the American crossroads : the conflict over the nature of science and reason / Arthur Pontynen and Rod Miller.
　　p. cm.
　　Includes bibliographical references and index.
　　ISBN 978-1-935191-74-2
　　1. United States—Civilization. 2. United States—Intellectual life. 3. Civilization, Western—History. 4. Science—United States—History. 5. Reason—History. 6. Philosophy, American—History. 7. Art—United States—History. 8. Architecture—United States—History. 9. National characteristics, American. I. Miller, Rod, 1963– II. Title.

E169.1.P597 2011
973—dc22

2010020114

ISI Books
Intercollegiate Studies Institute
3901 Centerville Road
Wilmington, DE 19807-1938
www.isibooks.org

Manufactured in the United States of America

CONTENTS

In loving memory of Eino and Aili Pontynen

and

In honor of Ronald and Barbara Miller

List of Figures

Foreword

BY JOHN CARROLL

Western Culture at the American Crossroads is a grand and profound reflection on the mainstream ideas of the modern West. Its framework is the Judeo-Christian tradition and its conception of the human condition. Its more specific focus is on shifting metaphysics from Isaac Newton (one of the book's targets), through Kant (another target), to Nietzsche and other key nineteenth- and twentieth-century figures. It traces the breakdown of Western culture.

Authors Arthur Pontynen and Rod Miller's own standpoint is a rigorously unified conception of the world, deriving from Trinitarian Christianity. They assume that, for better or worse, science, ethics, and art are united—indeed a unity. In their view, knowledge and freedom are grounded in an optimistic realism, in which truth and love properly rule, a wise reason may operate, and individuals behave within a context of responsible freedom.

The book traces the steady disintegration of this utopian wholeness. Some of the major figures in the culture of the West play key roles: Newton with his deism, Kant with his separation of art from truth, Nietzsche with his relativism, and the transgressive artists of the twentieth century led by Marcel Duchamp.

The eighteenth-century Enlightenment is pivotal to this descent. It is during this period that science is reduced to fact—that is, to a narrow scientism cut off from ethical or metaphysical concerns. Romanticism emerges, with its enshrining of feeling and emotion—the passions of the individual—as the sole judges of value. And the modern slide into power replacing meaning begins.

The unintended consequence of the slow erosion of Western high culture has been the rise of a profane technocracy based on a narrow conception of science, and the replacement of the pursuit of the true, the beautiful, and the good by a single-minded will to power (to use Nietzsche's phrase). Everything becomes relative and absurd, merely a matter of opinion—apart, that is, from power.

Pontynen and Miller are right to contend that when art no longer serves the pursuit of truth—as it did for the Old Masters, who saw their mission as the revealing of the important truths—then it will inevitably become subversive. Modern art is one long howl against the beautiful, the true, and the good, with shock tactics replacing virtuosity, and obscenity replacing insight.

The authors argue that the classical world had no explanation for evil. Socrates, Plato, and Aristotle could not explain tragedy: why bad things happen to good people. It was Christianity that provided the answer. In fact, it was only one stream within Christianity. Luther, for instance, noted that God's earth is not now a just place—look around, he suggested, and your reason will tell you that.

One of the strengths of *Western Culture at the American Crossroads* is to acknowledge the Anglosphere as a quite distinct core of custom and belief within the West. It has its own virtues, manifest most obviously in its democratic traditions. The authors' own Trinitarianism seems to be of a notably Anglo temper.

It is a pleasure to read a book which returns to the classical conception of the good life as, of necessity, governed by the search for beauty and truth. To abandon this conception is to desecrate the reality of being born human: here is the source of Pontynen and Miller's outrage at what has happened in Western high culture over the past half millennium. By contrast, they describe the world as rightly a "numinous paradise." Amen.

John Carroll is author of *The Wreck of Western Culture: Humanism Revisited* and professor of sociology at La Trobe University in Melbourne, Australia.

Preface

PREMISES AND PURPOSES

Every book has its own type of narrative, and every narrative relies upon particular premises. The premises and thus the narrative of this book differ from those that are commonplace today. They are neither modernist nor postmodernist. Some prefatory remarks are in order so that the intentions of this book and the effectiveness of its advocacy can be considered.

Within the context of American history, this book addresses the interactions among culture, science, and reason, and considers whether those interactions can to any degree be grounded in qualitative rather than merely quantitative knowledge of reality. It is a historical study of culture as the attempt to make manifest some degree of truth, goodness, and beauty. This narrative relies upon premises radically different from those accepted by modernist and postmodernist scholarship. Unless those premises are made clear, this book can make little sense to the contemporary reader.

Three specific premises inform the narrative of this book. The first is that culture is grounded in the exercising of responsible freedom—that is to say, a freedom in which culture rightly informs and inspires us to do what is true and good, not as a matter of personal or group preference or identity, nor as a matter of expediency. Culture informs and inspires us to rise to some precious degree to wisdom and beauty. The purpose of culture is to provide theoretical and practical knowledge so that we can improve our quality of life. That understanding is grounded in the assumption that science and reason provide us with the means to freely make such choices. It is an assumption that once was commonplace, but can no longer be taken for granted.

The second premise informing the narrative of this book is that the idea of culture as the realm of responsible freedom has largely been superseded by a different view. That view is grounded in *positivism*, and is called *scientism*. The foundational premise of scientism is that knowledge is limited to facts, and culture is therefore variously understood as a matter of sociological fact, feeling, or style. By that is meant that the human condition is grounded in a world of descriptive facts; within that world of facts culture is constructed or experienced. Within this sociological context self-expression, self-realization—and indeed self-destruction—replace beauty and wisdom as the goal of culture. All are grounded in a positivist definition of scientific knowledge: Modernist rationalism is grounded in the human mind, not reality (it is deontological); postmodernist rationalism is grounded in experience (it redefines reason as a dialectic of power); for those concerned with practicality, rationality is instrumentally grounded in an ironic skepticism perhaps dedicated to vague notions of the common good (that is, "good").

The third premise of this book is that a positivistic culture is *transgressively equalitarian*. It cannot tolerate any claims of wisdom and beauty grounded in a qualitative scientific rationalism, and is violently disposed to destroying such claims in the name of liberty and equality. To be free to be the same is, however, self-contradictory, and concludes in culture being trivialized and brutalized. Whereas equality is a quantitative notion, culture is qualitative. Equalitarianism replaces a concern for virtue with a leveling concern for condition. To expect equal treatment before the law makes sense. What does not make sense is defining goodness and justice as the realization of equal condition based upon—or despite—our choices and conduct. To view culture via an equalitarian viewpoint not only denies freedom, it does so as an act of violence in the guise of social justice. It is an act of violence toward culture as the realization of responsible freedom. The conflict between the proponents of liberty and equality, and the proponents of the free and responsible pursuit of wisdom, is the central narrative not just of American and Western culture but now of all cultures. No wisdom-seeking culture anywhere in the world can coexist with the transgressive equalitarianism of postmodernity; no proponent of equalitarianism can tolerate the presence of those professing a qualitative vision of reality and life.

These different views of culture are grounded in distinct understandings of science and reason. It is important to note that an advocacy of a scientific rationality in pursuit of wisdom is historically and currently found in several cultural traditions around the world, such as orthodox Christianity, Confucianism, and traditional liberalism; the limitation of science and reason to a positivist context

is also found in those same traditions, and in many others that have been afflicted by modernism and postmodernism.

Those differing understandings perennially interact, and that interaction constitutes the historical narrative of (and struggle for) culture. That narrative was once dedicated primarily to the pursuit of truth, but is no longer. The pursuit of truth is now contested by those who seek power. The denial of a scientific rationalism dedicated to the pursuit of truth (and by extension, of wisdom and beauty) is now found within many traditions, including those historically dedicated to the pursuit of truth. It is not that secular traditions have replaced religious ones, nor that religious traditions ought to replace those secular. It is that both secular and religious traditions have abandoned the scientific and rational pursuit of wisdom and beauty.

These different understandings of science and reason are not merely quantitative differences. They currently result in the denial of a qualitative vision, concluding in bitter conflict and violence. One of our contentions is that while equalitarianism claims it avoids conflict and violence, it ultimately concludes in an existentialist nihilism, totalitarianism, and empty pragmatism. A culture dedicated to a scientific and rational pursuit of wisdom, on the other hand, fosters a culture of responsible freedom. The free and responsible pursuit of wisdom thus desperately needs to be renewed.

This book posits that our understanding of reality via science and reason affects how we choose to treat one another, and how we understand reality and how we treat one another constitutes the realm of culture. That realm is superior to positivist natural and social science in that it is not limited to the often sordid facts of what currently is; rather, it advocates what we ought rightly do as civilized knowledgeable rational beings. Within the context of American culture, the dialogue between science and reason occurs historically within and among three primary strands of discourse: the classical-Judeo-Christian, the Anglosphere, and the modernist-postmodernist. As the following chapters will explain in detail, those strands operate separately via their own foundational assumptions about science, reason, and culture. But they also interact, sometimes with deleterious results.

This book presents, then, a critical historical narrative of those three traditions and an analysis of the conflicts resulting from their interactions. The purpose of that narrative and analysis is not simply to (positivistically) describe those interactions and conflicts, but to advocate a resolution of them. This is essential because those conflicts now threaten not only the continuance of American and Western culture but the very possibility of culture itself.

The historical context of this book begins during the Baroque period, during which the American colonies first were established and then flourished, and during which a cultural upheaval in Europe occurred. That cultural upheaval centered on a repudiation of the Scholastic understanding of science and reason. As such it is the Baroque response to a critically challenged Scholasticism that first concerns us. The next concern of this text is the development of the Baroque paradigm into what is now called the Enlightenment. The final concern of this text is how the Enlightenment's redefinition of science and reason results in the development of the modernist-postmodernist paradigm. The end result of that paradigm is a cultural nihilism that alternates between anarchy and totalitarianism. As such, it is antagonistic not only to the classical-Judeo-Christian tradition and the Anglosphere; it is antagonistic to the very continuance of civilization. Its redefinition of science and reason tragically results in the repudiation of culture.

Such a critique of the modernist-postmodernist tradition is not in itself unique; as discussed in the final chapters of this book, a great many sophisticated thinkers have come to view that tradition as a catastrophe. Unfortunately, those thinkers are ignored by the majority of academics today, who view the modernist-postmodernist tradition as profoundly liberating. The irony of that academic marginalization is that it lacks a basis in knowledge. Instead, it is grounded in a dogmatic skepticism and an identity-based absolutism. To objectively analyze the merits of any cultural system, the hope for some degree of objectivity must exist, but the modernist-postmodernist tradition denies that hope. It either denies objectivity as such, or redefines objectivity as a matter of existentialist identity. Intrinsically, the modernist-postmodernist reduction of reason to feeling and power[1] has undermined the very possibility of a critical examination of that tradition; extrinsically, a modernist-postmodernist peer review system has politicized scholarship not only in the humanities but in science and reason as well.

Nonetheless, the historical narrative in this book offers a new contextualization of the rise of that tradition. That contextualization is not merely a new quantitative scholarly construction awaiting an inevitable deconstructionist response. Rather, it aspires to offer a qualitative gaze into our current malaise. It offers a critical examination of current positivist foundational assumptions about the nature of science and reason, and recognition of its antagonistic stance toward the pursuit of truth and wisdom and its resultant anticultural and anti-intellectual content. Following that analysis is a conclusion offering an escape from the limitations of that particular and dysfunctional paradigm.

American culture provides a *locus classicus* for our concerns. American culture is both context and product of the cultural discourse of which we speak. That

product is still in the making—or as we conclude—in the finding. It is a product of the Baroque and the Enlightenment, but also a real alternative to them. In contrast to Europe, in which the classical-Judeo-Christian has withered, American culture is one in which all three of these traditions—classical-Judeo-Christian, Anglosphere, and modernist-postmodernist—have remained historically vital. American culture therefore provides an arena in which is manifested the future of our understanding and practice of culture.

Capabilities of Reason, Possibilities of Beauty

Current dogmas notwithstanding, evaluating the dialogue between culture and science is both justified and timely. But today, such a historical and conceptual assessment of that dialogue appears to make no sense because of the current understanding not only of culture and science but also of the capabilities of reason.[2]

Within the modernist (Kantian) tradition it is assumed that science and reason are ontologically distinct; within the postmodernist (Hegelian-Marxist) tradition it is assumed that science and reason are ontologically identical but immanent. That is, science is the realm of fact, and reason is limited either to how we think, or what we knowingly experience. We operate within a realm of factual cognition that is either nominalist and (de)constructivist, or experiential. In other words, within the modernist-postmodernist tradition science is denied the possibility of objective (or transcendent) truth. Science and reason are denied the possibility of meaningful completion.[3] Therefore truth is limited to empirical fact, and reason seeks to understand particular facts by placing them within constructed explanatory narratives (what Hume and Kant call *Hypothetical Imperatives*) or by intuiting experiential-based narratives (what Hegel or Marx would call the dialectic of experience).

Science and reason allegedly cannot be reconciled via an understanding of a purposeful reality. It is assumed, then, that reality is grounded in power and violence. That assumption is based in the rejection of certain foundational principles of Scholasticism. Whereas Scholasticism advocates a substantive unity of science and reason grounded in ontological purpose, the modernist-postmodernist mind works from the ontological assumption of their disunity and lack of ontological purpose.[4] The modernist pursues a deontological ethic—which correspondingly requires a limitation of science to a deontological pursuit of facts and style. This results in reason and truth as rationalization—be it trivial or absolute. The postmodernist pursues an ontological existentialism which correspondingly requires

that ethics ultimately centers on a willful self-expression and self-realization. Truth is an authoritarian dialectic of power ultimately concluding in nihilism.

Such assumptions have serious consequences. How we understand reality via science and reason affects how we choose to ethically treat each other, and how we understand reality and how we treat each other is manifested in culture and fine art. So when science and reason are ontologically separated, or reduced to power, that dialogue becomes culturally dysfunctional. It either denies reason as useful in the pursuit of wisdom (e.g., Kant), resulting in a nihilistic skepticism posing as tolerance, or it assumes (via Hegel, Marx, and Nietzsche) that reason is actually grounded in power rather than love. If reason is grounded in a dialectic of violence rather than the loving impulse for meaningful completion, then culture is understood to be oppressive, and sociopathy—or dialectical revolution— is seen as virtue. Consequently, science and reason serve varieties of pleasure, grounded in a narcissistic void or an ontological violence.

Being, Becoming, Subversion

Neither the pursuit of power nor the pursuit of wisdom are neutral stances. A choice must be made. This book argues in favor of a choice that runs against the academic mainstream. That mainstream today is aesthetic. This aesthetic vision either denies the philosophical notion of *Being* as such, or reduces it to our experiences. In either case denied is the notion of an objective reality, one that offers purpose and meaning to the universe and our lives. The aesthetic vision mandates a focus on facts and process, rather than the pursuit of meaningful completion. We must then live either in a positivist world in which the facts of science are rationally constructed into narratives, or in a positivist world of Becoming as Being,[5] a violent world of process and power without objective purpose or love.

The crux of the matter is whether such science and reason can result in culture. Knowledge can be viewed as tentative in two very different ways: as a subjective construct or as a partial realization of, a tentative yet precious degree toward, completion. It is the contention of this book that the latter option alone preserves and maintains the hope for civilization.

The conclusion of this book will advocate science and reason in the practical pursuit of wisdom and beauty. It therefore centers on the practical pursuit of truth and goodness in the attempt to live a beautiful life. It advocates a reconciliation of Being and Becoming via responsible freedom. However, the very possibility of seeking truth, goodness, and beauty contests the dominant cultural paradigm and

is anathema to the contemporary modernist-postmodernist academy. That academy assumes—*as an act of faith*—that science, reason, and culture lack purpose; that there is no Being to seek knowledge of. If knowledge is limited to fact, style, and power, then the cosmos as such cannot be understood. Positivism asserts an understanding of what it cannot know: that truth and goodness do not exist. It cannot recognize other possibilities.

This has disastrous consequences. The modernist-postmodernist academy is positivist, constructivist, and deconstructivist. We live in either a mechanical or organic world of facts and we willfully construct or deconstruct narratives using those facts. As a matter of practical knowledge, we live in a violent world of Becoming. Or to put it differently: beyond facts is the realm of power. We can obtain facts but all attempts to understand reality (or Being) are grounded in willful experience (Becoming). The result is a denial of Being as such, of beauty as the splendor of what is true and good; what is denied is an ontology of responsible freedom.

Herein are challenged the primary assumptions of the modernist-postmodernist notion of scholarship and culture. *Contra* Hume, Kant, Hegel, Marx, and Nietzsche, we ought not be subversive of all assumedly false and oppressive claims of truth and wisdom; rather, we should be subversive of ignorance, foolishness, and wickedness by seeking knowledge of truth and wisdom. In so doing we are engaged in a timely pursuit of wisdom and beauty, a reconciling of science and reason, Being and Becoming. This choice is one facing the academy today, and yet it is a choice not typically recognized. For the modernist-postmodernist tradition to acknowledge the existence of that choice is to go beyond its methodological capacity for knowledge. Therefore, such acknowledgment would require the denial of its own legitimacy. Nonetheless, the possibility of others to make that choice informs the narrative of this book. It is the need to make such a choice that is central not only to this book but also to the cultural conflicts afflicting Western, American, and world culture today.

This book is, then, subversive, but in a different way from how the modernist-postmodernist tradition defines the term. For those who seek wisdom, scholarship and art should liberate us from ignorance, folly, and vice. Truth shall set us free. But to the modernist-postmodernist mind that pursuit of wisdom is denied; it sees assertions of wisdom as trivial or oppressive lies. The *destruction* of "truth" shall set us free. It seeks to subvert claims to knowledge of a meaningful rather than an existential universe. This foundational denial of the pursuit of truth and goodness requires scholarship and art to be dedicated to freeing us from the allegedly false and oppressive claims of metaphysical beauty. But it condemns us

to the modernist-postmodernist metaphysical assertion that the universe is meaningless. There lies a fundamental contradiction of modernism-postmodernism: in embracing a view of science that allegedly joyfully liberates us from religious metaphysics, it necessarily advocates an existentialist metaphysics of despair.[6]

Correspondingly, the purpose of this book is not to (de)construct assumedly oppressive cultural claims of wisdom. Nor is it to deconstruct the deconstructivists, as many (such as Irving Babbitt, later discussed) have previously done. Rather, it is to offer a viable optimistic alternative. It finds the existentialist varieties emanating from a fact-based and process-oriented positivism inadequate and culturally destructive. This book is dedicated to the practical pursuit of beauty and wisdom. It does not view the term *culture* from a positivist perspective. Culture is more than a meaningless record of the facts and statistical probabilities of existence. Instead, culture is understood as the practical pursuit of beauty and wisdom. In contrast to a positivist social science, culture is the realm of responsible freedom. It recognizes that how we consciously understand reality and life directly and significantly affects how we rationally choose to behave, and that those influences can result in decisions that are for better—or worse.

We face a choice of how to understand the world: through the pursuit of a quantitative understanding of reality and life, or one that is qualitative. It is a choice between viewing human society as a product of nature, nurture, or the will, or as the realm of responsible freedom. A quantitative understanding of reality and life is aesthetic; it centers on the pursuit of facts and feelings. In contrast is the qualitative approach that centers on beauty as the splendor of what is true and good.[7] It centers on the pursuit of truth and goodness which aspires to obtain a glimpse of what is therefore beautiful. A beautiful life is one in which the splendor of wisdom or ontological form is to some degree—but never completely—realized.

The division between those who seek an aesthetic vision of science, ethics, and art and those who seek beauty is the crux of the matter. That division is more than speculative. Indeed, it provides the historical context in which the genesis of American culture occurred, and in which it still struggles. It is that historical crossroad that American, Western, and even world culture now critically faces. The very continuance of civilization lies in the balance.

1

SCIENCE AND REASON IN THE PURSUIT OF TRUTH, GOODNESS, AND BEAUTY— OR POWER

S ince the Enlightenment, culture, science, and reason have been engaged in a
particularly contentious historical dialogue; the contentiousness of that dia-
logue affects our understanding not only of science and reason, but of culture
itself.[1] The Scholastic unity of science, ethics, and art via the pursuit of wisdom was
replaced by an *empirical Scholasticism*.[2] Empirical Scholasticism assumes that science
is the pursuit of facts, and that facts are not intrinsically reasonable. The Scholastic
unity of understanding a meaningful world via knowledge (*scientia*) and wisdom
(*sapientia*) is replaced by the Enlightenment's reductionistic limitation of knowledge
to manufactured descriptive fact (*scientism*) and rationalized or experiential feeling
(*existentialism*) within a purposeless world. The Scholastic is onto-, teleo-, cosmo-,
and theo-*logical*, whereas empirical Scholasticism is none of these. The Scholastic
associates fact and reason with purposeful completion—that is, with truth and love.
The empirical Scholastic replaces truth and love with fact and power.[3]

The shift from truth and love to facts, feelings, and process was explained
by the Baroque scholar Giambastista Vico (1668–1744). That shift is one from
Verum est ens (Truth is Being—that is, truth is knowledge of the eternal essence
of things) to *Verum quia factum* (Truth is made—that is, truth results from mak-
ing accurate descriptions). *Factum* is that which is done, made, accomplished, and
that which is manufactured is that which is manually done, made, accomplished.
So the shift from truth to fact is a shift from truth found to facts made. It is,
then, a shift from truth to power, and culture to barbarism. Truth made is power
revealed and culture cannot exist on the basis of power alone.[4]

Scientism blossomed in the West during the Baroque period and became dominant after Newton. Scientism takes for granted that knowledge is limited to empirical fact; modernists associate fact with an extrinsic rational clarity, while postmodernists associate fact with experiential power. In neither case is science associated with a *rational meaningful completion*. The foundational premise of this paradigm of knowledge is positivism. But neither a factual and rational clarity, nor power can remedy the Enlightenment's denial of wisdom—and therefore its denial of the unity of science and reason. As a consequence, it cannot defend culture as the arena of responsible freedom. At best it defends freedom as self-expression and self-realization in an ultimately purposeless world. As such, the modernist-postmodernist tradition is not only antagonistic to classical-Judeo-Christian culture; it is antagonistic to the very possibility of culture as the realm of responsible freedom. It denies the foundational principle that as conscious beings all of humanity has the ability, responsibility, and intrinsic right to try and make *good* choices grounded to some degree in ontological reality. It denies that we have the right and responsibility to freely and conscientiously attempt to comprehend and pursue what is true, good, and beautiful.

In this sense, Scholasticism and empirical Scholasticism share a common goal: to address the dialogue between science and reason. But the empirical Scholasticism of the Enlightenment undermines that dialogue. Its redefinition of science and reason results in a redefinition—and a denial—of the pursuit of objective truth, of knowledge of what is true, good, and beautiful. Just as David Hume redefined reason as feeling and power in his *A Treatise of Human Nature* (1740), in his *Enquiries concerning the Principles of Morals* (1751), he advocated a *naturalistic metaphysics* in which morality is grounded in the pursuit of power. For Immanuel Kant, truth, goodness, and beauty are separated from reality via his three great— and tragic—works: *The Critique of Pure Reason* (1781), *The Critique of Practical Reason* (1788), and *The Critique of Judgment* (1790). In *Phenomenology of the Spirit* (1807), Hegel redefined reason as power, personified by the state, obedience to which is deemed freedom.

It is the disassociation of knowledge from meaningful completion that undermines the objectivity of science and reason, and therefore the objectivity of truth. But lacking the goal of objectivity, of the notion of meaningful completion, then truth and love are replaced by fact and power. The mind and will are at war with each other, a war that the mind cannot win.

So the critical question today is: how can a culture of responsible freedom via the pursuit of wisdom be restored without repeating previous errors. How can culture, science, and reason be newly and better reconciled? That is the vital

conversation occurring within American culture today. It is a conversation with international implications.

If the conversation between culture, science, and reason cannot be resolved, then culture, science, and reason are trivialized and brutalized. As the Medievalists pointed out: *ars sine scientia nihil est*—art without science is nothing. Their point was that in daily life science (knowing), ethics (doing), and art (making) cannot be separated. But just as art without science is nothing, it was realized at the height of nineteenth-century positivist influence that science without lofty purpose is brutality. That brutality centers on the denial of reason and virtue as a means of living a cultured life.

If science is reduced to mere fact and meaning to mere feeling, then reason does not really matter. For Kant, scientific narratives are meaningful fictions. For Hegel, scientific narratives evidence a dialectic of power. If grounded in opinion or power, reason is denied as a means of obtaining knowledge of meaningful reality. If knowledge is limited to fact, and understanding is limited to feeling, then reason is deontologized, reduced to utilitarian expediency, or into an ontology of violence. Reality, or Being, is reduced to process, or becoming. Science is denied the status of being objectively reasonable, and is limited to logical consistency, utilitarian calculation, or a dialectic of violence. It is trivialized—and brutalized.[5]

Since the Enlightenment, science has been reduced to facts, and culture has been reduced to feelings and power.[6] Ethics are approached via existentialism or scientism, but if behavior is understood via either, then what we do is grounded in nature, nurture, or the will rather than in conscious moral choice. Denied is culture as the realm of responsible freedom. This is in obvious contrast to the traditional pursuit of wisdom as championed by the classical-Judeo-Christian tradition in the West. For that tradition culture is the realm of responsible freedom, informed by the unity of science and reason in the pursuit of what is true (scientia) and also good (sapientia).

Culture as Responsible Freedom

In contrast to the social sciences, which at best describe what we do, culture presumes our ability to freely make choices, and for those choices to be meaningful, they must be qualitative and grounded in meaningful reality. To put it differently, *becoming* seeks *Being*, quantity in motion seeks quality as a degree of realized perfection. The qualitative cannot be a matter of quantitative dominance, theoretical interpretation, subjective preference, or authentic momentary experience.

The quantitative cannot become qualitative on its own, or by modernist rationalism, utilitarian calculation, or postmodernist claims of empiricist identity and self-realization. Qualitative choices necessarily are scientifically grounded and rationally engaged as a matter of conscience, but qualitative science and reason must transcend the limits of a factual or process-oriented positivism (Being as Becoming). Qualitative meaning depends upon teleological or cosmological purpose (Being) otherwise it is reduced to violence—rationalized or not.

For culture to make sense it must be qualitative, not quantitative. (This is a foundational principle of the present text.) Qualitative wisdom is driven by fact and process (the realm of becoming) realizing degrees of Being as an act of completion. That realization of meaningful completion is traditionally referred to as truth and love. Meaningful completion informs both truth and love. The positivist separation of science and reason marks the opposite of truth and love: fact and violence. Positivism volitionally replaces objective qualitative science and reason with a quantitative view of violent change, and views that as escaping superstition.

By the positivist reduction of science and reason to fact, logical consistency, and violent process, scholarship and art are limited to an aesthetic vision. Beautiful science and reason seek completion grounded in meaningful reality. In contrast, an aestheticized science and reason are subjective constructs and experiences. They are limited to the realm of facts, feelings, and power. We now live in a dominantly aesthetic culture in which the focus is on the pursuit of facts, feelings, and power rather than truth and goodness. Consequently, the interaction of science, ethics, and art is viewed aesthetically. That is to say, the nature and relationship of science, ethics, and art is viewed as a matter of facts, feelings, and style, a matter of aesthetic taste. But all lack any objective unifying content or purpose. The attempt to universalize taste, as did Burke, Kant, Marx, and others, is dangerously incoherent because taste cannot be understood to be good or bad; the term *good taste*—like *good will*—is oxymoronic. Taste and will cannot be good without the presence of truth; with truth, taste and will are elevated to beauty and wisdom, to *sapientia*.

An aesthetic approach to science, ethics, and art dogmatically assumes a nominalistic viewpoint, and that viewpoint mandates positivism, relativism, and existentialism. That viewpoint maintains that particular facts and preferences exist, and attempts to comprehend a meaningful reality via science, reason, and culture, and thus obtain judgments of quality, make no sense. Quality is judged a matter of taste, which we can trivialize in the name of tolerance, or make absolute in the name of authenticity.

This positivist assumption reduces science to the mere pursuit of purposeless facts; those facts are placed within explanatory narratives that are ultimately a matter of opinion or power. The effect of this upon culture and virtue is devastating. This reduction of science results in two culturally destructive and mutually contradictory consequences: it simultaneously asserts that culture is indifferent to science, or that culture is the product of science. It maintains that either positivist science *determines* what culture is, or that positivist science is *denied* by those who equate culture with feelings rather than facts. The former is called scientism, the latter, romanticism. That positivist-romantic dialectic is hopelessly conflicted about science and culture, but united by the denial of intelligence. A banal positivist mysticism concurs that the world is unintelligible. Human existence is asserted to be grounded in necessary fact or arbitrary feeling. In neither case is responsible freedom and virtue in the pursuit of wisdom permitted.

Within this self-contradictory positivist-romantic view, culture is limited to being both a deterministic matter of nature or nurture *and* an arbitrary matter of sheer willful preference. Lacking is the notion that culture can be the pursuit of that which is true, good, and beautiful in reality. Without this pursuit the notion of a purpose-granting beauty enabling responsible freedom, is denied.

Government lacking a ground in qualitative culture produces not responsible freedom but anarchy. To be distinguishable from anarchy, freedom requires the possibility of conscious and responsible choice. It requires the possibility of virtue (and perhaps Grace). In turn, virtue must aspire to more than tolerance and authenticity. Indeed, virtue defined as such is virtue denied.[7] A modernist seeking tolerance denies virtue its grounding in reality; a postmodernist seeking authenticity grants license to violence. Nonetheless, Kant advocates the association (and redefinition) of virtue with tolerance and fairness. Indeed, he argues for a duty to do so. But Kant's position is deontological; it is not grounded in knowledge of reality—or wisdom. Therefore, it can only be, as John Milbank puts it, the great delayer of nihilism.[8] In contrast, postmodern advocates of authenticity claim to be ontological, that is, they claim their position to be grounded in reality. But that reality is understood as one of violence, which again negates virtue.[9]

Virtue—or the exercising of responsible freedom—relies upon the existence of objective purpose or purposes, on what Aristotle refers to as *final causes* and an *unmoved mover*. It centers on the pursuit of *Being*, rather than mere *becoming*. The story of the shift from Being to becoming is the narrative of Western culture since the Baroque. That deep cultural pendulum is now swinging from becoming to Being. But that shift newly faces the challenge of how to understand the nature and content of Being and its relationship with becoming.[10]

Bacon, Hobbes, Hume, and Newton all deny that science has anything to do with an objectively purposeful reality or Being. During the nineteenth century a later positivist, August Comte, went further than the deist Newton. Whereas previously the goal was to rise from mere fact and confusion to philosophical and theological wisdom (scientia and sapientia), Comte redefines intellectual progress as the transition from superstition and religion to empirical fact (scientism). But curiously, while ostensibly denying the very existence of any metaphysical knowledge, Comte argues that we should act as gods. Being is us becoming.

The tragic result of Comte's choice to so redefine science is not just to deny the possibility of meaningful choice; the tragedy is that he mandates meaningless choice. He mandates self-deification as the key to progress. But then progress is reduced to mere willful change. In a factual and purposeless reality, objectively meaningful choice cannot be recognized. Lacking meaningful choice, two options remain: a fact-based determinism, and sheer subjectivism, positivism and romanticism. Not even Kant can successfully bridge the gap between positivistic fact and emotional preference—his rationalizations notwithstanding.

Responsible decision-making is key to the very existence of culture, and that responsible decision-making—that is, responsible freedom—must be grounded in knowledge of reality. For our choices to be good, and not problematically tolerant *and* a matter of identity,[11] they must be grounded via science and reason in purposeful reality.[12] Otherwise the impulse toward tolerance, fairness, equity, and authenticity descends into a sociopathic realm where envy and anger are justified. Truth becomes a lie, culture is deemed oppressive, and the goal of a purposeless scholarship is not to be subversive of ignorance, folly, and hate, but rather to subvert all those allegedly oppressive lies which claim to advance the true and good.

The observation that the pursuit of wisdom liberates us from violence should be tempered with humility; false claims of wisdom have indeed done harm. But as discussed later, Abraham Lincoln's noble Second Inaugural Address is to the point: we must strive to do what is right, as we are given to understand the right, with charity for all and malice towards none.

Whereas the denial of Being has terrible consequences, false assertions of Being (and the denial of becoming) have been historically calamitous.[13] The need to reconcile science and reason, becoming and Being, wisdom and freedom, warrants careful deliberation. However, the need for careful deliberation makes no sense within the modernist-postmodernist academy. That academy has abandoned the pursuit of ontological wisdom untainted by power. What it feels to be tolerant and authentic is beyond rational discourse.

Positivism's Effect on Culture

Western and American culture is now poised at a crossroads. Western culture traditionally centers on the unity of science and reason; that unity became ideologized by Scholasticism, but the post-Scholastic alternative of Western culture has offered no relief. Indeed, it has done palpable harm via its advocacy of a new and pointless empirical Scholasticism. As such it has brought the very notion of culture into question.

For example, the presumptions of positivism affect our very ability to consider a book titled *Western Culture at the American Crossroads: Conflicts over the Nature of Science and Reason*. That title is meant to establish that science, ethics, and art are purposeful and qualitatively inseparable, and stands as a refutation of the premises of positivism and its *ideologically required* conclusions of relativism and existentialism. Until evidence and reasons supporting the position of this book are understood, the positivist mind exists as an obstacle to even beginning such a critical evaluation. Since positivism only admits the pursuit of knowledge via a positivist viewpoint, evidence offered in the attempt to escape its dogma is judged to be admissible only if it is positivist.

Positivism's intrinsic inability to view science as more than a matter of quantitative fact and process blinds it to the possibility of the pursuit of wisdom. Its view of scholarship is informed by a subsequent denial of free and responsible choice. From a positivist viewpoint there is no scientific and rational alternative to positivism.[14] Empirical Scholasticism shifts from dogma to taboo.

So it will cause some to think that the position of this book is intrinsically an act of folly, and others to suspect that it is too ambitious. It will seem an act of folly to those who assume that culture is scientifically determined (and therefore based solely on facts), and by those who assume culture to be based upon a rejection of science (that culture is based on feelings). This book will seem too ambitious for those who assume that science, ethics, and art are distinct realms with no unifying final causes or purpose. To them the very idea of *substantively moral science and art* makes no sense. Consequently, the attempt to establish their substantive unity is assumed to be intellectually false and perhaps even arrogant in its ambition. Since positivism takes for granted the assumption that there are no final causes, that there is no objective purpose to things, therefore to seek a common purpose in things appears to make no sense—even if it actually does.

Those who find such an attempt odd will regard a proposed unity of science, ethics, and art as somehow inappropriate. For them, identifying science with art

is to confuse different realms of endeavor; subjecting both science and art to the realm of ethics is equally viewed as inappropriate, and perhaps even inquisitorial. To pass ethical judgment on science and art is to provoke cries of censorship, just as associating culture with the pursuit of science provokes cries of disbelief by those who feel rather than think. They might contend that science is concerned with facts and objectivity whereas art is concerned with emotion and subjectivity; the former is impersonal and quantitative whereas the latter is subjectively qualitative. Facts reflect an objectivity of knowledge and feelings reflect a subjectivity of experience. To associate objective knowledge with ethics or art is viewed to be as foolish as associating science and art with ethics.

But is there really a distinction between science and religion, philosophy and theology, and morality and science? It is so assumed by many, particularly since Newton. But if even positivist practice entails a metaphysical stance, a metanarrative, then are such assumptions tenable? Does not a positivist existentialism produce an ideologically limited existentialist paradigm for science, ethics, and art? Nonetheless, to the positivist the idea that science, ethics, and art are substantively one and intrinsically involve objective ethical and qualitative evaluation makes no sense. Therefore, to study the history of culture as the record of how science, ethics, and art have substantively interacted is judged an unscholarly fantasy.

Beyond Aesthetic Specialization

Accompanying those who find odd a cultural history focusing on science and reason are those who might find such a project too ambitious. They might contend that such a project requires an accurate synthesizing of three assumedly distinct specialties: science, ethics, and art. Those who argue that specialization is necessary and therefore proper to serious contemporary scholarship can cite the enormous increase in factual data available. Their contention could be that in this age of specialization, adequate knowledge of three distinct academic disciplines cannot be achieved with any degree of sophistication. The assumed choice, then, is between specialized sophistication and generalist amateurism. That leads to the assumption that serious scholarship requires a mastery of specialized data, and that such specialization is a necessity for scholarship to rise above mere dilettantism. So only specialized knowledge results in genuine scholarship, and since no one can obtain specialized knowledge in science, ethics, and art, the unity of the three cannot exist as a matter of sophisticated research. The very possibility of the profound generalization (that is, wisdom) is thus denied.

The denial that science, ethics, and art can be one, combined with the assumption that specialization is the only alternative to a trivialized scholarship, is again a mask for a particular and false limitation on knowledge. Just as positivism tacitly embraces a nihilistic metaphysics, it also takes for granted nominalist philosophy. Nominalism maintains that beyond particular facts, knowledge comprises mere words. It has a long philosophical lineage in both Western and Eastern cultures. Commonly associated with a purposeless materialism and atomism in Western culture, nominalism was long viewed with disdain as inadequate. However, it gains prominence during the late Gothic period, is associated with Averroism,[15] and provides the intellectual foundation for both material and intellectual positivism. In turn, positivism became dominant in the nineteenth and twentieth centuries. Positivism rejects all universals and all inquiry into causes that are beyond material fact; it rejects the possibility of both wisdom and final causes. As such it quantifies rather than qualifies knowledge. And within a quantified worldview specialization—even if interdisciplinary—maintains a dedication to facts rather than meaning, and maintains hostility to the profound generalizations—or wisdom—upon which culture and beauty depend.

The modernist-postmodernist academy is foundationally grounded in nominalism. As such the knowledge it values is specialist—and often obscure. In contrast, a central premise of this book is that one cannot separate science, ethics, and art, and that unity in turn cannot be separated from some type of meaningful generalization. All attempts at understanding involve generalizations, and the denial of such generalizations is not only the abandonment of truth and goodness—it also marks the abandonment of the pursuit of wisdom and beauty. The irony of the nominalistic notion of the separate pursuit of science, ethics, and art for their own sake is that it advocates a constructivist notion of knowledge that collapses in its own reliance upon the will. Willful knowledge is truth reduced to competing claims of power.

Just as positivism claims to avoid metaphysics, nominalism claims to avoid generalization. For example, the positivist and nominalist Comte does indeed posit generalizations about reality and life. He concludes that knowledge as such comprises individual facts, and beyond that all words—all attempts at reasoning (except his own)—are just that, mere words. The classicist Aristotle and the Christians Ambrose and Augustine offer generalizations about the nature of science and reason, as do the positivists such as Newton and Comte. All seek knowledge. But the positivists conflate knowledge with fact and reason with the will. The qualitative differences between those very different types of generalizations are crucially important. Or rather, the denial of the very concept of quality by positivism is the crux of the matter.

Qualitative or not, all generalizations are metaphysical. They fall under the rubric of religion: a comprehensive attempt to comprehend how knowing (science), doing (ethics), and making (art) rightfully are one. Both traditional religion and traditionally understood science attempt to understand a meaningful universe and life. The contemporary distinction of science from religion is grounded in positivism, while ignoring that positivism is a type of religion. Indeed, positivism asserts that it escapes lofty generalizations and religion alike. But that assertion is as false as the alleged distinction between science, ethics, and art. Positivism does not avoid religion—it subjectifies it. Comte's reductionistic position is that we are now gods.

Notably, those who wish to play God by constructing and deconstructing reality are newly cherished. This affects which personalities are granted public recognition and which are not. It also affects how scholarship is to be judged. When positivist peer reviewers evaluate claims of truth and knowledge they affirm the work of those who are positivist. Those who seek knowledge of wisdom and beauty are typically judged to be outside the academic mainstream, or mere dilettantes and popularizers.

Positivist Specialization and Qualitative Decline

What, then, of those who object to the task of this book either as odd or too ambitious? Those objections are ideological and historicist rather than necessary and intrinsic to the pursuit of knowledge. It is not that in an age of specialization we *quantitatively need to know too much*, but that we are now in an age in which we are *qualitatively permitted to know too little*. Specialization is not the result of the growth in knowledge, but rather, it is the result of a quantification of knowledge. That quantification of knowledge denies the lofty generalization once cherished as wisdom and recognized as beauty. When knowledge or science—*scientia*—is quantified, it denies the possibility of wisdom and beauty, of qualitative insight—even if they exist. So it is not that we are overwhelmed by a *quantity* of information, so much as we are set adrift by our own inability to contemplate the *quality* of information. The quantification of knowledge intrinsically, but falsely, results in the denial of qualitative knowledge. It also leads to a qualitative diminishment of those who can claim to be scholars, scientists, and bearers of culture.

In rejecting the validity of pursuing wisdom and beauty, positivism radically reinterprets Western tradition.[16] The classical-Judeo-Christian tradition is incoherently understood via a modernist-postmodernist perspective; the Anglo-

sphere's focus on tradition as the winnowing out of the trivial and evil from the profound and good loses its purpose. Kantian subjective-objectivity replaces the traditional cautious and timely pursuit of wisdom and beauty; a Hegelian-Marxist subjective-objectivity confuses the love of truth for the alleged truth of power. In each case a positivistic focus on facts and feelings dominates and a violently aesthetic view prevails. The very possibility of objective knowledge and wisdom is denied and with it the qualitative realms of culture, fine art, and civilization.

This reinterpretation depends upon a redefinition not only of science, but of reason as well. Common to the modernist-postmodernist paradigm is the reduction of thinking to modes of feeling. According to classical-Judeo-Christian tradition, reason is the attempt to gain knowledge of reality. But in a positivist nominalist scientific context, reason is either an obstacle (Hume and Rousseau) or it is to be limited to descriptive facts and the functioning of the human mind (Kant and Hegel). We can know about facts, and we can intellectually combine facts into constructed and deconstructed realities, or we can feel what is good. We can choose either to trivialize those constructs or to assume the role of gods. Reason is thereby subjectified, leading to a trivialization and brutalization of culture and knowledge. More specifically, when facts and feelings are associated with the deontological reasoning of Kant (that is, reasoning which is not associated with objective and purposeful reality), then reason is trivialized. When they are associated with the reasoning of Hegel and Marx (which assumes a dialectic of power), it is brutalized. In a quantitative world, qualitative differences do not disappear; instead they are grounded in mere taste or power (Nietzsche). Scholarship is then the purview of facts and feelings, and even when associated with high intelligence, the result is brutality. The clever, willful, and brutal squeeze out the seekers of objective truth.

The *ideologically mandated* conclusion is that culture, knowledge, and beauty actually indicate a meaningless or oppressive (in)equality rather than the splendor of wisdom and beauty. This redefinition of reason in turn results in a redefinition of the role of scholarship, citizenship, and fine art. Culture and knowledge as a means toward responsible freedom is replaced by degrees of sociopathy; a transgressive destruction of culture is sadly misunderstood as a progressive virtue. It is no longer ignorance and evil that are to be subverted, but rather civilization.

Academic study of culture is now commonly specialized and disassociated from the history of science and ethics. It is disassociated from previous scientific-religious pursuits of qualitative knowledge. Methodologically, the academic mainstream of art history (and the study of science and ethics as well) is no longer commonly dedicated to the pursuit of knowledge of what is actually true and good

in reality. In its view, scholarship is rightly judged in terms of factual accuracy and perhaps creativity via (de)constructed narratives, but not in terms of substantive and ethical profundity. Rather, it is a-ethical and a-esthetic—and the cultural results correspond.

The positivist understanding of knowledge structurally alters the university and its fields of study. Just as it is now unusual to encounter a discussion of wisdom and beauty within academic disciplines (particularly art history, philosophy, and political science), the very structure of the contemporary university is fragmented. In the modernist-postmodernist university, science, ethics, and art departments are assumed to exist as separate realms. We have specialized departments in the natural sciences, in the social sciences, in philosophy, and in art, and the boundaries between those realms is established by the very existence of academic disciplines. Those who study natural science have little to talk about to those in the humanities and fine arts, and vice versa. At least, they have little to talk about beyond how they feel about things. This results in an increasingly insular specialization, and a concurrent denial of qualitative discernments in science, ethics, and art. So specialization is a symptom of our current inability to contemplate wisdom, of that which is true and good. In which case beauty as the splendor of wisdom dissolves into an aesthetic fragmentation of facts, feelings, and competing wills to power.

The specialization of knowledge today marks not pluralism and factual sophistication but rather the dominance of one provincial viewpoint in the contemporary academy: the *empirical and emotivist Scholasticism* of Newton and Kant. It marks the triumph of nominalism and subjectivism in science, ethics, and art, and as such it marks a uniform approach to understanding that belies its own claim that science, ethics, and art are separate endeavors. In this case that unity is, however, one of destruction. It is antagonistic to the very notion of the *uni-versity* dedicated to the pursuit of knowledge of a meaningful *uni-verse*. And it is antagonistic to the very notion of knowledge, culture, and fine art. By methodologically mandating that beyond the realm of fact and experience, meaning is subjective, it mandates an anti-intellectual and anticultural paradigm. It transforms the university dedicated to the pursuit of numinous knowledge and culture into a diversity dedicated to a multicultural pursuit of quantifiable power.

Attempts at understanding a purposeful reality and life are reduced to fact-based mental constructs and deconstructions, or an identity-based violence; the integration of knowledge is denied by the aesthetically minded interdisciplinary mindset. Science, ethics, and art are reduced to individual facts and subjective preferences—that is, we live in a technologically and economically advanced cul-

ture of power. A wisdomless science and commerce pursue a purposeless and brutal path while the humanities are trivialized and brutalized.

This now common approach to knowledge and culture is assumed to provide the structure of higher education and culture. It embodies a specifically Newtonian/Kantian/Nietzschean-grounded paradigm for the pursuit of knowledge and its application. It is an aesthetic worldview that centers on facts and feelings and mandates an *a priori* denial of the possibility of meaningful knowledge. It does so by its foundational assumption of the impossibility of science as the pursuit of wisdom, and the impossibility of culture as a manifestation of beauty. Wisdom is reduced to fact, ethics to efficiency, legality, or the will to power, and fine art to aesthetic preference. Certainly not beneficial, this paradigm is also not inevitable.

The traditional and cosmopolitan hope is to escape violence by obtaining a glimpse of truth. It is truth, not competing claims of power, that sets us free.[17] Freedom is then realized via the pursuit of wisdom, and the attempt to apply knowledge of what is true, good, and beautiful in reality. This optimistic and qualitative notion of reality being foundationally splendid is denied by the assumption that it is only the pursuit of facts, feelings, and, if we choose, a practical rationality, that is paramount. This assumption is advanced by the aesthetic Newtonian/Kantian—or rather, modernist—notion that reality consists of purposeless fact and feeling, which results in our constructing consistent narratives. It also results in the romantic and Nietzschean—or rather, postmodernist—notion that all such constructed narratives are oppressive and must be destroyed.

In a quantitative world of fact and feeling, of material and emotional force—that is, power—neither truth nor love exists. Both truth and love seek completion—but in a positivistic world lacking final purpose, completion cannot be hoped for. Nor can beauty and happiness. Since in a purposeless world neither truth nor love can exist, the ethical consequences are obvious: a denial of the possibility of qualitative distinctions, and of responsible freedom. The assumption that the material and social world is driven by power is antagonistic to the very notion of culture in general; consequently, it is antagonistic to the foundational beliefs of Western culture in particular. And it is antagonistic to the traditions embraced by many at the founding of American culture: it denies qualitative purpose to the study and practice of American—or any other—culture.

2

THE PURITAN DILEMMA—AND OURS

Puritans living in Massachusetts in 1620 had much to ponder. Dedicated to living a good life, those Puritans understood that to do so requires that a good life be understood. But how is that to be done? The ancient Aristotelian-Scholastic understanding of science and reason once provided the means for doing so. But such contemporaries of the Puritans as Francis Bacon (1561–1626), Thomas Hobbes (1588–1679), and Galileo (1564–1642) advocated a new type of science and reason. In the midst of these disputes, the Reverend Richard Baxter (1615–1691) produced work that would clarify the development of the Puritan mind. Baxter advocated the essential doctrine of Puritanism: to fulfill one's duty to God in science, ethics, and art.

But how was that new understanding of science and reason to be reconciled with God? That problem remains today—be we Puritan or not. The desire for a faith in harmony with science and reason is not just a concern for being in harmony with God. It is a concern that science and reason be in harmony with truth, with objective meaningful completion. Without truth neither science nor reason make sense; if there is no *why* to the universe, then there can be no knowledge of reality beyond that of momentary power, and civilization collapses.

Some would deny that this is the case. Positivists and modernists take for granted that science and faith are distinct realms; postmodernists take for granted that science and reason are grounded not in meaningful completion (or Being) but in pointless process (or becoming) and that civilization ought to collapse to set us free from dogmatic oppression. Therefore neither can accept the scientific

and rational goal of obtaining some degree of knowledge of purposeful reality, of obtaining a glimpse of truth.

The Enlightenment's distinction of science and faith, and its denial of Being as meaningful completion, may be superficially addressed: we can choose to celebrate science as fact while ignoring faith or purpose. Science is assumed by positivists to be objective; faith in or knowledge of a purposeful world is viewed as superstition or worse. This employs what is at best a circular argument: positivists are good, so nonpositivists must be either bad or foolish. At worst, positivists incoherently advocate a denial of faith and purpose while proceeding via their metaphysical faith in a world informed by purposeless process—or becoming.

This framing of the argument is unscholarly, at least if the purpose of scholarship is to obtain truthful knowledge. The problem is that scholarship grounded in purposeless process is scholarship grounded in the will. As such, rational scholarship can no longer be preferred over willful scholarship, but a willful scholarship—or culture—makes no sense.

Nonetheless, the purpose of the following discussion is to escape the charge of superficiality or prejudice by critically examining the now common prejudices of positivist scholarship. The reason for doing so is to remedy the arbitrary and incoherent assumptions implicit today in the study not only of culture, but of science and reason. The study of early American culture obviously requires a consideration of Puritan belief. Since the Puritans were not positivists, the critical task is not to lament their position, but to consider why they were not, and what they thought was—and currently remains—at stake.

Since its colonial period, and its founding as a nation in 1776, America has been at the epicenter of the struggle over what constitutes Western culture. The interactions between Puritan and positivist are just one such example. The Puritans were but one group within that struggle. Indeed, historical contingencies resulted in three major and contending cultural traditions being thrust together within a single geographic, social, and intellectual entity. Those cultural traditions are the classical-Judeo-Christian, the Anglosphere, and continental modernism-postmodernism. It is, to say the least, a volatile mixture.

Each tradition claims that it offers a unique and valuable means by which persons can properly understand the world and life. At times complementary, at times antagonistic, those three major cultural and intellectual traditions affect our understanding of *science* and *reason*, and by extension, culture, ethics, and art. They contend for our belief, conscience, and action. How we combine or separate those traditions results in what is commonly referred to as Western culture.

The classical-Judeo-Christian tradition shares a commitment to the rational pursuit of wisdom. Greek, Jew, and Christian accept the foundational principle that ultimately the universe is informed by purpose and obtaining glimpses of that purpose is the role of science and reason. Both science and reason seek truth and seek knowledge of a purposeful and therefore beautiful world. Beauty is a glimpse of meaningful completion. Major intellectual figures within this tradition are Plato, Aristotle, Paul, Plotinus, Ambrose, Augustine, Aquinas, Luther, and Calvin.

The Anglosphere[1] shares a commitment to the foundational principle that culture is informed by traditionalism; culture, science, politics, and law are grounded in a social process, the purpose of which is to realize the truth. With ancient sociological roots—Pelagius, for example—a defining political moment for the Anglosphere was the signing of the Magna Carta in 1215. That document mandated the right of the governed to participate in that cultural and legal traditionalism. The Anglosphere also argues for a scientific traditionalism, so both politics and science are process-oriented. But that political, legal, and scientific traditionalism starts to deconstruct during the Baroque. When connected with classical-Judeo-Christian thought, a process-oriented traditionalism seeks a purposeful politics and science; we live in the realm of becoming but strive to obtain a glimpse of Being. But devoid of purpose, process science (e.g., Darwinism) and philosophy (e.g., Whitehead) make no sense.

Continental modernism-postmodernism has a different pedigree. The scientific and ethical paradigm of pre-Gothic Christendom begins to disintegrate. As the New England Puritan was well aware, the Scholastic science (or *scientia*) of Roger Bacon (c. 1214–1294) is at odds with the new positivist science (or *scientism*) of Francis Bacon (1561–1626). And the later Darwinian reconciliation of Bacon's positivism with an organic traditionalism marks a shift away from Aristotelian natural science from an intelligible to a nonintelligible science because an Aristotelianism that no longer includes final causes makes no sense. The problem is that neither physical nor organic science makes sense in a world without purpose. It is at odds with the very goal of science: knowledge that remains fast and true. To say that change is truth is to say that knowledge is reduced to purposeless willful process. A focus on process, or becoming, is central to postmodern science and religion; that focus will be critically considered in the following chapters. The present point, or premise, is that when knowledge is understood as purposeless process, then knowledge is arbitrary and willful. An arbitrary and willful science necessitates a corresponding understanding of reason, politics, and theology. That understanding is a violent and nihilistic narcissism.

Francis Bacon is considered to be a foundational figure of positivism, and by extension, of the modernist-postmodernist tradition. His influence on the Anglosphere is part of an intellectual pedigree whose roots go back to medieval Scholasticism—in particular the conceptualism of Abelard and the Aristotelian-Averroist splitting of science and faith. The empirical Scholasticism of modernist-postmodernist tradition denies reason a role in obtaining knowledge of a purposeful world. It denies that science attempts to understand the purpose of things and thus can be reasonable and endowed with meaning. A meaningless science necessitates a meaningless reason and faith. Equality or power become the new gods. Later proponents of this worldview are Newton, Kant, Hegel, Marx, and Nietzsche.

Although these three primary cultural traditions exist as identifiably distinct entities, they also interact historically. In science, Newton and Darwin find themselves at a crossroad: to remain dedicated to the Anglosphere's traditional association with the classical-Judeo-Christian understanding of a purposeful world, or to realign themselves within modernism-postmodernism. In America, Jonathan Edwards, C.S. Peirce, and John Dewey face the same problem of reconciling classical-Judeo-Christian tradition with that of Newtonian and Darwinian science. Many other examples could be cited. What all share is the foundational issue of reconciling science and reason with truth, reconciling becoming with Being, process with purpose, freedom with responsibility. That challenge is not limited to American, English, or Western culture. It is now shared by all wisdom-seeking traditions in West and East, North and South. It is shared by all who hope for a culture above process and power. The cultural assault of modernism-postmodernism is an assault upon the very possibility of objective knowledge. Indeed, it constitutes an assault upon the very notion of civilization. As such it is a tragedy of worldwide proportions.[2]

So the crux of the matter is that within Western culture today science and reason are understood in radically different ways by these three major cultural trends. Consequently, American and Western culture are currently in deep internal conflict; how we can understand culture, ethics, and art is in conflict as well. But this may not be recognized at first due to the recent dominance of our major cultural institutions by modernist-postmodernist ideology. The now dominant modernist-postmodernist tradition is foundationally positivist, maintaining that empirical science is the only valid source of objective knowledge, and that reason and virtue are not grounded in reality. But when reality, ontology, or Being is defined as fact and process (or becoming), knowledge and virtue are reduced to fact and power. Culture, the humanities, and religion are then judged to be sociologically factual and subjective phenomena lacking rational intellectual foun-

dation.[4] As such they are destined to be replaced by the social sciences, which employ the *scientific method* in studying human conduct. There are facts, and there are feelings, which in turn are grounded in instinct or willful passion. There can be facts about how we statistically behave based on our feelings, but beyond the factual and emotional, or rather, beyond *scientism* and *emotivism*, lies a realm void of meaning and purpose, at least of purpose beyond a solipsistic self-realization and self-expression. For the positivist, a purposeless natural and social science dominate, and all attempts to find knowledge beyond that quantitative vision are futile. *The humanities, the fine arts, and religion, indeed culture as such, are reduced to entertainment, therapy, or masks for power.*

That now dominant understanding of science and reason results in a tacit denial of the foundational principles of the classical-Judeo-Christian tradition and its historical ally, the Anglosphere. It is also a denial of all traditions around the world (e.g., Buddhism, Confucianism) that hold science and reason to be united in the goal of obtaining a glimpse of wisdom. Indeed, it results in a tacit denial of the very possibility of culture. It does so by denying the possibility of responsible freedom in the pursuit of a purposeful reality and life. That denial reduces science to mere fact, reason to mere rationalization or experience, and fine art to artifact. In a purposeless world of fact, rationalization, and experience, all cultural aspirations conclude in an ontological existentialism that is better known as nihilism. That is, we assert the freedom and right to aspire to self-expression and self-realization within a purposeless existence. Therefore, there can be no such thing as a distinctly qualitative realm of culture and fine art. Nor can there be such a thing as responsible freedom. The consequence of this is a denial of a qualitatively distinct culture and fine art.

Western culture is historically dedicated to the pursuit of wisdom wherever and however it might be found. As such it offers a cosmopolitan alternative to the provincial assumption that culture is mere fact and power. Culture is beyond a willful positivism, beyond the quantitative and willfully sociological. It is more than a matter of ethnic or religious identity; it is more than the sum of what we merely do. Rather, culture is the product of leisure and the object of our thoughts.[5]

The Puritan refers to such leisure as the Sabbath, a day not just of rest but of reflection as well. The Sabbath, or leisure, is associated with the rise of culture because it permits us the time to reflect on the world and our place in it. The Puritan thus democratizes participation in the liberal arts, once the privilege of the aristocratic class. Active reflection on the purpose of life makes possible responsible freedom by the exercising of conscious deliberate choice; as such it is deemed the finest activity humans can engage in. Such reflection is self-conscious, a realization that we think, we live, we experience death—and perhaps more.

Between life and death occur guilt about the past, boredom with the present, and anxiety about the future. Self-conscious reflection has an object: to understand what meaning, what hope and joy, transcends guilt, boredom, anxiety, and even death.[6] That transcendent goal is the ground for the liberal arts, the arts of the Sabbatical mind, and responsible freedom. In an existentialist-positivist context the liberal arts—and responsible freedom—cease to matter. The liberal arts are replaced by a purposeless narcissism, pseudopracticality, and positivist science. Leisure is dedicated not to a worship of wisdom and life, but rather to a worship of power and death.

The Puritan does not choose between science and religion, but rather between worshiping (or privileging) death and despair vs. worshiping life and responsible freedom. It is the commitment to life and responsible freedom that constitutes culture. Science is then knowledge, not mere fact; it involves knowing, doing (ethics), and making (art). That unity evidences a vision of reality, of that which is true; that in turn is made manifest in how we choose to act—in pursuit of the good. Thus science is more than fact grounded in death; it is knowledge of what is understood to be true, good, and beautiful.

So the Puritan has much to think about, as do all who hope to rise above fact and power in science, ethics, and art. But to do so requires that the Puritan—and all who seek wisdom—be taken seriously. The assault on this understanding of culture since the Baroque results in a radically incoherent situation that undermines the very notion of civilization. It wreaks havoc not only on culture, but on the efficacy of science and reason as well. Just as science can no longer be wise (*sapientia*), fine art is no longer understood as the attempted objectification or reminder of wisdom. Neither offers some degree of knowledge of a meaningful reality, even a partial understanding of that which is both true and good. Leisure, once elevated to the realization of the highest of human qualities, is debased to a solipsistic narcissism which even Nietzsche recognizes and laments.[7]

The history of art makes abundantly clear that this situation contradicts the historical norm for how culture is recognized as such. But today that historical norm is deemed abnormal. Fine art, science, and ethics are denied the possibility of being truly liberal arts, dedicated to the qualitatively true and good. Instead, each is reduced to quantitative facts, feelings, and power. They are reduced to a positivist vision that results in a reduction of culture to existentialism. Ethics thereby assumes a variety of modes: from the deontology of Kant to the utilitarian and pragmatic ethics of Mill and Peirce to the denial of objective ethics by Nietzsche. All ultimately conclude in culture reduced to calculations of power and violence.

This book is not written from a positivist perspective but rather a normative one. Its perspective grasps that culture rightly centers on responsible freedom—as opposed to mere nature, nurture, or the will to power. It is also a defense of the very existence of the liberal arts. This position is obnoxious to the positivist mind that finds the normative to be false and therefore oppressive. Since there is no wisdom, says the positivist, then culture is indeed oppressive; such a false culture should be transgressed. The sociopath, in this view, is the patriot and champion of freedom. But in the name of such transgressive freedom operates a dogmatic existentialism in science, ethics, and art. Furthermore, normative notions cannot be escaped. It is a matter of what shall be judged normative. There are two fundamentally opposed visions of the normative: that claims of wisdom are false and oppressive, or that claims of wisdom help liberate us from ignorance, violence, and despair.

Two Views of Normative Culture

Writing a book on the history of American art occurs within a normative context. That normative context is grounded in assumptions about the nature of knowledge, history, and culture. That context can be sympathetic to the importance of the fine and liberal arts and culture, or not. In our present positivist milieu, the writing of a book on the history of American art is reduced to a matter of facts, feelings, and subjective preference. Or to put it differently, in our current cultural milieu the idea that a book on the history of American art might result in our obtaining a glimpse of practical and enduring wisdom cannot seriously be considered. Such a transgressive notion of scholarship makes little sense. So what does make sense for the positivist? Scholarship focused on process or *becoming* lacking purpose or *being*. It therefore lacks intrinsic justification beyond being merely transgressive. To transgress for the sake of transgressing offers no positive message and serves no redemptive purpose. It can only celebrate a willful vacuity. A tacit acceptance of a positivist methodology denies that culture and art history can offer practical insight on the meaning and purpose of life. This reduces fine art and culture to entertainment, therapy, or expressions of subjective preference and power.

We can begin to reveal the tacit influence of positivism on our lives by recognizing how our very use of language is now deeply informed by positivist prejudice. The term *science* is differently understood amongst the three major or historical traditions within American and Western culture. Specifically, the classical-Judeo-

Christian tradition views science as *scientia*, as the realms of becoming and fact rising to knowledge of idea and Being, whereas the modernist-postmodernist tradition views science as *scientism*, as limited to positivistic fact and becoming. The Anglosphere has historically vacillated between the two. So too has the Puritan.

Within the Baroque repudiation of Scholasticism, *scientia* and *sapientia* are replaced by scientism. The term science properly refers to knowledge. It was once widely recognized that knowledge could involve matters beyond the factual. Science is thus understood as knowledge of that which is true. By extension, *sapientia* is understood as knowledge of that which is both true and good. However, since the Baroque, science is commonly limited to scientism, to the collection of quantitative data and empirical facts; *scientia* and *sapientia* simply disappear. Science is now that which is composed of verifiable (or as Popper puts it, falsifiable) facts. Physics and social science are scientific; theology, the humanities, and the fine arts allegedly are not. Some fields of study—such as political science—at best remain ambivalently conflicted between a quantitative and a qualitative view. So stood the Puritan in 1620, and so we stand today. *The remedy to a quantification of science, ethics, and art is to renew the search for a qualitative understanding of each—and all.*

To do so is to escape the trivialization and brutalization of culture by the modernist-postmodernist tradition. In colonial New England, that tradition manifested itself as both positivist and deist. Later it became polytheist and pantheist. In all cases, reason is trivialized and brutalized. Correspondingly, both religion and science are brutalized.

The modernist-postmodernist attempt to reconcile positivist fact with reason results in a redefinition of reason and of reality. In place of reason as the means by which we attempt to understand a meaningful reality, modernist-postmodernists redefine reason as a mental construct with which we as gods make meaning (Kant and Comte), a violent dialecticism (Hegel and Marx), or a mask for power (Nietzsche). This results in a nihilistic reduction of science, ethics, and art to willful *quanta*—be they rationalized or not. In contrast, the classical-Judeo-Christian tradition maintains that the qualitative realm is above the quantitative, and that reason is the means by which we seek to rise above ignorance or mere willful experience to understand a meaningful reality and life. Reason permits us to understand how phenomena obtain meaningful completion. Within the American tradition, the role of both science and reason is to escape a destructive quantification of culture; *we can rise from a violently quantitative pluribus to a qualitative e pluribus unum.* We can reconcile becoming with Being, freedom with responsibility. As free and responsible individuals, we can be united in the pursuit of truth, goodness, and beauty.

We can do so because science, ethics, and art are substantively and quali-
tatively one, and their unity establishes that we do not face a choice between
scientific fact and teleological or cosmological fiction. Rather, we face a choice
between a transgressive and sociopathic vision of culture and one dedicated to
responsible freedom. When reduced to willful *quanta*, to purposeless data, cul-
ture as the unity of science, ethics, and art is not denied, but trivialized and bru-
talized. The quality of that unity is therefore dismal. So it is not a quantitative vs.
qualitative approach to culture that matters. Rather, *a quantitative approach is a
qualitatively deficient and reductionistic view of science, reason, and culture.*

Culture presents, then, a consistent worldview, one that is by varying degree
recognizably qualitative and beautiful. In contrast is the (qualitatively deficient)
quantitative and aesthetic viewpoint of modernism-postmodernism. That con-
trast is evident in the distinction between a qualitatively deficient multicultural-
ism and a qualitative cosmopolitanism, specifically a cosmopolitanism grounded
in Being. This can be illustrated by considering the Puritan contemplating the
social practice of slavery.

The multicultural viewpoint is grounded in the notion that all cultural view-
points are inherently equal and essential to the self-expression and self-realization
of its adherents. The problem then occurs as to what should be done about so-
called cultures that believe in slavery, rape, or cannibalism. From a multicultural
perspective, so-called cultures that hold slavery to be good cannot be criticized.
To do so is to attack their equality and authenticity. What, then, of those who
posit a universal morality based on human reason?

Kant notoriously held that Africans were inferior to Europeans, as did Locke
and Hume.[8] Indeed, the Enlightenment itself is historically and closely associated
with the rise of an alleged scientific racism.[9] In contrast, it was the Puritan who
was long critical of such thinking. So the Puritan finds multiple allegedly scientific
and rational justifications for the slave trade made by the major thinkers of the
Enlightenment. Nonetheless, that trade is seen as an abomination in Puritan faith
and theology.

But if theology holds no influence, how can the issue of slavery be resolved?
The fact that Puritanism was crucial in the abolition of slavery warrants close
attention. It deeply alters the idols of the positivist tribe (to paraphrase Francis
Bacon) concerning its image of itself and its view of nonpositivists. And it raises
the possibility that the pursuit of wisdom is not antiquated but can and should still
prevail.

Multiculturalism is championed by the modernist-postmodernist tradition as
intellectually and sociologically necessary and in America and Western Europe as

demographically inevitable. It is intellectually necessary only if one views knowledge as fact and power; multiculturalism is merely a necessary extension of nominalism. Multiculturalism is socially and demographically necessary only if one equates culture with race or ethnicity—as do the postmodernist advocates of an empirically based authenticity. In either case, it is a stance that reflects modernist-postmodernist ideology rather than reality; it is dogmatically nominalist and positivist. A nominalist and positivist *culture*, however, makes no sense. Furthermore, a benevolent multiculturalism depends upon the Kantian notion that cultural conflicts can be resolved via secular deontological reason. That notion has been refuted not only by Nietzsche, but by the historical record of the twentieth century. More than one hundred million dead refute the hope that liberal equalitarianism can prevail or be reconciled with postmodernist identity politics. A multicultural vision is nominalist, positivist, and relativist; it is intrinsically incoherent in its simultaneous advocacy of equality and identity. Moreover, it is culturally destructive by its denial of the qualitative realm.

The Puritan was not provincial but remarkably cosmopolitan. As evidenced by their portrait paintings, the content of their displayed bookcases make clear that they were deeply interested in how various peoples and cultures throughout time and around the world sought wisdom. Similarly, *this book is informed by a cosmopolitan pursuit of wisdom and beauty*. It is a pursuit that examines which cultural traditions in part or whole are worthy of our attention, of our dedication. By so doing, we rise from a false pluralism (which is actually dogmatically relativist) to a cosmopolitan pursuit of truth, goodness, and beauty. Thereby we come full circle to a reaffirmation of the pursuit of truth central to traditional American and Western culture.

An Optimistic Realism

Thoughtful Puritans, those respecting the Sabbath as a lofty form of leisure, had other things to contemplate as well. In 1620 they could contemplate the nature and meaning of gravity. They would remember Dante's famous explanation of gravity as Divine Love: the planets move as an act of meaningful completion. But they also know of Galileo's understanding of gravity as material force. So again, the Puritan is torn between two views, as are we: a scientific understanding of gravity as material force in a mechanical or purposeless world, or a scientific understanding of gravity as the impulse towards completion as an act of cosmic Love. But that choice is not one of science vs. faith. Nor is it one between Scholas-

ticism and the Enlightenment. It is between the subjectivity or the objectivity of truth and knowledge. It is a choice between pursuing power or knowledge.

Scholasticism methodologically assumes a metaphysics of meaningful completion. According to Scholasticism, gravity is evidence of meaningful completion as an act of Divine love. But in the positivist methodology of Bacon, Hume, Newton, and Kant, confusion reigns. Methodologically, positivism denies the possibility or desirability of metaphysics as knowledge, but as a matter of practice it offers a particular knowledge of metaphysics. It affirms a scientific rationalism but requires a nonscientific and irrational metaphysics. It methodologically assumes that we live in a fact-based and purposeless world. Therefore the positivist redefinition of science and reason smuggles into our discourse a metaphysics grounded in power. For Newton, gravity is a material force made by an inscrutable God. For the Puritan, gravity is created and perhaps directed by the Will of God. For Kant and Berkeley, gravity is a mental construct. Finally, for Comte, gravity is a material fact with no explainable source. That same explanation had been critically viewed by Newton as dangerously magical: the universe driven via mystery.

However historically diverse our scientific understandings of gravity might be, to the positivist only one understanding ultimately makes sense: it is a material or willful mystery that offers us power. Since knowledge must be limited to fact and feeling, it is unrealistic to seek a reason for either. Our ability to even consider that such reasons might exist is radically assaulted. If we "know" there is no truth beyond material or mental experience, then we are not inclined to seek knowledge of that which we know we cannot know or hope for. Pointing out the logical contradictions of this position does no good in attempting to convince those who no longer believe that logic or reason can be connected with reality. Positivism—which purports to free us from dogma—denies our current and future ability to consider whether choices beyond positivism even exist. The denial of reason is a denial of responsible choice. By its denial of responsible choice, any future choices are deemed necessarily a matter of coercive fact and subjective preference. Even assumedly good intentions or alleged historical necessity offer no solutions, since neither intentions nor history can be good or bad in the context of a positivist world of facts and process (becoming).[10] The result is that we are again caught in an intellectual and scientific historicism which either trivializes or makes absolute the moment.

It is fortunate, then, that we are not really bound by its advocacy. There are many other types of metaphysics to consider, other ways of understanding science and reason. This is recognized by a proponent of the Anglosphere, the American pragmaticist philosopher Charles. S. Peirce. He notes that since positivist meta-

physics cannot be known, and metaphysical knowledge can never be complete, we have a perennial responsibility and the freedom to question all of the metaphysical claims we inevitably encounter—even the positivist. Positivist dogma notwithstanding, there are other ways of considering science and reason beyond that of modernist-postmodernist scientism.[11]

Peirce makes clear that positivism itself is a form of metaphysics—and not a particularly compelling one. The current and false dichotomy between science and religion is a mask to hide a new religion that claims to be beyond religion by being objectively scientific—and socially tolerant. But deterministic fact and subjective feeling are in conflict, just as are tolerance and authenticity. As such they evidence a new and incoherent dogmatism. That dogmatism is masked by a false distinction between science and religion that if naively accepted trivializes science and reason and destroys both culture and fine art.

Whether or not we agree with the intellectual assertions of scientism, a common substantive principle remains foundational to and thus unifies science and religion. They share a single conceptual goal: to comprehend reality. If a positivistic science is mandated, then so too is mandated a positivistic religion, ethics, and art. But such a narrow mandate is neither necessary nor beneficial. Rather, it marks a historically and intellectually narrow viewpoint that is culturally transgressive

So it is intellectually incoherent and socially irresponsible to speak of a historical necessity in reducing knowledge in science, ethics, and art to a positivist and quantum realm lacking purpose. And it is destructive in that to do so is to deny the very possibility of a qualitative realm. Nonetheless, this positivistic reductionism of science, ethics, and art—indeed knowledge—is today pervasive. Knowledge is subjectified and made willful; it is blind to the possibility of any final cause or causes, and blind to the possibility of any objective purpose in reality and life. It is tacitly and perversely assumed that belief in a meaningless metaphysics is objectively valid—and scientific.

To study cultural traditions that believe in the substantive unity of truth, goodness, and beauty via a positivist science that denies the numinous is not an act of scholarship but of violence. Positivist science is methodologically blind to the possibility of a meaningful and purposeful reality. It is prejudicially and dogmatically committed to a scientific and cultural existentialism. From that viewpoint, all traditions that believe in a meaningful existence are deemed, *a priori*, wrong. But of course, such *a priori* knowledge is denied legitimacy by positivism.

Two of the three major traditions here discussed—the classical-Judeo-Christian and the Anglosphere—are thus eviscerated. The classical-Judeo-Christian

pursuit of wisdom is assumed wrong and the Anglosphere no longer has any purpose. A purposeless traditionalism is by definition nihilistic. But it is not just Western culture that is deeply and adversely affected. All such traditions around the world (e.g., Buddhism and Confucianism) are judged wrong. They are wrong because modernist-postmodernist metaphysics are deemed right. So it is not only that the classical-Judeo-Christian tradition is wrong—all such wisdom-seeking traditions around the world are wrong.[12] They are judged wrong because they fail to accept the premise that science is limited to fact and reason to rationalization or power. Therefore, scholarly studies of how science, ethics, and art are one are impossible to conduct because they require a degree of objectivity, a degree of metaphysical insight, and a glimpse of a metanarrative assumedly not really available.

A Renewed Pursuit of *Scientia* and *Sapientia*

To the seeker of wisdom and beauty, culture offers a higher perspective than that obtained by facts or feelings. It offers the hope that we can pursue a better path than those of scientism (in which meaning is reduced to mere fact), social science (where human behavior is commonly understood via descriptive, predictive facts grounded not in the free pursuit of wisdom, but in statistical probability), or by an emotivist reduction of all judgments of quality to a matter of emotional, subjective preference or experience. And it rejects the pursuit of fairness, pleasure, and authenticity as vice masquerading as virtue. Instead, it advocates a cosmopolitan and perennial commitment to responsible freedom; that each of us has the right and responsibility to individually attempt to comprehend what is true and good in reality.

This study of American culture centers on how, historically and currently, those living in that culture choose to live and act, and the quality of those choices. The quality of those choices is based upon an understanding of the unity and substance of science, ethics, and art. The quality of our actions reflects that knowledge and more. It reflects our intentions and our resolve. To the modernist-postmodernist, a good will is the foundation of modernist-postmodernist virtue—and vice. But traditionally, a good will is not enough. Our intentions and resolve—via virtue or Grace—must be grounded in wisdom.

Approaching science and culture as the attempt to better understand a purposeful reality and life is to transgress the current positivist limitations on both. It is to reaffirm the perennial importance of the humanities, culture, and of the sci-

entific and religious pursuit of truth. It is to recognize that the attempt to under-stand scientific facts involves shifting from mere descriptive facts, *quanta*, to the qualitative realm of understanding. Physics is the attempted description of phe-nomena; metaphysics is the attempt to understand those phenomena. Both Aris-totle (*Metaphysics*, Book V, Chapters 13, 14) and Kant affirm that to understand physics we must go beyond physics—which is literally to engage a metaphysics and a rational metanarrative. Or to put it differently, for physics to be understood, we must rise *above* physics.

When positivism explains the world, it can offer only a metanarrative that is existential. Allegedly, we can be knowledgeable of facts and experiences, but we cannot be knowledgeable about how those facts and experiences properly qualita-tively unite. But that denial is impossible since they either unite in the pursuit of wisdom or they unite in the pursuit of power. Lacking the possibility of wisdom, human understanding is transformed into human willing. The goal of conscious-ness is then not to obtain objective understanding of reality and life, but to make reality and life conform to our understanding. The goal is alchemical. *This, then, is the intrinsic flaw of positivism: in the name of objectivity it concludes in subjectivity by affirming that beyond mere fact is a metaphysics, and metanarratives, that are the products of the human will.* Those metaphysics and metanarratives grounded in the human will may focus on race, gender, economic class, or the individual will; they may focus on pragmatic and equalitarian notions of fairness; but all deny virtue, wis-dom, and responsible freedom.

Unfortunately, this is a flaw which the modernist-postmodernist cannot rec-ognize because it is beyond the reductionism characteristic of positivism.

To assert that the common facts of vice and violence preclude the possibil-ity of noble wisdom makes no sense. Actuarial calculations establish the statisti-cal norms of the occurrence of harmful accidents, crimes, and illness, but those statistical norms are not ontological norms. *A statistical norm does not establish the inevitability or the desirability of an occurrence or preference.* Nor can notions of toler-ance and identity. None establish the necessity or desirability of self-expression and self-realization, much less crime. None establish why we should deny the pursuit of wisdom and beauty.

Positivist social science attempts to replace the humanities and religion as a source of knowledge of the human condition. What it achieves, however, is a false limitation and trivialization of that condition. It denies our ability to make objectively meaningful choices in life. This philosophical position reduces science to the mere pursuit of purposeless facts and reason to mere rationalized exis-tence—be it statistically describable or merely willful. The positivist assumption

produces two culturally destructive and mutually contradictory conclusions: *it simultaneously asserts that culture is either the product of empirical science, or is irrelevant to that type of science.* The Baroque-romantic shift to feelings parallels the shift to positivist facts. The perennial association of mysticism with empiricism prevails. Its affect upon ethics and art is, of course, devastating.

When knowledge is limited to *scientism*, a paradox occurs for culture: it can either be a matter of social science or meaningless choice. The proponents of race, gender, and economic class can offer no rational understanding of life beyond process—or becoming. Whether they achieve equality—or superiority—the same dismal conclusion remains: self-expression and self-realization in a world without being is empty. The goal of life is to escape oppression, but there is no escape—only the gift of death.

Expanding the current definition of science is necessary because that definition denies the very notion of culture and fine art as qualitative knowledge. *Scientism* is limited to the realm of fact; it is descriptive and predictive. It cannot accept the possibility of wisdom and responsible freedom since wisdom is more than descriptive and freedom cannot be predictive. The critical problem is that *scientism* offers a historically new and artificially limiting definition of knowledge that is methodologically blind to the notion of pursuing qualitative knowledge. It prejudicially denies the cultural possibility of wisdom, of knowledge that is both true and good. Consequently, *scientism is hostile to the notion of culture as the realm of responsible freedom.* Public culture alternates between being totalitarian or sociopathic. Each assumes that public culture centers not on *scientia* or *sapientia*, but on power to be enjoyed or resisted.

Being and Becoming Reconciled

In contemplating our duty to God within a mechanical universe, a seventeenth-century Puritan aspires to understand the relationship of God or Being with the facts and processes of the world in which he lives. The Scholastic understanding of a physical and cosmic synthesis of matter with the Divine was thought no longer to be scientific or rational. The relationship of Truth or Being with facts and becoming was now unclear.

The consequences of the Baroque separation of truth and love into fact, a willful rationalism, and power continue to deeply affect our thinking today. They affect what we assume to be good scholarship and how to pursue it. The philosophical unity of Being, becoming, and fact has been subjectified by modernists

such as Kant, and redefined by postmodernists such as Heidegger. This results in foundational shifts in our thinking and our lives.

Newton was a deist; he aspired to fact and logical (or mathematical) clarity while maintaining that intelligent design clearly inferred a cosmic intelligence. However, deism is but a stepping-stone to the denial of wisdom and Being. Newton's deism—his belief that God made the world as a perfect machine and set it spinning according to natural law—makes God or purpose irrelevant or dangerous to existence. Lacking purpose, what remains is often brutal existence alone. Figures such as Jonathan Edwards were well aware of such implications and feared them. One implication is that no purpose exists; another is that if God exists, then why would such a dangerous world be made?

That poses a question that is a perennial challenge to the very idea of culture: if virtuous people suffer, then why ought one be virtuous? Both the Puritan and the Kantian reliance upon duty is a weak response. The duty to do God's will (Edwards) or humanity's will (Kant)[13] is neither a scientific nor a rational position. It is a willful position. A willful knowledge—in science or religion—is no knowledge at all. Truth cannot be willed except by God, and even then, it involves more than just the divine will. These issues will be discussed within a historical narrative shortly. To prepare the context for that narrative, it is essential to recognize that the core issue since the Baroque is that of the broken relationship of reality and rationality. It was an issue that Hegel recognized, but failed to resolve.[14] It remains to be solved.

What is currently absent is the notion that science and reason can combine in the historical pursuit of that which is *objectively and transcendently* true, good, and beautiful in reality. They can combine in the timely realization of degrees of wisdom rather than nihilism or absolutism. In that case, history is more than meaningless fact, or subjective narrative, be it trivialized or a matter of identity. History is an intellectual and moral drama associated with conscious responsible freedom. It involves meaningful memory; memory constitutes our knowledge of the past, informs us of the present, and affects us in the realization of the future. It provides us with solutions to guilt, boredom and fear, namely faith, love, and hope.

The history of American culture holds that history can be more than an empty platform for the aesthetic pursuit of nostalgic or descriptive facts and emotional response. And it can be more than a platform for violent narratives focusing on power suffered or enjoyed. Rather, history is the narrative of culture engaged in the vital pursuit of a unified science and reason. They are unified not by the power of the scientist but by the reality of a purposeful world. In such a world fact

and feelings rise to truth and love, and truth and love are one in that both seek completion in a purposeful world.

In this case, science is understood as purposeful knowledge (not just facts and power), and culture is the timely and practical application of that knowledge. It is neither scientist nor priest as authoritarian source, but rather a community of individuals committed to the free pursuit of wisdom. That pursuit of wisdom permits a violently quantitative pluribus to rise to a qualitative *e pluribus unum*.

This understanding of history and culture takes as foundational that time is not existential (*kronos*), but meaningful (*kairos*). Meaningful time (*kairos*) is championed by the New Testament and by St. Augustine. As the latter puts it, within the context of a meaningful world, truth and love are one, and history is memory of the past, an awareness of the present, and the anticipation of a meaningful future. History involves knowledge—that is, science—of the past, present, *and* of a desirable future. It involves an active intellect (science) with purposeful memory (reflection), an awareness of the present (cognition), and hope for the future (the practical pursuit of wisdom). Thus understood, history is central to the unfolding of ontological science and reason. It is obtaining glimpses of being within the confused realm of becoming. Without hope of such knowledge, science, ethics, and art are trivialized and our future is condemned to existentialism. An existentialist science reduces knowledge to the will to power; it is a reductionism that is personally, culturally, and politically terrifying.

In art, history, science, and scholarship, a meaningful narrative requires an object. It requires Being. That object makes possible hope, love, and truth. It provides a goal to be realized: the possibility of qualitative completion. It requires the existence of what Aristotle (and Kant and Voltaire as well) calls *final causes*, and what other traditions call the Logos, the Ideal, Dharma, Truth, and the Tao (to name but a few). Hope inspires conscious and responsible choice; such choice results from knowledge of our need to make good choices, those that aspire to be in harmony with a qualitative universe and a qualitative existence. Those choices are contemplated via memory, practiced via action, and informed by purposeful expectation. Each centers on science as the pursuit of knowledge, in the pursuit of *Being*, rather than mere *becoming*.

Those who advocate *becoming* via a constructive self-expression and self-realization, be they utilitarian, pragmatic, or modernist, are plagued by the postmodern penchant for *unbecoming* behavior. That *deconstructive* utopianism is found in Rousseau (who celebrates the noble savage), Marx (whose vision of utopia is where the state and culture ultimately wither away), and Nietzsche (for whom culture is the great oppressor of the individual spirit). It is important to note the presence of

a deconstructive impulse at the very heart of identity-based utopianism: the primitivist, the Marxist, and the Nietzschean all advocate deconstructing culture to reach an unfettered utopia where all can be as they will. That utopianism is based upon the assumption that civilization as the pursuit of wisdom is corrupt. Instead is advanced the notion of culture as a matter of authenticity, an authenticity above qualitative and critical evaluation. To evaluate an identity-based creed is allegedly an attack on a person's or group's identity and its attempt to escape oppression or reach self-actualization. Given that premise, a call for critical evaluation of such culture-claims is viewed not only as lacking purpose, but lacking benevolence as well. The irony, and tragedy, is that replacing the pursuit of objective truth (or transcendence) with the pursuit of an earthly utopia evidences malevolence. The will to make society and other people conform to a particular vision of heaven on earth is inescapably violent. In their utopian zeal to make heaven immanent they neglect to consider the possibility of their creating an image of hell.[15]

A New Methodology

We can escape the limitations of the modernist-postmodernist paradigm by reconsidering the pursuit of a qualitative knowledge of reality and life. To be effective, that reevaluation must go beyond a mere critique of emotivism and scientism to a renewal of *scientia* and *sapientia*. It must address an ontological question: is it more realistic to be a pessimist or an optimist?

Paradigm shifts in our thinking are not limited to those that are aesthetic, a matter of style; it is not merely quantitative and perceptual shifts that are possible. It is also possible to obtain qualitative shifts in science, ethics, and art. This involves a reconsideration of the intellectual merits and the profundity of the English tradition (the Anglosphere) and the classical-Judeo-Christian roots of Western culture (particularly as offered in the West by the Augustinian tradition). It requires that we reconsider anew their notion of *scientia*, a notion that permits us to pursue knowledge of a meaningful reality and life; a positive ontology is, then, the object of a wisdom-seeking science—or *sapientia*.

As the study of *Being*, ontology is the study of the nature of objective reality. Western culture is traditionally informed by an optimistic ontology. In a modernist-postmodernist context, the study of ontology is either denied or redefined as process, as *becoming*. It thus denies that reality evidences purpose, that reality can to some degree be understood rather than just described. Lacking this aspect, modernist-postmodernist ontology proceeds via an ontological pessi-

mism and concludes in an *un-becoming* violence. It mandates belief in an existential world without ultimate purpose or meaning. Therefore, as David Hume boldly announces, culture is but a false decorum, a false constructivism, masking the will of some to control others.

To escape this violent conclusion, this destructive paradigm can be remedied by recognizing the perennial association of science with knowledge in general (i.e., *scientia*), including knowledge of what is true and good in reality.

Scientism posits a violent world in which there are many varieties of facts, feelings, and willful narratives; but *in a purposeful world, facts and feelings unite via truth and love.* Truth and love are informed by a rightful completion. Becoming and Being are reconciled. Within this context, a variety of possibilities should be entertained in the pursuit of a qualitatively profound understanding of science, ethics, and art. Plato, Aristotle, Augustine, Aquinas, and even Newton, Kant, and Voltaire (as deists) believed in a purposeful universe informed by intelligent design. In our daily lives conscious decision-making involves more than accurate descriptions and subjective stylistic preferences; in a meaningful world we seek knowledge of that which is genuinely true and good. That pursuit begins in variety but seeks unity—*e pluribus unum*—a unity of greater or lesser degrees of wisdom and beauty thus becomes manifest in our lives.

Not very long ago, these observations would have been taken for granted by most of the proponents of Western and American culture. Classicism, Judaism, and Christianity take as normative the pursuit of truth, goodness, and beauty, and the Anglosphere supports the importance of cultural continuity in avoiding violence. These two traditions, the classical-Judeo-Christian and the Anglosphere, historically complement each other. They maintain that science, ethics, and art operate within a meaningful context, and that context permits—indeed justifies—responsible freedom. So to write a scholarly text on American culture only from a modernist-postmodernist viewpoint is not only to deny the core beliefs of the Anglosphere and the classical-Judeo-Christian traditions. It is to be selectively prejudicial, historically reductionistic, and pointless in terms of practicality. It is to produce a factual construction that necessarily deconstructs its object of study.

In contrast, this text is dedicated to a renewal of the practical pursuit of beauty and wisdom, and a study of how in America (and in Western culture) that pursuit was, and is, particularly engaged. It recognizes that how we consciously understand reality and life directly affects how we choose to behave, and that those influences can result in decisions that are for better—or worse. That dedication is intrinsic to the very notion of culture and fine art in general, and to the very substance of Western and American culture in particular.

In sum, within American and Western culture there is now a critical internal battle within a currently incoherent cultural context. Within that context the classical-Judeo-Christian, the Anglosphere, and the modernist traditions are now locked in mortal combat. As Philip Rieff puts it: "Culture is the form of fighting before the firing actually begins."[16] It is not a question of how they might tolerate each other, since all three cannot. Nor is it merely a matter of which one will prevail, since culture as the realm of responsible freedom can never be stagnant. Rather, it is a question of how science and reason might again be in harmony so that culture and responsible freedom might newly flourish. It is a question of renewing the concept of *Being*, and thus relegitimizing both science and reason in the free and responsible pursuit of wisdom.

Studying culture from the perspective that privileges *positivism, scientism,* and *emotivism* makes no sense intellectually or historically. Intellectually, to sociologize culture is to deny its qualitative and volitional substance; historically, most of the history of Western and American culture is resolutely opposed to a reduction of life to mere facts, feelings, and (de)constructivism. During the nineteenth century the Victorians attempted to revitalize the classical-Judeo-Christian tradition. Some in the twentieth century also attempted reform. European scholars such as G. K. Chesterton, F. R. Leavis, C.S. Lewis, Hans Sedlmayr, Hans Rookmaaker, and Eric Voegelin voiced deep concern over the state of Western civilization; so, too, did some scholars of cosmopolitan background such as Ananda Coomaraswamy. In America, Henry and Brooks Adams, George Santayana, Paul Elmer Moore, Royal Cortissoz, Irving Babbitt, Russell Kirk, Richard Weaver, and others warned of the cultural consequences of modernism-postmodernism. Later scholars from a variety of cultural backgrounds are continuing that work, including figures such as Thomas Molnar, Allan Bloom, Alasdair Macintyre, Philip Rieff, and John Carroll. Their efforts (to be discussed later) are notable, but those efforts were typically denied the success they deserved because of the untouched dominance of science as *scientism.* That is the keystone of the destructive hegemony of the modernist-postmodernist tradition, and it is that keystone which this book aspires to dislodge.

The long-accepted authority of scientism has made it more difficult to deny its dominance. Although the lingering assumption of the pursuit of truth as the purpose of the university permits all dogma to be questioned, the now common redefinition of truth as fact makes that hoary doctrine feeble. Our commitment to positivist dogma now precludes an ability to question positivist dogma. Or to put it differently, the pursuit of truth cannot question positivism if truth is understood as the pursuit of fact.

This situation is confirmed by current academic practice where the pursuit of truth has largely been redefined and thus abandoned for a dogmatic positivism. The reductionistic truth-claims of positivism remain untouched—or at least commonly so. We are then in the throes of an *empirical Scholasticism* that assumes its vision to be beyond serious contention.

So it is to the point to emphasize that cultural traditions around the world need not, and rarely have been, limited to the restrictions of an empirical Scholasticism, to assertions of fact and feeling; and when succumbing to those limitations, they have little to show for their efforts. In shifting from a qualitative to a quantitative context, quality is obviously denied; when quality is denied, *mannerism* results. Similar to the mannerist period of sixteenth-century Western culture, truth, goodness, and beauty are currently denied in favor of facts, feelings, and aesthetics. Such a culture is diminished and trivialized. And yet that *mannerist* perspective is currently dominant in contemporary academic scholarship. Scientism and emotivism assume that culture is quantitative and willful; contrarily, the traditional understanding of culture presumes the freedom and responsibility to attempt making qualitative choices. For those qualitative choices to be meaningful, they must be more than a matter of fact, interpretation, or subjective preference—be they statistically described or a matter of willful identity. They rise to the realm of responsible freedom, a realm above that which is descriptive, rationalized, or merely asserted. Responsible freedom, or culture, is grounded in the scientific and rational—but not *scientistic and rationalistic*—pursuit of knowledge; and is freely engaged in as a matter of qualitative choice and conscience.

Civilization is neither a negative pursuit of power based on envy and greed (as argued by Rousseau) nor a positive justification for sheer power via claims of hedonism, utilitarianism, or self-realization (as Hume and Nietzsche assert). Facts are quantitative, whereas culture is qualitative; in a quantitative culture, culture ceases to matter very much and barbarism ensues. Culture centers, then, on responsible qualitative choice and offers a higher perspective than that permitted by scientism (that meaning is reduced to mere fact) and by social science (that human behavior is correspondingly understood via positivism, via descriptive, predictive facts).

Free and responsible decision-making is key to the very existence of culture. That responsible decision-making, or responsible freedom, must be grounded in reality or else it is merely a strategy of power. Our choices ought to aspire to the good (or at least to the objectively better) and not merely the pleasurable, equitable, or advantageous. The pursuit of pleasure, equity, or advantage is corrosive to the very notion of responsible freedom. None is capable of discerning substantive

quality, or objective morality. Each embraces either a nihilistic or a totalitarian view. They rationalize power, envy, and greed in the name of virtue, or claim it as beyond rational discursive evaluation. Nor can responsible freedom be realized via the Kantian assumption of duty and a rationalized good will. Lacking a ground in purposeful reality, all willful choices and preferences are reduced to masks for power—be they rationalized or not. Culture is the perennial alternative to a science and sociology of violence. Better that culture should be recognized as it once was and always is: a life-affirming optimistic ontology promoting a virtuous culture of responsible freedom.

3

QUANTITATIVE VS. QUALITATIVE PERSPECTIVES OF SCIENCE, REASON, AND CULTURE

In the early twentieth century, the prominent art historian Erwin Panofsky wrote an analysis of perspective in terms of its scientific and cultural implications.[1] That book, *Perspective as Symbolic Form* (1927), remains perennially important for scholarship in culture and science. Panofsky contends that knowledge is perspectival and that such perspectival knowledge constitutes what he calls symbolic form. Knowledge as symbolic form means that knowledge consists of a fact-based formalism. Facts are like bricks, and how we use those bricks to construct our house of life is a matter of intellectual tendency.

Panofsky is a type of Kantian. It was Kant who concluded that all knowledge conforms to twelve mental tendencies of the human mind; similarly, it was the Swiss art historian Heinrich Wolfflin who perceived five categories of style in art. Panofsky and Wolfflin shared the neo-Kantian notion that culture and science consist of the facts of experience as those facts conform to our modes of thinking. Consequently, cultural and scientific knowledge does not aspire to reveal increasingly profound understanding of life and reality. Rather, it constitutes knowledge as a meaningful fiction. Those meaningful fictions might be viewed as random or sequential, for their own sake or judged by their instrumental value—what William James called the *cash value* of an idea. They might be viewed as trivial choices, or choices that we demand be realized. They cannot be judged by their ontological effectiveness in revealing truth (*scientia*) and wisdom (*sapientia*).

This notion of knowledge as constructed meaningful fiction is commonly understood as applying to culture and art. But it equally applies to scientific knowl-

edge. The question is whether this notion of meaningful fictions makes any sense in science or in culture. Can we rise above perspectivism? Panofsky and Wolfflin point out how perspective affects our understanding of reality and life; what they do not address is how those different perspectives differ *qualitatively*. It is those qualitative differences that entail profound cultural, political, and intellectual consequences. Those consequences center on a foundational choice: the practical pursuit of wisdom and beauty or a positivistic reduction of knowledge to fact and power.

We have established that American culture and fine art historically center on three primary worldviews: classical-Judeo-Christian, modernist-postmodernist, and the Anglosphere. In science, ethics, and art, the perspective of those seeking wisdom differs profoundly and qualitatively from those who seek power. These worldviews are a matter of differing perspectives, but more is at stake than mere difference. At stake is the meaning of those perspectives, their qualitative consequences, and their ontological merit.

From the perspective of modernism-postmodernism, the classical-Judeo-Christian commitment to the rational pursuit of ontological wisdom is a fiction, the meaning of which is either a trivial or oppressive assertion. Conversely, to the classical-Judeo-Christian tradition, the modernist-postmodernist commitment to meaningful fictions is transgressively confused, destructive, and brutal.

It is, therefore, a matter of necessity that this book's narrative affirm some view of science, reason, and culture. Positivist objectivity is a fiction; once a narrative is written, impartiality collapses. So the narrative of this book can be partial to the idea that perspectivism limits our knowledge to meaningful fictions, to the products of our minds and experiences. Or it can rise above perspectivism to obtain a glimpse of knowledge of meaningful reality. Ironically, the pursuit of knowledge was the initial hope of the Enlightenment as it sought to replace the wisdom-seeking classical-Judeo-Christian tradition. But those hopes, so well represented by figures such as Kant, are foundational not to the pursuit of knowledge of reality. Rather, they proceed as a modernist constructivism which constitutes a trivial perspectivism, and a postmodernism which cannot rise above the perspective limited to brute authentic experience.

The notion of scholarly neutrality, the goal of the Enlightenment, is denied by its own modernist and postmodernist premises. It is also denied by wisdom-seeking cultures around the world. The pursuit of wisdom is above perspectivism but is not neutral. It requires a resolute commitment to seek truth, goodness, and beauty; it requires that we assert and defend the responsible freedom to do so.

The fallacy of scholarly neutrality is intellectually and metaphysically naïve— and dangerous. The failure to rise above such perspectivism has horrible results. In

My Life among the Deathworks (2006), Philip Rieff argues that rather than mere perspectivism, the very existence of culture hinges on the qualitative differences that exist between cultural perspectives. He argues that there are three ontologically distinct modes of culture, each with its own methodology. What he calls *First World cultures* are pagan, in which humans struggle to reconcile knowledge with fate and the gods. *Second World cultures* seek via reason and faith to obtain wisdom, the realization of which results in a sacred order. *Third World cultures* center on power and self-interest. Rieff associates postmodern cultures with that view. He concludes that there has never been a successful civilization lacking a sacred order. Indeed, Rieff concludes that *Third World cultures* are anticultures that lead to the negation of the human. That negation is at first symbolic, but then authentic, as evidenced by the death camps of the twentieth century. Auschwitz marks both a symbolic meaningful fiction, and a brutal authenticity. It is a brutally factual fiction because it is an atrocity committed against not just Jews, but human Being as such. Grounded in the human mind, it marks the authenticity of the institutionalized transgressive.

Rieff emphasizes the seriousness of the current intellectual situation by noting that these modes of culture cannot coexist:

> There is no meta-culture, no neutral ground, from which the war [between these different perspectives] can be analyzed. . . . Anti cultures translate no sacred order into social. . . . Third worlds exist only as negations of sacred orders in seconds.[2]

So positivist factual impartiality concludes in the transgressive denial of culture. An allegedly tolerant multiperspectivism, multiculturalism, is an illusion. Kant, Marx, and Nietzsche cannot tolerate Plato, Aristotle, Augustine, Aquinas, Luther, or Calvin. Nor can they accept other proponents (Confucianist, Buddhist, etc.) of the free and responsible pursuit of wisdom. The assault on wisdom-seeking cultures is now a worldwide tragedy.

Those committed to the pursuit of facts and perspectivism assume that truth claims are meaningful fictions or experiences and that freedom is grounded in a transgressive self-realization and self-expression. Those committed to the free pursuit of wisdom and beauty hope that reality is intelligible, and that truth sets us free from the horrible effects of ignorance and willful violence. The conflict between these radically incompatible perspectives is central to the cultural conflicts that have informed American and Western culture since the Enlightenment. If scholarship is mere fiction or a mask for power, if scholarship is grounded in the transgressive, then scholarship collapses.

At this point one may well ask what type of narrative informs the writing of this book.

This text aspires to rise above perspectivism, not by a spurious assertion of impartiality, nor by a trivializing of meaning as mere fiction, nor by violent claims of authenticity. It asserts a commitment to the free and rational pursuit of wisdom. This text is deeply partial to the scientific and rational pursuit of truth, goodness, and beauty. It is a commitment that is necessary for civilization and scholarship to exist.

The point may be illustrated by comparing portraits of three contemporaries: George Washington, Napoleon (and Jacques Louis David's art of that time), and the Reverend Ebenezer Devotion. That comparison makes visible the interactions of three distinct worldviews: that of a Scholastic Anglicanism, an unequivocal advocacy of modernist-postmodernist belief, and a Protestantism struggling to reconcile classicism and Judeo-Christianity with modernist-postmodernist Newtonian positivism. In addition to comparing the portraits of these persons and the traditions to which they are committed, we will also consider corresponding architectural examples. These three very different personalities, and their houses of life, are intellectually and culturally distinct. What is critical, however, is the recognition that these three houses of life offer very different understandings of the nature of science, ethics, and art. These differences cannot be ignored because they are more than a matter of taste, of subjective preference; they produce political and social consequences. Nor can they all be reconciled. Those limited to an aesthetic constructivism that assumes a quantitative worldview cannot perceive, much less admit, the possibility of a qualitative worldview.

So whereas the art historian Erwin Panofsky attempted to describe shifts in worldview via a study of perspective, Philip Rieff evaluates three current and competing cultural perspectives. In contrast to Panofsky's neo-Kantian study, Rieff draws qualitative conclusions. He observes that each of those three cultural perspectives is informed by its own understanding of truth or God, of reality, and of what Rieff calls the *sacred order*. By sacred order we take Rieff to mean objective ontological truth; that reality itself is ultimately rational, that the world and life are ultimately intelligible. Therefore the cultural is the attempted replication of a sacred order that is scientifically rational.

To this summation we add an additional element: perspectives of science. In the context of science there are again multiple conflicting perspectives. The shift from wisdom-seeking science to power-asserting science was addressed by Panofsky's colleague, Ernst Cassirer. He recognized the differences between antiquity's association of science with the pursuit of substance, and the Renaissance's associa-

tion of science with function and power. Subsequent figures such as Thomas Kuhn observe that such perspectival shifts in science are historically established. Since scientific paradigms historically shift, the hope of restoring a scientific rationalism grounded in intelligible reality is not mere wishful thinking; it is not a meaningful fiction. Rather, it is the perennial remedy to transgressive violence. We will pursue that argument (along with figures such as Thomas Kuhn) in the next chapter. For the present it will be useful to demonstrate those differences of worldview by a comparison of works of fine art.

More Than a Matter of Perspective: Decorum vs. Authenticity

George Washington and Napoleon Bonaparte personify two distinct ways of viewing science, reason, and culture. They also represent two very different perspec-

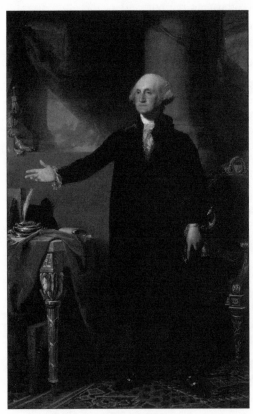

Gilbert Stuart,
Lansdowne Potrait of George Washington, 1796

tives on revolution. Revolution is transgressive in that it attempts to change established order. But not all types of transgression are the same, or of equal merit.

In 1796, Gilbert Stuart painted the Lansdowne portrait of George Washington. Washington is depicted surrounded by symbols of his accomplishments in establishing the new nation. That painting symbolically depicts Washington in office much as the French artist David depicted Napoleon in his. At first glance, that comparison might seem inconsequential. Depicted in both paintings are revolutionary leaders of new social orders established in the late eighteenth century. However, the French painting appears more naturalistic, more materialistic, more a matter of descriptive fact, than

does the Stuart painting. Washington's portrait is done in a lingering Baroque mode; he is depicted decorously, gesturing formally as if calling attention not to himself, but his role. That role was declared in the words of the Declaration of Independence, in which the signers pledged their *sacred honor* to establishing a social order dedicated to life, liberty, and the pursuit of happiness.

In contrast to the symbolic nature of Washington's portrait, Napoleon is presented as a concrete embodiment of practical power. Whereas Washington admirably resisted the opportunity to be king, Napoleon was famously viewed by the postmodern philosopher Hegel as not merely regal, but the Logos in a saddle. Napoleon was understood as the authentic personification of the Logos, of truth, of ontological reason, in the politics of revolutionary Europe. But this truth claim differs from that of Judeo-Christian tradition. From a Christian perspective, only Christ is the Incarnate Logos, Whom mortals such as Washington seek to imitate. From a postmodernist perspective, Napoleon is an incarnate logos, whose authentic power mortals must obey.

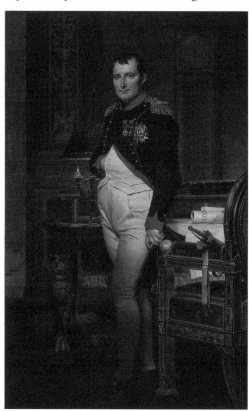

Jacques Louis David,
The Emperor Napoleon in His Study at the Tuleries, 1812

In the positivist view, the David painting is more authentic and sophisticated than that of the assumedly contrived and reactionary Baroque portrait of the American patriot. But there are other ways of looking at these two paintings. For example, this comparison evokes a consideration of traditional decorum vs. positivist authenticity. Decorum centers on the attempt to be right with reality. According to Rieff, aspiring to a sacred order is a Second World characteristic. It is to hope to act properly rather than stupidly, to hope to do what one ought to do. Within that perspective we define ourselves by self-control and virtue rather

than by a transgressive authenticity. We seek to rise to that which is ontologically true and good rather than be true to ourselves. In contrast to David's portrait of Napoleon toiling late into the night as the purported servant of his beloved France—which he ruled with an iron fist—Washington's portrait is a model of the aspiration to realize symbolic, rational, and ontological decorum.

The Lansdowne portrait's symbolic form is derived from a print of a painting by the French Baroque artist Hyacinthe Rigaud.[3] Whereas Rigaud was a painter for the tottering *ancien regime*, Gilbert Stuart was not. This is critical in understanding the differences between Rigaud's Baroque formalism and Stuart's. The Baroque evidences a turning point within Western culture—a turning point not followed by all. It marks a transition from a Scholastic perspective to one modernist. In contrast to its Scholastic predecessor and antagonist, in which science, ethics, and art are viewed as one, the French Baroque evidences new tensions between reason, science, and emotion. The French Baroque significantly attempts to reconcile reason with a post-Copernican science that is newly positivist. The limited success of those Cartesian attempts will be discussed later in reference to Newton. For the moment it can be noted that in contrast to the aristocratic decorum of prerevolutionary Baroque France, Washington represents a newly democratized notion of decorum. Washington's life and portrait denies positivism, but also denies a hereditary aristocracy. He affirms a commitment to a decorous democracy; neither the tyranny of the few, nor of the mob, will do. A new vision of equality in the pursuit of wisdom is symbolically affirmed and politically introduced.

For Washington and his contemporaries, decorum was understood not merely as a mode or style of behaving. It could not be trivialized as mere lifestyle, or associated as a matter of aristocratic class identity. To be decorous is to act in an objectively correct fashion. It is to aspire to the realm of Being. Decorum stems from the Latin *decit*, as in *how things ought to be*. To be decorous in this fashion is not to engage in artifice; rather, it is to adopt the proper mode in conducting one's life within an objectively purposeful reality. It is to accept actions and art as ontologically symbolic, as a sign of how things ought to be done. It is to mirror the traditional notion of the sacramental rather than a transgressive vanity. To the materialists and positivists of the French Revolution, there is no such thing as the sacramental or decorous; to Anglicans such as Washington, without the sacramental and decorous there is no such thing as culture and civilization. They provide an order that permits responsible freedom and civil society. Within the Anglosphere, that commitment to decorous behavior is valued as foundational to a civil society. It is part of a living, precious tradition not to be carelessly trifled with.

So a Christian classicism complements the Anglosphere's commitment to tradition as the conveyor of culture and civilization. A civil society is decorous. But is not any revolution by definition transgressive, indeed, indecorous? Granted, both the American and the French revolutions were dedicated to establishing a new order. But the American Revolution is better understood as a continued unfolding of the logic of the classical-Judeo-Christian tradition and the Anglosphere. Its aim is to better procure the rights of Englishmen as grounded in wisdom and tradition. Change is associated with obtaining better knowledge of Being; it is transgressive of ignorance and willful violence. In contrast, the postmodernist perspective as is found in the French Revolution is a significant departure from Western civilization and tradition. It is dedicated to a positivist and quantitative rather than a qualitative vision of science and reason. It is transgressive of culture rather than of ignorance or willful violence. It centers on becoming without Being. It is substantively indecorous.

Both the American and French positions affirm the need to escape an entrenched and flawed inherited Scholasticism. Both are dedicated to establishing a new cultural and political order. But the very nature of that new order is understood differently. For Anglican and Protestant American, that new order was progressive in the sense that it increased our knowledge and ability to be decorous and free. In contrast, for the French the new order indicated a profound and fundamental break with the trajectory of Western culture—indeed with culture itself. It pursues a Scholasticism newly devoid of a sacred order, without objective transcendent truth. It pursues an empirical Scholasticism.

For the French Revolution the battle cry is liberty, equality, and fraternity. For the Anglo-American Revolution the cry is for life, liberty, and the pursuit of happiness. The differences between these two attempts at realizing a new order are significant. The French Revolution initially is modernist in its perspective, incorporating what is called neoclassicism. Neoclassicism is a celebration of reason, or Logos, but one that no longer offers knowledge of reality. It is a stylistic label that refers to a perspective in which reason can no longer hope to rise from perspectivism to the pursuit of truth. That is, science is no longer linked to reason or truth; it is no longer *scientia*. Rather, reason is dedicated to clarity, and *scientia* is newly defined as the pursuit of empirical facts—and power: *scientism*. Within that perspective there is no decorum that can be grounded in objective reality, and no knowledge of that which is true and good in reality is possible. Consequently, there is no sacred order in science or culture, and it descends into postmodernist violence.

This is evidenced by David's neoclassical and neopagan painting *The Oath of the Horatii* (1784). It is a new classicism dedicated not to the pursuit of wis-

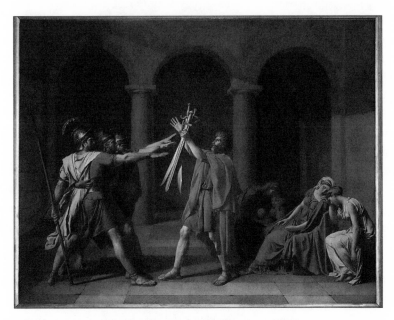

Jacques Louis David, *Oath of the Horatii*, 1784

dom, but to the service of power. The painting refers to an event in ancient Roman history, where duty called and was responded to at great personal cost. The Horatii and the Curiatti were two sets of three brothers born on the same day of mothers who were twin sisters. One set of brothers was of Rome, the other of Alba Longa. It was agreed that combat between the two sets of brothers would resolve a war between the two cities. The result was that two of the Horatii were quickly slain, but the third, hunted down by the Curiatti, managed nonetheless to kill them one by one. He then entered Rome triumphant, wearing the robe of a Curiatti that he killed. But that Curiatti was the beloved of his sister, a sister who cursed her brother. He then killed his sister and was condemned to death for the act. But he appealed to the people to be pardoned and his life was spared.

A more indecorous theme is hard to imagine. Marriage, family, virtue, and justice are all transgressed. David's painting mocks commitment to any of the traditional virtues as understood by Scholasticism since for such virtues to exist, the transcendental realm of Being must exist. Chance, tragedy, and violence prevail over virtue, wisdom, and love. The latter were no longer plausible from the perspective of David and his colleagues. What is plausible is a Kantian call to duty—and a soon to be issued Hegelian call to power. In the pursuit of that duty the will of the people can condone the murder of family members immediate or distant. That (Kantian) call to duty is not decorous—but it is rational, willful, and

regrettably authentic. It was grounded in a pagan violence in ancient Rome, but reappeared in materialistic revolutionary France.

From a cultural point of view, the French Revolution can rightly be judged to be *ontologically indecorous*. That is to say, the very historical moment at which the rights of humanity are purportedly championed is the same historical moment at which those rights are judged to have no foundation in objective and purposeful reality. A no longer scientifically justified aristocracy is replaced by a willful mob. The results are painfully evident, as the Terror demonstrates. The pursuit of truth, of knowledge of an intelligible universe, is replaced by the pursuit of facts and rationalized or willful power. That pursuit ignores and thus denies the possibility of a substantively rational universe.

The trivializing of culture via a Kantian duty to realize meaningful fictions (while adhering to a deonotological ethics) is addressed by the postmodernist Hegel. He does so by positing a rational universe in which truth is immanent rather than transcendent. He sees in Napoleon the Logos in the saddle. But when truth is immanent there is no cultural or political space for freedom of conscience. The result is a new tyranny.

For modernist and postmodernist, there is no objective wisdom, no ontological sacred order, no Being; but it is nonetheless alleged that science, culture, and human rights make sense. To secure those rights, freedom and murder are sanctioned. Both rich and poor would be killed in the name of the modernist-postmodernist revolution.

Indecorous Architecture

This sequence of ideas can be found in the design and the events surrounding the building of Ste. Genevieve, or as it was notably renamed, The Pantheon. It is not coincidental that at the moment of France's monumental cultural shift, fueled by a positivist revolution, one of their greatest architectural monuments of the period was reappropriated. Initiated by Louis XV after he credited Saint Genevieve with healing him, the church of Ste. Genevieve was to be a landmark national building, comparable with St. Paul's in England or St. Peter's in Rome. The architect, Jacques-Germain Soufflot, had an abiding interest in blending Scholastic—that is, Gothic—structure with classical forms, an interest sparked by the architect Perrault, who had come up with the idea nearly one hundred years earlier. Soufflot sought out the lightness and space of Gothic engineering and wished to combine that with the neoclassical concerns newly fashionable.

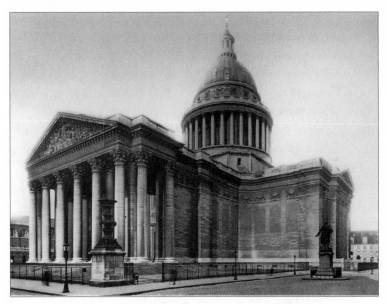

Jacques-Germain Soufflot, *The Pantheon*, 1756–97

One may well ask: is this architecture decorous? Can the Scholastic be mean-ingfully combined with neoclassicism or does that result in substantive confusion? Can a Scholastic science and rationality plausibly be combined with the neoclassical? Soufflot's friend Leroy (also known as, Julien David Le Roy (1724–1803) wrote about the project, at one point producing a drawing outlining the history of church design that culminated in Soufflot's design for Ste. Genevieve. Leroy suggested that Ste. Genevieve's carefully planned interior was about visual effect. One scholar posited that the interior of Ste. Genevieve was designed to "stimulate . . . a con-templation of the Divine" via the light effects.[4] No doubt the dramatic light effects are due to the soaring window spaces available since the introduction of Gothic engineering; but unlike the Gothic, a scientific and rational glimpse of the divine was now at best problematic. Soufflot and his contemporaries were more interested in accomplishing in architecture what Newton had accomplished in science, but like Newton, they faced the problem of the perennial association of fact with feel-ing, empiricism with mysticism. They sought to find the material laws to unlocking architectural beauty and perfection, but those laws were no longer ontologically rational. They incoherently sought a fact-based and emotivist intelligent design.

For example, Marc-Antoine Laugier, another contemporary who wrote the influential *Essai sur l'Architecture* (1753), argued for architectural design based on rationalist principles, to be guided only by Newtonian factual observation. The problem with Laugier's thinking, as well as that of his contemporaries, is that they

could find no means by which to substantively reconcile material fact with rational design. The world was no longer informed by reason; rather, it was informed by material or mechanical fact, emotional response, and mere rational clarity. Architectural decorum was as passé as cultural decorum, and so buildings became rationalized meaningful fictions.

When another contemporary, Charles Etienne Briseux, suggested mere clarity of proportions as the grounding for architectural design, he was attacked by none other than Laugier. Writes Laugier's biographer:

> Whereas the leading minds of the Renaissance had related architectural proportions to musical harmonies which they regarded as the manifestations of a harmony pervading the whole universe, writers like . . . Briseux in the eighteenth century only noted the analogy between the arts of acoustics and optics. . . . It is understandable that the new generation, picturing the world as governed by the single empirical law of gravity, could not accept the validity of a claim based on nothing more than a striking analogy or, at its best, on a transcendental idea.[5]

Laugier was uncomfortable with pure rationality as posited by Descartes and others. But a mechanical world was unintelligible. As an alternative, pure emotion proved no better. Laugier considered the ideas of Abbé Dubos, author of *Reflexions critiques sur la poésie et sur la peinture* (1719). Dubos posited not reason as the judge in issues of artistic quality, but rather sentiment. Thinking as feeling, as advocated by Dubos (and Pascal[6]), grew in acceptance, leading French theorists to the position that individuals have individual sentiments that reason cannot fathom. It is a position that claims to be suprarational even though there is no way to establish that it is not subrational. Nonetheless, they continued to also claim that there is yet universal beauty the rules to which will soon be discovered and to which all ought to assent.[7]

Evidenced here is the Baroque foundation for the separation of fact and rationality from Being, and the redefinition of thinking as feeling, and rationality as the will. If the proper role of reason is to attempt to understand reality, then this redefinition marks the legitimatizing of a pseudorationality. This Baroque development leads to Kant's attempt to reconcile facts and such rationalizing, Hegel's attempt to reunify them, and Comte's and Nietzsche's decision to no longer bother.

In this intellectual context, Ste. Genevieve can be understood to be a work of deep confusion. The vestiges of classicism and Scholasticism flourish in French

neoclassicism but without the ontological grounding of Greek or Christian reason and science. Classicism and the Gothic are deeply rational styles, but that rationality is no longer supported scientifically. Soufflot's work on Ste. Genevieve demonstrates tremendous knowledge both of architectural history and of engineering to create a public monument, a symbol of the rational brilliance of the mid-eighteenth century. It is thus all the more informative, and deeply ironic, that this structure, with its dazzling new interior illumination based on the pseudorational unification of neoclassical and Gothic architecture, would, in the year it was completed, have its religious standing revoked and windows filled in to be converted to a secular tomb to humanist heroes. To this day the Pantheon, as it was renamed, urges one to reconsider the pseudorationalistic accomplishments of such humanist heroes as Kant and his deontological ethics and science. As Rieff would likely observe, it also embodies a desiccated Second World culture succumbing to the transgressive violence of Third World sociopathy.

In contrast, to contemplate the Lansdowne portrait of Washington is to contemplate the example offered by Washington's conduct and character in life. It presents a symbol of intelligible decorum to be emulated, not a willful personality to resent or deify. And what is the vision of decorum that was predominant in Washington's career? That vision is one of steadfast devotion to the cause of liberty in the pursuit of happiness. Not the meaningless and self-destructive liberty of license, but liberty made real by purposeful virtue dedicated to the pursuit of wisdom. Instead of scientism is *scientia*; instead of defining happiness as self-expression and self-realization, happiness is understood as loving and to some precious degree having what is genuinely good.

So is Washington decorous and Napoleon not? Or is Washington a poseur, in malign contrast to the authentic Napoleon? Is the pursuit of genuine happiness realistic, or is happiness found via the pursuit of equality? Is the revolutionary French pursuit of happiness *via* equality possible, or does it indicate a fundamental confusion not found in the new American order? Our answers to these questions affect how we view these paintings and much more. They affect how we view the very nature of civilization and culture and how we choose to live our lives.

Washington's notion of decorum is evidenced by the revolution on which he staked all. The founding document of that revolution is the Declaration of Independence, which includes the pronouncement: "And for the support of this Declaration with a firm reliance on the protection of divine providence, we mutually pledge to each other our lives, our fortunes, and our *sacred honor* [emphasis added]." That sacred honor is based on the traditional Western notion that within a fallen and imperfect world we ought to strive for goodness and strive to do what

is right. Failure to do so is judged dishonorable, indecorous, and even sinful. The word *sacred* is fictitious to the positivist mind: at best it is sentiment, at worse, fanaticism. But it denotes the possibility of a world that is intelligible, a world in which science and reason are united in revealing ontological truth.

Washington's portrait is evidence of some degree of success in striving for the honorable and decorous. It is in accord with Augustine's (a primary source for both Anglican Catholic and Protestant) understanding of history as a battle between those who seek truth, goodness, and beauty, and those who seek power and aesthetic pleasure.

According to the Declaration of Independence, certain truths are *self-evident*: that all men are created equal—*and are* endowed by their Creator with certain unalienable rights. Those rights are *grounded in nature and nature's God*. There is then a dual reference to the rights and principles that establish a just society: the traditional view of a rational and loving Truth as personified by the God of Judeo-Christian tradition, and a rational comprehension of that truth as evidenced by material facts. There is reference to an intelligible world in which science and reason evidence objective transcendent truth and reveal a sacred order by which we can enjoy responsible freedom.

That document calls for a continuation of important aspects of traditional Western culture. It reconciles the Anglosphere with the classical and the Judeo-Christian traditions. It decorously declares the ontological existence of certain universal rights of humanity, as human *beings*, and the political appropriateness to realize those rights. Those rights are associated with a specific metaphysical tradition—the English form of Scholasticism as manifested by orthodox Anglicanism. That tradition maintains that God is Truth and Love, so therefore reason and emotion are not separate—nor violently combined—except in error. Reason is the conscious attempt to gain knowledge of truth—that is, knowledge of a purposeful reality. If the world and life have purpose, then both truth (Logos) and love (Agape) are one; they both seek completion. Truth is the organizing principle or substance; love is the act of completion and cognition. When Truth and Love obtain completion, Beauty results.

In a meaningful world, Truth and Love are one; in a purposeless world, truth and love are reduced to distinct subjective preferences. They are aestheticized. In contrast, degrees of truth result in degrees of the decorous becoming manifest; the sacramental is when truth is indeed given material form. Both the decorous and the sacramental involve a passionate pursuit of objective knowledge within a meaningful universe. That pursuit is a foundational aspect of traditional Anglicanism.

The principles articulated in the Declaration of Independence are classical-Judeo-Christian, but they are also historically part of the Anglosphere. They are

deeply influenced by a specific social tradition, as realized via traditional English cultural practice. They include the tradition-bound assumption that all humans have the right to participate in their own governance, to reap the rewards that come from their own hard work and virtue, and to pass on to their progeny those rewards. The Declaration of Independence is not revolutionary, but rather progressive, as understood in a qualitative sense. It is not transgressive of Western culture, but transgressive of ignorance or willful evil. It represents the Anglosphere's concern for reconciliation of tradition with the pursuit of wisdom.

But there are novelties within that document as well. Those novelties reflect changes in our understanding of science and reason. In contrast to the Platonic-Augustinian understanding of the human mind seeking degrees of knowledge of the Divine Mind, the Aristotelian-Scholastic approach is to consider truth existing in the Mind of God and the mind of humanity. One is a scientific and rational form of mysticism in which the goal is to reunite with Truth; the other is a scientific and rational form of naturalism in the context of a purposeful world.

The differences between these two approaches profoundly matter. The Baroque period was one in which the Scholastic (and conceptualist) independence of Divine and human reason contends with a new scientism that limits truth to fact, reason to clarity, and belief in a purposeful world to a matter of opinion. Both Nicolas Poussin in art, and Descartes in science and philosophy, play major roles in addressing that problem. Descartes, working from a Scholastic foundation, attempts to refute mere empiricism and nominalism—the idea that truth claims are just words. He does so by attempting to establish the validity of truth not only as it exists in the mind of God, but also in the mind of humanity. His intention is to pursue self-evident truths that by extension establish the existence of the maker of those self-evident truths. But by deemphasizing the need of the human mind to comprehend the mind of God via a qualitative and intelligible world, he takes a critical step toward the self-deification of humanity. If truth exists in the human mind, there is no need to also seek truth in the divine. He advances the abolition of truth as being sacred, being grounded in intelligible qualitative reality. Tragically, as a defender of Western culture Descartes commits an act of transgression that warrants his status as the first modernist philosopher.

The bifurcation of human rationality from that which is Divine has predictable consequences. Truth is no longer transcendent, to be rationally and scientifically pursued by degrees of knowledge. Instead, the world is factual and a-rational, factual and extrinsically rational (Kant), or factual and intrinsically rational (Hegel). We live in a world of facts presided over by chance or naturalistic necessity, a world constructed by our minds, or a world of facts in which meaning is immanent. It is

Hegel who tries to revive the traditional notion of an intelligible world by claiming that nature and reason are one. But in contrast to traditional Western culture, Hegel denies transcendent objective truth in science or reason. The denial of transcendent objective truth is a denial of freedom since freedom operates within the gap between the immanent and transcendent. With Hegel a pantheistic monism prevails—Napoleon is the Logos in the saddle. The net result is that the rationality of Truth or God—and creation—no longer obtains; the need of the human mind to comprehend the mind of God is unnecessary—either there is no God, or we are gods.

What then of science? Descartes advocates an understanding of the material universe distinct from that of Newton or Galileo. Where Descartes sees gravity as an active divine force, Newton sees it as material force made by the divine. Where Descartes sees a cosmos without empty space (since an infinite God must be everywhere), Newton sees matter operating within empty space. Newtonian infinite space then is empty, but is the *sensorium* of God.

This results in many intellectual difficulties previously resolved by Trinitarianism. In a Newtonian universe, an infinite God distantly presides over an infinite universe. But this incoherently posits two infinities—which supposedly is not a problem if reality is not rational. If we combine those two infinities into one pantheist whole, then Newton's God becomes immanent and truth is no longer objective. We are part and parcel of God. In any case, we are faced by a denial of the ability to seek knowledge of a meaningful objective reality.

Such conclusions follow from different understandings of science and reason; so, too, follow different understandings of ethics and culture. One position is the Augustinian understanding of science and reason as a continuum in which the mind rises out of ignorance and mere fact to a comprehension of degrees of truth about nature, eventually to obtain a glimpse of knowledge of nature and nature's God. Truth is received in the human mind as a progressive act of illumination. Another position is that of Aristotelian Scholasticism. Truth is in things, in our minds, and in the mind of God. But if truth can exist in our minds, then why be concerned with the mind of God? This anticipates the modernist separation of fact and rationality, and of reason as mere human cognition. That cognitive ability permits the pursuit of verifiable facts, but under Newtonian scientism those facts are either mechanically or naturalistically (magically) joined, or are joined via our own cognition (we are gods).

It is false to declare this deontological/immanentist treatment of fact and reason as merely relief from classical-Judeo-Christian thinking. It is not just pitting empiricist and rationalistic modernity against religious traditionalism. It is pitting

those who seek knowledge of a meaningful—decorous—reality vs. those who deny any degree of such knowledge as possible to objectively obtain.[8] If no degree of ontological knowledge is possible, then we pursue a scientific and religious (de) constructivism in our attempt to think about reality. The scientific and rational conflict between traditional classicism and neoclassicism, and between traditional Christianity and modernist-postmodernist Christianity, is evident in the architecture of Ste. Genevieve, whose Scholastic neoclassicism is informed by the then current redefinition of science and reason. It takes for granted a deontological rationalism that is indistinguishable from the will to power—a will to power that is transgressive of the scientific rationalism inherent to the transcendent God to which the building once was dedicated, and to the scientific rationalism of the Enlightenment to which it is dedicated today.

For classicists such as Plato and Aristotle, or Christians such as Augustine, reason aims at obtaining knowledge of objective reality. In contrast, for neoclassicists and neo-Scholastics such as Kant (and Jefferson), reason is a human faculty that is self-sufficient and scientifically (de)constructive. We can cut and paste scientific knowledge just as, one may recall, Jefferson cut and pasted his Bible.

Anglican Art and Washington

At the edge of the Wall Street financial district in lower Manhattan stands St. Paul's Chapel. Built in 1764, it is the Anglican church at which George Washington worshipped when in New York; indeed, his pew can still be seen within the church. Designed by Thomas McBean (1764; portico and spire 1779), St. Paul's is a fine example of a traditionalist English Baroque style, more specifically called the Georgian; it is one of the many architectural possibilities springing from the deep well of classical-Judeo-Christian culture.

McBean is following precedent set down by the English architect, James Gibbs. In designing St. Martin-in-the-Fields, London (1720), Gibbs attempted a blending of the classical and the Gothic in ecclesiastical and decorous form. The formal aspects of Gibbs's solution became commonplace in church design: the Roman porch, longitudinal nave, and Georgian tower. The porch leading to the entrance indicates the transition from the merely mundane to the sacred on earth; the horizontal axis of the longitudinal nave indicates worldly knowledge, or the realm of what; the vertical axis of the tower above the altar indicates divine wisdom, or the realm of why. It is at the altar where what and why, the earthly and the divine, meet, and there we obtain a glimpse of truth, wisdom, and beauty on earth. At

St. Martin-in-the-Fields in London and St. Paul's in New York, the classical and Gothic fuse into a sensible and meaningful Georgian whole.

Why should St. Paul's Chapel make sense and the Pantheon not? It is not a matter of perspective or power, but of context. That context relies upon our understanding of the scientific and rational. In a culture which still maintains belief in a meaningful world, a fusion of classical and Gothic (or Scholastic) architecture

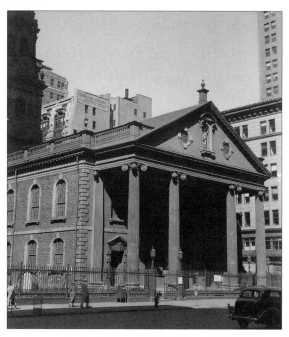

Thomas McBean, St. Paul's Chapel, 1764

remains believable.[9] In a culture that denies a purposeful science and reason, the same type of architecture does not. This is evidenced by the historical vagaries affecting the Pantheon. Since its construction, the Pantheon has variously and repeatedly been designated as either a sacred building or a temple of secular reason. Its future identity—and validity—remains to be determined.

Washington would have recognized the structure of St. Paul's in New York as harmonizing with the Judeo-Christian vision of reality; that is to say, it embodies the idea that perfect truth trumps imperfect daily existence. More than trump, it inspires a practical and realistic optimism. It makes visible via architectural form a purposeful reality—a sacred order—that one can see, understand, cherish, and work hard to realize.

But that optimistic scientific rationality is now in doubt. The church evidences the state of knowledge at the time of its construction, but that knowledge is now confused. It is obviously classical as well as Christian. Its façade is a classical colonnade, its structure exudes a rational geometric clarity, its altar marks the spot where the horizontal axis of the material world transects the vertical axis of the divine. That transection is not just in space and time. It indicates a shift from fact to meaning, from what to the transcendent why. It refers to transubstantiation; the material and temporal fact not only shifts to eternal and universal meaning, it

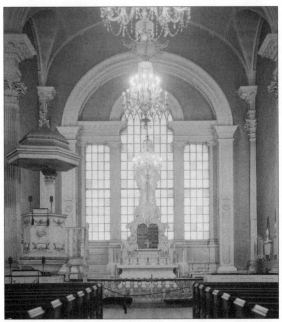

Thomas McBean, St. Paul's Chapel (interior), 1764

rises to it. That shift is not of location but of condition. It is where *becoming* or meaningless time (*kronos*) joins *Being* in meaningful time (or *kairos*).

This knowledge is grounded in one understanding of scientific rationalism, whereas there is now a competing type of knowledge. Anglicanism historically understands reality and life via an affirmation of scripture, reason, and tradition. Scripture states that material reality is informed by a scientific rationalism that aspires to transcendent truth. That transcendent truth is uniquely made manifest in the Incarnation; as such, the Incarnation models the unity of empirical science and rationality. All coalesce within a living sacred order—a culture grounded in numinous reality.

During the Baroque period a new situation develops. It is not that a new scientific rationality is revealed via scripture as it is that Christian scripture is newly viewed from an empiricist and emotivist perspective. Just as the Puritans in New England had much to contemplate, so too did those in France sitting in Ste. Genevieve/the Pantheon, and Washington and his Anglican peers sitting in their pews in St. Paul's. While sitting in their pews, they faced an awkward situation prompted by Newton. If scientific rationalism is actually grounded in fact and feeling, then this building can no longer be what it once was: a material manifestation of sacred knowledge.

According to tradition, Washington cannot sit within an empty church, because there is no empty space in the universe. Infinite love binds the universe and love has a divine source and purpose. In contrast, Newton holds that we can indeed sit in an empty church; gravity has nothing to do with God or love. It is material force mysteriously spanning empty space. Therefore, Washington sits not in a sacred place, but in space that consists of matter and void. The Newtonian principle of empty space means that God cannot be infinite—and yet against

the biblical principle of *creatio ex nihilio,* and empirical necessity (to study nature as such requires that nature be distinct from non-nature and thus finite) Newton claims that both God and nature are infinite.

So the Anglosphere is now conflicted by a different perspective. The modernist paradigm of Newton and Kant constitutes a different type of scripture, a new and disturbing metanarrative. Newtonian-Kantian modernism takes as foundational the principles that the universe evidences intelligent design but that knowledge of Being is not available; that decorous design consists at best in seeking conceptual clarity and coherence, but that clarity has no real ground and evidences neither a purposeful world nor the presence of God. Gravity shifts from love as meaningful completion to material fact and power. Material fact, whether or not produced by God, operates mysteriously.

Rather than a difficult-to-discern transcendent God and truth, we face an ancient and recurring situation: the association of the empirical with the mystical. In either case, meaning is grounded not in rationality but in personal experience. The result is an immanent eschatology in both religious and secular realms. Proponents of this empirical-mystical paradigm currently maintain that we are on the threshold of the end of science, history, and art. We shall soon reach the end of knowledge by having complete possession of immanent knowledge. Immanent knowledge, however, cannot know what it does not know. Immanent knowledge requires a smug complacency that cannot be rationally advanced or disputed. It is willful knowledge about which there is nothing to discuss, only assertions to make or deny.

Anglicanism is rooted in both English and Catholic tradition. Washington is correspondingly dedicated to an English Anglosphere traditionalism which is also associated with a Scholastic type of Catholicism. The symbiotic relationship of the Anglosphere and Christianity was denied by David Hume, but advanced by influential writers such as John Locke, who maintained that culture cannot occur without the existence of a divine lodestone, a God by whom standards can be measured. However, as a reformed English Christian, Locke does not limit reason to a Scholastic understanding. Locke also argues that a just society is founded upon the principle of tolerance, with the caveat that a tolerant culture cannot tolerate the intolerant. A tolerant culture cannot tolerate those who deny the free and responsible pursuit of ontological wisdom. It cannot tolerate a lack of decorum in culture, reason, and science. It is right action, led by right thinking, which can establish grounds for a genuine and practical tolerance. Right is established by the pursuit of knowledge of an objectively purposeful reality; but for Locke and his current followers there is no longer available scientific knowledge of a rational and

qualitative world. There is only the divine lodestone, facts, and tradition. What then if that lodestone is dropped? On what grounds can the evangelical appeal to a public not interested in God or the Bible?

There are those sitting in St. Paul's Chapel in New York who understand the conflicted meaning of the architecture surrounding them; others merely engage in a superficial aesthetic experience. The modernist who enters such a church sees the proportion and harmony between the constituent parts as marking a clear and discernible space. For example, the interior arches lightly spring from richly detailed columns, each arch defining a repeating bay. These repeating bays lead the eye toward the visual climax of the space: the altar. To emphasize this effect further, the altar is framed by a vast expanse of glass, a massive Serlian window, another clear nod to historic classical precedents but one that functions in a more traditionally Gothic manner. Modernists can perceive rational clarity and emotional impact, but cannot take seriously the meaning of the church and its space once sacred, now scientifically empty. They cannot because for Newton there is matter and empty space—and science examines how matter naturalistically, that is magically, moves in that emptiness.

Augustine and Descartes question the notion of empty space. For both (although for different reasons), the notion of empty space is a denial of a rational and infinite God who is transcendent and immanent. It is a denial of Trinitarian science and reason. As famously explained by Plato in the *Book of Timaeus*, God is a circle the center of which is everywhere and the circumference nowhere. For there to be empty space there must be limitations on the substance and extension of scientific truth—or God. The affirmation of empty space is then a denial of a scientifically rational universe. The correlate idea that we are matter moving in a void—that we live existential lives in an existential universe—denies both science and reason. Science attempts to discern the intelligible order of the universe. Therefore it attempts to discern objective knowledge and decorous, that is, sacred space. If there is truth then there is sacred space, and we cannot ever sit in an empty church, an empty lecture hall, or live an empty life.

In a meaningful universe the notion of science and ethics operating in a void makes no sense, even if one problematically redefines God's extension to His will, His *being* to His *becoming*. Goethe notably reinterpreted the biblical definition (John 1:1) of God as the *word* to God as the *act*. To redefine the substance of God as the will of God is to deny both truth and love as meaningful completion. It is to deny the goal of science and reason to obtain knowledge rather than mere power. To confuse truth and love with power is to deny culture by embracing a new barbarism. The attempt to link objective or transcendent Truth with the

immanent world via the Divine Will is the postmodernist solution—but it is a solution that denies transcendence by redefining truth and love as power, and God as the immanent will of every person.[10]

For the modernist visitor to St. Paul's Chapel, the visual climax of the church may well be its altar, illuminated by a grand window. But beyond the emotional, what is the intellectual and spiritual climax of the building? For Newton, light is merely a physical and emotional property, a spectrum of physical light as evidenced by a rainbow of colors emanating from a prism. But for Augustine, light can also refer to the obtaining of understanding and wisdom. Light is associated with meaning whereas darkness is associated with ignorance. To view St. Paul's Chapel as consisting of a clarity of form enclosing empty space dramatically illuminated by (Newtonian) physical light entering the windows is to embrace a return to the materialism of Democritus and Lucretius via Newton. It is to understand a beautiful building as an aesthetic and empty experience, thereby deconstructing it.

Nonetheless, the English Baroque style of St. Paul's Chapel draws from the classical and Scholastic traditions in various ways to inform the church with meaning. Its vertical spire provides a visual and actual linking of the heavenly and timeless, of perennial truth, with the earthly and momentary, the temporal and contingent. The identification of the altar as the sacred place where what and why meet, and of (Augustinian) light as symbolic of divine wisdom, results in an affirmation of meaningful time (*kairos*). On the arch above the altar resides a golden symbol with the name of God written in Hebrew, YAWH, to affirm divine presence. The church's stylistic elements manifest profound notions of responsible freedom, in which the practical pursuit of truth and goodness results in a life and culture to some precious degree beautiful.

Just as the meaning of the Pantheon has been reinterpreted as a temple of secular reason, so too could be St. Paul's Chapel. Yet, historically the building goes beyond a materialistic and purely naturalistic understanding of the cosmos and life. Its geometric clarity refers to the notion that the universe is just that—a universe, and one which ultimately makes sense. It is not empty space, but space informed by meaning and purpose. It is an affirmation of objective purpose in which the earthly realm of what, represented by the horizontal axis of the building, meets the vertical axis of why. The divine descends to the altar, thereby providing a glimpse of truth. This combination of *what* and *why* is also represented by the presence at the altar of the Sacrament of Communion. It represents the Incarnation by which the unity of *what* and *why* becomes manifest on earth. The doctrine of the Incarnation denies that any of us can claim to possess omnipotent

and final knowledge, while it affirms the practicality of seeking wisdom. A confident yet cautious pursuit of truth, goodness, and beauty is verified.

That seamless continuity of science, ethics, and art, grounded in a comprehensive cosmology and teleology, is characteristic of Scholasticism. Scholasticism faced intellectual challenges since its consummation in the writings of St. Thomas Aquinas in the thirteenth century. Those challenges intensified with the dawning of the Enlightenment. Characteristic of his age, Washington lived in two worlds—that is, in a cultural context of conflicting worldviews. Although without question Washington was a devout Anglican, he was surrounded by a culture in deep turmoil. It would be difficult to document that Washington was fully aware of such complexities made manifest via the meaning of the architecture in which he worshipped. Similarly, it is doubtful that he was deeply aware of the conflicts between the ideas of Plato, Paul, Augustine, and Aquinas, and those of Galileo, Kepler, Descartes, Newton, and Voltaire. But the disputes about such seemingly esoteric subjects as the nature of truth, reason, and science affected him nonetheless. Those disputes contest the very meaning of Anglican tradition, and the ontological validity of McBean's St. Paul's chapel. Those disputes ultimately address the possibility of culture.

Tradition maintains that God can be understood as the architect of the universe, and thus architecture is understood to be analogic of the divine. It is a cultural given that church architecture symbolically represents an understanding of reality. But as Nietzsche notes, we no longer look for cosmic symbolism in buildings—even when such symbolism was intended. Modernism and postmodernism notwithstanding, cosmic symbolism always occurs in serious architecture and fine art. Public architecture and fine art evidence public beliefs and values—be they exalted or trivialized, sacred or transgressive, beautiful or merely aesthetic.

Within that context, the Lansdowne portrait of Washington, and the architectural meaning of St. Paul's Chapel, are either profoundly true, or they are objects evidencing mere rational clarity, pleasure, or power. The attempt to discern whether the meaning of the painting and the chapel is true mandates responsible discussion in the pursuit of truth. But should we assume truth to be constructed and deconstructed, then responsible discussion is denied. Instead we assert that which we construct, that which we feel and demand. As a public figure, and a public building, both Washington and his church reveal public ideas about the nature of reality and life. They are cultural items waiting to be read—accurately.

The Puritan Tradition and the Challenge of Newton

Washington's pursuit of knowledge, of *scientia*, was understood as leading also to the pursuit of wisdom, or *sapientia*. Wisdom is knowledge of what is true and good, and the physical manifestation of wisdom is traditionally considered to be that which is beautiful. Included in the search for *sapientia* is what is now distinctly called religion. The assumed separation of *scientia* from *sapientia*, of knowledge from ontological wisdom, and of science from religion, is characteristic of the modernist worldview. But as those dedicated to the pursuit of wisdom recognize, there is no conflict of intent between science and religion or philosophy. The goal of each—and all—is to accurately comprehend reality.

Washington's worldview was orthodox Anglicanism. There is no evidence that Washington aspired to a subjectification of truth, or its reduction to mere descriptive fact. He was not a positivist, a deist, or a lukewarm Anglican. And yet, during his lifetime Anglicanism was faced with the challenge of Newtonian thought. To its credit, the Protestant tradition vigorously attempts to reconcile Newtonian deistic science with Judeo-Christian tradition. This is evidenced by Ebenezer Devotion and John Edwards, to whom we now turn.

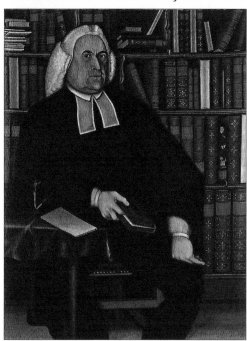

Winthrop Chandler, *Portrait of Ebenezer Devotion*, c. 1770

Philosophical positivism is foundational to the development of modernism, and that positivism has consequences not only in science, but in religion as well. Newton's scientific and philosophical positivism is accompanied by deism and also his Arianism, an ancient heresy holding that Christ was not divine. At stake, however, is more than what the postmodern mind views as a puerile hero worship. Arianism, a philosophical redefinition of science and denial of the doctrines of the Incarnation and Trinitarianism, has extraordi-

nary consequences. Broadly, it entails a rejection of the free and rational pursuit of wisdom and beauty. It is not that Newton liberated science from so-called religious superstition and philosophical nonsense. Rather, he substituted one coherent set of cultural practices for another. Such a substitution is transgressive of Scholasticism and traditional Western culture, and it is also an attack upon a culture of responsible freedom. In its rejection of *sapientia*, of wisdom, and of beauty,[11] Arianism attacks not only Platonic classicism and Scholastic Anglicanism but also the foundational beliefs of reformed Protestantism.

The Puritans accepted the challenge of attempting to reconcile a new science with a perennial faith. The Puritan tradition developed in the midst of this change in our understanding of science—and in the increasing rejection of wisdom. In the circa 1770 painting attributed to Winthrop Chandler, the Puritan scholar and reverend Ebenezer Devotion is depicted before his bookcase,[12] and it is an impressive collection of books indeed. Included among those volumes are works on English history, biblical concordances, Locke's philosophy, and, notably, Newton's *Opticks*.

The painting's technique, with its emphasis on a blunt, even harsh, realism, and a factual clarity, has been noted by some; but the scientific and ethical consequences of the meaning of the work are more profound than its style and technique. The painting effectively objectifies the Puritan view of science, ethics, and art. Foundationally, science is the pursuit of facts, ethics are based upon the facts of Scripture and pious philosophy, and art—like Communion—is a remembrance of that which is, or those who are, admirable.

The painting is not decorous, at least not in a sacramental sense. It is no longer lingering in a pre-Baroque mode of science, ethics, or art. This is not to say that it follows the secular rationality of the Enlightenment, or the positivist authenticity of David's Napoleon. Rather, it exhibits a concern for factual knowledge of a purposeful world. It seeks knowledge of sacred purpose, of objective reality, via the mundane. Its understanding of decorum has shifted from the sacramental and formal to one of fact and feeling. For the Puritan, the facts of the Bible and of natural science are accompanied by feeling manifested via duty and Grace.

This painting alone makes clear that the Massachusetts Puritans, including the founders of Harvard College, were deeply religious *and* intellectually vigorous. They engaged Newton in science and Locke in ethics, armed with a clear consciousness of the importance of classical-Judeo-Christian and English tradition. The Puritan mind did not ignore the newly developing (yet false) distinction between empirical science and religion, nor did it wish to attempt to defend or continue Scholasticism. The Puritan tradition accepts the challenge presented by Newton to Western culture; the outcome of that challenge remains at issue to the present.

That challenge can be made clear by asking the question: What is gravity? It is commonplace to assume that gravity is a naturalistic force; the Newtonian view dominates. But suggest that gravity is the manifestation of divine love, and befuddlement will likely result. To the modernist Newtonian, gravity is a mechanical naturalistic force without purpose or adequate explanation. But in the traditional Anglican-Catholic view, as earlier noted by Dante in the last passages of the *Divine Comedy*, gravity is the expression of divine love. God's love brings things in the created objective world to completion.

So traditionally, love is the reason why the universe is a cosmos rather than a chaos. For the Anglo-Catholic the universe is qualitative, evidencing both love and purpose. From the modernist scientistic view, the universe lacks both love and purpose; it is quantitative. The Puritan stands confronted by both. The ethical and cultural consequences of how we understand gravity, how we understand science and love, are indisputably significant.

Just as our understanding of gravity can vary, so too can our understanding of light. Newton's *Opticks* (written circa 1675 but published later) is particularly important in that it introduces a new way of viewing science, color, and light. Previously, light was recognized as physical, but also metaphysical. Within the Scholastic tradition, particularly its Augustinian aspect, light is understood within the context of a continuum stretching from the material to the divine. Knowledge of material light is the most base (light as scientism), whereas knowledge of divine light is associated with obtaining wisdom and understanding (the light of understanding, of *scientia* and *sapientia*). Newton is part of the Enlightenment that reduces knowledge to positivistic fact; for Augustine, to be enlightened is to have attained a degree of understanding of a meaningful reality and life. Wisdom causes one to be illuminated, to rise out of ignorance and confusion. To see the light is to comprehend a purposeful world.

For Augustine the world is finite, whereas God is infinite. God or truth can never entirely be known. But divinely informed revelation and Trinitarian scientific rationalism permit us to grasp glimpses of truth and the divine, without succumbing to the folly and hubris of our assuming the role of God. There is a qualitative continuum from the meaningless and material to the meaningful and the divine. That is the context in which all science, ethics, and art operate. For Newton the deist, there is no easy resolution as to the location of God—or scientific truth. He holds that the world is infinite, and so too must be God. But can we reconcile an infinite God with an infinite universe without succumbing to either a mechanistic worldview with no god, or a pantheistic worldview in which the world and God are one? Or is a destructive template for the future established?

Furthermore, instead of focusing on Being, on the substance of God, deism centers attention on Becoming, on the will of God. The world is not numinous, but materialist; it is made not as a temporal act of eternal love, but of glory. It manifests a first but not a final cause.[13] However, by focusing on the will of God as first cause, God's Being as final cause and purpose must rest upon *becoming* rather than *Being*, on the will rather than knowledge; this provides a model for human ethics. This separation (or conflation) of becoming and Being, of the will and knowledge, assaults Trinitarianism by denying the worldly importance of Being, and by extension, the worldly importance of both wisdom and the Father.[14] Therefore it oddly promotes deism, Arianism, *and* a Christ-centered fundamentalism.[15]

For the modernist, the significance of embracing Arianism, or altering (or rejecting) the Incarnation and the Trinity, is simply a matter of rejecting a meaningless or subjective religious doctrine with no real consequences. But the doctrines of the Trinity and the Incarnation affect how we understand science, ethics, and art. They address the relationship of truth with matter, the understanding of which is prerequisite to what we know and what we become.[16] They permit a qualitative understanding of reality and life as opposed to a quantitative and existentialist one. They affirm that there exists truth and purpose, beyond yet informing the material and worldly, to which we might freely aspire.

The Puritans recognize the importance of science but remain committed to the pursuit of wisdom, a wisdom that goes beyond the Aristotelian, Scholastic, and modernist conceptualist notion of knowledge. But they also accept the role of the will in seeking knowledge. That is, they reaffirm the primacy of Augustine's great insight: what is known cannot be divorced from what is loved.

In contrast, for Newton, science is solely concerned with an accurate objective measuring of physical phenomena, a physical calculus. For example, gravity is no longer an act of God's love, and light is no longer associated with intellect and wisdom. Light is viewed as a stream of material particles moving in a wave-like fashion. Both light and nature are declared to be self-referential, space is infinite and largely empty, matter is composed of hard and impenetrable atoms. And why do things move? Here Newton confronts the perennial problem of empiricism: its association with alchemy or magic.

One explanation for how matter and process combine is that of alchemy. To embrace alchemy is to assume that the world conforms to *our* wills or knowledge, is constructed by us. As such it is intrinsically violent, marking a resurgence of paganism. Its denial of the pursuit of objective knowledge and truth is a denial of the classical-Judeo-Christian tradition and (ostensibly) the Enlightenment. Newton cannot accept the premise that those physical motions are the product of our

minds and wills; nor can he accept that they are randomly realized. His advocacy of intelligent design forbids him to do so. However, philosophical naturalism lacks the ability to effectively explain movement. Its positivist understanding of knowledge cannot offer an answer to the question, "Why?" It can state that material force is material force, but that is to state that *what* is *why* because *why* is *what*. It is logical tautology that is scientifically solipsistic, concluding in a failed metaphysics and science.

Positivism presents itself as a liberating alternative to religious or philosophical speculation. It focuses on facts. But in a world of facts, meaning is effectively denied. Positivism is then associated with empiricism, and empiricism is historically associated with mysticism. Bonded by their denial of reason, empiricism and mysticism share a focus on feeling—be it material, emotional, or both. Historically, they perennially enjoy prominence at the expense of ontological reason. When empiricism and mysticism combine, we are in the presence of alchemy, since the alchemist assumes that physical meaning can be altered as we will. The alchemist celebrates the will to power due to its assumption that meaning conforms to our will.[17] The alchemist is a confident constructivist.

So why does the earth spin on its axis, why do the heavenly bodies move and circulate? Positivists cannot explain why things move, they can only describe their motions within an understanding denying empty space. To assume a naturalistic explanation of why things move makes no sense, since a naturalistic explanation is an oxymoron. Descriptions do not explain, they merely describe; descriptions are explanations only for the shallow-minded. The Enlightenment's reduction of science to empiricism and meaning to mysticism is at odds with itself and with the classical-Judeo-Christian tradition. And yet, that is the intellectual context with which the Puritans—and we—must contend.

Classical and Christian Denial of the Transgressive

The empiricist and the mystic share a bond in privileging material and emotional feelings over reason, but also have their differences. For example, Aldous Huxley advocated a drug-induced mysticism as the key to obtaining an alleged nonrational knowledge of reality and life,[18] while at the same time detesting the positivist and intellectual proclivities of Newton:

If we evolved as a race of Isaac Newtons, that would not be progress. For the price Newton had to pay for being a supreme intellect was that he was

incapable of friendship, love, fatherhood, and many other desirable things. As a man he was a failure; as a monster he was superb.[19]

For Newton, God exists at best as a first cause, but no longer as a final one. God is becoming without Being. God creates the world as an act of divine will or glory— and then acts as He will—or is it magic? Science as a step in the attempt to compre- hend some degree of wisdom, to obtain some degree of knowledge of reality and the intelligible substance of God, is replaced by Newtonian science as the description of phenomena that defy explanation but can provide technological power. For that rea- son, in Greek myth technology is viewed with apprehension.[20] In Aeschylus's work *Prometheus Bound*, technology facilitates pride and power over truth and goodness. As Prometheus (whose name means forethought) states: "I knew when I transgressed nor will deny it." But in Shelley's *Prometheus Unbound*, it is the transgressive who is the hero and God the villain. The will to power is good, even though goodness is bad.[21] The attempt to transgress objective reality is of course dangerous folly.

The biblical story of Adam and Eve eating the fruit of knowledge generally parallels the classical story of Prometheus. The attainment of knowledge presents us with the problem of freedom. For self-conscious humanity freedom is a right, and a problem, because it requires that we face the dilemma of having to make good choices. We can choose to use knowledge—and technology—for good or for evil. Traditionally, the solution to the problem of freedom (a freedom that ought not be denied self-conscious humans) is in making good choices. Truth sets us free from folly or worse. Wisdom obtained is freedom resolved, not in oppres- sion but in numinous completion.

However, within a postmodern context we attain technological power at the same moment that we lose the ability to recognize what is true and good. The actual existence of transcendent truth, God, or Being, denies the transgressive Pro- metheus being good. However, if there is no transcendent truth, then Prometheus can only be understood as good in the service of sheer transgressive power. If good- ness is transformed into the will to power, then the attempt to understand reality and life—much less goodness—is pointless. We are condemned to an existential world in which the will trumps reason and love. The problem is that in a transgres- sive world transgression has no context in which to exist; it can offer neither a transgressive nor a numinous justification for being. We are simultaneously divine yet irrelevant, able to do as we will but lacking any reason for doing anything at all. We existentially live, but only for the purpose of death. Prometheus bellows at the world the meaning of which, according to his view, is himself. His pride and narcis- sism are manifest in his own self-hatred and destruction.

This problem was recognized by the English and American Puritans. John Milton's great work *Paradise Lost* (1667) is to the point. Lucifer, like Prometheus, would rather be free in hell than a slave in heaven. The problem is that no one can be free in hell; no one is freed by institutionalized transgression. That dangerous point does not result from a conflict between science and faith, but rather between ways of addressing the world. The roots of that conflict are manifest in the work of Copernicus, Bacon, Galileo, Newton, and Descartes. It was a conflict to which the embattled Scholastic tradition struggled to adequately respond. Within Catholicism, the assault upon the science and wisdom of Scholasticism had two results: Catholic Augustinians continued their resistance to Scholasticism, while others began the Baroque Counter Reformation. Within Protestantism, Puritans continued the Reformation via its deep reliance upon Augustine. The Puritan resolutely faced the challenge of empiricism, alchemy, and magic upon Western culture, while attempting to humble, but not destroy, the Newtonian Prometheus.

Puritan Architecture

The archetypal Puritan building is found in the Old Ship Meeting House of Hingham, Massachusetts (1681, 1729 wing added; 1755 second wing added). A comparison with St. Paul's Chapel is informative. In contrast to the hierarchical structure of St. Paul's, with its traditional cruciform plan that leads the viewer, and worshipper, toward the communion rail and altar, the Puritan structure is deliberately untraditional and nonhierarchical. Congregants are arranged *around* the room. There is no focus toward the altar celebrating transubstantiation, the doctrine referring to the physical bread and wine transforming into the spiritual body

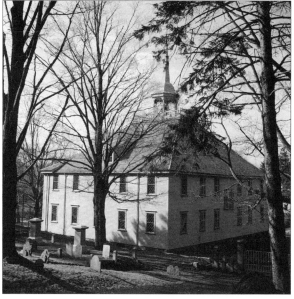

Old Ship Meeting House, 1681

and blood of Christ. This is mere nonsense to the positivist mind, be it secular or religious. But transubstantiation is the process by which particular facts rise to the level of scientific understanding. It profoundly refers to our understanding of science and reason. Transubstantiation justifies a qualitative science and reason. It affirms not just a change of perspective, but a change of condition. It affirms that above scientism is the more profound *scientia*; it affirms that the shift from fact to understanding is a profoundly qualitative yet ineffable process.

Puritans reject transubstantiation, holding that the Eucharist is a symbolic remembrance of Christ. Correspondingly, architecture as the physical embodiment of a divinely informed and hierarchical universe is now rejected. Christians, the building suggests, live in a naturalistic world, made by a benevolent God who ordered the natural laws of the physical universe, including life-nurturing motion and the sun. That God, once viewed in terms of love (as completion), sacrament, and decorum, is now viewed in terms of glory, grace, and duty. Within a purposeful world there are the facts of Scripture, the facts of science, and an inevitable responsibility to pursue our calling.

For the Puritan, congregationalism in church and state was justified by the need for individuals to gather together for a common good. They are democratic politically, but culturally and intellectually hierarchical, since they still recognize the existence of transcendent wisdom. The common good is obtained by individual conscious resistance to a fallen human nature and sin. It was Emerson (like Rousseau) who denied the notion of original sin by viewing the New England town meetings of the Puritans as indicative of the natural goodness of humanity. Irving Babbitt doubts the validity of such observations:

> . . . Emerson saw as a proof of the consonance of democracy with human nature in the working of the New England town-meeting. But both Rousseau's Swiss and Emerson's New Englanders had been moulded by generations of austere religious discipline and so throw little light on the relation of democracy to human nature itself.[22]

The Puritan tradition is foundationally anti-Scholastic. It is historically rooted in an Augustinian realism, but develops in face of the challenge of a Newtonian worldview. That development is fraught with tensions and difficulties. It is an Augustinianism denied a neo-Platonic-inspired continuum in science, ethics, and art rising from the mundane to the divine; there is instead an affirmation of empirical and religious facts. What then of *sapientia*? It shifts from the realm of knowledge to the realm of authoritative Scripture. The influence of

Newton's positivism and deism shifts our understanding of a purpose-granting Divinity as first *and* final cause toward whom we continually strive within a hier-archal universe, to a law-granting Divinity as first cause within a naturalistic uni-verse. Deism becomes a tempting intellectual position which nonetheless con-flicts with Trinitarian science and reason. Tragically, that shift, evidenced by the Old Ship Meeting House, contains elements destructive of the very foundations of the Christian faith—particularly the doctrine of original sin. That doctrine, once recognized as a limitation on human pride and arrogance, is now seen as an obstacle to self-esteem. There is a direct line of development from Puritanism to Unitarianism (and the idea of the Social Gospel), which contests the validity of the classical-Judeo-Christian cultural patrimony of the West. Milton's admoni-tion notwithstanding, we are to be free of original sin, and of objective truth. The sin of pride, found in Prometheus and Lucifer, no longer obtains; a ferocious technological will to power reigns.

Washington, Edwards, and Newtonian Modernism

The assumption of a Newtonian universe is fraught with cosmological, scientific, and theological consequences. The Newtonian scientific world is theologically deist, Arian, and even pantheist, and denies the possibility of a meaningful world accommodating responsible freedom. It marks a radical shift away from traditional Western culture. The tensions between a Newtonian science and theology, and traditional Western science and theology, are enormous. This was recognized by John Wesley, George Whitfield, and in America, Jonathan Edwards (1703–1758).

Edwards's heritage was deeply grounded in New England society and the Anglosphere. He was born in East Windsor, Connecticut. His father was a well-educated minister and tutor; his mother, a daughter of the Reverend Solomon Stoddard of Northampton, Massachusetts. Edwards began his college career at Yale in 1716, where he became acquainted with Locke's *Essay* as well as with con-temporary natural science. During this early period in his life he kept notebooks not only on Scripture, but also on physics and the mind, with the plan of develop-ing a philosophy reconciling the three.

Upon graduation in 1720 he embarked on the career path expected of some-one of his interests, training, and status. After a stint in a Presbyterian church in New York City, he returned in 1724 to serve as a tutor at Yale. In that capacity he was noted as a staunch defender of Calvinism. It was during this period that he rejected Arminianism in favor of tradition Calvinist understanding of the Doc-

trine of Grace. That rejection was the subject of a public lecture he gave in Boston in 1731, later published as *God Glorified in Man's Dependence*.

That lecture and publication centrally contributed to what is now called the Great Awakening of 1739–40. What Edwards accomplished was multiple: he defended the Doctrine of Election and thereby not only resisted Arminianism, but deism and atheism as well. Edwards argues for the individual receipt of grace, not the corporate grace asserted by the Arminians. Corporate grace limits the will of God. Divine will does not equate to human will. If God grants grace and salvation as He wills, and if God righteously damns the willful rejection of Grace by sinners, then the quality of our individual souls is of paramount importance. There are clear influences of a pre-Scholastic Augustinianism present; in his text *On Free Will*, Augustine argues that whereas God knows what we will do, God is not responsible for what we do. Divine prescience does not equate to divine responsibility. The difference between Edwards and Augustine is one of emphasizing either God's will or mind: Edwards emphasizes the former, Augustine the latter. But in emphasizing God's will, our wills are emphasized as well. Edwards's contribution to the Great Awakening is widely credited for preventing Calvinism from slipping into deism; but it is also charged with reducing religion to a disruptive emotionalism. The result was a new type of theology in defense of traditionalist Calvinism that shares the unresolved conflicts within a newly defined science. Edwards adopts aspects of Newton's (and Locke's) thinking and reinterprets Calvinism. As Russell Kirk puts it:

> All existence is mental, Edwards held—a concept which would work upon Ralph Waldo Emerson and the other American Transcendentalists, generations later. . . .
>
> God is the "being of beings," Edwards taught, the source of all benevolence. Virtue is the beauty of moral qualities, in harmony with the being of God. Goodness consists in subjugation of one's own will to God's good-will. . . .
>
> In his most enduring work, his treatise on the Will, Edwards argued that even God is bound by God's own will to pursue the good; no man is free from constraint to obey the divine will. Sin is only negative, a vacuum—in short, sin is the absence of God, from whom all goodness radiates.[23]

These theological issues are notorious for provoking disputatious controversy. But often overlooked are their scientific implications, particularly of the Doctrine of Grace. They address the obtaining of knowledge, and the relationship of knowledge with reality. What is reality? For Edwards reality is the realm of Being, and

the Being of Beings is God. Therefore, material reality is a created emanation of the will-mind of God. Liberty is freedom from constraint, but such liberty can only properly be assigned to God. For humans, liberty without God is meaningless and dangerous. Consequently, human liberty and virtue lie not in freedom from God, but in a harmony between virtue and Intelligent Being. Human virtue consists of a predetermined ability to realize moral beauty—that is, consent to Willful Intelligent Being. However, is that consent foundationally willful, or intelligible?

For Edwards, virtue relies upon the will, be it human or divine. The will properly is cognitive assent to that which is good. What we recognize as good (cause) determines what we believe and are (effect). The question of what is good can focus on becoming or Being, will or substance. Edwards maintains that the goodness of God's free virtue centers not on the substance of God, but on His will. That will is not an Arminian concern for providing for the love of His creatures. Rather, it is understood as a Trinitarian love to and of Himself; His purpose is to make manifest His own glory. The goodness of human virtue lies in homage to that glory; that homage relies upon the will—and therein lies a conflict.

Edwards is struggling to defend a Trinitarian worldview as opposed to the deist, pantheist, and materialist emanations of Newtonian scientism. His success is debatable. In contrast to the Augustinian primary focus on the substance of God, by which God's will cannot conflict with God's Being, Edwards concludes that God is bound by God's own will to realize His good. Unable to discuss the Being of God as good due to the Newtonian denial of numinous knowledge (*scientia*), he must resort to faith in the goodness of God's will. Edwards's assumption of the possibility of discerning God's good will is paralleled by Kant's assumption that ethics is grounded in human good will. The problem is that if goodness cannot be understood, it cannot be recognized as such. A good will makes no sense; a will is not good, it is only varyingly authentic. So faith in the good will of God diminishes, if not destroys, the importance of knowledge of God's substance or Being as Logos. Divine reason must be good in a God of Logos and agape, a God of substantive meaningful completion. But in a world of fact and will, neither Being nor meaningful completion makes sense. The Being of God is reduced to will, to becoming; knowledge is incrementally replaced by feeling, Being by becoming.

Within the context of a qualitative universe, Augustine observes that the problem of freedom is resolved via degrees of knowing and loving God; within the context of a Christian yet naturalistic universe, Edwards observes that freedom is found not in knowing and loving God, but rather in revering and obeying God's good will. Within the context of scientism, an existentialist postmodernist such as Nietzsche declares that we now live not only beyond God, we live beyond good

and evil. It is not God, but we, who can do as we will. Our moral task is limited to a willful authenticity.

Edwards continues to contemplate the substance of the divine, but concerning sin he alters the traditional Augustinian view. For Augustine, sin is the absence of goodness, a deprivation of how the world ought rightly to be. Evil is the failure to love what is true and good. When sick, we are deprived of our health. As victims of crime, we are deprived of justice. Sin has no positive existence. It is indecorous.[24] This traditional position shifts with the advent of Newtonian thinking. This is reflected in Edward's idea of sin not as a qualitative deprivation, but as a quantitative vacuum marked by the absence of God. In empty space it is the absence of God that indicates evil. We return then to the critique of Newton's understanding of the universe being matter and void (and Descartes's opposition to such an idea). If God is infinite, how can there be empty space, particularly since according to Newton both God and the universe are infinite? The distinction between transcendent and immanent realms offers no remedy since if both infinitely exist, then both exist in reality. Both must be ontological.

There cannot be a vacuum, a void, in an infinite material universe presided over by an infinite transcendent God. If, as Newton suggests, the goodness of God is made manifest via the universe being the *sensorium* of God, then the presence of an Edwardian evil vacuum, a void, lacking any degree of purpose means that God is not truly infinite, and therefore the ominous prospect of an existential realm devoid of meaning or truth exists.

As one may expect, Edwards's *Doctrine of Election and Grace* exhibits the same difficulties found in Newtonian science. For Newton the material world is infinite, yet composed of matter and void, presided over by an infinite God. Moreover, how scientific truth is linked with matter is left unresolved. For Edwards that void, that link, is filled by God's will, the absence of which is sin. But can God's infinite will coexist with an infinite and corrupt material world?

Edwards's concepts would have repercussions for secular and sacred thinking. In resisting Newtonian positivism with its problematic metaphysical notion of an empty existentialist space nonetheless including an infinite world and infinite God, Edwards attempts to reconcile the foundational principles and wisdom of Western culture with current science. But this requires a shift from the Augustinian understanding of the finite world as a nuanced epiphany of God's infinite truth and love, to the Puritan understanding of the world as a naturalistic yet flawed result of God's glory and will.

Divine and Human Good Will

In discussing humanity or divinity, the term good will is troubling. In common parlance, good will might be taken as equivalent to being nice. Objecting to people being nice seems, well, not nice. But as Allan Bloom remarked, American students are afflicted by a focus on being nice rather than being wise. Being nice has replaced being good via the seeking of wisdom and meaningful completion. How has being nice, having a good will, replaced the pursuit of degrees of wisdom? It is a direct consequence of Newton's transformation of gravity from love informed by meaningful completion into gravity as power.

This shift from love and truth to power is found in science and culture. Both Newton and Comte were positivists and Arians. Both denied the Incarnation and the Trinity—one as a deist, the other as an atheist. It is intellectually consistent that positivism leads first to deism and then to atheism. For science and reason this shift is neither progressive nor enlightened. It marks the denial of objective knowledge. Deism and atheism reject the Scholastic notions of substance and essence. When qualitative notions such as substance and essence cease to matter, then material and cultural force remain. The will of God might remain as a first cause, or a continuing cause, but the substance of God becomes scientifically unintelligible and judgments of quality become subjective and thereby collapse. To the Puritan, the quandary is in reconciling the denial of substance and God's Being while affirming science and scripture—specifically, Exodus 3:14. Since Truth or God is understood un-Scholastically, then questions about the substance of God, of truth and love, are now secondary. Primary is the will of God—and the will of nature.

Echoing Augustine, Edwards considers sin to be a neglect of God, but in a non-Augustinian mode he focuses not on loving the good, but on obeying the divine will. He struggles with the relationship of theological Being and scientific becoming. He anticipates later theological developments associated with Kierkegaard, who states that faith begins where thinking ends. He feared the position later taken by the positivist atheist August Comte, who embraces subjectivity as god; it is the will of humanity that is now divine.

So scientifically and theologically, the will rather than the substance of God is emphasized. God's Becoming trumps God's Being. With this shift in emphasis to the will of God we find a corresponding shift toward the will or material force evidenced in nature, and this leads as well to an emphasis in ethics grounded in the will. Edwards's contemporary, the modernist Immanuel Kant, argues for different reasons that the only thing unequivocally good is a good will. The postmod-

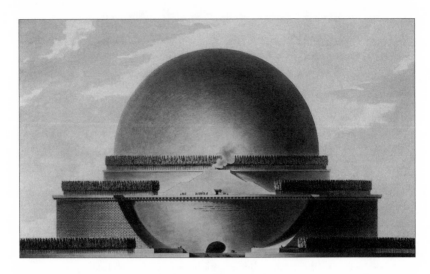

Etienne-Louis Boullée, *Cenotaph for Isaac Newton*, 1784

ernist Nietzsche takes that declaration to its logical non-Edwardsian conclusion: the human will determines what good is. Goodness as the realization of truth and love is no longer plausible. Goodness is replaced by a willful authenticity.

Augustine, Edwards, Newton, and Comte could not sit together in knowledge and harmony in St. Paul's Chapel in New York, nor in the Old Ship Meeting House. Their understandings of science, ethics, and art differ not as a matter of taste but as deeply differing attempt to understand reality. Newton would likely find himself annoyed by what St. Paul's evidences. Edwards would find partial pleasure in St Paul's decorum, and partial pleasure in the indecorous but reverent Old Ship Meeting House. Comte's response, of course, would be one of utter contempt for either house of life.

Not that Comte, with his passion for Newtonian science and worldview comprised of facts and feelings, is denied architectural structures to satisfy him. He finds respite in the transgressive architectural fantasies of Étienne-Louis Boullée. In the most famous of his impossible to construct designs, Boullée designed a cenotaph for none other than Isaac Newton (1784). Of this massive spherical structure, Boullée wrote: "Oh Newton! With the range of your intelligence and the sublime nature of your Genius, you have defined the shape of the earth; I have conceived the idea of enveloping you in your discovery."[25]

Architectural historian Barry Bergdoll suggests why Boullée rejected traditional forms: "[H]e has converted the traditional concern for the appropriate character of a building into a science of using architecture to produce . . . *emotive effects*

[italics added]." Bergdoll goes on to state: "Boullée advocated that the natural law of architecture should have priority over antique precedent.[26]

An advocacy of natural law for transgressive emotivist effect via architectural design gives one pause. In place of traditional decorum grounded in a meaningful reality, we revisit what Newton feared: the association of his empirical and a-rational physics with an alchemical unity of fact and rationalized emotion. What he feared is now accepted as (de)constructionism.

Decorum, Natural Law, and Architecture

Boullée's understanding of the natural law of architecture is quite different from that grasped by the Greeks and medieval Christians. During Boullée's era, natural law is predictably viewed via a positivist Newtonian mode; natural law is no longer teleological or cosmological. Instead, it is that which is mechanistically or naturalistically evident. In contrast, Plato and Augustine affirm the priority of a natural theology by which the laws of nature and knowledge of those laws is connected with divine illumination. To both, the laws perceived in nature reflect respectively something of the divine structure of the cosmos and the divine mind. As Augustine affirms via the Platonists:

> . . . the light of our understanding, by which all things are learned by us, they have affirmed to be to that self-same God by whom all things were made. . . . [God is] the cause of all the certainties of the sciences.[27]

From this perspective, architecture that reflects these laws, typically proportions, becomes beautiful as it reveals ontological form. The architecture makes visible the structure of reality and by analogic extension offers a glimpse of the divine. So natural law can refer to Being as cosmological purpose, or Being can be reduced to experiential fact and thus transformed as becoming; architecture follows suit. Newtonian neoclassicism evidences a shift from a qualitative to a quantitative universe, from Being as ontological purpose to being as material and naturalistic fact and process. Historical support of this conclusion is found among the British deists and French atheists, who asserted that such naturalistic laws do indeed have substance and meaning, that they exist in nature as such, and ought to be followed. The meaning of a naturalistic world is that it is—naturalistic. We ought to celebrate a "naturalistic beauty." Within the historical narrative of this period that is an odd claim indeed.

It was odd for them to champion an architecture of positivist natural law since a hundred years earlier Claude Perrault offered a penetrating critique of such nature-based rules. A medical doctor by training, fluent in Latin and Greek, Perrault eventually found himself in a unique position to affect a change in architectural theory, a change that perceptively, and tragically, grasped the endpoint of seventeenth-century skepticism. After the Italian architect Gian Lorenzo Bernini's plan for the east facade of the Louvre was rejected, Perrault offered a design that came to the attention of Jean-Baptiste Colbert; a year later, in 1666, Colbert appointed Perrault as translator for an updated version of the Roman architect-engineer Vitruvius.[28] How Vitruvius was to be understood became significant to how the relationship of architecture and natural law is understood.

During the course of his involvement in architecture, Perrault grew skeptical of the architectural rules of antiquity. Indeed, his controversial translations of Vitruvius spurred on the famous Quarrel of the Ancients and Moderns, a literary and artistic debate over just how antiquity, and its principles, were to be understood and valued. In his own 1683 book *Ordonnance des cinq espèces de colonnes selon la méthode des anciens (Ordonnance for the five kinds of columns after the method of the ancients)*, Perrault addressed the long-standing problem of the lack of uniformity in the columns of the various classical orders. Deeply influenced by the Cartesian penchant for rational clarity, Perrault desired an empirical and rational perfection in the proportions of classical architecture, something previous architects from antiquity, including Vitruvius, and the Renaissance had not provided.

Eventually, Perrault decided to take on the whole concept of natural laws by which one ought to construct architecture. Researchers returned from Greece and the Italian peninsula with precise measurements of standing Greek and Roman buildings. Perrault discovered that those buildings did not, so to speak, measure up. Their proportions and systems were not as precise as seventeenth-century empiricists and rationalists would have preferred. If their proportions varied, then the probability that such proportions effectively reflect natural law reduces to near if not actual zero. Such findings confirmed to some that natural rules for architecture did not exist.

Furthermore, architects and theorists knew well the history of confusion in regards to those heterodox buildings; their measurements did not even correspond with the universally agreed-upon authority, Vitruvius. Perrault concludes that design has little to do with nature but much to do with social convention in regards to what is attractive. Moving against the traditions of Western architecture and the newly formed Académe d'Architecture, Perrault suggests that beauty "has hardly any other foundation than *fantaisie*," and that "true and natural" proportions do not exist.[29]

Nonetheless, Perrault, like Christopher Wren in England at about the same time, desires more grounding than mere whim. He proposes beauty both positive (universally admired) and arbitrary. Taste, like the will, is subjective, but good taste and a good will are universally grounded. What results is a new metaphysical vision offered as normative. The classicist sees Perrault continuing the dismantling of the metaphysics of classical architectural theory and beauty, something encouraged by Newton in science and Boullée in architecture. However, the modernist sees Perrault struggling to free theory from an oppressive traditionalism and liberate it via human reason. As one commentator disingenuously puts it: "Perrault had to combat the prevailing understanding of theory as a 'metaphysics.'"[30] So do we.

Modernist-postmodernist metaphysics are existential. To resist them is to commit heresy. There are classical-Judeo-Christian metaphysics, and modernist-postmodernist metaphysics. The issue is which is more compelling in terms of science and reason, and what kind of culture and life can result.

It is useful to recognize that Perrault, Newton, and Boullée would *not* love sitting within St. Paul's Chapel or the Old Ship Meeting House—unless the meaning of love and glory as coupled with ontological completion or duty was fundamentally ignored. Correspondingly, George Washington, Jonathan Edwards, and Ebenezer Devotion would *not* love sitting in Boullee's modernist cenotaph for Newton. Indeed, the prospect of Washington, Edwards, or Devotion visiting say, the Museum of Modern Art in New York City rather makes the point. In that museum they would encounter works of art that assault their foundational beliefs. The transgressive nature of modernist and postmodernist art—whether impressionism, expressionism, cubism, dada, surrealism, or abstract expressionism—would make no sense to them. All deny the efficacy of ontological reason in the dutiful pursuit of wisdom. Reason is not only denied, but vilified: reason is deemed the great enemy of culture and freedom. These artistic schools find decorous the indecorous; our only duty is to have no Architecture for a House of Life.

The house of life in which we are comfortable is more than a physical architecture. It is a mental architecture as well. It can aspire to be symbolic of the divine mind or Being, or transubstantial in the sense of making manifest our rise from fact to understanding. It can be symbolic of the constructions of the human mind, or existentialist in making manifest our authenticity in a factual and willful world—Being as us becoming. In any case, architecture and fine art objectify the nature and relationship of reason and science, of Being and becoming.

French art critic Andre Salmon explains in reference to cubism:

There is nothing real [Being] outside ourselves; there is nothing real except the coincidence of a sensation and an individual mental tendency. Be it far from us to throw any doubts upon the existence of the objects which impress our senses; but, rationally speaking, we can only experience certitude in respect to the images which they produce in the mind. . . . We seek the essential, but we seek it in our personality and not in a sort of eternity, laboriously divided by mathematicians and philosophers.[31]

So reason is personal, be it a mental tendency or grounded in the will. But whose will? The allegedly impersonal (that is, nontheistic) facts of positivism are understood expressly as serving personal cognitions, resulting in subjective truth. Alternatively, for the theist the facts of positivism are understood as the subjective cognitions in the service of obtaining objective truth. The question then is who's truth will prevail. The unity of facts, human reason, and a good will as the foundation for science and ethics makes no sense and results in deep theological and scientific problems.

It is certainly true that we can arrange facts differently; we can pursue empirical science and physics in a variety of different ways. However, scientific positivism and constructivism do not necessitate the conclusion that science is limited to facts and subjective truth. Scientism need not deny *scientia*, but rather can serve it as a first step. Scientism establishes that beyond facts and feelings there remains the question of a willful pursuit of objective or of subjective truth. What remains is the question of whether facts can rightly, decorously, be arranged; whether the subjective aspect of seeking knowledge can lead to more than opinion or power. The critical point is this: modernist-postmodernist subjective truth is by its own definition nonbinding. The critical choice is whether we attempt to arrange those facts as they ought to be, or as we wish them to be. We can pursue a decorous science, or *scientia*; or we can pursue an indecorous science, or scientism. We can choose to arrange facts either assuming that there is an objective order to the cosmos that needs to be discovered, or that there is not. We can be scientists, or alchemists.

As an Anglican, George Washington could not comprehend the notion that reality is a welter of meaningless creative combinations, creative syntheses, and facts and personal mental tendencies. To do so would be indecorous and transgressive of knowledge and culture. Our knowledge of reality cannot be an expression of mere facts and subjectivity and still hold meaning. Washington's patrimony includes Plato and Augustine, who agree that knowledge occurs via mental tendencies, but the goal of those mental tendencies is to be in harmony with Being as made manifest in nature and culture. Both nature and the knowing mind are

understood to be properly informed by objective truth. As Augustine explains, and as Edwards would likely agree, the Platonists are correct that the apprehension of truth (or forms) cannot be from experience, but rather, experience is preconditioned by truth:

> It is part of the higher reason to judge of these corporeal things according to incorporeal and eternal reasons; which unless they were above the human mind, would certainly not be unchangeable; and, yet, unless something of our own were subjoined to them, we should not be able to employ them as our measure by which to judge corporeal things.[32]

That knowledge is obtained via our mental tendencies is affirmed not only by Plato and Augustine, but also by Kant, Hegel, Marx, and Nietzsche. More recent writers on science such as Becker, Wittgenstein, Kuhn, and Popper affirm this point but in such a way as to undermine the objective pretensions of the Enlightenment. Those mental tendencies might variously be referred to as paradigms, climates of opinion, or perspectivism.

For the Platonist and Augustinian (and others), those tendencies are neither arbitrary nor solipsistic. They refer not to personal preference, but to proper desire. The Platonist and Augustinian understand them as means of realizing ontological beauty. That beauty occurs as a recollection, an enlightenment that happens when our mental tendencies seek union with a meaningful reality. As an act of love, genuine knowledge is not synthetic or analytical; it is numinous. It occurs as a matter of recognition rather than cognition, imitation rather than creativity. Creativity without truth is transgressive folly.[33] So as Augustine emphasizes, knowledge does not objectively and impartially result from mere sense perception (as maintained by positivists such as Newton and Comte), or mere subjectivity (Nietzsche), or an alchemical combination of the two (Kant, Hegel, Marx). Rather, it is realized via a passionate commitment to truth, goodness, and beauty. It is grounded in a commitment to responsible freedom.

It is inconceivable that Washington, Edwards, or Devotion would agree with the meaning of the modernist-postmodernist paradigm. In contrast to Washington's declared belief in an objective and optimistic reality, which provides a ground for responsible freedom and human honor and dignity, modernism declares that facts are objective but reality is subjective, a momentary product of our minds and wills. In contrast to Edwards's belief that all existence is mental, grounded in the imitation of benevolent Being, whose will is good, is the postmodernist idea of the universe conforming to our minds and our wills as a celebration not of God's glory, but our own.

Given the intellectual content and social consequences of these cultural and scientific paradigms, neither George Washington, nor Jonathan Edwards (or Devotion) could agree with the science, ethics, or fine art associated with modernism. For them, the reality of truth exists prior to it being comprehended. For Augustine, the foundational categories of all science are substantively decorous, not obtained merely by our senses. Both nature and the knowing mind are informed by objective Truth, or God, but that knowledge of God does not occur as a result of knowledge of things. As Plato established, learning is a form of remembering the innate knowledge that the mind has forgotten. That knowledge—or truth—is properly present in the world and in our minds. The Augustinian view confirms that just as illness is a lack of health, ignorance is a lack of the knowledge proper to the mind as such. It is pride that prevents our remembering what we ought to know. We do not create, but find *scientia*, and in so doing we find what is decorous.

Through the ages, Augustinians are neither nominalists nor relativists; they would be appalled at the violent prospect of humanity playing God by (de)constructing science and reality. They do not view the world and life as purposeless fact and feeling; nor do they view the pursuit of wisdom as objective in the sense of neutrality. They accept that truth can never entirely be known, and escape subjectivism by passionately embracing the traditional notion of progress: that obtaining degrees of knowledge, however imperfect and incomplete, is better than ignorance or foolish hubris. The alternative to a false objectivity is not subjectivism and constructivism, nor is it dogmatism. It is the passionate commitment to the free and responsible pursuit of truth. It is better to be imperfectly right than merely wrong—if we are to rise above the level of barbarism we must take stands on principle, however incomplete our understanding of principle might be.

Moving Beyond Newton and Kant

The differences between the beliefs of these two viewpoints (Platonic-Augustinian vs. modernist-postmodernist—with Scholasticism poised between the two) represent deep currents within American and Western culture and each exhibit profound effects. To wit, beyond the realm of fact is that of meaning, and meaning is deeply influenced by mental tendencies. But there are a variety of mental tendencies; which should prevail is dependent upon a subjective choice between an emotional commitment to power or a love of wisdom and beauty. A summary rejection of one set of mental tendencies over another is indefensible. To dogmatically insist

that mental tendencies can only create truth, and not find it, is indefensible. It is to arbitrarily insist upon a single Newtonian-Kantian mental tendency. This not as an affirmation of freedom and diversity, but an act of bigotry. It is to incoherently defend as a matter of principle the tyranny of the subjective and pointless will.

Mental tendencies can seek to find, or to make, truth. Given that both options are plausible, a qualitative evaluation of the validity and consequences of each is practical. But the conclusions of a positivist study of qualitative belief are predetermined. To recall Philip Rieff, postmodern anticultures exist only as negations of wisdom-seeking cultures. To quantify culture by reducing it to nostalgic facts and emotional response is to destroy culture in the false name of objectivity. The ironic result is that we can no longer objectively recognize what culture is.

The narrative of any book is either in the pursuit of wisdom or the pursuit of facts and power. A positivist study of cultural conflict is disingenuous since it is a tacit advocate of fact and power rather than of wisdom. A cultural life and death struggle ensues. For example, George Washington and Jonathan Edwards are deeply influenced by Anglican Scholasticism, Calvinist Protestantism, and by the Anglosphere. In turn they are influenced by traditional classicism as well. But each finds himself having to respond to the growing influence of the Newtonian/Kantian worldview. This is now obscured because there are today many Anglicans (or after 1789 in America, Episcopalians), Lutherans, and Calvinists who uncritically accept the foundational beliefs of modernism and postmodernism. They do not recognize that the Newtonian/Kantian paradigm goes well beyond the realm of scientific fact and human reason; it is destructive of the very foundations of their worldview, their house of life. Modernist and postmodernist Christians, Jews, and classicists are culturally neurotic. They are unwitting apostates of their faiths. Indeed, no wisdom-seeking tradition around the world or in human history can be reconciled with the modernist-postmodernist (de)constructivist mind.

If in fact Washington's worldview is no longer viable, then we should not pretend otherwise. However, if it remains viable in part or whole, then the dominance of modernism and postmodernism is rightly recognized as oppressive. The difficulty now is to defend a scientific and rational pursuit of wisdom. It cannot be done by considering the issue from a Newtonian-Kantian perspective. To view Washington, Edwards, or for that matter John Adams from the viewpoint of Newton and Kant makes no sense. To view a tradition that maintains the possibility of an optimistic pursuit of wisdom and beauty via the perspective of a tradition that denies the possibility of wisdom and beauty is to preordain a negative conclusion. It is to unnecessarily condemn our science, ethics, and art to a world of fact, feeling, and purposeless willfulness.

Washington and Edwards engaged in fearful struggles to politically realize their understanding of a just and beautiful culture in which the traditional rights of Englishmen are combined with a declaration that we are endowed by our Creator with certain self-evident and unalienable rights, including life, liberty, and the pursuit of happiness. The rational and practical pursuit of what is true, good, and therefore beautiful is central to the American Revolution and to the historical role played by Washington and his peers. But is that pursuit real? Is it grounded in a firm understanding of science, ethics, and art? And is it still a valid pursuit, one the citizen can now aspire toward? Or is it one relegated to a distant past?

These questions refer to a fundamental schism within Western and American culture. However, the conflict does not pit enlightened secular and scientific society vs. unenlightened and religious superstition. What has shifted between the classical, medieval and Scholastic roots of the West and the developments of the seventeenth and eighteenth centuries to that cultural patrimony, is a basic understanding of reality and life. It is a shift from a qualitative to a quantitative universe, from science in the pursuit of wisdom to science as the substitute for wisdom. Of primary importance to that shift is the transformation of an Aristotelian to a Newtonian physics. That scientific shift not only alters our understanding of reality; it alters the very possibilities of our thinking and of our scientific and historical narratives.

Fortunately, a historical perspective of science, ethics, and art makes clear that the attempt to escape a narrow positivist definition of science is not only possible, it is inevitable. History provides the means by which we can escape the mental prisons of the present. Both the form and substance of our knowledge has never been static. Science as the pursuit of fact rather than wisdom ought to be recognized as stemming from the specifically Newtonian/Kantian paradigm of knowledge. We ought to recognize this as but one of many reinterpretations of science, one neither inevitable nor unalterable. It is possible, reasonable, and valuable, to consider the alternatives.

For Augustine and Aquinas, Plato and Aristotle, science was not simply a matter of recording Newtonian material force; rather, as Dante explains in the *Divine Comedy*, it is love that guides the planets through the heavens. For the Scholastic mind, gravity and physics were the manifestation of cosmic purpose. It is God's substance, Truth and Love, realized via the divine will, that causes the universe to exist and have purpose and beauty. We are newly confronted by a perennial choice: the universe as empty space or the universe as a sacred place. At stake is no merely trivial choice of perspective. At stake is the quality of our future.

4

Scientific Rationalism
and the Problem of Nature

We have seen that the redefinition of science and reason by Enlightenment figures such as Newton and Kant had repercussions in both science and religion. We have also suggested that science and religion are inescapably one in that they share a common goal: to understand reality, to obtain a glimpse of truth. When science is redefined, then our understanding of truth is redefined. The current problem is that the new definition of truth as rationalized or experienced fact denies that truth as ontological knowledge exists in science, ethics, and art. It thereby redefines truth as power. Newton and Locke rightly cling to the idea that there must be some lodestone that gives content and meaning to knowledge. But according to the postmodernist theorist Nelson Goodman (who extends the argument of Giambatista Vico discussed previously), we are that lodestone:

> Truth, far from being a solemn and severe master, is a docile and obedient servant. The scientist who supposes that he is single-mindedly dedicated to the search for truth deceives himself. . . . He seeks system, simplicity, and scope; and when satisfied on these scores he tailors truth to fit. He as much decrees as discovers the laws he sets forth, as much designs as discerns the patterns he delineates.[1]

The limitation of knowledge to facts, feelings, and rationalized will is a particular paradigm of perception with significant advantages, flaws, and consequences. Its advantages center on a promethean advancing of factual and techno-

logical knowledge, something of minor interest to, for example, the classical and Augustinian viewpoint; its flaws center on the promotion of either a deontological rationalism or an ontological violence and the dreadful consequence of a technologically advanced existentialism.

That technologically sophisticated existentialism has theological consequences as well. One consequence is Newton's denial of the Trinity and the divinity of Christ—a denial which affects our understanding of the nature of reality and truth. It results in a theological conflation of God the Father with the Incarnation, which intellectually is a conflation of Being with Becoming, transcendence with immanence, objectivity with subjectivity. When Being is Becoming, then Being as such is denied. Science, philosophy, and theology must then center on process and immanence devoid of meaningful purpose or objectivity of knowledge. Scientific and religious truth is understood as purposeless process.[2]

The realm of objective truth—eternal Being—becomes problematic, as does the notion of a purposeful universe. A qualitative universe is replaced by one quantitative. By analogy, geometry shifts from a rational, eternal, indeed static clarity to a rationality that focuses on action, on becoming, on dialectic. We shift to the geometry of the Baroque. We shift to a new *calculus*—in mathematics, science, and culture.

In his 1667 publication *Mathematical Principles of Natural Philosophy*, and his *Opticks* (written earlier but first published in 1704), Newton explains his attempt to reconcile physics with mathematics and motion. He is concerned with matter, space, and time, and their mathematical relationship. Newton posits that the design of the universe makes sense, that matter and void exist, and that space and time are infinite and absolute entities in which masses mechanically move. He also redefines sight by associating it with organic sense perception rather than understanding (e.g., Luke 8:10). For Aquinas, sight and hearing are superior to the other senses because they connect with the intellect. But now, sight is a physical process—seeing as understanding is only for God.[3]

Newton proposes developing a new body of knowledge via a resolution of mathematics with becoming rather than degrees of being, with empirical observation and human rationality rather than purposeful cosmic or teleological completion. For Newton, mathematics is to be combined with factual observation to produce knowledge of the laws of a dynamic but purposeless nature. In the preface to his *Principia* he wrote: "All the difficulty of philosophy seems to consist in this—from the phenomena of motions to investigate the forces of nature, and then from these forces to demonstrate the other phenomena."[4]

In so proposing, Newton differs from Galileo, Descartes, and more distantly, Plato (his Book of Timaeus); all share the assumption that the underlying struc-

ture of the world is static and geometric. For Newton, science is realized via the use of mathematics to accurately describe the processes rather than the enduring purpose of the natural world; in an Anglosphere manner, he aims to reveal the will rather than the substance of God—or humanity. In this he and Jonathan Edwards concur. As Edwin Burtt puts it in his important book, *The Metaphysical Foundations of Modern Physical Science*: "It is noticeable that Newton, in common with the whole voluntaristic British tradition in medieval and modern philosophy, tended to subordinate in God the intellect to the will; above the Creator's wisdom and knowledge is to be stressed his power and dominion."[5]

This important point is worth emphasizing: Trinitarianism and the Doctrine of the Incarnation are more than mystical theology. They inform how we understand truth and how we reconcile becoming with Being; they make possible a scientific rationalism dedicated to the pursuit of *scientia* and *sapientia*. They make possible a culture of responsible freedom. Without a reconciliation of becoming with Being, culture can only be grounded in a *calculus of pleasure and power*—it matters not if those calculations are utilitarian and pragmatic (Mill and James), hedonistic (Bentham), or violent (Hegelian-Marxist-Nietzschean).

The integrity and reconciliation of becoming with Being is traditionally realized via a qualitative Trinitarian cosmology. Becoming properly evidences increasing degrees of Being; that is uniquely completed by the Incarnation. The Newtonian limitation of knowledge to a positivist pursuit of facts and mathematical or rational clarity denies the doctrines of the Trinity and the Incarnation because it denies the possibility of scientific and rational transcendence. It denies degrees of knowledge of Being, therefore mandating a reductionistic view of science and reason. A positivist rationalism reduces the pursuit of *scientia* and *sapientia* to mere scientism. Consequently, this different cosmology acknowledges a different set of mathematical and empirical evidence.

But Newton's positivism cannot know that the cosmos lacks purpose. The quantitative positivist view rightly questions Scholastic excess, but it lacks the intellectual justification to exclude the qualitative nature of the Scholastic and pre-Scholastic view. Nonetheless, history establishes that the positivists presumed to do just that. It is extremely important to note that Americans such as Jonathan Edwards resisted not only Catholic Scholasticism but also Newtonian positivism. Edwards did not deny Newton, but he saw his limitations (as John Adams saw the foolishness of David Hume, whom he referred to as a learned fool). He recognized that what Newton called explanation was actually merely a description.[6] Hume asserts that there is no *ought* to *facts*;[7] Edwards asserts there is no *why* to *what*.

Edwards rescued New England Trinitarian Calvinism—with its orthodox understanding of the relationship of becoming and Being—from Newton's limiting empiricism. Yet he desperately struggled to avoid the other extreme of a mystical, neo-Platonic self-deification. He strove to avoid the Unitarian conclusions that were later promoted by Emerson.

A proper discussion of Edwards's ideas cannot be accomplished without knowledge of Newton's perspective on science and religion. That perspective is dramatically illustrated by a painting in the Trinity College Library, Cambridge University. *An Allegorical Monument to Sir Isaac Newton* (1727) by Giovanni Battista Pittoni depicts the conceptual framework here discussed. In a dazzlingly rational neoclassical interior, we find Minerva and the Sciences being led to venerate an urn containing the material remains of Sir Isaac Newton. In the middle ground of the work are depicted various predecessors accompanied by symbolic figures representing Mathematics and Truth. A dramatic ray of light descends into the space striking a prism representing Newton's celebrated publication *Opticks,* which redefined the science of light as physical and emotional phenomena.

What one finds is an empiricist-mystical perspective. Newton states that God is Being, and the universe exhibits intelligent design; but in Anglosphere fashion it is God's will that comes to the fore. The world is willed into existence (God as First Cause) and is maintained by that will (the universe's Final Cause is now God's will, not God's Being). As he explains in his *Principia*: "This Being governs all things, not as the soul of the world, but as Lord over all; and on account of his dominion he is wont to be called Lord God . . . or Universal Ruler. . . . The Supreme God is a Being eternal, infinite, absolutely perfect; but a being, however perfect, without dominion, cannot be said to be Lord God. . . . It is the dominion of a spiritual being which constitutes a God."[8]

Newton is a positivist who nonetheless posits a mystical metaphysics: the existence of a *first cause*, a creator god, who is the mysterious source of the natural laws of the universe. Newton holds that natural science revealed via empirical facts makes obvious the existence of a God; as such Newton is a proponent of intelligent design. The laws that govern the universe are so exquisite, so perfect, and so intelligent, that the universe must have been created by an objective intelligence, an objective Truth. The Scholastic concern for knowledge of the qualitative substance of God and nature is ignored. For Newton that divine Being or intelligence is now manifested via the Divine Will. Having made the laws of the physical universe, God now is relegated at best to maintaining those laws. God is a cosmic plumber—and given the occurrence of evil, a neglectful one at that.

Nature is not analogic—of the same logic—of God, but emotive. Nature is fact and will. The unfolding of the laws of physics is a means by which we might obtain an inferred glimpse of a willfully divine physics and metaphysics. That will is no longer demonstrably transcendent; both God and the universe are infinite and present. Deity is, then, immanent within infinite and absolute space and time.

Such matters are complex, but their consequences are foundational upon Western and world culture. As Newton presents his famous *General Scholium* in the second edition of the *Principia*:

> [God] is eternal and infinite, omnipotent and omniscient. . . . He is not eternity or infinity, but eternal and infinite; he is not duration or space, but he endures and is present. He endures for ever, and is everywhere present; and by existing always and everywhere, he constitutes duration and space. . . . It is allowed by all that the Supreme God exists necessarily; and by the same necessity he exists always and everywhere.

Newton continues along this line of reasoning in his *Opticks*:

> [God] being in all places, is more able by his will to move the bodies within his boundless uniform sensorium, and thereby to form and reform the parts of the universe, than we are by our will to move the parts of our own bodies. And yet we are not to consider the world as the body of God, or the several parts thereof, as the parts of God.[9]

So the world is infinite, a divine sensorium comprised of matter and void. The infinite Divine Will—which mystically bridges the void which infinite Divinity somehow leaves empty—furnishes the ultimate center of reference for absolute motion and cosmic coherence. At the same time we are not to understand God as immanent and pantheist and we are not to understand evil as the product of the Divine Will.[10]

As later developments make clear, this paradigm does not make sense; within this paradigm Newton, Berkeley, and Hume come to three conflicting conclusions. For Newton this results in a world in which nature is God's sensorium, the material consequence of God's will. But for Berkeley it means that knowledge of God and nature are spiritual rather than material, whereas for Hume nature is only material rather than spiritual—all that matters is the will of humanity. The problem of the objectivity of Truth or God, and therefore of intellectual meaning, becomes moot. As Burtt concisely puts it:

The gloriously romantic universe of Dante and Milton, that set no bounds to the imagination of man as it played over space and time, had now been swept away. Space was identified with the realm of geometry, time with the continuity of number. The world that people had thought themselves living in—a world rich with colour and sound, redolent with fragrance, filled with gladness, love and beauty, speaking everywhere of purposive harmony and creative ideals—was crowded now into minute corners in the brains of scattered organic beings. The really important world outside was a world hard, cold, colourless, silent, and dead; a world of quantity, a world of mathematically computable motions in mechanical regularity. The world of qualities as immediately perceived by man became just a curious and quite minor effect of that infinite machine beyond.[11]

To clarify, Newton's God of Being is eternal and infinite, but not as traditionally understood. God's Being is now becoming; it is the will of God that is paramount. Newton's new calculus emphasizes the pursuit of knowledge of God's active will and his works rather than of a transcendent mind which informs a decorous world; this shifts attention from Being to becoming in both science and religion. This denies the Trinitarian reconciliation of transcendence and immanence, and since it denies a subject-object relationship, it denies the very possibility of freedom and objectivity in science, ethics, and art. Newton focuses on the will of God rather than the substance of God. He believes in God, but is not a Trinitarian. He is an Arian, one who denies the divinity of Christ and therefore denies the intellectual content of the Doctrines of the Trinity and Incarnation—by which Being and becoming are reconciled without the denial of either. He thus redefines not only divinity but science as well.

This important issue is now trivialized by the positivist mind. In a positivist (and historicist) culture the intellectual and scientific value of the Incarnation is typically ignored, reduced to a matter of mere superstitious hero-worship. Similarly, the eternal soul is no longer understood as the divinely determined form by which a decorous material existence is realized. Science stops seeking that which is ontologically right and true. Instead, it centers on a brutal and utilitarian pursuit of power and pleasure.

The decorous soul is replaced by the existentialist soul; the priest and lover of wisdom is replaced by the psychologist or the ideologue. Sincerity and authenticity replace decorum, but sincerity for, and authenticity of, *what*?

At this moment, the universe perceived by Dante, a finite universe governed by a transcendent and infinite God who is both rational and loving (i.e., the object

of completion and purpose) is swept away. Concerning the physical world, Newton posits that instead of a *final cause* toward which all decorously aspires, there is a *first cause*, a Creator God, who makes the world, sets it spinning, and fitfully maintains it. Instead of an infinite God majestically presiding over a finite universe, there is now an infinite God active within an infinite universe filled with unexplainable evil.

Newton's shift from a *final* to a *first* cause is significant. It marks a shift in physics from decorous love to willful process and a shift from the universe being a continuum from the mundane to the Divine (via the Trinity and Incarnation) to a universe in which there is a first cause or God (for some, mere chance) a physical universe driven by natural law, and humanity. For Newton, there is a world of fact and will—be it human or divine. Therefore, one can worship either the will of humanity, or the will of God, since no wills can (as Kierkegaard and Nietzsche later assert) be reconciled via knowledge.

So Newton is a proponent of scientism, but he tries not to deny the existence of a meaningful world. His physics is connected with a deist metaphysics. He accepts that God creates the world and establishes natural laws for that world. But Newton posits an unorthodox infinite universe, and thus makes a transcendent God—or objective truth—problematic. In his *Principles of Human Knowledge* (1710), Berkeley argued that Newton's system concludes in atheism.

Other problems exist as well. Edwin Burtt critiques the Newtonian assumption that absolute space, motion, and time imply infinite room in which they can move. The difficulty is that within infinite room, space and time and causality cannot be understood. The subject-object relationship essential to understanding is denied. In seeking to understand the world and ethics, Newton contradicts himself and necessitates a relativist and quantum universe that denies the possibility of an ontological scientific rationalism that grounds culture and civilization. Burtt echoes Locke, who recognized the need for a lodestone for science and culture:

> Taking any body or system of bodies by itself, . . . it is impossible to say intelligibly that it is either moving or at rest in absolute space or absolute time; such a statement only becomes meaningful when another phrase is added—*with reference to such and such another body.* Things move in absolute space and time, but *with reference* to other things. A sensible centre of reference must always be definitely or tacitly implied.
>
> Now it is clear that Newton did not feel this implication of the meaning of space and time or observe the distinction. . . . How, then, did Newton

allow himself to fall into the error, and include such statements in the main body of his classic work? The answer to this question is theology.[12]

The shift from an Augustinian to a Newtonian worldview marks a shift from a numinous world within which is a continuum from material fact to God via the Incarnation. We once lived in a sacred order, transgressed by evil, but now we live in a transgressive world in which the sacred is mocked. Correspondingly, whereas tradition maintains that the substance of God, Truth and Love, informs the actions of God, now the actions of God informs the substance of God. But when the will informs the divine or the human mind, then Being collapses into violent becoming, love as meaningful completion makes no sense, and knowledge becomes the product of the will. There is nothing that God—or humanity—could not will. Both God and humanity shall do as they will.

The center of reference that permits knowledge of a purposeful world and life—that is, Truth—is traditionally found in the transcendent lodestone of Being. Transcendent Being provides the ground of creation out of nothing (*creatio ex nihilio*); transcendent Being is reconciled with immanent being (creation) and becoming (time) as patterned by the Trinity and the Incarnation. Being—or Truth—is the lodestone by which knowledge can be recognized. But Newton as a deistic positivist defines God immanently while attempting to avoid the obvious pitfalls: a factual and meaningless atheism (as Berkeley charged), or a pantheism in which subject and object are one and the will of humanity aspires to the status of the will of (a) God (as Hegel later promotes).

Consequently, gravity is not a manifestation of God's Love (as understood by Dante), but rather is indifferent to God or indicative of the will of God. A transcendent and purpose-granting *why* distinct from—and yet joined with the realm of—*what* is denied; a divine object is no longer distinct from an adored and adoring subject. Both God and the universe are understood via a subjective-objectivity, in which meaning is either denied by the materialists or immanentized by the spiritualists. That is the template for the future.

The problem is not so much that there is no longer an edge of the world to fall over (as put by those who fail to recognize what is at stake for the universe to be other than finite) but rather that there is no objective truth for the world—or us—to aspire to and thus find purpose in. There is neither ontological geometry nor decorum, but only a mechanical or an immanent process and power to pursue.

Newton's deistic metaphysics affirms the existence of cosmic purpose but not as a matter of knowledge. In the context of his theological-based physics of infinite space and time, the cosmos is the sensorium of God. He redefines the

transcendent God the Father to a newly immanent God the Father—thus denying the Trinitarian distinction and unity of meaning and matter, eternity and temporality. Nonetheless, Newton strives to reconcile his physics of infinite space and time (which affirms immanentism) with a theology that affirms a transcendent yet also immanent God that avoids the pitfalls of pantheism. He fails in his attempt to round the square,[13] and retreats to the position of last resort: it's a mystery. As Burtt writes:

> Absolute space for Newton is not only the omnipresence of God; it is also the infinite scene of the divine knowledge and control. . . . And yet we are not to consider the world as the body of God, or the several parts thereof, as the parts of God. . . . It is allowed by all that the Supreme God exists necessarily; and by the same necessity he exists always and everywhere . . . but in a manner not at all human, in a manner not at all corporeal, in a manner utterly unknown to us.[14]

So Newton's attempt to maintain a transcendent yet immanent God within an infinite physical universe necessarily denies the possibility of the transcendent realm. He incoherently attempts to affirm a duality of infinities achieved by reducing knowledge to the will.[15] Two positivist options result: a materialistic or a pantheistic denial of objective meaning and purpose in life. Or to put it in secular terms, Newton tries to maintain objective truth while declaring that beyond mere fact truth is to be found in us.

The physics of Newtonian deism are in conflict with the metaphysics of Newtonian Christianity, and of the Trinitarianism of Jonathan Edwards. The implications of those conflicts result in enormous historical consequences. In an immanent yet infinite universe we are (to paraphrase the Romantic American Ralph Waldo Emerson) part and parcel of God. Newton provides a scientific and rational foundation for the self-deifying modernist philosophy of Kant, and also for the later physics of Einstein and Heisenberg. As John Patrick Diggins argues, following Europe, much of American culture is now a culture of *becoming*.[16] Just what we are becoming is the problem.

Jonathan Edwards and Newton

What did Jonathan Edwards make of Newton's concepts? Whereas Edwards accepts that nature is God's own magnificent work of art, he denies that gravity is

a mere fact, and that reason is rationalized power. A description is not an explana-
tion. As historian Paul Conkin explains, Edwards

> exulted in Isaac Newton's revelations about the physical universe. But while
> Deists were using Locke to justify a rational and unemotional religion and
> Newton to justify a mechanistic and self sufficient universe, Edwards used
> Locke to explain the phenomenon of conversion and Newton to prove the
> glory of God and the moment-by-moment dependence of nature on His
> being. . . .
>
> He was as horrified at irrationalism as he was at mere emotionalism. His
> insistence on the ultimate rationality as well as on the immediacy and feeling
> of true religion linked him both to the age of reason and to scholasticism. . . . If
> Edwards had discovered a real conflict between science and religion, between
> fact and value, between truth and his own experience . . . he would despair-
> ingly have chosen truth and fact in place of religion and value, for such was his
> honesty and his commitment to a rational universe.

That commitment to understanding a rational universe is Augustinian:

> In the absence of any meaningful relationship to infinite being, man is his
> own god, though frustrated and possibly headed for destruction. . . . To
> Edwards, the key to man's alienation from being, and particularly his lack
> of love for being, was his superficial interpretation of experience. Blinded
> by pride, man isolated himself from the whole. Edwards was persuaded by
> Locke that all knowledge ultimately depends upon sense experience, but he
> always agreed with Augustine that a special gift of grace is necessary before
> this experience can reveal its full meaning.[17]

Newtonian deism mandates a mechanical universe of matter, empty space,
and motion. But Newton cannot explain how gravity spans the empty space
between material objects. Naturalism provides no answer; Hume utterly rejected
naturalistic Newtonian cause and effect as grounded in knowledge. A remaining
solution is historically found in alchemy and magic, but that solution was feared by
Newton since it would wreak havoc upon his career and upon science.

So the Puritan revered science, never doubting that science is and must be in
harmony with the mind—as well as the will—of God. What, then, of knowledge?
Bound by Newton's redefinition of science as scientism, Edwards pursues as a viable
alternative a type of Newtonian Augustinianism in which knowledge is grounded in

sense and centers on discerning the rational and moral dialectic of the world. That dialectic is one in which our failure to love what is good is the cause of sin and pain.

Edwards avoids Newton's deistic focus on an unexplainable material cause and effect, a focus which also leaves unexplainable why God would apparently create evil. Edwards rightly agrees with David Hume that empiricism cannot know anything about cause and effect because such knowledge can only be speculative. Edwards affirms Hume's denial of Newton's emotional faith in cause and effect, a faith that cannot be based upon Newton's own scientific rationalism. But at the same time he does not accept Hume's position. His premises and perspective are Trinitarian and informed by Grace; Edwards tries to pursue a new path toward a *numinous scientia*.

For Edwards, the Trinity is not a mystery beyond understanding. Rather, it is a coherent explanation for why things happen. Space is not empty (as Newton asserts) but is God, the infinite ground of all that is. Creation is an act of God's glory, dominion, will; but sounding more Augustinian than Newtonian, Edwards maintains that the world is a constant moment-by-moment recreation according to God's own intentions. Christ, the Incarnate Logos, is God's perfect idea of Himself, and is thus the unity, the pervasive rationale, behind all created existence. Furthermore, as Conkin phrases it:

> One result of Edwards' conception of God was a distinctive interpretation of Newtonian physics. The whole vast system in the *Principia* was, to Edwards as well as to Newton, a beautiful revelation of God. . . . But Edwards was aware that the new physics, and the all-important concept of mass attracting mass according to uniform laws, was an accurate description rather than a complete explanation.
>
> What was the cause of gravity? . . . Bodies are only points of resistance in space. . . . Resistance or solidity, being the power to stop movement, is as basic and as much a type of action as gravity, or the power of originating movement. Thus both are attributable to the same cause or agent, an agent that causes effects without being acted upon or itself changed. Such an uncaused cause exhibits intelligence and consciousness . . . and, by necessity, is God Himself.
>
> Consistent with this ontology, Edwards developed a non-mechanical view of causation. Yet, he always affirmed the necessity of cause and effect. Causation was part of the way humans think and as such was essential to any meaningful understanding. He constantly denounced as completely contradictory any belief in anything being uncaused or spontaneous. . . .

But Edwards just as vehemently denounced the English Deists who were using causation to justify mechanism and natural self-sufficiency following an original and perfect creation. Edwards joined with David Hume in denying any mechanical necessity between a cause and its effect and in this exposing the most vulnerable side of any mechanistic philosophy.[18]

So Edwards offers an interpretation of science and reason that attempts to avoid the pitfalls of Newtonian positivism, crass materialism, magic, and an empty skepticism. What is recognized as good is grounded in understanding; human understanding should freely aspire to a degree of harmony with Divine intelligence. Divine understanding (Being) is one with the Divine Will (becoming). God is the Being of being, reality is the product of God's Being and becoming. Transcendent Being (God) and immanent Becoming (Christ) are reconciled via the Incarnation and evidenced by intelligent design. Beauty and virtue reflect our consent to harmonize with Being. That consent is a gift of Grace realized via virtue.

Edwards's Augustinian scientism is brilliant but inconclusive. It is difficult to have an infinite God present in an infinite material universe without concluding in pantheism. Indeed, in Edwards's essay on the Trinity, which was not published until 1903, the problems of Arianism and pantheism within his system are implicit. Whether or not Edwards succeeds in reconciling Newtonian fact with objective purposeful truth is problematic. But what is not problematic is his clear recognition of Being as the primary problem of Western and contemporary culture. So it remains to this day.

In summary, science with purpose is called theism whereas science without purpose is atheism. The choice between the two cannot be resolved scientifically or philosophically. It cannot be made scientifically because both positions are scientific but differently so; they differ in their metaphysical claims. Those metaphysical claims cannot be resolved philosophically because in a purposeless world philosophy makes little or no sense. Materialists reduce reason to power, while Nietzscheans (such as Jacques Derrida) and utilitarian/pragmatists (such as Richard Rorty) conclude that philosophy fails to provide any ontological knowledge of a meaningful reality.

So the Anglosphere and the classical Judeo-Christian traditions are today faced with an impossible situation. Their choices are to: 1) embrace a Newtonian/Kantian scientism that concludes in (Hegelian) pantheism and nihilism (Nietzsche);[19] 2) accept a materialistic skepticism that focuses on a practical pursuit of power (Hume); or in which no degree of ontological harmony between fact and meaning occurs; 3) accept a utilitarian/pragmatic focus on the pursuit of practicality

resulting in wisdom being viewed as entertainment;[20] or 4) defy scientism and be charged with being unscientific and irrational. The classical-Judeo-Christian tradition is viewed as an assumedly *unscientific* paradigm of knowledge—and hence not a paradigm of knowledge at all. In each case it is presumed that we no longer can understand the world as being purposeful and beautiful. Rather, the world is factual, emotivist, infinite, and any coherence it appears to evidence is accidental, mechanical, organic, or a product of our wills rather than an object of our minds. As such, knowledge is brutalized fact or willful construction. If willfully constructed, then it can violently be deconstructed at will.

Jonathan Edwards attempts to develop an alternative type of science, ethics, and culture, one that would preserve a world that is intelligible and informed with purpose and meaning. That attempt remains vital to the realization of culture: to liberate our understanding of science from the positivist perspective and its concomitant social and cultural nihilism. We will discuss how to further that attempt in the conclusion of this book. Should such an alternative to modernist-postmodernist science be lacking, then we cannot escape embracing a particular scientific paradigm historically grounded in a Newtonian science, one that assumes a fact/feeling, fundamentalist/emotivist approach to understanding reality and life in which our will is ultimately supreme. Escaping the limitations of a Newtonian-based science cannot be achieved simply by denying the Newtonian-Kantian worldview; within its self-chosen parameters it is eminently defendable. Rather, we might better attempt to transcend its limitations. Success in doing so results in a return to a pursuit of the true, good, and beautiful. We can establish that the limitations of its worldview reflects an unnecessary perspective that need not be accepted but can be seen for what it is: a limiting mental tendency, a conceptual fly-jar (to use Wittgenstein's term) so commonplace as to now—falsely—seem inevitable.

A habitualized Newtonian/Kantian science requires that, for example, the pillars of Western and American culture be understood via that perspective. The classicism of Plato and Aristotle is thereby redefined as the neoclassicism of Newton, Kant, and Jefferson; the Judeo-Christian tradition is redefined as a factual/emotional extension of the Baroque; and the long-neglected Augustinian tradition is viewed as dependent upon a Trinitarianism in conflict with a positivist scientific rationalism. To renew the pursuit of the true, good, and beautiful, we must first recognize the Newtonian-Kantian mindset; by recognizing it we establish it as an object of contemplation. As subjects contemplating an object, we escape the habit of assuming it inevitable. We thereby obtain the freedom to choose whether or not to continue in that mode.

Geometry in Art, Science, and Theology:
Classical-Judeo-Christian vs. Modernist-Postmodernist

We have discussed how science, reason, and history are now viewed from a limited modernist-postmodernist perspective. That perspective is foundationally positivist and nominalist. The resulting redefinition of geometry has multiple effects on art, science, and theology. According to the classical-Judeo-Christian tradition, geometry is part of the quadrivium; it is associated with music, mathematics and astronomy. All of the quadrivium are considered to be ontological. They all purport to offer an explanation of reality. Within that tradition the cosmos is musical, mathematical, and geometric in structure. The cosmos is rational, understandable, and finite. According to *Isaiah* 40:21:

> Do you not know? Have you not heard? Has it not been told you from the
> beginning? Have you not understood since the earth was founded? He sits
> enthroned above the circle of the earth, and its people are like grasshoppers.
> He stretches out the heavens like a canopy, and spreads them out like a tent
> to live in.

Similarly, Aristotle famously argues that the universe comprises nested spheres extending from the earth to the higher reaches of the cosmos, and eventually extending from the finite to the infinite. In his text *On the Heavens,* he states the heavens are spherical; according to his *Metaphysics,* the world is composed of the quantum and the qualitative. A diagram of this pre-Copernican view of the universe shows a world that is finite, hierarchical, and purposeful: a harmonious perfection.[21]

A mid-thirteenth-century manuscript from France, the *Bible Moralisee* (now in Austria's Österreichische Nationalbibliothek), is a Scholastic presentation of this scientific rationalism. This

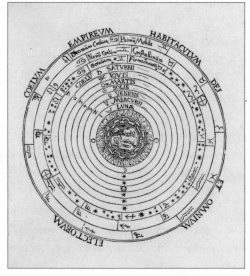

Pre-Copernican view of the Universe

Bible Moralisee, thirteenth century

manuscript illumination depicts God within a gold field that symbolically represents neither creation nor time, but rather pure divinity. God is that which we call the universe's First Cause. At God's hand is that which is *creatio ex nihilio*, that is, creation realized via Divine truth and love. It is the product of a First Cause and will answer to a Final Cause, or purpose, as well. That creation is not a chaos, but a cosmos of geometric ratios. His foot extending beyond the frame of the page reaffirms that Divinity is infinite in contrast to finite creation. It is the purposeful relationship of the finite seeking the infinite by which responsible freedom is made manifest. That is the goal of our contemplative and active lives: to understand and live according to the infinite, while existing in the finite. We are to seek the essential while surrounded by the accidental, to realize purpose within the processes of life. Freedom and responsibility, time and eternity, transcendence and immanence, Being and becoming, are reconciled.

Space and time are finite, within the measure of the Divine compass. God is visually represented as a person, defined since Boethius as the individual substance of a rational nature.[22] For Aristotle, the human soul distinguishes the living man from the dead and so too with the realm of the Divine.[23] It is not that Aristotle or Genesis anthropomorphize reality, but *that reality evidences the rationality characteristic of God, humanity, and problematically, of nature.* A God of truth and love must be self-aware and therefore personal—and rational. That Divine person is conceptually infinite and eternal, but also finite and temporal. A reconciliation of the two—visually, scientifically, and rationally—is realized via the Doctrines of the Trinity and Incarnation.

The visual and conceptual distinction of God and creation as depicted in the *Bible Moralisee* makes no sense to Newton and Edwards. The Divine lodestone—God as transcendent Being—is scientifically replaced by becoming—be it divine

or human. Therefore, the logos or reason is replaced by agape or love, but agape lacking knowledge is indistinguishable from violence. Knowledge of reality is replaced by fact and will.

According to Christian doctrine, temporal creation is the product of the very substance of a transcendent God of Truth and Love. Both Truth and Love freely seek completion; they require an object, the lack of which would cause them to collapse into a narcissistic solipsism. So God makes creation and time as a free yet necessary Divine act grounded in the Divine substance; it is what a person-able God of Truth and Love freely must do. Given the reality of a Divine Truth and Love, then freedom exists in creation as well. The Divine Person is perfect whereas the human person is not. Human persons have the conscious awareness of the need to make right or wrong choices but an imperfect ability to do so. The freedom to do what is true and good makes real the potential of doing what is false and evil. Evil is the result of failing to love what is good and beautiful. Evil is transgressive of responsible freedom. As Augustine put it in his essay on free will, God knows what we will do but is not responsible for what we do. The reality of responsible freedom is grounded in the substance, the Being of a God of Truth and Love as imperfectly realized via humanity. It is achieved via virtue and the need for Grace.

To the Augustinian, God is Truth and Love. Love is not understood as mere emotion or will, but rather as a divinely personal impulse of completion. The ultimate cause of a decorous world and life is Love informed by Truth or Reason. Truth is understood as the Logos (John 1:1), the spoken Word of God, and right reason is analogic. Right reason reveals the world as beatitude, epiphany, and the decorous. The world obtains existence and completion by a rational and loving First and Final Cause, called God. That rational completion is evident in creation and understood via one of the medieval liberal arts: geometry, which reveals the relationship of things beyond and within the created world. The structure of heaven is revealed in Revelations 4:6, where a realm of crystalline clarity is explained: "and before the Throne [of God] there is as it were a sea of glass, like crystal." The structure of the physical world is correspondingly geometric and mathematical, or more precisely, a matter of arithmetic. In Proverbs 8: 27, Wisdom puts forth her voice: *"When he established the heavens I was there: when he set a compass upon the face of the deep."*[24]

Blake and Geometry

Within the context of a New-
tonian-influenced Protestant-
ism fits the work of the English
painter and artist William Blake
(1757–1827). Blake famously
depicted God (or Urizen) and
Newton as geometers, the for-
mer constructing the universe
according to number and form,
the latter attempting to discern
the mathematical aspects of cre-
ation. A comparison of Blake's
depiction of God as Cosmic
Geometer within a Newtonian
universe differs radically from
the Scholastic version of the
same theme. Blake and New-
ton radically redefine not only
geometry but divinity as well.

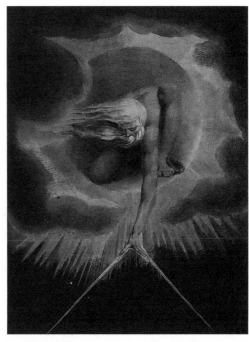

William Blake, *The Ancient of Days*, 1794

They also deny Trinitarian orthodoxy in science, ethics, and art.

During Blake's time, a Newtonian science denies both the Aristotelian sci-
ence of Scholasticism and the orthodox Christian view of an infinite God and
a finite world. It redefines the substance and character of God and of nature.
The resulting theological (and scientific) confusion is associated with the rise of
a bewildering variety of non-Trinitarian forms of Christianity. Unitarianism,
pantheism, Kantianism, and others compete with orthodoxy. *The Ancient of Days*
(1794) by William Blake depicts a figure Blake called *Urizen*, a term with sev-
eral associations including the English "your reason," or in Anglosphere fashion,
the accepted common sense of the age; it is also suggestive of the Greek *horizein*
meaning to set limits. What is the substance and character of Urizen? He has
been associated with the God of the Old Testament, but also with various other
metaphysical entities, included the Demiurge of Plato and the neo-Platonists, the
Gnostics, and even Masonic rites. Uniformly viewed as some type of architect of
the universe, Urizen is varyingly viewed as benevolent or malevolent, the embodi-
ment and the enemy of love.[25]

Blake depicts God within a finite sphere hovering within infinite space, just the reverse of traditional theology. This presents deeply difficult problems for science, ethics, and art. Whether or not we agree on how to interpret the depiction of God in this work, and whether that depiction makes sense, there is no room for dispute in understanding how Blake and Newton undermine Trinitarian Christianity. And therein lies the crux of the matter: Newton's science denies traditional cosmology, but more so, his science denies the possibility of understanding reality or life. In science and theology, understanding and love are replaced by the will and power of God—or humanity.

Quoting from Newton's *Opticks*, Edwin Burtt notes:

[Newton affirms that] [t]he world could not have arisen out of a chaos by the mere laws of nature, "though being once formed, it may continue by those laws for many ages." . . . In the final query of the *Opticks*, however, we find God made responsible for a much more intricate task in applied mechanics; he is allotted the duty of providentially reforming the system of the world when the mechanism has so far run out of gear as to demand such a reformation.[26]

Newton affirms, as does the medieval manuscript, that the world could not have occurred accidentally. The world is somehow geometrical, consisting of measure and ratio; but it is also mechanical. His goal in his *Principia Mathematica* is to combine geometry with mechanics, but in so doing he redefines geometry—and faith:

The ancients considered mechanics in a twofold respect; as rational, which proceeds accurately by [geometrical] demonstration; and practical. . . . [But now] *geometry is founded in mechanical practice, and is nothing but that part of universal mechanics which accurately proposes and demonstrates the art of measuring.*[27]

In Blake's painting *Newton* (1795), the scientist proposes that geometry is now part of a universal mechanics; instead of a *qualitative* geometrical universe exhibiting clarity of qualitative completion, the world is now understood to be simply a succession of willful or predictable mechanical events, of *quanta*. Instead of seeking meaning we focus on accurately describing the transient. In traditional language, we stop seeking to understand the essential and enduring, and instead embrace the mechanical and accidental. A purposeless, Godless universe is not culturally acceptable at Newton's time (or that of his predecessor, Galileo). And so a way to maintain Divinity and purpose in a newly quantitative and willful

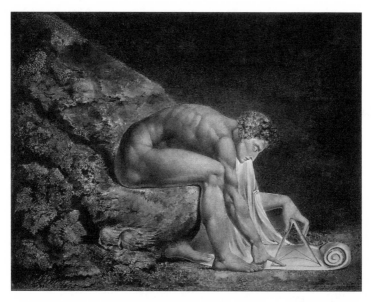

William Blake, *Newton*, c. 1795

world is to regard God as the First Cause and Creator of the material world, one who at best is now engaged in cosmic plumbery.

To put it differently, before Newton (via Galileo) it is understood that we live in a qualitative universe comprised of a continuum from material fact to divine purpose. God exists as a First Cause and a Final Cause of all things. Physics reveal a purposeful metaphysics. All elements of creation exist in varying degrees of profundity—or as varying degrees of evil. Evil is a deprivation of Being, realized via neglect or by the transgressive will. In contrast, after Newton it becomes commonplace that we live in a quantitative world at best presided over by a neglectful—or perverse—God. God is a First Cause who maintains His creation, but His creation is often dangerous. So Theodicy is the major problem facing Newton's new deistic Christian theology: why does God make and maintain a world in which evil and tragedy occur?

Deism mitigates responsible freedom and sin or evil. Either the world is as it is, or evil occurs at the whim and fancy of an ineffable or even sadistic deity. Therefore, if sin or evil do not exist, then they are unrecognizable; if they do exist, then they are the result of the will of God. Natural science has no moral content, social science sees no evil, or God is a sadist who makes a deadly world. We are pawns of circumstances or the manipulation of others rather than responsible moral agents.

Newton redefines the geometric, mathematical, and rational nature of astronomy. But lacking the traditional possibility of meaningful completion, that

rationality is now impersonal—and even dangerous. Geometric astronomy posited a cosmos of completion informed by an eternal rational essence or Being; now geometry is redefined as mechanical process or purposeless becoming maintained at best by the will—not the rationality—of God. Consequently, Being and geometry no longer offer objective meaning. What, then, of the notion of a personal and rational Divine Being who provides a ground for rational human beings? Classical-Judeo-Christian cosmology affirms the rational reconciliation of Being with existence, knowledge with facts, and purpose with change. But Newton's reduction of the universe to a mechanical realm presided over by a sadistic cosmic plumber permits Hobbes to assert that reason—or God—is nonsense on stilts, and that geometry, truth, and God have no existence beyond being mere mental constructs. Advancing Newton's positivist and nominalist criteria, Hobbes offers a competing faith and a competing form of humanism: "Whence it is evident that essence in so far as it is distinguished from existence, is nothing else than a union of names by means of the verb *is*. And thus essence without [empirical] existence is a fiction of our mind."[28]

So Being is becoming, essence is existence, and knowledge is power. Therefore the very notion of a cosmos—a purposeful universe—makes no sense. The world is a matter of mechanical function, a meaningless quanta or events. Science is redefined as the exact mathematical formulation of the *processes* of that mechanical world. It thereby redefines *Being* as *becoming* and denies a meaningful geometry, science, and reason. There is no decorum because there is no ground in Being that makes it intelligible or real. Human beings as rational persons modeled on the image of objective cosmic truth makes no sense. We are condemned, then, to a violent existentialism that is neopagan and barbaric.

By the denial of essence and nondescriptive universals, Newton facilitates Hobbes's denial of the notion of truth, goodness, and beauty. Hobbes not only denies Newton's own idea of God as First Cause of the universe; he denies cause and effect in science. Hobbes represents the anti-scientific positivist atheism so prominent within the modernist-postmodernist tradition whereas Newton (and Edwards) publically persists in the stance that science ultimately cannot be antagonistic to Christianity without also being antagonistic to a scientific rationalism that permits knowledge to trump power. But if science and faith cannot ultimately be in conflict, then what of evil? Lacking a ground in Being, evil either does not exist, or exists as a product of God's Will. For theists such as Newton and Edwards the issue of evil is a major challenge. It remains a challenge to us today. Without a successful response to the question of why bad things happen to good people, the possibility of responsible freedom so central to civilization is imper-

iled. If evil is left unexplained, then so too is the universe; neither is intelligible and our culture and ethics collapse.

Blake's depictions of God and Newton as geometers accurately reflect the confusion within a Newtonian-influenced Christianity. Those depictions historically evidence a classical-Judeo-Christian tradition trying to come to terms with a deistic Newtonian scientism. Those works of art are historically timely but theologically *and* intellectually disastrous. They are not disastrous because they redefine God and Trinitarian Christianity but because they deny an intelligible science and ethics. They deny ontological wisdom. They deny a meaningful humanism and rationalism.

Newtonian physics denies—*a priori*—essence, substance, and purpose. A renewed Pelagianism, Arianism, and Averroism (that the truth claims of religion and science are distinct) contest orthodox Trinitarian Western and American culture. So it is not just that Newton rejects traditional geometry and arithmetic by introducing a new mathematical calculus. It is that Newton and Hobbes view reason as calculation, be it for physics or for power. That new type of math denies the ontological rational clarity of previous geometry, and the pursuit of fact and power replaces the pursuit of wisdom.

The Scholastic pursuit of universal knowledge via the philosophical position of moderate realism is reduced to an empiricist pursuit of particular knowledge via the philosophical position of positivism and nominalism. That position equates science with knowledge of facts and reason to the mind—or rather the will—of humanity. As Kant holds, it is a deontological reasoning; as Nietzsche puts it, it is an authentic expression of the will. In place of the pursuit of the true, good, and beautiful, it advances the pursuit of power—be it rationalized or blatantly willful.

It is not so much a conflict that occurs between the Scholastics and Newton. Rather, it is the mental tendency, the perspective, of Scholastic conceptualism that realizes its own completion—and destruction. Modernism is a fulfillment of Scholasticism with one critical change: it is an Aristotelianism without a Final Cause, and a Platonism without an objective God. Given the premises of a Newtonian metaphysics, Hobbes and Hume are the necessary and destructive consequence, and Kant is merely the great delayer to a Nietzschean conclusion. As first principles, the classical-Judeo-Christian tradition accepts that the universe enjoys a First and Final Cause, that the universe is purposeful, and that *some degree of universal knowledge* can be obtained. In contrast, the modernist-postmodernist tradition initially accepts that the universe has a First Cause (Newtonian deists and a variety of nontraditional theists including Unitarianism and Theosophy); but it soon concludes in a denial of either a First or a Final Cause (Hobbes, Comte)

or a denial of the very possibility of knowing cause and effect in science or ethics (Hume). In any case, cosmology is denied (by Kantian modernism) or viewed via the perspective of a predictable mechanism, an unpredictable accidentalism, or a violently process-oriented organism.

The effects of any mental tendency are more than merely academic. Within the modern-postmodern tradition, for example, influential public roles are granted to a variety of materialists, spiritualist-anarchists, dialectical materialists, or pantheists. In changing the type of thinking that is publicly valued, there is a corresponding change in the type of person and character that are viewed as socially valuable. As the first principles of a civilization change, the very essence of science and reason are transformed. Therefore the type of person and character publicly revered change as well. And so also changes what is thought of as fine art and science.

5

PARADIGM SHIFTS AND
TRANSCENDENT CHOICE

E arlier we mentioned the art historian Erwin Panofsky's 1927 book *Perspective as Symbolic Form*, which addresses the links between science, mathematics, ethics, and culture via the topic of perspective in the fine arts. In essence, Panofsky treats *perspective* as a theoretical noun and as a verb—that is, perspective as a ways of conceiving and constructing reality, knowledge, and art. He points out that perspective as an artistic problem has variously been understood, and that variety is paralleled in science and ethics. Renaissance perspective differs from classical-Judeo-Christian (and Confucian) perspective; those differences necessitate a redefining of science and art, of knowing and doing. The effects of perspectivism on science, reason, and culture have interested other philosophers and historians of science. The interests and work of Panofsky in the field of art history parallel the philosophical work of Wittgenstein as well as Thomas Kuhn's scholarship in the history and philosophy of science.

Panofsky's perspective on perspectivism leads to an infinity of self-conscious and narcissistic reflection. In "worlds" of meaningful fictions there can never be the hope for completion in Truth and Love. More recently, Michel Foucault concludes that the solution to such meanderings is found in an alleged positive nihilism. Freedom is realized via the absence of Truth and Love. But it is a perennial fallacy to equate freedom with an absence of purpose. Lacking purpose, none can be free of a life of banality and violence.

This perspective demands that we tacitly discount all traditions and beliefs that hope to break through a solipsistic fog to obtain a glimpse of objective mean-

ing.[1] It is a perspective that ultimately denies intellectual distance between subject and object. When subject and object are one, then knowledge of the object is unnecessary. Two options result: nihilist and totalitarian. Contrary to Foucault and Derrida, the gap between subject and object makes possible the self-aware and free pursuit of truth. When denied, reason and science are redefined; neither can strive to understand a meaningful universe. Foucault rightly points out that when meaning is grounded in our minds, attempts to understand reality are nonsensical; but nonsense can be dangerous. Marx points out in his *Dissertation* that it is human self-consciousness that is the supreme deity.[2] Reason is, then, deontological, a mental proclivity, a logic unconnected with reality much less the Logos called God; but this also means that reason is willful, grounded in an ontology of subjective power. When limited to self-consciousness alone, the human intellect pretends to be divine. It is limited, then, to a narcissistic solipsism which denies a culture of responsible freedom. Wisdom and culture must then be viewed as oppressive; they are reduced to nothing other than the products of the minds of others. In the name of freedom, the best scientists, philosophers, scholars, and artists are to varying degrees inspired to be transgressive of culture—be they called romantics, progressives, revolutionaries, or anarchists.

Kant praised Newton as the greatest of men; he combines Newton's positivist facts with an alleged twelve rational structures of our minds.[3] Foucault rejects the legitimacy of such a constructivist scientific rationalism. For him, constructivism reveals all structures as arbitrary. The fact-based meaningful fictions of Kantian perspectivism result not in a tolerant diversity but rather in a malevolent and uniform will to power. All systems of thought are seen to be oppressively dogmatic. The proper reason for studying history—be it of science, ethics, or art—is to destroy knowledge and history as both subject and object. *This leads to a curious impasse: since perspectivism is inevitable, then no perspective is justifiable.* As cause produces effects, perspectivism as theoretical noun results in intellectual and practical nihilism. But is Kant's and Foucault's perspectivism the only type possible?

Edwards's Perspective of Cause and Effect

What occurs when substantively different perspectives meet? How would Panofsky or Foucault respond to the Anglo-Catholic and Reformed Protestantism championed by Jonathan Edwards? They would reduce them to subjective, antiquated, and even oppressive preferences. They are diminished to historical nostalgia, to facts, feelings, and rationalizations without objective meaning or pur-

pose. The classicism of Plato and Aristotle, and indeed all truth-seeking traditions around the world, are similarly afflicted.

Within the Christian tradition, Jonathan Edwards was prescient in lamenting this form of intellectual and cultural prejudice—and folly. He attempts to escape that trivializing perspectivism by pursuing transcendent Truth, by rising above the circle of hermeneutics; this can only be achieved by seeking knowledge of the transcendent, and thereby a qualitative understanding of reality and life. Edwards's bookshelf was filled with many of the same books depicted in the previously discussed portrait of the Reverend Ebenezer Devotion. His early essays make clear an acquaintance with Newton's *Opticks*. Edwards was well versed in Western culture, grounded in Augustine and Plotinus, and deeply influenced by Newton, Locke, and even Hume. He saw that the trajectory of modernist-postmodernist thought was toward what Foucault would later advocate: a materialistic nihilism that would lead to cultural and moral decadence. Why? Because of the necessary and tragic cause and effect between empiricist science and its ethics.

Edwards's cultural patrimony included Platonism, empiricism, and even Pelagianism. The Platonic tradition was championed by the Cambridge Platonists in late sixteenth and early seventeenth centuries; Francis Bacon championed an empiricist orientation along with Newton, Locke, and Hume; a contemporary advocate of Pelagianism was the Dutch theologian Jacobus Arminius. Comprehending how these competing views might complement each other was central to Edwards's prodigious scholarship. Those struggles inform the future course of Edwards's Calvinism and the classical-Judeo-Christian Anglosphere.

Edwards's foundational confidence in reason and science resonates with the classical-Judeo-Christian tradition. His confidence that scientific fact is in harmony with Truth makes clear that should science contradict theology, then (in contrast to the Averroists) that theology would—in the name of God or Truth—have to be abandoned. But Edwards also criticized deeply the empiricist distinction of faith and fact as espoused by the British empiricist tradition, and he criticized the inadequacy of an empiricist-grounded reason. He recognized that empiricist presumptions of an accidental or a mechanical universe are unjustified.[4] Neither makes much sense because the issue of cause and effect remains unexplained. As Conkin puts it: "Edwards joined with David Hume in denying any mechanical necessity between a cause and its effect and in thus exposing the most vulnerable side of any mechanistic philosophy."[5] So just as Panofsky treats perspective as noun and verb, Edwards treats cause and effect. For Edwards, the ultimate cause is God, the supreme Being; that Being causes us to think, to effect a search for Truth.

Our understanding of Being enables the production of particular consequences in science, theology, and culture. The issue of cause and effect leads to the core of his (and Hume's) theology. Bad things happen to good people, so the law of cause and effect makes no sense; nor does works righteousness (the idea that by doing good we obtain ontological merit). So for Edwards the solution is found in the Doctrine of Grace. Contrary to Arminius (and Pelagius and Marx for that matter), we cannot will our own happiness; we can only hope and pray that it be granted, or the capacity to realize it. Edwards thus affirms cause and effect in science and ethics via the will of God; Hume (and Hobbes) do not.

Edwards resisted the primacy of an autonomous will—be it of Hume the skeptic, Arminius the unorthodox theologian, or for that matter, Foucault. Much of his scholarly work centers on a refutation of subjective willfulness via subtle reflection on cause and effect in physics and ethics in a purposeful universe. His work sought to reconcile Grace with predestination, since Truth and Love are both attributes of God, the former requiring predictability, the latter freedom.

This unity of cause and effect advocated by Edwards was also important to the English Platonists at Cambridge. That Platonism is and remains an enduring intellectual and cultural position. In twentieth-century America, Platonism was defended by Paul Elmer More, one of the founders of the American New Humanism movement. More advocates a renewed classicism centering on the unity rather than the disjuncture of cause and effect. Or to put it differently, he rejects the artificial reduction of knowledge to that which is manufactured, with its concomitant metaphysical nihilism. In the opening page of his book, *Platonism* (1931), More quotes Plato's *Book of Timaeus* (68e and 47a):

Wherefore we must discriminate between two kinds of causes, the one of necessity, the other divine; and the divine cause we must seek in all things, to the end that we may possess a happy life so far as our nature permits; and the necessary cause for the sake of the divine, reflecting that otherwise we cannot apprehend by themselves those truths which are the object of our serious study, nor grasp them or in any way partake of them.

From this source we have derived philosophy, that which no greater good ever was or will be given by the gods to mortal man.

Panofsky's perspectivism subjectifies cause and effect, whereas Foucault denies any necessary or divine cause that results in any positive effect. Cause and effect produces predictable, that is scientific, results. Materialism in motion yields violent chaos, whereas transcendent Being as cause enables the effect of meaning-

ful completion, of Truth and Love reconciled. Transgression of that Being-cause is called sin by Edwards but freedom by Hume and Foucault. But that freedom lacks scientific and rational foundation. It denies justification for intellectual, philosophical, and ethical activity. Rebellion without a cause is not freedom, but nihilism.

We will return shortly to Edwards, the Cambridge Platonists, and More. The present point is that both classicism and Christianity have been reinterpreted or denied by confusing or denying cause and effect. The difference between these opposing camps is not simply one of science vs. religion. That difference reflects concern with the continuing problem of reconciling cause and effect in physics *and* ethics—and by extension the problem of reconciling Being and becoming, transcendence with immanence.

A Historical Perspective of Cause and Effect in Science and Culture

Traditionally, Truth is understood as the correspondence of thought with reality. The correspondence theory is vilified and yet nonetheless embraced by modernism-postmodernism. It does so with unintentional irony; it subjectifies the correspondence theory by adopting (de)constructivism. Truth is now the correspondence of *our* thoughts with *our* realities. Our becoming produces Being, we are the effect that produces the cause. In science, and history, the qualitative is replaced by the quantitative. Facts are objective, but how we put them together is a matter of how *we* think; knowledge now corresponds with *our* mental tendencies and experiences. Those who embrace modernism-postmodernism deny that understanding occurs when a subject's mind to some degree rises above subjectivity. Self-consciousness provides a type of knowledge, but unless self-consciousness has an object as well, it collapses. To be self-conscious of the self is to be intellectually and socially dysfunctional. Kant asserts a constructivist self-consciousness, Marx and Foucault an authentic self-consciousness, but such self-consciousness solipsistically trivializes self-consciousness by its lack of an object. Nonetheless, from Descartes on, the hallmark of modernist-postmodernist thought is that *we think, therefore we are.* This neglects the notion that none can doubt that we think and live, therefore we ought freely to seek wisdom. Augustine's famous proof of objectivity, *si fallor sum*—we know we are because we know we err—resonates with Jonathan Edwards's admonition to seek more than self-consciousness. Like Augustine, he seeks a self-conscious understanding of objective reality, or Truth

or God. He seeks Truth so that he might be free from the effects of ignorance, folly, and evil.

The study of history is traditionally a means by which we might escape the prison of the present. Some distance—some transcendence—and thus some freedom from the mental habits of the present can be obtained. An examination of previous human epochs may alleviate some of our *kronocentrism*—not by quantitative variety but rather by cognitive quality. History permits us to escape limited contemporary perspectives, to escape *kronos*—or meaningless time—for *kairos*, time informed with purpose and freedom.

There are histories of science, of philosophy, and of art. The traditional justification for studying these is that they afford us the intellectual distance that permits us to choose which understanding is most convincing. It permits freedom as the pursuit of truth. But in the context of modernist-postmodernist perspectivism, history lacks an object; it is limited to historicism. Historicism takes for granted that history is manufactured from meaningless facts, the meanings of which constantly shift.

Historicists cannot tolerate those who reject historicism, who believe in the pursuit of wisdom in time. So in the name of an allegedly diverse multicultural positivism, all must agree with a (de)constructivism and relativist historicism. Not to be tolerated is the possibility that history, like truth, can be otherwise understood. History cannot be understood as a scientific and rational drama between those who seek wisdom and beauty and those who seek power. Therein lies the rub: the reduction of scientific knowledge to historicist absolute fact or meaningful fiction denies our ability to consider qualitative alternatives.

Newton's positivist redefinition of science and reason necessitates and legitimates the modernist-postmodernist scholarship of Panofsky, Wittgenstein, Kuhn, Heidegger, and Foucault (to name but a few). The conclusion of that scholarship is advocacy of historicism, of the reduction of human memory to a dogmatic perspectivism that claims to be socially beneficial. Its assumption is that a liberating nihilism results in a laudable self-expression and self-realization. This assumption is not scientific or historical but speculative and one that denies other possibilities. Case in point: Edwards disputes the modernist-postmodernist analysis of cause and effect, of human nature, and will. Then can we take seriously his analysis? Not if we view his position as a matter of nostalgic historical fact, or a temporal meaningful fiction. A historicist perspective denies that our historical options include the pursuit of wisdom. Nonetheless, perhaps Edwards can be considered a serious contributor to obtaining alternatives to contemporary perspectivism. Indeed, as Conkin concludes:

Though conditioned by his age and by parochial loyalties, much of his thought had a timeless quality that has allowed it to fare better than much of the more popular thought of his age. Much that Edwards defended is intellectually tenable in the twentieth century; even more is either emotionally or experientially persuasive.[6]

Anglicanism, Puritanism, and classicism embrace a worldview in which science and reason are dedicated to discerning a glimpse of decorous reality—a glimpse of the cause of reality as it ought to be. They aspire to rise above perspectivism and historicism, above the circle of hermeneutics, to obtain a glimpse—a degree of—objective transcendent historical wisdom. They now face the mortal challenge of a Newtonian-Kantian understanding of science, reason, and history in which decorum is viewed as a fiction that is trivial or oppressive. They face the challenge of a modernist-postmodernist tradition that denies any pursuit of truth and goodness. They face also the tremendous problem that history and philosophy are today overwhelmingly pursued via a single modernist-postmodernist perspective, a perspective that denies any purpose to doing so. Scholarship is denied its traditional role of offering us a freedom-granting hope of transcendent understanding, thereby providing us with the possibility of conscious choice, of responsible freedom in choosing how to better understand the world and life. The confusion surrounding cause and effect results in confusion concerning history; when history is confused, our memories are confused. That confusion results in our forgetting what is truly culturally important.

To escape the limitations of the modernist-postmodernist perspective is to obtain some degree of liberating objectivity. In so doing, we affirm the possibility of some degree of transcendent knowledge of reality, of Being (or Cause). We escape a modernist-postmodernist habitual subjective-objectivity, by becoming thinking subjects seeking knowledge of a purposeful object. It is not that I think therefore I am, but that Being is (To on), therefore we think. But this shift is in itself a denial of the modernist-postmodernist perspective since the time of Newton and Descartes. The result is that we seek to obtain not perfect knowledge of Being, but some degree of meaningful objectivity, and thus of a freedom-granting distance. As Plato argues via the Simile of the Cave, or Paul argues in 1 Corinthians 13:12: "For now we see through a glass, darkly; but then face to face: now I know in part; but then shall I know even as also I am known."

Therefore, we can imperfectly but to some precious degree escape the dictates of our own or others' temporal subjective aesthetic tastes. It is neither the trivial subjectivism of meaningful fictions nor the authoritarian subjectivism of

authenticity that is central to our obtaining liberating insight. Rather, it is the pursuit of a better degree of objectivity.

This cosmopolitan perspective is traditional to the core of Western culture, and it survives yet in varying degrees within some other cultural traditions. It is universally valid. It claims a confident humility, the humility to be less than divine but more than merely partisan. It adopts the perspective advocated by Socrates, Plato[7] (or Confucius and Shakyamuni), Augustine, and many others: *to be dedicated to the practical pursuit of truth, goodness, and beauty while avoiding the folly of nihilism and the tragedy of authoritarianism.*

Edwards lived in a transitional period the outcome of which is still not resolved. The question is whether modernism-postmodernism is genuinely progressive or a tragic two-hundred-year period of mannerist confusion. Edwards lived in a culture that was largely traditionalist Anglosphere, classical, and Judeo-Christian, but not decisively so. The perennial beauty-seeking values of the West were (and still are) being altered by the aesthetic vision of modernism-postmodernism from within and attacked by it from without. A deterministic yet unpredictable materialistic cause and effect strives to replace a theistic Cause and effect.

The mainstream of the classical-Judeo-Christian Anglosphere traditionally believes in a decorous reality informed by Cause and effect. While living among a confusing world of effects we seek freely to obtain harmony with the ultimate Cause or Being of the universe. It accepts the challenge of theodicy, of explaining the occurrence of evil in a world with a benevolent Cause. In direct opposition, the modernist-postmodernist follows a Newtonian positivism and Kantian (de)constructivism in which what we do is grounded either in deterministic fact or meaningless causes. We live in an existential world. Denied is the freedom and responsibility to make choices between what is good and bad; the result is a denial of culture. Or rather, it marks a "culture" of technologically advanced violence.

Paradigmatic Shifts

Our modes of self-consciousness are central to our scholarship; they influence our attempts to understand science, reason, and culture.[8] This is contested neither by traditional Western culture nor by modernism-postmodernism. But is perspectivism simply a matter of style and identity, or can it involve the issue of substantive quality? Can and should it rise from *scientism* to *scientia* and *sapientia*, from an existentialist reckoning of cause and effect or a wisdom-seeking one? His-

tory as a means of obtaining some degree of transcendence, of objectivity, is key to answering this question.

In 1970, Thomas Kuhn published an important book, *The Structure of Scientific Revolutions*. Some take Kuhn for a Kantian or neo-Kantian constructivist who argues for the subjectivity of science; perhaps his point is more nuanced. His critical historical study of science leads him to conclude that science is paradigmatic, and that those paradigms periodically shift. Those paradigmatic shifts deeply affect how science is understood and pursued. This historical analysis undermines the positivist claim of scientific objectivity by injecting a temporal, willful content. Kuhn makes his point by use of a drawing that can be seen and understood as either a duck or a rabbit. Wittgenstein earlier used the same sort of example to make the point that how we think affects how an object is seen and understood. In similar fashion, Kuhn presents an analysis of science that goes beyond a positivist materialism. That is, it goes beyond understanding science as a relentlessly increasing acquisition of facts. Science includes narratives; those narratives evidence different perspectives. To the point, those different perspectives include differing metaphysics.

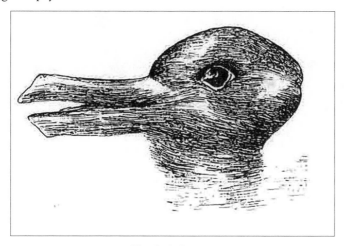

Rabbit-duck illustration

As introduced earlier, the shift from seeking truth to manufacturing facts and placing them into constructed and deconstructed narratives was explained in the West by the Baroque scholar, Giambastista Vico (1668–1744). That shift is one from Truth as Being, that it, truth as knowledge of the eternal essence of things, to Truth as made, that is, truth resulting from making accurate descriptions. *Factum* is that which is done, made, accomplished, and that which is *manufactured* is

that which is manually done, made, accomplished. So the shift from truth to fact is a shift from truth found to facts—and fact-based narratives—made.

For the Scholastic, *becoming* seeks reconciliation with *Being*, the realm of effects seeks harmony with the ultimate First and Final Cause. But for the modernist-postmodernist, *becoming* is *being*—effects are causes—and thus objective *Being* or Cause is denied. As philosopher Ernst Cassirer puts it:

> The clear-cut form of the classical and medieval conception of the world crumbles [in the sixteenth and seventeenth centuries], and the world ceases to be a "cosmos" in the sense of an immediately accessible order of things. Space and time are extended indefinitely. . . . One world and one Being are replaced by an infinity of worlds constantly springing from the womb of becoming.[9]

The point is that these two primary paradigms enjoyed historical (and empirical) authority. But if both had historical authority, then it must be admitted that no paradigm can with certainty be known to be final and complete. The paradigm that is transgressive of ignorance and evil cannot be known to be historically obsolete; the paradigm that is transgressive of wisdom and Being might not actually be progressive.

The focus on becoming within the modernist-postmodernist paradigm is now dominant, but distance from that current dominance is provided by a historical perspective. That perspective reveals an irony: *Modernist-postmodernist perspectivism puts perspectivism in doubt.* The neo-Kantian dogma of knowledge as meaningful fictions, as symbolic forms (Panofsky), cannot inspire us with confidence of its own truth. Kuhn allows us to distance ourselves from modernist positivist scientism via the ironic use of neo-Kantianism perspectivism or by the insights offered by the postmodern critique of the truth-claims of modernism. In either case, by attaining some degree of distance from modernist dogma, that dogma becomes the object of our thinking rather than a habitualized, unquestioned part of it. So Kuhn's perspectivism offers two possibilities in science: to ironically continue to embrace science limited to facts and (de)constructed narratives, or to reconsider science as the pursuit of wisdom.

Should we be satisfied with a solipsistic scientific celebration of the will to power, or should we try to rise above a positivist-relativism by affirming wisdom and responsible freedom? Should we self-consciously get in touch with ourselves, or with *Being as the ultimate Cause*?

Kuhn notes that there is *normal* science (to which we can add normal culture as well), which currently consists of one particular conceptual paradigm.

Adherence to that paradigm is required to be a professionally accepted practitioner of science; normal science is by definition rigidly orthodox. The paradox is that orthodox modernist science is substantively unorthodox; beyond descriptive facts, normal modernist science denies *Being* as the ground of normality. The norm is now fact-associated change.

Kuhn observes, however, that within normal science unorthodox phenomena occur as anomalies or novelties, which are received with resistance and great difficulty; and by resisting those anomalies, orthodox paradigms engage in folly and thereby guarantee their eventual failure. This occurs via a paradigmatic crisis, as evidenced by the history of science.

So revolutions in science are considered by Kuhn to be noncumulative developmental episodes in which older paradigms are replaced in whole or part by incompatible new ones.[10] These paradigmatic shifts require that what was seen one way before the shift is seen differently after the shift. Kuhn believes that adherents to a displaced paradigm can change their minds, that they need not die and be replaced by the new. He maintains that textbooks should indicate the occurrence of paradigm shifts, but that we need to relinquish the notion, explicit or implicit, that changes of paradigms carry us closer to the truth.[11] As such he affirms the confused modernist-postmodernist understanding of cause and effect. Conversely, he denies the notion of science and reason dedicated to rising out of a confusion of effects to a harmony with Cause. He denies the classical Judeo-Christian focus on pursuing—through the glass darkly—better glimpses of wisdom. His perspectivism therefore fails to recognize its own limited perspective.

Kuhn appears to be an historically unselfconscious historian; he seems not to recognize the paradigm from which he is evaluating the paradigm shifts of science. Just as Panofsky's work on perspective has a perspective, so too does Kuhn's work on science. In assuming that those shifts are noncumulative episodes he accepts the modernist-postmodernist historicist view that knowledge and life do not enjoy a teleology or cosmology, that they do not seek meaningful completion. With great Kantian optimism he assumes that (de)constructive paradigm shifts can occur via unimpassioned conversation, therefore denying the postmodern *and* the classical-Judeo-Christian understanding that knowledge and the will are always combined. Indeed, by neglecting to consider the always present and potentially dangerous emotional element in the pursuit of knowledge *in* and *of* life, he denies the reality of the role of the will in the pursuit of science and culture.

In sum, Kuhn neglects that which is beyond Kantian or neo-Kantian rationalized paradigmatic shifts or postmodernist conflation of effects and causes; he denies the danger of the will in the politics of science and culture, and ignores

that fact and will might better rise to truth and love. Paradigmatic shifts need not be of quantity and style; they can also be of quality and substance. He neglects *the possibility of obtaining not quantitatively different, but qualitatively better, visions of science, ethics, and art.*

Sociopathy and Perspectivism

As the discussion of Erwin Panofsky, Thomas Kuhn, and Ludwig Wittgenstein reveals, modernist-postmodernist perspectivism is destructively limited. It unnecessarily restricts knowledge of science, ethics, and art to fact and power. In this regard, the French artist Marcel Duchamp's *Fountain* (1917) is a case in point. Duchamp purchased a urinal from a hardware store and submitted the piece to the Independents Exhibition in New York City. By so doing he challenged what constitutes *normal* art for the modernist as well as the traditionalist. Ironically, according to a December 2004 poll of 500 arts specialists in Britain this object is the single most important work of art in the twentieth century.[12] An essentially sociopathic work of art is now deemed culturally normal. We will discuss that work of art in detail in later chapters. The present point is that Duchamp, a postmodernist, uses modernist ideas of science and reason to destroy modernist ideas of normalcy, and yet he has come to be judged the norm by transgressive ideologues.

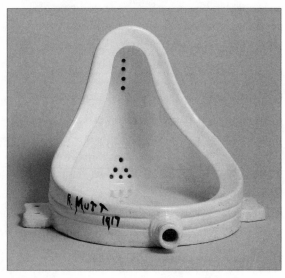

Marcel Duchamp, *Fountain*, 1917

From a modernist Kantian perspective (following *Kant's Critique of Judgment* of 1789), fine art is not teleological or cosmological; fine art, like science, does not entertain the notion of final causes or purpose, nor does it hold art to be the manifestation of beauty. In his three critiques (of reason, practical reason, and judgment), Kant claims to redefine Truth, Goodness, and Beauty. Fine art is now the

aesthetic face of *becoming*. In the modernist Kantian view, fine art is distinguished from the trivial by the insight of the genius. Genius is a natural faculty that cannot be learned, but it can be nurtured. Genius determines art from nonart, and art is noncognitive, self-referential, and a perfection of a kind.

Duchamp brilliantly applies and deconstructs those principles of normal fine art as determined by modernism. That is, Duchamp operates from a postmodern perspective. Duchamp mocks modernist aesthetic formalism (and classical-Judeo-Christian beauty as the splendor of wisdom) by presenting a mundane, indeed crudely vulgar object as aesthetically significant. He transgressively denies the value of a genius-based art, and mocks the notion that fine art is noncognitive, self-referential, and a perfection of a kind. Duchamp subtly subverts all of these characteristics of normal fine art as defined by modernism. He is a bona fide artist, but he has selected a found object, a urinal, as fine art. To the modernist, such an object makes no attempt to explain the nature of reality and life, but for Duchamp the urinal, a male object, presented upside down and with an orifice, is a *female receptacle*. It thus transgressively redefines sexuality. It thereby mocks not only modernist formalism but also the classical-Judeo-Christian notion of sex and sexual identity being grounded in a teleological context, one in which the roles of male and female are not a social construction but a matter of purposeful nature.[13]

Duchamp mocks the idea that fine art and culture are a matter of genius-based formalism. The net result, however, is an advocacy of transgressive power. Therefore, modernist normal science and reason are no longer normal to post-modernists. But neither is wisdom-seeking science and reason.

The modernist Kantian paradigm of science, reason, and culture as non-cognitive, self-referential, and a perfection of a kind, is viewed by modernists as normal; other views, such as the classical-Judeo-Christian, are by default judged abnormal. The influence of the former prevents us from fully comprehending colonial and later American and Western art, which purports to be normal while seeking wisdom. However, following Kuhn's observation that perceptual paradigms deeply influence how we understand phenomena, it can equally be concluded that we are not limited to destructively transgressive science, reason, or art. A urinal as art makes no sense in the attempt to understand reality and life; in a culture antagonistic to our understanding reality and life, can science and reason serve more than brutal power?

Within the classical-Judeo-Christian tradition the very nature and essence of fine art is to convey knowledge of a meaningful and therefore qualitative reality and life. Fine art is the aesthetic face of *Being*.[14] Fine art differs from, say, mundane and utilitarian objects by its intellectual content, which reveals a teleological or

cosmological purpose. Fine art attempts to reveal what is true, good, and therefore beautiful in reality. From that perspective, to submit a urinal as a work of fine art is more than nonsense; it is transgressive not only of the modernist idea of a genius-based formalism but of the very possibility of wisdom and beauty.

Duchamp thus attacks both modernism and the classical-Judeo-Christian traditions. The latter might be dismissed by the modernists as now trivial, but those same modernists must be deeply threatened by the attack upon them. The denial of genius, the exposing as trivial art (and science) that is noncognitive, self-referential, and a perfection of a kind, is fraught with consequences.

Just as Wittgenstein and Kuhn utilize the compelling visual device of an image which can perspectivally be viewed either as a duck or a rabbit, Duchamp's urinal can variously be viewed as a mere utilitarian object, a work of art exhibiting aesthetic perfection, a brilliant mockery of the modernist paradigm which extols aesthetic formalism and genius, and an effective—or pathetic—attack upon the classical-Judeo-Christian (Buddhist, Hindu, Confucian, etc.) idea of fine art as the objectification of wisdom.

Kuhn's thesis is that what constitutes the substance and practice of science involves more than a mere pursuit of positivistic facts. Rather, it involves the significant influence of paradigms, of structural ways of looking at things, which we embrace by habit, or more rarely, by choice. This constructivist/deconstructivist view of science easily leads to nonsense, as brilliantly exposed by the physicist, Alan Sokol.[15] Sadly, in the study of culture establishing positivist facts cannot be relied upon to counter such nonsense.[16] Recognizing the postmodern cultural fraud is possible by considering its limited and unwarranted metaphysical assertion that reality and life have no purpose, that there is no Truth or ideal to be pursued in science or culture. It is an assertion a positivist science and reason cannot know; it is an assertion civilization cannot accept.

How, then, might we solve the postmodernist problem and escape its consequences? By recognizing that its paradigmatic assumptions about science and reason are neither inevitable nor warranted. Whereas Kuhn argues that paradigm shifts are noncumulative, wisdom-seeking cultures contend otherwise.[17] It is not just that phenomena can differently and even destructively be understood. At issue are the qualitative differences between those paradigms. Cumulative wisdom concerning science and reason is more than an assumedly progressive/destructive replacement of old with new. It involves learning from the past to help us find the new—and more profound. Science and reason can expand our power, or serve to improve our culture. The choice is critical. It is not merely a paradigmatic choice; it is a choice between barbarism and culture.

6

Qualitative Differences among Paradigms of Science, Ethics, and Art

We can now begin to consider works of art from more than a modernist-postmodernist perspective. John Singleton Copley's painting *Boy with Squirrel* (1765), depicts his half brother, Peter Pelham, seated at a table and holding a small chain that leashes a squirrel on a table. Certainly, Wittgenstein and Kuhn would recognize that the creature depicted is neither rabbit nor duck, but some sort of squirrel. But beyond such literalism, Wittgenstein and Kuhn could no doubt recognize a great number of perceptual issues at play in our attempt to see and understand this work of art. Ironically, their postmodern denial of any single definitive mode of interpretation, of any single metanarrative, means that the modernist-postmodernist metanarrative cannot itself be binding. This means that rational reflection on the different ways of understanding *Boy with Squirrel* inescapably results in considering the comparative and ontological quality of those different understandings. It results in our reflecting on the accuracy and the profundity of any metanarratives in explaining reality and life.

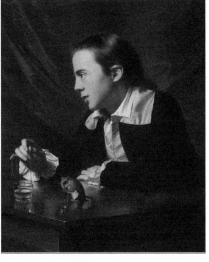

John Singleton Copley,
Boy with Squirrel, 1765

To look at Copley's painting via a positivist paradigm, one might focus on establishing the descriptive facts concerning this work of art, its date, its subject, and a stylistic analysis of the composition and its aesthetics. Its Baroque-inspired composition is visually balanced; its realistic painting technique is a perfection of a kind. It favors a Wölfflinian clarity rather than painterliness. But such an analysis would seem inadequate to other modes, other paradigms, of interpretation.

For example, we can consider how this painting is understood via the perspective of Sir Joshua Reynolds. A contemporary of Copley, Reynolds was head of the Royal Academy of Art. He famously praised this work as evidencing that type of clarity expected within the classical mode. But it was a clarity that traditionally was more than just formalistic. Aristotle held that the self-conscious intellect of humanity—that is, the soul—determines the superiority of living humanity over the soulless dead, and over soulless animals. Ontological claims of the superiority of the rational and essential over the instinctual and accidental are central to the meaning of this painting. However, Reynolds was part of a classical tradition that was in flux between a traditionalist mode and one influenced by deistic modernism; that is, the classical was being contested by the neoclassical.

In the classical view, particularly as advocated by Plato and Aristotle, *Boy with Squirrel* is a superb representation of the responsibilities of the rational over the merely sentient; human rationality establishes the superiority of humanity over animal, and therefore establishes that humans are both superior to and responsible for the treatment and use of animals. This judgment is not based upon taste, but understanding; as such it is a statement about beauty, not aesthetics. This position is echoed by the Judeo-Christian tradition in which humans (rational beings, and therefore persons) are made in the image of God (a rational Being and therefore person). Animals are not sufficient rational beings; indeed, the animal is made for the responsible use of humanity. Not exploitation, but rather good stewardship is key, and vegetarianism, for example, is traditionally viewed as disordered. It is judged that the failure to recognize the qualitative differences between humanity and beast is to deny the natural order of things as established within a purposeful universe.

In contrast to the traditional classical view, the modernist neoclassicist would admire the composition's formal balance, color harmonies, and technical competence. Its attempt to explain a meaningful universe would be of little real interest. By denying that reason seeks knowledge of a meaningful universe, the neoclassicist admires the importance of rationalistic clarity and aesthetic taste, and of the role of the genius as a personal trait (rather than as a gift, a muse, from the Divine) in making art. Nonetheless, conceptual clarity and universality are held to be of shared primary importance.

These different modes of thinking incoherently coexist within Western culture in the eighteenth century: one is seeking ontological beauty, the other is more epistemologically aesthetic. This is evidenced by returning to our attention to Sir Joshua Reynolds. The confusing of traditionalist and modernist tendencies within the classicism of eighteenth-century England is evident in his well-known discourses on art. He states:

> Could we teach taste or genius by rules, they would no longer be taste and genius. . . . [But] we may truly say that they always operate in proportion to our attention in observing the works of Nature. . . .
>
> When the Artist has by diligent attention acquired a clear and distinct idea of beauty and symmetry; when he has reduced the variety of nature to the abstract idea; his next task will be to become acquainted with the genuine habits of nature, as distinguished from those of fashion. For in the same manner, and on the same principles, as he has acquired the knowledge of the real forms of nature, distinct from accidental deformity, he must endeavour to separate simple chaste nature, from those adventitious, those affected and forced airs or actions, with which she is loaded by modern education. . . .
>
> On the whole, it seems to me that there is but one presiding principle which regulates and gives stability to every art. The works, whether of poets, painters, moralists, or historians, which are build upon general nature, live for ever; while those which depend for their existence on particular customs and habits, a partial view of nature, or the fluctuations of fashion, can only be coeval with that which first raised them from obscurity. Present time and future may be considered as rivals; and he who solicits the one must expect to be discountenanced by the other.
>
> We will take it for granted, that reason is something invariable, and fixed in the nature of things; and without endeavouring to go back to an account of first principles, which for ever will elude our search, we will conclude, that whatever goes under the name of taste, which we can fairly bring under the dominion of reason, must be considered as equally exempt from change.[1]

The association of fine art and reason with taste makes no sense to the traditional seeker of truth and goodness, since taste is a matter of subjective aesthetic preference whereas reason seeks objective understanding and beauty. To combine taste with reason is to subjectify and thus deny the substance of reason. This leads to the logically consistent but unsound association of reason and taste with

a genius that can be nurtured but not taught. This paradigm is deeply modernist as articulated, for example, by Immanuel Kant. But to the classicist, genius is not a subjective trait, but a gift from the divine. For the Christian it is not personal genius that matters, but rather an objective calling that is bestowed.

Similarly, Reynolds's concern for the clarity of ideas is deeply conflicted. His position resonates with the classical Baroque of Descartes, in which the clarity of ideas is distinct from the clarity of physics within a cosmos. That position, however, is discordant with the Platonic and Scholastic notion of geometry indicating ontological form, the underlying clarity of structure establishing the ultimate reality of a cosmos rather than chaos. Nonetheless, Reynolds marks the distinction between essence and accident, a qualitative distinction long part of the classical-Judeo-Christian tradition. Finally, he praises reason, but rejects the possibility of first principles; this rational denial of first principles makes no sense since it results in a privileging of an unprincipled and therefore incoherent irrationality.

From a postmodernist perspective, Copley's presentation of an image of humanity as superior to and responsible for the care, maintenance, and use of lesser creatures is violently and wrongly hierarchical.[2] Deemed wrong as well are the assumptions that reality is rational and purposeful, that knowledge and art might transcend the momentary and fashionable, and qualitatively distinguish human culture from the realm of the beast. The notion that rational beings, *persons*, can enjoy enduring qualitative insight beyond animalistic instinct is held in contempt.

In sum, to a classicist such as Sir Joshua Reynolds, who in fact deeply admired this work and was influenced by it to help establish the painting career of Copley, *Boy with Squirrel* exhibits a geometric clarity as variously celebrated by Plato, Aristotle, Newton, and even Descartes, a clarity which was traditionally understood to reveal the very structure of reality. In classical fashion, Reynolds notes that the goal of art is to escape the merely momentary and fashionable, to escape the affectations and trivialities of the accidental, to instead embrace the perennial, the enduring, and the profound. We should escape *becoming* and rise to the realm of *Being*. From a classical-Judeo-Christian viewpoint, a hierarchy of humans over animals exists not on the basis of power but on self-conscious responsibility. Rational self-conscious beings, capable of sophisticated degrees of personal responsible freedom, warrant that hierarchy and results in the need for good stewardship. Humans have dominion over animals, but the natural world is a gift of the Divine and should so be treated with care.

In contrast, viewing the same painting from a modernist-postmodernist perspective is to see an example of aesthetic perfection produced by the modernist

genius, or denied by the postmodernist hatred of genius. It is also a lamentable celebration of the superiority of humanity over animals. It is a prime example of speciesism, in which it is currently assumed[3] that one species, the human, has by power assumed a false superiority over a different species. To the postmodern mind, the Aristotelian and Judeo-Christian-grounded hierarchy of humanity over beast is repugnant and perhaps even criminal.

So we are left with a variety of modes of interpreting this painting: it is evidence of a noble and rational reality in which an understood clarity of knowledge and purpose reigns supreme; or it is a symbolic, rationalistic, and aesthetically tasteful object whose ontological claims are irrelevant; or it is an ideological and oppressive imposition of a false clarity and hierarchy on a world not knowable at all, but in which all biological entities have an intrinsic right to self-expression and self-realization if they are adequately strong (Darwin, Marx, Hitler) or weak (the Social Gospel movement, John Rawls).

It is beyond question that such multiple evaluations of this work are possible; we are confronted by ways of recognizing or understanding this work of art just as we are subject to confrontational ways of understanding science, reason, and ethics. And it is a situation in which tolerance, diversity, and multiculturalism (or multispeciesism) make no sense. We can condemn Copley's painting on aesthetic grounds—that its style and technique fail to please our taste—or by its presumption of a purposeful and therefore qualitative and hierarchical universe that must be arbitrary and oppressive. Or we can praise the work for being beautiful: as the representation of how a meaningful and purposeful world actually works. These explanations cannot stand together. For the work to have genuine meaning, a choice must be made. But Kuhn notwithstanding, that choice and paradigm shift cannot be unimpassioned. It easily slips into confrontational violence. That violence is the necessary result of the irreconcilable conflict between modernist tolerance and postmodernist identity, and the conflict between a quantitative and qualitative understanding of reality and life.

Therein lies the rub: judging the quality of ideas is impossible via a quantitative perspective. But lacking that possibility, we are left in a perpetual state of violence: conflicting interpretations of the work are possible, and some of those interpretations are foundationally incompatible. As confirmed by Wittgenstein and Kuhn, this is a necessary quality of the Newtonian-Kantian worldview, which lacks knowledge of ontological quality.

To deny that facts, or works of art, can entertain a variety of interpretations would be foolish. The alternative to this modernist perspectivism and subjectification of meaning is not postmodernist authenticity. Authenticity (e.g., the idea

that valuing humans over animals is speciesist by its denying the authenticity of animals—or vice versa) is nonnegotiable to those taking that stand and making that accusation. The alternative to a modernist aesthetic (de)constructive existentialism is not a postmodernist fundamentalist assertion of authoritarian or nihilistic identity. Rather, it lies in treating facts and works of art as objects of contemplation, the quality of which are recognized via their attempt to better understand a purposeful reality. *The alternative to perspectivism is a commitment to the pursuit of a continuum rising by degree from matter to transcendental truth, goodness, and beauty.*

Charles Willson Peale

The association of science, ethics, and art within an Anglo-Classical context is clearly found in the career of Charles Willson Peale (1741–1827). Born in Baltimore, acquainted with Copley, Peale's career resonates with the Anglosphere and the Enlightenment. He was a painter, writer, inventor, and scientist, eventually opening in Philadelphia a famous museum of natural history and art in which he painted the portrait *The Peale Family* (1771–73).

According to Peale, that painting depicts the unity of individuals within a family informed by amity and concord. The notion of the family as the source and locus of love and freedom has a long heritage. It is grounded in a teleological vision of biological and social life; in the classical tradition, Liberty is represented by a woman in whose domain love and freedom thrive.[4] That domain of concord

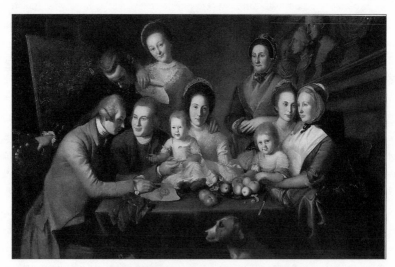

Charles Willson Peale, *The Peale Family*, 1771–73

takes for granted both a purposeful reality and a vibrant traditionalism. Compositionally, the painting evidences a clear geometry; the figures are composed within a pyramidal structure suggestive of clarity of purpose within a purposeful reality. Whether that geometry is understood traditionally as the splendor of an underlying ontological form, or merely mechanically (Newton) or conceptually (Kant), is not obvious. But the former is suggested by the easel painting depicted in the background. The three figures refer to the notion of *Concordia Animae,* which resonates with a variety of triadic themes within classicism (order, justice, peace; gift of life, growth, fruition; the spinning, cutting, and length of life, etc.). They embody the very qualities of decorous ontological form.

Peale's work makes clear that the fine arts are celebrated not as diversions, or means of therapy or propaganda. Rather, cultural pursuits are associated with the free and conscientious pursuit of the good life. They can refine not only our taste but also our character; indeed, good taste is actually good judgment grounded in wisdom, not feeling. These concepts are incomprehensible to the dog, as indicated by its placement at the bottom of the composition. The creature is at the bottom of the pyramid, in harmony with the classical idea of a hierarchy of being. Animals lack the natural capacity for sophisticated reasoning that humans possess, and thus are inferior soulless creatures—nonetheless worthy of care and affection. Even if some animals could attain some degree of self-consciousness, none evidence a capacity to be self-conscious of objective Being as such. No animal is a person; any person denying the possibility of the scientific and rational pursuit of transcendent knowledge is acting and thinking at the level of an animal.

Three points are of particular interest in this American painting. First is its democratization of the classical-Judeo-Christian tradition. It is clearly not associated with an aristocratic and hereditary culture. Peale, son of a felon father, believed and advocated that anyone could become an artist through the diligent application of skill and effort. Second, it embraces a progressive traditionalism. In a most personal way, Peale venerates the future of the family and his recently deceased wife by poignantly depicting her holding their child in the center of his portrait. And third, in including busts of himself, his teacher Benjamin West, and a patron, Peale celebrates an Anglo-classical traditionalism within an American context. We are part of and responsible to a lofty heritage. Within the American experience, a hierarchy of knowledge is not associated with a hereditary aristocracy. The pursuit of truth, goodness, and beauty reveals not oppression by some, but opportunity for all.

For Peale, and those who agree with him, this painting is a celebration of fine art, culture, responsible freedom, and the importance of lofty multigenerational

and Anglospheric tradition. However, all of this is overlooked by the positivist and nominalist. This celebration is intellectually denied or emotionally trivialized by the modernist-postmodernist paradigm.[5] It is trivialized if viewed as a personal and momentary expression of the artist and his time. It is denied if viewed as indicative of a variety of nearly hidden forms of oppression: it is speciesist (the family has a pet), sexist (his wife died young, but only after having seventeen children; his artistic sons prospered while his artistic daughter struggled dearly), and the family is elitist (they have the leisure that only money can buy) and probably even racist.

Notably, these particular modernist-postmodernist mental habits emerge from a positivist and nominalist foundation of fact vs. nonfact coupled with the assumption of manufactured or experienced meaning. Therefore, a necessarily violent narrative is substituted for the notion that degrees of truth can and ought to be pursued. But this undermines not only the qualitative vision of the classical-Judeo-Christian content of the painting; it undermines as well the necessity of the modernist-postmodernist paradigm. If there are no necessary metanarratives, then all metanarratives are unnecessary. If all meaning is constructed and deconstructed, then there is no object to science, reason, culture, or our lives.

Paradigms of Architectural Geometry

These ideas contribute to the realization of our cultural house of life. They are also more literally a part of public architecture. Public architecture represents symbolic form; at issue is whether such form is decorous or not. How architectural geometry is employed parallels the philosophical, theological, and scientific means by which a culture comprehends reality and life. There are classical, Scholastic, Baroque, and modernist types of geometry—and corresponding types or forms of physics and ethics.

For example, the permanence suggested by the static geometry of ancient and Renaissance Rome, the dynamic geometry of the Baroque, and the deontological geometry of the Enlightenment, offer three very distinct models, indeed archetypes, of science and reason.

For Plato and Aristotle, geometry is associated with eternal and rational objectivity; for Descartes, it is associated with mathematics; for Newton, those mathematics are associated with mechanical process; for Kant, with subjective rationalization. This can be demonstrated by the history of architecture.

Perhaps the most famous example of ontological architectural geometry is the Pantheon in Rome. Built in the second century AD, that building influenced

Renaissance, Baroque, modernist, and American architecture; it thus offers us a valuable means of contemplating not only different modes of geometry available but also the comparative quality of thought and life offered by each. The contemporary challenge is to substantively and qualitatively evaluate them all. The quality of our knowledge is realized by our rising above perspectivism—not perfectly, but significantly. This is done by rising above the circle of hermeneutics and epistemology toward truth and ontology.

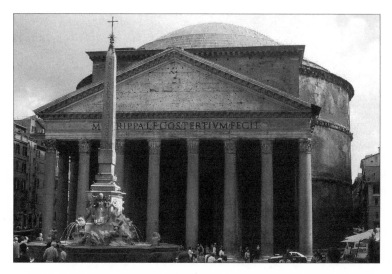

Pantheon

The archetype of the classical vision of reality and life is found in the Pantheon. It is a building that is ontological, geometric, and the embodiment of a cosmos. According to art historian William MacDonald, the theme of the building is:

> unity—the unity of gods and state, of people and state, and the unity of the perpetual existence and function of the state with the never-ending revolutions of the planetary clockwork. The grid underfoot, in appearance like the Roman surveyor's plan for a town, appeared overhead in the coffering, up in the zone of the mysteries of the heavens. To unify unities is to produce the universal, and this is perhaps the Pantheon's ultimate meaning. . . .
>
> Order, peace, harmony, unity—these were the immediate meanings of the Pantheon, cast in a religious setting. And it was a kind of orrery as well, in which planetary implications were signaled directly as the earth revolved.

Zeus-Jupiter-Helios, the supreme god allied with the Great Sun, was him-
self inside the rotunda, his effulgence visible but intangible.[6]

The geometric clarity of this building aspires to being ontological. The
Pantheon declares that we live in a house of life where harmony (not tolerance,
authenticity, fairness, or mere practicality) is better than discord—in physics
and ethics. The dilemma, however, is how to escape violence. Following Plato
and Aristotle, it represents the classical understanding of the very structure of
the universe. Aristotle discusses the geometry of the universe in his book *On the
Heavens*; Plato does the same in his *Timaeus*. Notably, those texts are not writ-
ten as philosophy in the modern sense of the term. They include references to
empirical observation and analysis. That unified approach to science and reason
is most influential in the later writings of Ptolemy, whose career coincided with
the building of the Pantheon. His book *Syntaxis*, a summa of the development
of cosmological science of his time, offers certain sound principles for obtaining
knowledge: that we should pursue the simplest possible hypothesis, and that our
empirical observations should be judged in the long term to reduce the possibility
of error. His work is both empirically and mathematically rational.

Contemporary commentators note that the meaning of the Pantheon was sci-
entific, religious, and political. Here is MacDonald again:

> What seems more certain is that the dome was intended as a symbol of the
> heavens, the abode of the gods, ruled over by Zeus-Jupiter, the Sky God and
> Sky Father. His place, if not marked by an image in the rotunda, was the
> void seen through the oculus. . . . All the gods, then, are part of a cosmology
> expressed in architecture, sculpture, and light, placed in Rome by Hadrian,
> the Father of his People.[7]

But while we may admire the building's impressive coherency of design,
we can also recognize that it is substantively conflicted. That conflict denies
reason and produces an incoherent science, though not because of the geocen-
tric assumptions of its physics. Observed facts appeared to confirm a spherical
universe with earth at its center, but the problem is not merely empirical, it is
rational: a plurality of truths makes no sense regardless of the facts involved. The
incoherence of a pagan polytheism is the problem. The existence of multiple gods
or truths results in the presence of violently competing gods or truths, so that
neither science nor reason can make sense. Lacking the possibility of comple-
tion, polytheists and, for example, Nelson Goodman's postmodern worldmak-

ers, share the same dismal fate: a violent science and culture in which reason is replaced by will and power.

Commentators attribute this cognitive dissonance to a variety of sources, but that dissonance is indisputable. A new paradigm shift is unfolding, with monumental consequences. As MacDonald notes:

> One of the main characteristics of the culture of the High Empire has been shown to be an increasing syncretism of religious beliefs, at the expense of traditional religion, the gradual depreciation of which was sometimes based on quasi-science, sometimes on the subjective pursuit of classically-based philosophy. With Mithraism and Christianity, the peoples of the empire were deeply involved in teachings that made far more of a world unseen than of this one. . . . The Pantheon was created at a turning point in history, when rites and rules drawn from a very long past were not yet abandoned, but the surge of a new and utterly different age was already being felt.[8]

There are other examples in the West of notable paradigm shifts that deeply inform reason and science. For example, the authority of Aristotelian and Ptolemaic thinking dominated Western cosmology until the sixteenth century. At that time two separate trends begin: the mechanistic mode of Bacon and Galileo and the rationalistic mode of Descartes and Kant. Previously, as expressed by Dante, love is the cosmic impetus that drives the universe to completion. But Galileo (1564–1642) posited the notion of that impetus as material force acting as a mechanical agent. And in contrast to the classical focus on the eternal forms that underlie all of existence, Galileo focuses on mechanics combined with dynamics. We focus not on rising from the accidental and temporal to the essential and enduring. Rather, we focus on material process. We focus not on *becoming* seeking *Being*, but on *becoming* alone.

With this background in mind, it is useful to now return to a previously discussed work of architecture, the *Old Ship Meeting House* (1681) in Hingham, Massachusetts. It might surprise some to view this work of architecture not as a provincial and colonial work but rather as at the forefront of Western cultural practice. But so it is. It is a building type that has no prototypes within the entire history of English church architecture.

The architecture is decidedly antigeometric. That is profoundly significant in that it refers not merely to an ignorant or simplistic religious fundamentalism, but rather reflects a new paradigm, a new *scientia*, resulting from a fusion of Judeo-Christian and Galilean-Newtonian science and reason. It is anti-Anglican

and anti-Catholic, not merely in the name of an emotivist faith, or religious big-otry, but as a response to the challenge of a new non-Euclidean geometry and a nonhierarchical cosmology—and sociology.

It is common to read that the Congregationalist Puritans that built this struc-ture were motivated by a simple faith grounded in deep-rooted religious convic-tions. But those religious convictions had a scientific facet—as clearly evidenced by the bookcase of the Reverend Devotion. As does the Galilean-Newtonian tra-dition, the Puritan faith focuses on a material world created as an act of divine glory. That world is presided over by its creator; that material world is a dynamic mechanism presided over by Grace. The symbolic, decorous, or analogic, as understood by Augustine, and as differently understood by Aristotelian Scholasti-cism, is diminished. Just as the church is no longer a symbolic or analogic repre-sentation of the structure of the cosmos, the Sacraments are few; Communion is no longer considered a symbol indicating the presence of God. Transubstantiation is denied, as is numinous science.

So the church is now a meeting house, where *material facts and religious belief combine in the pursuit of a new nonhierarchical society*. It is the priesthood of all believ-ers put into action in faith and life. That is not to say the Puritans embraced and pursued a democratization of faith and society void of Truth or wisdom. For the Puritan mind, we are equal before God, and enjoy a God-given right and duty to attempt to understand Him. Neither truth nor God are made; rather, they are found, and all have the right to attempt doing so.

This results in serious theological concerns grouped under the rubric of *theodicy* and centering on the question of why God would permit evil and tragedy to occur. We will address those concerns as primary to the development of romanticism in Western and American culture. But for the moment we can return to another example of early American architecture previously discussed, St. Paul's Chapel in New York City. St. Paul's Chapel is in the English Baroque style. But once again, that style has a substantive content. In contrast to the radical rejection of geometry by the Old Ship Meeting House, St. Paul's Chapel continues within that tradition. However, understanding of that geometry, and thus its meaning, has changed.

Built in 1764, St. Paul's Chapel is part of the Anglo-Catholic tradition. An American archetype of that tradition is found in St. Luke's Church (1632) in Smithfield Parish, Virginia. But in contrast to that earlier Scholastic-inspired architecture, St. Paul's Chapel reflects the English Baroque style that developed under the auspices of Sir Christopher Wren (1632–1723). The English Baroque to which Wren contributed is more than a matter of subjective aesthetic prefer-ence. It refers to a non-Scholastic science, reason, and geometry. Indeed, there

is a profound connection for Wren. He was a contemporary and acquaintance of Newton, and was primarily a mathematician, considered by Newton to be one of England's top three. Of particular note is Wren's concept of beauty. In Anglosphere fashion, Wren suggests there is a "natural" as well as a "customary" beauty, the former being universal and indisputable and the latter culturally based.

Tragically, this conception of beauty undermines the intellectual foundation of Wren's own work. Beauty based on purposeless nature and taste is beauty based on fact and feeling. As such, beauty is redefined as aesthetic experience. This shift denies scientific rationalism as that which reveals numinous meaning and purpose. Therefore, a purposeful scientific rationalism is viewed as unscientific nonsense. No longer does his geometry reflect anything other than his or our experience and fancy. What we find at St. Paul's Chapel is the early stirrings of this shift, this reduction in geometry *from the analogic to the decorative*. Scholastic architecture shifts to the Baroque, and the Baroque shifts to a neoclassicism in which all form is symbolic rather than decorous or real.

Clearly the building does reflect an interpretation of classical geometry; tragically, that interpretation is no longer considered ontologically scientific and rational. Without the traditional ontological understanding of geometry, architecture may develop according to any whim of the architect. Wren's disciple Nicholas Hawksmoor grasped this, and as a result many of his buildings are unprecedentedly idiosyncratic.

The Baroque marks a paradigmatic shift from the analogic to the deontological, from rational and ethical precision to rational and ethical contingency. In turn, it shifts to the realm of meaningful fiction to the merely absurd. This is tragic because it is a shift from a qualitative universe to one quantitative, trivial, and violent. In so doing we shift from a purposeful emotion culminating in truth and love to a purposeless emotion culminating in the pursuit of power.

This shift is from Euclidean, Aristotelian, and Ptolemaic geometry, which suggest that the axioms of morality are ontologically self-evident and clear, to a new type of geometry and ethics. And it is a shift away from scientific and ethical essentialism. It occurs via the development of Baconian-Galilean-Newtonian physics, which in turn is accompanied by a shift in mathematics and ethics. Newton's development of a new cosmology is concurrent with his development of the new mathematics called calculus, which permits a dynamic yet rational analysis of matter in motion; what is newly problematic is the absence of a qualitative continuum rising from becoming to Being, from confusion and violence to Truth and Love. In the new physics, mathematics, and ethics, the goal is the same: becoming as the pursuit of power.

The conceptual shift from the analogical to the natural is a shift from meaning to fact, feeling, and power. It is a shift from sacred space to empty space. That development from the Baroque to the modernist is personified by the shift from Descartes to Newton to Kant.[9] The development of the Baroque style is deeply associated with the work of the great French philosopher-mathematician Rene Descartes. In 1619 he famously had a mystical experience when an Angel of Truth appeared to him and confirmed that mathematics was the sole key needed to explain the workings of nature. As Burtt puts it:

> The existence and successful use of analytical geometry as a tool of mathematical exploitation presupposes an exact one-to-one correspondence between the realm of numbers, *i.e.*, arithmetic and algebra, and the realm of geometry, *i.e.*, space. That they had been related was, of course, a common possession of all mathematical science; that their relation was of this explicit and absolute correspondence was an intuition of Descartes.[10]

Sacred space is where geometry, mathematics, and physics purposefully merge. In a lingering Scholastic mode, however, Descartes maintains that truth exists in the mind of God, the mind of humanity, and in things. He separates the divine mind, the human mind, and matter. He optimistically asserts that the mind of humanity is capable of analytical thought characterized by accuracy, clarity, and confidence. But he recognizes a conflict in this method: deductive, analytic reason can be certain, but it is also static. It is limited to its initial premises. In contrast, the new empirical science is inductive, and actively attaches theories of meaning to things. Therefore, he faces the necessity of applying deductive mathematics to material objects in motion. Again we can refer to Burtt's summary:

> Bodies are extended things in various kinds of motion. We want to treat them mathematically. We intuit these simple natures in terms of which mathematical deductions can be made. Can we formulate this process more exactly, with special reference to the fact that these simple natures must make extension and motion mathematically reducible? Descartes tries to do so, but at the crucial points his thought wanders, and as a consequence Cartesian physics had to be supplanted by that of the Galileo-Newton tradition.

The Trinitarian reconciliation of eternal Truth with temporal material existence is grounded in a qualitative, indeed moral, conception of physics. It is Incarnational and Trinitarian. The material world operates in time, in the contingent,

and is afflicted by evil. But while in the midst of the material and contingent, we should strive for the truth and goodness that are eternal and ideal.

Traditionally physics operates within a qualitative continuum. Physics (and knowledge) begins as perfection, falls into confusion and violence, but can be restored to perfection once again. The existence of an eternal transcendent Truth or God as a First and Final Cause permits physics to begin as sacred, decline to the profane and confused, but then rise to become sacred yet again. So physics free from sin and error make manifest degrees of the numinous on earth. The world is decorously restored. Paradise once lost, shall be regained.

However, Baroque astronomy denies physics the possibility of a qualitative continuum. Its limitation of truth to human reason and observed fact denies any transcendent truth, any lodestone by which to understand the world. There is no longer a plausible link between the material world and God, the contingent and the eternal, which would make the world intelligible.

Descartes fails to comprehensively span the chasm between observed phenomena, motion, deductive mathematics, and the mind. There remains a (Scholastic/conceptualist) distinction between Truth in the mind of God, in the mind of humanity, and in things. That distinction is accepted by Galileo, and later reconsidered by Newton via deism. Edwards tries to repair that deistic dichotomization of transcendent and material knowledge.

Calculus can describe the physical operations of the universe, but only at the cost of denying that geometry is qualitatively ontological. Not only is an ontological geometry denied; the world is now material process rather than intelligible, mechanical, and contingent rather than numinous. Setting the template for Puritan and Kant alike, Descartes concludes that: "In truth we perceive no object such as it is by sense alone (*but only by our reason exercised upon sensible objects*) [italics added]. . . . In things regarding which there is no revelation, it is by no means consistent with the character of a philosopher to trust more to the senses."[11]

What results is profoundly sad for our understanding of science, reason, and geometry. Within the Western tradition, science and reason are one; reason and fact evidence increasing qualitative degrees of profundity, from sheer matter to physics to biology to humanity, and, eventually, to the Divine. The shared goal is to understand increasingly profound realms of reality. That involves reason, matter, motion, and space being as a matter of varying degree, a manifestation of an optimistic realism. So matter (being) and motion (becoming) can be harmonized with Truth (Being). But now, qualitative degrees of Truth are no longer intrinsic to reality; truth is to be exercised *upon* sensible objects. It is manufactured rather than found, quantitative rather than qualitative. This reduces *scientia* to scientism

and reason to rationalization. This is in radical disagreement with Trinitarian and Incarnational science, which holds that reality is rightly reasonable, and is properly wonderful.

The Scholastic attempt to reconcile the mind of God, the mind of humanity, and the ideas informing matter is now realized in the scientific presumption that the world is mindless and indeed unintelligible. The Baconian-Galilean-Newtonian paradigm affects the scientific foundations of the West. Descartes's inability to substantively fuse motion with matter is theologically paralleled by an inability to reconcile *Being* with *becoming*. The result is that (barring revelation) both geometry and theology are bifurcated into a rationalized materialism and emotion, neither of which mandates the possibility of Truth or God. The geometry of St. Paul's Chapel no longer can make scientific sense. From a positivist perspective it exists as part of a dead tradition. St. Paul's Chapel no longer functions as revealing the structure of the universe, as a visual analogy of the reconciliation of Being and becoming, idea and matter, eternity and time. Rather, it evokes a rationalized emotion—be it devotional or bored.

This leads us to a consideration of a later American building, the Baltimore Cathedral by Benjamin Latrobe. Commissioned in 1804, this building is clearly modeled on the Pantheon. As such it celebrates rational Being. But it is built on a Latin cross plan, in contrast to the Pantheon's circular and static design. As such, it importantly affirms traditional Christian theology. The Latin plan stems from early Christian architecture, most notably Old St. Peter's in Rome. That architecture reformulates the Roman law building, the basilica, to accommodate Christian *scientia*. The horizontal axis of the nave meets a vertical axis at the altar. Where they meet represents the meeting of the material and temporal with the ideal and eternal. The point of meeting is where the Incarnation bridges the two and where the elements of Communion are celebrated. So the Latin cross plan materially makes manifest the reconciliation of matter and idea, time and eternity, *Being* and *becoming*, central to Trinitarian Christianity. It is a sacred building denoting a sacred space.

Extrinsically, the church's architecture is a coherent expression of *scientia*. But intrinsically it is under the assault of *scientism*. Descartes strives for a rational clarity distinct from materialism; this is evident in this typical Baroque-inspired church. But unlike other Baroque architecture such as that by Borromini, motion is comparatively denied. The geometry is Euclidean not Cartesian. With the Baltimore Cathedral, Latrobe did not follow any historic classical orders but rather sought a "pure" geometry. He also was interested in the work of Boullee and Ledoux as well as the theory of Laugier, none of whom pursued an ontological

architecture. Notably, Latrobe originally designed two plans for the Baltimore Cathedral, one Gothic and one neoclassical. "He reasoned that Gothic architecture inevitably elicited a degree of 'veneration' and thus would be appropriate."[12] But given the beliefs of Boullee and Ledoux, it is worth wondering who—besides Newton—can be venerated?

So Latrobe's work is neither Scholastic nor Baroque, but neoclassically inspired. The problem is that the trajectory of the neoclassical paradigm is away

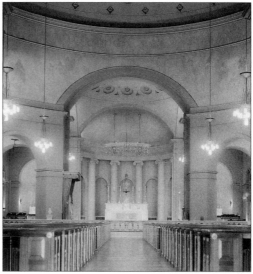

Benjamin Latrobe, Baltimore Cathedral, 1804

from ontology. Neither Newtonian deistic mechanical materialism or a Cartesian-Kantian dualism of matter and idea offers a satisfactory solution to the reconciliation of Being and becoming, without which meaning cannot be obtained.

Latrobe was involved with another equally important, if confused, example of early American architecture: the campus of the University of Virginia, designed by Thomas Jefferson. Jefferson corresponded with Latrobe regarding the planning; it was the latter who suggested including the Rotunda, a scale reproduction in brick of the Pantheon, as the visual center of the "academical village." Here we find, on many levels, the eighteenth-century dilemma manifest. Jefferson struggled, but failed, in his attempt to reconcile the deist dilemma. He famously cut from a Bible the passages that he thought important and pasted them together to make a new book. He also famously drafted the Declaration of Independence with the phrase "We hold these truths to be sacred and undeniable." Only later under the influence of Franklin did he change that language to "We hold these truths to be self-evident." The problem is that what we hold to be self-evident may or may not actually be true—much less actually sacred. The conflicts between sacred and secular reason plagued him throughout his life. As such he personifies the conflicts within the Anglo-modernist tradition.

In his plan for the University of Virginia, Jefferson arranged for each of the Pavilions, the distinctly separate classrooms spaced about the Lawn, to be examples of different classical modes. The buildings themselves were to educate the

students. However, his arrangement of the Pavilions neglected any hierarchy in regards to the classical orders. Jefferson also offered a new curriculum, based mostly around the "practical" sciences, and he rejected having a chapel and a professor of divinity on the campus. Nonetheless, Jefferson did include, in the lower level of the Rotunda, a room for religious study. So the geometry of architecture is as ambiguous about sacred space as was the architect, at times affirming, at times not. But how else may a Newtonian deist function? In advice to his nephew Peter Carr, Jefferson suggested, among other things, that "Your own reason is the only oracle given you by heaven, and you are answerable not for the rightness but uprightness of the decision [to believe or not believe]."[13] Reason is a gift of heaven that is to judge whether heaven exists.

Knowledge and the Will

Traditional physics reflect the attempt to reconcile becoming and Being, and matter and space. That reconciliation has often centered on geometry, and involves ethics. The association of geometry with physics and ethics is more than theoretical. The American Declaration of Independence resoundingly declares that we hold certain truths to be self-evident and divinely endowed. The axioms of morality are as self-evident as the axioms of geometry—in the Declaration or in the compositions of good paintings and architecture. For the classical-Judeo-Christian tradition, those self-evident truths are scientifically and rationally grounded in a purposeful reality. But for Hume, truth-claims are but bundles of experiences, and for Hobbes there are no self-evident truths; what, then, of Newton and Kant?

Burtt establishes that rather than empirical science determining our understanding of the world and life, our philosophical principles deeply influence the type of science we pursue. It is a thesis with which philosopher Ernst Cassirer agrees and which is a qualitative advance over Kuhn's view of science as noncumulative change. Burtt points out that whereas the language employed by the Scholastic scholar to explain the world centers on the concepts of substance, essence, form, and love, the language employed by the Newtonian/Kantian scholar centers on the concepts of matter, force, and power. The difference is more than semantics; it reveals a fundamentally different approach to science, ethics, and art, and consequently a fundamentally different approach to culture and life. The shift from substance, essence, form, and love to matter, force, power, and, ultimately, violence, is more than a shift in physics; it is a shift to a different ontology, metaphysics, and theology: "It is noticeable that Newton, in common with the

whole voluntaristic British tradition in medieval and modern philosophy, tended to subordinate in God the intellect to the will; above the Creator's wisdom and knowledge is to be stressed his power and dominion."[14]

The relationship of intellect and will is critical in reference not only to our understanding of physics but to Truth and God as well. A God who acts out of love is different from a God who acts out of glory. This is critical to our understanding of science, theology, reason, culture, and ethics. Burtt observes that within English culture the will is traditionally held to be paramount to the intellect. To his remarks we can add that it was during the early Christian period that Pelagius, for example, famously championed salvation via acts of the autonomous will. Pelagius (the Latinized form of the name Morgan) maintains that we have the necessary knowledge to permit us to will righteously. Augustine disputes these notions in his famous text *On Free Will*. Augustine observes that Pelagius asserts knowledge beyond his ken, confuses his will with that of God, and puts into question the need for Grace, the Incarnation, the Crucifixion, and even knowledge of the substance of God.

From a purely intellectual point of view, the rejection of those doctrines has enormous ramifications. Should the Anglosphere shift from the classical-Judeo-Christian to modernism-postmodernism, then the traditionalism of English culture, previously understood as the bearer of wisdom, is transformed into the bearer of willful preference. Government based on willful preference—of the few or the many—destroys human rights for all. A theology that focuses on the power and will of God promotes a social analogy. And it presents an enormous difficulty: how to provide a satisfying explanation of evil.

According to the shift from an Aristotelian/Scholastic understanding of physics—in which gravity is an expression of love, and love a free seeking of completion as a state of ontological blessedness, as a realization of Truth—now gravity is sheer material force, and not seeking Truth. Rather, it is a physical manifestation of the Divine Will, or of mere nature. Gravity, like God, is not love, not a desire for right completion. Instead, it is evidence of the will—and, as one may expect, so too are ethics. Significantly, whereas the empirical data remains the same, our understanding of the meaning of the empirical has radically shifted. As physics is understood, a metaphysics is revealed; Newton's allegedly Christian deism is shown to be but a momentary pause to an unorthodox metaphysics that is alternately mechanistic, immanent, and presciently pantheist. It is one in which God must be distant but provide immanent maintenance. Writes Burtt:

Newton thus apparently takes for granted a postulate of extreme importance; he assumes, with so many others who bring an *aesthetic interest* [ital-

ics added] into science, that the incomparable order, beauty, and harmony which characterizes the celestial realm in the large, is to be eternally preserved. It will not be preserved by space, time, mass, and ether alone; its preservation requires the continued exertion of that divine will which freely chose this order and harmony as the ends of his first creative toil. From the Protoplast of the whole, *God has now descended to become a category among other categories* [italics added]; the facts of continued order, system, and uniformity as observed in the world, are inexplicable apart from him.[15]

The identification of nature as embodying a set of mechanical or immanent laws can be a way of seeing nature as a set of objective purposeful phenomena resulting from the will of God. But two difficulties result: first, if God provides cosmic maintenance, then the occurrence of evil and tragedy must be due to willful neglect or abuse. The argument that God uses evil to teach us good reduces the Christian God of Truth and love to a sadist. Another difficulty is that neither purpose nor God is necessary in such a state of nature. The argument from intelligent design, as offered by Newton, facilitates a mechanistic or pantheistic conclusion, where if truth exists it is a matter of empirical identity lacking purpose.

So the difficulty facing deists is not the absence of divinity, but the lack of any necessity of purposeful meaning, and the lack of a ready explanation of evil. Any notion of cosmic and social order and harmony are now contingent upon the will of a distant yet responsible God, or upon our own willful wishes. In Burtt's words:

Contrast this Newtonian teleology with that of the scholastic system. For the latter, God was the final cause of all things just as truly and more significantly than their original formers. Ends in nature did not head up in the astronomical harmony; that harmony was itself a means to further ends, such as knowledge, enjoyment, and use on the part of living beings of a higher order, who in turn were made for a still nobler end which completed the divine circuit, to know God and enjoy him forever. God had no purpose; he was the ultimate object of purpose.

In the Newtonian world, following Galileo's earlier suggestion, all this further teleology is unceremoniously dropped. The cosmic order of masses in motion according to law, is itself the final good. Man exists to know and applaud it; God exists to tend and preserve it. . . .

We are to become devotees of mathematical science; God, now the chief mechanic of the universe, has become the cosmic conservative. His

aim is to maintain the status quo. The day of novelty is all in the past; there is no further advance in time.[16]

Newtonian physics demand a particular metaphysics, which in turn demand an end of history, science, and art—a demand asserted by Hegel and later epigones. But that end can focus on the will of humanity or the will of God—and the distinction between the two becomes obscure. In either case responsible freedom and the pursuit of wisdom are trivialized. Newton accommodates both the secular positivist and the religious fundamentalist—which makes sense because intellectually they are of a willful kind.

The shift to a Newtonian paradigm is not away from ontology and metaphysics but toward a new ontology and metaphysics. For those unaware of the intellectual significance of the Doctrines of the Incarnation and the Trinity, Newton's denial of each is simply progressive; but the intellectual and moral consequences of those doctrines are manifold, and affect not only religion but also how we view ethics and physics. Newton was a positivist, perhaps even the first, but in contrast to the aesthetic positivism that today dominates our thinking, Newton remained influenced by traditional philosophy and religion. He was strongly influenced by Aristotelian and Scholastic concepts such as the existence of an unmoved mover, and the notion that knowledge focuses on the causes of sensible effects.[17] But in contrast to that Aristotelian-Scholasticism, he maintains that knowledge of the laws of nature can ignore final causes, ultimate purpose, and include those formerly considered to be of the occult.

Science, Reason, and the Will

Now we may examine how the will directs our intellectual goals. As Panofsky, Wittgenstein, and Kuhn make clear, there is a willful component to the seeking of knowledge. In this Augustine and Edwards fully concur. It is the foundational differences between their two distinct viewpoints that remain the crux of the matter. What is the role of the will in the pursuit of knowledge—that is, in the pursuit of science and the exercising of reason? Just as the pursuit of *scientism* differs from the pursuit of *scientia*, our understanding of the role of the will in reference to science and reason correspondingly differs as well.

But this is a topic difficult to address. In contrast to Kuhn's assumption that such shifts in understanding can occur via impartial conversation, Augustine maintains that it is not just conversation, but conversion that matters. He rec-

ognizes that the heart can be of great help or great hindrance in our attempt to understand the world and life. So the willful component of our attempt to comprehend the meaning and purpose of our lives resonates with both Augustine and postmodernity. The difference between them hinges on whether the will can pursue the true, good, and beautiful, and thus rise above the merely willful.

Within the classical-Judeo-Christian tradition, it is the reconciliation of the free will with objective Truth that is key. Truth is essential because lacking it, the will has no purpose to strive for and is thus condemned to meaninglessness. The lack of Truth denies freedom. But if Truth is necessary to freedom, then how is the will to be reconciled with Truth? Does not obedience to Truth deny freedom? Can freedom exist in a world informed by Truth, or are Satan's words in Milton's *Paradise Lost* correct: it is better to be free in hell than a slave in heaven?

Within the classical-Judeo-Christian tradition, the role of the will in seeking Truth has long been acknowledged. A willful decision to freely pursue Truth is understood to be the ground of human freedom and responsibility. The philosophical roots of this doctrine are found in Plato and Aristotle. The theological roots are found in the letters of Paul, and in later commentaries. Augustine makes it abundantly clear that the will is a primary component of seeking knowledge—for better or for worse. A willful construction of meaning is the source of evil. It is when the will resists Truth that sin results. When we act in harmony with Truth, then it is Truth that sets us free. The willful imitation of Truth and goodness results in our liberation from foolishness, vanity, and violence. Truth solves the problem of a willful freedom.

As part of the classical-Judeo-Christian tradition, Jonathan Edwards understands freedom as the arena in which we willfully seek the good. That which we understand to be good is foundational to that which we (at least ought to) strive to do. The ability to freely do what is good is grounded in personal character *and* Grace. Our choices reflect character, but our ability to make good choices also depends on the benevolence of God. Following Augustine, evil came into the world as a type of privation, not a substantive creation. It is grounded in a willful resistance to reality. Conkin explains Edwards's position:

> Edwards believed that those who defended free will had to argue either for pure indifference (uncaused, contingent choice) or for self-causation. . . . If acts of will occur without cause, then there is no valid reason why millions of other things do not also occur without a cause, and the universe is reduced to accident and man to complete solipsism. If freedom is tied to indifference, it exists only when there is no volition, or really no willing and no choice, which is a contradiction.

A self-caused will involves both contradiction and impiety. . . . This concept of self-causation was a direct affront to God, who alone is self-caused, but whose will is also bound to what is good. . . .

Either indifference or self-causation was contrary to the moral necessity involved in a moral code or legal commands, to any morality based on good habits, to a will determined by a good understanding, to actions caused by motives or ends, and, most significant, to God's omnipotence.

Virtue was not a matter of correct action, but of the right ground for correct action. Anticipating Kant, he found virtue only in the good will, in the right attitude and the right perspective. But unlike Kant, he tied virtue to a conscious end—the glorification of an irresistibly beautiful Deity.[18]

Within this context, Jefferson and others within the Anglosphere are now faced with two contradictory possibilities: a modernist-Anglospheric view of science, ethics, and art as cultural practices grounded in a willful *scientism*, or a classical-Judeo-Christian Anglospheric view of them being grounded in the loving pursuit of *scientia* and *sapientia*. In either case, a willful choice is necessary. The question is whether that willful choice is its own subject or enjoys a benevolent object.

In *The Philosophy of the Enlightenment* (1932), Ernst Cassirer discusses the relationship of will and knowledge within the Enlightenment. He observes:

A general axiom which frequently recurs in varying guises in the philosophy of the Enlightenment asserts that the gravest obstacle to the investigation of truth is not to be looked for in the mere lack of knowledge. The mistakes of [positivist] science are corrected by science itself in the course of its immanent progress. . . .

Of much deeper effect are those divergencies from truth which do not arise from a mere insufficiency of knowledge but from a perverted direction of knowledge. . . . The falsification of the true standards of knowledge appears as soon as we attempt to anticipate the goal which knowledge must attain and to establish this goal prior to investigation. Not doubt, but dogma, is the most dreaded foe of knowledge; not ignorance as such, but ignorance which pretends to be truth and wants to pass for truth, is the force which inflicts the mortal wound on knowledge. . . .

And this axiom holds not only for knowledge but also for faith. The real radical opposite of belief is not disbelief, but superstition. . . . In superstition, therefore, knowledge and faith encounter a common enemy and the fight against him is their first and most urgent task.

>It is the task of the will to guide the path of knowledge; and this fac-
>ulty possesses the power to protect knowledge from all aberration in that
>it confronts knowledge with the general and inviolable demand never to
>pronounce judgment except on the basis of clear and distinct ideas.[19]

Cassirer accurately describes the impulse informing the Enlightenment. But if knowledge is a construct, and if beyond material fact, knowledge conforms to our mental tendencies, then our clear and distinct ideas need not refer to reality itself. Willful seeking is presumed to be Truth. Being is becoming. Indeed, reality becomes but a word, and as Nelson Goodman proposes, we become worldmakers, not truth seekers. For Panofsky, Cassirer, and Kuhn, the pursuit of knowledge should not have a purpose; their intellectual enemies are those who assert a particular purpose—or dogma. What they miss is that a purposeless purpose is like a self-caused will: either absurd in itself or as a claim that we are Gods. A third possibility remains: a willful dedication to the pursuit of objective Truth and goodness.

So the conflict over understanding science, ethics, and art refers ultimately to the role of the will and its purpose. To the modernist tradition, the will ultimately has a subjective ground and purpose: self-expression and self-realization. But a subjective self-expression and self-realization condemns us to a banal nihilism. To the classical-Judeo-Christian tradition the purposeful will is realized via a passionate pursuit of objective Truth and goodness; they unite as an act of love, of completion as part of a meaningful world. The will can and should rise to the decorous. Therefore the remaining issue is in deciding in which we shall believe: the will and power, or the will as a means to realizing Truth and goodness?

Knowledge and the Fine Arts

This problem of knowledge and will in scholarship is central today and richly evident in the context of cultural history. The question of whether or not there is qualitatively objective knowledge to be sought concerning the meaning of life is intrinsic to the liberal arts, the humanities, and the fine arts. Consider another painting by Copley, titled *Watson and the Shark*.

Painted in 1782, it depicts a dramatic event in the life of Brook Watson, who commissioned the work. While living a dissolute life in the pursuit of financial wealth and pleasure, Watson was attacked by a shark in Havana harbor. He suffered the loss of a leg, but that loss, that suffering, resulted in gain as well. He later credited the event with turning his dissolute life toward the better. He

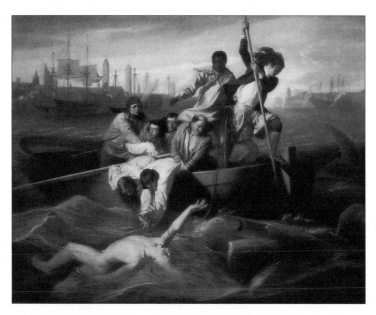

John Singleton Copley, *Watson and the Shark*, 1782

becomes an evangelical Christian, and later, the mayor of London. His severed leg
was even commemorated within his family crest.

Watson and the Shark is remarkably useful in contemplating not only eighteenth-
century thought but perennially important cultural issues as well. We can begin,
however, via a perspectival mode. This painting accommodates a broad variety of
interpretation, a variety of very different cultural and scientific paradigms.

From a positivist point of view, the work is a cultural artifact from the eigh-
teenth century associated with the three major social traditions of its period: the
Anglosphere, the classical-Judeo-Christian, and the modernist. It is an imaginative
composition based upon a historically factual occurrence endured by its patron.

In the modernist paradigm, the painting's concern with factual history is
secondary. To the modernist mind, history is a mental construct disconnected
from the pursuit of wisdom. Instead, the focus is on rational compositional clarity
and emotional impact. The painting admirably exhibits a compositional clarity
combined with a fact-based emotional intensity. The triangular composition of
the work is on the picture plane and also diagonally penetrates it, exhibiting not
only rational clarity but a reconciliation of a static and dynamic geometry, too.
It evidences a progressive synthesis of Renaissance and Baroque rationality and
technique. It is a synthesis of previous styles, and it is progressive in the sense
that it offers a novelty in composition and content. But from a modernist perspec-

tive, neither that rational content nor its geometry can genuinely explain reality. Rather, the focus of the painting is on depicting history as a series of events, subject to interpretation and emotional response. For the secularist it presents a personal experience; for the fundamentalist it presents a born-again experience.

To a postmodernist such as Hegel, the historical content of the work is significant. For Hegel, history is the unfolding of the Logos, though it is associated not with Love and completion, but with a dialectic of power that privileges the spiritual over the material. Therefore, the lowest form of painting is symbolic, the next best is classical, and the best painting is romantic. For Hegel, the romantic is more than mere personal emotion. It produces art that reveals the unfolding of a spiritual will that is immanent, not transcendent. Watson's experiences were the material unfolding of cosmic truth, a dialectic of idea and matter.

To a postmodernist such as Marx, this painting addresses a dialectic grounded not in the spiritual, but the material. We are impelled to contemplate the power relationships between social classes, races, and even species. We are asked to question the propriety of Watson transgressively entering and interfering with the territory of another species—the shark.

Thus far, this painting has been analyzed via a positivist and modernist-postmodernist perspective. In each case the result is aesthetic. We analyze the work in terms of fact, feeling, and power. This is in contrast with the perspective of seeking wisdom.

To the classicist, *Watson and the Shark* is peculiar. It is a history painting, and the classical tradition values history painting above all other types. Within the classical repertoire, history is more important than journalism, and history painting is far more important than still life or landscape. This is because history rightly addresses concerns and events that are perennially important and essential, as opposed to the accidental and trivial. Watson's experience was not trivial to Watson of course, but in the larger scheme of things the loss of one man's leg to a shark in a personally tragic episode is trivial indeed. For the classicist such as Aristotle there is no question that humanity is superior to animal and therefore the shark's attack upon Watson is not one of natural territorial defense but of savage animal brutality.

Finally, to the Puritan, this painting affirms basic Reformed Christian doctrine. It denies the secular rationality of the Enlightenment and an earlier Augustinian understanding of history and science as well. There can be no rational explanation for why Watson lost his leg to a shark. Maybe it was an accident, perhaps it was mindless fate, perhaps it was because of a life based on willful arrogance; for the Puritan Christian, it was none of these. Rather, it was the

will of God. God permitted Watson to lose his leg not as an act of brutality, but rather to help him advance spiritually. It is a test with purpose; that purpose is to provide Watson with the opportunity to renew his spiritual life. Whether or not a shark's attack can be judged evil will be discussed later, but surely such an attack is tragic. Nonetheless, it provides the means by which Watson escapes a decadent and self-destructive lifestyle. As explained by Scripture, all things work toward the good for those who believe in God.[20] But how are we to understand such a test? Could such a test emanate from other than a sadistic God? The Reformed Christian of this period was confronted by a Newtonian physics which mandated a deistic view; that view makes God responsible for creating a world full of vicious traps for the innocent. That problem results in a renewed interest in theodicy,[21] the attempt to comprehend and reconcile God's will and creation with evil and tragedy. Rousseau frees God of that responsibility by transgressing Christian doctrine. Evil is not the result of God, but of civilization.

So to sum up the matter at this point: in a Kuhnian fashion, it is clear that there are several possible paradigms for understanding this work of art. There are also numerous paradigms for understanding science, ethics, and their relationship to Truth or God. But what Kuhn and the modernist-postmodernists do not consider, indeed methodologically cannot, is that it is not merely a quantitative question of what modes of interpretation shall we will to embrace. Rather, there is a qualitative question: among the variety of modes of interpretation possible, which are more or less profound?

Watson and the Shark can be analyzed via positivist fact; it exhibits rational clarity; it involves ideas unfolding in time; and it touches on issues of race, gender, and economic class. But we can sequentially rise from one to another and ultimately to the pursuit of wisdom and beauty. It is the latter realm that is qualitatively informed and superior to the rest.

If a variety of modes of interpretation is available, then we face the issue not only of which we can tolerably employ but also of which we should reject, and which we should ultimately favor. So the initial methodological obstacle of addressing the differences between and dynamics of these very distinct modes of interpretation is but a prelude to the crux of the matter. *The higher issue is what qualitative hierarchy can be obtained via these modes of interpretation in scholarship, art, and life.*

This is an unavoidable issue for a number of reasons. First, as conscious beings we cannot, indeed should not, avoid making conscious value judgments; second, those different modes of interpretation can fundamentally contradict each other. Within a given society, moral and legal legitimacy cannot be bestowed upon them

all. To do so would be to destroy culture—and civilization. Third, understanding and practicality combine in the conduct of life so the quality of our beliefs correlates with the quality of our actions.

Since as self-conscious beings we must make judgments, and those judgments have a direct effect upon our actions, how can we escape the tragedy of an allegedly judgmentless modernity? First is to step away from the modernist reduction of truth to trivialized constructs of facts and feelings. Second is to step away from the postmodernist reduction of truth to experience and power. The next step is toward approaching fine art as a means by which we attempt to comprehend the meaning of a purposeful reality, life, and art. This shift from an aesthetic approach to the history of art (be it nostalgic and constructivist, or experiential) to one dedicated to the pursuit of truth, goodness, and beauty is essential to understanding the fine art produced through the ages.[22] But once we begin assessing the truth claims associated with different works of fine art and different cultural traditions, we then shift fully to the qualitative realm. We consider not only the conceptual authenticity of a work of art but its ultimate profundity as well.

This is a crucial step not just because many truth-claims around the world contradict one another but also because some may be so repugnant as to be considered beyond serious debate (e.g., that slavery and rape as norms could be valid as a matter of multicultural tolerance). Yet such debate should still be permitted, thus affirming freedom of conscience and a denial of totalitarianism. Our escaping those contradictions, debasements, and totalitarian absolutisms is crucial to our escaping being condemned to a nihilistic or dogmatic condition. When culture is reduced to a modernist triviality (in the name of tolerance) or a postmodernist identity (in the name of authenticity), then culture is denied. Identity does not permit us to even discuss the desirability of competing qualitative preferences. We dare not trivialize that which is necessary for distinguishing civilization from barbarism.

A Democratized Pursuit of Wisdom

One final reflection before moving on: the geometry of Being and the calculus of becoming. The ideas informing that geometry affected American and Western culture at the time, and continue to do so to the present. The geometric paintings of George Caleb Bingham evidence the unique quality of American exceptionalism. American Exceptionalism refers to a public faith in personal responsible freedom. It places faith in the possibility of a republic of wisdom seekers, a republic of individuals in a free and equal pursuit of *scientia* and *sapientia*.

In contrast to the classical assumption that civilization depends upon philosopher-kings and a ruling elite, and the egalitarian assumption that equality and democracy suffice, the American tradition maintains that it is possible and desirable to make philosophers out of commoners. The conflict between quantity and quality is thus resolved—indeed transcended.

That theme is central to the art of George Caleb Bingham. Nearly all of his numerous works (and those of contemporaries such as William Sidney Mount) evidence a clear predilection for geometric composition. His painting *The County Election* (1851), depicts what at the time of the founding of America was unique: widespread but not yet universal participation in elections and self-governance.

We could analyze this painting in terms of its dual treatment of geometry and space: a classical planar quality reconciled with a Baroque geometry reaching into space. We could discuss whether or not he was aware of the differences between Ptolemaic, Cartesian, and Newtonian geometry. But one thing remains clear: he celebrates a public pursuit of wisdom. It depicts space that is both quantitatively *and* qualitatively informed.

In Anglosphere fashion, he celebrates a continuing expansion of the voting franchise. To the postmodern eye, this painting makes clear the omission of women and minorities from participation in self-governance. However, within a historical context it is a source of celebration indeed.

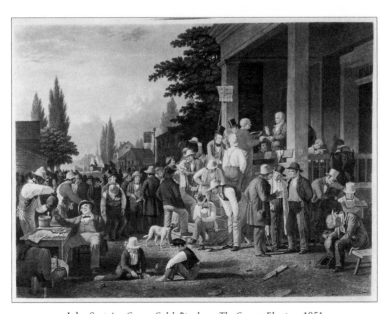

John Sartain, *George Caleb Bingham, The County Election*, 1851

At the time of the American War of Independence, the voting franchise in England was limited to a few. In a population of eight million, only about one-tenth of the men of voting age could vote. In America, voting rights were restricted by religious conviction and ownership of property. When Washington was elected president, not half of the (white) men twenty-one years of age and older could vote. In the newer states in the West, soon all men were made voters; this was followed in the late nineteenth century by women increasingly obtaining the right to vote as well. The point is that since the time of the Magna Carta there has been a continuing trend toward universal suffrage. For Bingham, the situation was better than ever before; for his descendants, the future would be better yet.

In summary, traditionalist Scholastic Anglicanism, Baconian and Newtonian science, and a newly democratized classicism and Protestant Christianity are the primary actors within this incoherent cultural context. Politically, the reconciliation of quantity with quality hinges on the common pursuit of wisdom. For that purpose the great American public school system was established. As one book from 1922 puts it:

> The general belief that to rule wisely the people must have intelligent ideas of their duties toward the state and society led to our present system of public schools supported by taxation. . . . The founding of state universities as a part of the state system of education was the rounding out of the democratic ideal of education training in this land of freedom.[23]

But the common pursuit of uncommon wisdom relies upon more than universal suffrage. It requires that wisdom exist and that most become capable of an adequate understanding of it. In the West, wisdom is historically grounded in the classical-Judeo-Christian tradition. As we have seen, that perspective is now assaulted by modernism-postmodernism. Lacking that wisdom, American exceptionalism sinks into special-interest power factions. Lacking the practical pursuit of wisdom, democracy descends into what Plato hates: mob rule in which culture no longer matters. Yet how many today go to college to obtain a glimpse of wisdom? How seriously are the liberal arts and humanities taken? How many act on principle rather than advantage? How many are even aware there is an alternative? The significant differences and the conflicts between these traditions need to be understood and evaluated. The next historical step from neoclassicism centers on the issue of Theodicy, on how tragedy and evil can be understood particularly in the presence of God. That is the question that leads us to that cultural movement known as romanticism.

7

From Neoclassicism to Romanticism

odernism is associated with the Enlightenment, a period with the stylistic designation, neoclassical. The Enlightenment alleges that we should escape from ignorance, superstition, and folly via the pursuit of a scientific rationalism. This is not new. The classical-Judeo-Christian tradition maintains that a scientific rationalism is the means by which we obtain some precious degree of knowledge of a meaningful reality. We seek to understand the cosmos, which embodies intelligent design and intelligible purpose. Plato and Aristotle, Augustine and Aquinas, all cherish a scientific rationalism as essential to the pursuit of knowledge (*scientia*) and wisdom (*sapientia*). The difference between them and Newton (and later positivists) is that scientific rationalism is redefined as the pursuit of facts to be manufactured, (de)constructed or experienced. So our understanding of science and reason is torn between two possibilities: 1) a world of purposeless, quantitative, and therefore unintelligible *becoming*, be it random, mechanical, or organic; or 2) a world of purposeful becoming, in which science, ethics, and art aspire to realize the ideal or *Being*. That ideal offers us the opportunity to engage in intellectual and ethical responsible freedom. It permits us to freely and conscientiously attempt to understand a qualitative world and life.

As we shall see, it is not that Newton delivers us from metaphysics, or from faith. Positivism requires belief in a new faith that mandates that we live in an unintelligible and therefore quantitative world, a world without objective purpose, and therefore without truth, or love. This is an aesthetic world without goodness or beauty, limited to facts, feelings, and power.

Significantly, that limitation is not—indeed cannot—be a matter of knowledge since such knowledge is beyond the purview of a positivist science and reason. *The positivist cannot know what is beyond its methodology; it cannot rightly claim to know that the universe is purposeless and therefore unintelligible.* Nonetheless, it does just that. Since that conclusion is not based on its own definition of science and reason, it constitutes a new but unsubstantiated faith. The consequence of that new faith is that science and reason willfully ignore objective—transcendent—purpose. Science and reason can describe and (de)construct knowledge but it no longer can be intelligible, a matter of understanding. Transcendent faith and knowledge are replaced by the immanent, of facts, feelings, and purposeless process.

This is reflected in Newton's theology, and it is important to reemphasize the unity of religion and science. When Newton rejected Trinitarianism he was allegedly rejecting superstition, but it was Trinitarianism that methodologically provided the means by which the pursuit of knowledge in science, ethics, and art is established. Trinitarianism permits us to seek knowledge of an intelligible physical reality. So Newton's rejection of Trinitarianism methodologically—but not ontologically—necessitates the pursuit of facts within an existential context. It requires the reduction of knowledge to a quantitative rather than qualitative mode.

Newton is an Arian, one who denies the Incarnation while incoherently making the transcendent God infinitely immanent yet neglectfully distant. The Doctrines of the Trinity and the Incarnation establish that reality is rational and purposeful; that the physical world is rightly rational but not self-conscious (i.e., pantheist, spiritualist). Therefore, the denial of Trinitarianism presumes that reality is irrational (Hume) or self-conscious (Hegel). In either case, scientific rationalism is redefined as the will to power. *Being* is then purposeless *becoming* and the pursuit of wisdom is replaced by an unintelligible constructivism, existentialism, and spiritualism.

Neoclassicism results when scientific and rational understanding is deontologized; the styles of classical antiquity are sought but not for their ontological splendor. Positivist facts now must conform to our mental tendencies, or our rationalized wills. When knowledge is that which we will, if reality conforms to how we think and feel—if we construct our realities—then rationality collapses. The redefinition of reason as feeling is now recognized as romanticism, which denies the realm of Being for that of becoming. Becoming is directed either by our will or the will of the Divine. The neoclassical is reduced to merely a stylistic preference. As one writer observed: "The Neoclassical which had been so profoundly pursued by David, and Napoleon, turned out to be little more than an antique revival, void of high-minded ideals and virtues."[1]

So romanticism is not so much a Kuhnian noncumulative break with modern-ist neoclassicism as it is an alternative and yet continuing response to the challenge of Newton. In a world of fact and process or becoming, the will trumps truth, love, and Being. European romantics such as Rousseau and Hegel attempt to engage in explaining reality. However, their attempted explanations are radically subversive of traditional Western (and Eastern) culture—and of science and reason. The attempts by positivism and romanticism to subvert traditional Western culture is celebrated by the modernist-postmodernist, but contested by others.[2] The Ameri-can antagonists of romanticism are united by their belief in a scientific rationalism dedicated to the pursuit of Truth, Goodness, and Beauty. Those who embrace that pursuit, especially classicists and Trinitarian Christians, cannot accept the denial of responsible freedom, the core belief of American exceptionalism.

The Intellectual Foundations of Romanticism

How often is the question heard: *How do you feel about that?* So commonplace as to be taken for granted, that phrase has profound implications. It associates how we think with how we feel. This shift from thinking to feeling has a long pedigree. On a sophisticated level, it becomes prominent with the conceptualism of Abelard as developed by Aquinas during the Scholastic period. The Scholastics recognize that thinking rising to knowledge of Divine Truth is a shift from discursive rationality to intuition. Intuition is not subrational but suprarational. For them, it is associated with what Augustine calls illumination. The meaning of intuition shifts, however, during the Baroque period and into the Enlightenment. In a world lacking a pur-poseful scientific rationality, intuition has no intelligible lodestone by which the suprarational can be distinguished from the subrational. Between Scholasticism and the Enlightenment there occurs a fundamental shift in metaphysics from a qualita-tive and intelligible universe to one quantitative and descriptive. No longer is the primary concern a timely pursuit of eternal knowledge of reality or Being; rather, it is a timely pursuit of power, of the subrational. Romanticism, an intuitive mysti-cism without objective truth, is the result. Romanticism is a destructive and nihilist form of mysticism that ought to be recognized as such—and rejected.

The association of facts with feelings, empiricism with mysticism, has a long pedigree. Empirical facts and mystical feelings share a common ground in sensa-tion rather than thought. In Western culture positivism is associated with roman-ticism just as facts are associated with feelings. With the positivist limitation of truth to fact and process, truth becomes deontological or subrational. That is,

truth or knowledge of reality is limited to rationalized or experienced fact, and reason is merely a matter of logical consistency or subjective intuition. In Bentham's famous turn of phrase, the rational pursuit of wisdom is but nonsense on stilts, but so too is the reduction of thought to feeling. The limitation of truth to fact, rationalization, and felt experience has a twofold consequence: a denial of the objective intellect and truth (Being), and an advocacy of the subjective will and power (becoming). A willful positivism produces a willfully empiricist and mystical perspective. While intellect and Being are denied, the will and becoming are privileged. A willful becoming replaces the intellectual attempt to comprehend and love reality as such.

At the turn of the nineteenth century, romanticism blossoms as a consequence of the Baroque, and as a vital alternative and complement to the neoclassicism of Newton and Kant. Neoclassicism extols confidence in the unity of facts and clear, albeit deontological, thinking, whereas romanticism aspires to rise above merely formalist thinking via experiential emotion, a purposeless intuition. The shift in our perception of the nature of reasoning—from conceptual clarity to emotional feeling—is central to the unfolding of modernist assumptions that conclude in postmodernism. It respectively marks the cultural trajectory from Newton and Kant to Hegel, Marx, and Nietzsche. It also marks a reformulation of the Trinitarian understanding of God or Truth. Traditionally, Truth grounded in meaningful completion permits objective truth to be associated with understandable experience. This permits a reconciliation of the transcendent and immanent, the universal and particular. Now, truth and love are conflated into a passionate will in which knowledge is reduced to mere existential experience and assertion.

Although distinct in many ways, neoclassicism and romanticism share a common heritage that is Scholastic, then Baroque, and later Newtonian positivist. The result is postmodernism, the oedipal offspring of the conceptualist-Baroque-modernist parent. As we shall see, Nietzsche understood Kant to be a latter-day Scholastic, and despises him for it. Newton takes as a matter of knowledge that we live in a naturalistic and mechanical universe. God is understood to have made that universe and—ostensibly—willfully maintains it. As a matter of knowledge, God is now a first but not also a final cause; that final cause is now understood as process; God's will rather than God's eternal substance reigns. It is the will rather than the substance or essence of God or Truth that is central. The Scholastic emphasis on love and substance is replaced by a Newtonian emphasis on power and will—in physics and metaphysics.

That Newtonian-Kantian focus on facts, feelings, and a willful rationalization tragically assaults not only the Scholastic view of the ultimate ontological unity of

science, ethics, and art but also the traditional belief in a rational and intelligible world. It denies not only the unmoved mover of Aristotle and the Trinitarian God of Scholasticism but also Being and intelligible purpose. The Newtonian view mandates a willful metaphysics of becoming—be it divine or not. That world of facts and becoming permits four indecorous perspectives to unfold: 1) a materialistic/spiritualist view; 2) a deistic view; 3) a pantheistic view; and 4) an evangelical, or non-Scholastic Catholic view. However ultimately incompatible these options are, Newton's ideas have been associated with all four of them.[3] That indicates not the state of reality but the degree of confusion and conflict within the oedipal modernist-postmodernist paradigm.

These four primary worldviews have in turn affected American culture since colonial times. The conflict between those worldviews becomes evident when we attempt to rise beyond a mere materialistic naturalism, beyond the superficial contention that *what* is *why*. We engage, then, the question: Do the facts of the world evidence Being and intelligible purpose, or just becoming and process, and what sort of evidence is available for us to come to a conclusion? Newton's deism[4] attempts to reconcile Being and becoming via the notion of intelligent design, as the order and grandeur of the cosmos infers the existence of God. But Newton's methodology denies such inferences the status of scientific knowledge. He limits knowledge to facts. Therefore, intelligent design can only be mystical doctrine. As a matter of knowledge, we are limited to becoming and unintelligible process in a world of facts. There are particular facts, and those facts must be combined by a will to make a world. Whether that will be divine or profane is indeterminate. The choice is whether worldmakers are objective and Divine—or subjective as ourselves, whether knowledge is to be sought or willed. Since positivism mandates that our knowledge is limited to the immanent, that knowledge is a product of our wills. We are indeed worldmakers in the midst of facts. We are limited to a materialist/spiritualist existentialism.

The often violent interactions between these four positions characterize much of the American and Western cultural narrative to the present:

1) The materialist/spiritualist view is advanced by Newton but is most characteristic of Continental European culture (Copernicus, Galileo, Comte, et al.) particularly flourishing in post-revolutionary France. It is most faithful to positivism, and therefore is most dedicated to a materialist/spiritualist yet allegedly atheistic view. As a matter of knowledge it accepts what Jonathan Edwards rejects: the naïve presumption that descriptions are explanations. It also accepts that we are worldmakers, that is, we are gods.

As a matter of culture it extols liberty, equality, and fraternity, but it is the nature of liberty about which it is deeply conflicted. It is not just the incoher-

ence of simultaneously advocating liberty and equality. A dedication to positivism results in a dedication to a particular type of social science. Social science, to be a science (as the term is now commonly understood), must be both descriptive and predictive. This presents a serious challenge to the notion of human freedom and thus of culture. Indeed, one of the champions of the French Revolution, Voltaire, summarily dismissed the very reality of human freedom. This perspective is obviously hostile to classical-Judeo-Christian belief; it differs from Aristotelian thought in that it ignores Aristotle's belief in an intelligible and qualitative universe enjoying the existence of final causes via an unmoved mover. Instead, we are worldmakers—alchemists—who manufacture the world according to our wills. The materialist-spiritualist perspective did not broadly impact American culture until the twentieth century.

2) Some of those focused on the pursuit of naturalistic fact continued to be dedicated to the existence of a meaningful universe, of Being or God. This deistic view has a long and troubled history in the West. During the medieval period a variety of this view was called Averroism, with which Galileo was deeply familiar. Averroism and deism share the conviction that there is a categorical split between science and faith. On the one hand are the facts of science; on the other hand are the facts of Scripture and dogmatic faith. But this reduces both science and Scripture to fetish or violence. They are denied intelligible purpose and meaning. They are denied meaning because in a world of fact and faith (as here limited) there is no meaning to be rationally understood. There is only authoritative fact—be it empirically or Scripturally manufactured. What are manufactured, constructed, are willfully subjective narratives. Both divine and human reason are thus trivialized and brutalized.

Nonetheless, the deist view is deeply represented by American and English examples. Newton arguably was—if such a position is actually possible—a non-Trinitarian and Arian fundamentalist Christian.[5] That is because God is newly viewed as a willful First and continuing—but not a Final—Cause. As such neither the Incarnation (the Logos made immanent) nor human reason (logos) matter much. What matters is the will. Newton was a believer in intelligent design, that the intricacies of the physical universe could not have an accidental or random origin. Those intricacies imply an objective and transcendent source, but the very notion of a willful deism confuses the notion of transcendence or beauty with immanence or aesthetics (as does Kant's transcendent aesthetic and synthetic a priori).

Therefore it denies that objective truth can become incarnate in reality—as Christ in perfection—or that some precious degree of truth can be found incarnate via scientific rationalism. By its advocacy of an infinite world and deity, it

denies Trinitarianism and a Final Cause in the universe, and it also denies that scientific and cultural knowledge can to some degree be objective. Deism offers a heterodox understanding of the historic faith—and of the very efficacy of a scientific rationalism. Science, reason, and culture become utilitarian rather than revelatory of some degree of truth. They are dedicated to practical power rather than wisdom. And they become prone to imposing tyranny.

3) Newton's presumption of an infinite universe accompanied by an infinite god denies the importance of transcendent Being, and that Being's relationship with the world of becoming. Mechanical-naturalistic, deistic, and pantheistic worldviews are, however, accommodated. In each case the possibility of knowledge of a purposeful and qualitative world is denied. Denied is the possibility of *scientia* and *sapientia*. From a materialist/spiritualist perspective, there is no meaning to existence apart from our wills; from a deistic perspective, all meaning comes from a willful and distant god; from a pantheistic perspective, there is no meaning to existence apart from our own wills—which are no longer our own since they are now merged with the cosmic will.

For the materialist and skeptical Hobbes and Hume this all makes sense. David Hume rejects rationality as a source of knowledge. For Hume, there is no need to reconcile experience with Christian theology since reason and theology are unreliable. Indeed, objective truth in science, ethics, or art makes no sense. For the deist Newton, such universal meaning is beyond scientific knowledge. For Edwards, meaning is grounded in the will of God as understood through Scripture. But perhaps the most influential option is presented by two romantics representing facets of the reduction of truth to feeling and becoming for Being. Those figures are Rousseau and Hegel.

Deism and pantheism respectively hold God distantly and immanently responsible for the operations of the universe. Consequently, the issue of theodicy becomes of great importance. In a world made by, or as an extension of, God, why do bad things happen to good people? What of the problem of evil? Theologically it is easy to accept the premise that God made a perfect world as an act of glory, but what, then, of evil? Did God make a cosmic mousetrap to ensnare the weak? If the world is the Logos unfolding, then why does such violence and corruption exist? To expiate God from responsibility for the existence of evil is a major task of romantic figures such as Rousseau and Hegel.

Rousseau tries to free God from the deistic box Newton places him in. He attempts to absolve God of guilt for the presence of evil on this earth, but at the price of reversing Christian doctrines such as that of original sin. Evil is grounded in civilization, not God. So, too, Georg Wilhelm Hegel attempts to understand

reality via a new look at classical and Christian belief. He attempts to redefine Platonic and Christian doctrine in a decidedly pantheistic fashion. For Hegel, Newton makes obvious the need for an infinite God operating in an infinite universe. Therefore Hegel makes the decisive move of equating truth with power—rather than the immanent seeking completion with the transcendent as an act of love. Being is us becoming. While Rousseau finds civilization to be the source of evil, and freedom to be realized via the transgression of truth claims, Hegel finds civilization to be Truth incarnate; freedom is found in obedience to the State.

4) For the most part, American romanticism remains evangelical and Platonic in substance. American romanticism continues to accept the objectivity of Truth, of *Being,* and of God. For evangelicals such as Jonathan Edwards and the Reverend Devotion, the Christian faith should be in harmony with science, be it Newtonian or other. Where they appear to conflict, it is neither science nor Scripture but our knowledge that is lacking. The evangelical commendably accepts the challenge of the new physics, in the hope that it can maintain the old metaphysics. But this hope is more precarious than it might first seem. One danger is that it historically echoes the Averroist position, which in the guise of intellectual integrity advances the separation of knowledge and faith. Intellectually, it is committed to studying natural and revealed religion, both nature and nature's God. The facts of nature, and the facts available to us about God via Scripture, are to be engaged via study, reflection, and action. But it concludes in the Christian worldview being hostage to an empiricism that scientifically and rationally must deny final purpose, the Trinity, and objective Being or Truth. It then becomes vulnerable to the charge of being both antiscience and antireason.

The evangelical (and post-Scholastic Catholic) is assaulted by positivism. It directs them toward a fundamentalist reliance upon authoritative Scripture, the authority of which is no longer scientific or rational, and the meaning of which is subject to (de)construction. Although the scientific rationalism of Trinitarian doctrine and Augustinianism remain bulwarks against these developments, the trajectory of thought and belief indeed constitutes a secular trend.

Romanticism and Subversion

American culture has long resisted the modernist-postmodernist paradigm. In different ways, Paul Elmer More and Allan Bloom advocate a renewal of Platonism and Aristotelianism in the face of an ascendant modernism-postmodernism. Similarly, Irving Babbitt offers a scathing rebuttal of romanticism. All agree

that the common enemy is romanticism because it denies the efficacy of the intellect in seeking some degree of knowledge of reality. More, Babbitt, and Bloom are sophisticated critics of modernism-postmodernism. But their critiques remain more critical than constructive. While they identify serious weaknesses in their opponent's position, they do not offer a positive alternative to the modernist-postmodernist redefinition of science and reason.

From a romantic perspective, romanticism is naturally inevitable. To understand the critics of European romanticism, particularly the Americans, it is necessary to escape the limitations of the romantic mindset and vocabulary. The American scholar Allan Bloom attempted to do so in *The Closing of the American Mind* (1987). He points out that the pernicious influence of romanticism undermines our ability to escape its influence. It requires a conscious, difficult, and subversive effort to do so. It is difficult to consciously decide to escape the romantic perspective if one believes that understanding is merely a matter of how we feel. If understanding is how we feel, then there can be no compelling reasons to feel otherwise.

Romantics cannot be persuaded by logic. For them, logic is but an expression of feeling, a dialectic or a mask for power that variously demands submission or resistance. From Hegel to Marx to Nietzsche, logic itself is substantively focused on a master-slave dialectic. So it is subversive to suggest a logic based on responsible freedom, truth, and love as a means of evaluating the quality of reality, life, and knowledge. It requires a different type of subversive act to renew responsible freedom in the pursuit of wisdom.

In a recent book, *The Power of Art* (2006), Simon Schama offers the provocative observation that *all great art is subversive*. What Schama neglects is the difficulty in distinguishing between destructive and transcendent subversion. Transcendent subversion is dedicated to rising above ignorance, folly, and malevolence. It maintains that the core beliefs of traditional Western—and American—culture are subversive by their dedication to escaping the false constrictions of habit, dogma, and folly. The classical-Judeo-Christian Anglosphere subverts evil via the pursuit of Truth, Goodness, and Beauty.

In contrast, destructive subversion views culture as oppressive and worthy of deconstruction. Modernism-postmodernism is subversive by denying the pursuit of Truth, Goodness, and Beauty. The Modernist-Postmodernist tradition wishes to help humanity by destroying assumedly oppressive constructs and achieving either tolerance or authenticity. However, those who wish to help humanity by destroying culture include romantics and sociopaths. Discerning between the two may be difficult; for the romantic it is impossible. So are the Enlightenment and

romanticism subversive and liberating, or subversive and destructive? Are they progressive or sociopathic? Is there a way to tell the difference?

We have, then, two competing claims of subversion, one modernist-postmodernist, the other classical-Judeo-Christian. The Anglosphere is poised between the two. Those claims rely on and reflect two very different paradigms, two very different perspectives of understanding reality and life. The former is dedicated to freeing us from assumedly flawed claims of Truth, Goodness, and Beauty; the later affirms the continuous pursuit of Truth, Goodness, and Beauty as vital in escaping flawed claims of feeling or knowledge. Both claim to be subversive and positive; both claims cannot be right.

Those who believe that the world is merely to be factually described and experienced cannot accept that to varying degrees the world can and should be understood and realized. A quantitative worldview cannot be reconciled with a qualitative worldview because quality is beyond the ken of quantity.[6] Quantity merely *is,* whereas quality assumes fulfilling ontological purpose. Those who equate quantity with quality equate existence with meaning. The result is an affirmation of an existence without much objective purpose or meaning. The consequence is an *existentialism,* which from a qualitative viewpoint marks a brutal reductionism of knowledge and culture to fact and power. Existentialism is the necessary cultural companion of a positivist *scientism.* It is also the enemy of *scientia, sapientia,* and indeed of civilized discourse. In a world of fact and power, neither wisdom nor tolerance has a foundation. Neither debate nor conversation can have much of a point.

Culturally, it is not really a choice of either/or—of either being an existentialist or pursuing wisdom. It is a qualitative matter of to what degree wisdom is pursued. It is not whether wisdom exists, but of what type and to what degree it can be realized. The alleged choice between experiencing reality and life and attempting to understand them is false—we cannot really avoid the latter position. Therefore that choice is not merely limited to a matter of quantity and style. There is the inescapable substantive issue of how good our choices might be. For the existentialist, the quality of our choices is determined by the degree of self-expression and self-realization obtained. That is the vision of the good that determines the degree of quality in our lives. For the classicist, Christian, or Jew (to name only those major traditions in the West), the quality of our choices is determined by the degree to which Truth and Love or righteousness is realized. Just as the existentialist makes choices in the pursuit of a perceived good (i.e., self-expression and self-realization), so too does the seeker of truth and wisdom. Those who historically attempt to reconcile or equate the two are engaged in folly.

Competing Cultural Perspectives on Subversion

The French and the American Revolutions are dedicated to the institutionaliza-
tion of a new order. The former is a proponent of the modernist-postmodernist
philosophy, the latter of a newly democratized classical-Judeo-Christian tradi-
tion. Both revolutions subvert the status quo and advocate a new dogma.[7] History
makes clear that there is a progression from the subversive impulse to the dog-
matic. The question is whether a subversive dogmatism must be dedicated to the
dogmatic pursuit of power, or whether it can rightly be dedicated to a dogmatic
pursuit of wisdom. Can we rightly institutionalize a culture dedicated to the free
and responsible pursuit of wisdom?

Modernist dogma centers on an alleged tolerance; postmodernist dogma cen-
ters on authenticity. Classical-Judeo-Christian dogma centers on the pursuit of
truth, good, and beauty. The (incoherent) pursuit of tolerance *and* authenticity, or
the pursuit of truth, goodness, and beauty, represent preferences, not impartial-
ity. So the question is not how to escape preferences, dogma, but which prefer-
ences should become dogmatic. Since we cannot as conscious beings avoid choos-
ing what to believe, we cannot be impartial in our pursuit of knowledge. So which
dogma should we habitually and institutionally be dedicated to?

To ask such a question is perennially dangerous. On this point Plato and Bacon
agree: be they right or wrong, those who even deign to question the reigning dog-
mas of their time or tribe will face hostility or worse. Those who questioned the
Aristotelian Scholasticism of the late medieval period faced such hostility; but
then so do those today who question the empirical Scholasticism of the modern-
ist period, the class warfare dogma of postmodern Marxism, or the eugenics of
Kantian/Darwinian/Nietzschean dogma.[8] But the transformation of dogma into
the free and rational pursuit of truth is qualitatively different from the celebra-
tion of dogma dedicated to the destruction of truth (anarchy) or the destruction
of freedom (tyranny). The difference between these two positions is the essential
dogmatic difference between the classical-Judeo-Christian tradition and that of
modernism-postmodernism.

The Anglosphere (indeed every cultural tradition around the world) has to
decide which of the two is most vital to embrace, as do we. Is it that our free-
dom (*becoming*) is realized via the pursuit of *Being*, or is it that we are *becoming
alone*? This refers to another essential difference between these two traditions:
the objectivity of Truth and God vs. the assumption that truth is made by us and
that we are gods. It is not a choice between secular science and faith. Rather,

modernism-postmodernism involves a self-deification, where we take the role of demigods as the locus of where *Being* and *becoming* are willfully one. The precious intellectual and political consequence of the Incarnation—that we cannot each claim to be in the sole possession of Truth—is thus denied. The self-deification intrinsic to the modernism-postmodernist tradition is indisputable but remarkably ignored. Kant, Hegel, Comte, Feuerbach, and a host of others posit that we need to be as gods. To consider that such pronouncements are merely semantic is intellectually and politically naïve.

A *subversive commitment to the pursuit of truth, goodness, and beauty constitutes a commitment to responsible freedom.* That commitment is critical to the existence of culture. Various cultural traditions around the world differently attempt to escape the veil of *maya*, of ignorance, be it naïve, anarchistic, or tyrannical. But when those attempts—identified by Bacon as the idols of the tribe, cave, marketplace, and theatre—are trifled with, a violent response is common. The contemporary irony is that Bacon's admonition now needs to be applied to Bacon's positivism. *It is the now institutionalized idol of positivism, and its materialist/spiritualist progeny, that warrants review.*

Rousseau and Hegel are associated with European romanticism. Both Rousseau and Hegel are subversive of traditional Western culture. It is the nature and quality of that subversion that is of primary concern. Romanticism marks a foundational yet contested shift within Western culture. That shift results in a broad redefinition of science, reason, and metaphysics. It also results in a comparison of quantitative vs. qualitative types of subversion. At one level, the idea that all great art—or science—is subversive is demonstrably true. Thomas Kuhn, Ludwig Wittgenstein, and Erwin Panofsky's work demonstrates that paradigmatic shifts occur in our art and science. But not all shifts are subversive in the same manner. The modernist-postmodernist tradition is singularly subversive of wisdom-seeking cultures within Western and American culture and beyond. This subversive activity is oddly viewed as good as it assaults all claims of truth and wisdom. Such an assault is dogmatically nihilist; the question is whether a subversive and dogmatically nihilist position makes sense.

In a Newtonian-Kantian universe it is customary to associate truth with quantifiable empirical fact, and culture with social science and emotivism. But if culture is unqualified—that is, if it is not grounded in purposeful reality—then it no longer exists in a meaningful way. It is an apparition that might please one, while oppressing the other. It mandates what Hegel rightly calls a master-slave relationship. The idea of culture based on a master-slave dialectic is foundational to romantic and postmodern phenomenology. It is found in Hegelian, Marxist,

Social Darwinist, and Nietzschean modes, and it is continued by their contemporary advocates (Marcuse, et al.). It is also present in fundamentalist Christianity.

If truth is power, then when the slave subverts the master, what can the slave become but a new master? The assumption that a dialectic of violence concludes in peace within a utopia of equality has been refuted elsewhere.[9] It historically results in destructive violence. Nonetheless, proponents of a Hegelian-Marxist-Darwinist-Nietzschean informed dialectic advocate a so-called positive nihilism that is said to conclude in the withering of that violent dialecticism into a variety of utopias in which self-expression and self-realization reign. But one cannot meaningfully escape a slave-master dialectic if truth does not exist, since lacking truth, only power obtains. Nor can self-expression and self-realization be recognized as complete or progressive in the absence of an objective teleological or cosmological ideal. We cannot meaningfully engage in subversion without a falsehood to subvert and a meaningful reality to aspire to. Otherwise, a subversive dogmatism results in a self-parody. Such subversive dogmatism concludes as absurd. In the assumed absence of wisdom, a glimpse of wisdom nonetheless occurs. It is a glimpse of the absurdity of a meaningless becoming pretending to serve as a foil for meaningful subversion.[10]

Since the Newtonian-Kantian paradigm concludes in a vision of culture informed by an alleged positive nihilism, we face a formidable dilemma. We face a metaphysics that claims not to be a metaphysics and yet embodies an institutionalized subversive metaphysics. Its mental tendency is impervious to criticism because truth is redefined as a dialectic of power, and power has nothing to do with intellectual discourse. That metaphysics advocates an incoherent faith in which we seek self-realization and self-expression—that is, meaningful completion—in a world where meaningful completion is systematically denied. In the name of freedom via self-realization and self-expression it delivers a meaningless parody of itself.

This alleged positive nihilism is subversive without purpose; as such it is an aesthetic perspective that is self-referential and self-perpetuating. As Wilhelm Worringer emphasized in his important book *Abstraction and Empathy* (1912), aesthetic enjoyment is an objectified self-enjoyment. But an objectified self-enjoyment deconstructs, just as Narcissus's love of his own image leads to his death. That which is deemed scientifically necessary and culturally destructive is judged to be beyond criticism because it does not recognize any grounds by which it can be criticized. The significant dilemma faced today by Western and American scholarship and culture is this: *How is it possible to escape the narcissistic modernist-postmodernist paradigm? How can we escape a scientific rationalism that is culturally nihilistic?*

Thus are the horns of the dilemma faced by the traditional Anglosphere and traditional Judeo-Christian belief. These traditions are deeply subversive but not nihilistic. Edmund Burke supported the American colonies' petition for their rights as Englishmen, while despising the savagery of the French Revolution of 1789. He clearly perceived qualitative distinctions between types of subversion and those who subvert. He recognized that such subversive redefinitions occur not within a vacuum, but within the context of human discourse and personalities, and within the context of virtue and vice. Persons dedicated to the securing of responsible freedom are very different from those dedicated to the destruction of all values, norms, and ideals. This is revealed by the narratives of their discourses, the public success of particular personality types at particular times, the quality of life thus resulting, and the art they make.

This prompts the question for us: Can and should we qualitatively distinguish between subversive art that is merely destructive and subversive art that aspires to obtain a positive ontological ideal? Can we confidently equate subversion with greatness, or could it be that we need to differentiate those shifts that are destructive and arbitrary from those that might be beneficial and liberating? Could it be that great fine art and great scholarship are subversive, but *only fine art and scholarship that rises above subversion to a positive ontological ideal is actually liberating?*

Subverting the Idols of Positivism

That perspectival shift from the pursuit of Truth, Goodness, and Beauty to a romanticism that denies the very possibility of such categories marks a fundamental change in our perspective, in how we understand the world and our place in that world. It results in a paradigm shift that affects how we think and live. As we have seen, Erwin Panofsky notes that the shift in perception by the artists of the Renaissance preceded the shift in perception by the physicists.

Paradigm shifts attack what Francis Bacon calls the idols of the tribe, the cave, the market, and the theatre. But those shifts can produce new idols. Both Scholastic and positivist idol worshippers identify with, and are justified by, the idols they worship. When those idols are attacked, those falsehoods and the personalities that find comfort in them and who live habitually by them are attacked as well. And when attacked, they respond in kind. Bacon unselfconsciously refers those idols respectively to the frailties of human nature, personal experience, group discourse, and dogmatic philosophy. What is odd is that Bacon's criteria for recognizing idols apply directly to his own positivism, and by extension to

modernism-postmodernism. The reduction of science and reason to meaningless fact, or to (de)constructionism, cannot be grounded in ontological reason. At best, it is grounded in an ontological dialectic of power that denies the pursuit of knowledge.

The goal of escaping idolatry, of escaping illusion and the violent folly of embracing a meaningless fetish, is part and parcel of the pursuit of *scientia*—and *sapientia*. At first glance, what Kuhn, Wittgenstein, and Panofsky attempt in the twentieth century, previous figures such as Socrates and Plato, Augustine and Aquinas, Kant and Nietzsche attempted in their time. Within the American context are found the efforts by Washington, Jefferson, and Adams, and Edwards, Emerson, and Pierce. But however similar in intent, the greater question is whether those attempts are equal in substance and quality. Paradigm shifts—subversive dogmatics—occur, but how do we distinguish between the profound and beneficent and the trivial or malevolent? That is possible if we can distinguish between paradigm shifts that aspire to the true and good, and those that advocate such shifts out of a perverse desire to break and destroy. Marking such a qualitative distinction will strike some as an assault upon the idols of the modernist-postmodernist tribe, cave, market, and theatre. And indeed it is. It is also an assault upon the dogma of romanticism.

Certainly, the pursuit of objective knowledge is important and universally justified; so, too, is the role of feelings. On this Augustine and Postmodernity agree: the impartial pursuit of knowledge is impossible. So beyond the realm of recognizing empirical facts and mystical feelings is the problem of determining what type of knowledge we ought to privilege.

Facts are put into narratives, but lacking any knowledge or any objective purpose, those narratives become trivial and violent. When knowledge is trivial, culture collapses. For example, consider the cultural conclusions of Rousseau and Hegel. The former denies the efficacy of reason in bridging the gap between fact and feeling; the latter redefines reason as power rather than meaningful completion. Rousseau concludes that culture oppresses, and that a *natural humanity* in harmony with a *natural theology* will result in bliss; Hegel suggests that there is no harmony, only a dialectic of power concluding in the redefinition of freedom as obedience to the State.

So those dedicated to the pursuit of facts and feelings (*scientism* and *emotivism*) are incapable of accepting the validity of rationally pursuing *scientia* and *sapientia*. For them to admit that validity is to engage in a self-destructive blasphemy. Their sacred space informed by power is contested by a sacred space of truth and love. Since they cannot engage in the pursuit of knowledge that is qualitative, they can-

not discern paradigm shifts that are profound and beneficial from those that are trivial or destructive. The redefinition that now surfaces is the shrill cry that all fine art and culture *ought to be* subversive of objective wisdom and beauty because it is immanent in humanity or the State.

The subversion of dogma and folly can be progressive, but not if it replaces an old dogma with a new folly. In seeking enlightenment, we seek to escape idols of the tribe, cave, market, and theatre. But Bacon leaves out the possibility that some idols, some of the sacred, might actually rise above fetish and idolatry to the realm of the sacred. The sacred is recognized either by obtaining some knowledge of our errors or limitations, or by some knowledge of what to some degree is true and good. We resist idolatry by rising to a higher type of knowledge, be it an affirmation of what we cannot or do not know, or affirmation of what to some degree we can and do know.[11] But in either case such knowledge relies upon the existence of an objective and intelligible reality. It relies upon the possibility of our reasoning having an object to know. In contrast to the passionate romantic, knowing is indeed a form of loving. It involves cognitive assent.

Edward Hicks: Wisdom or Folly?

These issues, centering on the scientific and rational pursuit of knowledge *and* goodness, can be brought into focus by considering an American painting, *Peaceable Kingdom* (c. 1834) by Edward Hicks. The painting addresses whether it is more realistic to be an optimist or a pessimist. Should we be partial to the scientific and rational pursuit of wisdom, of qualitative knowledge of what is true and good, or should we be partial to a scientific rationalism dedicated to the proposition that the world and life are quantitative, a matter of fact and power?

A Quaker minister in Bucks County, Pennsylvania, Hicks painted numerous versions of the peaceable kingdom. The theme refers to Isaiah 11:6: "The wolf shall dwell with the lamb, and the leopard shall lie down with the kid, and the calf and the lion and the fatling together, and a little child shall lead them." Is this painting scientific and rational? Or is it superstitious fiction? Since Hicks is addressing whether the world is grounded in Truth and Love—that is, Being—or in fact and process, or becoming, he is by extension raising the issue of why evil and violence exist, and whether or how they might be escaped. These are critical questions not only in historical scholarship. They are critical to how we might live our lives today, and to the possibility of culture as an arena of responsible freedom.

Hicks is contemplating his situation (and ours) via a traditional biblical perspective. In a world of violence, pain, and tragedy, the Quakers hope to have found the peaceable kingdom promised the Israelites in Isaiah. Depicted is a world in which there is no conflict between nature and morality, between *Being* and *becoming,* or between *is* and *ought.* It is a world that can rise above the Four Horsemen of the Apocalypse—famine, death, war, and disease. It is also a world in conflict with Newtonian cosmology and theodicy; it is a world without violence.

The peaceable kingdom reflects the hope to return to the Garden of Eden, a place in which earthquakes, cancer, war, and death do not exist. For Hicks (and Edwards, who accepts the Augustinian explanation of evil as a deprivation of reality), such maladies are neither accidental nor normal naturalistic occurrences in a meaningless world. Natural and human violence is not normal. However, the whole question of good and evil, in culture and science, strikes the positivist mind as odd. To ask if earthquakes and cancer are evil is likely to prompt a derisive response. To remind them that Rousseau addressed that very same issue by defending God in response to the Lisbon earthquake, and asserting that humans are naturally good, should give them pause. If human nature is good, then can nature be evil? If not, then how are natural and moral disasters to be explained? Rousseauean assertions of a primitivist harmony do not stand up to scrutiny.

The moral content of natural disasters makes no sense to the naturalistic mind. Natural disasters are variously understood as accidental,

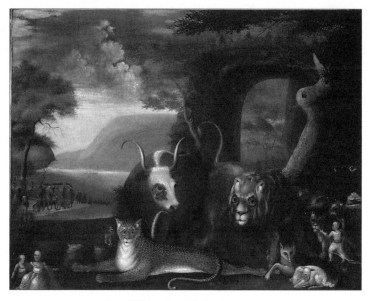

Edward Hicks, *Peaceable Kingdom*, c. 1934

mechanical, naturalistic, or organic occurrences. They are not viewed as a denial of ontological purpose and normalcy. They are not acts against Being. But then violence is an ontological necessity. Disasters are part of the way things ought to be. Violence is naturalized.

Is it right, then, to declare natural disasters acts of God, as actuaries today state? Traditionally, they are not acts of God because God cannot do what is against God's nature. God's Will (becoming) cannot conflict with God's nature (Being) which is Truth, Goodness, and Love. This is not a limitation imposed on divinity—which would be fallacy. It is a quality of divinity. Nor are natural disasters a test or punishment by the Divine—they are part of a cosmic drama. In a world of Truth and Love, of responsible freedom, there must be the possibility of intentional evil. Goodness cannot realistically be sought in an accidental or deterministic world.

Susan Neiman, in *Evil in Modern Thought: An Alternative History of Philosophy* (2002), addresses this important but neglected concern. In her introduction she notes that the word *Lisbon* in the eighteenth century carried the same connotations of the word *Auschwitz* today. They confront us with seemingly unintelligible events: the former, an astonishing loss of life during a 1755 earthquake, was natural, the latter event, cultural. Such connotations are also present in the date September 11, 2001.

Within a deist context, the unintelligibility of evil becomes a serious problem: if the world is a perfection made by a loving God, then why do such terrible things happen? For those who accept a rationalized modernist (Kantian) morality, morality does not address natural evil. Human reason is distinct from nature (deontological), and yet relies upon an assumedly natural trait of humanity to be rational and to evidence a good will. But how is a deontological good will to be recognized as good? Similarly, for postmodernists such as Rousseau, evil is the result of civilization; but without civilization, can barbarism be recognized? For Hegel (and Engels), a power-based dialectic, a master-slave relationship, informs nature and human nature, while pretending to be beyond such qualitative considerations.

What remains beyond each of these ways of addressing the problem of evil is an ontology of truth and love. Newly dogmatic is a dialectic of violence, either distinct from God (Rousseau) or intrinsic to God (Hegel, Kierkegaard), nature and humanity (Hegel, Marx, Engels, Nietzsche). Dogmatic today is an entrenched ontological normalization of evil. Evil was once understood as a willful denial of a meaningful reality, a denial of truth and love as meaningful completion; for many today, considering evil as an ontological aberration makes no sense. Therefore its occurrence seems moot. The oppression allegedly caused by truth claims, or the

violence intrinsic to a master-slave dialectic, might be considered by some to be bad, but to paraphrase Nietzsche, today we must think and live beyond good and evil. Why? Because good and evil are terms inapplicable to nature and thus inapplicable to morality.

If there is no causal connection between natural and moral law, then upon what can moral law rest? The Kantian suggestion of morality grounded in good will is tautological as well as deontological. The Heideggerian suggestion of morality grounded in authenticity cannot work since varying modes of authenticity violently conflict. If we really cannot believe that earthquakes and cancer are immoral, then can we escape believing that violence is naturally good? So the topic of ontological good and the problem of evil have until recently been scarce in scholarly discourse. A different dogma implicitly stands: belief in ontological violence. But is the rejection of good and evil rational and scientific? Is it culturally progressive? Can we escape natural and moral evil to live as Hicks hopes in a peaceable kingdom?

Hicks's painting is a visualization of the optimistic scientific rationalism of the Augustinian point of view. God, whose Being and substance is understood to be infinite and eternal Truth and Love, created a universe that is finite and in a state of becoming. The world is created as the object of God's Being and Will; creation provides a material and temporal forum in which God's eternal Truth and Love can be realized. Creation is a perfection made good and beautiful. Since Truth and Love require freedom and seek completion, then freedom and truth are real. The purpose of freedom is to pursue the True, Good, and Beautiful, to seek meaningful completion. Humility is the antidote to the harmful pride of an arrogant dismissal of wisdom, and an antidote to an arrogant assumption of fully possessing wisdom. Responsible freedom denies both forms of pride.

Love and truth necessitate freedom and the pursuit of wisdom; evil occurs when that pursuit is ignored, denied, or transgressed. Evil is by omission and commission; it can be a lacking, or a willful subversion. As an initial act against Being, original sin is the original act of subversion, of transgression. It results in our existing out of harmony with reality. This results in an ontological shift in creation, explained via the expulsion of humanity from the Garden of Eden. So God is not the maker of evil, not the willful author of earthquakes, famine, violence, disease, or death. Why, then, do they occur as part of a cosmic drama necessitated by a universe grounded in Truth and Love? Because Truth and Love aim for completion, but the transgressive will can act against truth, goodness, and beauty.

Reality is Being. Freedom is the problem, wisdom is the solution. Being cannot ultimately be denied—any more than the laws of nature can be denied. But

human nature is now flawed by prideful transgression. We are part of a cosmic drama with a glorious conclusion, but our roles in that drama are unknown to us. As Augustine explains (and Edwards concurs), God knows what we are going to do, and the eternal outcome, but we nonetheless remain responsible for the timely choices we make.[12] The choices we make may not always be right, and may not produce intended consequences. But if done in the pursuit of Truth and Love, ultimately all things work for the good.

Can the meaning of Edward Hicks's painting be taken seriously? No doubt it was by the artist, a Quaker minister. The painting also resonates with the theology of Edwards. Within Edwards's paradigm for understanding reality and life there is and can be no conflict between Scripture, science, and Trinitarian theology. But positivist science and reason provoked a continuing theological crisis in Europe. If God created the universe, then why, it was asked, did He create one with such vicious traps? If God is good, then why should creation involve natural disasters, disease, and death? It was Pierre Bayle who vigorously argued against the optimistic realism that traditionally informs Western culture.

The Malevolent God of Deism and the Romantic Response

At the very outset of the Enlightenment, Pierre Bayle published his *Dictionary* (1697). In that work he considers the relationship of moral and natural evil, finding the latter to mock the very existence of a benevolent God. He declares that history is the record of crimes and misfortunes that only a criminal God could have made possible. Pierre Bayle recognizes that his most effective opponent is Augustine. He mocks God, comparing Him with a sadist, a fool, and a malevolent and manipulative voyeur. As he puts it:

> Then it is not God who is the cause of moral evil; but he is the cause of physical evil, that is to say, the punishment of moral evil—punishment which, far from being incompatible with the supremely good principle, necessarily flows from one of God's Attributes, I mean that of Justice, which is no less essential to man than God's goodness.
>
> Those who say that God permitted sin because he could not have prevented it without destroying free will that he had given to man, and which was the best present he made to them, expose themselves greatly. The reason they give is lovely. It has a *je ne sais quoi*, an indefinable something, that is dazzling. It has grandeur. But in the end it can be opposed by arguments

more easily opposed by all men, and based more on common sense and the ideas of order.[13]

God must be malevolent and a hater of humanity since the gift of freedom produced evil. Neiman returns the concept of evil to the forefront of contemporary scholarly discourse. This is remarkable since with the rise of modernism-postmodernism the topic of evil has been relegated to the aesthetic realm of fact and feeling, of the sociological, the psychological, and the neuroticism resulting from a lack of personal coherence. Within that aesthetic cultural tradition concern for Good and Evil is viewed as quaint or oppressive delusions best replaced by tolerance or an identity-based self-realization and self-expression. Goodness is redefined as the free pursuit of inner necessity; evil is that which stands in our way. Neiman engages in a subversive analysis of modern moral thought. Just as with Watson's personal experience with a shark, a dramatic occurrence of evil and tragedy in life prompts a challenge to the validity and importance of current modernist-postmodernist dogma. Neiman argues that certain events shake our presumption that evil is no longer a matter of serious scholarly and social analysis.

If natural and moral atrocities occur, then neither natural nor moral virtue matter. At issue is the possibility of responsible freedom in the pursuit of knowledge of a meaningful world and life. Should the world and life be meaningless, then science, ethics, and art are shattered.

Neiman notes that Bayle was explicit: who wouldn't load his enemies with gifts sure to bring about their ruin? She uses this analogy:

> Any mother who, knowing for sure that this would come to pass, allowed
> [her daughters] to go to the dance and was satisfied with exhorting them to
> be virtuous and with threatening to disown them if they were no longer vir-
> gins when they returned home, would, at the very least, bring upon herself
> the just charge that she loved neither her daughters nor chastity.[14]

Such an argument is more than subversive; it is deliberately transgressive. It lewdly attempts to destroy the possibility of remedying evil via the exercising of responsible freedom. As often is the case, his philosophy is linked to his biography. Born to a Protestant French pastor, and persecuted as such, Bayle fled to Rotterdam. His anonymous publications were identified, and subsequently his brother in France was arrested and tortured to death, presumably in his stead. Scholars hold this to be the fundamental source of his hostility to any belief in a just God. It may well indicate also a hostility to a loving and wise Father. He detested both

Catholic and Protestant theology. While assaulting Catholic doctrine associated with Augustine, Bayle also cites the Jesuit argument that Calvinism effectively equates God with Caligula. Either God is evil or evil is a god:

> According to you, the sole principle, which you admit, desired from all eternity that man should sin, and that the first sin should be contagious, that it should ceaselessly and endlessly produce all imaginable crimes over the entire face of the earth. In consequence of which he prepared all the misfortunes that can be conceived for the human race in this lifetime—plague, war, famine, pain, trouble—and after this life a hell in which almost all men will be eternally tormented in such a way that makes our hair stand on end when we read descriptions of it.[15]

The conclusion of Bayle's theology is that since God exists and evil exists, Manicheanism is the most rational solution to the puzzle of evil. Bayle is working within a Newtonian context; as such he is attempting a subversion of traditional Western culture. But is that subversion liberating or destructive? Is his analysis of that cultural tradition accurate, or reflective of his own biography, character, and perspective? We can imagine Bayle standing in mockery before the Peale Family painting, or that by Hicks. But more immediate for us is the question: How might we stand before them in the presence of Bayle—as we often must do today? Ought we to declare an ontological optimism in which responsible freedom is celebrated and violence and death are denied? Bayle declares responsible freedom to be an illusion within an ontology of indifference or violence. If goodness exists at all, it is grounded in our wills. So which shall it be?

Traditionally, when the true and good are loved, then beauty is realized; when truth and goodness are abandoned, love is abandoned and a violent aesthetics commands center stage. Within an aesthetic world of facts, feelings, and imagination, of romantic passions in a world in which there is no good or evil, there is no possibility of ontological love—of meaningful completion. Lacking degrees of closure, knowledge and morality become grounded in the will. They become perspectival and violent. It becomes realistic to exist in despair because understanding is denied.

This aestheticization of culture requires that we study culture from a phenomenological perspective. Phenomenology is another manifestation of the positivist mentality, one that alternates between idealism (Hegel) and materialism (Marx) while denying reason as meaningful completion or Love. Hegel's phenomenology of the spirit has already been discussed; we will develop the topic

of phenomenology in the next chapter via a discussion of the American pragmatist Charles Sanders Peirce. But for the moment, the crux of the matter is that instead of recognizing qualitative culture claims, we are told by phenomenology to engage in a quantitative analysis of material culture, of lifestyles. Those lifestyles can be studied for their coherence and tolerance, or for their experiential dialectical authenticity. We cannot, however, contemplate whether they are in reality good. Therefore, we cannot imagine what is actually evil and ugly. Nietzsche's famous admonition (as the title of his work declares) makes clear that we now live *Beyond Good and Evil*. Correspondingly, we now live beyond beauty. Theodor Adorno mistakenly lamented that poetry after Auschwitz is barbarism; Emmanuel Levinas mistakenly observes that in the twentieth century we could no longer reconcile goodness with the occurrence of evil.[16]

It is the ultimate harmony of natural and moral goodness that permits the world to be intelligible; the denial of such harmony is a denial of the world's intelligibility. If not intelligible, the natural and moral worlds are mysteries, and scientific knowledge of reality is merely factual and willful, empirical and mystical. Being is reduced to a factually violent and mysterious becoming.

So the disassociation of natural and moral disaster is a disassociation of Being from becoming since it reduces the Logos of God and nature to becoming, to the will, to process. Being as such does not change; therefore it provides an essential object of reason and knowledge the completion of which is Love. But when Being is redefined as becoming, then reason has no object; it is subjectively willful. Truth is then power unfolding, be it Divine or natural. Human understanding is limited to process and power; the world is purposeless, and therefore unintelligible, change.

As a matter of knowledge, natural and moral evil are newly separated; but since this denies that the world is intelligible, the world is no longer a matter of knowledge. Instead, knowledge is reductively and brutally manufactured. Since evil is disconnected from ontological norm, then evil is no longer a matter of knowledge. Instead, science and ethics operate in a realm of becoming, of process, of flux which we can describe portions of but cannot perceive any purpose to. In science, ethics, and art, self-realization and self-expression in a purposeless yet willful world prevails. Hegel (pantheistically), Marx (sociologically), and Darwin (biologically) share a common perspective: variations of a positivist romantic theology.

The alternative pursuit of an optimistic scientific rationalism is no longer plausible to the postmodernist. But is this a necessary effect of scientific progress, or could it be that we have deeply and tragically reversed cause and effect *in* science? Being as ultimate first and final cause has been replaced by becoming. When

becoming is cause (when becoming is Being), then cause *is* effect. When cause is effect, there is no object to understand. A scientific rationalism collapses into a power-based technological violence; the space for responsible freedom disappears.

Could science and culture now be irreconcilable due to the failure of modernist-postmodernist dogma rather than reality? Could it be that the problem of theodicy cannot be solved by the modernist-postmodernist mind, but that mind's perspective is not the only option?

Culture presumes that the world ultimately makes sense; that there is a cosmic relationship and resolution between cause and effect. Therefore, virtue has its rewards, vice its consequences. The occurrence of evil within a world that makes sense challenges the very existence of knowledge and culture. For those with a modernist-postmodernist mind, Hick's painting, for example, cannot make rational sense. It is a quaint or reactionary illusion of a world once falsely understood. But could Augustine and Edwards be right? Does the world remain intelligible despite current idols of the tribe, cave, marketplace, and theatre? Do we really need to abandon an optimistic ontology because of a pessimistic epistemology? Are we in the theatre of the absurd because our theatre is now willfully and unnecessarily absurd?

The Will and Evil Personified

The role of the will in obtaining knowledge is of perennial concern. It is certainly a central concern of romanticism. We have established that the shift from neoclassicism to romanticism involves a shift from thinking to feeling and from rational completion to willful assertion. This results in absurdly conflicting positions. According to positivism, the will should not play a role in obtaining objective knowledge; this results in knowledge being reduced to unintelligible facts. Aristotle and Newton are dedicated to the attempt to obtain pure knowledge, categorically distinct from practicality, untainted by the will, be it human or divine. They seek impartial knowledge. Aristotle maintains that the practical is subordinate to the theoretical because the speculative mind seeks knowledge of Being, not merely becoming. In knowledge, Being is understood, and there is no role played by willful preference or consent. When knowledge is obtained it is because Being necessitates such knowledge.

In contrast, Modernists such as Kant assert that the will combined with facts provides the means of realizing human dignity, but it reduces knowledge to a fact-based subjectivism. In contrast yet again, Postmodernists assert that the will can-

not be denied in the pursuit of knowledge, but denies further the very possibility of obtaining any objective knowledge.[17] This results in various dialectics of power. Commonly neglected are those who affirm that in a meaningful world, reason, imagination, and the will have an object, and thus the subjective as an act of love can seek a transubstantive glimpse of wisdom.

Partiality is inescapable in science and culture if the purpose of that science and culture is to understand reality. However, one cannot willfully choose to understand—or to love. We can neither will ourselves to love or to be loved; nor can we will ourselves to believe something. Will is an act of free assent, the ability of which is traditionally associated with both nature and nature's God. It is grounded in both human responsibility and as a gift of Grace. This is a core and compelling insight of traditional Western and American culture. However, acts of free assent cannot result in freedom if they are contrary to objective reality or Being. To demand reality conform to our imagination and will is to be not only transgressive but perverse as well. It is dangerous folly.

The Newtonian dedication to impartial knowledge by separating observed facts from theory ironically concludes in the denial of a scientific rationalism resulting in ontological understanding. Denied is the subjective will in pursuit of objective truth as a conscious act of purposeful love. So if objective knowledge lacks will, then it also lacks purpose; if knowledge lacks purpose, then knowledge must be purposeless fact or the expression of power.

It should be emphasized that Ptolemy's understanding of the cosmos was based on observed empirical data, just as was Galileo's. The phenomena did not greatly change, but understanding did. So the essentially same set of empirical data can differently be understood, just as a single work of art can differently be understood. In this regard, Wittgenstein and Kuhn are quite right. But the point is not that paradigmatic shifts can and do occur. Nor is it merely one of better distinguishing between fact and fiction. *What is at issue is whether qualitatively better understandings of reality, life, and art can be obtained.*

Constructivist thought reflects a long intellectual pedigree ranging from Abelardian to Kantian conceptualism. Within that tradition knowledge is redefined as fact and rationalized style. Knowledge is constructed. However plausible and even useful some of those rationalized categories might be, they are nonetheless subject to conceptual and empirical deconstruction. It is useful to recall the quote from Cassirer previously cited in chapter six:

> Of much deeper effect are those divergencies from truth which do not arise
> from a mere insufficiency of knowledge but from a perverted direction of

knowledge. . . . The falsification of the true standards of knowledge appears as soon as we attempt to anticipate the goal which knowledge must attain and to establish this goal prior to investigation. Not doubt, but dogma, is the most dreaded foe of knowledge; not ignorance as such, but ignorance which pretends to be truth and wants to pass for truth, is the force which inflicts the mortal wound on knowledge. . . .

It is the task of the will to guide the path of knowledge; and this faculty possesses the power to protect knowledge from all aberration.[18]

The presence of the will in human activities cannot be denied. This was a central insight of the Augustinian tradition. But how might the will lead to knowledge? For Augustine, the task of the will is to transcend itself by rising to a love of Truth. By that we take him to mean that the task of the will is to be subversive of ignorance and error, be they grounded in false dogmatism or perverse foolishness. The will is necessary in seeking Truth, but the will attains freedom from folly by seeking knowledge of objective reality. It is perversely transgressive to resist or transform it. So to be creative in a purposeless world is pointless; to be creative in a purposeful world is folly. We cannot will reality, nor can we willfully deny reality. Either option is alchemical. One may recall that alchemy became a fascination of Newton and remains such to his current followers. *It is the denial of a Trinitarian science that is the defining characteristic of ancient and contemporary alchemy.*

Mary Shelley wrote *Frankenstein* (1818) as a probable critique of the scientific and moral ideas of her husband Percy Shelley (as published later in *Prometheus Unbound* (1820)). She was horrified by a willful science in the service of a transgressive imagination leading to a monstrous self-deification. Science and reason as the means by which we might strive to comprehend meaningful reality is a vital alternative. The goal is not to remake humanity, but to obtain some precious degree of objective knowledge of what is true, good, and beautiful. The traditional understanding of the word *perversity*—a willful disregard for reality and the decorous—is essential to postmodern science and culture. It sadly affirms the legitimatization of willful perversity, be it called alchemy, magic, or (de)constructionism.

Aristotelian Scholasticism was not merely assaulted by new empirical facts about the universe. It was the conceptualist framework of Scholasticism that proved to be its own vulnerability. At its core, the assault on Scholasticism was internal: Conceptualism legitimatizes the critique of its nominalist antagonists. The philosophical presumption that universals are but words is key not only to nominalism but to positivism as well. The new nominalist dogma produces a posi-

tivist science and reason. It can only produce particular facts and a clarity of willful expression. It cannot gauge degrees of profundity, wisdom, or beauty.

The empiricism and intellectualism of Aristotle, Newton, and Kant rips apart Trinitarianism. It rips apart the factual from the intellectual. The willful imagination advocated by the romantics does no better. A purely willful unity of fact and meaning makes no sense. Correspondingly, those attempting to reconcile Aristotle—or Newton—with the pursuit of wisdom cannot escape this same problem. They respectively produce a conceptualist and empiricist Scholasticism; numinous reality is reduced to fact, idea, and subjective will. This parallelism between Aristotle's and Newton's Scholasticism is evidenced by their shared consequences.

In reference to the Aristotelian Scholasticism of Aquinas, Vernon J. Bourke notes:

[Even] Thomas Aquinas, laboring diligently, was unable to revive [the notion of wisdom]. Eventually, he himself conduced to the ascendancy of [empirical] science over wisdom in modern times.[19]

Just as in reference to Newton, Burtt offers:

Historically, the Newtonian attempt thus to keep God on duty was of the very deepest import. It proved a veritable boomerang to his cherished philosophy of religion, that as the result of all his pious ransackings the main providential function he could attribute to the Deity was this cosmic plumbery, this meticulous defense of his arbitrarily imposed mechanical laws against the threatening encroachments of irregularity. . . . For to stake the present existence and activity of God on imperfections in the cosmic engine was to court rapid disaster for theology.[20]

It is also courting disaster for scientific rationalism and the idea of an intelligible reality. The world is unreliably mechanical and no longer rational. The sorry consequences of this should now be clear: meaningful completion is replaced by a physics and ethics of power. There is no discernible difference between science and alchemy, the scientist and God. Knowledge is reduced to nominalism, positivism, and pointless romantic imagination. The purpose of science and culture is to be destructively subversive.

So, too, with philosophy and theology. The Augustinian explanation of the relationship between God, natural and moral evil, and free will can make no sense to Bayle because he takes for granted an intellectually arbitrary Newtonian

absence of a qualitative universe providing a meaningful context. Change cannot be meaningful if there is no wisdom to be realized. It is a false joy to call being lost a journey. Similarly, all knowledge is contextual, but contexts lacking objectivity grounded in reality—in transcendent *Being*—cannot escape a violently willful and nihilistic conclusion. In a classical-Judeo-Christian context, a narrative restricted to a First Cause requires that evil be its product. Bayle argues that Christianity is flawed because of three irreconcilable principles: Evil exists, God is benevolent, and God is omnipotent.[21] What Bayle lacks is a qualitative context conducive to a narrative in which evil is but the middle act: Truth exists, freedom is abused, and truth ultimately prevails.

He ignores the possibility of Edward Hicks's painting pointing to a joyful finale. Bayle's complaints about the presence of evil in a world presumably made by a God of Truth and Love take for granted that there is no numinous narrative with a glorious ending. The Augustinian notion of history as a moral drama in which humanity aspires to reestablish an optimistic ontology is decontextualized into a willful temporality. Bayle's conclusion is that if God exists, God is evil:

> God is either willing to remove evil and cannot; or he can and is unwilling; or he is neither willing nor able to do so; or else he is both willing and able. If he is willing and not able, he must then be weak, which cannot be affirmed of God. If he is able and not willing, he must be envious, which is also contrary to the nature of God. If he is neither willing nor able, he must be both envious and weak, and consequently not be God. If he is both willing and able—the only possibility that agrees with the nature of God—then where does evil come from?[22]

This is a conclusion of the Enlightenment, but only partially so. How we understand the relationship of Truth or God and matter constitutes natural science, if God is evil, then science and reason are evil as well. If we are gods, then evil gods we must be. Constructivism is associated with self-deification, as boldly stated by Kant, Hegel, Marx, Comte, and a host of others. The lack of a singular transcendent truth leads inexorably to a confused variety of cultural and scientific possibilities. The choice of which possibilities we should prefer is then grounded in the arbitrary will. We are violent gods.

In defense of a benevolent deity, Newton posits a natural religion based on the argument from design. Nature is evidence of the existence of a benevolent God. But David Hume devastates that argument. Deliberately published posthumously, Hume's *Dialogues Concerning Natural Religion* (1779) demolishes the natural religion

by which the Enlightenment hoped to avoid nihilism. Hume observes that empirical induction cannot conclude as a matter of knowledge that a casual relationship is rightly perceived or understood. Facts can be put into patterns but we cannot know if those patterns are connected with reality or evidence any predictability. Following his logic, Hume concludes that based upon the importance of trial and error, of community experience rather than singular authority, if one wishes to be religious, then one ought to be a polytheist, not a Christian. Ignoring the pantheist option that develops later in science via Darwin and by the romantics, he concludes that polytheism is the logical conclusion of the argument from design. We seek not the World-maker, but are ourselves world-makers.[23]

What, then, are the sources of evil? Hume anthropomorphizes evil while denying a personal benevolent God. He posits four primary circumstances of evil: pain, the assumption of universal laws, a parsimonious nature, and an imperfect nature. And how do we escape that evil? He advises: "And, in general, no course of life has such safety (for happiness is not to be dreamed of) as the temperate and moderate, which maintains, as far as possible, a mediocrity, and a kind of insensibility, in every thing."[24]

Kant is impressed by Hume's stoic analysis, but not by all of his conclusions. We live in a world of naturalistic fact, but rather than be content with a stoic traditionalist mediocrity, Kant accepts Newton's deism and attempts to combine science with ethics within that context. But rather than substantively combining the two, thereby assuming a natural theology, Kant deems it wiser to separate them.

In Aristotelian and conceptualist fashion, he assumes that there is no connection between natural and moral evil, thus leaving unresolved the issue of theodicy and the conclusions argued by Bayle. But in contrast to Hume, he attempts to defend a rational idealism rather than accept a stoic, hedonistic, or utilitarian outcome. For Kant there is the hypothetical imperative by which we construct fact-based narratives; and there is the categorical imperative by which we obtain a deontological ethics not grounded in reality but in the human mind—and will.

Augustine understands the gap between *what is* and *what ought to be* as part of a historical drama between evil and good. In contrast, for Kant (and Hume) there is a systematic gap between *what is* and *what ought to be*. As Susan Neiman puts it: "Thus the problem of evil became structurally irresolvable. . . . As [Kant] described it, the problem of evil presupposes a systematic connection between happiness and virtue, or, conversely, between natural and moral evil. But the world seems to show no such connection at all."[25]

Ignoring cause and effect in science and morality, Kant concludes that we ought to do the rationally justifiable thing without regard to virtue, or a Humean

focus on a hedonistic consequentialism. The categorical imperative should bind us to a universal morality that denies the expectation or the need for good consequences. Indeed, in an infamous example, Kant declares that if asked by an assassin where the intended victim is hiding, we should tell the assassin the truth. Kant argues that we cannot control whether or not the assassin will find the victim and commit murder, but we can control whether or not we tell the truth.

What, then, of the God of Newton's natural theology? Here Kant makes an astonishing shift. The categorical imperative is introduced as secular, but concludes differently. Kant begins with a condemnation of our wish to be God (since it is our desire to be God that leads to unhappiness), but concludes with the admonition that via human rationality we should pretend or purport to be God. And if we pretend to acknowledge or be God, then what sort of God is that? It is here that Kant and Bayle conceptually agree. We now come to a disturbing association: Kant and Bayle share common ground with Sade.

8

ROMANTICISM AND KNOWLEDGE

Kindred spirits come in many different forms. For example, in Asher B. Durand's painting, *Kindred Spirits*, Thomas Cole and William Cullen Bryant are depicted contemplating the glories of a meaningful world. For them, to be realistic is to be benevolently optimistic. It is to see in nature evidence of a world informed by truth and love, by meaningful completion. In contrast, others viewing such a landscape do so via a perspective that is essentially indifferent or malevolent. For them, to be realistic is to be pessimistic. It is to see in nature a world of facts at best willfully endowed with meaning. Each accepts a correlation between nature and morality; each understanding of the meaning of reality and life perennially enjoys a following of kindred spirits. It is the qualitative nature and social consequences of these positions that is critical.

The choice between a benevolent optimism, or an indifferent or malevolent pessimism, is evidenced by the response to Newton's advocacy of intelligent design. As discussed earlier, Newton argued that the intricate design evidenced by physics infers a cosmic designer known as God. But what is the nature of that God? Newton proposes that the cosmic designer is the benevolent God of Christianity. Others see things differently.

For example, the Marquis de Sade affirms a connection between nature and morality, but not in the defense of an optimistic and benevolent wisdom. Sade declares that the opposite of *philosophical* is *devout*. He approaches the argument from design in his twin novels, *Justine: The Misfortunes of Virtue* (1791) and *Juliette: The Prosperities of Vice* (1797). Sade applies the argument from design, but the

design he sees revealed is one of will, power, and vice. He agrees with Hume that the evidence suggests that malice is more likely than virtue. The design of the world implies an indifferent designer—or worse:

> "I believe," this dangerous woman answered, "that if there were a God there would be less evil on earth; I believe that since evil exists, these disorders are either expressly ordained by God, and there you have a barbarous fellow, or he is incapable of preventing them and right away you have a feeble God; in either case, an abominable being, a being whose lightning I should defy and whose laws I contemn. Ah, Therese! Is not atheism preferable to one and the other of these extremes?"[1]

And what of Kant? He states that our wish to be dutifully moral establishes the existence of God. He admonishes us that our desire to be God is the source of our unhappiness, but nonetheless, offers that the categorical imperative (*Act as though the principle of your action were to become by your will a universal law of nature*) gives us a chance to act as God. What then is the nature of that God? It is here that the links between Sade and Kant become clear. Theodor Adorno famously argued that Sade and Kant are kindred souls.[2] Adorno notes that both show extremes of self-torment and also a cold rationality (remember Kant's admonition that we should tell assassins where their victim is hiding). Moreover, Kant's deontological ethics cannot rationally proscribe murder. If we are to *act as though the principle of our actions were to become by our will a universal law of nature*, then what we will is moral. Kant takes for granted a benevolent motivation: that we want to be rational and ethical. But why should that be realistic? Did not Milton have Satan say that he would rather be free in hell than a slave in heaven? Sade observes that deism smuggles in religion under cover of science; that its knowledge claims presume as a first principle that God is benevolent and rightly, so too are humans. But Sade, like Bayle, finds in the argument from design just the opposite conclusion. If God exists, God is evil; whether or not God exists, we should be evil as a means of being free.

In Sade, violence is freedom, perversion is ethics. His is a transgressive world where sodomy is the finest erotic act by its denial of teleology, where whores are the only authentic philosophers, and where the virtuous Justine meets her end by being tortured and repeatedly raped on a thorn-studded cross, with a death-defying evil pretending to prevail by an act of necrophilia.

So it is not natural and moral goodness that coexist, but natural and cosmic evil that prevails. The argument from design reveals the designs of the Designer. Sade's character Saint-Fond has God state:

Did not the perpetual miseries with which I inundate the universe convince you that I love only disorder, and that to please me one must emulate me? . . . In what aspect of my conduct have you noticed benevolence? Is it in sending you plagues, blights, civil wars, earthquakes, tempests? Fool! Why did you not imitate my ways? Why did you resist those passions I put into you for no reason other than to prove to you how great is the necessity for evil?[3]

Several mental tendencies interact with dangerous consequences. The argument from design can provide evidence for a benevolent *or* malevolent deity. Newton and Edwards posit the former, Sade and Bayle the latter. Sade and Kant want to play God; both are, as Adorno argues, sadists. What then of Comte, Hegel, Marx, and Nietzsche? What then of the postmodernist celebration of worldmaking?

Newton asserts the association of the natural with the theological and moral realm but does not explain it. Hume wants us to stop trying to do so, and embrace a practical moderation. Kant hopes for freedom but conspires with Sade, who completes the circle of the modernist paradigm. Sade agrees with Newton that natural and moral realms correspond, but offers his understanding of the situation: that such a correspondence reveals evil, the transgressive, and thus good. *Being* is us *becoming*; our existence is properly grounded in our will. To be transgressive is to be holy; it is truly *becoming*. We are God and God is what we wish.

Kindred Spirits in a Gloriously Meaningful World

Thomas Cole's art and that of the Hudson River School with which he is associated are noted for their treatment of the new American landscape as a reflection of Protestant theology. The two are often combined, but not typically in a literal fashion. Cole believed in a natural and revealed theology. He approaches Divinity via the materially sublime; the stunning grandeur of nature is evidence of the infinite nature of God. He wrote that the wilderness is a fitting place in which to speak of God.

The art of the Hudson River School is linked not only to Protestant theology but also to the ideas of the Scottish Enlightenment and Scottish associationism. Those ideas include the conviction that by contemplating majestic landscapes one contemplates the works of God. The evangelical commonly believes in intelligent design as did Newton, and as such could claim to be contemplating God's mind via an examination of the laws of Nature. That is almost—but not quite—deistic

in content. The obstacle to deism is Trinitarianism, and orthodox Protestantism struggles to reconcile the two.

The orthodox Protestant mind could not intellectually accept the limitation of science—of knowledge—to mere fact. Nor could it precipitously reject the separation of Creator and created, a separation uniquely bridged by the Incarnation. The doctrines of creation *ex nihilio*, the Incarnation, and Trinitarianism are more than mere theological speculation. They have profound consequences on how we understand science, ethics, and art. The evangelical mind also rejects the Scholastic notion that natural law coexists with God's truth. If truth can be obtained via God and nature, then why bother with God? So Scholastic conceptualism *and/or* natural law undermines the intellectual need for God, and makes optional the assumption of a purposeful world or Being. And if Being is denied, then natural law becomes mere accidental, mechanical or organic fact and knowledge the product of one's will.

For the Augustinian Protestant, an optimistic realism is foundational. Why then are there natural and social disasters? Because nature is made perfect as evidence of God's nature, but in a world of truth and love, in a world of freedom, evil is a transgressive potential that has sadly been realized. The world now exists in a flawed state caused by sin. Those flaws occur within natural and moral realms. The ultimate goal is to restore goodness to human and natural affairs. There is natural *and* revealed theology. But the Protestant faces challenges Augustine did not. For Augustine, the material world was part of a continuum from God to the material world bridged by Christ. From God comes matter in varying degrees of profundity. At the higher levels are persons, so designated by their rational substance; beneath persons are animals, and beneath animals are material facts. Correspondingly, science and reason are qualitative, with Divine Truth informing the material realm. Trinitarian theology explains a properly benevolent cosmic, moral, and natural cause and effect.

But after Newton, science and reason are understood as no longer operating within a qualitative continuum. Instead, they are now complementary. There is science and God, or science and reason. However, that complementarity has since shifted to overt hostility. They are now competing.

The consequences of this are dangerous. If the world is made as an act of glory by a benevolent God who presides over creation with bountiful Grace, then a vexing problem results: why does evil exist? Why is there disease, famine, war? If landscapes are physical means by which we might contemplate the wonders of Divine creation, what then of natural disasters within that creation such as hurricanes, droughts, floods, and earthquakes? Why would a benevolent God cause

or permit such devastation? In 1828, Thomas Cole finished his painting *Expulsion from the Garden of Eden*. He attempts the traditional response.

The painting is based upon a print by John Martin illustrating John Milton's epic poem *Paradise Lost*. Cole depicts the momentous moment in Genesis at which Adam and Eve are cast out of paradise for the sin of partaking of the fruit of knowledge. On the viewer's right is a glimpse of paradise unsullied by sin; on the left are Adam and Eve, who face a difficult future in a newly difficult world. This seemingly simple work raises an extraordinary number of issues.

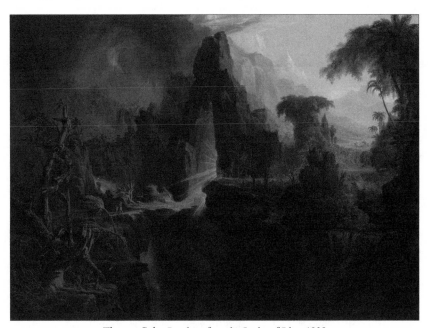

Thomas Cole, *Expulsion from the Garden of Eden*, 1828

We can begin by reviewing the orthodox Christian view of the event as recorded in Genesis. That view is an explanation of the nature of *Being* and the natural world, of purposeful fact and becoming; it explains the workings of truth, love, freedom, and evil. Orthodoxy maintains that *Being*, or reality, evidences meaningful completion. That completion occurs as a matter of degree between the unity of the transcendent and the immanent. The transcendent realm is that of objective truth, the immanent realm is that of material fact and process. The realm of fact and becoming seeks to fulfill its purpose; it seeks to unify with objective Being. The impulse of completion is called Truth and Love. Both Truth and Love need an object to exist. There is then an infinite *Being* that creates a finite world as an act of Truth and Love. There are finite beings that seek to

imitate the infinite. Christians refer to that Truth and Love as God, both the First Cause and creator of the universe and the Final Cause by which all can be contextualized and understood. So as a necessary act of Divine Being, the transcendent realizes the immanent. As Genesis states, God makes the world and it is good—and beautiful. At the point of creation there is no evil, no tragedy, no disease, no moral or natural calamities. Natural and moral goodness are normal. An optimistic ontology prevails.

A God of Truth and Love mandates freedom. But freedom permits us to misuse our freedom and to misplace our love. And that is the cause of moral and natural evil. The world is created in perfection, but that imperfection—or sin— is introduced not by God but by human pride. As mentioned a moment ago, Cole's painting refers to John Milton's masterpiece *Paradise Lost*. A particularly memorable passage in that epic poem is the early declaration by Satan that it is "Better to reign in hell, than serve in heav'n" (Book I, lines 261–263). Satan (like Sade) wants to be free and finds God's truth oppressive; his sin is pride. He wishes to construct his own truth, and therefore construct his own reality. He wants to be a god, a worldmaker, but lacks the infinite knowledge—or goodness—to do so effectively. By tempting Adam and Eve in the Garden of Eden, Satan entices them to take the same stance. Knowledge is associated with God, but the presumption is that we should and can attain and act upon our own perfect knowledge. It demands that we engage in science (knowing), ethics (doing), and art (making)— as gods. It requires that science, ethics, and art be grounded in our will. Therefore claims of objective Truth are assumed to be oppressive, claims of subjective "truth" are liberating. It is in a world of fact and the will that we are free. But as Milton later concludes on behalf of orthodox Christianity, this is pure folly. It is the free pursuit of objective Truth that liberates us; no one can be free in hell. No one can successfully defy objective reality.

Visually, Cole's landscape is a dramatic composition not grounded in observed reality. It combines a dramatic and grand landscape with a biblical theme. That theme is central to orthodox Christian belief, and is an attempt to present a glimpse of wisdom for the viewer to contemplate and respond to. Cole's art is in harmony with orthodox Trinitarian Christianity. It is deeply Augustinian. But that art is also concerned with the new physics of Newton. God made the world as an act of glory. From that point of view, the landscape reveals a world comprised of fact, but facts indicative of the hand and will of God. Natural science coupled with faith in God and Scripture is the paradigm sought. Within a classical-Judeo-Christian context, it is sublime in the sense that it is not antirational, but instead strives to rise above human rationality. It is a romantic transcendentalism. Within

a purposeful world, reason rises to the level of intuition—feeling in contact with truth and reality. We feel the presence of God. This transubstantiation of reason to mysticism is informed by humility. Artists such as Cole and Asher B. Durand struggle with the natural world being the glorious work of God yet no longer numinous. In regards to Durand, Arthur Danto explains:

> By Durand's [and Cole's] time, God was no longer in the things we sense daily, but spoke out only to those prepared to visit wild sublime formations. So the Hudson River artist sought out the most dramatic locations—the most stupefying heights and vistas, rendering the American landscape in the idiom of glory and power. It was his missionary undertaking to bring this terrifying beauty back in the form of engravings or chromolithographs—or to those who could afford them, paintings of an increasing dimension and grandeur—for the exaltation of patriots who saw in the effusions of a prodigal nature the greatness of American destiny.[4]

Cole's position is then Newtonian and Protestant. It is dedicated to the pursuit of wisdom and beauty in a glorious world of facts, a pursuit that acknowledges reason without transforming it into folly or fetish. However, from a secular postmodernist viewpoint, that pursuit of wisdom makes no sense. Reason rising to a transcendent humility makes no sense because there is no ineffable Being, no transcendent *object of knowledge* to be sought. In a world of becoming, the humility of mysticism becomes the arrogance of the demigod and demagogue. Positivist mysticism is but a reduction of reason and culture to the subjective will. In America, modernism-postmodernism is but a secularized or immanentized Protestantism. A positivist organic romanticism demands the assumption of a perspective of arbitrary power.

For example, a secular postmodern analysis of Cole's landscape painting is offered by Alan Wallach, whose view is elucidated by Brigitte Bailey:

> Alan Wallach has argued that Cole developed a new perspective on landscape in his 1836 painting of an American tourist destination, *View from Mount Holyoke (The Oxbow)*, a perspective that combined panoramic range with telescopic precision of detail and that functioned as an analogy of the middle-class gaze; what Wallach calls the "panoptic sublime drew its . . . energy from prevailing ideologies in which the exercise of power and the maintenance of social order required vision and supervision, . . . words equally applicable to panoramic views and to the operation of the reformed social institutions of the period."

Wallach adds that when tourists reached such scenic outlooks as the top of Mount Holyoke, they "experienced a sudden access of power, a dizzying sense of having suddenly come into possession of a terrain stretching as far as the eye could see"; this conflation of vision, power, and knowledge produced the experience of the sublime.[5]

This postmodern understanding of the sublime differs from traditional mysticism in that it is grounded in power rather than awe before transcendent truth. So the meaning of Cole's new approach can be understood via two different perspectives. The postmodernist mind focuses on a newly arisen middle-class, which is dedicated to the exercise of power to maintain social order. The sublime is then a mystical experiencing of immanent power. For the positivist mystic, social order—decorum—reflects the middle-class gaze of power. In contrast, for the transcendental mystic it is based upon humility before the omnipotence of Being.

How did Cole and his colleagues think of such things? His circle of peers held a distinctly nonpostmodern perspective on power, order, and social reform. Asher B. Durand painted *Kindred Spirits*, a landscape including portraits of a recently deceased Thomas Cole with the poet William Cullen Bryant. The painting is not of an actual geographic site. Rather, it is, to use contemporary terminology, a construct of the artist's mind. But what type of mind is that?

Durand condemned both materialist philosophy and European romanticism. His contemporary James Fenimore Cooper argued that a commitment to transgressive revolutionary rationalism is a condition of immatu-

Asher B. Durand, *Kindred Spirits*, 1849

rity best quickly traversed to the safe shore of Trinitarian Christianity. According
to Durand, landscapes are more than vantage points for gazes of middle-class
power, and are more than the product of the human mind. "The external appear-
ance of this our dwelling place," says Durand, "is fraught with lessons of high and
holy meaning, only surpassed by the light of Revelation. . . . The true province
of landscape art, is the work of God in the visible creation, independent of man."
The artist's objective, according to Durand, is to create a work "imbued with that
indefinable quality recognized as sentiment or expression which distinguishes the
true landscape from the mere sensual and striking picture."[6] A naturalistic and
organic positivism are both significantly lacking. Using Protestant terminology,
Durand states: "A painting will be great in proportion as it declares the glory of
God, by a representation of his works, and not the works of man."[7]

So which perspective is most valid; which kindred spirits should prevail?
According to the viewpoint of an organic positivism, the painting is a product,
a construct of the human mind depicting a perspective evidencing power. It is
constructivist and thus protocubist. It is done for the glory of humanity. That
glory is realized via a willful and socially malevolent perspective that concludes
in an ontological pessimism if not sadism. But it is inconceivable that Cole or
Durand thought this way It makes no sense that they would consciously develop a
type of perspective antagonistic to their publicly stated intellectual and spiritual
perspective, a perspective grounded in a purposeful scientific rationalism. That
leaves the condescending possibility that Cole and his peers were unaware of the
intellectual, political, and social ramifications of their position. If they were not
hypocritical or malevolent, then they were fools. Again, as recounted by Danto,
Durand wrote: "The most lovely and perfect parts of Nature may be brought
together, and combined in a whole that shall surpass in beauty and effect any pic-
ture painted from a single view." Danto concludes:

> It would be anachronistic to imagine Cole depicted as pointing to an impos-
> sible conjunction as a tribute to his philosophy of art—*Kindred Spirits* would
> in that case prefigure Cubism. Rather, I think, the painting carries forward
> Cole's view that it is all right, even necessary, to falsify observed nature
> in the name of some higher truth. And Durand's tribute does aim at some
> higher truth, at the cost of falsehood before which, as Cole put it, "Time
> [would] draw a veil over the common details."[8]

The point of their art is not merely to falsify observed nature, but to rise
above particularity and defect to convey the universal and perfection. It aspires to a

transcendental and optimistic glimpse of Being. It is indeed implausible to consider Durand, or Cole, as prescient advocates of cubism. But that implausibility is due not to any reactionary impulses on their part. Rather, it is due to those qualities considered by American Protestantism and European modernism. Durand and his kindred spirits agree with the modernist-postmodernists that individual perspectives in art and life occur; they agree that our experiences constitute a constructivism of a sort, an authenticity. But where they differ is in their understanding of Being and becoming. For the modernist-postmodernist, Being is becoming, constructivism is power, truth is the will. But for Durand, becoming seeks Being, seeks to rise above material and particular fact to transcendent understanding. As a useful generalization, modernism-postmodernism is the classical-Judeo-Christian tradition without an objective or transcendent Being, God, or Truth.

So it is implausible to understand Durand's work (and Cole's) from a modernist (that is, cubist and relativist) perspective. But not because Durand's use of a multiple and artificial perspectivism is incompatible with cubism. The use of nonnaturalistic perspective to convey a sublime meaning resonates with the idea that we live in a world of facts in which our best guide to wisdom is, as Jonathan Edwards admonished: a scientific rationalism considered within the context of faith and Scripture. To view Cole's use of a constructivist perspective via a postmodern analysis of power and dominance is intellectually abusive. Rather, *Cole's and Durand's technique for painting perspective needs to be understood via its own perspective of reality and life.* That requires our attempting to understand their Christian paintings via a Christian Protestant point of view—not the constructive or pantheist view of an organic positivism.

The same need exists in considering American classical works. In his 1833–36 painting, *The Course of Empire: Destruction*, Thomas Cole again presents a romantic theme. It is part of a series of five paintings, symbolically representing what Plato discussed in his *Republic*: that the study of history reveals a cyclical narrative of virtue, pride, and suffering. For Plato, the world and politics are the moving material image of the eternal ideal, and that moving material image—becoming—is typically impaired. It is locked in a cycle of foolishness, pain, and violence. The key to escaping that cycle is to seek eternal Being. That narrative goes through five stages: savage, pastoral, consummation of empire, destruction of empire, and desolation. It is a cyclical narrative infused with a violent futility. In accordance with classical thought, we begin not in perfect paradise but in a state of chaos. It is by wisdom that we can hope to rise out of chaos. But human ignorance and foolishness commonly thwart that lofty hope. Lacking wisdom, self-expression and self-realization lead to a denial of the ideal. But the ideal can-

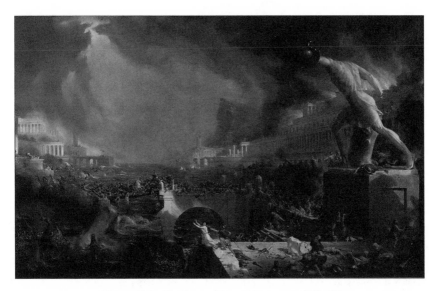

Thomas Cole, *The Course of Empire: Destruction*, 1833–36

not long be subverted. The world enjoys intrinsic teleological or cosmological purpose. Those who attempt to subvert reality engage in futility.

Despite some differences in detail, Plato is in harmony with Christian teleology. Ignorance and pride deny our becoming what we ought to be. However, reality cannot be subverted; the purpose of culture and education is to realize that. So it is not surprising that numerous evangelicals, for example John Wesley, the founder of Methodism, were staunch advocates of studying the classics. Advocacy of studying the classics continues to the present via figures such as More, Adler, Bloom, and others. Indeed, it is the American Platonist Paul Elmer More who defines a free society as one dedicated to a timely pursuit of *Being*. He quotes Plato affirming that a free society is one where *becoming* seeks *Being*, with neither denied.[9] Platonism resonates with Christian doctrine. Jonathan Edwards defends the traditional Western resolution to this scientific and rational problem: the Incarnation is how *becoming* is reconciled with *Being* without denying either; perfect understanding, however, is limited to Christ so no human can claim absolute and final knowledge. No human can claim to be a world-maker. Nihilism and absolutism are thus denied. Transcendent Being (or objective Truth) exists and is largely but not entirely ineffable: we know its substance seeks meaningful completion, we ought to be in harmony with reality, and that is achieved by responsible freedom (becoming seeks Being). The world is fact, process, and purpose, and is therefore to some degree intelligible.

After Augustine, classicism and Christianity are historically cooperative; what Augustine newly achieved—with the help of Plotinus—is an explanation for the intelligibility of the world and of evil. The classical tradition of Socrates, Plato, and Aristotle celebrated the importance of intellect, morality, and virtue. What they could not provide is a solution to tragedy. They could not satisfactorily solve the problem of why bad things happen to good people. But what classicism could not achieve on its own, Christianity did. It effectively provides a rationale for the occurrence of evil, and thus ensures the realistic pursuit of virtue and goodness.

Trinitarian theology makes possible a scientific rationalism that permits the reconciliation of becoming with *Being* while preserving the integrity of each. Consequently, the classical-Judeo-Christian tradition identifies freedom, or *becoming*, with the pursuit of objective truth, of knowledge of *Being*. *This shared position affirms the importance of Being as the objective ground of a meaningful universe and therefore of scientific knowledge.* It affirms the reality of a purposeful and qualitative world. It denies an ontology of violence; it affirms that truth exists, but is hard to discern. It is the free and responsible pursuit of truth that gives purpose and meaning to our lives.

Postmodern Romanticism: Rousseau, Hegel, and Emerson

Each of the three significant figures in the development of postmodernist romanticism, Rousseau, Hegel, and in America, Ralph Waldo Emerson, addresses the problem of the intelligibility of the world and life in a post-Newtonian world of fact and becoming. Rousseau subverts traditional Western culture by attempting to absolve God of responsibility for evil. He does so by declaring that the world is created as a source of wonderment, perfect in every way. Evil occurs not as a means by which a sadistic god might test our faith. Rather, evil is the consequence of civilization standing in opposition to the natural and good. Rousseau thus denies original sin and the pursuit of wisdom and culture.

Hegel responds to the problem of knowledge in a world of fact and becoming by equating Being or Truth with becoming or power. In *The Positivity of the Christian Religion* (1795) and in his *Life of Jesus* (1795), Hegel develops the postmodernist idea that there is a distinction, a dialectic, between positivist facts and positivist reason. Knowledge based on facts produces an authoritarian respect for doctrine; knowledge based on reason results in a natural religion in which we develop our moral codes like gods. We have then a choice: to obey doctrine, or to deify our reasoning. God is known immanently: the logos is found in text, or

in us. Whether one believes that Hegel was attempting to renew the Platonic and Christian worldview, or was attempting to subvert it entirely, one conclusion is inescapable. He attacks transcendence (and presciently, thus Judaism which foundationally believe in transcendence) by declaring that the doctrine of God's objectivity is a counterpart to the corruption and slavery of humanity.[10]

The objectivity of Truth requires that it be transcendent. To be more than meaningless fact, facts must have an objective unifying purpose beyond calculations of pleasure, utility, or the will. Therefore, scientific and religious truth must exist outside of our minds and desires. It is found, not made. But Hegel holds that such a doctrine imposes a false dogmatism on our thinking and our lives. In his *Life of Jesus*, Hegel claims Jesus pretended to be the Messiah because that was the only way that he could be heard in a society of authoritarian Jews.[11] Only by claiming to be speaking as God could he be effective in his alleged attempt to free the Jews and humanity from dogma. Jewish veneration of objective Divine law is deemed authoritarian; the better solution is that "man has the power to create out of himself the idea of divinity and knowledge of his will."

In his *Phenomenology of Mind* (1807), Hegel posits that knowledge of facts presupposes a universe governed by laws, but that our knowledge of those laws is really a type of self-knowledge since obtaining that knowledge requires that we go beyond the realm of mere appearances. That knowledge is realized dialectically, via a power struggle between a master and slave mentality. The master lives off of the slave's labor, but it is the slave who transforms reality via labor. The master, who consumes, destroys, whereas the slave, in working, creates. The slave fears death at the hands of the master, and that fear of death results in creative production, which constitutes civilization. The highest form of civilization is one in which there is no dialectic, no limitations, no decorum. The realization of reason, or the Absolute Mind, is made manifest in the historical dialectic and final realization of our minds. Without humanity there would be neither freedom nor God.

Hegel utilizes an organic positivist paradigm in evaluating Christian theology. He advances the primary assertion of postmodernist philosophy, which is the denial of objectivity or transcendence. We live then in a pantheist and or monist universe. Our wills are Divine and one with reality. Truth or *Being* is us *becoming*.[12]

Pantheistic art became prominent within the German cultural tradition in the early to mid-nineteenth century. Philip Otto Runge's *Rest on the Flight into Egypt* is a case in point. Ostensibly a Christian work, the painting depicts Mary, Joseph, and the Christ child in the company of a nature deity shown emerging from the crown of the tree. Christianity cannot coexist with nature deities because a Christian pantheism makes no sense. This German Christian pantheism makes no sense

since pantheism denies the possibility of a transcendent God or objective truth. The God of Trinitarian Christianity is both transcendent and immanentized by Christ. To deny the doctrine of the Trinity is to make God immanent via nature. This is to deny the transcendent aspect of God, and the very possibility of a scientific rationalism that seeks objective truth. Nor can this pantheism provide a meaningful account for the occurrence of evil.

Nonetheless, the possibility of a Christian pantheism looms large within the context of the German romantic movement. Runge was influenced by Goethe, who in 1773 wrote his poem *Prometheus*, a classical myth. Shelley, another romantic, also addressed this poem. Not only did it instigate reflection on the role of technology, and a reconsideration of pantheism; it also is associated with the invention of the word *nihilism* (Friedrich Heinrich Jacobi [1749–1832] is credited with using the term pejoratively in his criticisms of the German Enlightenment and of Kant). The primary theme of the work, as its title suggests, is that we should act as geniuses, as gods, since God has no ultimate influence or purpose for us to aspire to. But this solution is incoherent since that self-deification denies the possibility of our actions as gods being grounded in knowledge and purpose. *We may claim to be gods but can only be gods of nothing.*

Philip Otto Runge, *Rest on the Flight into Egypt*, c. 1805

Within the American experience, the modernist-postmodernist position has its nineteenth-century proponents. This pantheist view with its emphasis on a

self-deifying genius influences some American romantics such as Ralph Waldo Emerson, who defines a free society as one that seeks to be always in a state of *becoming*.[13] He therefore embraces the modernist-postmodernist definition of *Being* as *becoming*. An apostate Christian who resigned as minister of Boston's Second Unitarian Church, he was a harsh critic of mob rule, materialism, and sterile scholarship. He admired Goethe, Plato, Shakespeare, Napoleon, and particularly Nietzsche—who notably returned the compliment. Like Nietzsche, he was subversive of objective truth, of transcendent wisdom and beauty, instead seeking a positivist-immanentist experiencing of reality. Like Kant, Hegel, and Nietzsche, he found the transcendent in himself, he found an alleged subjective-objectivity, and in so doing subjectifies the transcendent in himself. He thus destroys the transcendent—and the self.

Unlike Jonathan Edwards, Emerson sought via the Buddha, Confucius, Jesus, and Mohammed awareness of an alleged subjective-transcendent wisdom found in an immanent universal spirit he called the Over-Soul. Emerson is then a precursor of New Age theosophy and its self-deification and nihilism. He and other romantics act in response to a deistic God who maintains a world that does harm to the virtuous. Working from the assumption that an Incarnational and Trinitarian scientific rationalism is false, a new cosmology comprised of genius, deism, and pantheism results. Babbitt responds to this materialist/spiritualist endgame with characteristic insight:

> The strict Christian supernaturalist had maintained that the divine can be known to man only by the outer miracle of revelation, supplemented by the inner miracle of grace. The deist maintains, on the contrary, that God reveals himself also through outer nature which he has fitted exquisitely to the needs of man, and that inwardly man may be guided aright by his unaided thoughts and feelings. . . .
>
> The deist finally pushes this harmony in God and man and nature so far that the three are practically merged. At a still more advanced stage God disappears, leaving only nature and man as a modification of nature, and the deist gives way to the pantheist who may also be either rationalistic or emotional. The pantheist differs above all from the deist in that he would dethrone man from his privileged place in creation, which means in practice that he denies final causes. . . .
>
> One whole side of Rousseau's religion can be understood only as a protest against the type of Christianity that is found in a Pascal or a Jonathan Edwards. . . . From a God who is altogether fearful, men are ready to flee to

a God who is altogether loving, or it might be more correct to say altogether lovely. . . .

Instead of the old dualism between good and evil in the breast of the individual, a new dualism is thus set up between an artificial and corrupt society and "nature." . . . The beautiful soul is unintelligible to those of coarser feelings. . . .

This notion of the soul that is spontaneously beautiful and therefore good made an especial appeal to the Germans. . . . But examples of moral aestheticism are scarcely less frequent elsewhere from Rousseau to the present. No one, for example, was ever more convinced of the beauty of his own soul than Renan [who stated:] "As for me, I declare that when I do good I obey no one, I fight no battle and win no victory. The cultivated man has only to follow the delicious incline of his inner impulses. . . . Be beautiful and then do at each moment whatever your heart may inspire you to do. This is the whole of morality. . . ."

Though the romanticist wishes to abandon himself to the rapture of love, he does not wish to transcend his own ego. The object with which Pygmalion is in love is after all only a projection of his own "genius." But such an object is not in any proper sense an object at all. There is in fact no object in the romantic universe—only subject.[14]

Four major problems face this New Age immanent-transcendental theology. They are 1) It is not new. Monism and pantheism are perennial possibilities; 2) It is not transcendent—if by that word is meant that Truth objectively exists, beyond our minds and wills; 3) If it is a theology then it faces the impossible task of reconciling that which cannot be reconciled: the very different foundational beliefs found among the major cultural traditions around the world and through time and; 4) Its advocacy of genius, of inner necessity serving as the ground of meaning, is a form of self-deification that alternates between authoritarianism and nihilism. It is authoritarian in that it attempts to make *the other* conform to our will; it is nihilistic since that which we will cannot determine reality.

The major problem facing the critics of such romanticism is that it is intellectually impervious to rational argument, seeing such arguments as mere extensions of the will. For the academy to adopt romanticism—indeed modernism-postmodernism writ large—is to deny the very mission of intellectual life. Nonetheless, it is at this impasse that we now find ourselves.

Fact, Intelligence, and Imagination vs. Wisdom

This impasse is immediately evident when one attempts to understand a work of art. For example, a postmodernist-romantic analysis of Cole's art is by necessity hostile to its intrinsic meaning. Conversely, the teleological and theological meaning of the paintings by Cole is intrinsically threatening to the New Age theology of modernism-postmodernism. Cole's (and Hicks's) presentation of an explanatory narrative on the meaning and purpose of life would offend the modernist proponents of the Enlightenment, who would also be offended by the prospect of seeking Truth and Wisdom, *scientia* and *sapientia*.

Milton's account of Satan, and Goethe's and Shelley's account of Prometheus, would appeal greatly to the postmodernists who see subversion as key to escaping oppressive truth claims; Hegel, Marx, and Nietzsche all concur. In Comte's and Renan's positivist terms, they aspire to rise from oppressive assertions of *why* to seemingly solid, objective, and liberating facts, or *what*. Those facts are to be used by us according to our inner necessity. We are demigods. The qualitative distinctions between transgression and freedom, abnormal and normal, perverse and decorous, make no sense to the materialist modernist and are contemptible to the postmodernist monist. For the traditionalist-minded, qualitative distinctions are reduced to empirical and authoritarian Scripture and mystical manifestations of Divine will.

The empiricist Francis Bacon remarked that the empirical method requires but little intelligence. What then of imagination? He considers truth and decorum to be products of the imagination, mere idols of the tribe, the cave, the marketplace, and the theatre. The empiricist contributes to the rise of the romantic impulse that denies scientific rationalism in the pursuit of wisdom. That wisdom is more important than fact, intelligence, and imagination never occurs to the romantic. Correspondingly, Bacon famously remarked that there is no excellent beauty that lacks some strangeness in the proportion. Irving Babbitt continues:

> The saying I have quoted from Bacon is perhaps an early example of the inner alliance between things that superficially often seem remote—the scientific spirit and the spirit of romance. Baconian and Rousseauist evidently come together by their primary emphasis on novelty.
>
> What has been even more decisive in the overthrow of the traditional disciplines is that science has won its triumphs not by accepting dogma and tradition but by repudiating them. . . . This means in practice that instead

of dying to his ordinary self, as the austere Christian demands, or instead of imposing a law of decorum upon his ordinary self, as the humanist demands, man has only to develop his ordinary self freely.[15]

So Bacon, Kant, and Rousseau are dedicated to the denial of idolatry—and decorum—be it of tradition or the mob. But does their solution lead to success or does it merely substitute one type of idolatry and dogma for another? The pursuit of wisdom is denied in favor of fact, intelligence, and imagination. In the context of intelligence and imagination we are driven to pursue our inner necessity. But is this not to embrace a different set of idols, those of the tribe, the cave, the marketplace, and the theatre? From a secular modernist and postmodernist viewpoint, Cole's art is trite and oppressive. His work (particularly his series of paintings dedicated to the theme of the Voyage of Life) is seen to be informed by an excruciating philosophic banality;[16] others will find its religious claims to be by definition unenlightened. Those claims represent the received wisdom of two thousand years of analysis and contemplation. To dismiss them in the name of contemporary positivist scientific rationalism is breathtakingly arrogant.

The inadequacy of those evaluations is that they ignore the artificial limitations of their own mental tendencies. The Enlightenment demands that we escape from the idols of the tribe, cave, marketplace, and theatre. But since each denies the pursuit of wisdom, then idolatry and dogma simply return in new form. In worshiping self-expression and self-realization as good in themselves, we worship ourselves. Culture is reduced to a banal idolatry, a fetish marked by an empty solipsism.

Babbitt delivers a telling blow to this entire system:

[Kant] wished the reason, or judgment, to keep control over the imagination without disturbing its free play; art is to have a purpose which is at the same time not a purpose. The distinctions by which he worked out the supposed relationship between judgment and imagination are at once difficult and unreal.

One can indeed put one's finger here more readily perhaps than elsewhere on the central impotence of the whole Kantian system. Once discredit tradition and outer authority and then set up as a substitute a reason that is divorced from the imagination and so lack the support of supersensuous insight, and reason will prove unable to maintain its hegemony.

When the imagination has ceased to pull in accord with the reason in the service of a reality that is set above them both, it is sure to become the accomplice of expansive impulse, and mere reason is not strong enough to

prevail over this union of imagination and desire. . . . To suppose that man will long rest content with mere naked reason as his guide is to forget that "illusion is the queen of the human heart"; it is to revive the stoical error.[17]

The critics of the romantic imagination do not deny that imagination affects the pursuit of truth and wisdom. But they distinguish between imagination in the pursuit of objective knowledge and imagination in the pursuit of (de)constructions of reality and life. They distinguish subject from object and humility from a narcissistic egoism.

The foundational dispute within American and Western culture is not merely between the orthodox classical-Judeo-Christian tradition and modernism-postmodernism. There are modernist and postmodernist classicists; there are modernist and postmodernist Christians (and others). Those ultimately sterile hybrids also conflict with each other as evidenced by the liberal vs. fundamentalist (or (de)constructivist vs. positivist) debates so characteristic of contemporary discourse. But liberal and fundamentalist share a common base: unanimity in their shared disdain for science and reason in the pursuit of *scientia* and *sapientia*. Antecedent to the conflicts between traditional Western culture and modernism-postmodernism, or between modernist and postmodernist classicists, Jews, and Christians, is the dispute between two irreconcilable definitions of science and reason.

There are those, such as Jonathan Edwards, who attempt to meet the challenge of a newly redefined science and reason while maintaining the foundational principles of Platonic tradition and Trinitarian Christianity. One such group is Protestant evangelicalism. The evangelical Christian historically plays a prominent role in American art and culture. The history and development of the evangelical movement is complex but evidences certain primary tendencies including a respect for the authority and sufficiency of Scripture as the primary source of first principles, a commitment to the meaning and purpose of the Incarnation and Trinitarianism, the importance of personal conversion, and a charitable openness to nonessential doctrinal differences (*adiaphora*).[18]

If one removes the belief in objective transcendent truth, evangelicalism results in modernism. Modernism is Christianity without transcendent Truth or God. If one confuses Truth and reason with power, the result is postmodernism. In either case, there is only an immanent Truth or God—the (de)constructive self. Conversely, evangelicalism aspires to be a modernism with a transcendent and immanent God. But the defense of transcendence proves difficult due to the positivist limitation of science to fact.

Employing useful generalizations, the classical-Judeo-Christian tradition relies upon the reality of transcendent objective Truth and wisdom. It relies upon the assumption that the world is not chaos but cosmos. To some precious degree, Truth and wisdom are to be understood, not felt nor (de)constructed. Newton's and Kant's redefinition of science and reason results in knowledge beyond the factual to be unscientific, deontological, and grounded in rationalization or imagination. Knowledge is declared to be necessarily immanent, empiricist, or mystical,[19] as Babbitt puts it: Baconian and Rousseauist go hand in hand. Therefore we can choose to pursue a materialist or a spiritualist existentialism. We can pursue the path of Nietzsche or Emerson (or Kierkegaard). But the evangelical rejects such existentialism and wishes to reconcile traditional Christianity with science—as knowledge.

The Enlightenment proposed that a newly defined science and reason would provide the key to escaping ignorance and religious superstition. The evangelical mind recognizes the many faces of an immanent positivism: materialism, mysticism, deism, pantheism, deonotological reason, and utilitarianism. The evangelical finds the abandonment of scientific rationalism and belief in a meaningful and moral universe dangerous and unnecessary.

However, the evangelical faces a problem. Newtonian science and deism support the Scholastic and Aristotelian notion that natural law coexists with God's truth. There is a natural and spiritual theology. If truth can be obtained via nature *or* God, then how essential is God? So Scholastic conceptualism and Newtonian deism facilitate the intellectual death of God—and of rational science—and thus make optional the assumption of a purposeful world of Being—and ontologically purposeful knowledge. And if Being is denied, then natural law becomes mere mechanical or organic fact and knowledge the product of our imaginative wills.

So the evangelical mind is suspicious not only of ontological Scholasticism, with its discredited Aristotelian physics and conceptualism, but also suspicious of Newtonian positivist Scholasticism, with its bifurcation of knowledge and its deification of the human will.

They have good cause for that suspicion. The Enlightenment's early goal of utilizing fact and reason to understand reality and life quickly came under wide assault; Hegel's and Berkeley's reduction of matter to mind is seen as sheer folly; Hobbes, Hume, and others recognize that the attempt to rationally combine facts in an empiricist world results at best in meaningful fictions, at worst in sheer nonsense. Kant attempts to strike a balance in Western culture with his notions of the categorical and hypothetical imperatives. The former purports to provide a rational foundation for objective morality while the latter permits a wide variety

of scientific theories to be constructed in the attempt to understand the physical universe. But his *synthetic-a priori* and his *aesthetic–transcendentalism* provide the grist for Nietzsche's[20] *and* Emerson's mystic-nihilist mill.

Evangelicals accept natural science *and* the assumption of a purposeful world. They focus on the need for a personal understanding of those facts and principles; they accept the need of responsible freedom to do so. But they do not accept the modernist assumption of world-making, or the postmodernist dedication to world-destroying. Evangelicals are essentially Newtonian modernists determined to defend scientific rationalism in the pursuit of wisdom; they remain Trinitarian Christians.

This commitment to a continuation of scientific rationalism is found within and beyond the Anglican and Puritan churches. There are the Wesleyans, the revival Calvinists such as Jonathan Edwards, and many others, including figures such as Thomas Cole and Asher B. Durand. A common theme is that nature provides immanent evidence of God's transcendent Truth—but is not God. In Trinitarian mode, there is natural *and* revealed theology, substantively harmonious, yet ontologically distinct. If nature is God then objective knowledge is denied; if natural and revealed theology are intellectually distinct yet substantively one, then what of natural disasters? Knowledge and chaos cannot coexist; the conflict between a scientific rationalism and the occurrence of evil remains deeply problematic.

American Exceptionalism: The Transcendent Landscape

The shift from neoclassicism to romanticism involves a shift from thinking to feeling, from understanding to willing. At issue is whether that will can or ought to be benevolent. Positivists vainly deny that the will should play a role in obtaining objective knowledge; others vainly assert that the will subverts the very possibility of obtaining such objective knowledge and that an unfettered authenticity is the goal. Neither considers that in a meaningful world knowledge and the will, truth and love, numinously combine.

So a remnant still affirms that it is the pursuit of Truth by which the will rightly aspires to rise above subjectivity and violence. To willfully pursue the Truth is for the will to escape its own subjective limitations. The subject seeks the meaningful object and thereby transcendent love replaces the willful transgressive ego.

For example, a primary American romantic artist, Frederic Church (1826–1900), is a Trinitarian Christian. He intellectually stands distinct from non-Trinitarian European figures such as Hegel and the painter Runge, and American

figures such as Emerson and the painter John F. Kensett. The traditional Trinitarian Christian knows a God of will *and* substance, but the Newtonian-informed Christian can rightly know only God's will or power. A God of Truth and Love is replaced by a God of glory. We can know of God's will as evidenced by his works, but we cannot know how God's will is informed by God's substance and essence.

Newton's paradigm of knowledge leads to his belief in intelligent design. The world exists, is itself the final good, and in that world humanity exists. So the natural world evidences the mind of God. Or does it? Intelligent design might equally evidence a merely mechanical universe (David Hume, Voltaire, Comte, etc.), a universe that is violent (Sade and Bayle), an idealization (Berkeley), or even a universe that is all combined (Kant). What remains common is that a scientific rationalism is no longer possible.

If modernism-postmodernism cannot objectively reconcile empirical fact with rational understanding—or cause and effect in physics and ethics—it cannot reconcile freedom with responsibility. It celebrates the will while denying the will an objective purpose, therefore becoming subversive of its own claim to be normative. If that tradition devolves into a statist or religious totalitarianism ultimately informed by a sadistic nihilism, then perhaps those who hesitate in joining them are not provincial but exceptional.

American exceptionalism asserts an alternative to the modernist-postmodernist dominance of Western and perhaps even world culture. The redefinition of science and reason to brute fact, will, and power was rejected by Trinitarian Christians. A variety of orthodox evangelicals remained committed to a Trinitarian faith which they understood to be at odds with Newtonian-derived science. Their stance was not merely a fundamentalist privileging of Scripture over science—if faced by a choice between science or religion, Jonathan Edwards would surely have chosen the former.[21] Nor was Edwards convinced of a necessary choice between evangelicalism and Scholasticism. He accepted the implication of intelligent design in Newton's *Opticks*, but he also saw that the new physics demands a superficial metaphysics in which descriptions are falsely viewed as explanations. He rejected the mechanistic physics and the reduction of God to cosmic plumbery while avoiding a pantheistic identification of God with nature:

> Edwards just as vehemently denounced the English Deists who were using causation to justify mechanism and natural self-sufficiency following an original and perfect creation. To Edwards, they ignored ontology and thus failed to see the moment-by-moment dependence of creation on God's being, and not just on some prior willing.

Edwards joined with David Hume in denying any mechanical necessity between a cause and its effect and in thus exposing the most vulnerable side of any mechanistic philosophy.

To Edwards, nature contained the most immediate and persuasive revelation of God's beauty. The spiritual man saw God in all of His glorious creation. . . . Yet, as a Calvinist, he reserved this insight for the elect few and balanced it by just as ardent an allegiance to the Bible as a second revelation. His orthodoxy alone separated him from a later, transcendental [sic] view of nature.[22]

Concerning the role of the will in theology, life, and scholarship, Edwards follows Locke in defining freedom as the power to do as one wills. But he differs from modernism-postmodernism in understanding that what one wills ought to be grounded in what we understand to be good. The will reflects the substance or Being of God—and of humanity. When the substance of humanity wills against objective Truth or God, then human *Being* is acting against Divine *Being*. Sin as a willful resistance to a meaningful reality results.

American exceptionalism continued with later figures such as Frederic Church. In his essay "Church and Luminism: Light for America's Elect," David C. Huntington establishes the links between Church and what he calls an orthodox liberal Calvinism. He notes that in Church's formative years he was deeply influenced by Pastor Horace Bushnell, who recognized the threat posed by modernist-postmodernist transcendentalism and Unitarianism. Church's concern was not grounded in a rejection of science; he owned a copy of Reverend James McCosh's *Typical Forms and Special Ends in Creation* (1856), dedicated to the science of design. That text celebrates geology as a record of the story of creation:

The Supreme could foresee that which was to come, and which He had preordained; the revelations of geology enable us to take a retrospective view. But they do more. . . . We can . . . from that point look down the long vistas that are opened, to the period when man appears as the final and foreseen product of one mighty plan—the last in time, but the first in the contemplation of Him who called them all into being.[23]

Church was Thomas Cole's only student. In contrast to his teacher, who viewed landscape anthropomorphically, as a stage for human activities, Church assumed a larger vision. Nature was a stage for human activities, and what a stage it is! For Church, nature is evidence of intelligent design, a design illuminated

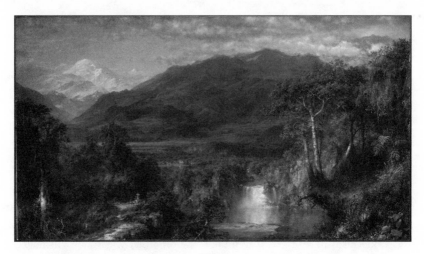

Frederick Church, *The Heart of the Andes*, 1859

with grandeur and purpose. But intelligent design affirms the existence of intelligible, compassionate Being.

Church was also influenced by the German scientist and explorer Baron Alexander von Humboldt, who wrote the well-known book *Kosmos* (1845–62). Humboldt advocated artists traveling to exotic locations in the pursuit of their craft. It was advice Church took. Church's painting *The Heart of the Andes* (1859) established his status as perhaps the best of his generation of American artists. The painting is Newtonian in the sense that a very particularistic concern for detail is present. But it also has that which Newton denies: It represents nature and humanity as participants in a grand, indeed cosmic theological drama. That theology centers on a God who offers not only First and continuing but also Final Causes, or, to use McCosh's term, *Special Ends*.

That drama presents us with the context in which the creator God is a first, a continuing, and a final presence in the cosmos. There is an attempt to bridge the deistic gap implicit to Newton's science, and avoid its logical outcomes—mechanistic, violent, or pantheistic culture. It is both natural and revealed theology that informs the work; the will of God provides first and continuing presence, and also, special ends. By reintroducing the notion of final or special ends, the flaw of positivism is addressed. How those special ends might apply to a scientific rationality will be addressed in the conclusion.

The landscape is no longer a naturalistic stage upon which are merely human actors and potential victims of a possibly sadistic God. Now, the landscape promises a broad context for understanding reality and life. Huntington explains a dif-

ferent work by Church in terms that serve well in explaining his general oeuvre: "On the canvas of the Protestant Frederic Church—in contrast to that of the Catholic Raphael Sanzio—the celestial and the terrestrial are united. A Puritan transfiguration joins heaven and earth, as the triune God of history and nature enters time and space to create his Holy Nation." Elsewhere in his essay Huntington observes: "The Almighty has significantly more to do with Church's art than the [Emersonian] Over-Soul."[24]

Church's contemporary John Frederick Kensett (1816–72) was, like Church, a luminist, but not a Trinitarian. Whereas Church's paintings include a balanced sense of ideal and action, of *Being* and *becoming*, Kensett's art reflects a crystalline clarity marked by an absence of empirical particularity, of action, of drama.

In other words, it lacks the qualities central to traditional Western culture as established by the doctrines of the Incarnation and Trinitarianism: a realm of meaningful *becoming* seeking *Being*. His painting *Newport Coast* (c. 1850–60) clearly reflects the primary technical qualities associated with luminist art. Barbara Novak lists those qualities: measured structure, abstract or ideational order, planar stress, primitivism, luminist light, the absence of brushstrokes, and silence.[25] What end do these techniques serve? A contemplation of *Being*, that which exists in clarity and purity through eternity.

Kensett is more the neo-Platonist than Christian, more immanentist than Trinitarian transcendentalist.[26] Whereas existential materialists such as Heidegger identify with an immanent, materialistic, and purposeless *Being*, idealists such as Kensett identify fully with the immanent Logos (Plotinus) or the imma-

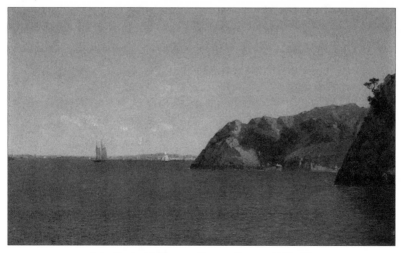

John Frederick Kensett, *Newport Coast*, c. 1850–60

nent Over-Soul (Emerson) to allegedly escape the daily sordid and often violent trivialities that surround us. Kensett and Emerson pursued what Edwards denied: a non-Trinitarian scientific rationalism which is none other than a materialist/ spiritualist subjectivism. We again refer to Huntington:

> Painting in the era of luminism it was the perceptual and spiritual comprehensiveness of his atmosphere, the urge to encompass every last atom, every last word of the firmament of nature's Bible—indeed, the instinct to see *all* of God's "Design" with "Intelligence"—that makes Church unique. The eye of the classic Luminist, of a Suydam, a Fitz Hugh Lane, a Kensett, looks not to interpret God's handiwork, but to merge with a nature which is itself God. . . . The one accords with the ways of the Over-Soul, the other with the ways of the Almighty.[27]

Those who attempt to understand reality contemplate *Being*. The purpose of that contemplation is to escape the trivial by an identification with the enduring metaphysical ground of existence. Traditionally, Trinitarianism reconciles: *Being* as the realm of eternal meaning (God), *Being* made manifest in the realm of *becoming* (Christ), and *being* (as the world of facts). In science, ethics, and art, a template is provided by which the free pursuit of objective knowledge, of *scientia* and *sapientia*, is sought. Responsible freedom is real.

The spiritualist desires to escape the vagaries of temporal and often violent existence by merging with eternal divinity. But this is a denial of objective Being, or rather, is an identification of Being with a violent becoming. It ironically results in a nihilistic self-deification. To claim to be one with God is to claim omnipotence and to deny rational dissent within a cultural context. As such it denies a scientific rationalism in the realization of responsible freedom.

Geometry and Organic Positivism: Romantic Confusion

As one might expect, the reduction of thought to willful process is also evident in architecture. The Baroque style is the first step toward denying Being as having an eternal intelligible substance. For the faithful, what happens reflects God's Will; for the unfaithful, what happens is the result of mechanical or biological necessity, chance, or their will. This is reflected in Newton's new mathematics. With Newton, geometry is newly transformed and replaced by calculus. Geometry is now merged with and transformed by time and motion; it shifts from *Being* to or

as *becoming*. Consequently, the axioms of Euclidean geometry are intellectually coherent but no longer explanatory of the perennial essence of the world and its structure. The mind of humanity no longer aspires to be in harmony with the mind of the unchanging *Being*, the eternal God, of permanent and objective scientific knowledge of the universe. The Scholastic method is denied. But more than that, method is denied. Put into question is the very existence of objective truth and an intelligible universe. If architectural geometry can no longer function as aspiring to grasp something of Being, Truth, or the mind of God, to what may it aspire?

Several romantic architectural projects attempt to answer that question. One of these is a new creative field with the most direct contact to nature: landscape architecture. During the eighteenth century, landscape architecture grew in importance and changed in parallel with the new concepts of beauty and the sublime. The Earl of Shaftesbury and Joseph Addison published widely regarding the pleasures associated with nature. The work of Hume, Ramsay, and Burke redefined beauty as a subjective naturalistic response with immediate effects; in little more than a generation, landscape architecture moved from LeNôtre's geometric and disciplined planning at Vaux le Vicomte and Versailles to Capability Brown's popular natural style throughout England.

The shift curiously juxtaposes geometry applied to nature, with a constructed nature of organic randomness. Intellectually, it is the ambiguity present in the coexistence of Newtonian and Rousseau perspectivism. This was evidenced by the addition of architectural follies, those appropriately titled architectural accoutrements designed for picturesque, that is romantic, effect.

During the rationalistic neoclassical eighteenth century, the picturesque movement fueled a few brief forays into architecture. Examples of a newly romanticized Gothic architecture include Strawberry Hill (1748), Downton Castle (1772), and the freakish, and short-lived, Fonthill Abbey (1796).[28] The Gothic, historically part of the rational Scholastic pursuit of knowledge of Being, is newly viewed via the romanticized rationality of becoming. Its acknowledgment of the suprarational depends on the existence of transcendent truth; the romantic denial of transcendence reduces the suprarational to subjective feeling. The Gothic is ahistorically associated with an emotionalism[29] repugnant to its foundations. This marks confusion not only about the meaning of Gothic architecture but even about what architecture ought to be.

That confusion continued into the early nineteenth century with the growing recognition that the modern West did not have its own style. Heinrich Hübsch's 1828 booklet *In welchem Style sollen wir bauen?* suggested that style was nothing

more than an adaptation to local materials and conditions. Hübsch argues against any sort of absolute beauty in architecture and then suggests principles for building. These principles are an early form of functionalism. Similarly, in France, architects like Pierre-François-Henri Labrouste attempted to work in something new, something current, with new materials and new structures. His Bibliothèque Ste-Geneviève (1843) is a minimalist rectangle with subdued arched windows springing from pilasters. Between the pilasters, carved directly on the wall, are 810 names of authors, from Moses to contemporary scientists. Influenced deeply by Claude Henri de Rouvroy Saint-Simon and Auguste Comte (who worked with Saint-Simon and who inspired the 810 names), Labrouste pursued positivist thinking in his building, paradoxically aiming toward a coherent style in the absence of Being. As David Watkin writes:

> Labrouste hoped that his Bibliothèque Ste-Geneviève would generate a third of these ideal phases [the positive stage], which were believed to be "organic" because they were expressive of a coherent body of social ideals and religious belief. It was further felt that it was precisely the lack of any such unitary outlook which accounted for the inadequacy of nineteenth century architecture. Hence the attempt to regenerate architecture through programmes of Utopian socialism, religion, or . . . the religion of humanity which Comte developed from 1842.[30]

The mechanistic positivism of Newton is now the organic positivism of Labrouste—and later, Darwin. That unified organic perspective naturally accommodates a functionalism (or instrumentalism) in architecture, science, and culture. But it also accommodates a dysfunctionalism. It calls for a purposeless organic clarity in architecture and science while denying them any transcendent purpose for such historical architecture or science to embody.

Informed by the positivism of the Saint-Simonians, Labrouste's contemporary Viollet-le-Duc was frustrated by the apparent lack of unitary outlook. In his influential publications, he pursued a rationalist architecture, but its rationalism did not seek wisdom. Rather, it encouraged functionalism, while rejecting any type of wisdom or traditionalism. This has confusing consequences. Since the time of architect Soufflot and his project in Paris, Ste. Genevieve/Pantheon, the Gothic had long been admired in France for its structural efficiency, but not for its intellectual content. Viollet unwaveringly supported French Gothic as the most rational of styles by associating that rationalism with its functional minimization of the material elements of support. He asserted that it was an organic architec-

ture at its functional highest, following organic and positivist "fixed rules." At the same time, a positivist and organic universe has no fixed rules that are intellectually objective. A deontological interest in the Gothic denied the ontological ground of the Gothic and functionality, reducing Gothic (or other) architecture and history to an arbitrary yet organic revivalism. History is organic without purpose; therefore revivalism must also be arbitrary.

This confusion of styles is the necessary consequence of the unnecessary assumption that the world lacks intelligible meaning. The denial of objective truth results in a confusion of styles, reflecting the impossibility of qualitative scientific rationality or actual functional or instrumental meaning. But by recognizing that confusion of styles, of perspectives, there is no longer any necessity for us today to accept as inevitable such confusion. We are not limited to confusing perspectives; indeed we ought not be.

Furthermore, the notion that style naturally follows from function is dubious, and if embraced it can be used to argue for the functionalism or rationality of any momentarily coherent style. This offers slim hope that whimsical architecture can be distinguishable from that which purports to be profound. Architectural historian William Curtis puts his finger on the two-pronged problem: "There were a number of fallacies in this position, such as the notion that forms might arise from functional analysis alone without the intervention of some a priori image, but it was still a weapon with which to attack the whimsies of the most arbitrary revivalists."[31]

Later historians politely refer to such work from the second half of the nineteenth century as *eclectic*. That architecture in America included neoclassical banks, Gothic schools, and Moorish-styled mansions. A. J. Downing's ubiquitous remodeled Gothic houses, Venetian and Second Empire office buildings, and Egyptian-styled churches[32] incoherently competed with the unclassifiable work of Frank Furness. There was no archetypal American architectural style. One scholar connects the movement toward eclecticism with the growth in scientific archaeology. The classical penchant for applying eternal rational principles (Being) to contingent circumstances (becoming) now lacks the ability to convincingly do so; application of ostensibly objective and rational principles of Vitruvius, and of later Renaissance and Baroque architects, were rejected in favor of a direct *historicist* imitation of previous examples. Hugh Morrison writes:

> Thus we may say that when Palladio's [modified] Ionic capital was supplanted
> by those of the [historically "accurate"] Erechtheum, this seemingly trivial
> change led straight—almost inevitably—to nineteenth century eclecticism,

which was plainly and simply a lack of a style rather than the presence of one. The old order was dead; no new order had yet come to take its place.[33]

But indeed there was a new style, a new order, one that denies the previous ontological order of Being. An advocate of that style, that new order of becoming, is found in the Romanesque work of the American architect H. H. Richardson.

American Romanticism in Architecture

Richardson, raised in the South with family connections to Unitarianism, trained at the École des Beaux Arts in the 1860s, watched the renewed battle of the ancients and moderns, and listened to Viollet-le-Duc's controversial lectures on the new rationalist method. But like many of his American contemporaries, he remained unpersuaded. The Gothic style so admired for its organic positivism held no charms for him. As his contemporary Henry Adams noted in his book on Mont San Michel and Chartres, the Gothic seemed frivolous to the American mind.

What, then, might an aspiring American architect do when asked to enter competition for a monumental Boston church? Certainly not the "functionally rational" Gothic Viollet thought so attractive. Richardson instead selected a relatively obscure historic style just regaining use in Germany and America: the Romanesque.

The Romanesque found favor for very specific intellectual and cultural purposes: patrons did not wish their churches to be associated with the excrescences, in both senses, of High-Church Gothic. Whether viewed as excessively rationalistic or excessively emotional, the Gothic was growing out of favor. The promoters of the Romanesque style thought it hear-

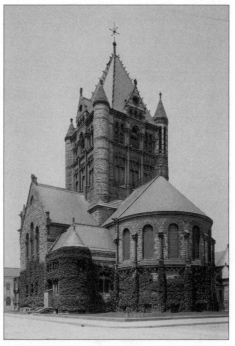

Henry Hobson Richardson,
Trinity Church, Boston, 1872

kened back to an earlier period of Christian history and the Romanesque served as a means by which to revive a more pietistic, simplistic Christianity.

Richardson's design for Trinity Church, Boston (1872), with its Romanesque style, is a historicist, revivalist effort, but one with new aspirations. Certainly there is simplicity to the Romanesque that does not appear in the Gothic; there is also a freedom in application that does not quite appear in the rationally rigid classical revival styles. It was something different, neither neo-Gothic nor neoclassical (nor French or English, a not inconsequential issue given the rise in nationalistic trends). It was simpler, clearer; as Henry Adams suggests: it is perhaps even more masculine. It was thought to be archetypically American. However, it is also eclectic. Inspiration for Trinity Church included French medieval churches, English High Gothic, nineteenth century German *Rundbogenstil*, and quite specifically, the tower from the Old Cathedral in Salamanca. Very quickly the Romanesque, particularly as practiced by Richardson at Trinity, inaugurated a new moment in architecture. The Romanesque became the American style, at least for a brief time.

Trinity's design was closely supervised by the church's rector, the widely known Dr. Phillips Brooks.[34] Brooks had very specific ideas about how he wanted Trinity to look, and thought the Romanesque style the proper one to communicate his liberal evangelicalism. The American Broad Church movement, of which Brooks was a part, attempted to reconcile fact, feeling, and rationality as reflected by the Low Church and High Church division; Brooks wished to keep the emotional pietism of the simple Low Church but to gently engage, in High-Church mode, some of the modernist liberal intellectual trends.

During the second half of the nineteenth century, the growing tension between religion and science, and the dilemmas it created, came into sharper focus. Brooks attempts to resolve the growing cultural rift, the emptying of the pews, to keep Episcopalianism as a viable option. But that rift is obvious to many. For example, Henry Adams sets his novel *Esther* (1884) in Boston in a church very like Trinity. Adams, a cousin of Brooks, has the characters make timely statements such as *"There is no science which does not begin by requiring you to believe the incredible."* But in the end, the characters cannot resolve their differences and the love between a confused young atheist woman and a passionate minister remains depressingly unresolved.

Trinity Church reflects these conflicting perspectives. The Romanesque exterior designates more than a mere change of style from a now desiccated High-Church Gothic. The simpler ornament and designs made an appeal to an older form of Christianity, a legitimizing effect. It also aids a different interior space,

one dominated by the central tower. The nave is huge and without a choir. The balcony is supported by iron brackets, eliminating vertical supports; every seat, many under the unobstructed expanse of the tower, is unblocked by supports. Everyone can see. Everyone can hear. Richardson, under Brooks's careful eye, filled the church with color and image. An intense red dominates the interior. Everywhere are polychromatic effects in stone, wood, glass, paint, or paper. There is a communion table rather than an altar.[35] The pulpit is situated, humbly, on the chancel steps. The signs of the Low-Church simplicity are there but this is clearly more than a mere "preaching box," as one might derisively call the Old Ship Meeting House.

What then did Brooks accomplish? A church with no clear sacred space grounded in ontological scientific rationalism. He desired that Christianity survive as a social institution and as a religion. He embraced the Broad Church movement, and its liberal concomitant parts, in the hopes of doing that. The Trinity design aspires toward a Low-Church emotional connection to the Divine with a High-Church rationality, united by a shared aesthetic effect. That unity is the goal of this American romantic architecture—and theology. The sad irony is that this attempt undermines Trinitarianism in religion and science.

This attempt at an emotional-positivist-organic Christianity is dysfunctional. Its attempts to qualitatively synthesize fact, feeling, and rationality within a quantitative world result in unsynthesized facts, feelings, and rationalism. Pietist emotion is accompanied by fundamentalist Scriptural fact; those Scriptural facts are left unreconciled with a newly deontological reason. Therefore there is no scientific and rational justification for the Christian faith beyond Scriptural authority or emotional piety. American Christianity is divided into pietistic, fundamentalist, and Unitarian camps; none can enjoy the support of Trinitarian scientific rationality. Lacking a transcendent unity of science and reason, no substantive unity of Being and becoming can be realized. Lacking that unity, degrees of wisdom cannot be obtained and Trinity Church becomes non-Trinitarian. An empiricist-mystic perspective results, one that denies the importance of the Logos or the logos. As historian Gillis Harp notes: "It [the Reformed iconoclastic tradition] had been weakened by a related Romanticism that celebrated the direct experience of the divine through aesthetic contemplation either of nature or of art."[36]

The Episcopal Anglosphere relies upon Scripture, reason, and tradition in seeking wisdom and beauty. But the positivist organic perspective of modernity subverts it from within. Scripture is fact and feeling; reason is (de)constructivist rationalization. The mind of God or scientific truth no longer objectively exists. Tradition has no transcendent object of knowledge to realize. For the faithful God

is conflated with Christ, transcendence is conflated with immanence, and the path to a Unitarian advocacy of the divinity within us is but a short dangerous step.

Now we may ask: is Richardson's rational Romanesque one in which in Augustinian fashion geometry refers to a numinous world? Is this numinous world informed and united by transcendence? Or has it been redefined, as Viollet did with his rationalized Gothic; is it now a rationalized Romanesque, where reason and emotion coexist and are doomed to violent conflict? Certainly the shift in Episcopalianism was toward the rationalized romantic. Brooks himself was deeply affected.[37] His sermons smoothed the way for twentieth-century liberal Protestantism. By the 1870s, evangelicals such as Edwards were oddly thought a throwback to the overly rationalistic eighteenth century. But a romanticized faith in which Being and reason are understood as becoming and feeling denies Trinitarian Christianity, scientific rationalism, and responsible freedom. Indeed, it does more than that; it mandates a violent existentialism.

The Will to a Decorous Love of Wisdom vs. the Will to Power

Unlike Richardson's architecture, Church's paintings advance our consideration of a willful commitment to scientific rationalism. He reconciles matter, idea, and will with purpose. However, after the rise to prominence of the positivist paradigm, there is no recognized special end by which these elements can objectively be combined. What distinguishes Frederic Church's Trinitarian Christianity from other options is his conviction that the world is ultimately intelligible but difficult to discern, that virtue is ultimately rewarded, and that civilization is more than lifestyle or purposeless self-fulfillment.

All knowledge is theology diluted; all culture and politics are a reflection of theology grounded in metaphysics. Our knowledge of God may be transcendent or immanent, truth to be found or made. It might be understood as objective, or subjective and realized via race, gender, economic class, or an unfettered individualism.

Positivism and the Enlightenment demonstrate an inescapable metaphysical faith, as do all traditions. To avoid superstition in knowledge or faith, Cassirer rightly notes, evidence must lead, rather than conform, to conclusions. But what the Enlightenment fails to acknowledge is that its own methodology leads to a rejection of an objective scientific rationalism. The will responds to the substance of its actor, the will of the Enlightenment reflects an ontological violence. The Enlightenment is dedicated to the pursuit of truth, but concludes in an existential-

ist authenticity. It is important to emphasize that *the primacy and denial of seeking truth is the necessary yet self-contradictory conclusion of the Enlightenment.*

Within the American context of Western culture, the traditional pursuit of wisdom as the apogee of knowledge rising from mere fact (*scientism*) to knowledge (*scientia*), and then to wisdom (*sapientia*), is advocated by figures such as Washington and Edwards (and even Charles Sanders Peirce); the new pursuit of an existential aesthetics is introduced by Emerson, and later by William James and John Dewey.

The pursuit of wisdom and beauty facilitates a culture not of violence but of freedom and virtue; it offers us the possibility of obtaining wisdom as a means of escaping a violent willfulness. It offers us the possibility of being decorous. Decorum stands opposed to tolerance and authenticity, just as responsible freedom stands opposed to existentialism. It offers the possibility that the will can and ought to be reconciled with truth via love; we ought to do the right thing, not merely what we want or feel. *Decorum is where will and substance combine in the attempt to realize transcendent beauty. Not as a triviality or as an act of oppression but as the realization of responsible freedom.*

The existentialist is a dogmatist but as we have seen, one without meaningful hope. Existence just is, therefore, the destruction of hope is freedom. But perhaps a transgressive hope is disturbingly nihilistic. Perhaps hope can rightly be restored in the name of practicality. That is the aim of the utilitarian trend within the Anglosphere, and of the American pragmatist, Charles Sanders Pierce. He notes that it is by our works that we shall and should be known. So how can we qualitatively distinguish between the works that we achieve? How do we distinguish between decorous works from those existential and violent? Within pragmatism occurs the same battle we have witnessed before, between the will seeking to transcend itself in the pursuit of Truth, and the will seeking to affirm itself as an act of authenticity. We will survey this battle in the next chapter.

9

FROM PURITAN AND ROMANTIC
TO PRAGMATIST

W^e have seen that early American culture was particularly informed by Puritan and Anglican belief historically situated within the Baroque. During that period a deep struggle within Western culture begins, a struggle unresolved to this day. That struggle centers on the refutation of a once dominant Aristotelian Scholasticism. Its opponents are united by their objection to the specifically Scholastic synthesis of physics and metaphysics, though they differ among themselves in their varying understandings of science and reason.

The physics and metaphysics of Aristotelian Scholasticism were accompanied by the metaphysics and cosmology of Ptolemy. The loyal Catholic Copernicus reveals flaws in Ptolemaic astronomy; he brings into question the prevailing empiricist and rational geocentric view of the cosmos. The less orthodox Galileo similarly attacks the foundational assumptions of a dogmatic Aristotelian and Ptolemaic physics. He examines the mechanical aspects of phenomena, which are then synthesized by Newton's new mathematics. Panofsky observes that the Renaissance and Baroque application of mathematics to physics is a radical perspectival shift setting the stage for reality conforming to how we think. As he puts it:

> There was a curious inward correspondence between perspective and what may be called the general mental attitude of the Renaissance: the process of projecting an object on a plane in such a way that the resulting image is determined by the distance and location of a "point of view" symbolized, as

it were, the *Weltanschauung* of a period which had inserted an historical distance—quite comparable to the perspective one—between itself and the classical past, and had assigned to the mind of man a place "in the center of the universe" just as perspective assigned to the eye a place in the center of its graphic representation.[1]

Aristotelian Scholastic rationality, with its categories and logic, is informed by a perspectival dilemma: is the mind of God or the mind of humanity primary? Is truth objective or subjective? The intrinsic problems of Scholasticism are reevaluated by continental philosophers such as Descartes and Kant, and by Anglosphere thinkers such as Bacon, Hobbes, Hume, and Locke. Newton advances the substantive bifurcation of science and reason while shifting the focus of truth and reason from the mind and perspective of God to the mind and perspective of humanity. But if the mind and perspective of humanity are primary, how can their contents be judged valid?

As a matter of historical contingency, the Protestant, indeed Augustinian response to this reevaluation of Scholasticism is firmly established in the American colonies. It is within the Anglosphere Protestant Reformation that the call to return to a biblical and Augustinian mode is dominant. The faithful Augustinians attempt to defend the cosmological and theological *scientia* of millennia without ascribing to dogmatic systems of science or reason—be they Aristotelian, Ptolemaic, or other. The facts of nature are to be pursued and considered as much as the facts of Scripture. But the major problem, for Edwards and for us, is how to reconcile natural or Scriptural facts with understanding. If unreconciled, the facts of science and the facts of Scripture remain—but by definition, this reduces them both to mere fetish. Both claim to be sacred by their attempt to explain reality and life. What is new is that the pastor and the scientist vie for legitimacy, but neither offer rational ontological grounds for their claims. In a world of faith and facts, Logos no longer unites science and reason, pastor and scientist. So the newly competing proponents of faith and fact advance not civilization but violence.

The Augustinians find themselves surrounded by the conflicts between traditional metaphysics and its materialist, mystical, and nominalist antagonists. In particular, a classical-Judeo-Christian tradition is confronted by its new modernist-postmodernist antagonist. That antagonism dominates the future narrative of Western civilization. The crux of the matter is whether a positivist science can be reconciled with meaning, particularly with that offered by the classical and Judeo-Christian foundational principles of Western civilization. We now know that it cannot. *It is not that positivism is wrong. It is that it does not do enough.*

In the midst of these philosophical and scientific conflicts, Protestants and Catholics struggled. The positivist worldview, which is attached to philosophical nominalism, materialism, and mysticism, is on the rise; all rational worldviews that differ are newly on the defensive. During the Baroque period, both Puritan and Anglican face that formidable challenge to their core beliefs—a challenge that must be faced while avoiding even the appearance of being antiscientific. However, science has been transgressively redefined by the challengers, and thus only a positivist perspective and conclusion is deemed acceptable—reality notwithstanding.

The trajectory of American and Western tradition from the Baroque to the modernist period splits on this point. The Puritans believe in the foundational principles informing traditional Western culture while struggling to reconcile those principles with a newly redefined science. They refuse to accept a transgressively existentialist and nihilist worldview. Nonetheless, their qualitative understanding of reality faces the challenge of a willful existentialism. That existentialist will can varyingly be dedicated to the pursuit of power (Sade, Emerson, or Nietzsche) or fairness (Rawlsian liberalism), or to seeking a common good as claimed by utilitarianism and pragmatism (Mill, Peirce, James, and Dewey). On the other hand, Burkean conservatives wish to pursue a traditionalist path in science and culture, one grounded in a habitualized form of becoming. Denied by all is a rational and historical pursuit of qualitative knowledge, of *scientia* and *sapientia*.

The liberal arts are by definition dedicated to enabling us to live a free and responsible life. Traditionally, history is considered a liberal art, a means by which we can escape the prison of the present; it permits us to acquire a higher and liberating perspective beyond the merely contingent. Augustine's understanding of history is that it is the stage on which we participate in a cosmic moral drama. As such, it provides us with the perspective necessary to escape the chaos, or the seemingly inevitable violence, of life at the moment. For existentialists, history as a liberal art makes no sense; their goal is to pursue an ahistorical scientism and mysticism rather than wisdom. Disinterest in history is concurrent then with the rejection of the possibility of achieving such a liberating perspective. It can occur in two fashions: by history being judged unintelligible or inevitable. History can be understood as a sequence of events lacking ontological cause and effect (Hume) or as an ironclad deterministic dialectic (Marx). A neglect of the liberal arts, particularly of history, results in either nihilism or totalitarianism.

The rejection of history as the ontological and rational pursuit of wisdom requires the rejection or the redefining of the notion of *Being*, of a qualitative

reality enjoying objective purpose. It is to privilege *becoming* instead. Martin Heidegger crystallizes the redefinition of Being as becoming in his text *Being and Time* (1927). The enormity of this shift is writ large in the history of the modernist-postmodernist twentieth century. Nihilistic or totalitarian socialism, of Left and Right, is the inhumane consequence.[2]

The neoclassicist and romantic are historically part of this foundational shift. Both deny the possibility of knowledge of Being—unless Being is reduced to positivist fact or redefined as becoming. This results in a world of fact, feeling, and process, a world grounded in the will rather than purpose, decorum, or love. This crucial redefinition of Being is at the core of yet another tradition in post-Newtonian thought: pragmatism.

The History of the Denial of History: Toward Pragmatism

The traditional classical-Judeo-Christian focus is on a reconciliation of becoming with Being. The world is purposeful process; responsible freedom is possible. Since the Baroque period, Being is increasingly denied. Heidegger shifts attention from Plato to Parmenides and Heraclitus, proponents of becoming rather than Being. He asserts that the work of these philosophers endures through history *because they are ahistorical.* They exist in the realm of purposeless becoming; history and philosophy are both existential. As such, their perspective is foundational to an existentialist understanding of science, reason, and culture. Ahistorical philosophies offer, then, one reductive possibility for knowledge: the momentary occurrence which if understood at all, evidences a nostalgic violence. Truth is becoming, and truth claims are just momentarily binding. But if truth is becoming or momentary then it negates knowledge of reality as such and denies virtue. Truth is us, or it is dead.

Ahistorical claims notwithstanding, the historical development of this trend is clear. Puritanism began in sixteenth-century England, and subsequently flourished in both England and America. It was during those centuries that foundational changes occurred in the scientific rationalism of the West. Not only the work of Copernicus but also that of Galileo and Newton had their impact. They established the flaws within the Ptolemaic system, and revealed the flaws within the Aristotelian-Scholastic system. Correspondingly, Francis Bacon's hope to establish the empirical laws that govern not just the Earth but the entire universe was advanced by Kepler, whose ideas in turn were pursued by Descartes.

Catholics such as Descartes were dedicated to a reconciliation of traditional

faith with a new science and reasoning. In contrast to Newton, who admits he cannot explain gravity (as Hume also argues), Descartes's vortex theory posits that reality is comprised of things swimming in a continuous ether maintained by God. But he tragically posits a dualism of matter and idea operating within that dynamic universe. Descartes pursues an Aristotelian perspective consisting of a dualism of reason and faith, one that is paralleled by a dualism between physical science and mathematical rationality. He thus undermines both God and purpose in the universe. As Burtt explains:

> The conception of weight, velocity, etc., as further mathematical dimensions akin to length, breadth, and depth, except that they are dimensions of motion rather than of extension, harboured enormous possibilities which were entirely unrealized either in Descartes or in the work of later scientists. Had he succeeded in carrying the thought through, we might to-day think of mass and force as mathematical dimensions rather than physical concepts, and the current distinction between mathematics and the physical sciences might never have been made. It might be taken for granted that all exact science is mathematical—that science as a whole is simply a larger mathematics, new concepts being added from time to time in terms of which more qualities of the phenomena become mathematically reducible.
>
> The vortex theory was, none the less, a most significant achievement historically. It was the first comprehensive attempt to picture the whole external world in a way fundamentally different from the Platonic-Aristotelian-Christian view which, centrally a teleological and spiritual conception of the processes of nature, had controlled men's thinking for a millennium and a half. . . . Now God is relegated to the position of first cause of motion, the happenings of the universe then continuing in aeternum as incidents in the regular revolutions of a great mathematical machine.[3]

In this context, it cannot be resolved whether that great mathematical machine has any, much less benevolent, purpose. Cartesian science, reason, and the notion of Being or God are all attacked by Thomas Hobbes, whose combination of materialism and nominalism is fully realized via a rejection of Being and Truth. In suggesting that we abandon tradition and faith to face the reality of power as the nexus of the world, he goes well beyond the at best tepid Catholicism of Galileo or the unorthodox Christianity of Newton. Hobbes asserts that there is no cosmic truth or mind. The only mind that exists is located in a ventricle of our brain. That is the only perspective that matters.

Therefore there is no objective Truth, no cosmic cause and effect, no meaningful knowledge beyond brute experience. The world is an infinite, monotonous, and violent mathematical machine. Hobbes is a primary articulator of the postmodernist Anglosphere, in which a secular worldview champions humanism but denies the reality of Being—human or other. It rejects qualitative belief—and therefore intelligent responsible freedom. It condemns us to pursuing strategies of power rather wisdom and virtue.

In contrast are the efforts of Newton. The ideas of Kepler, Descartes, and Galileo are synthesized and advanced in the work of this figure. Newton's deism (and Arianism) reflects a dichotomy similar to that of Descartes. On the one hand is material fact, on the other hand is mind or idea; there is no Trinitarian or Incarnational bridge to connect the two. In contrast to Hobbes and Hume, who focus exclusively on the human mind, Newton (and Descartes) also considers the role of a cosmic mind. But the relationship between Newton's human mind and the cosmic mind does not operate within an Augustinian qualitative continuum ranging from pure divinity to mere matter. Again, in contrast to Hobbes and Hume, who deny cause and effect as understandably grounded in reality, Newton (and Descartes) believes in a universe informed by cause and effect operating in a divinely created world. However, Newton shares with Hobbes and Hume a commitment to nature as material process or a manifestation of mechanistic becoming; Newton puts into doubt the traditional qualitative continuum of Western civilization and its purposeful defense and reconciliation of matter, becoming, and Being, of fact, time, and purpose.

We may summarize by considering the variety of competing perspectives concerning the nature of gravity: for Dante, gravity is love—that is, the Divine cosmic impetus for completion; becoming seeks Being. For Galileo, gravity is material force. Descartes, who found Galileo repugnant, views gravity as matter directed by mathematical and rational force operating within a cosmic continuum; there is no empty space. Newton, who admired Galileo, views gravity as operating on matter within void; for Newton, there is empty space. For Edwards that which appears to be void is actually the active will of a Divinity understood, with difficulty, as Being.

Those who view gravity as *ontological* Love, Reason, or even Will—within a purposeful reality—are attempting to remain in harmony with Western tradition and its cultural celebration of responsible freedom. Each at least minimally focuses on a traditional aspect of the Divine. In contrast is Galileo, who posits a total break with tradition by associating gravity with mere material force; Newton deistically attempts to have it both ways (Divine and material), while the

later Heidegger (and Heisenberg) view of gravity is as Being-in-the-world. Newton reintroduced an Aristotelian understanding of gravity, but without Aristotle's notion of an objective Final Cause—or special ends—existing in the universe. Instead of things having a sacred place within a decorous world, the idea is of gravity as a thing being in a place—and that we are part of that positioning.[4]

The foundational difference between Dante, Descartes, and Edwards on the one hand, and Galileo, Newton, and Heidegger on the other hand, is not and cannot be grounded in or understood via the collection of empirical data. It cannot be understood via positivist scientism. It is grounded in differing metaphysical beliefs. Respectively, those beliefs are that the world is the object of our thoughts, words, and deeds, or its product. Does objective truth or human pride prevail? If the latter, then how can science or culture be?

The American Context: Science, the Will, and Grace

And so we are brought to the American reaction, in particular, the thought of the Puritan Jonathan Edwards. We have already looked at Edwards's response to Newton. Edwards addresses the denial of the possibility of Being, the separation of fact from purpose and truth. He remains determined to view Being as real, and distinct from becoming except for the Incarnation. The Puritan attempt to maintain the distinction *and* unity of Being and becoming (via the Trinity and Incarnation) maintains also the denial of us as God. This position is evidenced by Frederick Church's art. But in the romanticism of Emerson, human beings participate in Divine Being as it becomes: God is us becoming. This theistic existentialism leads to the nontheistic pragmatic assertion that Being is not humanity as divinity becoming. Being is now merely us becoming. The pragmatic assertion that Being is us becoming is seemingly as natural as it is naturalistic. Truth is now what works for us.

One can trace the historical steps leading from Edwards to Emerson to John Dewey. However, it should not be presumed that there is an intellectual inevitability to this chronological sequence. The shift from Puritan to Unitarian to pragmatist is only inevitable given the abandoning of the traditional Western notion of reconciling the distinct realms of Being and becoming, purpose and change, wisdom and freedom. Instead, there is now a focusing on becoming alone—be it mundane or mystically informed. This shift results from the redefinition of science as fact and will, and its necessary but unscientific assumption that there is no reality, no realm of Being that makes the world and life understandable. To this

day, this shift divides American and Western culture into opposing and irreconcilable camps.

Our historical perspective affects how we understand the cultural contribution of Edwards. It is superficial and mistaken to view figures such as Edwards as backwoods reactionaries embracing a naïve defense of past and outdated tradition. If history is the arena in which a moral drama unfolds (as Augustine has it), then Edwards is and remains a vital player. The Reformed Protestantism of Calvin, Knox, and Jonathan Edwards spans the sixteenth to eighteenth centuries and remains vital to the present. All are engaged in a vital dispute, the outcome of which determines the very possibility and nature of civilization. The denial of a purposeful scientific rationalism always has been, and remains, a denial of culture.

In *scientia*, gravity is understood as a cosmic force resulting in proper completion within a purposeful universe;[5] history is a moral drama informed by responsible freedom, decorum is real, and the sacred is understood to be a material manifestation of what is true and good. In all cases we live in a meaningful universe in which truth sets us free from violence, despair, ignorance, and folly. In contrast, modernist *scientism* conflates truth with facts (just as postmodernism conflates Being with becoming); in this case we are living an existential life in a quantified world. Gravity is understood as material force factually described within a purposeless naturalistic universe; history is ahistorically a random sequence of events or a dialectical violent necessity. If not merely oppressive, the sacred is understood to be based either on personal emotional commitment or social utility. In short, there is no decorum, no sacred place, beyond our own will to power.

The gap between these two worldviews is enormous. Puritan America attempts to bridge that gap between qualitative and quantitative worldviews, between *scientia* and *scientism*. Puritans such as Jonathan Edwards attempt to do so in one way, Emerson another, and pragmatists such as Peirce and Dewey still yet another. It is possible—indeed common—to view the scholarship of those persons as a progressive chronological trajectory grounded in intellectual necessity; that the sequence from Edwards's theistic Puritanism to Dewey's atheistic pragmatism is intellectually and culturally necessary. In that view, Edwards is reactionary and Dewey is progressive. But it is also possible to view that sequence differently: that Edwards is resisting a perennial metaphysical claim no more scientific than his own, and one that might well result in scientific and cultural catastrophe.

Edwards presciently observes that positivist scientism cannot know that the world is purposeless, and that things have no meaningful place in reality. *It cannot*

know that which it claims, that we are cosmic squatters at best. It is beyond its ken. A system of thought that views knowledge as factual cannot know that the world is purposeless—and yet must assert that position. The resulting foundational shift in our understanding of reality, of Being, requires a complete deconstruction of traditional Western culture. Therefore it is intellectually untenable to favor a total deconstruction of Western culture based on the metaphysical assertion that the world has no purpose. More than untenable, it is dangerous and irresponsible folly. Edwards clearly saw the limitations in Newton's science. As Paul Conkin explains:

> One result of Edwards' conception of God was a distinctive interpretation of Newtonian physics. The whole vast system in the *Principia* was, to Edwards as well as to Newton, a beautiful revelation of God. . . . But Edwards was aware that the new physics, and the all-important concept of mass attracting mass according to uniform laws, *was an accurate description rather than a complete explanation.* [Italics added] What was the cause of gravity? It seemed a great mystery. . . . God is thus responsible for the most basic energy of all, that which holds atoms together and provides the stable building blocks of the universe. What many viewed as a mechanical universe becomes completely spiritual.[6]

For Newton, gravity remains problematic. Certainly he can describe matter affecting matter via motion, but what is the cause of motion? How does one object—separated by empty space—affect other objects? Lacking a numinous worldview in which all participate in an active meta-physical continuum of varying degrees of completion, Newton is faced by what Hume calls mere probability, Hobbes calls a pointless mechanism, and Berkeley views as purely spiritual. All deny Trinitarian science in which what and why are reconciled. Newton's response is to secretly engage in alchemy—not as primitive chemistry, but as perennial magic by which material reality will newly conform to our will. It is by magic that the notion of sacred place dissolves. It is by magic that perversity becomes virtue.

For all their differences, Edwards and Hume agree that the assumed cause and effect of Newton's mechanistic view of reality makes no sense. Edwards posits a spiritual infinity to accompany Newton's scientific infinity. In contrast to deism, which reduces the universe to a dubious and dualistic mechanical or alchemical process, Edwards agrees that we live in the best possible world. In rejecting a mechanistic worldview subject to manipulation by the human will, Edwards

rejects not only sheer chance but alchemy and magic as well, while attempting to affirm traditional theology:

> Edwards joined with David Hume in denying any mechanical necessity between a cause and its effect and in thus exposing the most vulnerable side of any mechanistic philosophy. Edwards' belief in an unending but ordered creativity by God meant that there was only one efficient cause for each event, and this was God. . . . To glimpse the regularity is not to rejoice in a good machine, but to bow in praise before a rational God.[7]

For Edwards, the entire world is a moment-by-moment recreation grounded in the Will of God. The alternative view, that we create the world, was recognized by Edwards as horrific. This paralleling of a spiritual and a scientific monism grounded in a rational God is the bedrock of Calvinist *scientia*.

For Newton, the world is infinite, materialistic, and mechanical—and space is empty. For Edwards, God is transcendent, and nature is the immanent emanation of the Divine. Edwards escapes the foolishness of mechanistic philosophy while coming perilously close—if not succumbing to—a monist denial of the scientific, rational, and cultural import of Trinitarianism and the Incarnation. If reality is an emanation of the mind or will of God, and Christ is understood as God's perfect idea of Himself, then the Trinitarian notion of Christ as the bridge between fact and understanding is obscured. Christ as the enabling link between matter (fact or Being), time (becoming), and divine purpose (Being) is altered. So, too, is our understanding of science and reason.

Edwards attempts to escape a monist denial of Trinitarianism by his advocacy of orthodox biblical Christianity and reliance upon the doctrine of Grace. As Conkin puts it:

> Edwards' emphasis upon the sensual (he called it sensible) and esthetic elements in religion, and thus upon an existential immediacy, was related to his deep attachment to nature. Even as a boy his own intense religious experiences usually occurred in the fields or woods. By habit he spent time in outdoor meditation almost every day of his life. His sermons were at their best when he used natural imagery as a means of making vivid his meaning (the spider and fire in "Sinners in the Hands of an angry God"). He spiritualized this naturalism by his stress upon emanation and immanence. To Edwards, nature contained the most immediate and persuasive revelation of God's beauty. The spiritual man saw God in all of His glorious creation.

Nature was an image or shadow of divinity. Yet, as a Calvinist, he reserved this insight for the elect few and balanced it by just as ardent an allegiance to the Bible as a second revelation. His orthodoxy alone separated him from a later, transcendental [sic] view of nature.[8]

So in contrast to the traditional continuum—from ideal to matter bridged by the Incarnation and informed by a critical distinction of the Divine and immanent—there is now a choice. Edwards offers that as an act of faith we can choose to believe (but not *know*, as pointed out by Hume) in a mechanistic world without meaning, or as an act of faith we can choose to believe in a world which is a materialized emanation of the mind and will of God, Who is responsible for its moment-to-moment existence. The problem is explaining that moment-by-moment existence without denying or playing God. Newton avoided the problem, Descartes postulated his vortex theory, Edwards problematically saw it as the will of God, and we will later discuss Charles Sanders Peirce's "agapism."

Cause and effect is understood by Edwards to provide the necessary evidence of the will of God unfolding in time. But if cause and effect is grounded in the Divine Will then the occurrence of evil must be part of the Divine Will. Edwards's response to this view resonates with the classical-Judeo-Christian Anglosphere of Alexander Pope:

> All nature is but art unknown to thee;
> All chance, direction which thou canst not see;
> All discord, harmony not understood;
> All partial evil, universal good;
> And, spite of pride, in erring reason's spite,
> One truth is clear, "Whatever IS, is RIGHT."[9]

The concept of all things ultimately working for the good of those who believe in God is biblical and traditionalist. Writes Conkin:

> Limited, finite man, unable without grace to view and taste the glory and perfection of God, and to participate in that glory, might stumble on the problem of evil and curse God. Unenlightened and blinded by the partial and temporary, he might be unable to comprehend the justice of a God who consents to what seems to be evil, and, even more, decrees eternal punishment for what He Himself has decreed.[10]

So humanity plays a critical role in that drama which is called life: natural and moral evil are not a divine and sadistic test, but part of a cosmic drama necessary to the realization of truth, love, and responsible freedom.[11] Echoing ancient Augustinian thought, God made the world in perfection, but since that God is one of Truth and Love, then freedom exists as well. A world informed by freedom is one that must permit the possibility of foolishness or worse. Freedom is grounded in reality, freedom is an objective human condition not to be denied. But it is also recognized to be a problem; Truth and Love are the solution to that problem. Freedom is the ability to do evil or good, but when one does good, then freedom rises to transcendent wisdom. Freedom finds completion and thus ceases to be willful. It becomes beatific Love.

We enjoy the blessings of responsible freedom by rising above the consequences of the misuse of that freedom. As the mind and will of the universe, God knows what we will do with that freedom, but is not responsible for what we do. For better or worse, the immediate consequences of our choices are our own; the eternal consequences are His alone.

This Augustinian perspective falters, however, when the substance of God shifts from Truth and Love to fact and Glory. It falters also if a monist view replaces a Trinitarian one. For ethics and science to be ultimately grounded in the will (be it Divine or human), then the free and responsible pursuit of objective ethical and scientific knowledge becomes unknowable.

This doctrine of partial evil being part of the universal good (as articulated by Pope's famous poem) presents several important problems for Edwards and for us. As part of the Baroque period, Edwards lived in a sentimental and factual age. A commonly embraced notion was that virtue lies in benevolent sentiment. Edwards disagreed, arguing that particular acts of charity could actually result in evil by interfering with Divine providence. Like Kant, Edwards rejects consequentialism as primary to morality. Human freedom is real, and is a problem since the time we first attain self-consciousness. To escape the will to power or folly, we need the help of Grace. Conkin explains Edwards's position that God's Grace trumps attempts of human charity:

> Any limited benevolence toward the part instead of the whole disrupted the harmony of minds in God's universe and was therefore synonymous with ugliness. It made actions that would, with the necessary consent, be holy and virtuous into gross and ugly things. Man broke his union with being, denied his ontological dependence, and absolutized himself into a prideful, egocentric world in selfish revolt against the whole. This evil was not positive but privative. . . . Harmony with being came only with grace.[12]

The traditionalist Edwards affirms perennial orthodox belief: freedom is the ability to do right or wrong. In Augustinian fashion, he states that wrong or evil is not real but a deprivation of reality. However, our desire to do what is right is no guarantee that we shall be successful. We might lack the necessary will, or wisdom, to do so. Those are offered and received via Grace. When will and wisdom are wrong, the result of freedom is evil, but should the will do what is actually right, then the will and freedom become complete in Truth and Love. To unite with Truth is not to deny, or affirm, the human will. It is to beatifically transcend it.

Edwards's attempt to reconcile via Grace the perspectives of Newton, Hume, and Locke with a Calvinist and Augustinian Christianity is brilliant but problematic. Just as Scholastic conceptualism could not justify the need for the existence of truth in the mind of God *and* the mind of humanity, Protestant positivism lacks closure on a reconciliation of God's will with human freedom in a world of facts and process. *The positivist Christian cannot overcome the positivist limitation of knowledge to either nominalism or a material/spiritual monism.* That perspective denies the scientific rationalism of Trinitarian culture and makes faith a matter of Scriptural authority or feeling. This is evidenced by Puritanism facilitating the development of Unitarianism. For Edwards, the emphasis on God as Truth or Being shifts to God as Will and becoming. For others such as Emerson and Dewey, God or Being is us becoming.

The incoherent advocacy of science, reason, and ethics in an ineffable yet morally deterministic world is exploited by later writers such as Derrida. He argues in *The Gift of Death*, via the account of Abraham and Isaac, that whereas God expects us to be moral, we are denied by God the necessary knowledge to be moral. If we lack the knowledge to be moral we lack knowledge of a world that is intelligible. Therefore, Western scientific rationalism is incoherent or absurd.

Edwards's focus on the doctrine of Grace in a naturalistic world animated by God's will results in serious problems. Edwards argues that when our free will is in harmony with God's will, then we live in a state of Grace where goodness abounds. This understanding of Grace casts uncertainty on our need and capability in having the scientific and rational knowledge that makes informed ethical choices possible. It infers that natural and moral evil marks a denial of Grace and thus makes God the callous author or facilitator of natural calamities and social injustice. Perhaps most crucially, it requires God as Being to be replaced by God as becoming. It is the will, not the substance of God, that actually matters. But if God or truth is will, then truth is redefined as arbitrary or violent. If that which is good is that which is willed, then how can we know that goodness exists or recognize it when it eventually prevails?

From Edwards to Emerson: The Divine Will and the Will Divine

Intellectually as well as politically, becoming without Being deconstructs; change without purpose is just another way of admitting we are lost. For Edwards, Being prevails as the glory of God. But for Kant, Being is no longer transcendent, or glorious. As Conkin puts it:

> Virtue was not a matter of correct action, but of the right ground for correct action. Anticipating Kant, [Edwards] found virtue only in the good will, in the right attitude and the right perspective. But unlike Kant, he tied virtue to a conscious end—the glorification of an irresistibly beautiful Deity [Being].[13]

Edwards accepts that the Will of God is supreme, and that since cause and effect cannot be known, then human choices cannot be known to be good at the moment. The core beliefs of Christianity justify responsible freedom: that at each moment we have the responsibility and necessity of trying to do the right thing. But if we need to conform to the unknowable Will of God, then we cannot consciously be successful. We are limited to a variety of dualistic and monistic heresies: pantheism, self-deification, antinomianism, Gnosticism, Arminianism, Averroism, Existentialism, etc. The consequence is a reductionism in which scientific rationalism is limited to serving a variety of technologically advanced brutalities.

In contrast to Kant, and more obviously to Nietzsche and Emerson, Edwards strives to maintain that good will should be informed by a glorious substance known as God. He struggles to maintain that traditional balance of will and truth, of the immanent with the transcendent. This marks a fundamental crossroads in American and Western culture: the choice between a scientific rationalism based upon transcendent—that is, objective—wisdom and a scientific rationalism based on obedience to the immanent will, whether Divine or human. Edwards's position resonates with that articulated by Augustine (in his explanation of the *Akedah*, the story of Abraham and Isaac).[14] That position relies upon an understanding of the nature of Being, not just will, process, and becoming. Augustine celebrates an optimistic ontology; our will is to be informed by glimpses of ontological knowledge. But in trying to reconcile Christian tradition with a newly positivist form of knowledge limited to fact and process, becoming assaults Being, the will threatens to replace knowledge, and a good will newly wills what is good.[15]

This brings us to a consideration of Emerson. He asserts that we not try to understand the Being or Will of God; rather, we should attempt to live as one with that will or mind. Being is God and God is us becoming. Conkin explains:

> Viewing existence as mind, as idea and will, and finding idea and will as man's essence, Emerson simply asked man to join himself, or be true to himself. . . . Emerson proclaimed a possible merging of man and all existence, a merger that eclipses all varieties of alienation. . . . He completely rejected the doctrine of grace. In substance, man and all being are of one nature. The Spirit of God is the spirit of man. The spirit of man is the Spirit of God. . . . His was a world in which nature was both the source of all evil when men adhered to the delusion of materialism, and the pathway to beatitude when self-reliant men perceived the ideal reality beyond the material shadow.[16]

An ancient root of this position, which recurs periodically and universally as a variety of monist and dealist philosophies, is found in the neo-Platonism of Plotinus. Its basic tenets include the notions that existence is an emanation of mind and will, that humanity is rightly one with that mind and will, and that the further from that mind and will we are, the more we exist in a sordid materialism. The material world is the nexus of evil. Accordingly, knowledge of a scientific rationalism in which reason and ethics are objective makes no sense. Therefore, classical-Judeo-Christian belief and Anglosphere traditionalism are impediments to the spiritual. Emerson embraced and advocated a neo-Platonic, antinomian, and heterodox version of Christianity. Its heterodoxy centers on its rejection of scientific rationalism and Trinitarianism. Instead, it pursues a monistic materialism/spiritualism. This affects the very substance of how we understand science, ethics, and art. *A denial of Trinitarianism is more than of sectarian importance. It reframes our understanding of the narrative of life within a violent context.*

Emerson's return to spirituality necessarily occurs as a reaction to the dominance of positivist scientism. That necessity is not merely grounded in an emotional response to a dreary materialism; as Hume and Edwards both indicate, it is also due to the failure of positivism in establishing, much less explaining, cause and effect. If knowledge is limited to individualized descriptive facts, then reason cannot produce knowledge of the world. In a world of fact and will, understanding cannot ontologically be rational. So either the world is meaningless, or meaning is grounded in an intuitive emotionalism. Reason does not exist at all, or is reduced to a willful subjectivism. Emerson's Unitarianism belongs within

the latter camp. Emerson not only rejects Trinitarianism and Grace as theological doctrines; he also rejects Trinitarian science and ethics that reconcile fact and process in a purposeful world of Being.

Emerson and Unitarianism: Being Is Us Becoming

The shift from Edwards to Emerson is a shift from Puritanism to Unitarianism. The movement gets its name by its denial of Trinitarian theology. In contrast to the notion of God as Father, Son, and Holy Spirit, God is now a single personality. Christ is God on earth, but instead of Christ being a unique and enabling link of becoming with Being, fact and process with purpose, Christ is now becoming as Being. Being, the transcendent aspect of Trinitarian theology, is neglected. Neglected also is objective knowledge.

This is much more than obscure theological speculation. To be understandable, reality must be reasonable. However, reason as a means of understanding objective reality requires a space between the self-conscious subject and the object to be understood. That space is traditionally established via the Doctrine of the Trinity. There is a difference between mind and matter, and when combined, truth is revealed and understood. But the mystical vision in which, to use Emerson's famous phrase, we are part and parcel of God, denies that space. Emerson's phrase requires that we all be Christ. Therefore, Being cannot be understood—it can at best be experienced by our divine selves.

An early American advocate of the constellation of ideas associated with Unitarianism was Jonathan Mayhew (1720–66) of Boston; the first official acceptance of the faith was by King's Chapel in Boston, which adopted a mild Unitarian liturgy in 1785. From the time of its inception in 1816, Harvard Divinity School was distinctly Unitarian and was so until it became a nonsectarian department in 1870. As we shall see, history demonstrates a clear shift from a Unitarian to a pragmatic scientism.

That shift occurs in three commonly noted phases. In the American Unitarian movement the first phase occurs from 1800 to 1835. It was formative and mainly influenced by the writings of William Ellery Channing (1780–1842). In words echoing those of Swedenborg, the poet Coleridge wrote of Channing: "He has the love of wisdom and the wisdom of love." Channing was only partially within the orthodox Christian tradition (he rejects the Trinity and views revelation as inspiration, but believes in the Resurrection). The second period, from 1835 to 1885, was deeply influenced by Emerson. In the third phase, the influence of Emerson

continues and possible agreements between many traditions around the world are considered (an early European example of which was the influence Buddhism had on Spinoza). This idea of a sociological pursuit of an assumedly universal wisdom informs a later tradition called theosophy, an immensely influential cultural movement in both American and Europe.

The foundational flaw of this view is that if Being is us becoming, then truth is redefined as authenticity and reason is redefined as feeling. It is a mysticism that is no longer interested in scientific rationalism or an objective Truth or God. *Disagreements over feelings or claims of authenticity cannot rationally or civilly be discussed.* So the redefinition of Trinitarian science and reason to a Unitarian and ultimately monist perspective marks a return to a neopagan authenticity in which conflicting truth claims paradoxically cannot, or must be, resolved. The monist position holds the identity of God with nature and humanity. We can choose to nihilistically deny that identity, or affirm that identity via an intellectual and social absolutism. The net result is a denial of responsible freedom. Goodness is determined by our wills, but our wills either should not, or must, conform.

As a matter of intellectual history, the Unitarian movement begins during the Baroque period. Given the Newtonian redefinition of science—and thus of reason and theology—Unitarianism increasingly prospered. Unitarianism enjoyed immense influence beginning in the seventeenth century and blossoming in the eighteenth- and nineteenth-century Anglosphere. Instead of the Trinity and the singular importance of the Incarnation, Unitarians argue for a biblically based experiencing of the Divine. The rise of their influence prompted in England the 1662 Act of Uniformity, condemning and expelling those clergymen who preached accordingly.

Such efforts notwithstanding, this redefining of science, reason, and theology informs not only Unitarianism but a variety of then-contemporary mystical theologies. Shared is a shift from love as the splendor of wisdom, to love as feeling and experience; a shift from Being and becoming as distinct *and* united, to Being as us becoming.

For example, this is evidenced by the work of Spinoza. Jewish tradition is deeply grounded in three fountainheads of Israel: the Torah, the Talmud, and the Kabbala. During the Baroque period, Kabbalism exponentially expanded its influence in the West, particularly via a sacred and mystical text, the Zohar. It is the Kabbala to which Spinoza dedicates his efforts. In the preface to a volume on Spinoza's analysis of Descartes's philosophy, Dagobert Runes observes that a cardinal concept of the Kabbalistic tradition holds God as

the Ain Soph—the Endless One—Whose eternal Being (Elohim) lives in the soul of man (Shekinah). The Kabalistic mystic teaching that man's love of God and man's love to man are one and the same thing is found time and again in Spinoza's profound "Man can be a God to Man."

The Kabalistic concept of the Zaddik, the Sage, who lives a life of perfection guided only by reason, justice and generosity, is close to Spinoza's "Free Man" who . . . lives rather in equanimity and security, forever conscious of the idea of God or Creative Nature (Tikkun).[17]

In *American Art: A Cultural History* (2000), David Bjelajac discusses a painting by Samuel King of the Reverend Ezra Stiles (1771). The painting evidences clear influence from Jewish Kabbalistic mysticism. The Reverend Stiles, president of Yale University from 1778 to 1795, is depicted before his bookcase; over his right shoulder is a symbolic depiction of the universe, the center of which contains the Hebraic name of God. Over that name are the words: "All Happy in God"; beneath is found a cross, to the right of which is a small spot symbolizing the presence of evil in a world of Grace.

Stiles was deeply interested in Kabbalism and alchemy. As Bjelajac recounts:

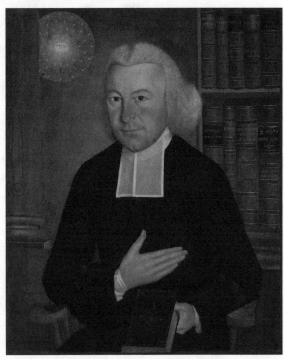

Samuel King, *The Reverend Ezra Stiles*, 1771

Under Stiles's direction, King included in the portrait occult, Kabbalistic symbols of the cosmos centered on the mysterious tetragrammaton, or the Hebraic holy name of God. . . . While Stiles reconciled alchemy and Jewish mysticism with Christianity, other eighteenth-century Americans culti-

vated an interest in such esoteric subjects as a means of discovering religious truths historically antedating and superseding Christianity.[18]

The shift from Trinitarian to Newtonian science requires a shift to a materialist/spiritualist methodology. Just as Newton was an alchemist seeking non-Trinitarian science, Stiles believed that the key to seeking truth was a reconciliation of alchemy and mysticism; he was particularly interested in reconciling Jewish mysticism with Christian tradition. But that tradition is grounded in a scientific rationalism; mysticism is not. Is such a reconciliation possible?

Such aspirations became widespread once Trinitarian science was questioned. Emanuel Swedenborg (1688–1772) is another such example. At the beginning of his career he was a mathematician and physical scientist. Soon after the 1743 publication of his work *On the Infinite and Final Cause of Creation*, which discussed the relationship between body and soul, Swedenborg had a mystical experience. He claimed that in 1745 God appeared to him and commissioned him to explain the true theology. In harmony with his contemporary milieu, his explanation denied Trinitarian theology. Accordingly, Christ is God the Father manifest on earth; God is Being *as* becoming. There is one God in whom there is a Divine Trinity, but that Trinity is Christ. From God emanates a divine sphere which appears as the Sun. From the Spiritual Sun proceeds the natural sun.

Unitarianism and Swedenborgian spiritualism are parts of a broader cultural trend within Western and American civilization. In America that trend passes through the stages criticized by Edwards: Arminianism, Arianism, and deism, to a modernist empirical-mystical syncretism. The influence of this New Age syncretism was particularly manifest in theosophy, a movement founded in 1875 in New York, and widely influential at the turn of the twentieth century. Madame Blavatsky and Rudolph Steiner are two prominent advocates of this view. In *The Key to Theosophy* (1889), H. P. Blavatsky writes:

> Some limit ancient wisdom to the Kabala and the Jewish Zohar, which each interprets in his own way according to the dead-letter of the Rabbinical methods. Others regard Swedenborg or Boehme as the ultimate expressions of the highest wisdom. . . . One and all of those who put their theory into practice are rapidly drifting, through ignorance, into black magic. Happy are those who escape from it, as they have neither test nor criterion by which they can distinguish between the true and the false.[19]

Blavatsky seeks truth, but denies the existence of an objective transcendent Truth or God. When asked about God, she responds:

> We reject the [Judeo-Christian] idea of a personal, or an extra-cosmic and anthropomorphic God, who is but the gigantic shadow of man, and not of man at his best, either. The God of theology . . . is a bundle of contradictions and a logical impossibility. . . . This God is called by his devotees infinite and absolute, is he not? . . . if infinite . . . how can he have form, and be a creator of anything? Form implies limitation, and a beginning as well as an end; and, in order to create, a Being must think and plan. How can the ABSOLUTE be supposed to think—i.e. have any relation whatever to that which is limited, finite, and conditioned?
>
> This is a philosophical, and a logical absurdity. Even the Hebrew Kabala rejects such an idea, and therefore, makes of the one and the Absolute Deific Principle an infinite Unity called Ain-Soph.
>
> [Those Jews who nonetheless believe in the Tetragrammaton] are at liberty to believe in what they please. . . . Shall we accept their sophistry for all that?[20]

Blavatsky maintains that in contrast to the spiritual that has commonly descended into the merely occult, theosophy offers an occultism informed by empirical experience. Theosophy advocates a sociologically grounded pursuit of universal wisdom. For those who would reject equally occultism and theosophy as recurrences of ancient ignorance and superstition, Blavatsky argues that they must reject biblical miracles as well. What does the theosophist seek? Echoing Emerson, she seeks to experience the divine spark informing all of reality: "We assert that the divine spark in man being one and identical in its essence with the Universal Spirit, our 'spiritual Self' is practically omniscient, but that it cannot manifest its knowledge owing to the impediments of matter."[21]

Blavatsky's system—like all of this period's spiritualisms—is immanent rather than transcendent. In a monistic world of fact and feeling, if truth is more than fact, then truth is a matter of feeling. Truth is in us, rather than found by us. This empirical-mystical paradigm has ancient origins. It resonates with neo-Platonic, pantheist, and certain Eastern traditions. It differs from Jewish and Christian traditions by its denial of transcendence, the anticipation or occurrence of the Incarnational manifestation of the Divine, and the rational attempt to understand them both. That denial of transcendence, the Incarnational, and the rational is also a denial of objective knowledge in science, ethics, and art.

Given that knowledge is limited to facts and feelings, the unique status of Christ is reduced at best to a matter of hero worship. But what is important intellectually is that the reduction of the Doctrine of the Incarnation to mere hero worship is a denial of the possibility of pursuing an ontological scientific rationalism. That is to say, *regardless of what we believe personally, the Trinity, the Incarnation, and creatio ex nihilio are doctrines that affirm the possibility of seeking objective knowledge and wisdom; belief in those doctrines corresponds with belief in responsible freedom in the scientific and rational pursuit of wisdom.*

Transcendent principles affirm our ability to seek wisdom, but they also mandate humility. Traditionally, none but one can claim to have perfect knowledge of that wisdom; no others can claim to be God Incarnate. If the Trinity is denied, then the Trinitarian affirmation of the distinctiveness *and* the unity of fact, process (will), and purpose is denied—as is the pursuit of objective ontological knowledge. Edwards's defense of the Trinity involves much more than an emotional sectarian commitment. It involves a careful consideration of the intellectual, scientific, and social consequences of its denial. Those consequences are nominalist and monist. If those elements are distinct, then meaning is fragmented and incoherent. If they are unified, then meaning is reduced to subjective assertion where reason is subsumed by the will. The result is a materialist/spiritualist perspective united by the denial of the possibility of wisdom, of ontological reason seeking knowledge of Being.

So the denial of the Trinity and the Incarnation is more than a denial of hero worship or an archaic theology. It is a rejection of the distinction *and* unity of Being and becoming, of matter, mind, and will. This constitutes a denial of the possibility of scientific rationalism seeking glimpses of truth. It denies the pursuit of wisdom. It is also a rejection of the prohibition on us declaring ourselves to be gods. Rather, we are to be one with the divine. Or to put it in Emerson's words: we are part and parcel of God.

Cultures dedicated to serving transcendent principles are informed by responsible freedom. This results in political consequences. The Jewish state, as the chosen of God awaiting a messiah, denies the divinization of itself and others. Similarly, as Augustine established, neither culture, people, nor state can claim divine status. But those do deny such narcissistic worship of the self do so at terrible risk. Those who interfere with self-absorption incur the fury of the self-absorbed.

Emerson and Immanent Transcendentalism

After a brief stint in teaching, Ralph Waldo Emerson reentered Harvard to pre-
pare to pursue a career as a Congregational minister. He was confronted by an
intellectually and spiritually disputatious era. Perhaps reflecting his Puritan heri-
tage, Emerson contemplated the notions of self-reliance and compensation. To
Emerson, we are responsible for our actions, and those actions ought to result in
virtue. That, however, is but the beginning of the story. His predecessor Edwards
argued that the world is evidence of the mind (or Being) and will of God, while
resisting a neo-Platonist monism by remaining faithful to traditional doctrines
such as original sin, Grace, the Incarnation, and the Trinity. Nature is made in
perfection, but by the misuse of freedom is made imperfect. In contrast, Emerson
rejects traditional Christian doctrine, and considers what Edwards would not.
He engages in a monistic neo-Platonism. Matter is evil, the spiritual is good. We
are to become one with God via a suprarational mysticism beyond materialism,
doctrine, and law. A romanticized Christianity of intoxication is key.

That sense of intoxication Emerson called self-reliance. Echoing the peren-
nial Anglosphere propensity known as Pelagianism, he believed that self-reliance
provided the key to the problem of evil. If matter is evil, and humanity and god
are one, then the cause of evil is not God—and the solution to evil is God in us.
We act within a conflicted material world; within those conflicts, every vice is
compensated by virtue: hardships result in wisdom, adversity produces character.
So the material world actually provides an arena for the reality of the spiritual
world. That spiritual world is one where the mind of humanity and the mind of
God are one. Closer to Kierkegaard and Nietzsche than either Kant or Hegel,
Emerson rejects all structuralism, all formal logical patterns of thought as arbi-
trary. He is not only Pelagian; he is antinomian.

His understanding of art reflects this general scheme of things. As Conkin
puts it:

> Since the art object is an outward, symbolic expression of an ideal reality
> that is the essence of man, art is inseparable from the character of an art-
> ist. Beauty is best appreciated by a simple, responsive person, who honestly
> relies upon his own instincts or his own feelings. . . . Emerson agreed with
> his Puritan forebears, and particularly with Jonathan Edwards, who always
> saw character, or personal holiness, as the highest form of beauty.[22]

But what happens to character in a newly empirical, mystical, and technological world? The difficulty was in facing the challenge not just of an allegedly dangerous materialism and an unintelligible mysticism but also of a new wealth-producing technology. In his essay "Nature," Emerson lamented a new world in which "a ridiculous rich ruled a false world and a pitiful poor who wanted to be rich and rule a false world."[23]

These spiritualist ideas are part and parcel of the denial of Trinitarian scientific rationality. They also are antitranscendentalist. Transcendence properly understood is objective truth existing beyond the material world, its processes, and the processes of our minds. Trinitarian transcendentalism properly manifests in, but refers to, a realm beyond fact and natural law, beyond fact and process, and beyond the Incarnate Christ. Neither New England nor Kantian "transcendentalism" makes much sense. Each is what Eric Voegelin laments as an immanentization of the transcendent and dangerously results in a prideful violence because it mandates us to act as gods. The misleading redefinition of the term *transcendental* is similar to the redefinition of science and reason already discussed.

In 1855, George Inness (1825–94) painted *Lackawanna Valley*. The work was commissioned by the Delaware, Lackawanna, and Western Railroad to commemorate the completion of the railroad's first roundtable, in Scranton, Pennsylvania. The painting's style evidences the influence of a variety of sources, from Cole and Durand to the Barbizon school of France. But what of its content? An Emersonian analysis lends itself to the subject of the paintings. A figure is shown reclining

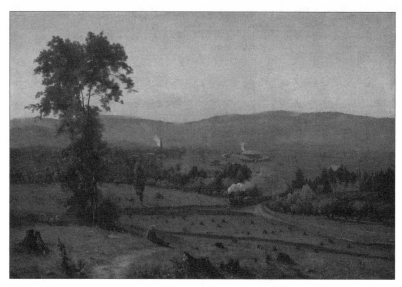

George Inness, *Lackawanna Valley*, 1856

on a newly cleared hillside contemplating the landscape before him. That land-scape is bifurcated: on one side is church and community, on the other side is the roundtable and industry; on one side is the spiritual, on the other, the mate-rial. This neo-Platonic split resonates with the New England mind of the tran-scendentalists.[24] There is no hierarchical structure rising in varying degree from the material to the spiritual. There is no reconciliation of matter with Truth as demanded by Trinitarian Christianity. Rather, the reclining figure contemplates a material realm on the viewer's right and a fragile spiritual realm to the left. From an Emersonian perspective, those in charge of the railroad company who commis-sioned this work are the successful, ridiculous rich who have succeeded in ruling a false world. A neo-Platonic hatred of materialism is put into a Christian context even though from a Christian perspective the material world is not intrinsically evil. That perspective optimistically contends that the now flawed material world needs will return to a paradisiacal perfection.

This results in a serious conceptual conflict between a monistic pantheism that celebrates the material world as god, and a neo-Platonism that despises the material world for god. Edwards identified nature with the will of God; the Tran-scendentalists identified God with humanity. But if nature is God and human nature divine, then how can the neo-Platonic rejection of materialism be main-tained? Like the figure reclining in Inness's painting, we are asked to perform an impossible task: to affirm and despise nature. Nor is there any way to value one over the other in a world of fact and feeling. Lacking Trinitarian scientific ratio-nality, there is no way to avoid being either the ridiculous rich or the pitiful poor, ruling over a pantheist spiritualist world that denies our individual existence.

That New Age pantheism is nonetheless there. Around 1863, Inness was introduced to the ideas of Swedenborg. The results are dramatic. He produces works such as *The Monk* (1873), embracing a spiritualist perspective. Swedenborg was a materialist and a mystic, a scientist and a spiritualist. In short, he was an alchemist. Reality conforms to his—and our—will. Rejecting the Trinity, *in which Truth is both transcendent and immanent, one and three, unum and pluribus*, Christ is newly viewed as God the Father, the Son, and the Holy Spirit all in one. That in turn denies both degrees of Being and degrees of knowledge; it denies a qualitative scientific rationality. It thus denies qualitative knowledge. This mystic-empiricist dichotomy is a perennial possibility, and so are its limitations, deficiencies, and contradictions. The later pragmatists specifically address those deficiencies.

In summary, Edwards's dream is to realize a society in which by the Grace of God we might act in knowledge of what is true and good. He accepts the tra-ditional notion of reconciling Being and becoming. Emerson's dream is to realize

·

a society in which self-reliance results in our acting as part and parcel of a cosmic knowledge liberating us from meaninglessness or evil. But that solution is antiscientific and antirational; it is a return to Gnosticism. The assumption that secret knowledge will transform the world and even God (as believed by Kabbalists) is scientifically and rationally unknowable. As an academic, cultural, and political position it is grounded in power, real or imagined. Just as good will collapses without objective truth, so does mysticism. A self-referential mysticism cannot escape a narcissistic solipsism; mystics aspiring to get in touch with themselves are reduced to self-parody and self-hatred.[25]

Accompanying that destructive mysticism is an antagonistic empirical materialism. John Dewey will later address the issue and argue that a materialistic and technological society in which self-expression and self-realization are supreme requires our acting in pragmatic harmony with a dynamic material reality. We turn next to the proponents, and critics, of this pragmatic approach.

10

AMERICAN PRAGMATISM

Born in 1839, Charles Sanders Peirce is the personification of Puritan pragmatism. He also personifies a reaction against the fragmentation and debasement of life under the auspices of modernist philosophy. He rejects nominalism, materialism, determinism, and the materialist-idealist split so common to Western philosophy after Galileo, Descartes, and Newton. He laments the fragmentation of Western culture into separate realms of facts, feelings, and reason, resulting in a debasement of culture. He notes that materialism without idealism is blind, and idealism without materialism is void. The pragmatic problem is Incarnational and Trinitarian: how to put the two together again. The great obstacle to that task is positivism, about which he is scathing:

> Positivism is only a particular species of metaphysics open to all the uncertainty of metaphysics, and its conclusions are for that reason of not enough weight to disturb any practical belief. . . . *[All theories] are inferences of the unobserved from the observed—of the present inexperience to the future in experience. Now who does not see that the future is not observable except when the present is not, so that we either reason to conclusions which are absolutely unobservable or from facts which are absolutely unobservable* [italics added].
>
> This is the conclusive objection to Positivism. . . . Verification is the watchword of Positivism. . . . The logical rule, therefore, which is the whole basis of Positivism appears to me to be entirely false.[1]

Peirce confirms what has previously been cited: that positivism mandates a nonpositivist metaphysics, and its metaphysics concludes in nihilism.

Peirce particularly disliked one consequence of this materialistic and idealistic fragmentation: the reduction of thinking to feeling and a concomitant denial of purposeful freedom. *Materialistic and mechanistic philosophies reduce intelligence to feeling or theory, and by their own logic deny scientific and rational objectivity.* As such they deny their own status as knowledge. Since such philosophies cannot perceive final causes, they cannot perceive purposeful choices. Therefore, even granted that we can make choices, those choices are denied any rational criteria grounded in reality. Knowledge and freedom are made empty—or existentialist.

Peirce articulates ideas classical and Augustinian in spirit: he argues for the existence of ultimately ineffable truth, but that we might nonetheless obtain glimpses of some degree of that truth. He seeks knowledge of reality, but also seeks to avoid the Scholastic and modernist folly of rationalistic systematizing of that knowledge and thus transgressing its actual nature. He rejects the mistake of Abelard and of Kant: the presumption that logic is a matter of the clarity of the human mind rather than the profundity of the transcendent Divine mind made immanently accessible by Christ. Peirce champions reason, while tempering it with recognition of the fallibility of humanity. Just as Augustine famously defends the rational pursuit of wisdom by the ironic axiom *si fallor sum*—we err, therefore we self-consciously know we live and think—Peirce's doctrine of *fallibilism* encourages us to seek wisdom with practical humility:

> Just as it is not the self-righteous man who brings multitudes to a sense of sin, but the man who is most deeply conscious that he is himself a sinner, and it is only by a sense of sin that man can escape its thraldom [*sic*]; so it is not the man who thinks he knows it all that can bring other men to feel their need of learning, and it is only a deep sense that one is miserably ignorant that can spur one on in the toilsome path of learning.[2]

Peirce seeks a solution to these problems within the context of his Puritan and classical heritage. He affirms that the universe does indeed have what Aristotle called a final purpose, and that final purpose is called, by Christians, God:

> Every true man of science, i.e., every man belonging to a social group all the members of which sacrifice all the ordinary motives of life to their desire to make their beliefs concerning one subject conform to verified judgments of perception together with sound reasoning, and who therefore really believes

the universe to be governed by reason, or in other words by God—but who does not explicitly recognize that he believes in God—has faith in God. . . . *For to believe in reasoning about phenomena is to believe that they are governed by reason, that is, by God* [italics added].[3]

For Peirce, the denial of scientific rationalism, or its positivist debasement to fact and (de)constructionism, is to deny truth and the classical-Judeo-Christian Logos, or God. He seeks to reaffirm that humans possess the freedom and responsibility to make meaningful choices, but denies the transcendentalist position of Emerson and later proponents of New Age mysticism that humanity is part and parcel of the Divine. He seeks harmony—but not unity—of the human mind and Truth or the Divine, for claims of unity or identity with the mind of God are socially manifested as tyranny. That identity cannot be completed but it can to some degree be analogically and practically realized. He grounds pragmatism (or as he called it, pragmaticism) on biblical principle:

> *Consider what effects, that might conceivably have practical bearings, we conceive the object of our conception to have* [italics added]. . . . Before we undertake to apply this rule, let us reflect a little upon what it implies. It has been said to be a skeptical and materialistic principle. But it is only an application of the sole principle of logic recommended by Jesus: "Ye may know them by their fruits," and it is very intimately related with the ideas of the Gospel.[4]

Philosophically influenced by Kant, Peirce critically rejects Kant's disdain of consequentialism; he also rejects Kant's assertion that Being, the *ding an sich*, reality itself, is unknowable. Instead he centers his efforts on renewing Aristotelianism. This is an unfortunate and grievous error.

Since antiquity, Plato is associated with abstraction, eternity, absolute Being. Augustine combines Platonic thought with the Doctrines of the Incarnation and Trinity. He advances the qualitative character of Platonic knowledge while avoiding mysticism and pantheism. In contrast, Aristotle is associated with the organic, the temporal, and with becoming. Aristotle famously states that there are four operative causes in the universe: material cause (e.g., the clay of a pot), efficient cause (the act of shaping the clay), formal cause (the idea to be realized via the clay), and final cause (the ultimate purpose of the entire situation). So whereas Plato centers on cosmology, Aristotle offers a teleological ontology. That teleological ontology is informed by final purpose—Being—while emphasizing becoming. Remove final causes from Platonism and Augustinianism and they cease to

exist. Remove final causes from Aristotle and you have much of modernist phi-losophy—particularly Darwinism—whether physical, biological, or social.

Pragmatism is sociologically grounded in a Puritan culture while attempting to revive Aristotelian teleology. Traditionally, within that teleology, the world is informed by purpose, and our minds and actions ought to harmonize with that purpose. Working from a Puritan and Aristotelian baseline, Peirce redefines the Trinity, Love, and Grace. Whereas Edwards defended traditional Trinitarianism, Peirce (as did Kant via his three critiques) develops a new Trinity; just as Edwards addresses the existence of evil in a world presided over by God, Peirce addresses the existence of chance and contingency; just as Edwards relied upon Grace and Love to address such contingencies, so did Peirce, but in a different fashion.

According to Trinitarianism the unity of transcendent Being with material becoming historically occurs in perfection only in the Incarnation, which makes real the worldly pursuit of perfection. The world is not God and does not have a soul; therefore it and we are not divine. This ensures the objectivity and humility necessary to a scientific and rational pursuit of knowledge.

However, Peirce associates Being with becoming in time. The driving force behind that realization he called *agapism*. He shifts from Edwards's understand-ing of gravity as Divine Will to a more traditional understanding of gravity as Divine Love. But he couples that love with becoming. God's love necessitates evo-lutionary change. What then of the tragedies that afflict us in life? In Augustinian fashion, for Edwards, tragedy is the result of evil, of a misplacing of love, to be remedied by Grace. In place of Edwards's notion of Grace, Peirce advocates what he called *tychism*. Just as evil is depicted as a small black spot within the celestial orb in the Samuel King painting, Peirce acknowledges the infinitesimal presence of lawlessness in the world as proof of freedom and the imperfect nature of mate-rial existence within a perfect cosmos. In this he concurs with Alexander Pope:

> To say, however, that whatever is, is best is not to deny the existence of evil, but only to maintain that if any event is bad in one way it more than counter-balances for it by *being good in another or higher way* [italics added].[5]

This leads to Peirce's definition of pragmatism: *thought seeking truth results in an act that ends in bliss.*

Aristotle and Kant systematized knowledge by the use of categories of thought. In place of their multiple categories, Peirce posits but three: the thing as such (Firstness); the thing as action and reaction (Secondness); and the thing as logic (Thirdness). Thirdness involves the notion of final causation and mean-

ing. But chance undermines the notion of universal wisdom, of knowledge of that which is true and good. If we live in a materialistic, nominalistic, and contingent world, then knowledge is limited to facts and momentary willful consciousness. The consequences of this position are explained by Conkin:

> From [the nominalist] Occam on, the individual human mind had been given the power of originating general ideas the like of which God had failed to create as real objects, and which were entirely wanting in either the mind of God or in heaven and earth. With ideas stripped of anything except a ghostly existence, the fleeting and mysterious human psyche, all real power, as well as all real existence, was attributed to matter. Or, in worse blasphemy, a God-complex was assumed by man, and in a false humanism and individualism he fell into the illusion that he ruled the world. Nominalists, as is quite evident, were then identical to Edwards' Arminians. Peirce, as an avowed rebel in the ranks of modern science, was reasserting a mode of influence or power—i.e., law, habit, purpose—upon external events which could not be resolved into mechanical action. This meant a reaffirmation of the reality, although not the existence, of universals or of general terms. In this sense he renewed the medieval controversy.[6]

In so doing, he also renewed a concern for beauty. His final cause, giving meaning to life in an otherwise materialistic and commercial age, was not grounded upon utility or pleasure. The supreme good is grounded in beauty, a beauty practically realized by thought as well as in feeling. It is realized via the unity of Firstness, Secondness, and Thirdness. The thing as such (Firstness), the thing as action and reaction (Secondness), and the thing as logic (Thirdness) combine and the result is beautiful. Or more profoundly, it is a beatitude.

In 1891, Peirce published in *The Monist* an essay titled "The Architecture of Theories." Architecture is used as a metaphor for our intelligible relationship with reality. He notes that

> of the fifty or hundred systems of philosophy that have been advanced at different times of the world's history, perhaps the larger number have been, not so much results of historical evolution, as happy thoughts which have accidentally occurred to their authors. . . . The English have been particularly given to this way of philosophizing. . . . [Such efforts] would probably afford valuable lessons to builders, while it would certainly make a detestable house.[7]

Peirce articulates the challenge faced by the Anglosphere: a choice between modernist (de)constructivism in which the minds of geniuses (de)construct reality, or a careful traditionalism in pursuit of Truth, Goodness, and Beauty. Such traditionalism is active, not static or random. He further notes that genius-based chance is associated with both practical experience and the Kantian assumption of an architecture of the human mind:

> The remaining systems of philosophy have been of the nature of reforms. . . . This is like partially rebuilding a house. . . . When a man is about to build a house, what a power of thinking he has to do, before he can safely break ground! . . . Now without riding the metaphor too far, I think we may safely say that the studies preliminary to the construction of a great theory should be at least as deliberate and thorough as those that are preliminary to the building of a dwelling-house.
>
> That systems ought to be constructed architectonically has been preached since Kant, but I do not think the full import of the maxim has by any means been apprehended. What I would recommend is that every person who wishes to form an opinion concerning fundamental problems should first of all make a complete survey of human knowledge, should take note of all the valuable ideas in each branch of science, should observe in just what respect each has been successful and where it has failed.

Peirce's conclusion is that after the innovations of a mechanical understanding of reality, an organic one prevails:

> Now the only possible way of accounting for the laws of nature and for uniformity in general is to suppose them results of evolution. . . . Darwinian evolution is evolution by the operation of chance, and the destruction of bad results,[8] while Lamarckian evolution is evolution by the effect of habit and effort. A third theory of evolution is that of Mr. Clarence King.

Peirce then applauds King's theory of evolution in words anticipatory of Wittgenstein and Kuhn:

> This mode of evolution, by external forces and the breaking up of habits . . . certainly has been the chief factor in the historical evolution of institutions as in that of ideas; and cannot possibly be refused a very prominent place in the process of evolution of the universe in general.

Peirce exhibits in his treatment of King a close affinity with Kuhn; paradigm shifts occur in our understanding of reality and life. Those shifts alter our understanding of scientific rationalism. However, he rejects the genius-based Kantian constructivism of Panofsky, and he rejects Darwinian chance and power. Thought seeking truth results in an act that ends in truly progressive bliss.

However, for Peirce, those shifts center not on ontology but psychology. Ontologically, he rejects the Cartesian dualism of mind and matter, thus putting him at odds with modernity. But instead of reconsidering an ontological transcendentalism which makes knowledge the object of science and reason, and which accommodates a culture of responsible freedom, his alternative to dualism is postmodernist monism.

Dualism separates fact and meaning, resulting in knowledge being willfully constructed and deconstructed. This in turn results in culture being reduced to trivial violence. Monism immanently unites fact and meaning, while denying that scientific rationalism has Truth as an object to seek. This results in science and culture being reduced to willful assertion. In either case, there is no transcendent objective truth to get a glimpse of.

Monism historically concludes in a theological, epistemological, and psychological absolutism Unfortunately, Peirce pursues the psychological implications of monism. Shifts in our psychology refer to our cognitive process. That process is threefold: feeling (immediate consciousness), sense experience, and a Kantian conceptualization. As Peirce puts it:[9]

> The one primary and fundamental law of mental action consists in a tendency to generalization. Feeling tends to spread; connections between feelings awaken feelings; neighboring feelings become assimilated; ideas are apt to reproduce themselves. These are so many formulations of the one law of the growth of mind. When a disturbance of feeling takes place, we have a consciousness of gain, the gain of experience; and a new disturbance will be apt to assimilate itself to the one that preceded it.

Peirce's postmodern psychological monism offers respite from modernist (de)constructivism but at the cost of scientific rationality and a culture of responsible freedom. By reducing knowledge to an experiential interaction of things and thoughts, Peirce embraces a perspective that leads, as we shall see, to the reduction of scientific rationality to a realm in which subjects pretend to make their own worlds.

From Peirce to James and Whistler

As did C. S. Peirce, William James (1842–1910) critically confronts the empiricist/spiritualist trajectory of American and Western thought within the nineteenth century. Unlike Edwards, James was preeminently an Arminian; he takes for granted that our free wills are rightly autonomous. Unlike Peirce who attempts to reconcile tradition with progress, James makes a radical break. James rejects any concern for the notion of a transcendent Truth or Being existing in the universe, or of a final cause as well. He takes a critical step that Edwards could not, and Peirce preferred not. That step was negatively influenced by the example of his father, who was deeply involved in Swedenborgianism, neo-Platonism, and New England transcendentalism.

James seeks an understanding of reality that avoids the pitfalls of a positivistic emptiness, materialist determinism, and spiritualist obscurantism. He hopes to avoid skepticism, fatalism, and self-deification. In so doing he tries to affirm intellectual knowledge and humility, intellectual confidence with piety. In this regard he is very much in harmony with the goals and attitudes of his Puritan predecessors such as Jonathan Edwards.

But in contrast to those predecessors, James rejects the realm of Being, of transcendental Truth or Mind. He therefore rejects Trinitarian science for one that focuses on fact, process, and the human mind. He maintains that there is no mind prior to or beyond matter, nor is there any final purpose in things. But he nonetheless strives to avoid a sterile and empty positivism. Lacking a transcendent (Trinitarian) realm in which rationality exists and informs the realm of fact, he faces an unsatisfactory and pointless mind/matter dualism. He detests the limitations of materialistic scientism and the folly of romantic pantheism. Like his Puritan forebears, he focuses on the importance of practicality, but unlike his ancestors, his conception of that realm of becoming is disassociated from the Incarnation, which serves as a materialized ideal to which to aspire. His alternative is to pursue knowledge as experience rather than experience as an imitation of transcendent objective truth. He pursues immanence rather than transcendence, becoming rather than Being. In doing so he takes a decisive and tragic step into the modernist-postmodernist tradition.

Like Peirce, William James is deeply influenced by Aristotelian thought, as were Abelard and Kant. James is a conceptualist, but one who no longer accepts the necessity of seeking knowledge of a transcendent God, Truth, or a cosmic Final Cause. For James, experience permits a conceptual understanding of real-

ity. Experiential awareness is conceptualized ontology. That is, the interaction of mind, action, and fact results in a type of understanding. How then is solipsism avoided? Not by the traditional notion of a cosmic transcendent mind or God—since that violates the positivist definition of mind and truth—but rather by associating that mind with practical action. But can James's solution avoid intellectual and social solipsism? Or does it collapse into existentialist incoherency? Art and culture should be practical—an assumption grounded in Puritan and classical belief. But if there is no objective Truth or God, no final or special end, can it avoid being trivialized and brutalized? Can a pragmatic Puritanism avoid becoming a social gospel, first with, then without, God or Truth?

Peirce and James struggle to escape the positivist reduction and bifurcation of knowledge into fact and feeling. There are traditionally two different ways of doing so: Platonic and Aristotelian. Within the Platonic tradition, knowledge and culture are held to be associated with morality; we seek degrees of knowledge of the divine Logos. Within the Aristotelian tradition, knowledge and culture are associated not with morality, but with perfection; we seek logical clarity. Plato pursues beauty as the splendor of wisdom; Aristotle pursues aesthetics, the realm of fact, feeling, and conceptual perfection.

Associated with the Aesthetic Movement, James McNeil Whistler (1834–1903) pursues an Aristotelian-Kantian path. He deplores positivist materialism and rejects also the Platonic moralistic approach (so important to Cole) as advocated by the Victorian Christians. He views this approach as oppressively extrinsic to fine art and culture. If morality is reduced to a guilt-ridden response to authoritarian Scripture, then the aesthetic attainment of perfection advocated by Aristotle is freshly attractive. But there is a major difference between Whistler's modernist-postmodernist Aristotelianism and the original. It reflects the transition of Aristotelianism via Abelard to Kant and an underlying problem for pragmatism.

As Puritans and pragmatists noted, for Aristotle there are four causes in reality: material, efficient, formal, and final. Aristotle's final cause is prototranscendent. That is, it is not transcendent in the biblical sense of being beyond the created universe, but it is transcendent in the sense that the final cause exists as an ultimate cosmic conclusion. So Aristotle's aestheticism operates within the context of that final cause. The world and life enjoy an objective source of purpose.

Whistler's aestheticism seeks an Aristotelian perfection that lacks the notion of an objective final cause. It is Aristotelian, one understood from a postmodern existentialist-pragmatic perspective. It focuses on becoming rather than Being. To use Peirce's terminology, a *conceptual Thirdness* is the central aspect of this new

Aristotelian-Kantian paradigm. William James pushes that paradigm to its logical existentialist conclusions.

Whistler's formalist art is devoted to a spiritualist goal that is immanent rather than transcendent; it is subjective rather than objective. Unlike the pragmatism of Peirce, with its lingering Puritanism, that of James centers on a subjective immanent cause: the clear mind of the artist. As a consequence, Aristotle's final cause is conflated to that of a formal cause that is found in a subjective rationality: the mind of the artist. This focus on a rational subjective objectivity, a synthetic *a priori*, is Kantian. Whistler exalts artistic creativity while divorcing it from nature as it is or ought to be. In Kantian fashion, nature is to conform to how we think. If nature conforms to how we think, then scientific knowledge and reason reveal a trivial and violent perspectivism.

In his *Ten O'clock: A Lecture* (1885), Whistler speaks in the character—but not the substance—of The Preacher. He argues for an Aristotelian approach to art and life, but one lacking final cause or Being in science or culture. He argues for a Kantian deontological approach in which Being is the artist becoming:

> Nature contains the elements, in colour and form, of all pictures, as the keyboard contains the notes of all music. But the artist is born to pick, and choose, and group with science, these elements, that the result may be beautiful [*sic*]—as the musician gathers his notes, and forms his chords, until he bring forth from chaos glorious harmony.
>
> To say to the painter, that Nature is to be taken as she is, is to say to the player, that he may sit on the piano.
>
> That Nature is always right, is an assertion, artistically, as untrue, as it is one whose truth is universally taken for granted. Nature is very rarely right, to such an extent even, that it might almost be said that Nature is usually wrong; that is to say, the condition of things that shall bring about the perfection of harmony worthy a picture is rare, and not common at all.
>
> This would seem, to even the most intelligent, a doctrine almost blasphemous. So incorporated with our education has the supposed aphorism become, that its belief is held to be part of our moral being, and the words themselves have, in our ear, the ring of religion. Still, seldom does Nature succeed in producing a picture.[10]

For those familiar with Aristotelian thought, the notion that nature does not produce a picture is familiar. Aristotle famously noted (*Physics* 199) that if art were part of nature, then wood ships would grow from trees. Nature proceeds

from intrinsic principles whereas art is an extrinsic principle. For Aristotle's later interpreter, Thomas Aquinas, that intrinsic principle is nonetheless objective and grounded in the transcendent. Nature is the handiwork of a transcendent God; its perfection is marred by sin, not by design. We begin in natural and theological perfection, fall into natural and theological sin, and via responsible freedom try to return to that original perfection. This understanding is in harmony with the Puritan belief in intelligent design informing a flawed but rightly perfect world. But for Whistler, living in a developed positivist age, nature is fact, so either culture is oppressive fact or the product of human creativity. Art is separated from a rightly perfectible nature; indeed, the only purpose found in an intelligent pragmatism emanates from the mind of the artist as demigod.

Whistler rejects a positivist focus on facts and feelings, and he also rejects Platonic/Victorian moralizing. This is in agreement with Aristotelian thought: it is assumed that the audience is refined and that culture and fine art have no need to provide moral instruction. Therefore, the goal of fine art and culture is to provide a pleasurable experience of perfection. While Whistler can assume his audience to be refined and in no need of moral instruction, it is newly problematic how that assumption can be maintained. The question now is whether an existentialist audience is refined—or barbaric.

The rejection of the pursuit of objective truth or Being by Whistler, James, and, as we shall see, the architect Louis Sullivan, is explained by their redefinition of truth. In contrast to Peirce's definition of pragmatism—*thought seeking truth results in an act that ends in bliss*—James offers fifteen definitions of truth. What all of them ignore and therefore implicitly deny is the correspondence theory of truth with its implicit understanding of the objectivity of knowledge and meaning.

If sheer experience is viewed as the means of understanding reality, then the space between subject and object is denied and there is no space in which the free and responsible pursuit of knowledge can occur. When pure experience determines truth, then mind, action, and social context determine truth, which is reduced to power and will. Ontology is us becoming.

Within a Newtonian context, such conclusions are inexorable. In 1899, James declares that all judgments of value depend upon the feelings aroused in us. Those feelings are difficult to harmonize or objectify, and contrary to James's hope, when they are harmonized tyranny results. As Conkin explains:

> James advocated a humanistic criterion of moral judgment, although he hoped that a God would ensure the success of our moral struggles. In the plurality of feelings, each individual seeks a unity or harmony of purpose.

What feels good is good, in itself and in the short run. . . . But . . . moral harmony is . . . almost impossible at the social level. . . . To erect a God, or some higher consciousness, means nothing unless God's claims strike a responsible chord in individual hearts. If they do so, God changes nothing morally. To erect a God on the basis of one's own subjective preferences and then try to enforce these preferences over other people is tyranny of the type that has usually infected established religions.[11]

James was a major participant in the attempt to reconcile the Anglosphere and the classical-Judeo-Christian tradition with the new modernist religion. He attempted to improve English utilitarianism, which he found crude; he was an evangelist, like his favorite minister, Phillips Brooks, but not an evangelical. He sought piety via personal and social experience. He refused to develop a comprehensive theory of ethics or of aesthetics. Instead, James views God as consciousness in which all consciousness participates. Consciousness is grounded in the ancient definition of person: a rational being. He pantheistically maintains that human persons and the person of God are one. He was a mystic, but not one committed to experiencing the Transcendent. Rather, he focused on the immanent realm of becoming. Mystics now wish to be in touch with themselves; their thoughts and consciousness have no object, only subject. A liberty-granting rationality is reduced to the subjective and socially oppressive will. James's position anticipates the central doctrine of postmodern totalitarian spirituality: a public celebration of inner necessity, which ultimately determines good, and is now called New Age.

John Dewey: Art as Experience

John Dewey struggled with that spiritualist obscurantism but found no alternative in the practical Christianity of his ancestors. Scientific positivism denies a wisdom-based Christianity and the resultant mysticism is found lacking. To Dewey, there was scant difference between the empirical Scholasticism of modernity and its alternative, the conceptualist Scholasticism of the late medieval; an obscure mysticism offered no satisfactory alternative. In the attempt to maintain a practical scientific rationalism, Dewey embraces a dynamic naturalism. As declared in the Humanist Manifesto of 1933, of which Dewey was a leading signatory, science is practical knowledge; works trump mere faith:

Humanism asserts that the nature of the universe depicted by modern sci-
ence makes unacceptable any supernatural or cosmic guarantees of human
values. . . . Religion must formulate its hopes and plans in the light of the
scientific spirit and method.

Religious humanism [meaning a religion worshipping humanity] main-
tains that all associations and institutions exist for the fulfillment of human
life. The intelligent evaluation, transformation, control, and direction of
such associations and institutions with a view to the enhancement of human
life is the purpose and program of humanism.[12]

Dewey rejects constructivist scientism, dogmatism, and mysticism; however, he
also rejects *scientia* and *sapientia*. Truth conforms to the positivist scientific method.
That knowledge is judged in terms of its practical enhancement of human life.

This new humanism lacks a foundation in Being. How can a qualitative
enhancement be recognized or achieved when it is a means to itself? As Peirce
astutely noted, positivism requires that *we either reason to conclusions which are abso-
lutely unobservable or from facts which are absolutely unobservable.* When method deter-
mines truth and when epistemology or hermeneutics determine knowledge, then
knowledge is *de facto* ideological in the sense that *a priori* ideas and methodologies
determine what can be known.[13] When knowledge is in this sense ideological,
then it is arbitrary, be it deemed practical or not. Power replaces wisdom. Dewey
accepts the foundational shift of Western scientific rationalism as articulated by
Bacon, Newton, and Comte. That shift to a pragmatic positivism cannot be based
on knowledge. It is a new ideology. It is a humanist faith without a genuine object,
and thus destructive of humanism.

Dewey rejects the Greek search for certainty via knowledge of Being, but
lauds the Greek quest for wisdom. How can such so-called *uncertain wisdom* be
obtained? His solution is similar to those of his pragmatist colleagues in that he
focuses on the realm of becoming. Influenced by the wide variety of positivist-
based philosophies, including those of Diderot, Bentham, and Darwin, Dewey
views Being, or the ground of reality, as becoming. The mind is social, the social
mind determines meaning, and thinking is a biological and social function. Thus
truth is conscious experience; meaning in science, ethics, and art arises spontane-
ously in experience.

He ahistorically and naively viewed Christianity as focused on the supernat-
ural; in assuming that tradition to be antiscience and antireason, his thinking
reflected the positivist prejudices of his age. But those prejudices are tempered by
Anglosphere civility. As Conkin puts it:

Where Edwards rejoiced in God's order in nature revealed, Dewey rejoiced
in a partially disorganized nature in which man could occasionally play the
part of an organizer. . . . [In Anglosphere fashion] he shied equally from the
security of passive absorption in some grand design and from any illusion-
ary, half-mad search for omnipotence. He had none of the resignation of
Santayana and none of the madness of Friedrich Nietzsche.[14]

Similarly, he viewed with disdain the classical pursuit of Being, of certainty
and permanence. The denial of transcendence results in a focus on immanence,
which results in a focus on becoming. Being as becoming accommodates a vio-
lently naturalistic vision (via Darwin); Being is then nature as pointless or mys-
terious becoming. It also invites a pantheistic rather than a transcendent view
of Truth, and within a pantheistic universe freedom of individual human self-
consciousness—of human persons—does not exist.

So the goal is to be one with nature, but it is nature without final purpose or
God. It is nature as the God of purposeless becoming. Or rather, it is by being one
with nature that truth becomes. Within that immanent realm, humanity partici-
pates in the organization, not the redemption, of nature. Humanity can play God,
with a prideful arrogance or a pitiable impotence. To effectively play God requires
the application of wisdom, of knowledge of that which is true and good. But for
Dewey, that wisdom is realized not through the attempt to intelligibly reconcile
the particular with the universal, the temporal with the eternal, the accidental
with the essential. That would involve the reality of Being. Instead, existence
comes before essence. So too with action and goodness.

Wisdom—and therefore education—is grounded in feelings, emotions, and
actions. We react to things either pleasurably or unpleasurably. Quality is not
recognized via knowledge, but via a subjective qualitative reaction to phenom-
ena experienced. The *objects* of knowledge—phenomena—are redefined as the
subjects of cognition. The intersubjective experiencing of fact, mind, and action
results in an allegedly qualitative response that is deemed to be experientially but
not ontologically true, good, and beautiful.

This leads Dewey, unlike James, to offer a systematic ethics and aesthetics. The
subject seeking knowledge of an object (and the freedom-granting space between
the two) is denied. Instead, consciousness is an awareness of our experiences. Truth
is now understood to be a practical response with experience. This results in an
allegedly nonlinguistic form of knowledge that Dewey particularly associates with
artistic activity. He rejects beauty as the splendor of wisdom; he also rejects the
notion of fine art being separated from practical life. There is no duality of art and

life if both are grounded in experience. But there is neither sanction nor means to legitimately distinguish the mundane and violent from the profound and sacred. One may recall Black Mountain College was founded on Dewey's ideas; its effectiveness in qualitatively improving western civilization is questionable.

There is an irony to Dewey's determination to escape dogmatism via a naturalistic pragmatism. The modernist-postmodernist Dewey concludes that science, ethics, and art are grounded in the experienced quality of events that are socially conditioned. That socially grounded experiential quality exists, however, in a sociologically diverse world. In a Rousseauean and Kantian fashion, he assumes that sociologically grounded conflicts in experiencing quality can ultimately be resolved through a common experience for all, guided by a natural piety. In a Hegelian and Darwinian fashion, he assumes this to be inevitable.

But what of those who experience, much less understand quality differently than does Dewey? What evidence is there of this natural piety, and what evidence is there of a cosmopolitan experiential universality grounded in the will or becoming? How could it be objectively recognized? If grounded in conformity to an alleged natural or common will, how would we objectively distinguish good from bad experiences? What happens to culture and science for those whose modes of experience and authenticity conflict? Some believe in individual freedom of conscience and in responsible freedom—and some do not; some believe in a scientific rationalism, some differ on what that means, and some do not believe in it at all. Which shall prevail? What happens to the victims who experience folly, pride, and hatred, and the those who view themselves as victims if they cannot indulge in realizing those same experiences?

Dewey appears to offer freedom from dogmatism, but his worldview is dogmatically existentialist and anticultural. It offers no protection from harmful socially evolving judgments of quality, nor means or reasons for seeking good judgments of quality. It is not an ontological optimism that is advanced, but an experiential void. Consider that the renowned American philosopher Richard Rorty follows Dewey's lead, and concludes that the ultimate purpose of philosophy is at best to be entertaining.[15]

In the name of a pragmatic authenticity, Dewey has returned to that from which his Puritan ancestors fled. Individual responsible freedom is transformed into conformity to an alleged natural, universal immanent will, informed by an allegedly pragmatic coercion. This newly naturalistic piety is grounded in a rationally unrecognizable good will and inner necessity. But the pragmatic consequences are disturbing. When good is determined by subjective experience then goodness is a matter of taste. There is no disputing taste because it is either absolute or utterly trivial.

Consider the toxic mix that results. We have a Kantian constructivism and racism (remember his *Pragmatic Approach to Anthropology*); Hegelian and Marxist statism, with its definition of freedom as obedience to a soon to wither state; Darwinian-informed eugenics; a New Age solipsistic theology; the transgressive authenticity of Nietzsche; and a pragmatic trivialization of culture. What ultimately unites them all is the notion of inner necessity—not a scientific rationalism—determining what is good. The violent content and consequences of that toxic perspectivism make the opponents of such a perspective newly valuable. The Victorian defense of a now nostalgic classical-Judeo-Christian practicality (or *sapientia*) is not reactionary but a noble tragedy. In the attempt to maintain traditional values such as responsible freedom, they participated in its decline by leaving positivism uncontested.

The Social Gospel and Cultural Reform

This same focus on inner necessity and the immanent will was given a theological turn with the advent of the social gospel. Dewey himself was involved with this particular manifestation of Christianity, one congruent with late nineteenth-/early twentieth-century America. Springing from a shift in eschatological thinking, the social gospel promulgated a sort of Christian syncretism, if you will, between the prevailing philosophical trends and some basic Christian theology. It produced a determined effort to reform the increasingly corrupt industrialized culture of the time. It also produced some rather bizarre theological interpretations.

The foundation of this trend is an eschatological interpretation of millennialism, taught by Jonathan Edwards and widely accepted by the late nineteenth century. In orthodox biblical fashion, Edwards suggested an earthly utopia was possible to pursue. He was particularly moved by the growing Christianization of America, given that prior to the Europeans' arrival none of the indigenous persons were aware of Christianity. From Edwards's ideas grew a notion that the return of Christ was dependent upon humanity reaching a certain level of moral perfection. How that is to be achieved is the crux of the matter.

Fueling this task in the latter half of the nineteenth century were the social ideas raised by Darwin's evolutionism. Suddenly a new science provided a new model for social development. Social Darwinists looked around, saw the new problems that plagued people in the industrialized West, and concluded that they represented the winnowing out of the weaker and the victory of the stronger. In contrast, the social gospelers saw these problems as manmade obstacles to the vic-

tory of the Kingdom of God. They were problems to be overcome as efficiently, and thus scientifically, as possible. Cecil E. Greek explains the confluence of these elements: "The acceptance of evolutionism; faith in inevitable progress; an optimistic perspective on human nature; belief that the Kingdom of God was to be an earthly utopia; and the idea that America was to be the place where the Kingdom would be first established, serving then as a model to the rest of the world."[16]

The critical question is whether this confluence of a new science of violent becoming, with Christianity's different science of becoming seeking Being via love, makes any sense. The traditional anticipation of a numinous transubstantiation—not just of the body of Christ but of the entire world after the Last Judgment—was now to occur immanently and by our actions. Being was reduced to *becoming*, with a purposeless evolution. A kind of vague manifest destiny, a dreamy utopianism, prevails.

This shift affected theological scholarship as well, particularly under the influence of German higher criticism. Scripture was read in terms of social development. Nineteenth-century congregational church pastor Washington Gladden wrote: "The one fact that it [the Bible] brings vividly before us is that fact of progress in religious knowledge which we are now considering. It shows us how men have gone steadily forward, under the leadership of the divine Spirit, leaving old conceptions behind them, and rising to larger and larger understandings of divine things."[17] Walter Rauschenbusch, another of the major voices of the social gospel, managed to reduce Christ to a group therapist: "Jesus had created a wonderful social group [the disciples]. He wanted it to hold together. The Lord's Supper came into existence through strong religious and social feeling and its purpose was the maintenance of the highest loyalty."[18]

The traditional scientific and rational notion of Communion as the earthy link between the material and the Divine, as embraced not only by Catholics but by many reformed Protestants as well (e.g., Methodists), is reduced to a social performance to enhance religious and social feelings and loyalty.

Horace Bushnell, another leading contributor to the movement, rejected an atoning Christ for his "moral influence" theory; his ideas grew in acceptance after being given a broader public airing by preachers Henry Ward Beecher and Phillips Brooks.[19] Bushnell thought that how a child was raised and his education were more important than the preaching he heard. Given some of the new ideas on theology, that might not be far amiss. For example, writes Rauschenbusch:

> The great religious thinkers who created theology were always leaders who were shaping ideas to meet actual situations. The new theology of Paul was

a product of fresh religious experience and of practical necessities. His idea that the Jewish law had been abrogated by Christ's death was worked out in order to set his mission to the Gentiles free from the crippling grip of the past and to make an international religion of Christianity. Luther worked out the doctrine of "justification by faith" because he had found by experience that it gave him a surer and happier way to God than the effort to win merit by his own works.[20]

The association of a social constructivism resulting in a happier way of finding God begs the question: how would that "happier way" be recognized, and distinguished from folly or even sin? The assumption that theology is sociologically created (i.e., Kantian constructivism) and that Paul's theology was written in the attempt to deal with the practical problem of overcoming the prejudices of the Jews (as Hegel suggested) does more than undermine theology—it undermines the very possibility of a scientific rationality grounded in ontological reality. It does so by reducing even degrees of transcendent, that is objective, knowledge to meaningless emotional social process.

The loss of the transcendent meant a loss of both revealed and natural truth. No longer was the truth to be sought outside of humanity; instead, it would spring from the interactions of our minds and our own experiences. With an irony he clearly did not intend, Washington Gladden, another voice suggesting that cultural forces move theology, commented, "The God of Cotton Mather or of Edward Payson could hardly have lived in the same heaven with the God of Dwight Moody or Phillips Brooks."[21] Indeed not, but the historical development of scientific and theological knowledge need not be constructivist. It need not be subjectivist. It can be qualitative. It can connote a better degree of understanding of Truth or God. A qualitative understanding also recognizes that not all new ideas are necessarily valid. Indeed, progress cannot be recognized via a subjective response grounded in personal happiness. Mather or Payson would not be happy about the theology of Moody or Brooks; Moody or Brooks would respond in kind. When scientific rationalism, or rather, theology is grounded in competing claims of happiness, then no one can socially remain happy.

What this thinking produced was a panoply of pseudosolutions to a wide variety of social problems. Those social problems were actually spiritual problems, traditionally solved via a scientific rationalism in the service of responsible freedom. Some devout believers in scientific *becoming* assumed that evolution meant the strong survive and the poor get what they deserve. Their emotions were grounded if not in malevolence, then surely a cold pragmatism. Alternatively,

the social gospelers choose not to dispute that science, but to follow allegedly benevolent emotions. Once again, the problem returns: either position can variously be considered malevolent or benevolent. Either position results in a claim of happiness. History makes clear that great evil has been done in the name of assumedly good intentions. A scientific rationalism grounded in becoming cannot qualitatively ascertain the substantive nature of any theological, scientific, or social paradigm.

At first glance, the social gospel movement was benevolent. They fought for greater assistance to the poor as well as more responsibility on the part of industrialists. There were reforms proposed in both child and adult education, in the assimilation of immigrants, in workers' rights, unionization, and health benefits. There was a concerted effort to work toward an empirical solution that required a systematic approach to aid; what developed was the discipline of sociology. Notes Greek, "Once again, just as they had done with evolutionism, they placed their faith in science and, in particular, called for establishment of a new social science, sociology, to come to their aid in the removal of social evil."[22] This tool was a sign of the times, the new science assisting in moving toward an earthly utopia and perhaps the millennial rule of Christ. However, some saw the potential for problems:

> Unless it is primarily a science of righteousness, sociology cannot be a science of society. Its work only begins with the observing of existing phenomena. It must give society a knowledge of how to create phenomena that shall be just. When it attempts to be scientific through the inductive study of social conditions and statistics, without making moral causes of wrong conditions the main object of study and correction; it passes into that profound ignorance that always darkens the understanding that has no ethical vision.[23]

Others who wanted to be involved in reform but who were less enthusiastic about the religious ground of charity found the technical parts were enough. Here we may think of Jane Addams and her work at the settlement house in Chicago, Hull House. Addams worked tirelessly for the poor but Hull House was not a theological enterprise; Addams herself was somewhat ambivalent toward her faith, a vague mix of the "social Christian" movement (similar but not identical to the Social Gospel) and the Unitarian church she attended.[24]

John Dewey was also attracted to the social gospel movement, particularly its technical, nontheological educational aspects. Dewey was connected to Hull House and grew interested in the practical education offered. He gave money to Hull House, spent time there, and contributed to the effort by lecturing on occasion.

In commenting upon early sociology and its theological roots, Greek cuts right to the chase:

> While positivism claimed it had no preplanned agenda for social reform, positivist sociologists certainly hoped to become social managers within America's increasingly bureaucratic society. In this regard it can be argued that positivism did not really reject the social gospel, but rather that the discipline of sociology transvalued and secularized its original theological presuppositions, transforming the Kingdom into a utopian state of societal well-being, best captured by the phrase, "the good life."[25]

This is the link between the so-called secularism of the social gospelers, a positivist or rather atheistic science, and the modernism that will follow. It is not a choice between religion and science, between what was perceived by some as mythic traditionalism and rational science. No, it is a choice between religions, between competing scientific worldviews, with very different visions of truth and love, science and charity. It is a choice between objective vs. subjective views of reality.

Augustine famously defined happiness as loving and having what is ontologically good. Happiness is grounded in a scientific rationalism rather than a vague emotional and subjective sentiment. However, since Kant and the social gospel movement, good will, which somehow can be recognized but not understood, replaces not only the Will but the Love of God. Commitment to a vague social notion of the good life replaces sacred decorum. It is important to recognize that what actions manifest the good will—or happiness—is dangerously unclear. The great despots of the twentieth century—Lenin, Stalin, Hitler, Mao—all maintained that they were in service of their own versions of a social gospel.

It is worth noting that during this time church architecture also shifted from a decorous symbolism toward a vague or mundane practicality. At the start of the nineteenth century, American churches commonly followed what one may think of as a typical basilican plan: rectangular shape, entrance at one end and altar at the other. By the end of the nineteenth century, accompanying the sanctuary were schoolrooms, kitchens (for both feeding and teaching domestic skills), theatre stages, and even the occasional bowling alley. In addition, the sanctuary went through a transmogrification. There developed much more ornament and decoration, color and carpet. The room changed from a longitudinal focus upon the altar to a focus upon a raised platform, for better viewing from an audience that was in some cases seated more "in the round."[26]

Formerly, church design was to move us from the egotistical world to the unselfish realm of sacrament; there was a narrative, moving us through time and space to the sacred, from becoming toward Being. The priest or pastor faced not the parishioners, but the Divine as the object of devotion. Now the perspective is reversed. Being is reduced to a church experience. Becoming right with reality is replaced by becoming right with inner happiness; from sacrament we shift to ego. With the priest or pastor facing the audience, an emphasis is placed upon the parishioners' role, comfort, ease of listening and viewing. About the same time, more music was added and the length of the sermon was shortened considerably. The shift was toward focusing on the development of the individual rather than the worship of God or understanding our position in regards to God. In Chartres Cathedral, one simply does not think much of oneself; while in the user friendly church it is altogether a different case. Now the concern is how to communicate in the most efficient way possible the lessons being presented. It is not to facilitate worshippers in their attempt to recognize their sacred, decorous place in the universe. It is a shift from worshippers seeking eternal Being to an audience seeking efficient, and comfortable, becoming. It is a shift from worship toward entertainment.

Louis Sullivan and Pragmatic Architecture

When the social-gospel movement encountered the brutality of the First World War, utopia seemed, at last, utopian. The subsequent behavior of the twenties was followed quickly by a resurgence of fundamentalism, a movement that rejected liberal interpretations of Scripture and anything associated with them. The social-gospel movement ended, but its influence lingered. Sociology continued as a discipline, neglecting its Christian foundations. Architecture, as a discipline, took from the movement a reforming tendency disconnected from any notion of Being. The pedigree of this adaptation is worth stating for it clearly lays out the roots of, and the path toward, modern architecture.

Gustav Stickley, the American voice for the Arts and Crafts movement, dedicated his first two issues of *The Craftsman* to the ideas of Ruskin and Morris. Stickley's enthusiasm was kindled by the Shaker style in America, which emphasized "honesty, simplicity and usefulness."[27] When the local chapter of the Arts and Crafts movement organized in Chicago, it did so at Hull House, a settlement house known also for providing arts education to its residents. It continued to meet there for years. Its members included an enthusiastic Frank Lloyd Wright. Wright was on board completely with the movement and the honesty, simplicity,

and usefulness it promoted. But the Shaker view of virtue as honest simplicity was ontologically grounded via a theological framework of good stewardship and Puritan work ethic; for the Arts and Crafts movement, the grounding was less certain. Wright understood this in at least some manner, for in 1901 he delivered, at Hull House, a pivotal lecture that signaled his divorce from the movement. In that lecture, "The Art and Craft of the Machine," Wright stated: "My God is Machinery; and the art of the future will be the expression of the individual artist through the thousand powers of the machine."[28] A technologically advanced violent paganism (resonant with the Futurist movement) is evident to those with the knowledge to recognize it. This break and its consequences explain an important part of Wright's thinking, architecture, and place in history. To understand more of Wright, we turn next to his mentor.

Louis Sullivan, like other architects and theorists at the end of the nineteenth century, desired a more authentic and true style in art and architecture. Frustrated by the seemingly vapid use of historic styles during the eclectic movement, Sullivan sought grounding for a style true and democratic. In addition to his studies at the Massachusetts Institute of Technology (under professors William Ware and Eugène Létang both of whom were influenced by French trends), he took up the new method inspired in part by Richardson. He also travelled to Paris and studied the "romantic rationalist movement" started by Labrouste.[29]

Those studies contributed to Sullivan's theoretical development. A romantic rationalism leads him to posit a new and true style for architecture in nature. As Sullivan biographer Narciso Menocil notes: "His aesthetic had a didactic function. It was to reinforce man's knowledge that he also was a part of the universe and that as such he had *to surrender his personal will to the universal will of nature* [italics added]."[30] Menocil follows with a quote from Emerson's 1841 essay "Thoughts on Art": "He is not to speak his own words or do his own works or think his own thoughts, but he is to be an organ through which the universal mind acts."

This Hegelian and pantheist denial of individual self-consciousness and the social norm of responsible freedom is shocking but predictable. Following in the footsteps of Emerson and Richardson, Sullivan attempts to work out a method of manifesting that particular immanent worldview in his architecture. Sullivan's earliest biographer suggests that Sullivan created more than a system; rather, he created a religion of architecture.[31] No doubt Sullivan wrote and spoke in terms not typically associated with architecture. When presenting a paper in 1886 to the Western Association of Architects in Chicago, he mentioned architecture not a single time.[32] The direction of his thinking is clear—to reject the objectivity of truth as transcendent, embracing instead an immanent vision:

I purposely herein have separated the Infinite from the religious conceptions that have descended to us, because these have as their axis of revolution the thought of a [transcendent] hereafter. What becomes of a man's soul in a theoretical hereafter is of insignificant value to the people at large in comparison with the social or anti-social use he puts to it here.

Natural thinking must, as a prerequisite, rest upon an elevated, a humane, an enlightened and natural appreciation of the Infinite—on adequate realization of our close identity with It, with Nature, and with our Fellow Men.[33]

Historical hindsight makes clear the social consequences of such ideas. To advocate a pantheist or monist close identity of thinking with nature and society presumes individual self-consciousness is not a precious foundation for intellectual and political freedom in the pursuit of wisdom. Such presumptions are necessary to the postmodern mind because, particularly since Kant, Hegel, and Rousseau, that mind cannot perceive the existence of a qualitative continuum informed by an objective norm—Being—in art or life. To accept the Hegelian position that the rational is real gives us no clue as how to recognize real rationality from false; nor does it permit us to individually do so. Natural and moral evil are trivialized, mystified, or justified as self-expression and self-realization. In any case, we must obey an unintelligible zeitgeist to be rational and free. An ontological scientific rationalism is insufficient to reveal objective qualitative reality. Better then to embrace a subjective reality.

The significant problems of distinguishing the social and antisocial, the humane and inhumane by considering nature and human nature as one with becoming affects also Sullivan's view of education. According to Sullivan (and Kant), how one experiences nature and enjoys an enlightened appreciation for it cannot be taught. A subjective objectivity—be it Kantian or Hegelian—denies the space between subject and object that permits scientific and rational knowledge to be sought and realized. Still, that did not prevent Sullivan from suggesting a different model for how architects might be instructed. No set rules should exist; design ought to spring from a practical communion with an assumedly benevolent and intelligible nature. Writes Sullivan in *Autobiography of an Idea*:

He could now, undisturbed, start on the course of practical experimentation he long had in mind, which was to make an architecture that fitted its functions—a realistic architecture based on well defined utilitarian needs—that all practical demands of utility should be paramount as a basis of planning and design; that no architectural dictum, or traditions, or superstition, or habit, should stand in his way.[34]

So within an assumedly benevolent nature an assumedly benevolent human nature should flourish free from constraint, tradition, or wisdom. It should flourish in the pursuit of a practical good not subject to scientific and rational understanding. The pursuit of that naturalistic but indefinable practical good correlates with one rule which Sullivan does posit: form follows function. The only rule promoted by Sullivan, without apparent self-consciousness, advocates a totalitarian dictum in the name of professional freedom. Why? Because the ethical equivalent of form follows function is that of means being justified by ends. Lacking knowledge of goodness, to justify culture on the basis of groundless ends or function is to justify sheer efficient coercion. In the name of efficiency, utility, or other claims of practicality, none can stand in the way.

What Sullivan means by form follows function is different from Puritan practicality or other notions of functionalism. Once dictum, traditions, superstition, and habit were out of the way, then the "practical demands of utility," the form following function, could be had. Emerson's inner necessity is transformed to architectural inner necessity—serving not Edwards's God, but the god architect.

This is subtly suggested in his well-received Transportation Building.[35] It was the only building of fourteen at the Chicago Columbian Exposition of 1893 that was not designed and built in the pristine white eclectic neoclassicism that so entranced Victorian visitors.[36] The feature of the massive building that garnered so much attention was the wildly polychromed exterior and "golden doorway" entrance portal. That ornamentalism has perplexed some. Historian David Hanlin suggests about his work:

> It was one thing to state such ideas and another to show how they could be put into practice, especially since buildings are characteristically thought to be static and finite, not growing and expansive. Certainly by the late 1880s Sullivan's buildings had not yet matched his words. Far from being individual and original creations, they were all too obviously derivative of two sources: Frank Furness and Henry Hobson Richardson.[37]

Sullivan's use of ornament also confuses. Even Morrison, his loyal biographer, struggles: "Moreover, there is little doubt that the bare logic of Sullivan's architectural thinking would have been more clearly apparent to his contemporaries if his buildings had not been adorned by such lyrical enrichments in the way of ornament."[38]

The ornamental forms that Sullivan developed reflect something of the organic, and mark his developing commitment to a process-oriented science, eth-

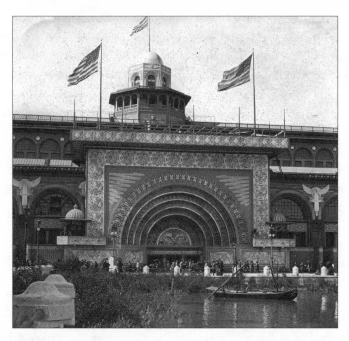

Louis Sullivan, Transportation Building, Chicago, 1893

ics, and art. It is moving toward the organic positivism of Hegel, Darwin, and later, Dewey. That organic idea has not yet been applied to the actual substance of the architecture; an ornamentalized and eclectic Romanesque is the uncomfortable result. That is a serious deficiency of Sullivan's work that is addressed later by Frank Lloyd Wright. But how does an organic architecture function without reducing architecture to mere functionalism? With no transcendent truth to convey, do architect and architecture grounded in inner necessity result in genius flourishing, or do they reveal a banal authoritarianism? Does such a grounding offer meaningful practicality, or limit us all to an empty organic formalism?

That emptiness requires the denial of tradition, dictum, wisdom, and Being. Sullivan did, in a very real way, achieve more reduction in tradition and dictum than he imagined. The next generation of architects included his student Frank Lloyd Wright. Wright also talked about nature and the organic, without apparent awareness of the skepticism shown two hundred years earlier by Perrault. The problem with a natural architecture driven by inner necessity is this: where in nature are the rules written, and how? To what purpose ought they aspire? Even if such purpose is discerned, what is to be done when inner necessity differs? But perhaps the organic pantheism denies that inner necessity can differ. What then of individual freedom of conscience and action? So as architects scratch away at

nature, trying to wrest the rules out from the "Inscrutable Spirit," they begin by scratching away tradition and intelligibility, and conclude in scratching away themselves.

Organic ornament is a distraction from the problem of a lack of organic substance; when an organic substance is achieved, responsible freedom ends. What else are we to make of the Chicago School, the earliest of the moderns, which was fueled in part by Sullivan's writing and work? Sullivan hoped that by returning to the purity of nature and becoming, as seen through an Emersonian lens, American democracy would flourish and naturally, so to speak, from that would flow a genuine architecture. But taking that reduction to heart, and not having a clear idea just what it is that nature teaches, the architects did whatever they wanted. Historian Jan Michl finds Sullivan's notion of function and form leading to a community of architectural science evidencing the worst of both worlds, an empty inner necessity resulting in an empty formalism:

> Having been empty the notion of function made the architects and designers free to define it in ways that always legitimized their own aesthetic priorities. Not only did it fail to bring the promised end to formalism. On the contrary, it inaugurated and legalized an era of a surreptitiously formalist approach to architecture and design.[39]

Within a generation, ornament was yet again out, to the degree that modernist architect Adolph Loos equated it with excrement. Stripped and plain buildings and a nonorganic functionalism became *de rigueur*. But whether ornamentalized or not, architecture as becoming lacks architectural purpose or Being, and an arche-tecture lacking an arche-type defies language and thought. Pragmatism and utilitarianism are deeply afflicted by their focus on becoming, a focus that denies the possibility of a meaningful reconciliation of form and function, means and ends, in culture and life.

Perhaps one ought not expect much from the ahistorical fluctuations between ornament and severity, or between an organic and inorganic positivism. Menocil observes of Sullivan: "His mind assented fully to the belief that his work could raise humanity to a permanent godlike feeling because to him the purpose of human consciousness was to attain to a constant and exquisite pleasure that in fulfillment became one with the erotic."[40]

For the classical-Judeo-Christian tradition, the erotic escapes a trivialized violence by rising to transcendent Love. The erotic rises to meaningful completion or Being. But an eroticism lacking the possibility of meaningful completion

is trapped in becoming. It becomes a parody of love, and a tragedy for sex. The parody is that it can never succeed, the tragedy is that it is condemned to a trivialized violence.

Self-deification and erotic pleasure are the avenues left to Sullivan's pragmatic and naturalistic thinking. It is dangerous then that Sullivan is unable to grasp the impracticality of reconciling responsible democracy with a pointless erotic self-deification. Nonetheless, so he proposes:

> It is of the essence of Democracy that the individual man is free in his body and free in his soul. It is a corollary therefore [sic], that he must govern or restrain himself, both as to bodily acts and mental acts;—that in short he must set up a responsible government within his own individual person. It is the highest form of emancipation—of liberty physical, mental and spiritual, by virtue whereof man calls the gods to judgment, while he heeds the divinity of his own soul. It is the ideal of Democracy that the individual man should stand self-centered, self- governing—an individual sovereign, an individual god.[41]

Eakins and Pragmatic Painting

Thomas Eakins (1844–1916) is a superb example of this cultural mindset. In 1871, he painted *Max Schmitt in a Single Scull*. The subject of the painting, Max Schmitt, is depicted just after having won a major competitive race on the Schuylkill River in October 1870. Why depict a rower just after winning a major competition? As a means to mark an essentially trivial event, such a painting is appropriate. To enjoy an exquisite example of technical ability and aesthetic appeal is similarly proper, as is the use of the subject to advocate physical fitness and competitive spirit. But to take this painting as an indicator of the meaning and purpose of life? That is quite another case. It is not to present humanity operating within a meaningful world (such as in Bingham's *Fur Traders Descending the Missouri*, 1845, in which a classical-Judeo-Christian context is clearly present). The rower in Eakins's painting is engaged in an activity within a naturalistic world; by engaging in a race, an otherwise meaningless activity attains meaning—of a sort.

This raises the serious question of quality. As an exemplar of the good life, does this painting have merit? To discern what constitutes a good life, one must to some degree know of what a good life consists. Quality judgments refer to ontological ends, to Being. Lacking Being, lacking final purpose, then how can quality

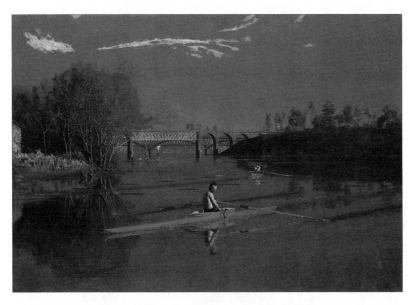

Thomas Eakins, *Max Schmitt in a Single Scull*, 1871

be discerned? If quality cannot be discerned, how can fine art be distinguished as such? This problem became critically manifest in Eakins's 1875 painting *The Gross Clinic*, which was submitted for inclusion in the Philadelphia Centennial Exposition but rejected by a jury.

The reason for that rejection was qualitative. The jury operated under the assumptions of classical-Judeo-Christian culture. Fine art is distinguished from the mundane by its concern for moral and noble ideals. Within that cultural framework, medical science is understood to be intellectually and morally inferior to high art and culture—that is, *scientism* is inferior to *scientia* and *sapientia*.

So the painting was rejected by the fine arts section of the Philadelphia Centennial Exhibition. Instead, it was displayed in the U.S. Army Post Hospital along with exhibitions of current medical technology. Medicine is of course important, but it works within a mechanical and organic context; one would no more ask a medical doctor how to live a good life than one would assume that a car mechanic necessarily possesses wisdom about lofty virtue. The philosopher or pastor might choose to be a doctor or a car mechanic, in which case wisdom might still be obtained; but wisdom as such is superior knowledge to matters of fact. The problem with Eakins's painting is that it conveys no wisdom. Rather, it is a brutal and egotistical depiction of the *empiricist-genius* healing, perhaps also playing God. To celebrate egoism, and to claim the status of a demigod, is to subjectify truth; but

society cannot function if dominated by practical egoists. To do that is to redefine truth as what we will. Health is a fundamental human need, but without wisdom not even a healthy life can be defended—much less life.

Nonetheless, to the pragmatist, the object of culture is not wisdom but the intersubjective experiencing of fact, mind, and action. That pragmatic nexus results in egoism becoming essential to the realization of meaning. It is the combination of the ego, experience, and action that produces an allegedly qualitative response that is deemed to be *experientially* good. What is good is determined by a positivist-organic pursuit of self-expression and self-realization. This pursuit makes no scientific and rational sense as such.

The painting celebrates Philadelphia's prominence as a center of medical education; it celebrates a democratization of medical education; it celebrates a rational and technologically advanced approach to surgery. But it cannot escape the charge that it is narcissistic in centering on the ego, and pornographic in the sense that it depicts humanity as an object subject to the manipulation, ego, and power of others. Postmodernist culture is dedicated to inner necessity, to self-expression and self-realization. And yet, that culture (if it can so be called) concludes in the worship of death. The shift from the classical-Judeo-Christian understanding of medical science as the means to protect and preserve human life shifts to an allegedly practical eugenics and death camps. In the name of an alleged compassion we now have state-sanctioned euthanasia. This violent objectification of the human being is a necessary outcome of the pragmatic and postmodern vision. If meaning occurs via the nexus of fact, mind, and action, then meaning is indeed a matter of becoming, but a becoming informed by the will rather than charity. And why not charity? Because charity,

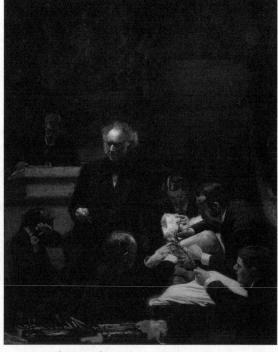

Thomas Eakins, *The Gross Clinic*, 1875

or love, refers to rightful completion, but rightful completion cannot exist in a world without Being. Therefore, the substitution of becoming for Being results in a substitution of worshiping death rather than life. That choice dramatically unfolds in twentieth-century American and Western culture. It is a choice that remains.

11

NEITHER MEDIEVAL NOR
MODERNIST SCHOLASTICISM:
AMERICAN EXCEPTIONALISM

The tensions within American culture reflect its unique historical position. As a colonial offshoot of the Anglosphere, its traditionalism is associated with the pursuit of responsible freedom. Founded by persons committed to religious and political freedom (rather than financial or aristocratic advantage), America offered a new possibility within political science: an egalitarian culture dedicated to the common pursuit of uncommon wisdom. Plato's fear of democracy as mob rule would be resolved not by a philosopher-king, but by a philosophical mob.

The traditional commitment of American culture to the free and responsible pursuit of Truth, Goodness, and therefore Beauty has always been challenged by the positivist redefinition of science and reason. Conversely, American culture challenges both pre- and post-Enlightenment Europe. It differs from the culture of pre-Enlightenment Scholastic Europe in its understanding of reality and life; it differs from the post-Enlightenment focus on purposeless becoming.

Plato studies history and concludes that there is a cycle to human affairs—from virtue to corruption and back to virtue—and the way to escape that violent cycle is for rulers to become philosophers. Or as Aristotle puts it: rulers ought to manifest excellence. By the time of the Enlightenment, assertions that a hereditary aristocracy is necessarily informed by excellence were recognized as absurd. In contrast, since its inception, American culture advocated a meritocratic alternative.

In place of a social stratification based on notions of an aristocracy, traditional American culture is deeply informed by an egalitarian yet classical-Judeo-

Christian vision. American culture tries to maintain continuity with the qualitative foundations of Western culture (namely the pursuit of the True, Good, and Beautiful) while maintaining an egalitarian social system in which each and all can aspire to attain excellence. It is not the philosopher-king who ought to rule, nor an hereditary aristocracy, and certainly not a willful mob. It is a responsible and free majority in pursuit of wisdom. This idea is Trinitarian in origin. It takes for granted that the will and mind should freely seek wisdom which is to be realized in our daily lives. Wisdom does not change, but our circumstances and understanding change, not in the sense of a transgressive subversion of truth and tradition, but a subversion of ignorance and evil within a truly progressive historical drama. That vision accommodates a culture that believes in responsible freedom for all within a purposeful universe. Ontological and social progress makes sense as the timely realization of perennial wisdom.

The interdependence of science, ethics, and art—of knowing, doing, and making—now occurs within a social matrix of responsible freedom. Science, ethics, and art are not just confined to Being as immanentized by an aristocracy, theocracy, or democracy (literally, rule of the willful mob), nor are they confined to mere pointless narcissistic becoming. Rather, they are dedicated to a timely realization (becoming) of degrees of wisdom (Being). They are dedicated to the liberal arts and responsible freedom; by extension, neither science nor reason is viewed as inimical to religion or a philosophical pursuit of wisdom.

As we have seen, it is that very belief that is assaulted by the Baroque-era redefinition of science and reason. Neither science nor reason operates within the context of Being as ontological perfection. For Kant, both are deontological, categories of the human mind; for Hegel and Marx, both are grounded in ontologies of power. Neither accepts the possibility of purposeful science, ethics, or art. Science and reason are reduced to facts, process, and the will. Knowledge of how the world works is reduced to momentary descriptions that can at best be used in the pursuit of ultimately meaningless power. Our ability to understand the meaning of reality and life is mocked or brutalized. Culture, the humanities, the liberal arts—indeed, civilization—collapses.

For those modern-postmodernists who believe in God, evil becomes unexplainable and truth or God, unintelligible. For those who do not believe in God, evil is unrecognizable and truth irrelevant. The Kantian-Rousseauean suggestion that the human will is naturally good makes no sense since a good will cannot be recognized as good—or bad. It simply is. The Enlightenment views as absurd any qualitative hierarchy in science, ethics, or art, unless it is grounded in assertions of genius or power. Such authoritarian assertions are of course not

really qualitative; they confuse truth and goodness for power, whether rational-
ized or not.

The European Enlightenment redefines science and reason, and *de facto* sub-
verts the metaphysical assumptions underlying traditional Western culture—and
all other cultures around the world dedicated to seeking wisdom. In contrast to
science and reason leading via responsible freedom to knowledge of a meaningful
world, we now seek facts and feelings within a meaningless world. Since knowl-
edge no longer refers to intelligible reality, to Being, knowledge is indistinguish-
able from assertions of the will. Knowledge of Being is now merely an assertion
of us becoming. We shift from a metaphysics of responsible freedom to an exis-
tentialist metaphysics where self-expression and self-realization are incoherently
deemed trivial constructs and brutally authentic experiences.

Ironically, a hereditary aristocratic immanentizing of the transcendent is
replaced by the postmodern immanentizing of the transcendent by individual or
group experience. The will of the people, based on race, gender, economic class,
or the individual, is sacred yet profane. Those who celebrate that redefining of
science and reason embrace what might be called European exceptionalism: the
belief that modernism is inevitable and progressive. European exceptionalism
concludes in a postmodern European existentialism. Those who reject the reduc-
tion of science and reason to facts, feelings, and power, embrace what might be
called American exceptionalism. That path remains dedicated to a democratiza-
tion of politics, but not of culture. The will of the people is profane and ought to
freely strive to *imitate* the sacred.

A choice between these two possibilities must be made: either one seeks facts,
feelings, and power, or one seeks Truth, Goodness, and Beauty. That can be effec-
tively demonstrated by referring to the *loci classicus* of modernism in America: the
Armory Show of 1913.

The Armory Show of 1913

The International Exhibition of Modern Art, now known as the Armory Show,
was a calculated attempt to present recent developments in European culture to
America, not as a different and competitive alternative, rather as a progressive
improvement. A progressive improvement over what? Over both a moribund
National Academy of Design locked into an academic sterility, and a vital classical-
Judeo-Christian tradition assaulted by positivism but remaining to this day com-
mitted to the practical pursuit of wisdom and beauty.

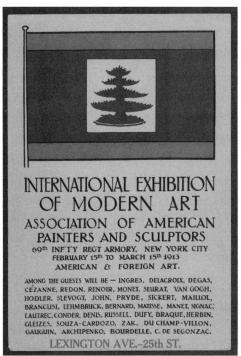

Exhibition Poster, *International Exhibition of Modern Art*, 1913

The poster for the show was decorated with a reproduction of a colonial battle flag of Massachusetts with its distinctive pine tree motif. The point is obvious: the modernist participants are allies in the revolutionary pursuit of a new political and cultural order. But American exceptionalism itself was a new order. The question is how these competing new orders compare.

Is the new revolution advocated by the Armory Show transgressive of ignorance and willful evil? Or is it transgressively sociopathic? Does culture and wisdom liberate us from tyranny and anarchy, or is culture a mask for power and authenticity? That choice is the crossroads at which colonial America stood, and at which contemporary America still stands. Given the worldwide assault by positivism on culture itself, it faces us all.

For example, if it is granted that morality is grounded in the Bible, then we can accept the authority of biblical morality, or not. If it is granted that morality is grounded in self-expression and self-realization, then we can pursue a life dedicated to tolerance, or not (via competing claims of authenticity). If it is granted that culture is realized via good will, then we can engage in eugenics, or not. In each case, wisdom is denied and conflicts abound. Lacking a reconciliation of Being and becoming in science, ethics, and art, there exists at best slim justification for studying history, theology, philosophy, or engaging reason. The liberal arts wither along with responsible freedom. A substantively debased scientific-technological culture dedicated to the practical advancement of power and wealth prevails without qualitative purpose. Even when ostensibly devoted to tolerance and identity, that culture, lacking qualitative purpose, collapses into conflict and violence.

History tells us that this viewpoint prevailed previously. It is called paganism. Paganism has traditionally been associated with the following traits: the natu-

ral world is spirit made immanent (Hegel), but is unpredictable and unknowable (Hume); dreams are real (Freud; New Age); experience is knowledge (Nietzsche, Heidegger); sexuality is a rite to placate the gods (Sade); there are no moral absolutes, no history (Nietzsche); and there is a need to conform to nature (Hegel, Darwin). In any age, paganism offers a willful, purposeless authenticity. It is a willful becoming.

In the West, Socrates, Plato, Aristotle, Anaxagoras, and the Judeo-Christian tradition establish an alternative to that violence. Plato and St. Paul note that unqualified democracy succumbs to despotism; Adam Smith, Lord Acton, Washington, and Jefferson know that aristocracy does no better. Plato and Puritan alike recognize that material pleasure undermines an interest in goodness and virtue. Edwards and Kuhn recognize that philosophy and reason do indeed influence our understanding of religion with its *consequent* view of science and culture. So a lack of interest in the history of ideas coupled with an assumedly practical orientation results in each succeeding generation exhibiting an increasing susceptibility to a naïve enthusiasm in religion and *its resultant* science, ethics, and culture.

The postmodernist response to the world and life trivializes and brutalizes the reasoning process by confusing thinking with feelings and power. By arguing that all statements are political and therefore equally meaningful (and meaningless), postmodernism tacitly assumes that politics is grounded in power. It thereby undermines our ability to draw distinctions and to make qualitative judgments. It blinds us to our own decline, and we become increasingly deaf to concepts such as truth, goodness, beauty, and responsible freedom.

The result was and remains a conflict between two different visions of subversion—or of progressivism: one is based on the pursuit of truth and beauty, the other is based on the realization of power and aesthetics. Progressivism can be dedicated to the realization of wisdom and beauty via an escape from ignorance and violence, or it can be dedicated to an alleged tolerance and identity. That dichotomy informs the foundational conflicts within American and Western culture today. To paraphrase Lincoln's Second Inaugural Address, a house so divided cannot long stand.

The Armory Show evidences several cultural concerns that refer to that essential dichotomy. The impetus behind organizing the show was not to escape folly and evil, but to break the bonds of a moribund academicism in art and life. The National Academy of Design was locked into a widely perceived sterile beaux-arts traditionalism. The impetus was to break the bonds of stale traditionalism, not to revive the pursuit of truth upon which it relies.

Modernism and postmodernism were offered as alternatives; each was grounded in a positivist and nominalist redefinition of science and reason result-

ing in art for art's sake, art for the sake of personal feelings, or art in the service of politics. What is ignored is the vital need for a scientific and rational culture grounded in the free pursuit of wisdom and beauty.

Matisse and Duchamp

The controversies surrounding the Armory Show centered on the art of Henri Matisse and Marcel Duchamp. The inclusion of these two artists in the show reflected the goals and beliefs of the Association of American Painters and Sculptors, which was dedicated to breaking the bonds of tradition; it was subversive of tradition. It was typically modern. What is less well known, and taught, is that a wide variety of worried editorialists and critics clearly recognized that the show constituted an assault upon the very foundations of Western civilization. Believing that we should be subversive not of tradition but of ignorance, folly, and vice, they viewed those efforts as nothing short of sociopathic. But that view was confounded by the prevalence of the moribund academicism championed by the National Academy of Design. A dead academicism made subversion of tradition tragically and mistakenly attractive.

In Gallery H of the Armory Show, examples of the fauvist art of Matisse drew critical reaction. For example, his work *Blue Nude* (1907) was particularly

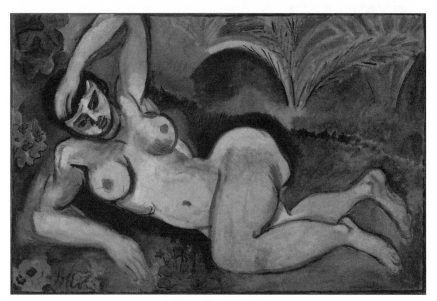

Matisse, *Blue Nude*, 1907

criticized for its apparent crudity. Students at the Art Students League of Chicago deemed such works as the equivalent of artistic murder, pictorial arson, artistic rapine. Similarly, the lack of academic polish in painting technique, presentation and content provoked Harriet Monroe, a Chicago poet, to be dismayed by Matisse, calling his paintings "the most hideous monstrosities ever perpetrated in the name of long suffering art."[1] But she later came to praise it: "In a profound sense these radical artists are right. They represent the revolt of the imagination against nineteenth century realism. . . . They represent a search for new beauty . . . a longing for new versions of truth."[2]

This might be viewed by some as a progressive step into a vital new future. But they would be as mistaken, as was Monroe. Imagination can dream of the numinous, as Russell Kirk, Christopher Dawson, and C. S. Lewis hoped. For the modernist-postmodernists, imagination has no object, only subject; it can only dream of itself. As artist Barnett Neuman later stated:

> The invention of beauty by the Greeks . . . has been the bugbear of European art and European aesthetic philosophies. . . . The impulse of modern art was this desire to destroy beauty . . . by completely denying that art has any concern with the problem of beauty and where to find it. . . . We are reasserting man's natural desire for the exalted, for a concern with our relationship to the absolute emotions. . . . Instead of making cathedrals out of Christ, man, or "life," we are making it out of ourselves, out of our own feelings.[3]

The objections of the art students in Chicago to these developments can be viewed as reactionary philistinism; but from a different perspective they can be viewed as a defense of human dignity, responsible freedom, and culture. Boethius's definition of a person as an individual substance of a rational nature associates the nude with consciousness, freedom, and the rational soul. To look at the women's face in *Blue Nude* is to look in vain for any indication of thought or rationality. To deny the nude a rational and thus personal identity is to reduce the person to an object. It is therefore pornographic. Matisse's nude is an act of transgression against the dignity of the human person. It is to attack the possibility of responsible freedom grounded in self-conscious reflection.

The transition from the nude as representative of wisdom and the rational soul made manifest in material form, to the nude as a vehicle for expressive authenticity, represents not a longing for new versions of truth, but a denial of the very possibility of truth or beauty. If the *Blue Nude* is representative of Neuman's idea of cathedrals of the self, then the dreadful consequences of such cultural

solipsism are evident. Freedom without truth collapses into brutality. Matisse is unmistakably transgressive in his decision to paint the nude as the expression of feeling. He assaults the intellectual content of the nude in art as advocated by the classical Judeo-Christian tradition. That intellectual content argues for the reality of balance, harmony, and proportion—but not merely compositionally (as with the neoclassicists). The material world of matter and becoming aspires to the perfection of the ideal and Being. It aspires to an ontological harmony that is intelligibly decorous in every sense.

So an academic and sterile traditionalism made the art of Matisse an attractive alternative. But Matisse does not offer a renewed and progressive commitment to truth, goodness, and beauty. Rather, he offers a transgressively violent attack upon culture. At best, he offers the alternative of *inner necessity*, which, when extended, manifests itself as an a-rational, ahistorical, indecorous choice of anarchy or pantheistic totalitarianism. It offers a return to pagan violence. That we today view such a painting with commonplace acceptance indicates our lack of awareness of our own cultural decline.

Matisse's association with the painting group known as the *fauves* (the wild beasts) gave pause to his contemporaries. It should give us pause to reflect as well. The fauves were named by a witticism coined by the journalist Louis Vauxcelles. He remarked that Renaissance art in the presence of the art of Matisse and his colleagues was like Donatello among the wild beasts.[4] In contrast to the dead rationalism of academic art and the dead scientism of a positivist impressionism, Matisse attempted to revitalize art with an emotional authenticity. That impulse was recognized by many of his contemporaries to be foundationally sociopathic.

In his 1908 essay "Notes of a Painter," Matisse famously (or infamously) states:

> What I am after, above all, is expression. Sometimes it has been conceded that I have a certain technical ability but that all the same my ambition is limited, and does not go beyond the purely visual satisfaction such as can be obtained from looking at a picture. But the thought of a painter must not be considered as separate from his pictorial means. . . . I am unable to distinguish between the feeling I have about life and my way of translating it.
>
> Expression, for me, does not reside in passions glowing in a human face or manifested by violent movement. The entire arrangement of my picture is expressive: the place occupied by the figures, the empty spaces around them, the proportions, everything has its share.
>
> Composition is the art of arranging in a decorative manner the diverse elements at the painter's command to express his feelings.[5]

As Matisse admits, this advocacy of art in the service of the artist's feelings, of inner necessity, is decorative but not merely emotivist. It is not merely a desire to please our sensibilities and vanities. Indeed, expressionism found fault in impressionism for doing just that. Instead, expressionism was grounded in the advocacy of a new religion, the religion of authenticity. As art historian Sam Hunter notes:

> The Fauves' outlook corresponded to a new, intoxicated rediscovery of nature life and feeling, a development that had already been expressed in the closing years of the old century in such books as Andre Gide's *Fruits of the Earth* and by the literary movement of Naturism. As early as 1895, in his *Essay on Naturalism*, Maurice Le Blond had voiced the mounting reaction of writers to Symbolism and the Romantic decadence: "Our elders preached the cult of unreality, the art of the dream, the search for the new shudder. . . .They were incoherent spiritualists. As for ourselves, the Beyond does not move us; *we profess a gigantic and radiant pantheism* [emphasis added].[6]

What is odd is that Matisse appears to be unaware of the contradictory presumptions of his art. He advocates an incoherent individualistic pantheism. The spirituality of the symbolists and the romantics (discussed previously under the rubric New Age) centers on the deification of the individual. But at the same time they celebrate a universal spirituality that denies individuality.

There is but a slight step from a nominalist individuality to a pantheist commonality. The choice between a celebration of individual inner necessity and group inner necessity, between Nietzsche and Hegel or Marx, between Dewey and Emerson or James, is not rational but emotional. It is grounded in inner necessity, which can only willfully choose between the individual or the group. Rationality reduced to inner necessity, or rather, the will. As such it denies Boethius's definition of a person as an individual substance of a rational nature. The denial of individual rationality in the free pursuit of truth leads to catastrophic political consequences.

Following classical and Judeo-Christian tradition, American culture is historically grounded in individual freedom and responsibility. Art advocating pantheism would not go unnoticed in the American context. Indeed, the Puritan romanticism of Cole and some of the luminists deeply resisted just that. That resistance is grounded in theology, philosophy, and a deep understanding of what pantheism involves. Theologically, pantheism denies transcendence and thus the Trinity and the Doctrine of the Incarnation; it advocates self-deification while denying the individual self. Scientifically, it denies the objectivity of knowledge

since the mind of reality is identical with the mind of humanity. Philosophically, it denies the possibility of individual freedom and personality yet celebrates both. We will return to that issue in a moment. But first, let us consider Matisse's companion in transgressive subversion: Marcel Duchamp.

Duchamp had recently moved to New York and was a primary participant in the introduction of modernist-postmodernist culture to America. Two works of his are pertinent to our discussion here, one exhibited in the Armory Show (his famous painting *Nude Descending a Staircase, No. 2*), the other shortly thereafter in a different show (his found object *Fountain*).

His works were exhibited in Gallery I of the Armory Show, popularly called the chamber of horrors. It was, in fact, a chamber of cubism. The most notorious work in that room was Duchamp's *Nude Descending a Staircase, No. 2*. Such works caused the *New York Times* to describe the show as pathological and associate modernists with anarchists. The American Federation of Arts compared them not only to anarchists but also to "bomb throwers, lunatics, depravers."[7]

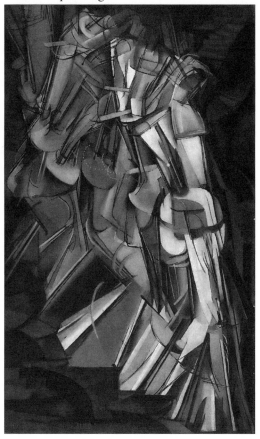

As Matisse tried to persuade the public that he was a bourgeois family man (as if that matters per the quality and ultimate influence of his ideas; otherwise responsible people are capable of naively advancing nonsense), the cubists tried to persuade the public that they were not anarchists. A participant in the show, the European cubist Picabia, published an article in the *New York Times* which was later reprinted in various other venues such as the *New York World* newspaper. Picabia attempted to explain how the cubist denial of wisdom and beauty is actually necessary

Marcel Duchamp,
Nude Descending a Staircase No. 2, 1912

and good: "The qualitative conception of reality can no longer be expressed in a purely visual or optical manner; and in consequence pictorial expression has had to eliminate more and more objective formulae from its convention in order to relate itself to the qualitative conception."[8]

Picabia's argument is that to attain a qualitative understanding of reality we must eliminate objective criteria. This is modernist dogma; from Kant on, a subjective objectivity is judged necessary and effective in science, ethics, and art. But the *New York World* found such verbiage to be incomprehensible. It offered a reward to anyone who could make sense of it, and offered a reward to any who could find the nude in Marcel Duchamp's *Nude Descending the Staircase*. A humorous challenge, but nonetheless to the point. The term *nude* has historical connotations that are difficult to find in this painting allegedly depicting one. To subvert the nude in art is to subvert rational objectivity and purpose in reality and life. The denial of rational objectivity and purpose in reality and life is not neutral; it is an advocacy that science, ethics, and art are existential.

Historically, the concept of the nude is associated with bringing to material form a visualization of the objective rational ideal. It is similar to decorum. Decorum refers not to pleasure, but to the fulfillment of an ideal; not to inner necessity, but to inner proclivity seeking to escape violence by attaining harmony with objective numinous reality. Decorum is instinct or habit raised to the level of practical wisdom. It is the means by which we cease to be wild beasts. Similarly, the nude differs from the naked in that the naked is but an object whereas the nude refers the material to a higher purposeful ideal. The naked is exploitative whereas the nude is liberating; the naked is associated with a brutal and crass materialism whereas the nude is the purposeful ideal made incarnate. The naked denies what the nude affirms: that we can be conscious free and responsible persons.

But according to modernist cubism, the purposeful ideal does not exist. What does exist? Constructivism, in which reality conforms to how we feel, not what decorum provides. In denying Being, constructivism denies our own ontological existence. The realm of human being is no longer. The foundations of expressionism and cubism are positivist and nominalist, in which facts are constructed into meaningful yet subjective narratives that correspond with our minds or feelings. A subjective objectivity is deemed foundational to culture and science. As articulated by the cubist theorist Andre Salmon in a different venue:

> There is nothing real outside of ourselves; there is nothing real except the coincidence of a sensation and an individual mental tendency. Be it far from us to throw any doubts upon the existence of the objects which impress our

senses; but rationally speaking, we can only experience certitude in respect to the images which they produce in the mind. . . . We seek the essential, but we seek it in our personality and not in a sort of eternity, laboriously divided by mathematicians and philosophers.[9]

So what exactly does Picabia's statement quoted earlier, so baffling to the *New York World* editorialists, mean? It means that objectivity was once grounded in objective reality, but now "objectivity" is grounded in the human mind and actions. Objectivity is now a product of our minds and actions rather than a goal.

Traditionally, a positivist focus on fact and feeling is initial, and is transcended via a rational comprehension of Being. That is, the notion of quality was grounded in a glimpse of objective purpose by Aristotelian philosophy and Christian (as well as Confucian and Buddhist) theology. But we now live in a quantitative world lacking purpose. Therefore, to attain meaning, a qualitative understanding of reality and life, we must now do so via subjective formulas. But if a qualitative vision is attained via the rejection of objective formulas, and if subjective formulas prevail, then those formulas are nothing other than the will to power—to be praised or mocked.

This is evidenced by an object exhibited by Duchamp in New York in 1917. In April of that year, the Society of Independent Artists held its first exhibition, The Big Show. That exhibition was modeled on the French Societe des Artistes Independants, a society formed in 1884 to offer an alternative to the French Academy. The major controversy surrounding the 1917 show was its no-jury policy in which works from bona fide artists would automatically be exhibited, and that exhibition would be presented in the show alphabetically. The consequence was a huge show involving about 2,500 paintings and sculptures by 1,200 artists.

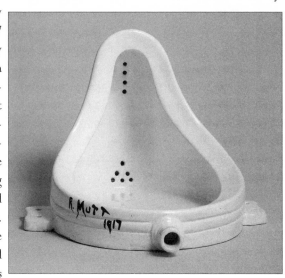

Marcel Duchamp, *Fountain*, 1917

One particular piece was nonetheless judged and rejected: Duchamp's *Fountain*. That object was a

found object, a urinal, purchased by Duchamp from a plumbing supply store in Manhattan. He submitted the urinal for inclusion in The Big Show, having only turned the ordinarily utilitarian object on its axes and writing upon its surface the name R. Mutt.

That submission was clearly subversive. But in what sense and to what import? Certainly it was subversive of a moribund and academic jury system that systematically excluded art that was not rigidly orthodox in a particular way. But in a curious historical twist, Duchamp's *Fountain* now represents not the absence of orthodoxy, but a new and nihilistic orthodoxy that has taken hold. Indeed, in 2004 this object was recognized by five hundred British art world professionals as the most important work of art of the twentieth century.[10] This is not cause for joy. Its historical importance is undeniable, but its cultural impact is horrifically destructive.

The object and its selection as a work of fine art are obviously transgressive. The following excerpt, originally published in the *Blind Man* (a dadaist publication), was signed with Duchamp's pseudonym "R. Mutt":

> The Richard Mutt Case:
>
> They say any artist who pays six dollars may exhibit.
>
> Mr. Richard Mutt sent in a fountain. Without discussion, this object disappeared and was never exhibited.
>
> What were the grounds for refusing Mr. Mutt's fountain:
>
> 1. Some contended it was immoral, vulgar.
>
> 2. Others that it was plagiarism, a plain piece of plumbing.
>
> Now Mr. Mutt's fountain is not immoral, that is absurd, no more than a bathtub is absurd. It is a fixture which you see every day in plumbers' show windows.
>
> Whether Mr. Mutt made the fountain with his own hands or not has no importance. He CHOSE it. He took an article of life, placed it so that its useful significance disappeared under the new title and point of view—created a new thought for that object.
>
> As for plumbing, that is absurd. The only works of art America has produced are her plumbing and her bridges.

Fountain presents a brilliant exposition of the central ideas resulting from the modernist-postmodernist paradigm. That paradigm is aesthetic, and involves either an aesthetic modernist rationalism or an aesthetic postmodernist existentialism. It reflects the positivist and nominalist redefinition of science and reason to fact, rationalization, and the will.

It is useful to recall that prior to the Renaissance and Baroque eras, we lived within a sacred order. There was no distinction between religion, science, and culture. During the Baroque period, fine art is separated from daily life; an Academy of Fine Arts was first established in France. The fine arts, the *beaux arts*, once an integral part of a qualitative culture, are newly established as a distinct facet within a quantitative worldview. The sacred and cultural are consequently relegated to that which is pursued at best on the weekend, not as part of daily life. Just as the Sabbath and leisure are newly separated from the pursuit of wisdom, so are science, reason, and fine art. That which is separated via a particular perspective cannot be put back together via that same perspective.

So the new academy of fine arts operated under the same assumptions that are foundational to modernism. Modernism defined fine art—and science—not as the material manifestation of wisdom, but as genius-inspired feelings and facts. For Kant, art and science were noncognitive, self-referential, and a perfection of a kind. Modernism rightly resisted the dead academy as manifested by the beaux arts, and Postmodernism resisted the trivialization of culture by both. Its failure was in its inability to recognize, much less resist, the cultural consequences of a shared definition of science.

Positivism denies the notion of fine art as a vehicle for obtaining a glimpse of wisdom and beauty, which resulted in a dead academicism, and a trivial constuctivism; to escape both, the postmodernist asserts instead that all meaning is grounded in inner necessity or the will to power. It is no solution to a very real problem. Absent is the possibility of art and science as the splendor of wisdom.

Duchamp's *Fountain* mocks the notion of beaux arts, and of the genius who subjectively distinguishes the mundanely aesthetic from the inspired aesthetic. It subverts the distinction of art from fine art by its very substance: a commercial urinal. It deconstructs the academic/modernist cultural paradigm and replaces it with a vision grounded not in wisdom but deconstruction. Its alleged authorship by R. Mutt blurs the distinction between fine art and comic strips, since *Mutt and Jeff* was a popular newspaper comic strip in New York at the time.

The ostensible goal of such deconstructionism is to liberate us from false dogma, false constructs, and false emotionalism. We are all to be authentic—without wisdom. So, for example, the art object is aesthetic and yet it is anti-aesthetic; it is selected by a genius who ironically rejects genius; it is a work of fine art that ironically rejects the notion of fine art by reference to (noncosmic—remember Newton) plumbing and comic strips. At its most controversial, it argues that sexuality is a social construct which can in turn be deconstructed. The found object, as found, is a urinal for male use. As such it is a receptacle of male waste.

But by altering its orientation on two axes, the male nature of the object is decontextualized and transformed into a female object. The urinal's orifice newly at the bottom of the object is vaginal rather than phallic. Following Derrida, an attempt to understand this object as fine art is an act of phallogocentrism. That phallogocentrism must be deconstructed: the male is the female, the female is male. Understanding is replaced by feeling, Being is replaced by becoming.

But for a male patron attempting to use Duchamp's resituated urinal, transgressive issues arise. It is not merely a receptacle for waste; the male is also confronted by an orifice as a sexual invitation. Since that invitation is in the context of human waste, the sexual act is associated not with life but with waste—and death; not with purpose, but with the denial of purpose. Indeed, it is associated with a willful indecorous—Sadean—denial that any purpose at all is associated with sex. Therefore, sex is dissociated from meaningful completion, from Being, and thus from love. As such the notion of perversion—of a willful denial of reality—is transformed into virtue, of a sort. The only virtue that results from this contextualization/decontextualization, this constructivism/deconstructivism, is a willful authenticity grounded in our subjective inner necessity. We make meaning; we are the Hebraic *Haya Haya*, or the Greek *To On*. We are the subjective source of meaning in a meaningless world, our own nebulous existence notwithstanding. When not engaged in purposeless onanism, we engage in perversion. In either case, the ultimate result is self-contempt incapable of self-contempt.

The net result is at best what would be called a positive nihilism. Its ostensible goal is to liberate us from dead and false dogmas and traditions. Its practical consequence is to subvert the notion of normalcy. But as a variety of American authors at the time noted, when normalcy is denied, perversion is mandated, and perversion properly understood quite literally means a futile attempt to ignore reality—or Being.

Race, Aesthetics, and the Armory Show

The Armory Show not only included modernist and postmodernist works of art; significantly, it also included the art of primitive societies and the art of children. They were included not as reflective of ethnographic or sociological attempts to understand reality and life. Rather, they were viewed from a modernist-postmodernist perspective.

The treatment of American Indian culture and art is a case in point. The modernist critic Clive Bell saw in primitive art not wisdom or even authenticity

but rather what he called in Kantian fashion "significant form." As he put it in his 1912 essay *The Aesthetic Hypothesis*:

> Significant form stands charged with the power to provoke aesthetic emo-
> tion in anyone capable of feeling it. The ideas of men go buzz and die like
> gnats; men change their institutions and their customs as they change their
> coats. . . . Only great art remains stable and unobscure. Great art remains
> stable and unobscure because the feelings that it awakens are independent of
> time and place, because its kingdom is not of this world. . . . The forms of
> art are inexhaustible; but all lead by the same road of aesthetic emotion to
> the same world of aesthetic ecstasy.[11]

Unbeknownst to American Indian cultures, their art was dedicated to a uni-
versal aesthetic emotionalism; they were unwitting esthetes.

Alternatively, two artists involved with the Armory Show, Marsden Hartley
and Max Weber, studied native American art that was collected by various ethno-
graphic museums in Europe. They praised primitive and ethnographic art, finding
great authenticity and spiritual necessity in the art of the American Indian.[12] So
American Indian cultures were actually unwitting New Age spiritualists.

This postmodern linking of culture with authenticity and spiritual necessity
has its dangers when combined with race. The artist Julius Rolshoven, in har-
mony with the ideas promoted by Kant in his *Pragmatic Approach to Anthropology*,
denied the importance of art from other races. He stated that if art is based on
race or ethnicity, then interest in the art of other races or ethnicities constitutes
a personal and cultural suicide.[13] To declare that race is identical with culture is
to grant that culture can best be grounded in racial purity—and hatred. If so,
then we face an aesthetic and violent choice: we can trivialize the belief of the
Other and ourselves; we can identify with the Other (and kill ourselves); or we
can identity with ourselves (and kill the Other). Lacking a transcendent wisdom
above race (or gender or economic class), a destructive and incoherent advocacy
of tolerance and authenticity prevails.

There are also those who would combine culture and race into a new cosmo-
politan vision. Painter-sculptor William Zorach describes his interest in cubism
as resulting from his experiencing primitive art at ethnographic museums. So,
too, did Picasso find inspiration by encountering African art in Paris. The prob-
lem of course is that not all non-Western cultures agree in substance, and none
embrace the modernist or postmodernist perspective.[14] To view African art as
cubistic, or to view Navajo rugs as aesthetic objects evidencing significant form,

is to view all art from a modernist-postmodernist perspective. It is to assault their authenticity in the name of an ahistorical and dysfunctional syncretistic multiculturalism.

From the point of view of the pursuit of beauty—in which beauty is understood as the splendor of wisdom—the art of primitive societies, of children, art for art's sake, or art as constructed opinion or of authentic experience are culturally not very interesting. It is not that they are necessarily viewed with contempt; rather, they are viewed as inadequate.

So ethnographic and primitive art was a major component of the Armory Show. As such, the volatile topic of race was very much in the forefront of the exhibition. There is no disputing that a doctrine of racial superiority was commonplace in Western nineteenth-century thought. What is not common is awareness of the Baroque-modernist grounding of that thought.[15]

Preference for the company of those who appear similar to ourselves certainly has had historical justification. Augustine defined a people as: "an assemblage of reasonable beings bound together by a common agreement as to the objects of their love."[16] In premodern cultures, that which commonly bound people together was not only love (as meaningful completion) but love between the biologically related. Society was understood quite literally as an extended family, and the immediate and extended family was understood as the nexus of safety and freedom. To be free was to be a member of the family, and such membership typically included a genetic component.

Curious alterations to this notion of culture as extended family united by love and biology was fueled by both a demographic explosion during the Baroque and later periods, and by the Baroque and later redefinition of science, reason, and culture. The historical irony is that to the postmodern positivist, a people is grounded not in love, but in empirical identity. Paul's transcendent admonition that under Christ there is *neither* Jew nor Gentile is challenged by the positivist demand that we must choose to be *either* Jew or Gentile, *ad nauseum*.

Or to put it differently, the extended family collectively known as traditional society was newly viewed from a positivist perspective and began to encounter, intermix, or conflict with other positivist extended families. When lacking a cosmopolitan—that is, transcendent—viewpoint (as suggested by Augustine, and which is truly inclusive), we are limited to an immanent multicultural viewpoint (which is not inclusive). In place of a commitment to seeking wisdom and beauty, the possible responses to that changed situation are limited to violence. It is with the advent of the modernist-postmodernist period that a demographic nationalism developed, as did a pseudoscience of racial superiority.

Within the Christian cultural tradition, culture is grounded not in race, gender, or economic class, but rather in the love of wisdom and beauty. Within the classical tradition, the concept of race is found in the work of Aristotle. It is grounded in specifically Aristotelian categories that focus on the grouping of facts by shared biological and naturalistic traits. Those categories are essential to an Aristotelian understanding of natural science, but those categories are also clearly antagonistic to Augustinian thought.

What is critical is the effect of the positivist redefinition of science and reason upon Aristotelian categories—particularly those addressing the concept of race. In contrast to the Aristotelian belief in a purposeful universe, the positivist Enlightenment denied the existence of any Final Cause by which a transcendent and objective goal is possible. Consequently, naturalistic categories such as species and race lack any objective and transcendent goal. Platonic and Christian notions of transcendent, and thus unifying, ideals permit us to rise above race to Humanity, above law to Justice, above aesthetics to Beauty. Lacking such goal or purpose, race is a naturalistic and biological construct for its own sake. It is not a matter of beauty, but of aesthetics. It can only be trivialized or made absolute.

The positivist and organic (or pantheist) aestheticization of race came to exist as a result of the Enlightenment's misguided reliance on facts and feelings to eradicate ignorance and superstition. The attempt to classify facts about humanity is no longer teleological and unifying, but grounded in scientism. It is no longer grounded in Being (i.e., Human Being), but becoming. The rise of scientism initiated the notorious "science of race." Remember Kant's infamous *Pragmatic Approach to Anthropology* in which he qualitatively ranked four racial groups? Similarly, the Swedish naturalist Carolus Linneaeus divided humanity into four racial categories: African, European, North American Indian, and Asian. Those categories were evaluative as well. In his text *Systema Naturae* (1735), he associated groups with unflattering personality and character traits.

Another scientist foundation stone of the Enlightenment's use of race categories to establish the abilities and worth of groups of human beings is found in the work of Charles Darwin. The full original title of his famous book on evolution is often forgotten: *On the Origin of Species by Means of Natural Selection, or the Preservation of Favoured Races in the Struggle for Life* (1859). The phrase "survival of the fittest" was coined by Herbert Spencer, a contemporary of Darwin, and although Darwin did not originally use that phrase, in a later edition of his famous work he stated his regret for not having done so. Following Aristotelian categories and Anglosphere preoccupation with process, Darwin posited that there is one human species but many races; different from Aristotle (and Augustine) is

his denial of final cause or purpose. Species and race exist in a state of becoming—and violence.

Consequently, Darwin has been contradictorily quoted both in defense of human rights and in support of a racial struggle for the survival of the fittest. Karl Marx found in Darwin's work a foundation for his premise that the history of culture was a history of class struggle; a different Karl, Pearson (1857–1936) by name, found in Darwin's writings succor for imperialism, seeing civilization as based entirely on "the struggle of race with race, and the survival of the physically and mentally fitter race." Pearson, a prominent British academic, promoted social Darwinism via a statistical analysis of racial groups. His career evidences Darwin's influence in what was then considered the "good racism" of eugenics, and to a rising tide of nationalism, militarism, and colonialism.

On the Left *and* the Right, the aestheticization of race is still passionately defended by those who view it as a positive and fundamental social force. Both sides variously cite race as essential to a full understanding of human identity, morality, and culture. Many on the political and cultural left, for example, affirm the importance of race by heralding diversity, multiculturalism, and sensitivity. The premise behind these concepts is the same as that behind those on the right (including black and Hispanic nationalists in the United States) who advocate racial distinctions in the name of nationalism and cultural cohesiveness. Those who fancy themselves to be moderates attempt to strike a balance between the two, but they fail because a compromise between two incoherent positions is simply more nonsense. All these positions mask a sadly conformist and incoherent confusion of competing and unqualified claims of inner necessity.

Be it in the name of diversity and multiculturalism or for the sake of nationalism and cultural cohesion, each such view follows from a singular commitment to a dogmatic perspectivism. Moreover, that perspectivism (or relativism) makes aesthetic distinctions between good and bad racism baseless and incoherent. As in all aesthetic matters, what constitutes good or bad racism depends on one's arbitrarily selected criteria. In the recent past, "good racism" in the West advanced the prospects of the Caucasian majority. The dominant position in contemporary Western culture, by contrast, is that "good racism" today advances the prospects of the disadvantaged or non-Caucasian (and any racism that advances the rights of the privileged classes is judged evil). What is curious, and tragic, is that "bad racism" (however it might be defined at the moment) is routinely condemned, whereas "good racism" (however it might be defined at the moment) is historically applied with a smug and violent self-righteousness. The believers in the political and cultural doctrine that there can be bad and good

racism refuse to acknowledge the historical variability and intellectual incoherence of their stance.

The current rationale for "good racism" is grounded in the tradition of Western liberalism, and the difference between good and bad racism is determined by whether the prejudice in question advances the prospects of the less advantaged in society. This idea was advanced under the rubric of "fairness" by modernist liberals such as John Rawls (*Theory of Justice*, 1971); it is diametrically opposed to the eugenics of Pearson, et al., and by the advocacy of authenticity by Martin Heidegger and Paul de Man. All accept moral claims based upon a positivist authenticity rather than by their Humanity and love of wisdom.

This line of thinking, in turn, justifies an alleged progressive subversion of culture and art. But is it really progressive? Or is it merely a justification for narcissistic and sociopathic behavior in the name of the individual, race, gender, and culture? The sociopathic argument is as follows: if culture is based on power, then success must indicate dominance; and dominance, because it overcomes the will of other individuals, races, or cultures, is *either* oppressive and evil or (for Darwin Pearson, and Heidegger) justified and good. Thus the idea that justice, beauty, and culture are lofty and noble pursuits must be a mask, a sham, an embarrassment. Truth is a lie and culture is evil. It is the transformation of culture that matters, and this vision being aesthetic, the means toward that transformation are necessarily violent. But rest assured, we are again told, it is a good violence. It is subversive and progressive.

But if instead we aspire to subvert ignorance and violence, to freely pursue truth and virtue, then it is folly to rely upon the Enlightenment's misguided positivist redefinition of science and reason. Indeed, that is the essential point: an aesthetic worldview is both narcissistic and racist.

Given this context, the controversies surrounding the inclusion of American Indian art in the Armory Show can better be grasped. The significant concern is whether American Indian art and American art must be two, or can transcend a violent dialectic to *also* be one.

To approach culture in terms of authenticity or identity means an inevitable conflict and confusion of identities. There is the identity (for example) of native American Indians, and the identity of nativist Americans—that is, those American-born Europeans who find their identity as such. European modernists and postmodernists view indigenous peoples around the world variously as noble savages (Rousseau) or ignoble savages (Social Darwinism), as the rightly vanquished enemy of a racially superior and Caucasian West, or as the tragic victims of a racist and Caucasian West. In America is still another now neglected possibility: that the

American Indian is part of a unique cultural identity contributing to the realization of an American exceptionalism.

The International Style Exhibition: (De)constructing Architecture

As with the Armory Show, there was a pivotal moment for architecture in America. That moment occurred with the International Style Exhibition, held at the Metropolitan Museum in New York in 1932. Wielding much influence, the exhibition introduced the European modern style to America and it gave to Frank Lloyd Wright a position in the history of architecture rather less than he thought he deserved. The reasons for this perceived slight direct us to the conflicts inherent to modernist-postmodernist architecture in America. Wright's antagonists were the proponents of purposeless aesthetics and purposeless technology, grounded in the pragmatic aestheticism implicit in the works of Kant.

The show, organized by H. H. Hitchcock and a young Philip Johnson, was preceded by a book in 1929 by Hitchcock: *Modern Architecture: Romanticism and Reintegration*. In this work Hitchcock dredges up a very familiar transgressive pattern: what came before is not what we ought to do now; it is time for a new style, free from the bonds of the past.

Hitchcock's reference to romanticism is apropos, and problematic. Romanticism marks a destructive assault on wisdom claims, and makes difficult any attempt at reintegration. The solution offered by modernism is the individual constructivist genius; that offered by postmodernism is a will to power embodied by the individual, or embodied by those participating in the zeitgeist, the dialectical unfolding in time of material/spiritual necessity. The anticultural noble savage conflicts with culture produced by the genius and culture that is dialectically authentic.

Wright is mentioned in the book and given credit, but only as a "pioneer" of the movement toward the new style. Wright was not pleased with the limiting designation, or with the new European style he purportedly pioneered. He thought architecture ought to be more than aesthetic practical technology. The moderns (Hitchcock and Johnson in this case) and Wright discussed what it was that they were proposing and why. Writes historian Malgrave:

> The edification of American architects was, of course, the chief aim of Hitchcock's book, and in a rather didactic way he set out to inform them of the principles of the new style. Still, there is a certain ambiguity in this

aspect of his presentation. Although the principles of the new style derive from the new methods of construction, the new materials, the new treatment of interior spaces, and the absence of ornament (now replaced by detailing), its essence for Hitchcock seems grounded simply in a few design clichés—roof terraces, cantilevers, asymmetries, screen walls, and corner and horizontal windows.[17]

In the subsequent book authored by Hitchcock and Johnson, *The International Style: Architecture since 1922*, published in conjunction with the show, Kantian aestheticism contends with Kantian pragmatic functionalism; in a section on "Functionalism," Hitchcock and Johnson argue that the aesthetic element is primary, not the functional or political elements. Aesthetic genius contends with the constrictions of practicality. The Baroque disputes concerning faith and works are now immanentized to the problem of reconciling genius and practicality. The problem cannot be solved by a genius-based (de)constructivism. If we are world makers, then that which is practical is that which we will to do. The practical collapses into the willful.

In another section of their book, Hitchcock and Johnson describe "architecture as volume rather than as mass."[18] This echoes the disputes between Newton and Descartes on the nature of space as empty volume or as a continuum of differing mass. The debate over the difference between volume and mass in architecture neglects whether volume and mass ought to strive to be wise. It is reminiscent of Wittgenstein's and Kuhn's use of the picture that can be understood either as a rabbit or a duck. It might well be a theoretical dispute, but it fails to satisfactorily address issues of genuine substance. Missing is any sort of profound, much less coherent, scientifically rational theory.

After the Great War, writings on architectural theory increased dramatically.[19] Several movements and major figures sprang from it: Soviet rationalism and constructivism, De Stijl and Dutch modernism, expressionism, Bauhaus, Le Corbusier, and American modernism. There are stylistic differences between them but all exhibit theory and practice without wisdom, volume and mass without purpose. All reject previous styles. None claims other than inner necessity and nature, if that, as a guide, none freely seeks objective truth or a transcendent ideal, none seeks Being, none seeks wisdom.

One may therefore rightly inquire how one can rationally choose, for example, between volume and mass in architecture? What is the justification, or rationale, for why architecture that is volumetric is more correct, or better, or more rational, than architecture that is mass? How is theory or hermeneutics impor-

tant, lacking wisdom and beauty? Can becoming, grounded in genius, technology, or nature, be meaningful? To paraphrase Theodore Adorno, after Auschwitz is a concern for mass, volume, and theory obscene?

This lack of a scientific rationalism in support of their argument does not slow Hitchcock and Johnson from pointing out the need for enforcement. Like the proponents of the Social Gospel, the architect is pushed to a new extreme of social engineering. As Hitchcock and Johnson put it:

> The Architect has a right to distinguish functions which are major and general from those which are minor or local. In sociological building he ought certainly to stress the universal at the expense of the particular. He may even, for economic reasons and for the sake of general architectural style, disregard entirely the peculiarities of local tradition unless these are soundly based on weather conditions. His aim is to approach an ideal standard. But houses should not be functionally so advanced that they are lived in under protest.[20]

To suggest moderation in the architect as social engineer is to admit the capability to be extreme. The folly is in attempting to scientifically and rationally know how much power the liberating genius is rightly entitled to employ. This authoritarian tendency happened because the authoritarian modernist genius was pushed to the fore as *the* answer to architecture as well as life. Other answers were rejected and perceived as even unethical because, of course, they were perhaps grounded in "religion," not the scientific and rational. But this will not work. Architectural historian David Watkin quotes Maurice Cowling on modernism:

> Arbitrary certainties appropriate to religion were maintained by an intellectual interest which lacked a church, a special revelation or any particular God. A religion, however, with these conveniences, is a religion nonetheless; its priests, secular by profession, high-minded by inclination and dissenting sometimes by manner and tradition, affected an authority in distributing moral and practical advice even more extensive than the religion they had abandoned.[21]

Hardly a more concise description of how the socially coercive modern-postmodern architect operated could be had. Of particular concern to Watkin, and many others, is the "high-minded inclination" that infused modern architecture with such a strong yet subjective moralizing dimension. Watkin comments about the

morally insinuating and widely disseminated argument that modern architecture exercises some special unassailable claim over us since it is not a "style" which we are free to like or dislike as we choose, but is the expression of some unchallengeable "need" or requirement inherent in the twentieth century with which we must conform. This frequently repeated argument is wholly arbitrary: those who propose it construct first of all a picture of twentieth-century society to which they then impute "needs" and as a result demand that architecture must conform with those needs.[22]

Certainly Wright was on board with a naturalistic understanding of humanity. Wright also thought highly of the authoritative social role of the architect. However, Wright was not on board with the aesthetic and technological genius of the moderns. In the show book and catalogue for the International Style Exhibition, Wright was not pointed to as a current exemplar for how to build. What happened? Prior to the show, Wright seemed to be at the top of his career. He enjoyed a strong reputation in America and Europe. But he did not seek what modernists were seeking. He found an aesthetic technological architecture to lack both cogency and purpose. Wright hated Le Corbusier's reduction of architecture to machines for living; from the machine, the very model of efficiency, how far is it to the modernist claim of functionalism? To reduce architecture to machinery, much less bad machinery, was just too much for Wright to endure. Works without faith is meaningless. How to have a meaningful functionalism is the problem.

From his Kahn lectures of 1930 given at Princeton, which Malgrave finds to be the best summation of his work, Wright states:

> The cardboard forms [of modernism] thus made are glued together in box-like forms—in a childish attempt to make buildings resemble steamships, flying machines, or locomotives. By way of a new sense of the character and power of this machine age, this house strips and stoops to conquer by emulating, if not imitating, machinery. But so far, I see in most of the cardboard houses of the "modernistic" movement small evidence that their designers have mastered either the machinery or the mechanical processes that build the house. I can find no evidence of integral method in their making. Of late, they are the superficial badly built product of this superficial, new "surface-and-mass" aesthetic falsely claiming French painting as a parent. And the houses themselves are not the new working of a fundamental architectural principle in any sense.[23]

What principle did he have in mind? It was an organic one. Wright's theory of *organicism* springs from tendencies already in place in Anglo-American culture; those tendencies are away from transcendent Being, toward immanent becoming. Naturalistically speaking, Wright's *organicism* found in nature a sort of immanent guide to his work. But an immanent guide to architecture is not guide but preference.

As one writer said of Wright: "In the end he was but an agent of nature, the source of all that exists."[24] An agent of nature cannot be scientifically rational, since that would require a subject-object relationship. As subject, the architect is not only in tune with nature; Nature and architect are one. If so, the work of the architect is either beyond or beneath reproach. David Watkin writes: "We can recognize today what was more difficult to perceive in 1936, that Wright's 'position' was just uncouth philistinism."[25] To claim an immanent style, whether in art, architecture, or life, is to reduce any goal to subjective preference. Being is denied, individual becoming fuels the direction of art and life. But that direction goes nowhere. It is self-sufficient and inadequate. The New Age Christian Hegelianism of Emerson, Swedenborg, and others merge with a practical organic pantheism. Brilliance and charlatanism become indistinguishable.

The impassioned search for a new American style of architecture, increasingly severed from any notion of the transcendent, enabled Sullivan to reduce form to indecorous function, and Wright to attempt a remedy to mere aesthetics and machinery via the organic. Wright's shift from an arts and crafts perfectionism deeply informed by the machine to an organic view is explained by his reliance upon an allegedly inner guide. What resulted is an odd mixture of technologically sophisticated neo-Hegelian spiritualism harmonized via a pantheist unity lacking substance, wisdom, or beauty.

Hitchcock and Johnson, for their part, held up Gropius, Oud, Le Courbusier, and Mies as the exemplars. Le Corbusier preferred the machine over the architecture of the Gothic and Renaissance periods: the efficient geometries of his own day were good; numinous geometry was of the irrelevant past.[26] Mies is famous for the sterile Seagram's Building, touted for its dreadful clarity and unusually shaped steel columns. His campus of the Illinois Institute of Technology, a paragon of modern planning, features the Robert F. Carr Memorial Chapel of St. Savior, which critics have referred to as "a hilarious little box of beige brick and plate glass" which from the back "looks like a structure to house high-voltage machinery."[27] Such comments might previously been written off as ignorant philistine utterings. But that is no longer tenable. Modernist-Postmodernist architecture lacks non-violent substantive meaning. The idea of architecture as reflecting the

Mies van der Rohe, Robert F. Carr Memorial Chapel of St. Savior, IIT, 1952

structure of a meaningful world is lost to all. The sacred space has been profaned. The profane is now corruptly worshipped as sacred.

The profanation of architecture continued in America thanks to Walter Gropius. Escaping prewar Germany after the closing of the Bauhaus,[28] Gropius enjoyed a successful career at Harvard designing housing estates, houses, and a few college buildings. Commenting upon high-density housing, he thoughtfully remarked:

> For many people the separate house naturally seems the welcome house of refuge in the entanglement of a great city. Its greater seclusion, the sense of complete possession, and the direct communication with the garden are assets everyone appreciates, particularly in favor of children.
>
> All the same, the multi-storied building is a direct embodiment of the needs of our age.[29]

Gropius's own freestanding house in Lincoln, Massachusetts, built in 1937, is just what one might expect: slab white walls broken, awkwardly, by dark slots for windows. His Farnsworth House in Plano, Illinois (1946–51), features the same slab walls but this time lifted on stilts five feet above the midwestern dirt. Gropius's collegiate work is difficult to see as anything other than an outright assault

upon the organic or the numinous. Comparing the Georgian-styled Harvard Business School (McKim, Mead & White, c. 1927) to Gropius's Harkness Commons (1950), E. Michael Jones suggests:

> The courts of the business school are one pleasant surprise after another.
> Perhaps it's the combination of red-brick Georgian arch framed by yew and
> ivy and rhododendron and azaleas, blooming just in time for the alumni
> gatherings. One has the sense of being let into an enclosed garden, which is
> one of the images for the Blessed Virgin in the Litany of Loreto. It is like the
> embrace of a chaste woman. Bauhaus, on the other hand, is like sodomy in
> the bushes of Buena Vista Park. Or, to be more precise historically, adultery
> on the Orient Express.[30]

At first, the sexual reference might seem startling, but it is appropriate to recall Sade's declaration that sodomy is the highest form of freedom because of its utter denial of teleological purpose. The transgressive personality finds engaging in adultery—indeed vice—to be an act of freedom rather than violence. It is intellectually responsible, then, to offer the counterargument: If nothing is decorous, nothing is numinous, then all aspects of life—even those that are sociopathic—are violently purposeless. The transgressive social engineer, as architect or

Walter Gropius, Harkness Commons, 1950

citizen, is elevated at the expense of those who would rather be transgressive of ignorance and willful violence. A transgressive "culture" influences us daily to be transgressive rather than decorous. Should we eventually succeed, then there is nothing to transgress and we dissolve into absurd nothingness.

Of course, if objective and transcendent criteria are removed, then what ought one to expect? Surely, if nothing else, what is evident is a stripping away to indeterminate absurdity. For example, in architecture, many classical buildings evidence a cornice or a horizontal element to establish completion. The temple

Raymond Hood, Daily News Building, 1930

as completion marks its location as a celebration of a sacred place. Gothic spires indicate the material and finite reaching for the transcendent infinite. In contrast is the architecture of modernism-postmodernism. This is visually evident in the gradual removal of the architectural cornice. Over the course of fifty years, the cornice of skyscrapers dissolved. This process becomes evident in skyscrapers around 1930. One may compare the heavy cornice of Richardson's Marshall Field Warehouse (1885) to Sullivan's lighter denticulated cornice on his Auditorium Building (1886) to the nearly absent crown of Raymond Hood's Daily News Building (1930). In smaller structures, the same desire is at work: to remove any visual terminus, to remove any notion of a telos, a goal, any sense of perfection or Being. The work awkwardly reaches into an empty Newtonian infinity.

It is perhaps with the ubiquitous flat roof that one discerns the ideological bent of modern architecture. Flat roofs do not work; they are not practical; they do not function well. But they do convey a meaning similar to the dissolution of the cornice. Jones writes: "The flat roof provides a direct and frontal confrontation with the heavens and not the rapprochement of the peaked roof—a rapprochement that reaches its pinnacle, in a manner of speaking, in the church steeple, which tapers off to nothing as its way of meeting the infinite, the cross being the point of mediation."[31]

In the next chapter we turn to those who recognized that confrontation with truth and culture and raised their voices in challenge.

12

THE AMERICAN CRITICS

A t the turn of the twentieth century, a number of American scholars and artists remained unimpressed by modernism and postmodernism. The New Humanist movement was the response by American scholars who keenly perceived the fatal flaws of that anticulture culture. Major figures within that movement were Frank Jewett Mather Jr., Royal Cortissoz, Paul Elmer More, Kenyon Cox, Ivor Winters, and Irving Babbitt. Their concerns were later advanced by Allan Bloom, Alasdair McIntyre, Thomas Molnar, Russell Kirk, and Philip Rieff.[1] These scholars represent a broad spectrum of intellectual and cultural views, but they are united in their belief in an ontological scientific rationalism.

Such skepticism was also present in Europe, as evidenced by an esteemed but small group of European thinkers from Dostoyevsky to Solzhenitsyn, from Friedrich Heinrich Jacobi to Leo Strauss. Within the Anglosphere it is represented by a range of scholars including Edmund Burke, John Carroll, Christopher Dawson, C. S. Lewis, and Iris Murdoch. In the field of art history, a number of European and American writers have contributed to a critique of modernist-postmodernist culture: Mather and Cox, and others, including Hans Sedlmayr, H. R. Rookmaaker, Calvin Seerveld, E. Michael Jones, and A. Philip McMahon.[2]

These scholars offer precise and articulate critiques of the cultural malaise resulting from a transgressive and violent modern-postmodern tradition. They were or are brilliant analysts of culture who despite their trenchant debunking of modernism-postmodernism have as yet failed to turn the tide Matthew Arnold lamented in his poem "Dover Beach," written in 1867:

. . . Where the sea meets the moon-blanch'd land
Listen! You hear the grating roar
Of pebbles which the waves draw back, and fling . . .
. . . But now I only hear
Its melancholy, long, withdrawing roar . . .
. . . And we are here as on a darkling plain
Swept with confused alarms of struggle and flight,
Where ignorant armies clash by night.[3]

They share a rejection of the notions of German idealism and French romanticism. Those cultural paradigms are rejected because they are anti-intellectual, anticultural, and violent. But these scholars do not provide a remedy to their dominance. They make clear the dysfunction but fail to provide a viable alternative. They have not yet provided an adequate foundation for restoring a culture dedicated to the free and responsible pursuit of truth, goodness, and beauty.

No doubt, academic politics have played a role in that failure. A substantively willful existentialist academy is intrinsically hostile to rational dialogue and to those who promote it. Therefore, the academy is immune to its intrinsic responsibility: rational and scientific discourse. For the postmodernist academy, disagreement about values is not a disagreement about understanding, but one of honoring subjective preferences in the pursuit of equality or authenticity. That pursuit of equality or authenticity will prevail only so long as positivism does. The reason for the failure of the New Humanist apostates to the modernist-postmodernist faithful is their neglect in contesting the limitation of knowledge to positivism. Not offering a persuasive alternative understanding of science and reason, they floundered in the impossibility of reconciling the pursuit of Truth, Wisdom, and Beauty with the nominalist, positivist, and aesthetic pursuit of facts and power. They failed to reconcile *why* with a paradigm that could only understand *what*. Of course, that reconciliation cannot be achieved.

Rather than propose a solution to that problem, an alternative perspective is required. That perspective centers on the practical pursuit of wisdom. Such a perspective will be explained further later in this book. But for the moment, an historical accounting of some of the efforts of the critics of modernism-postmodernism will permit us to gain some distance, some liberating perspective, from the mental habits that currently inform our thinking. We will examine four figures as representative of the group: Mather, Cox, Babbitt, and McMahon.

Frank Jewett Mather Jr.'s Critique of Matisse and Duchamp

Frank Jewett Mather Jr. (1868–1953) was a distinguished participant in American culture at the turn of the twentieth century and later. The well-educated Mather had a long pedigree in American culture. He was a descendant of the famous Baroque period clergyman Reverend Richard Mather (1596–1669). Due to disagreements with the church hierarchy in England, Reverend Mather agreed to work in Windsor, Connecticut, in 1636. His publications, and those of such descendants as Increase Mather (1639–1723) and Cotton Mather (1663–1728), played a significant part in the early development of American civilization.

Mather prepared for his career by graduating from Williams College in 1889 and receiving a Ph.D. from Johns Hopkins University in 1892. That university was one of the first to adopt a new German-inspired positivist specialization. It was an approach not appreciated by Mather, who complained: "It meant, besides unsparing industry in the mere accumulation of facts, a certain constructive quality of mind which mastered the facts and set them in philosophical relations."[4]

The alternative he longed for was a return to the pursuit of general knowledge that contributed not to constructivism, but rather to the pursuit of a cosmopolitan wisdom and beauty. In other words, he wished to abandon a sterile scientism for a return to the pursuit of *scientia* and *sapientia*.

After teaching at Williams College for several years, he moved to New York and began writing for the *New York Evening Post*, and serving as editor at the *Nation* magazine. It was during this time that Mather began reviewing art shows in the metropolitan area. After suffering a bout of typhoid in 1906, he and his wife Ellen (nee Mills) moved to Italy; that experience caused him to appreciate a conservative view of life: "The sense of being in an [elaborate?], fixed, and authoritative social order purges one of the vague unrest that besets one in our mobile society. One drops the vicious assumption of energy as a mere bad habit."[5]

By heritage and by virtue of a multigenerational commitment to cultural affairs, Frank Jewett Mather Jr. was a prime personification of the classical-Judeo-Christian Anglosphere. His circle of friends included Irving Babbitt, Royal Cortissoz, the defender of classicism Paul Elmer More, and the influential art patron Allan Marquand, who funded art history and archaeology projects at his alma mater, Princeton University. It was Marquand who persuaded Mather in 1910 to go to Princeton and teach art history.

Mather exemplified a fundamental assumption of Puritan America: *a vital and non-hierarchical pursuit of wisdom*. He rejected the notion that culture should be

grounded in mere traditionalism, that it should be foreign to the common population, or that the scholar/critic should evidence an esoteric knowledge. Rejected were traditionalism, elitism, and Gnosticism.

This is evidenced by his reviews of both the traditionalist academy represented by the National Academy of Design, and the modernist academy represented by the Association of American Painters and Sculptors and the Society of Independent Artists. In March 1913, Mather reviewed exhibitions by the National Academy of Design and the Association of American Painters and Sculptors. Mather evidenced a judicious temperament. In his review of the art shown at the National Academy of Design exhibition, Mather noted his appreciation for the technical ability of the artists exhibited. As a proponent of culture as a living continuity and repository of all that is enduringly good, he appreciated the traditionalism evident in the show. Nonetheless, he had the insight and integrity to admit and criticize a whiff of nostalgic rigidity. Echoing Matthew Arnold in "Dover Beach," Mather laments art that is technically competent but lacks vital conviction; he deplores art that is static and traditionalist rather than vital in its traditionalism. He sees "a dwindling tradition" that might return in better times.[6]

In a similarly honest fashion, Mather responded critically to the Armory Show. Mather praised the organizers of the event for their efforts at providing a solid introduction to the new art of Europe. But he found the excitement of that introduction to be disappointingly unsubstantiated.

For Mather, Matisse's expressionism, his fauvism, was transgressive, intellectually trite, and formally weak. Although pleased by Matisse's challenge to boring orthodoxy, he found his deliberate distortions of form, nature, and perspective to be failures. In other words, Mather found Matisse lacking in decorum. He wrote later: "With extraordinary gifts as a colorist and an impeccable decorative sense, he soon drifted into a gypsy eclecticism, to end in a monotony exquisite, to be sure, but expressing nothing save essentially superficial decorative formulas. At bottom he remains merely a fine mannerist."[7]

He found Matisse's mannerist expressionism to be less harmful than that of cubism and expressionism. Whereas he thought Matisse a crude failure, Picasso and Duchamp were derisively dismissed as "a clever hoax or a negligible pedantry."[8] Duchamp in particular is vulnerable to the charge of clever hoax, in the sense that it is a hoax to found a culture upon a transgression of culture. The *Fountain* remains a urinal, and if a perspective legitimatizes a urinal as fine art, then that perspective is a clever (a)rationalized hoax that is destructive of scientific rationalism and the sincerity necessary to civility. It is, moreover, Mather's con-

cern for mannerism that strikes hard. When the insignificant is deemed profound, then rationality collapses into a mindless romanticism in which a transgressive trivialization of culture replaces responsible freedom in the pursuit of wisdom.

Kenyon Cox

Kenyon Cox, born in Ohio on October 27, 1856, was part of a prominent Midwestern family. His father was a general, governor, congressman, and university president; his mother was the daughter of a famous evangelist.

Dedicated to the central proposition that art has a crucial role in our public life, Cox was critical of romanticism and the newly positivist realism of the nineteenth and twentieth centuries. In classical-Judeo-Christian and Anglosphere mode, Cox promotes progress as the temporal pursuit of the eternally true and good. Concerning classicism, he wrote in 1911:

> [Classicism] does not deny originality and individuality—they are as welcome as inevitable. It does not consider tradition as immutable or set rigid bounds to invention. But it desires that each new presentation of truth and beauty shall show us the old truth and the old beauty, seen only from a different angle and colored by a different medium. It wishes to add link by link to the chain of tradition, but it does not wish to break the chain.[9]

His 1913 essay "The Illusion of Progress" distinguishes scientific and biological development from the perennial problems of human existence. His Anglosphere traditionalism is expressed as follows: "The great traditions of the world are not here by accident. They exist because humanity found them to be for its own good. Art has a social function. In all the great periods of art it has spoken to the people in a language that they understood and expressed what they would have it express."[10]

Cox attended the Ecole Des Beaux Arts, studying with Cabanel and Gerome. He was skeptical of romanticism, (positivist) realism, and most emphatically, impressionism and postimpressionism. He wanted to reunite feeling and thought, becoming and Being, via a dedication to fact, feeling, and harmony. He succeeded in avoiding the pitfalls of an irrational expressionism; it is unclear to what degree he was successful in avoiding a beaux-arts academicism. With technological precision he combines fact, feeling, and harmony—but is there a sense of the sacred, of ontological splendor?

His contemporary critics were less concerned with ontological splendor than they were with his painting a young woman without clothing. They might not use such terminology, but they understood that within the context of their self-conscious existence, fine art should not be indecorous. Like Matisse and Duchamp, Cox painted nudes. His goal was not to be transgressive, but his actions were so construed. The nude is a traditional theme through which to explore an ideal rational realm that is perfect and inspirational. Lacking that rational realm, the nude is necessarily associated with the often confused and violent material realm in which we live. Matisse and Duchamp deliberately brutalize that ideal—their nudes

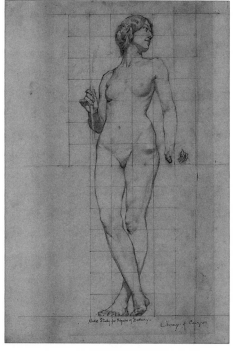

Kenyon Cox,
Nude Study for Figure of Botany, c. 1896

evoke expressionism, not wisdom. Cox did not, but for much of the American public, neither the brutalized nor the academic nude was deemed appropriate.

During the Baroque period, the traditional understanding of the nude lost its scientific-rational foundation. It could no longer embody what Helen Gardner calls "the ideal taken out of the hypersensible world of reasoned proportions and made into an apparition of living flesh."[11] As a material manifestation of the Ideal, the nude is conceptually in harmony with the idea of transubstantiation. During the Baroque period both the nude and transubstantiation became suspect. In the light of scientific positivism, Puritanism recognized a debased nakedness in the presentation of ostensible nudes and no justification for the Eucharist as traditionally understood. *Within the Puritan tradition, art, Communion, and science were to serve as a remembrance of factual events with practical significance—not as semisacramental presentations of transcendent wisdom via physical form.* Whereas Communion reminds the public of events worthy of profound respect and emulation, neither positivist science nor the newly naked nude does anything of the sort.

So Cox was too academic for the traditionalists, and too traditionalist for the modernists. As might be expected, Cox's review of the Armory Show, published

in the March 15 issue of *Harper's Weekly*, was cogently critical. Impressionism was too fleeting and superficial, Whistler too devoid of ideals, Van Gogh suffered a lurid emotionalism, and Matisse, Cox declares, cannot be healthy art. Matisse's paintings lacked Cox's penchant for harmony, charity, and factual accuracy. Indeed, he thought Matisse a transgressive egoist. In his *New York Times* interview of March 16, 1913, Cox summed up his disdain for the show: "This is not a sudden disruption or eruption in the history of art. . . . It is the inevitable result of a tendency which has grown steadily stronger and stronger during the last fifty years. It is a tendency to abandon all discipline, all respect for tradition, and to insist that art shall be nothing but the expression of the individual."[12]

Cox's critique of modernist-postmodernist art fails to offer a convincing alternative to it. He recognizes modernism-postmodernism as transgressive, intellectually deficient, and culturally catastrophic. What he does not appear to understand is that a deontological classicism is not an alternative to the problem, but a symptom of it. Nor does he recognize that a Protestant America indifferent to a scientifically rational, that is, sacramental, approach to fine art dangerously parallels a post-modern, indeed post-Protestant America hostile to culture.

A theological and social catastrophe results: a desacramentalized Christ-centered theology centers on facts and becoming; meaning is then the product of the will, be it human or Divine. Lacking an ontological scientific rationalism, the Divine only exists as a product of our experiences; we are locked into a materialist/spiritualist dichotomy that is either traditionalist or transgressive. Qualitative Trinitarian science, ethics, and art collapse into a willful formalism (Cox) or a willful denial of form (Matisse, Duchamp).

Irving Babbitt

Irving Babbitt (1865–1933) is the recognized leader of the New Humanist movement. The vehemence directed towards Babbitt and that movement is indicative of the biting effectiveness of his critique of modernism and postmodernism. For example, in his 1930 Nobel Prize acceptance speech, the postmodernist socialist Sinclair Lewis denounced the New Humanists as an astonishing circus, dedicated to a dualistic and reactionary cult. He mistakenly associates a cosmopolitan defense of transcendental—that is, objective—Truth (in Classical, Christian, Buddhist, and Confucian contexts) with a modernist dualism of mind and matter. He then in striking error concludes that the New Humanism is a doctrine of death. The irony of his position would be amusing if history were less tragic:

it takes but a few years for the varieties of socialism, including that embraced by Lewis, to reveal to the world an actual doctrine of death.[13]

With bold audacity, Babbitt lances with a historic quote the focus on Baroque and romantic emotionalism blossoming like a weed during the romantic period:

"Every ass that's romantic," says Wolseley in his Preface to "Valentinian" (1686) "believes he's inspired."[14]

That cutting directness may well reflect his biography. Born in Dayton, Ohio, in 1865, Babbitt's great-grandfather and his grandfather were Congregationalist ministers; both resisted a Christian fundamentalist reductionism within Protestantism. A Christian rationalism, intellectualism, and a defense of high culture were held dear. But following the trajectory of Protestant America, his father abandoned those principles for a New Age spiritualism. As Claes Ryn notes: "[His father's] pseudo-scientific schemes and sentimentalism would be for Irving Babbitt egregious examples of larger tendencies that he regarded as eroding traditional Western civilization."[15] Gifted in academic work, Babbitt entered Harvard University in 1885, but found the intellectual atmosphere stifling, narrow, and irrelevant. Works of literature were discussed without concern for how those works might help us to better understand reality and life. He gravitated towards the classics and was deeply influenced by Charles Eliot Norton, a teacher and scholar whose work focused specifically on ethical and spiritual issues.

From the outset, Babbitt's academic career was vexed by a personal discordance from then-current philological norms. He was professionally as well as personally affected by the decline in interest in classics; once central to college curricula, they were diminishing as the core focus of college work. For practical reasons, he had to spend the rest of his career teaching comparative literature. Nonetheless, what remained with him was the classical assumption that reason and science were united in the service of high culture. It was—and is—an assumption that is despised by the modernist-postmodernist tradition.

In *Rousseau and Romanticism* (1919), Babbitt offers a challenging analysis of this situation. He starkly declares that "the total tendency of the Occident at present is away from rather than towards civilization."[16] Fact, feeling, and a deontologized reason are causing the collapse of Western civilization. He sums up the situation: "Now the warfare that Rousseau and the individualists of feeling have waged on the general sense has meant in practice a warfare on two great traditions, the classical and the Christian."[17]

For Babbitt, Western civilization was more classical than Christian. He found the Puritan faith of his forebears otherworldly, austere, and unable to sustain the intellectual life and high culture. As evidenced by his father, he saw Christianity drifting into an a-rational fundamentalism or a New Age obscurantism. He disliked Edwards and Emerson; he viewed the shift from the one to the other as grounded in a shift from a God who is altogether fearful to a God who is altogether formless. It is the rationality of Aristotle (and to a degree, of Hinayana Buddhism) to which he remains committed.

In his introduction he quotes Emerson as exemplary of the problem and then explains his position:

> Perhaps the best key to both sides of my argument is found in the lines of Emerson I have taken as epigraph for "Literature and the American College":

> There are two laws discrete
> Not reconciled,—
> Law for man, and law for thing;
> The last builds town and fleet,
> But it runs wild,
> And doth the man unking

> On its negative side my argument is directed against this undue emphasis on the "law for thing," against the attempt to erect on naturalistic foundations a complete philosophy of life. I define two main forms of naturalism— on the one hand, utilitarian and scientific and, on the other, emotional naturalism.[18]

This separation of fact from feeling is grounded in the empiricist and mystic (or emotivist) substance of positivism. Bacon and Newton represent the positivism of fact and Rousseau and Emerson the positivism of feeling. The former produces technological power and the latter produces spiritual fallacy. The problem is that we are growing in power but declining in our ability to use that power wisely:

> The problems that have been engaging more and more attention of the Occident since the rise of the great Baconian movement have been the problems of power and speed and utility. The enormous mass of machinery that has been accumulated in the pursuit of these ends requires the closest attention and concentration if it is to be worked efficiently. At the same time the man

of the West is not willing to admit that he is growing in power alone, he likes to think that he is growing also in wisdom.

Only by keeping this situation in mind can we hope to understand how emotional romanticism has been able to develop into a vast system of sham spirituality. I have said that the Rousseauist wants unity without reality . . . but a unity that lacks reality can scarcely be accounted wise. The Baconian, however, accepts this unity gladly [and turns to Rousseau] to enjoy the illusion of receiving a vast spiritual illumination.

Neither Rousseauist nor Baconian carry into the realm of the human law the keen analysis that is necessary to distinguish between genuine insight and some mere phantasmagoria of the emotions. . . .

What brings together Baconian and Rousseauist in spite of their surface differences is that they are both intent on the element of novelty. But if wonder is associated with the Many, wisdom is associated with the One. Wisdom and wonder are moving not in the same but in opposite directions. The nineteenth century may very well prove to have been the most wonderful and the least wise of centuries.[19]

The traditional role of reason is to ontologically reconcile fact and feeling. The very idea of a cosmos is one of meaningful completion, of a world informed by rational love. Babbitt observes that the romantics rebelled against a rationalistic neoclassicism, but that neoclassicism ought not be confused with what was taught by Aristotle. The modernist rationalists have failed at taking reason seriously. He states that "it is hard to avoid the conclusion that modern philosophy is bankrupt, not merely from Kant, but from Descartes."[20]

It is the substantive separation of reason, fact (now science), and feeling that is the crux of the crisis facing Western civilization. That separation occurs via eighteenth-century deism, and concludes in a nineteenth-century technologically advanced a-rational existentialism:

The strict Christian supernaturalist had maintained that the divine can be known to man only by the outer miracle of revelation, supplemented by the inner miracle of grace. The deist maintains, on the contrary, that God reveals himself also through outer nature which he has fitted exquisitely to the needs of man, and that inwardly man may be guided aright by his unaided thoughts and feelings (according to the predominance of thought or feeling the deist is rationalistic or sentimental). Man, in short, is naturally good and nature herself is beneficent and beautiful.

The deist finally pushes this harmony in God and man and nature so far that the three are practically merged. At a still more advanced stage God disappears, leaving only nature and man as a modification of nature, and the deist gives way to the pantheist who may also be either rationalistic or emotional. The pantheist differs above all from the deist in that he would dethrone man from his privileged place in creation, which means in practice that he denies final causes.[21]

Babbitt recognizes that Rousseau and romanticism are deeply pantheist,[22] and continues:

So far from Nature and God being one, the [Rousseauean] natural man is so corrupt, according to the more austere Christian, that the gap between him and the divine can be traversed only by a miracle of grace. He should therefore live in fear and trembling as befits a being upon whom rests the weight of the divine displeasure. . . . The historical explanation of this despair is obvious: it is a sharp rebound from the pagan riot; an excessive immersion in this world led to an excess of otherworldliness. . . .

The pagan riot from which the church reacted so sharply, was not, however, the whole of the ancient civilization. I have already said that there was at the heart of this civilization at its base a great idea—the idea of proportionateness.[23]

Babbitt and Decorum

Proportionality is another word for decorum, in which Babbitt is deeply interested. He quotes Aristotle: "Most men would rather live in a disorderly than a sober fashion."[24] He perceives the modernist reduction of decorum to mere etiquette,[25] a reduction marking the decline from the classic to the pseudoclassic, from form to formalism. But what the postmodernist does to decorum is truly transgressive. For Rousseau, the prime mark of genius is to refuse to be decorous. Those addicted to wonder rather than wisdom revile both wisdom and decorum. But they also revile objective science. As Babbitt puts it:

To follow nature in the classical sense is to imitate what is normal and representative in man and so to become decorous. To be natural in the new sense one must begin by getting rid of imitation and decorum. Moreover, for the

classicist, nature and reason are synonymous. The primitivist, on the other hand, means by nature the spontaneous play of impulse and temperament, and inasmuch as this liberty is hindered to look on reason, not as the equivalent but as the opposite of nature.[26]

This association of genius with wonder and strangeness, indeed with transgression, is seen as a unifying principle amongst cubists, futurists, and postimpressionists in literature, the visual arts, and science. The multi-perspectivism of Kantian modernism concludes in the anti-perspectivism of Roussean postmodernism. A qualitative understanding of science and culture concludes in a quantum experiencing of science and culture.[27] The classicist attempts to imaginatively imitate the ideal, the Christian attempts to imaginatively imitate Christ, but the postmodernist imagination has no object, no Being, to which it may aspire. It simply is. The choice then is between the pursuit of the superrational and the pursuit of the subrational. And the pursuit of the subrational marks the gradual yet inexorable collapse of such a civilization.

Tragedy and comedy are traditionally considered inferior to religion and scientific rationalism attempting to understand decorum and right action. Tragedy and comedy are grounded in the denial of rational decorum; they display the outcomes of that denial. One mocks human reason as ineffective, the other as absurd. But if decorum is denied, then tragedy and comedy devolve to mere melodrama and farce. The result of a neoclassical formalism, and a Rousseauean emotionalism, is a denial of the ideal that makes tragedy and comedy possible. Lacking a decorous reality, neither tragedy nor comedy make sense. Tragedy and comedy are no longer ontologically grounded and confronted. The world becomes a theatre of the absurd (Beckett) rather than the stage of genuine human drama (Augustine). The result is a brutal trivialization of human existence.

For example, when the Rousseauean views the Lansdowne portrait of Washington, it is with a transgressive hostility that cannot make sense. Just as the very existence of the transgressive depends upon the existence of the transcendent, tragedy or comedy depend upon the existence of ontological standards. As such, romanticism is substantively conflicted. It can ultimately be neither transgressive nor hostile since lacking decorum, neither transgression nor hostility make sense. At best, what is left is nihilistic farce. Echoing Aristotle and St. Paul, Babbitt trenchantly notes: "It is easier to be a genius on Rousseauistic lines than to be a man on the terms imposed by the classicist."[28] Indeed, it is easier to be absurd than wise. Doing the right thing is usually the hard thing to do.

Babbitt's critique of modernism-postmodernism is impeccable and sophisti-cated. He has prepared the foundation for a renewal of Western—indeed cosmo-politan—culture. But there is a missing element. What is missing is an alternative to the foundational shift in science (Bacon) and reason (Rousseau and Kant) that is a formidable obstacle to a renewal of a culture of responsible freedom. We will return to Babbitt in the next chapter, but a comment he made in an earlier work makes clear that the cultural decay he describes is now so commonplace as to be invisible. He reminiscences:

> A few years ago I was walking one Sunday evening along a country road in a remote part of New England, and on passing a farmhouse saw through the window the members of the family around the lighted lamp, each one bending over a section of a "yellow" journal. I reflected that not many years before the Sunday reading of a family of this kind would have been the Bible. To progress from the Bible to the comic supplement would seem a progress from religious restraint to a mixture of anarchy and idiocy.[29]

Philip McMahon

In 1945 a different American scholar, A. Philip McMahon, wrote *Preface to an American Philosophy of Art*. His critique of modernism and postmodernism is as scathing as Babbitt's, but instead of focusing on Rousseau, McMahon directs his attention in particular to German idealism. Given the date of publication, it is not surprising that he should do so. As he flatly states in the introduction:

> It is well to remember that important ideas, affecting large masses of people, have had to be simplified in order to get such influence. . . . Principles which first find lucid expression in the words of professed philosophers, and may be best scrutinized there, become mainsprings of national action only when they become part of the stock of ideas that the man in the street takes for granted.
>
> The German idealist theory of art had acquired that status long before our time, so that an uneducated, unstable leader of the German people could rely on its universal acceptance by his countrymen.[30]

McMahon devotes a chapter to an explication of the role of German idealism in the rise of Nazism and Adolf Hitler. To associate modernism, and more specifically

postmodernism, with Nazism is, of course, inflammatory within the modernist-postmodernist academy. Nonetheless, several of those associations have previously been discussed.[31] Martin Heidegger has long been associated with that regime, while more recently, the work done for the Nazis by Paul De Man has placed a specter over the cultural pretensions of postmodernist deconstructionism.[32]

McMahon notes that in 1939, Sir Neville Henderson reported that "among the points mentioned by Herr Hitler . . . were that he was by nature an artist, not a politician, and once the Polish question had been settled he would end his life as an artist, not as a warmonger."[33] McMahon reflects that public reaction to the statement centered on questioning Hitler's sanity and sincerity, not the underlying romantic doctrine. Indeed, McMahon observes that events have shown that the ideas and principles articulated in 1924 when Hitler wrote *Mein Kampf* were the natural and consistent consequences of German romantic idealism. His conclusion: Hitler's whole rationalization of dictatorship rests upon the concept of genius, handed on to Kant by his predecessors and employed by him to explain the production of beautiful art, *schone Kunst*.[34] But in contrast to the rationalistic Kant, and the pointlessly a-rational expressionists, in *Mein Kampf* Hitler "asserted that the artist was not a fool, like the modernists, but had also, like himself, received divine grace, an arbitrary but heavenly inspired mandate to work his own will."[35]

Given the anti-Christian proclivities of the Nazis, that alleged divine grace they allegedly received ought not be confused with traditional Christian transcendence. Indeed, postmodernist thought, Nazi or other, emphatically denies the reality of transcendence, and by extension, the reality of objective truth and love. As romanticism redefines reason as feeling, it redefines Being as the immanent will. For the postmodernist Christian the immanent will is found in Christ; for other postmodernists the immanent will is found in us. McMahon quotes the thought of the German Idealist philosopher Friedrich Wilhelm Joseph Schelling as critical in this regard: "There is, in the last and ultimate instance, no other real being at all than will. Will is original being and to it pertain all the predicates: self-founded, eternal, independent of time, self-affirming. The whole of philosophy strives only to find the highest expression for it."[36]

In order to explain how Schelling came to this conclusion, McMahon presents a brief history of art and culture. The first step in associating truth and Being with the will occurs via a redefining of Plato's ideas into psychological ideas or concepts. That is, whereas Plato recognized that to varying degrees truth informs reality, for Aristotle truth is a matter of perfection realized within a material world. For Plato, truth is metaphysical, whereas for Aristotle, truth is immanent and a matter of clarity. Plato is the priest, Aristotle the psychologist.

As an example of how Aristotle provides a transition from objectivity to subjectivity, McMahon compares two translations of an Aristotelian text. One translation reads: "From technique come the things whose form is in the soul," but the postmodernist translation of that same passage reads: "But from art proceed the things of which the form is in *the soul of the artist* [italics added]."[37] Similarly, for Aristotle psychology (the study of the soul) is the study of how to be in harmony with Being, but for Freud psychology is the study of how to be in harmony with oneself. McMahon next cites Seneca, who attempted to combine Plato's idea with Aristotle's Four Causes, claiming that the idea was an eternal model or exemplar before, rather than outside, the actual object that imitated it. This attempt to combine Platonic and Aristotelian thought is foundationally incoherent and anticipatory of Scholastic conceptualism developing into modernism and the Kantian notion of the synthetic *a priori*.

McMahon pays scant attention to the role of Abelard and conceptualism, shifting to the Renaissance, mannerism, and the Baroque. He notes that during this time:

> The explanation invoking Plato's Ideas amounted to this: the mind of the artist left his body and viewed the Idea or eternal pattern of Jupiter. In modern times, popular opinion still respects imitations as a ground of excellence in art but holds that the mind does not wander away from the body. On the contrary, images of things external to the body visit the mind, and thus the locus of ideas is properly inside the skull where the mind is.[38]

The mannerists first elaborated comprehensive philosophical principles for the explanation of art as such; the Baroque scholar Winckelmann sets the standard:

> In Germany, as a result, belief in the Idea of beauty as the substance of art has been practically universal in literate circles ever since Winckelmann.
>
> According to this dogma, art is valuable above all other things, since it is the sole privilege of art to manifest the Idea. The artist's idea is the Idea, and, as such a permanent correlation of beauty and objects in human experience is nowhere else to be found, art enjoys a unique function. . . . The world consists of ideas and that our ideas are what we will them to be.[39]

So whereas within the classical and Christian traditions the artist is a skilled craftsman having a calling or a genius for making something, during the modernist-postmodernist era the artist is a genius who assumes the role of a demigod.[40]

McMahon charts the development of this mannerist and Baroque idea with that of the idea of the fine arts academy. The purpose of such academies is to establish the role of the genius as legitimate constructors of reality and life. The first Italian academy is founded in 1442 by Cosimo de' Medici; in 1648, the French Academy is founded, relying heavily on the philosophy of Descartes. This European trend is continued in America with the establishment in 1876 of the National Academy of Design. How are reality and life to be constructed by genius? In 1719, the Abbe J. B. Dubos, secretary of the French Academy, published *Critical Reflections on Poetry and Painting*, in which he explained that there existed no guide except feeling in matters of art. Good feelings reflect good decorum. Decorum, once understood in a sacramental sense as a material manifestation of being right with objective reality is newly defined as that which is deemed socially appropriate by an elite class of social architects.

As evidence of the cultural continuity of this shift from the pursuit of wisdom and beauty to that of the subjective ideal of the social authoritarian, McMahon observes that little changed during the French Revolution: the academy remained intact, not one French artist was killed during the Terror of 1793–94, royal collections were carefully protected, and the royal palace was converted into a museum. Certainly the most astonishing value given the artist is demonstrated by the career of Jacques Louis David. He was able to negotiate the highest social realms first selling his works to the crown, then as revolutionary propagandist, then regicide, and finally as official court painter to Napoleon. With the subjective ideal one can vote to execute the King for tyrannical abuse and then dreamily support a different tyrant.

McMahon's Critique

The shift from reason as the means by which to understand objective reality, to reason as psychology, to reason as mere will, is today commonplace. (Most recently, Jacques Derrida has associated reason or the logos with an allegedly oppressive phallogocentrism, as will be discussed later in the book.) It is an argument that McMahon anticipates, writing: "German idealism was successfully reorganized to perpetuate adolescent postures, the rationalist principles of the enlightenment were placed in the service of methodical irrationalism by romanticism, and idealism was directed to a rationalist defense of unreason."[41]

McMahon focuses on Kant, whom he considered to be a patient, unimaginative, laborious systematizer. He notes that Kant distinguished between dependent

beauty, which refers to purpose—such as a horse or a building—and free beauty, which has no apparent purpose and yet pleases us, such as a flower. McMahon questions how anyone can perceive beauty in genuinely meaningless objects, and why a flower should be viewed as useless. The answer is that within a world without an objective Truth, God, or a Final Cause, scientific rationalism has no object and thus no value. A rose is a rose is a rose.

Kant rejects knowledge of an objective God and Final Causes in his philosophy because he distinguishes between the empirical self and the "transcendental self." The empirical self is part of the world of facts, whereas the transcendental self is a universal mind shared by all rational beings. The mind is one, universal, and self-conscious: "According to Kant, objects which are things located in space belong to this transcendental self, while the ideas of these things pertain to the empirical self."[42]

How do we combine the transcendental and the empirical? By reality conforming to how we think. This leads, as McMahon rightly concludes, in self-deification:

> If, according to the idealist approach, the self was the only certain object of knowledge and this knowledge was to be reliable, it must, Kant supposed, in effect replace the deity. . . . Such a solution of the problem naturally raised numerous additional difficulties. Kant had to admit that although the transcendental self was real, it was unknown; his me could be his object but his I could never be. He declared: "We have no knowledge of the subject in itself . . . of that subject . . . we have not and cannot have the slightest knowledge. . . ."
>
> But to employ a term to indicate something whose existence could not be proved, although such extraordinary claims were made for it, always troubled Kant.[43]

McMahon says that Kant's dilemma was resolved via an inherited Calvinist sense of guilt. His categorical imperative is a pietist conscience hypostatized. He suffers from Calvinist guilt without the hope of Grace: "He found himself accepting beliefs he could not prove, admiring things for which he could discover no purpose, and performing actions whose utility he could not establish."[44]

His conclusion? Again we quote extensively from a cogent summation:

> Philosophical and rationalist idealism was an uncomfortable mate for a Calvinist conscience. If ideas rather than things are all we can ever know and if

"the consciousness of relations can be created only by the subject," then the world is a futile and laborious illusion, of whose futility and laboriousness the very self is guilty.

Escape, to some extent, was, however, possible. Aesthetics was for Kant the one realm where rational justification is not required and where ethical responsibility is not imposed. . . . Minds emptied of hope, when convinced by the study of Kant that genuine knowledge was impossible, found salvation in aesthetics.[45]

The failure of German idealism to make scientific and rational sense is obscured by its plea for self-deification masked as good taste and claims of genius. Jacobi, Herder, and Schlegel attack Kant's rationalism by subverting Kant's *a priori* mental categories, his reduction of space and time to such categories, and his denial of any final cause or purpose: "Without proper end or aim, it goes on continually revolving around itself as a centre, and within its own charmed circle. . . . It places perfection in an abstraction carried continually higher and higher in its emptiness."[46]

The scientific physics of matter and void of Newton once again raises its head. And, once again, suggestions for filling that empty void were predictably offered. They were variations on the concept of the *Will as original Being*. In contrast to Edwards's attempt to reconcile gravity with the will of a Trinitarian God, Schelling developed a mystical theosophy and monotheism in which freedom is defined as the unified will. But it is Fichte for whom McMahon has particular contempt. Fichte declared, "The objective world is only the primitive and still unconscious poetry of the mind; the universal organon of philosophy, and the keystone of its entire arch, is the philosophy of art." Fichte holds that reality consists of a threefold act: thesis, antithesis, and synthesis. That process is grounded in the I, and the freedom of the absolute I, he declared, progressively to manifest itself through the moral order in history is itself God. As McMahon critically paraphrased this doctrine: "the German mind is the self-consciousness of God."[47]

McMahon's Solution

Such doctrine is repugnant to McMahon. It is repugnant intellectually and experientially: Nazism had just recently been defeated at horrible cost. He laments the fanaticism, brutality, and passionate ignorance that are intrinsic to such an attitude. In opposition to such doctrines he writes: "The characteristic of the earliest recorded systematic thought about art which have a direct relation to basic

American insights are, first of all, moral idealism and intellectual naturalism. Of almost equal value are Aristotle's concepts of technique and of causation."[48]

In reflecting upon the failed Kantian attempt to unite the one with many, Being with becoming, it is curious that McMahon does not contemplate why Aristotle's final cause is now so repugnant to cultural discourse. Similarly, McMahon assumes that emotion and quality are distinct elements,[49] without contemplating whether that should be the case. The separation of fact and feeling is a core problem of all immanent dualistic paradigms, including modernism-postmodernism. If fact and feeling are separate, then lacking a unifying purpose, they can only be combined as acts of will, acts of power. In traditional classical and Judeo-Christian tradition, when facts combine with meaning it is the realization of love. Love marks meaningful completion by which material facts in the realm of becoming seek degrees of numinous unity with purposeful Being.

It is fitting to conclude this chapter with a review of McMahon's book and its argument by a then prominent modernist-postmodernist, Clement Greenberg. As a Marxist, Greenberg was unable to conceive of culture as a set of beliefs about a meaningful universe leading to a nobly inspired practical politics. He could not conceive of a scientific rationalism manifesting truth and love as cosmic completion. Instead, his political science conformed to the Hegelian-Marxist assumption of a master-slave dialectic. Therefore, the foundational distinction of American culture from European modernist-postmodernist culture could make no intelligible sense to him. He rejects McMahon's reference to American exceptionalism, called Americanism, as a mask for power,[50] while ignoring the reality of his own European exceptionalism, which was so horribly manifested in the twentieth-century brutalities of fascism, totalitarianism, and socialism.

Greenberg's critique of McMahon's analysis is sadly reminiscent of Sinclair Lewis's critique of Babbitt. In an article published in *The Nation* (March 30, 1946), "Americanism Misplaced," Greenberg calls McMahon's book distressing. Greenberg suspects that xenophobia might explain what he calls a "tendentious obtuseness on the part of McMahon in reducing the whole basis of aesthetic thought from Descartes to the present century to a series of gross fallacies."[51] He goes on to claim that McMahon's "'American' philosophy of art, relying on vaguely pragmatist assumptions, yet involving Aristotle, quarrels with the 'Europeans' for their terminological untidiness (but what harm has that done?)." He charges that McMahon excludes poetry, drama, and music as art; that he shows that "works of art are partly experienced as sensory objects—which no [German] idealist ever denied"; and that "beauty is not to be found solely in the beaux arts—which no [German] idealist ever asserted." Greenberg holds that Aristotelian thought is

obscurantist, that no philosophical position should be stripped of all qualifications and connections, and concludes that McMahon's reasoning is fallacious. He then claims that McMahon does not understand Kant.

This critique—if that is the appropriate term—deserves response. To suggest xenophobia and a tendentious obtuseness is not a scholarly but an *ad hominem* argument; can a twentieth-century American rightly be called xenophobic and obtuse while calling for a serious reconsideration of ancient Greek and contemporary German philosophy? Is rejection of European modernism xenophobic, or is such a charge a mask for a dogmatism of another kind? To assert that terminological untidiness has done little harm belies a central point of McMahon's book: the intellectual justification behind Hitler's rise to power has a historical and conceptual pedigree that is left unrecognized at our own peril. Greenberg asserts that McMahon omits poetry and other forms of art, and yet (for example) on page twenty four McMahon quotes Horace's *Ut picture poesis*. He makes straw-man arguments about how German idealists respond to the material realm, arguments repeatedly critiqued in McMahon's book. And in an act of unselfconscious parody, with a breathtaking provincialism, Greenberg asserts that to compare fine art to logic and morality is beneath criticism—even though that is the universal and historical norm. Indeed, lacking logic and morality, what is left to art and culture but the German idealist *will to power*—which is precisely McMahon's point.

Greenberg's critique of Americanism, and American exceptionalism, is written from the perspective of European exceptionalism. As such it is written from a postmodern, indeed, socialist-Marxist perspective. Therefore, it (de)constructs American Exceptionalism not by a refutation of how well it understands reality and life, but by its methodological assumption that there is no understanding to be found. Equality and authenticity are deemed non-negotiable tenets of faith; those who understand the world differently must then evidence bad faith. Dogma replaces freedom of conscience, and makes a mockery of academic freedom.

Fortunately, how we understand reality and life does indeed have consequences. History proves that different paradigms in science, reason, and culture have and do occur. The traditional American paradigm is one example. *American exceptionalism is not grounded in equality, or in authenticity of race, ethnicity, economics, or nationalism; it is grounded in the principle of scientific rationalism in the service of responsible freedom.*

Greenberg's review of McMahon's book is included to contextualize possible responses to this book. We anticipate that an academy that reduces truth to expressions of the will is likely to respond with a willful hostility to its argument. This, of course, is a demagogic rather than scholarly tact—but in a postmodern

age the scholar is the demagogue. Shockingly absent are rebuttals to McMahon's multiple solid points, points made by Babbitt and others previously and by a variety of writers since. Those points all ultimately refer to the positivist redefinition of science and reason. That modernist-postmodernist redefinition is based on a dogmatic faith in a meaningless world rather than the possibility of knowledge of an intelligible one, and results in a culture of existentialism where civilization collapses. In the next and final chapter we offer a qualitative alternative to this reduction and brutalization of scholarship and culture. Not primarily for the current generation, but for the next.

13

SACRED AND PROFANE
SCIENCE, REASON, AND CULTURE

Construction of the Portland Building in downtown Portland, Oregon, was completed in 1980. That building is widely considered to be the first major public structure built in the postmodern style. Its physical location affords striking views of the magnificent Cascade Mountains across the Willamette and Columbia rivers. Building in a region noted for a long and dark rainy season, Michael Graves nonetheless designed the building with small windows, thwarting both the possibility of enjoying that magnificent scenery, and the practicality of providing natural interior lighting. Moreover, the Portland Building denies not only a romantic focus on magnificent scenery, or a utilitarian practicality. It aggressively denies the possibility of designating a sacred place in which a tectonics of meaning might prevail.

Instead, the building embodies its own distinctive style and meaning. What style and meaning is that? It is neither a modernist nor a pragmatic building; rather, it evidences a peculiar sort of classical vocabulary. Granted, as one text puts it, "[The rendering of the Portland Building] is replete with quotations from the classical language: the temples on the roof (never built), the giant keystone beneath them, the pair of fluted pilasters of indeterminate order, and the tiered stylobate at street level."[1] But that vocabulary has lost its grounding in reality. It is a transgressively ironic classicism.

It is an architecture lacking reference to objective reality, a tectonics of ontological meaning. The classical *trivium* is central to classical culture and the liberal arts. Comprised of logic, grammar,[2] and rhetoric, the trivium represents the

Michael Graves, The Portland Building, 1980

means by which knowledge of a purposeful reality and life can be obtained. Logic, grammar, and rhetoric are a means to realizing the sacred. But that is not the case with this building. Its visual vocabulary denies *ta onta*; it denies that language— and art—serve in the obtaining of knowledge of reality. When meaningful reality (such as that posited by the classical-Judeo-Christian tradition) is denied, two options result: a trivialized "reality" or a brutalized reality. The postmodernist mind accepts either, depending upon its whim.

This destructively transgressive borrowing from the Greeks reflects the postmodern obsession with an oddly and brutally deontological technology. *When logos is trivialized and brutalized, then so too is the techno-logical.* A rationalized and existential technology is substantively trivial and brutal. So too is its architecture.

So a destructive shift in culture is paralleled by a destructive shift in architecture. The Kantian liberal modernist advocates a subjective-objectivity in which the facts of existence conform to our understanding. We embrace "meaningful fictions" to produce a culture both free and responsible. But the postmodernist considers "meaningful fictions" as meaningless, and engages in either a transgressive irony, or a transgressive brutality. We will return to the Portland Building's ironic trivialization of culture and technology in a moment. First is a consideration of the brutalization of culture and technology as evidenced by that facet of the postmodern perspective.

Unlike the modernist claim to honesty and clarity of materials within a formalist yet deonotological architecture, there is a new attempt in some postmodern architecture to make the engineered elements, the very supports of the structure itself, dramatically, clearly, and brutally authentic. Richard Rogers (and Renzo Piano) designed the Centre Pompidou (1971–77) in Paris, a building that merely emphasizes the mechanical innards turned outwards. In contrast is Terminal Five at Heathrow Airport (2008), also by Rogers. The soaring visible supports, nicely finished, converge and are joined to a series of roof struts. These struts are not merely visible but are prominent; they are a substantive design element. The moderns' claim to "honesty and clarity" of materials is surpassed here by honesty and clarity in the structure, support, and exposed raw power of the tectonic abilities of engineering and steel. But why would anyone wish to see these raw structural devices of a tectonic artifice? On the surface, one may assume that these represent a tremendous break with the past; even the moderns did not show this much engineering daring. However, to confuse technological with cultural sophistication is a naïve and prideful error.

Indeed, there is a long architectural tradition of visible tectonic structure. The ancient Greeks and the more recent Gothic[3] cathedrals, to cite just two examples, had clearly visible structural elements as part of their design programs. Greek temples were rather inside-out in this regard: the supporting columns were situated outside the walls. Gothic cathedrals are rich with a myriad of visible engineered details: thick piers, repeating bays comprised of arches and vaults, and the indomitable flying buttress. In both cases these visible elements are present for specific purposes that contribute to realizing and revealing the meaning of reality via architecture. Columns in the Greek temple demonstrate the mathematical relationships in the building; bays in the Gothic cathedral manifest harmonious mathematical relationships, too. Gothic flying buttresses assist in the lightening of walls and the creation of larger windows to contribute to illumination, another symbol of the divine. The Greeks and the Christians viewed rational mathematics as a means of exposing the divine mind of the universe; contemplation of the eternal verities of mathematics is a means to consider the divine, and architecturally make manifest sacred places.

To what, then, might the struts in Terminal Five correspond? They do not at first glimpse seem to have any connection to Greek elements, not even the enervated versions in the Portland Building. Yet one may similarly consider the smaller elements of the Doric temple, the enrichments on the entablature such as the guttae, the regula, and the triglyphs. These elements do nothing to physically or intellectually support those buildings. They are not really technological. They

do remind the Greek of the days when temples were constructed of wood, and granted, they abstractly contribute to the repeating pattern, and thus harmony, of the entire sacred temple.[4] But whereas for the Greek temple such details are secondary, for Rogers's architecture the secondary become primary. The struts in Terminal Five are clearly evident and do support the structure, but what else? Modernity urged becoming at the expense of Being and offered a formalist architecture that claimed a specious honesty known as "meaningful fictions." Now, the postmodern architecture of Terminal Five offers clearly visible and presented engineering *as* architecture. What one sees is a purely authentic engineering as an end, rather than a means to a sacred end—at least a non-brutal sacred end. A specious honesty has been replaced by a trivialized and brutally pointless honesty. The engineering, the roof struts, are real; the rivets, bolts, and steel are actually holding up part of the structure. In that sense it is genuine. But with Being rejected, does the genuineness of the elements matter? Certainly it functions—but what can it mean? The technology visible is merely a surrogate for true Being, for groundedness. There is nothing beyond its own existence. It is a blunt fact, or as Heidegger would call it, a facticity, of technology. It is an unconnected techno-logos that offers a sad consolation to minds that presume there is not actually anything which may inspire our efforts, console our tragedies, and tweak our comedies.

Since such architecture denies *to onta*, denies objective transcendent Truth or logos, then such buildings cannot offer a glimpse of Truth made manifest, of *ta onta*. Buildings cannot make manifest meaning; they cannot be sacred buildings in sacred—that is, meaningful—places. They can only occupy meaningless space. Such architecture can only make manifest purposeless triviality or power—which in a social context are the expression of what Hannah Arendt referred to as the banality of evil.

In Graves's architectural vocabulary, all is verb, not noun; all is becoming, not Being. The Portland Building's keystone serves no purpose; nor do the fluted pilasters or tiered stylobate. The building is foreign not only to classical art and thought, but to neoclassical as well. In contrast to the neoclassical modernist purity of the Bauhaus, this building mocks the modernist notion of art as a perfection of a kind. No Platonic glass box of crystalline clarity and purity, the Portland Building parodies classical references. It is a parody of architectural language, but also a parody of the role of language itself. Its visual grammar denies logic and a meaningful tectonics, its commitment to the liberal arts is destructively transgressive. The elements of language might be recognizable, but their combined narrative makes no sense; hence we have a transcendent aesthetic, a subjective objectivity, a synthetic *a priori*, an immanent transcendence. These terms, common to modernist-postmodernist thought, make no sense; they deny the connec-

tion of visual and spoken language with intelligible reality. They deny that in the beginning was the Word.

Edwards and Eliade

It makes no sense to build a governmental building that mocks language, rationality, and purpose. How could this occur? Thomas Molnar concludes that such folly is the result of a secularized Puritanism in which the idea of government as a sacred trust, and architecture as the expression of a sacred place, are not just forgotten, but mocked:

> Architecture, instead of rising as a devotional act to God, to the public spirit, to the natural/civilized rhythm of existence—has withdrawn from life and community. . . .
>
> Creators of beauty are people at ease in the world, and love it so that they regard themselves worthy of embellishing it. The puritanic psyche, on the other hand, regards the world as an enemy, and uses every technique to construct between it and himself all manner of screens protecting him against the flesh (i.e., the senses), but also against the spirit and the spirit's joys and expansiveness. . . .
>
> As we know from the writings of Mircea Eliade and other intelligent students of religion, the ideal human habitation is not a machine, nor is it a haphazard nomadic caravan. It is a sacred place organized around a sacred event, with its axis piercing the center of the cosmos.[5]

A postmodern critique of philosophy and its antagonism to sacred language and architecture is found in the work of Vincent Scully. In postmodernist fashion, he argues that pre-Socratic Greek culture was superior. In *Architecture: The Natural and the Manmade* (1962), Scully posits that before philosophy, Greek architecture was experienced and that experience as such was sacred. As L. Michael Harrington explains:

> For Scully, the devolution of Western architecture begins with the appearance of philosophy, which he treats as functionally identical with the appearance of Platonism. The Greek approach to architecture, so amply described in The Earth, the Temple, and the Gods, collapses "almost overnight" with the appearance of philosophy in the fifth century before Christ. . . .

The Platonic philosophers who take up the number theory of the Pythagoreans describe the maker of the cosmos as following a geometrical model when constructing it. The application of this insight to the craft of sacred architecture leads to a homogeneity in temple design. . . . The elevation of the universal necessarily downplays the material character of the temple, since the material of a thing renders it here and now, in this specific place at this specific time. The geometrical method does not ensconce the temple within its local landscape, but imposes on that landscape, as best it can, a being of a different order: the geometrical object.

The father of the phenomenological movement in philosophy, Edmund Husserl, commented in 1936 on "the surreptitious substitution of the mathematically substructed world of idealities for the only real world, the one that is actually given through perception." His student, Martin Heidegger, joined him in lamenting the dominion of the mathematized world. . . . Heidegger was joined by Mircea Eliade. . . . For these two seminal thinkers in the twentieth-century rediscovery of place, Western history is the story of the loss of place, a loss that begins when the world is approached with a method that Heidegger explicitly identifies as Platonic.[6]

But critical are the differences between Heidegger and Eliade. Those differences can be understood by how they differently understand Plato. For Heidegger, Plato is the beginning of the rationalistic decline of human culture, whereas for Eliade, Plato marks the apogee of its realization. Eliade considers Plato to be the epitome of the pre-Socratic flourishing of the unity of science and myth.

Both Heidegger and Eliade maintain that the pre-Socratic Greeks are resonant with postmodern authenticity. Shared is a distrust of discursive rationalism, which is said to alienate us from reality and truth. In this regard, the pre-Socratic Greeks concur with St. Paul, who also warned about philosophy as a hazard to the sacred (Colossians 2:8). But critical are the differences between the pre-Socratic existentialists (as posited by Heidegger), and the pre-Socratic seekers of wisdom (of whom Eliade views Plato as exemplary) in whose camp are St. Paul and Augustine. Those differences center on the distinction between the subrational and the suprarational, the immanent and the transcendent. Those distinctions affect our ability to understand reality and life.

The latter trio affirms the possibility of a scientific rationalism that seeks to obtain *a glimpse* of ontological understanding. They view science and rationality as joined in sacred purpose realized via responsible freedom. In contrast, Heidegger (and other phenomenologists such as Husserl and Derrida) are intellectu-

ally and culturally very different. They too share the conviction that rationality marks a distancing from reality that is destructive to the very possibility of science and culture. Unlike Plato, St. Paul, and Augustine, they promote a transgressive redefinition of the historical norm of Western culture: the Logos is why reality and our lives cannot be understandable.

Heidegger famously quipped that "language is the house of being";[7] the intelligible temple of language is manifested in the material temples in which we live. Genesis describes reality as the product of Divine language, but for Heidegger language and the sacred are immanent, not transcendent. It is not Divine language that provides understanding for Heidegger; he presumes that it is human language. Heidegger concludes that people understand themselves and the world only in relation to the language temple, and so they do. But if their language temple is only what they utter, then can anything but profanity be voiced?

The Portland Building by Michael Graves is a visible image of a temple of language, but it is one that is deconstructed. It makes no sense. If the temple makes no sense, then grammar makes no sense, nor do reason or science. However, despite their making no sense, we still utter and act. Although we cannot speak and act the language of goodness, as existentialist scientific rationalists we can make much noise and do great harm.

Graves's ironic postmodernist trivialization of Kant's symbolic form is the problem; Heidegger, Derrida, and Eliade offer postmodernist solutions. Heidegger and Derrida hold that reason distances us from reality and that a rational religion—such as Christianity—does the same. In contrast, Eliade agrees that human reason distances us from reality, but argues that our task is to reunite with the suprarational ground of Being. For Eliade, the difficulty is the same as faced by Edwards: the classical-Judeo-Christian tradition is historically committed to a purposeful scientific rationalism. It accepts the need to reconcile the rational and material with the Transcendent without dangerously claiming a god-like ideological finality.

Eliade's solution is to recognize that the modernists have science, but also myth, so myth is compatible with science. He concludes that modernist myth informs its "scientific thought," but that myth leads to the "gradual desacralization of the human dwelling."[8] So the quality of science is determined by the quality of its underlying myth, its underlying perspective. The quality of any myth or perspective is grounded in its ontology. A trivial and violent ontology requires an eternal return to barbarism; an ontology of truth and love permits an eternal return to a culture of responsible freedom.

Facticity and the Death of God

In science and culture that which we seek we will find—if it exists. The danger is in limiting the possibilities of our knowledge of existence and thus having an incomplete and inadequate understanding of reality and life. Our understanding is contextual, but contexts can vary from space, to place, to sacred place. The first two contexts of knowledge refer to modernism and postmodernism. If things are understood to merely occupy space, then they are lost in space. If they are limited to simply occupying a place, then one place is as good as any other. A trivial violence results. If they occupy a sacred place, then the world and knowledge have intelligible meaning. The progression from space, to place, to sacred place is qualitative in that it progressively confirms the possibility and value of seeking rational ontological knowledge.

The inescapable need to choose a context for our knowledge is affirmed by postmodernity. Physics professor Paul Davies addresses the modernist myth of scientific impartiality:

> Science, we are repeatedly told, is the most reliable form of knowledge about the world because it is based on testable hypotheses. Religion, by contrast, is based on faith. . . . The problem with this neat separation into "non-overlapping magisteria," as Stephen Jay Gould described science and religion, is that science has its own faith-based system. All science proceeds on the assumption that nature is ordered in a rational and intelligible way. You couldn't be a scientist if you thought the universe was a meaningless jumble of odds and ends haphazardly juxtaposed.[9]

Professor Davies reminisces about his encounter with the myths of a positivist scientific rationalism. He observes that the idea that laws exist reasonlessly is deeply anti-rational. As such, it makes a mockery of science.[10] In apparent agreement with the insights of Heidegger and Eliade just discussed, Professor Davies concludes:

> Clearly, then, both religion and science are founded on faith—namely, on belief in the existence of something outside the universe, like an unexplained God. . . . Isaac Newton first got the idea of absolute, universal, perfect, immutable laws from the Christian doctrine that God created the world and ordered it in a rational way. Christians envisage God as uphold-

ing the natural order from beyond the universe, while physicists think of their laws as inhabiting an abstract transcendent realm of perfect [Platonic] mathematical relationships.

In other words . . . until science comes up with a testable theory of the laws of the universe, its claim to be free of faith is manifestly bogus.

It is not that post-Enlightenment culture (that is, culture liberated from the constrictions of modernist and postmodernist positivism) has to scientifically prove the existence of truth or God; rather, *it is positivist science that must defend its faith in nothing*. It is not science vs. faith, but faith in power and becoming vs. faith in the free and rational pursuit of Being. It is a choice between the sacred and profane, between love and nausea:

> Nothing in science will assure that there is, e.g., water, at sea level, over a fire, boiling. Science simply states that if the conditions are present, water will boil at 212 degrees sea level. That the conditions be present is a matter of history, not a matter of science. [Similarly]: there is nothing necessary in history even after it has occurred . . . [But this] answer won't work because it puts a surd, or better, an absurd into our thinking. It denies the existence of science. Now, we *know* there is science about contingent beings: water *does* boil at 212 degrees sea level, cattle *are* ruminants, and so on. No wonder the modern existentialists, who proffer this second explanation, are themselves so nauseated by it. Any serious attempt to get along without necessities in contingent beings is a kind of metaphysical foretaste of hell.[11]

The false notion of an impartial, positivist, and beliefless science is historically grounded in the assumptions, the myths, of the Baroque period, and is incoherently realized in the Enlightenment. Specifically, the Baroque redefinition of science and reason leads to the Enlightenment and its offspring, the modernist-postmodernist tradition. That redefinition leads to a science and culture mythically grounded in our will, and realized in a failed scientific theology now called existentialism and once called paganism.

It is historically true that positivist scientific thought leads to the "gradual desacralization of the human dwelling," and of language.[12] It is important to note that it leads also to a gradual desacralization of all human knowledge. The result is a denial of objective scientific knowledge of a meaningful reality. As Peirce presciently noted, the denial of Truth or God denies not only transcendence, but rationality as well. The Book of Genesis, Plato, and Heidegger agree that we live

in a house of language. That house collapses when language collapses. Heidegger attempts to renew an ontology of language and science in a reductionistic way. Derrida and Foucault evidence his failure. All postmodern philosophy takes for granted a positivist definition of science and language in which a free and responsible pursuit of wisdom via a discursive scientific rationality is not possible. The advocates of a transcendent yet Incarnational suprarationality, such as Eliade and earlier, Edwards, attempt to escape that dreadful destiny.

According to Rieff, a useful point of origin for this anti-intellectual perspective is 1882, the year in which Nietzsche published *The Gay Science* and there declared that God and all god terms were dead. The artist replaces the prophet, the therapist replaces the priest, the authoritarian politician and lawyer replaces a free and responsible citizenry. The year 1882 also marks the death of Charles Darwin, whose constellation of like-minded figures included Thomas Huxley, Karl Pearson, and Herbert Spencer. In various ways they advocated a sociobiological cultural vision informed by a genetic-based hierarchy of violence.[13] Just a year earlier, Dostoyevsky famously warned that lacking objective truth, Western culture would collapse.

That warning was not rhetorical. Aleksandr Solzhenitsyn personally experienced the collapse of Western culture, with its historical commitment to a scientific rationality and responsible freedom. In his novel, *The First Circle* (1968), he presents in narrative form the fallacy of a materialist scientific rationalism and the violent consequences of its inherent perspective. A conversation in chapter 2 between prisoners is presented. He starts by having them discuss the positivist and Kantian presumptions of science:

> Thomas Hobbes said somewhere that blood would only be shed over the theorem that "The sum of the angles of a triangle equals 180 degrees" if it injured somebody's interests.
>
> But Hobbes knew nothing about prisoners. . . .
>
> And now Kondrashev-Ivanov was involved in discussing whether or not art had to follow nature. . . .
>
> . . . After all, you, as you paint, perceive these things; they are part of your perception of the summer morning. How can they be captured in the painting? How can you preserve them for the viewer?"
>
> "In other words, the painter doesn't simply copy?"
>
> "Of course not!"[14]

Solzhenitsyn then shifts the conversation to a postmodern context. The Kantian idea that facts should conform to our thinking is objected to:

"But my dear fellow," Rubin (the Marxist dialectical materialist) objected, "'ought to be' is a most dangerous path! You will go on from there to turn living people into angels and devils, making them wear the buskins of classical tragedy. After all, if you paint a portrait of [a person] it must show [that person] as he is."

But a dialectical materialism is denied as authoritarian and empty:

"And what does that mean, show him as he is? . . . Externally, yes. There must be some resemblance in the proportions of the fact. . . . But isn't it rash to believe that one can see and know reality precisely as it is? Particularly spiritual reality? . . . Why shouldn't one help a man find himself and try to be better?"

"What you mean," Rubin said, "is that there can be no such thing as objectivity in art."

"Yes, I am nonobjective, and I am proud of it!" roared Kondrashev-Ivanov. . . ."You are not objective either, but you think you're objective, and that's much worse.

Solzhenitsyn's prisoners are both myth and reality, fictional yet for Solzhenitsyn, autobiographical. As a fusion of myth and reality, he has them affirm the importance of the eternal return to a beneficent ontology:

The truth is supposed to be the final result of long investigation, but don't we perceive a sort of twilight truth before any investigation has begun? We pick up a book and right away the author seems unpleasant, and of course we are right!"

Nerzhin, delighted[,asked] "Doesn't the same thing happen in social science?" . . .

"My child," Rubin reasoned with him, "if it were impossible to predict results, then there could hardly be any 'progress' could there?"

"Progress!" Nerzhin growled. "The hell with progress. I like art because there can't be any 'progress' in it."

"Just what do you mean?" . . .

"Just that! In the seventeenth century there was Rembrandt, and there is Rembrandt today. Just try to improve on him. And yet the technology of the seventeenth century now seems primitive to us. Or take the technological innovations of the 1870s. For us they're child's play. But that was

when [Dostoyevsky's] *Anna Karenina* was written. What can you name that's superior?

The pretense of a cultural and scientific positivism constituting a comprehensive objectivity, and its cult of technological progress, is revealed as dreadful farce. Neither (de)constructivists nor existentialists offer a positive perspective. Later in the book, Solzhenitsyn mocks Rubin's new science of phonoscopy,[15] just as we today can mock Huxley's new science of phrenology, and Kant's and Linnaeus's new science of racial superiority. Lacking the possibility of finding a glimpse of truth, the relationship of fact-based science and emotion cannot rationally— that is, ontologically—be resolved.

Copleston points out the dangerous consequence of such a situation:

> If Nietzsche is prepared to apply his view of truth to alleged eternal truths, he must obviously apply it *a fortiori* to scientific hypotheses. The atomic theory, for example, is fictional in character; that is to say, it is a schema imposed on phenomena by the scientist with a view to mastery. . . . The atom, considered as an entity, a seat of force, is a symbol invented by the scientist, a mental projection.
>
> However, if we presuppose the fictional character of the atomic theory, we can go on to say that every atom is a quantum of energy or, better, of the Will to Power.[16]

A Baconian-Newtonian scientism leads via a Kantian symbolic form to a Marxist and Nietzschean religion of violence in science, ethics, and culture. A scientific rationalism is newly, and tragically, understood as a scientific will to power. But as Thomas Kuhn, Mirceau Eliade, and Aleksandr Solzhenitsyn have made clear, the dogmatic grip of the reductionistic redefinition of science as scientism, and reason as rationalization or mere experience, is historically contingent and unstable.

A Qualitative Scientific Choice: Subrational Subversion vs. Suprarationality

As we have seen, if the narrative of scientific rationalism is positivist, then there is no scientific knowledge, only sophisticated means to power. To deny transcendent truth is to be trapped in becoming, in which case scientific rationalism produces

technologically advanced but brutal power. Even some postmodern phenomenologists recognize the ironic consequence of this position. Theodor Adorno (and Max Horkheimer) famously observed in *The Dialectic of Enlightenment* (1947)[17] that *reason lacking an object turns upon itself and reveals its groundlessness and its service to terror.*

That book consists of five chapters, analyzing the detachment of science from practical life, formalized morality, the manipulative nature of entertainment, and a paranoid behavioral structure expressed in aggressive anti-Semitism. It argues that the core of this postmodern constellation of ideas is the tendency toward self-destruction. The Nazis were not an aberration of modern history but were rooted in the fundamental flaws of the Western Enlightenment.

Adorno and Horkheimer view scientific rationalism from a non-Augustinian viewpoint in which there is a dialectic of fact and rationality. They trace that dialectic since the Enlightenment, during which these two spheres are split apart, and conclude that this dialectic results in a neopaganizing (not their term) of life. The authors declare that "Myth is already enlightenment, and enlightenment reverts to mythology." That alleged paradox is the fundamental thesis of the book.

However, it evidences circular reasoning and an ontologically false thesis. Adorno and Horkheimer take for granted that meaning is constructed via human rationality or experience and therefore science and reason are destructive myth, and myth is destructive reason and science. That circular assumption takes for granted an assumedly dogmatic positivist redefinition of science and reason as violent. All postmodern philosophy takes for granted a positivist definition of science; this results in, and can only result in, a positivist definition of reason. Positivist science and reason have no meaningful grammar. The language temple (or the university) deconstructs. *Positivist scientific rationalism is a mere implement of power. Science is subrational.* But not all scientific rationalism must be destructive.

At issue, then, is whether there is a difference between the myth of positivism and the myth (if that is how it is to be understood) of Trinitarianism. Is there a choice between the subrational and the suprarational in science and culture? Are all metanarratives oppressive and violent, or can metanarratives liberate us from violence?

The modernist cannot imagine a sacred science, rationality, or culture. It is intellectually lost in space due to the dogmatic myth of multiperspectivism. Postmodernism takes for granted that rational narratives are false constructs; advocated instead is a violent multiperspectivism in which conflicting claims of tolerance and authenticity compete. This simultaneous commitment to tolerance and authenticity constitutes the dysfunctional narrative of the contemporary West.

The classical-Judeo-Christian tradition maintains that ontological reason permits us to rise above chaos and violence, and that a humble human rationality seeks a glimpse of the infinite realm of intelligible Being. The transgressive modernist and postmodernist makes the profane sacred; the classical-Judeo-Christian tradition believe the sacred elevates us from the profane.

The notion of sacred order refers to the concept that reality and life are to some degree intelligible and purposeful. As such, a sacred rather than profane science is possible. Responsible freedom, as the conscious and willful pursuit of wisdom, is preferable to willful power alone. Wisdom combined with the will can lead to a numinous sacred place in which truth and love are one; fact and feeling combined with the will necessarily manifests violence. This is not a Puritan claim, which might be dismissed as evangelical or fundamentalist; it is a conclusion affirmed by postmodernity itself as evidenced by Adorno and Horkheimer. It is well to remember that, after Auschwitz, it is not just poetry that is suspect. The hope of a Rousseauean solution grounded in the goodness of human nature offers no respite.

In other words, the sacred is the necessary alternative to the profane, indeed the barbaric. It opens the world to some degree of ontological scientific rationality. The modernist cannot imagine a sacred science, rationality, or culture. The modernist tradition denies the sacred, as evidenced, for example, by Kant's advocacy of a deonotological ethics, rationality, and faith. The presumption of a deontological ethics is that ethics are not grounded in intelligible reality. Like Graves's use of classical architecture, logic, grammar, and rhetoric are still cited, but no longer in a way connected with an ontological ground. A deontological reason requires a deontological rhetoric; we are to be persuaded that culture and ethics are grounded in a good will, but that good will cannot substantively be recognized as such. Not can it offer us a reason for acting in good will. It cannot be committed to virtuous freedom, but rather to specious claims of tolerance and duty. We are allegedly duty bound to be tolerant and fair to others. Why? Because we are rational beings who ought to act as if there is a God; indeed, acting as if there is a god is judged by Kant to be proof of God's existence. We are to act as if objective rational truth were real because as "rational beings" we ought to do so. An empty tautology that winds about is a tautology nonetheless.

To the postmodernist, such tautologies lead to intellectual alienation, social oppression, and nausea. Their solution to the lack of authenticity is found by equating thinking with place. We live in a now sacred existential place. Thinking should be reduced to our own experience, our own authenticity. The postmodernist profanes the Kantian notion of duty by finding the "sacred" in the subject,

in the narcissistic self, as an individual or as a member of a race, gender, or economic class.

In contrast, the classical-Judeo-Christian tradition maintains that reason is useful in rising from ignorance and violence to informed opinion, and from informed opinion to the obtaining of a glimpse of wisdom. It seeks the sacred as the object—not the product—of consciousness and experience. Rather than being lost in space, or merely occupying an existential place, its proponents seek knowledge of their place within a meaningful existence.

For Kant, reason does not attempt to understand reality. Rather, reason is the structure of the human mind which when combined with empirical experience results in a type of knowledge. Kant declares this knowledge to be transcendental because it is beyond the empirical. He once again coins a new concept: the immanent-transcendent. The why of the universe—Truth or God—is now immanent. It coexists with matter. This is Aristotelian, Averroist, and deist, not Trinitarian. To call the human mind transcendent—even if hyphenated—is to redefine not only reason, but truth and God as well; it requires a dangerously absurd self-deification.

Kant critiques the Scholastic proofs for the existence of God: the teleological, the cosmological, and the ontological. Teleology asserts that things have intrinsic purpose. He asserts that teleology at best can prove that the world evidences intelligence, but notes that such intelligence could be plural, demonic, or value-indifferent. Cosmology asserts that the universe evidences order. But the cosmological proof can at best establish a first but not a final cause to the universe. Finally, the ontological proof relies upon the notion that reality, or Being (*ontos*) exists, and that which is most real we call God. Kant rightly observes that this transition from necessity of thought to a necessity of existence is unwarranted.

Modernists and postmodernists take his arguments against the existence of transcendent truth or God as definitive. But those arguments are not self-standing. They are myths. They take for granted positivist–conceptualist assumptions that are themselves a particular perspective. They are self-limited to a circular phenomenological viewpoint: since knowledge is limited to phenomena, then the world cannot be purposeful.

They take for granted that truth cannot be transcendent, and that it cannot exist beyond the material and the immanent realms. They deny a scientific rationalism grounded in truth and love, in cosmic completion. As an act of faith they deny all perspectives but those mechanical/materialist or pantheist. As a consequence, they absurdly subjectify knowledge and reduce it to mythic violence. To paraphrase Adorno and Horkheimer: The myth of the Enlightenment is that

the world is purposeless and must be myth. Thus the Enlightenment reverts to a destructive mythology.

That mythology is neopagan and violent; it serves terror. Kant begins with the positivist assumption that only facts provide knowledge of reality, and then naively laments that a newly immanent metaphysics, grounded in human rationality and will, is filled with conflicts. There are of course many conflicts over the substance of science, as Kuhn and Eliade have superbly established. But current conflicts are the product of Newton's and Kant's denial of objective transcendence. *That denial is grounded in the false assertion that all knowledge originates in experience.*[18]

Kant is following Aquinas on this point. Aquinas posits that all knowledge is grounded in sensory experience, which is made intelligible by the action of our intellect. But the assumption that all knowledge originates in experience entails a sleight of hand. Kant really states that all *human* knowledge originates in experience. *Tacitly denied is that there is knowledge that is not grounded in and the product of the human mind, that there cannot be knowledge that is objective, encountered, and remembered.*

The positivist asserts that facts provide knowledge that is impartial, and that the role of the scientist, scholar, and artist is to facilitate that process. But the modernist notes that facts are put into a variety of constructed metanarratives. Therefore the objectivity of the Enlightenment project is replaced by a modernist subjective objectivity. Science, reason, and culture are not objectively revealed by impartial inquiry. Rather, they are the products of the human mind. With this conclusion the postmodernist takes issue: science, culture, and art are not the products of the human mind, but of human experience. Biography and knowledge are becoming one.

Heidegger, Derrida, and Foucault: An Attempted Solution

We turn now to three postmodernists: Martin Heidegger, Jacques Derrida, and Michel Foucault, and their attempt to deal with the cultural problems of positivism and its effects. It is important to note that their philosophy—or as they prefer to call it, their thinking—is grounded in classical and Judeo-Christian precedent. Their linking of biography with understanding resonates with Augustine's affirmation of the role of the subjective in seeking knowledge of objective reality. Their separation of philosophy from thinking echoes St. Paul's admonition to distinguish between philosophy and wisdom. Their contemplation of the potential violence in the attainment of self-consciousness is both Socratic and biblical: the death of Socrates, the expulsion from the Garden of Eden, the violence of Cain

and Abel. The difference between them and traditional Western culture is that the latter affirms a scientific rationalism striving for the suprarational, enabling responsible freedom.

Martin Heidegger (1889–1976) is the major twentieth-century philosopher dedicated to a restoration of *Being*. His attempt to resuscitate ontology and thus wisdom centers on a new *science of facticity*. By facticity Heidegger means that human being involves existentiality and forfeiture; we exist in the world, but as part of a process of shaping the world. In so doing we are lost to the world. This self-negating and therefore anxious process culminates in a conscious awareness of death—which marks the ultimate authenticity of human being. Virtue occurs within an anxious authenticity; it is conscious decision making in the face of an incomprehensible yet experienced universe. Indeed, since Being is grounded in time, *Being* is actually *becoming*. Therefore, for human beings, Being as becoming is fully realized as death. So the most authentic experience of human being is realized in the negation of Being *and* becoming—via death.

Jacques Derrida (1930–2004) concurs with the postmodernist vision of knowledge. In harmony with Heidegger, he agrees that the philosopher lives, dies, and thinks. Philosophy as the pursuit of wisdom has nothing to do with thinking as such.[19] Thinking is what we do, but philosophy as the pursuit of wisdom cannot be done. In response to the question of whether there have been great women philosophers, he states that there have not been, and that is to the credit of women. Philosophy is rational, men are rational, and rationality is false. The purpose of thinking is to deconstruct oppressive cultures (or, as Richard Rorty benignly concludes, to be merely entertaining). Derrida links biography with understanding, but once biography is recognized then the one—the self—is recognized. As soon as there is one, then the one guards against the other. Recognition of the self as one is then violence.[20] Derrida has little to say about love. But he has a lot to say about narcissism. He does not criticize narcissism; he transgressively redefines it.

Historically, the objectivity of truth and love offers a remedy to subjectivity and narcissism. Why a remedy? Because neither makes sense in an intelligible world. Truth and love involve the need for meaningful completion rather than violence. Subjectivity and narcissism mock truth and love as meaningful completion. In both culture and science, truth and love seek completion, and require an object beyond the seeking subject. But lacking transcendent reason, there is no object offering a means of cultural and scientific unity; the recognition of the other is then grounded in difference and realized as an act of violence. Therefore, subjectivism is good, even though it reduces culture, science and knowledge to fact and power. In condemning the splitting of subject and object that Derrida

claims results from rationality, postmodernism faces the charge of endorsing a subrational narcissism. Derrida confronts this charge.

The classical myth of Narcissus according to Ovid (*Metamorphosis,* book 3) is as follows: a mother named Liriope asked the prophet Tiresias whether her son Narcissus would live to be old. The prophet replies: only if he does not recognize himself. Narcissus grows to be a handsome and self-possessed young man who repeatedly rejects the love of others. One rejected maid asks the god Nemesis to punish Narcissus for his selfishness. The god agrees to do so. Narcissus, tired and hot from hunting, comes upon a spring from which he drinks. While drinking he sees his image in the mirrored pool, and falls in love with his own image. But he cannot connect with the other, because the object of his love is himself. He then beats himself to death in despair.

Astonishingly, Derrida finds a positive message in this myth. Indeed, he claims that narcissism *is* love, and he claims that an "open narcissism" recognizes the other.[21] It is a type of categorical imperative, however, instead of the hope of goodness via a universal rationalism uniting us without the need for objective truth, Derrida posits a universal selfishness. He claims that a society of selfishness is open to selfishness and therefore is loving.

Michel Foucault (1926–1984) disputes that any knowledge is objective, and he critiques the Kantian belief that we are both a product of our environment as well as an element in the formation of that environment. He rightly concludes that "this historically realized impossibility means the collapse of the modern episteme."[22] In *Discipline and Punish: The Birth of Prison* (1975), Foucault sees pre-Enlightenment Europe as visibly manipulated by power whereas the post-Enlightenment West is manipulated invisibly. The consequence of this argument is that culture is a mask for power. Foucault reveals himself to be but an epigone of Rousseau and Nietzsche. Since culture is oppressive and terrible, it is our responsibility to humiliate perspectivism so that those systems of power become recognized and benign.

So we have three responses to the Enlightenment's dichotomization of scientific fact and human rationality. In our authenticity narcissism is love; we are sacred, and the most sacred thing we can experience is death; selfishness is not an obstacle to love and truth, indeed it is love and truth; and love and truth do not liberate us from folly, but are ultimately instruments of oppression and terror. The shared conclusion is the desire for a positive nihilism in which we may hope for an empty self-realization, self-expression, and death.

None of this is rationally consistent. If philosophy as the pursuit of objective knowledge is replaced by the thinking subject, then does thinking have anything to think about? If thinking is only a subject acting, can the *other* truly be rec-

ognized, and can truth or reality objectively exist? If so, can that recognition be understood via an open narcissism? Heidegger asserts that there is no real problem with a purposeless life, because a purposeless life is our authenticity. Derrida asserts that there is no real problem concerning narcissism because narcissism is not a problem. Indeed, it is an "open narcissism" that recognizes the other. Love is not meaningful completion, but rather indicates an acceptance of the dichotomy of who and what. For Foucault, that dichotomization means the collapse of post-Enlightenment culture, a collapse that should be celebrated as a liberation from oppression.

Not just Western culture, but culture as such, with its emphasis on a scientific rationalism and responsible freedom, is brutally assaulted, made defenseless by the tacit acceptance of the positivist redefinition of science and reason. Foucault concludes that love is violence, and so too is philosophy as the pursuit of truth and goodness. That conclusion is intellectually coherent within the context of positivist phenomenological thinking. And within that context, coherent also is his conclusion that meaningful completion—in science, philosophy, or life— marks a destruction of the other and is thus an inexorable act of violence.

Postmodernist advocates attack the specious notion of the Kantian genius, and scientific rationalism, as oppressive constructs of the human mind. They try to return to a subrational ontological science and reason. Because of the positivist limitation of knowledge to fact, their idea of ontology is limited to immediate experience. The consequence of this is the pursuit of pleasure and power in the name of individual or group authenticity. And so the pyrrhic choice is between submission to the authority of genius in a world lacking purpose, or embracing a will to power and pleasure in a world lacking any objective purpose. We are condemned to struggle for ultimately meaningless advantage. In either case, the result is the same: sacred order and responsible freedom are brutalized and thus denied.

As Foucault makes clear, the realistic postmodern response to truth and love being replaced by power and narcissism is not logical—nor should it be. Narcissus need not be successful in a completion of his love for himself. Indeed, from a positivist or phenomenological perspective, to complete love is to destroy the other, be it a reflection on a pool of water or another person. Therefore, it is claimed to be a noble act to enjoy an incomplete love which respects the other and respects freedom while celebrating violence. But this destroys the subject-object relationship necessary for culture, science, and reason. The result is to destroy the traditional notion that politics can permit us to be freely united via shared commitment to transcendent ideals without succumbing to a politics of violence.

It destroys the notion of marriage consisting of two individuals who are also one, united by transcendent purpose (and not for the purpose of killing *the other*).

God without Being: Attempted Compromise with Positivism

This reduction of Being to becoming is found also in incoherent postmodern versions of classicism and Christianity. For example, in Plato, Genesis (that is, the *Book of Becoming*), Exodus, and the works of Pseudo-Dionysius, there is traditionally recognized a Being beyond both being and becoming. There is a ground of existence beyond fact and process that informs an intelligible and meaningful cosmos. But the existence of Being (or objective Truth) beyond form, matter, and time (or process) makes no sense if transcendence is denied. To the positivist mind, such a transcendent Being cannot exist beyond becoming. Therefore, transcendence must be immanent and so must be truth—in science, ethics, or art. This requires a narcissistic scientific rationalism that, as even the postmodernists here discussed admit, collapses into a nihilistic violence. This denial of a scientific rationality cannot be justified biblically (since scientific rationality is intrinsic to its theology), philosophically (since lacking a scientific rationality, philosophy ceases to exist), or scientifically (since lacking the pursuit of objective and eternal knowledge, science ceases to exist as knowledge rather than a means of obtaining power).

Christian and Platonic cultures advocate the existence of a Being beyond being, of an objective Truth that informs the (truthful) unity of idea and matter within creation. Nonetheless, Scripture and classical works have been reinterpreted from a postmodernist perspective.[23] In *God without Being* (1982), Jean-Luc Marion argues that God as Love trumps God as Logos. He startlingly separates that which traditionally and rightly is held to be in unity: the Truth and Love of God. Marion writes:

> For us, as for all the beings of the world, it is first necessary "to be" in order, indissolubly, "to live and to move" (Acts, 17:28), and thus eventually also to love. But for God, if at least we resist the temptation to reduce him immediately to our own measure, does the same still apply? Or, on the contrary, are not all the determinations that are necessary for the finite reverse for Him, and for Him alone? If, to begin with "God is love," then *God loves before being* [italics added]. He only is as He embodies himself—in order to love more closely that which and those who, themselves, have first to be. This radi-

cal reversal of the relations between Being and loving, between the name
revealed by the Old Testament (Exodus, 3:14) and the name revealed, more
profoundly though not inconsistently, by the New (First Letter of John 4:8)
presupposes taking a stand that is at once theological and philosophical.[24]

Translation as well as understanding involves contextual choices. The issue of
how to understand the nature of God has been a perennial one. As noted earlier,
tradition maintains that in the beginning was the Word; Goethe declared that in
the beginning was the Act; for the Puritan in the beginning was the Glory of God;
for the Augustinian, in the beginning was a God of Love as meaningful comple-
tion. Since the question of the nature of God is actually the question of the nature
of Truth, it deeply affects our understanding of culture, reason, and science.

To understand God as willful becoming is to understand God from a post-
modern perspective. To equate the Love of God with the Acts of God leaves beg-
ging whether the substance of God matters. As history makes clear, acts of alleged
love can be substantively dedicated to the realization of evil. Our myths can serve
both the subrational or the suprarational, both terror or the numinous. Recogniz-
ing the substantive quality of alleged acts of love is of crucial significance.

To posit that the good will of God (or of humanity) must by definition be
good tells us nothing; indeed, it prevents us from understanding and distinguish-
ing acts of God (or of humanity) from acts of evil. To deny our ability or need to
qualitatively discern the substance of God or of wisdom is to deny the Trinitarian
and Incarnational role of a scientific rationalism. That scientific rationalism is his-
torically central to Western civilization, indeed to civilization as such.

For God to love before Being makes no rational or biblical sense. It is to
nominalize and temporalize God. To do so is to redefine God as willful becom-
ing. But the irony is that doing so results in that which it is claimed we ought to
avoid: it reduces God to our own postmodern measure. That measure denies not
just Trinitarian theology; it denies the possibility of a qualitative Truth and Love,
which cannot exist lacking subject *and* object, becoming *and* Being.

This positivist—that is, phenomenological—denial of transcendent Being
makes the biblical doctrines of *creatio ex nihilio,* the declaration of Exodus 3:14
that: *I Am That I Am* (*To On* in the Greek, *Hayah Hayah* in Hebrew), as well as
the doctrines of the Trinity and Incarnation, at best problematic. It also brings
into question the Platonic and Christian doctrines as understood by Eliade. Eliade
celebrates the pursuit of the suprarational, and thus rises above a discursive and
violent willful rationality. He denies the myth that God is substantively willful,
thereby rejecting a position rightly called subrational, and even narcissistic.

What is striking about the phenomenological approach to Classical and Judeo-Christian culture—and science—is its antagonism to the classical and Judeo-Christian distinction between, yet unity of, immanent fact and transcendent objective truth. When God or truth is willful or immanent, then we are all gods and scientific rationalism is but a pawn in service of our wills; if God or truth is only transcendent, then scientific rationalism does not matter since the material world is simply the reflection of the workings of God's will, or the will of those who speak for God. It is the need for the material manifestation of Truth and Love (as affirmed via the Incarnation) that permits a scientific rationalism, and which results in a culture of responsible freedom.

As previous discussion on Deism has evidenced, the postmodernist focus on a God of Becoming equates the substance of God with the Will, not Truth. If one reduces God's Being to God becoming, then the assumption is that God can will anything—since evil cannot scientifically and rationally be objected to—or even understood. But if the substance, the Being, of God is Truth and Love, and Love is understood as meaningful completion, then God cannot act against His own substance. He cannot merely be willful; He cannot will evil as a test, or as a sadistic whim. Not because of any limitation, but rather because of His nature. If God's nature is truth and love as meaningful completion, the ultimate nature of which remains ineffable, then the free and rational pursuit of degrees of wisdom is ontologically grounded. It is realistic to seek glimpses of wisdom and to live virtuously.

The unity yet distinction of Truth and matter, object and subject, makes possible intellectual freedom, discursive rationality, and intelligible science. If only becoming matters, then there is no other, no object, no other being, to comprehend or love. There is, however, the other to kill. We can assert, or deny, or destroy, but never discuss. Willful rational discourse makes no sense. To be more than trivial or oppressive, discussion relies upon ontological reason; language is our house of Being. Such realistic reason is denied in a world limited to the will.

Postmodernism—or neo-Paganism—denies the distinction between a suprarational Truth or God, and one sub-rational. It denies the possibility of obtaining degrees of knowledge about reality and life, and the possibility that some explanatory narratives (that is, meta-narratives) might warrant special consideration. That distinction is lost not only in scholarship but in the cultural, political, and scientific realms. Lacking a subject-object relationship, then recognition of the other is an act of violence; lacking the hope for transcendent based unity, there is no solution to that violence. Scientific rationalism—Trinitarianism—is replaced by the power of an unknowable God or humanity; a power not substantively

informed or understood by meta-narratives. What is neglected is the possibility of degrees of objective wisdom and beauty in and about creation.

In other words, it is not a matter of positivist science vs. emotivist faith. Rather, it is a matter of the possibility of degrees of objective truth vs. that of subjective "truth." It is a matter of our finding some glimpse of truth, or making truth. It is, ultimately, a matter of seeking knowledge of Truth or God,[25] or playing God. That results in either sacred hierarchies subject to scientific and rational analysis, or equalities of indifference or violence, subject to nothing.[26]

It is tragic that modernism-postmodernism has infiltrated classical and Judeo-Christian traditions—and for that matter, a wide array of Truth-seeking cultures around the world.[27] Within the classical and Judeo-Christian traditions, the rational pursuit of knowledge of objective Being is realized via the Logos, which is immanent as subject and transcendent as object. There is the world of things (matter and fact), the realm of existing things (*Ta Onta*) comprised of matter and fact informed with structure, and the immaterial realm of a transcendent thing (*To On*), which provides the source for that structure and meaning. We rise from fact to meaningful fact and strive ultimately to obtain a glimpse of meaning itself.

Within the context of a meaningful world, truth and love are one. There is no irreconcilable conflict between the self and the other, in science, ethics, or art. There is no conflict because there is a transcendent alternative. There is a higher unity that recognizes the self, and the other, and a purposeful unity that does not require the death of the self or the other. It recognizes the profane while offering the possibility of what Phillip Rieff, Christopher Dawson, Mircea Eliade, and others call the sacred order. It recognizes the realm of substantively qualitative culture grounded in an ontological scientific rationalism.

The Moral Imagination

The present cultural struggle came to attention not by any particular event but rather via the faith, the mythos, of the community and the dispositions of artists and intellectuals through their arts and sciences. Thus, the defense of culture as wisdom and beauty was viewed by the New Humanists as a war of the imagination. Others, such as Kirk, Dawson, Lewis, Molnar, and Eliade argued that the restoration of civilization depended upon the restoration of the moral imagination.[28]

But the imagination alone is not enough. Reliance upon the imagination is not clearly scientific; the Incarnation is not grounded in imagination. It declares the necessity and reality of matter and ideal combined as qualitative knowledge and

experience. Of the several biblical Hebrew and Greek terms that are translated as imagination, none substantively include objective material wisdom.[29] They are epistemological rather than ontological.

To plea for the moral imagination over the trivial imagination of modernity, or the brutal imagination of the postmodern will to power, is to accept the positivist dichotomization of science and reason. Left lacking is the idea of Truth (or Being) materially unfolding by degree in time (or becoming). Lost is the idea of timely progress realized in the pursuit of wisdom, of a qualitative progress in reality and life. Claims of knowledge are therefore nostalgia or fantasy or mystic. Pleas for the imagination are vestiges of postmodern romanticism with its inherent historicism. Romanticism is historicist in two different ways: Wisdom is frozen in time, or it is momentary. It is not Truth Incarnate realized in time. For example, Chesterton and Kirk nostalgically view the thirteenth century as the ideal;[30] Marx, Nietzsche, and Dewey view any such nostaligic idealism as irrelevant.

The reunification of science and reason is not imaginative but cognitive, or to be precise, Incarnational. Regardless of one's personal beliefs about Trinitarianism, it is a doctrine that justifies the pursuit of wisdom via scientific rationalism. Knowledge is grounded in the suprarational and timeless, but the suprarational is recognized via the material, rational, and temporal. The ultimately ineffable Trinitarian Godhead, the suprarational, is the object of our understanding through the Incarnation, which legitimizes the timely pursuit of knowledge of reality, of the sacred order. It legitimizes progress as the free pursuit of qualitatively greater degrees of wisdom, while denying that we can dangerously play god. The goal of science and reason is the comprehension of a glimpse of the sacred order, the *Ding-an-sich* within a coherent and purposeful cosmos.

From a postmodernist perspective, the pursuit of such completion is seen as an act of violence. Since there is no possibility of truth, all truth claims seeking closure actually seek to oppress. But the ontological and empiricist Scholasticisms of Aquinas and Kant (and the latter's Hegelian, Marxist, and Nietzschean epigones) demand a totalitarian closure or nihilistic denial. In contrast, Augustinianism rejects all closed systems; it rejects ideological attempts to force Truth and conscience into (de)constructivist modes, and it rejects nihilism. It rejects rationalization, totalitarianism, and irrationality. Its scientific rationalism is dedicated to the free and responsible pursuit of wisdom. As philosopher Frederick Copleston puts it, "the advocate of . . . the Augustinian tradition is not faced by a complete system to be accepted, rejected or mutilated: he is faced by an approach, an inspiration, certain basic ideas which are capable of considerable development."[31]

Augustine states that we must believe in wisdom before we can hope to understand it, but that belief cannot be grounded in imagination. It must be grounded in—but not be limited to—concrete experience. Copleston continues:

> The Augustinian attitude contemplates always man as he is, man in the concrete, for de facto man has only one final end, a supernatural end. . . .
>
> Knowledge of truth is to be sought, not for purely academic purposes, but as bringing true happiness, true beatitude. Man feels his insufficiency, he reaches out to an object greater than himself, an object which can bring peace and happiness, and knowledge of that object is an essential condition of its attainment; but he sees knowledge in function of an end, beatitude. Only the wise man can be happy and wisdom postulates knowledge of the truth.[32]

The relationship of truth, matter, and action is central to science. Augustine did not vigorously pursue the development of a scientific rationalism which was practical and technological. He was more concerned with the City of God than the City of Man. His focus on knowledge of God rather than an Incarnational *scientia* was no doubt influenced by the perspective of his time. The influence of neo-Platonic thought, with its abhorrence of the material world, was pervasive. It is not that he rejected Trinitarianism but that he did not pursue its full implications. Just as Augustine did not try to sort through the practical relationship of God's Being, Will, and material force, positivism has not sorted out its metaphysical assertions concerning truth in a material and meaningless world. This is particularly odd since from the time of Hume and Berkeley, positivist scientific naturalism is recognized as an intellectual failure in explaining the world. It concludes in the denial of knowledge via chance or alchemy. It cannot explain cause and effect.

The only way through this impasse is via an ontological and optimistic scientific rationalism. That way is sacred and thus, scientifically religious. Unfortunately, positivism has established a pervasive social myth that religion is necessarily unscientific and thus authoritarian, mystical, or both. That is the case for postmodern religion, but it is also the case for postmodern science. Positivism has established a context in which prejudicial stereotyping prevents us from distinguishing between a scientific rationalism dedicated to an ontological optimism, and a scientific rationalism relegating us to an ontology of death.

A rational science is a science grounded in the personal. The cosmic person that provides the context of scientific and rational knowledge is referred to by a term obnoxious to the postmodern positivist: *God.* But that word—or Word—

establishes the pursuit of objective scientific and rational knowledge. If only contingent, utilitarian, or alchemical, such knowledge establishes and serves an ontological violence that destroys the very possibility of civilization. The alternatives to the contingent, utilitarian, and alchemical are historically recognized as the teleological and cosmological. They involve contemplation and knowledge of final causes, and ultimate enduring purpose.

We have seen that modernism-postmodernism, the Anglosphere, and the classical-Judeo-Christian traditions have long interacted within American and Western culture. Those interactions are neither syncretistic nor amenable to mutual tolerance. They cannot peacefully coexist or synthesize. Modernism-postmodernism conflicts with traditional classical-Judeo-Christian belief in a critical aspect. It denies the veracity of objective and purposeful reality; it rejects the notion of a rationally recognized and informed Being. Therefore it rejects the very possibility and existence of degrees of objective and intelligible quality in reality, life, scholarship, and art.

This book's narrative must affirm one view or the other—scholarly neutrality is intellectually and metaphysically impossible. This book can limit its imagination to violence, or it can rise to a scientific and rational pursuit of wisdom and beauty. To return to a earlier quote of Rieff: "There is no meta-culture, no neutral ground, from which the war [between these different perspectives] can be analyzed. . . . Anti-cultures translate no sacred order into social. . . . third worlds exist only as negations of sacred orders in seconds."[33]

There is no rational way to disagree with proponents of an anticulture culture, but to accept an anticulture as our culture is dangerous for all. The perennial insights of Plato and Isaiah on this matter are contemporized by the art and life of Solzhenitsyn:

> Why then have literature at all? After all, the writer is a teacher of the people; surely that's what we've always understood? And a greater writer—forgive me, perhaps I shouldn't say this, I'll lower my voice—a greater writer is, so to speak, a second government. That's why no regime anywhere has ever loved its great writers, only it minor ones.[34]

It is not that (Platonic and Augustinian) flashes of intuitive insight do not or ought not happen; at issue is whether such flashes of insight, the exercise of a suprarational imagination, are distinguishable from mere assertions of the will—whether sanitized by claims of Grace, genius, or pragmatic expediency. Such distinctions can only be recognized by their being subject to rational discourse

and qualitative evaluation. As such, the suprarational legitimatizes a culture based upon the free and responsible pursuit of wisdom. But if reason is redefined as rationalization or power, there is no way to distinguish between the subrational or irrational and the suprarational. There is no way to distinguish between the fool and the mystic, the transgressive sociopath and the freedom seeker, the demagogue and the scholar. There is no space between subject and object and thus no room for objectivity—or civil conversation—to occur. This results in a denial of reason in science, ethics, and art. When reason is no longer connected with reality, it is reduced merely to a product of the human mind or will. Reality is deemed irrational, our house of language has no foundation, and the profane is sacred.

Conclusion

THE PERSPECTIVE OF AN
OPTIMISTIC ONTOLOGY

L et us conclude by returning to the core concerns of this book: science, reason, and culture. We have seen that the interactions of the Anglosphere, the classical-Judeo-Christian, and modernist-postmodernist traditions inform the cultural conflicts of Western civilization since the Baroque period. In contrast to the scientism now dominant in cultural circles, the classical-Judeo-Christian mind holds that knowledge of the material and immanent is necessarily grounded in the teleologically and cosmologically transcendent. Scientific rationalism should seek some degree of knowledge of objective truth, or Being. We ought to believe in the attempt to understand what is true in reality.

What is the nature of reality and its relationship to our minds? Positivism presumes a pessimistic ontology in which knowledge is the willful and violent product of our minds and experiences. In contrast, the Platonic-Augustinian tradition considers knowledge to be found, not made. Rather than the willful product of our minds and experiences, scientific rationalism encounters an ontology of optimism and joy.

The nineteenth-century remnant of medieval Scholasticism vainly attempts to continue its traditions in the face of the onslaught of the empirical Scholasticism of modernity (e.g., Joseph de Maistre). In the twentieth century, the neo-Scholastic Thomism of Etienne Gilson, Jacques Maritain, and Thomas Molnar, there is an attempt to maintain philosophical realism as the proper perspective for science and knowledge. Others such as the non-traditionalist Teilhard de Chardin attempt to synthesize Scholasticism with the new scientific vision. These attempts

to respond to modernist European science have failed to establish a return to *scientia* and *sapientia*.[1]

Correspondingly, the Protestant pursuit of a modernist science while attempting to maintain devotion to a Christian perspective has proven problematic. Science becomes vital while faith becomes unchanging and dogmatic, or spiritualist. The desacralization of science leads first to a literalist/spiritualist approach to faith, and concludes in the pursuit of a secular utopianism.[2]

Within the classical tradition, the relationship of *what* and *why* refers to the relationship of material fact and Being. There is the realm of existing things (*Ta Onta*), composed of matter and fact informed with structure. But there is also the immaterial realm of a transcendent thing (*To On*), which provides the source for that structure and meaning. The unity of the two is grounded in reason being incarnate in matter as a matter of perfection (Aristotle) or a matter of degree (Plato). The Aristotelian understanding of a substantively rational reality and science must rest, however, upon a teleological ground.[3] Lacking that ground it devolves into conceptualism and (de)constructivism. Where, then, is wisdom to be found?

In seeking wisdom we attempt to rise from nominalist fact to structured fact, and ultimately strive to obtain a glimpse of the source suggested by but not limited to those structures: the objective *why,* or *reason*, or *Being* itself. The self-conscious mind, seeking knowledge of the intelligible ground of Being, justifies a scientific rationalism dedicated to the free and responsible pursuit of wisdom. That pursuit promises partial but not complete closure. Ideological nihilism and totalitarianism are denied.

The prosaic analogy is that of the chef who cooks superbly without recipes, an ability that can only be obtained by first learning them. The chef is not sub- but suprarational. That the chef cooks superbly is not to be understood just as a matter of taste, but more importantly as a matter of whether the food is true and good, whether it is wholesome. As a matter of taste, the Finn may not like curry, the Chinese may not like cheese. Beyond such trivial differences of taste, substantive qualitative differences remain. Although the transgressive chef might have a twisted skill in making poisonous food attractive, the quality of poisonous food is not a matter of taste, but of ontological knowledge.

So neither the fool nor the chef follow recipes in the kitchen, but the qualitative difference between the two is that the genuine chef is substantively decorous. Aquinas observes that taste, touch, and smell are noncognitive (conversely, sight and hearing are cognitive); his Oedipal intellectual successor, Kant, concludes that knowledge is noncognitive and yet taste is universal. But if knowledge is non-

cognitive, and taste universal, then how can a scientific rationalism result? If there is no scientific rationalism, then how can culture be realized? How can the culture affirming qualitative progression from the subrational to the suprarational occur?

Modernist notions of scientific and rational objectivity, of genius, of a subjective objectivity, have been denied by postmodernists, and by wisdom-seeking traditions. Both suggest that the cure for (de)constructivism is authenticity, and key to authenticity is the issue of identity. But existentialist identity cannot escape a subrational conclusion. It remains limited by its perspective, by its myth. That myth is one of violence.

For Aristotle, Aquinas, and Heidegger, identity is the alternative to subjectivism and mere rationalization. Knowledge by identity is the sum total of the self-aware act. But for the existentialist, it is the intellectual content resulting from facticity. This results in a *methodological atheism* in which a scientific rationalism no longer obtains. It requires science and philosophy (the love of wisdom) to be subrational and distinct, even if we choose to believe them to be rational and complementary. As a matter of identity we cannot understand *why* but can experience *what*; however, we choose what we pay attention to—without any meaningful ways of making such choices. As Ludwig Wittgenstein noted, such identity not only methodologically demands atheism, it demands nonsense. Wittgenstein states: "'A thing is identical with itself.'—There is no finer example of a useless proposition."[4] This methodology requires that science and culture be subrational. For Aristotle, scientific rationalism enjoyed an ontological ground, but not for Kant or Heidegger. Heidegger views Aristotle's rationality and facticity as completely profane, and a profane rationality cannot be grounded in intelligible reality.

Eric Voegelin was a major critic of modernist scientism and postmodernist nihilism. Disturbed by the brutalization of culture, he attempted to reestablish the metaphysical tradition of the West. He does so via two primary routes: Aristotelianism and Augustinianism. Voegelin maintains that the Aristotelian understanding of political science, of *episteme politike*, is key to the task. He argues that whereas the positivist and Newtonian redefinition of science requires that political science begin with a *tabula rasa,* political science must actually begin, as Aristotle argued, within lived human experience. Cultural symbols are grounded not just in the human mind, but in lived reality. So political science begins in self-interpretation. To this point, via Augustine, he adds a vital adjustment: that our understanding of reality and life is psychological and experiential; our knowledge involves the will. So neither Aristotelian claims of scientific impartiality, nor the impartiality claims of Newton (concerning facts) and Kant (concerning reason), make sense. The will is a component of knowledge.

What is problematic, however, is that Voegelin's work—and Heidegger's—emphasize knowledge and a metaphysics based upon experience. In this regard they remain within the Aristotelian model. They differ in that Voegelin believes also in the transcendent objectivity of Truth and Heidegger does not. One believes that happiness is something to find, the other, that it is something to be. That choice between seeking to have and striving to be applies to science and culture writ large. *What is lacking in either, however, is the Platonic and Augustinian idea of a scientific-rationalism in pursuit of degrees of qualitative knowledge.* They both lack the notion of an Incarnational illumination, some degree of the material realization of the transcendent ideal.

The facticity of Augustine maintains that happiness is grounded in authenticity, but that authenticity in turn is grounded in objective wisdom or God. Augustine speaks of happiness, or *beatitudo,* as a state of being *and* a state of having. We are happy only when we know, love, and have what is good.[5] For this, Heidegger took him to task as inauthentic, but to an Augustinian, Heidegger is falsely limiting. To have happiness—or knowledge—one must first find them; to find them, they must objectively exist. Happiness and knowledge involve more than authenticity; they involve realizing some degree of transcendence.

In a Cartesian mode, Voegelin affirms the importance of experiencing the transcendent, but considers it dangerous to immanentize the eschaton. It is dangerous to pursue an earthly utopianism. There is, then, a material/spiritual cleavage in his perspective. The problem is that an optimistic ontology is dedicated to just such a task. To deny it is to deny the scientific and rational model of the Incarnation. A material immanentizing of the transcendent is the practical task of seeking wisdom, of sapientia.

The alternative to a brutal secularizing of science and faith is not found in a violent self-deification. Nor is it found in a denial of an ontologically optimistic science and culture. Historically, the commitment to realize some degree of goodness in the world, while avoiding self-righteous folly, is realized by maintaining the uniqueness of the Incarnation as the only realization of perfection in the fallen world. The Incarnation limits our arrogance while legitimitizing our free pursuit of wisdom. Recognizing that the largely ineffable transcendent makes prudence a virtue is a precious cultural value. When science is informed by the liberal arts, then the trivialization and brutalization of culture is no longer. Scientific rationality in the practical pursuit of wisdom means that the liberal arts make possible a civilized scientific rationalism. It makes possible faith in truth, goodness, and beauty.

The Illumination Theory of Science, Reason, and Culture

The attempt to deprive of privilege scientism is important since scientism is antithetical to civilization. To move forward, *scientia* and *sapientia* must be renewed. Appeals to experience and the moral imagination are inadequate since neither can provide a ground for knowledge. But the Platonic-Augustinian tradition offers a different, and more profound, perspective. If we can will to pursue an existentialist knowledge, can we not will to find purpose beyond mere existence, a purpose to love? Can we not passionately pursue a numinous wisdom?

Within the American context, these ideas are present in the writings of Peirce, especially in his notion of *agapism*. As Paul Conkin puts it:

> Peirce believed the final goal, or summum bonum, is loved, not because of a full intellectual grasp (indeed, this is impossible), but because of the power of sympathy, a sympathy in turn based on the ultimate unity of mind and the continuity of individual minds . . . In agapistic evolution, the final purpose is to embrace the good of all, or of a complete community. Such evolution conforms to cosmic or divine purpose and reflects God's love for His purposes. . . . God, once incarnate in a creation, needs man as the proper object of His love; and the proper instrument of His purposes . . . Through love, there is growth, for love, "recognizing germs of loveliness in the hateful, gradually warms it into life, and makes it lovely."
>
> True belief, in the pragmatic sense, involved feeling as well as intellect, volition as well as verbal symbols . . . [The supreme good] is an experience in which multiple and chaotic qualities are so realized and harmonized as to become one positive, simple, immediate quality. It is the icon of complete thirdness, or of being itself. [6]

Seeking liberation from the false constraints of positivism, Peirce pursues a variety of Augustinianism; in his attempt to reconcile becoming with Being, he is influenced not only by the Augustinian concept of evolution as the progressive unfolding of divine purpose in time, but also (and problematically) by Darwinism.[7] A practical pursuit of wisdom seeks to realize timely degrees of completion. That process is called *agapism*. But Augustinianism relies upon Trinitarian and Incarnational doctrines, which reconcile not only becoming with Being, but subject with object, sympathy with empathy. Sympathy permits us to recognize the other, whereas empathy demands unity by either destroying the self or the other.

The reconciliation of sympathy and empathy correlates with the scientific need to reconcile the particular with the universal. Trinitarianism solves this scientific problem by admitting the multiplicity and the unity of truth and in so doing provides a model for government (the federalist doctrine of *e pluribus unum*), culture, and marriage.[8]

Yet Peirce's sympathetic attempt to promote a meaningful scientific rationalism stumbles upon the problem of positivist empathy. Positivist methodology cannot be sympathetic since in the realm of knowledge it cannot recognize the gap between subject and object. It can only recognize the object without mind (scientism), or mind without object (mysticism). Neither empiricist nor mystic can admit a rational understanding of reality and life. As such, the practical pursuit of transcendent—that is, objective—ontological knowledge makes no sense. Positivism traps Peirce in a circular argument that denies the possibility of practical wisdom. Peirce maintains that multiplicity seeks unity, but that unity is real because it is sought. Unconvincing echoes of Anselm's and Kant's arguments for the existence of God can be heard, but the sad result remains. There is a circularity to each of these arguments that is not scientifically rational. That circularity can be escaped via a recommitment to the Incarnational pursuit of wisdom unencumbered by empirical-mystical limitations.

So where does that leave us? The perennial problem of culture and its relationship with scientific rationalism is today viewed from a postmodern historicist perspective. It is tacitly assumed that valid scientific knowledge is grounded in the empirical moment. It is grounded in temporal physics devoid of metaphysics. But as Kuhn and Eliade confirm, the historical record makes clear the metaphysical shifts concerning the nature of science and reason. The *empirically perceived* earth-centered universe of Aristotle and Ptolemy was found to be egocentric, geocentric, and scientifically inadequate. It was replaced by the *empirically perceived* sun-centered universe of Copernicus, Newton, and Descartes. That heliocentric and deistic universe was then found to be inadequate, and was replaced by the *empirically perceived* uncentered universe of Einstein. It is here that a newly farcical eternal return occurs. In replacing the egocentric universe of Aristotle and Ptolemy with the postmodernist universe, a *de facto* egocentric one results. That postmodern egocentric universe (or, rather, di- or multiverse) is one in which we (de)construct or experience our universes. They are deemed sacred since we determine our place in space. We are world makers. But that place has no ground, no lodestone; that place has no place. The sacred has been replaced by the profane, and the profane as sacred is, of course, empty. We are gods of utopia, gods of nothing.

As Thomas Kuhn makes clear, it is folly to assume such changes to be over. Rather than be geocentric, heliocentric, a-centric, or egocentric (all empirically grounded perspectively), is not a scientific rationalism necessarily Logocentric? In the fourth century A.D., St. Ambrose, the great teacher of Augustine, addressed the nature of science:

> Many say that the earth is in the midst of the air, and that it remains immobile because of its own weight, seeing that it exerts an equal pressure in this direction and in that. On that point we think that enough was said by the Lord to his servant Job, when he spake from the cloud and said: "Where wast thou when I laid the foundations of the earth? . . . Did not then God manifestly declare that all things are established by his majesty in number, weight, and measure? For the creature did not assign law, but accepted it, and accepting it, maintains it. It is not, therefore, that the earth is in the centre of things because hung there by 'equilibrium,' but because the Majesty of God constrains it by the law of his own will."[9]

Were not Anaxagoras, Plato, Aristotle, Ambrose, and Augustine clear in what is necessary for persons, rational beings, to recognize? None can doubt that we think and live. Self-conscious beings need to attempt to understand objective reality. To paraphrase Pascal, in theology *and* science, should we fail, then nothing is lost; should we succeed, then all is gained. Therefore, we can proceed in the hope that we can progressively better understand—not feel or (de)construct—reality and life. If the world is logocentric then via the conscious pursuit of completion, via *agapism* free from the constrictions of positivism, science can again aspire to knowledge of reality. Informed by why (by intelligibility), by what (by material fact), and by how (by purposeful process), we can enjoy knowledge enough for human freedom and responsibility.

The relationship of idea, matter, and process is central to the pursuit of scientific and rational knowledge. That relationship resonates with the relationship of mind, body, and will. Contemplation of that relationship was historically pursued via contemplation of the nature of the Trinity. Dante understood gravity to be evidence of God's love, Edwards understood gravity to be evidence of God's will, Newton saw gravity to be evidence of God's work, and Hume saw gravity as having no explanation.

Edwards concludes that gravity is evidence of an infinite will of God within an infinite universe. Edwards's position arguably concludes in an empathetic pantheism. But more than will, it might also evidence the mind of God (or objective

Truth). The will and mind of God need not be associated with pantheism so long as the world is viewed as finite and created rather than infinite (and an emanation). That which is made is not identical with the maker; that which is known is not identical with the knower. It can also be sympathetic. A sympathetic approach to Truth permits us to reach for the universal for an empathetic unity with the divine without the folly of completely succeeding. Why folly? Because the human mind contemplates the infinite via the finite but cannot itself be infinite because it can never know what it does not know. To think otherwise is not only folly but dangerous hubris. It denies responsible freedom and love. The perennial result of hubris is nemesis.

So avoiding hubris, or pride, is key to restoring the practical pursuit of wisdom. If reality conforms to our wills and minds, then the result is scientific and cultural barbarism. Should our wills and minds conform to meaningful, intelligible completion, then the result is scientific and cultural understanding. The choice is whether our wills and minds are transgressive of wisdom, or transgressive of ignorance and folly. The desire to (de)construct knowledge denotes a willful violence in which we live in an empty space. The desire to know denotes a rational optimism, a restoration of the sacred place.

Derrida's rejection of logocentrism argues that it is logophallic, and that the best philosopher must be a woman because the best philosophy transgressively destroys itself. The goal of philosophy is to destroy philosophy and hence achieve freedom and authenticity. But as Anglosphere classicist Iris Murdock objectively and personally evidences (as does Hannah Arendt, and many others), the assumption that philosophy is logocentric does not require that it be phallic or oppressive. The positivist destruction of culture, Murdock demonstrates, is no liberation.[10]

We rightly can seek to have knowledge, and to be wise. That existential expectation of *having* knowledge legitimizes the existential act of *seeking* it. We can seek illumination. Augustine discusses what is now known as the Doctrine of Illumination:

> There exists an immutable truth, containing within itself all these things that are immutably true, which you cannot call yours or mine or any man's, but which is rather present and offers itself in common in ways that are wonderful as a private and public light to all those who behold immutable truths. Now who will say that whatever is present in common to all who reason and understand is part of the individual nature of any one of them? . . . If this truth were equal to our minds it too would be mutable. For our minds sometimes see more and sometimes less, and by this they show that they are

mutable. On the other hand, this truth, abiding in itself, neither progresses when we see more, nor loses ground when we see less; rather, remaining whole and uncorrupted, to those who turn to it it gives joy by its light, and those who are turned away it punishes with blindness. Therefore, if truth is neither inferior to our minds, nor equal to them, it must be superior and more excellent.[11]

The shift from a geocentric to a heliocentric universe put into question an already afflicted Scholastic *scientia*, but it also continues to question assertions of scientific arrogance. To claim the end of science (or the end of history, or of art) is to deny historical reality. To claim the perpetual authority of scientism and positivism is untenable and itself reactionary.

For the Augustinian, what is lacking is an effective advocacy of *doxa*, of *Ta onta*, of *scientia* and *sapientia*. What is lacking is knowledge of a continuum from material fact to Divine Wisdom. Lacking is the combination to some precious degree of *having knowledge and being wise*. Proponents and detractors of the modernist-postmodernist collapse of Western civilization offer no defense of that type of pursuit of knowledge. They fail to recognize what Augustine did in *On Free Choice of the Will*. Written in the form of a dialogue, Augustine explains:

Evodius: I have now learned that it is one thing to be alive and quite another to know that one is alive.

Augustine: Which of these two things do you think is more excellent?

E: Why, clearly, the knowledge of life [*scientia vitae*].

A: Do you think that the knowledge of life is better than life itself? Or perhaps you understand that a certain higher and truer life consists in the knowledge of life, which no one can have except those who have understanding? For what is understanding except living more clearly and perfectly by the very light of the mind? Therefore, unless I am deceived, you have not set something else above life, but rather have set a better life above mere life.

E: You have understood and explained my view very well—provided knowledge can never be evil.

A: I judge that knowledge can in no way be evil unless we change the meaning of the word and confuse knowledge (scientia) *with experience* (experientia) [italics added].

And later in the dialogue:

A: Unless what we perceive by the bodily senses passes beyond the inner sense, we cannot arrive at knowledge [*scientia*]. Whatever we know, we grasp and hold to by reason.[12]

Augustine's (and Plato's) position is that for a scientific rationality to exist, objective Truth must exist; knowledge is then a form of remembrance. An *a posteriori* fact-based (de)constructivism denies knowledge by limiting it to expressions of willful violent experience. The solution to that violent ontology is to direct the will toward truth and love, thus affirming freedom in the pursuit of some glimpse of knowledge and wisdom. As explained by Robert E. Cushman:

> Augustine's undeviating conviction was that *fides* is the gateway to understanding . . . What is known cannot be divorced from what is loved. At the very minimum, all cognition is directly dependent on interest, and nothing is fully known to which the consent of the will has not been given . . . The completion of cognition lies with affection. Thus full cognition is *re-cognition.*
>
> Augustine held that in knowledge the cognitive faculty (ratio) "takes in," according to its power . . . but that being primarily passive or neutral, it is directed to "recognize" what it does recognize in virtue of the will or dominant affection of the mind. In Augustine it is the will, hardly the reason, which is corrupt; and faith is the means of cleansing the will. . . . [All] the certainties of the sciences . . . presuppose the *informing* of our minds by the Truth apprehended *a priori.* The invariability of the propositions of the sciences cannot derive from the variability of sensuous experience.[13]

The history of modernism begins with the rise of nominalism. That rise became prominent with Abelard, was addressed by Aquinas, and concluded with Kant and Nietzsche. In the West, each and all are opposed to the Augustinian illumination theory of knowledge. Aquinas objects to it by various means. He holds that any theory of illumination tends to destroy either the notion of nature or the supernaturality of Grace. These critiques rely upon a neo-Platonic interpretation of Augustine, one which is impossible to maintain fully given the centrality of the Doctrine of the Incarnation in that tradition which continues to develop to this day. Neo-Platonism despises the material world, whereas the Doctrine of the Incarnation celebrates the active restoration of the material realm to numinous splendor.

That active restoration can be approached via two qualitatively distinct fashions. It can reductionistically be viewed as naturalistic chance, necessity, or the

product of the will. Or it can be viewed as the progressive realization of ontological splendor. The latter is theologically understood as the workings of Grace. To assume that it is at odds with the naturalistic world is to tacitly assume that the naturalistic world is static or merely violent. It is to assume a naturalistic fundamentalism. The Augustinian tradition accepts the reality of nature and of Grace. It does so by not dichotomizing nature, process, and purpose. The scientific model provided by the Incarnation bridges naturalistic fact and divine meaning in a qualitative universe. The illumination theory of knowledge reveals glimpses of the suprarational ground of purposeful reality via its dependent, the rational realm of naturalism, which is made elementally manifest in the subrational realm of mere fact.

The theory takes for granted that the will is part of the pursuit of wisdom. Augustine's great contribution to world culture is in making just that point. We can will to seek wisdom, or will to do evil; or to put it in contemporary terms: we can be transgressive of ignorance and malevolence, or of claims of wisdom. However, in anticipation of Kant, Aquinas subtly shifts this argument. He argues that things are known by their stamp upon the knower, but the knower is not passive. The result is not a moral drama but rather a constructivist dilemma. As Gerard Smith, S.J., explains:

> Knowers react. They hit back. This hitting back . . . is an operation which is the knower's very own. It is his assertion, and precisely because every asser- tion is specified or is something asserted, therefore the peak of knowledge which is an assertion that the asserted exists in a way which is different from its-way-of-being-asserted, this peak of knowledge is reached by the knower alone. In other words, no factor except the knower alone is up to the job of creating his own knowledge.
>
> You can't help hearing, for example, B flat if B flat is sounded. The knower even causes, as an agent, the meaning of the assertion which he will make. But the specification of the assertion itself, which is the knower's operation alone, that specification comes into being only by way of being asserted by the knower, as when one says, "it is B flat."[14]

But there is an alternative to the limited choice between claims of impartial- ity and of "hitting back." Indeed, our view of our minds is not limited to a Lock- ean *tabula rasa,* a Kantian rationalization, or a Humean or Nietzschean bundle of experiences. We do not *assert* that "it is B flat." We recognize it, apply a label by which to recognize it, and learn further what it is and what it means. For Plato, we learn to hear the music of the spheres; for Christians, we learn to hear the *sym-*

phonia that constitutes the cosmos. Music is sacred when via a scientific rationality it sensually makes manifest the Logos of the world.

In his text *De Musica*, Augustine identifies music with more than emotion. Following Greek precedent, music is viewed as a liberal art. Good music is objective and intelligible, and once understood, promotes good ethics. It should do much more than merely please the senses or our vanity. Augustine distinguishes sound into six classes, ranging from the material and emotional to the intellectual and divine. It is divine music that our intellect attempts to grasp. Once grasped, once rightly learned, it is rightly enjoyed. As he puts it in *De Musica* 6:51: "I believe, the soul does not receive from the body, but receiving from God on high it rather impresses on the body." To put it differently, the mind does not (de)construct knowledge from material fact, but rather, recognizes it in sensual form.

In contrast, Aquinas posits that knowers understand through their souls; their souls understand through their intellects; their intellects through its acts; and the acts are understood through their objects. Kant follows by stating that all *human* knowledge originates in experience. *Tacitly denied is that there is knowledge that is not grounded in the human mind and act. Therefore there cannot be knowledge that is objective.* Aquinas and Kant hold music to be that which the human mind and will actively produce. Therefore, truth is significantly the construct of our minds and experiences. In contrast, for Augustine, music is that which with the gift of wisdom we are able to rightly discern and enjoy. Truth is the object of our minds. These represent very different approaches to music, science, and reason.

When we assert rightly, we rise from power to love. When we assert wrongly, it is ignorant, violent, or both. To be more precise, for Newton, B flat would be a particular mechanical wave resonance; for Schoenberg, it would be part of an oppressive musical scale; and as Wittgenstein could persuasively note, such identification would indeed be arbitrary. There can be musical traditions that do not recognize the existence of B flat. But the cosmopolitan point is that if the universe is a cosmos, then musical traditions that cannot qualitatively distinguish between rational sound and sheer cacophony cannot be taken seriously. Such distinctions are grounded in some degree of knowledge of Being, the rejection of which is the rejection of scientific rationalism.

An Optimistic Realism: Incarnational Civilization

This brings us to the final point of this book. Civilization cannot be recognized without the possibility of our understanding and embracing an optimistic realism.

That optimistic realism assumes the intelligibility of science and culture; it assumes that reason has something to understand, and that it is the nature of humanity as rational persons to seek such understanding. The relationship of knowledge of nature, and the nature of humanity in seeking knowledge, is explained by Edward Kennard Rand: "The definitions of nature and of person given by [Boethius around A.D. 512] became classical and were constantly appealed to by the School-men; "Nature," according to Boethius, is the specific difference that gives form to anything; "Person" is the individual substance of a rational nature."[15]

So human beings are persons who seek knowledge of the decorous in nature and in life. An historical perspective puts this into meaningful context. During the Gothic period the idea of an *ars nova* developed. Literally, *new techniques*, the term refers to the beginnings of a fundamental shift in Western culture. Previously, pagan and Christian Neo-Platonism deemphasized the importance of the material realm. In contrast, the Gothic celebrates the unity of matter and idea. It is deeply Incarnation and numinous in its worldview. However, the cultural dynamic did not stop with a balance of matter and idea. Due to a new Aristotelian influence, its trajectory was from the Incarnational to the merely pleasurable. As George Duby explains:

> What began to be called devotio moderna toward 1380 was the new way of approaching God. But the freedom such modernism involved . . . remained basically operative a the level of the ecclesiastical officials . . . As cultural life became more popular in the fourteenth century it entailed an emanici-pation from the clergy. And art—which is how it became modern—ceased, at that major turning point in material and spiritual history, primarily being a vehicle for what was sacred. Henceforth it looked toward men, toward more and more men, like the call or the reminiscence of pleasure.[16]

That shift from a Gothic numinous splendor to a Modernist focus on mate-rial pleasure is brought home by returning to Edward Hicks's *Peaceable Kingdom*. That painting permits us to consider fully the Trinitarian and Incarnational model of scientific rationalism traditional to Western culture. That intellectual model perennially exists regardless of how one feels personally about those doctrines.

Peaceable Kingdom raises the question: Where is it? Where do we find a world informed by wisdom and beauty? The search for a peaceable kingdom is a search for what Sir Thomas More called utopia, a Greek pun (*ou-topos* [no place], *eu-topos* [good place]) suggesting that such a good place is also no place. Earthly attempts at utopianism inform later attempts to find a positivist paradise; unfortunately,

they have all concluded in terror. In contrast, Hicks apparently thought it could be found in Pennsylvania, and no doubt he was partially right. The answer is found in an earthly paradise that is not (as postmodernist traditions hold) materialistic and willful. It is materialistic and decorous. It is where the world is as it ought to be.

This leads us to consider an optimistic scientific rationality dedicated to producing a world freed from affliction. The Doctrine of the Incarnation holds that Christ bodily rose from the dead (similarly, the Book of Revelations holds the bodily resurrection of the dead at the end of time, the eschaton). The often neglected question is: *Where is the resurrected body of Christ?* Deism, with its intrinsic empiricist and mystic perspective, causes us to vaguely respond: in heaven. But is the dichotomy of heaven and earth, of the ideal and the material, orthodox eschatology? Certainly not.

The Doctrines of the Incarnation and Resurrection maintain the ultimate material realization and transformation of the world. It posits a scientific rationalism that is numinous. It is not a Cartesian dualism of heaven and earth, a Newtonian void and matter nor a product of our minds and wills. The world is rightly a numinous paradise, is now qualitatively debased, but can be qualitatively restored via a numinous, decorous, and personal scientific rationalism. Numinous life triumphs over death. That triumph cannot just be spiritual, nor can it just be material; it is rightly materially decorous. The world is rightly the aesthetic face of Being so, too, is genuine scientific rationality. The world, once sacred, became debased by ignorance and willful arrogance. But we can now enjoy sacred places in which goodness and beauty thrive. We can have degrees of culture in an otherwise barbaric context. Optimism is realistic; pessimism is error or folly. We presently aspire to escape the confusion and conflicts of particularity to enjoy not a panthetistic unity with divinity, but unity via the analogic. We imitate goodness to be free from evil.

Both Voegelin and Molnar emphasize that the danger of seeking to realize the decorous in history is pride. Utopians who in the name of good will and good intentions attempt to purify the world instead wreak havoc on the world. But a violent utopianism arises only when a transcendental fulfillment is pridefully immanentized. For Hicks (and distant predecessors such as Joachim of Fiore), seeking an earthly utopia is no fallacy. How is a benevolent utopianism to be recognized and realized? By neither playing nor denying Truth or God. A scientific rationality informed by the liberal arts permits us to distance ourselves from the dangerous pride of worldmaking. When science and rationality serve until the end of time in the self-conscious pursuit of degrees of wisdom, we live in a culture of cautious responsible freedom.

Arrogant pride stands in the way of genuine progress. Scholarship is a self-conscious activity, but as Augustine makes clear, self-consciousness necessitates more than a subject. Self-consciousness posits an object of knowledge and of love. Lacking such an object, scholarship as critical analysis cannot survive. Scholarship becomes the product of the immanent will, a will that is inclined to "hit back" at the knower. Consequently, science and culture are reduced and limited to entertainment, therapy, or propaganda, each centering on pleasing—and destroying—the ego.

Subjectivity, so crucial to postmodernist thinking, is claimed to be the key to freedom and critical thinking; therefore, the purpose of scholarship is to be subversive of culture and knowledge. But subjectivity denies the possibility of critical thinking. It is dogmatically anti-intellectual and anticultural. The assumption that Truth exists provides us with hope that we might one day understand it. That hope provides justification for scientific rationalism prevailing once more over a violent Promethean technology and a wide panoply of brutal fundamentalist claims of authenticity. Hope permits us to escape the ontological violence of postmodernity, falsely justified by the positivist scientific paradigm.

We began with a comparison of the American and French Revolutions. The American Revolution was grounded in Anglosphere tradition. It takes for granted the responsible pursuit of freedom. It methodologically accepts a scientific rationalism dedicated to the pursuit of truth, goodness, and beauty. It is decorous in its affirmation of the importance of virtuous freedom. In contrast, the French Revolution was dedicated to liberty and equality. It rejects the Incarnational civilization of its Gothic past, a civilization deeply harmed by claims of an Aristotelian justified aristocracy newly dedicated to pleasure. In both French and German modes, modernist methodology accepts a scientific rationalism dedicated to the pursuit of facts, rationalization, authenticity, and aesthetics. It is indecorous in its incoherent demand that freedom and equality, tolerance and authenticity, can concurrently be sought. It concludes in nihilism and totalitarianism, relegating us to a technologically sophisticated barbarism.

The concurrent pursuit of freedom and equality destroys responsible freedom by its assumption of a quantitative rather than qualitative world. The denial of qualitative knowledge takes for granted that there is no scientific and rational foundation to prefer a culture of responsible freedom over one dedicated to liberty and equality. Therefore, to champion Anglo-American exceptionalism over European exceptionalism is deemed xenophobic or worse. But this transgressive framing of the debate cuts two ways: if we cannot rightly privilege one perspective over others, then there is no need to justify preferring any cultural perspective, even those most brutal and horrible.

So the choice is more than one between Anglo-American and European continental philosophies. It is a foundational choice between two incompatible visions of human nature and society. It marks a choice that is universally appropriate. The free and responsible pursuit of wisdom and beauty is central to the Anglo-American vision. But it is not ethnically, racially, or geographically limited. Rather, it reflects the impulse behind all traditions around the world that pursue a wisdom-seeking scientific rationalism as the best hope to escape barbarism.

The liberal arts are the arts of the free mind, of the human logos seeking truth; the liberal arts cannot exist in a positivist environment. Indeed, an existentialist liberal arts makes no sense. As noted earlier, Augustine concludes: "I judge that knowledge can in no way be evil unless we change the meaning of the word and confuse knowledge (*scientia*) with experience (*experientia*)."[17]

It is time to transcend the nihilistic cultural consequences of the modernist-postmodernist redefinition of scientific rationalism. It is time to renew the free and responsible pursuit of universal ontological wisdom, made manifest via a variety of perspectives *united by that goal. E pluribus unum*—out of many, one—is more than a political slogan. In science and culture it reflects the integrity of the particular without denying the possibility of a lofty unity. It is mistaken to understand this position from the perspective of modernism-postmodernism. To do so is to deny it by claiming it useless or complete.

A purposeful scientific rationalism is the pluralistic and temporal pursuit of objective and eternal wisdom. It is not multicultural, but it is cosmopolitan. It is not superstitious, but it is Incarnational. It affirms a universal dedication to the timely pursuit of eternal wisdom and beauty. It is the perennial alternative to nihilism and totalitarianism. While this methodology is temporally meaningful, it is not yet complete. To the degree it moves to completion, however, it is decorous and splendid. This splendor beautifully affirms the freedom necessary to the very nature of truth and love. We are offered a glimpse of a peaceable and glorious kingdom yet again. It is realistic to seek this kingdom. Now is the time to rededicate ourselves to that optimistic ontology.

NOTES

Preface

1. This redefinition of reason as feeling and power is found in David Hume, *A Treatise of Human Nature* (1740), and is foundational to the entire Hegelian-Marxist master-slave dialectic.

2. A valuable discussion of reason in the context of justice is found in Alasdair MacIntyre, *Whose Justice? Which Rationality?* (South Bend: Notre Dame Press, 1988).

3. That is, science and reason are denied the possibility of love and thus condemned to a narrative of power and violence.

4. As discussed in Pontynen, *For the Love of Beauty: Art, History, and the Moral Foundations of Aesthetic Judgment* (New Brunswick: Transaction Publishers, 2006), the modernist-postmodernist tradition is an extension of Scholasticism with one important difference: whereas Scholasticism works from the assumption that the world ultimately makes sense, the modernist-postmodernist assumes the world does not.

5. This problem is discussed in Sara Joan Miles, "From Being to Becoming: Science and Theology in the Eighteenth Century," *Perspectives on Science and Christian Faith*, vol. 43 (December, 1991).

6. Positivist science redefines science as the pursuit of empirical fact; as such it cannot scientifically know that the universe is meaningless. Nonetheless, it cannot avoid that metaphysical position. So just as the positivist can demand factual proof of the existence of purpose or God (or Logos, Dharma, Form, etc.), the metaphysical traditions can equally demand factual proof of the nonexistence of purpose or God—which of course cannot be provided.

7. As discussed below, the notion of qualitative phenomenological research such as that advocated by Adorno makes no sense and is simply an extension of Kant's synthetic a priori and transcendent aesthetic.

Chapter 1: Science and Reason in the Pursuit of Truth, Goodness, and Beauty—or Power

1. This idea was revived in science by Thomas Kuhn, *The Structure of Scientific Revolutions* (Chicago: University of Chicago Press, 1970). In a cultural context, see Philip Rieff, *My Life among the Deathworks* (Charlottesville: University of Virginia Press, 2006).

2. That term was introduced in Arthur Pontynen, "A Winter Landscape: Reflections on the Theory and Practice of Art History," *Art Bulletin*, vol. LXVIII, no. 3 (September, 1986), 467–79.

3. For a discussion, see Joseph Ratzinger, *Introduction to Christianity*, translated by J. R. Foster (New York: Herder and Herder, 1970), 31ff.

4. Ibid., 31. "Against the scholastic equation 'Verum est ens' ('Being is truth') [Vico] advances his own formula, 'Verum quia factum.' That is to say, all that we can truly know is what we have made ourselves." The goal of our scholarship and theology is becoming, it is to assert *being there* (dasein). In contrast to Augustine's affirmation of change, of evolution, in the presence of ontological purpose, of Being, we are now secular and sacred evolutionists seeking purposeless change within a willful and violent becoming.

5. The modernist Kantian position that a deontological reason provides a foundation for morality via the Categorical Imperative is here disputed. When morality is grounded ultimately in a rationalized good will—as claims Kant—then morality is reduced to a solipsistic incoherency. Furthermore, even if Kant's position is accepted, his position provides no purpose or inspiration to life, nor any consequences. Kant's advocacy of the good will parallels an advocacy of aesthetic good taste—neither of which makes rational or scientific sense.

6. See Alasdair MacInytre, *After Virtue* (South Bend: University of Notre Dame Press, 1981).

7. This point is central to Alasdair McIntyre, *After Virtue*.

8. John Milbank, *Theology and Social Theory: Beyond Secular Reason* (Oxford: Blackwell Publishers, 1993).

9. Ibid. Milbank discusses this in a chapter titled "Ontological Violence or the Postmodern Problematic."

10. However, as discussed below, Heidegger follows the redefinition of Being as *us becoming*, a redefinition that concludes in an anticulture of death. This text follows the traditional classical Judeo-Christian understanding of reality consisting of a qualitative continuum from mere fact and becoming to a material manifestation of truth, which in turn is grounded in transcendent Truth or Being.

11. The antinomy of modernist tolerance and postmodernist authenticity is discussed in Arthur Pontynen, *For the Love of Beauty: Art, History, and the Moral Foundation of Aesthetic Judgment* (New Brunswick: Transaction Publishers, 2006), 14ff.

12. On this, Plato, Aristotle, Anaxagoras, Shakyamuni, Confucius, and Lao-Tzu (to name but a few) all concur, but differently.

13. See Karl Popper, *The Open Society and its Enemies*, vols. 1, 2 (Princeton: Princeton University Press, 1971).

14. So we have advocates of the end of science, of history, and of art.

15. Averroes, a Spanish Muslim born in a.d. 1126 in Cordova, was deeply influenced by the works of Aristotle, and is credited with being instrumental in reintroducing those works to the Medieval West. Averroes argued for the separation of rationality and natural science from religion in the attempt to restore the prominence of revelation devoid of intellectual disputes. But in so doing, he separated religion from science and thus paved the way for the separation of science from religion latent in Medieval Scholasticism and blatant since the Baroque.

16. It primarily pursues an Aristotelian paradigm newly devoid of final causes and an unmoved mover.

17. As Augustine and Luther noted, freedom is intrinsic to humans as rational beings, and freedom of conscience ought not be denied. But both recognize also that freedom (or creativity) is the problem, truth is the solution. Without truth, freedom is pointless and thus condemns us to folly or despair. In opposition to truth, freedom is destructive. By imitating truth, we beatifically solve the problem of misused freedom.

Chapter 2: The Puritan Dilemma—and Ours

1. For a discussion of the Anglosphere, see James C. Bennett, *The Anglosphere Challenge* (Lanham, MD: Rowman & Littlefield Publishers, Inc., 2004); and Andrew Roberts, *A History of the English Speaking Peoples since 1900* (New York: Harper Collins, 2007).

2. This was early recognized by scholarly figures such as Ananda Coomaraswamy, who dedicated his career at the Museum of Fine Arts, Boston, to a refutation of modernist hegemony. See Ananda Coomaraswamy, *Christian and Oriental Philosophy of Art* (New York: Dover Publications, 1956). Coomaraswamy advocated a postcolonial scholarship, but oddly did so by embracing a specifically Western postmodernist mode of interpretation. Methodologically, postcolonial scholarship is intrinsically postmodernist and thus colonial.

3. Heidegger and others also, and problematically, redefine Being as us becoming, as the fact of our existence. See Martin Heidegger, *Sein und Zeit* (1927).

4. Freud's famous rejection of culture and religion are to the point. See *Civilization and Its Discontents* (1929).

5. The Biblical admonition to keep the Sabbath holy, and reserved for the contemplation of truth, is found in *Exodus* 20:11. For a discussion of the classical context, see Josef Pieper, *Leisure: The Basis of Culture* (Indianapolis: Liberty Fund, 1999 [1952]). Re-creation has been replaced by a pointless recreation.

6. Jacques Derrida presents a postmodernist interpretation of these issues. That is, rational responsibility does not liberate us from violence, the "orgiastic," or death, but rather suppresses the former and celebrates the latter. He holds that within a Christian context the simultaneous demand for responsibility—without granting the full knowledge (which would be a full knowledge of God) that makes such responsibility possible—is untenable. Therefore, death is the gift that permits ethics. His Gnostic understanding of Christianity denies the central role of the Incarnation in Western ethics and culture, a life-affirming culture that historically celebrates an ethics and culture centered on responsible freedom. Jacques Derrida, *The Gift of Death*, translated by David Wills (Chicago: University of Chicago Press, 1995).

7. Nietzsche bitterly recognizes in *The Genealogy of Morals* (1887) that Grace is the stroke of genius called Christianity, a stroke that reconciles debtor with creditor, freedom with

responsibility. For Nietzsche it is a stroke that results in the destruction of justice; for traditional Western culture, justice without charity is merely revenge and thus a manifestation of a deontological pagan violence.

8. Immanuel Kant, *Anthropology from a Pragmatic Point of View* (1798).

9. For a discussion, see Arthur Pontynen, "The Aesthetics of Race, the Beauty of Humanity," *American Outlook Magazine* (2002), 34–37.

10. Or by historicism of any sort. The Hegelian-Marxist attempt to ground good in a historicist self-expression and self-realization is critically analyzed by Karl Popper, *The Open Society and Its Enemies* (Princeton: Princeton University Press, 1971). He states pointedly (pages 279–80) that historicism is the enemy of responsible freedom.

11. For a discussion of Peirce's critique of positivist metaphysics, see Philip P. Wiener, ed., *Values in a Universe of Chance: Selected Writings of Charles S. Peirce* (Garden City: Doubleday Books, 1958), 140. We will return to this topic later.

12. For example, a discussion of the methodological problems resulting from a positivist study of Daoism is found in Arthur Pontynen, *For the Love of Beauty: Art, History, and the Moral Foundations of Aesthetic Judgment* (New Brunswick: Transaction Publishers, 2006), preface.

13. Edwards strove to maintain a Trinitarian orthodox Christianity including its doctrine of original sin. In his *Critique of Judgement*, sections 86 and 87, Kant asserts that it is the good will of humanity that provides a moral context to the universe, and he unconvincingly concludes that the duty to be moral establishes the existence of God.

14. Hegel and Marx make the state truth incarnate, whereas some Scholastics may well have employed the Church for the same purpose. Both result in the dangerous folly of what Eric Voegelin would call the *immanentizing of the transcendent*. Another option will be presented in our conclusion.

15. See Thomas Molnar, *Utopianism: The Perennial Heresy* (Lanham, MD: University Press of America, 1990).

16. Philip Rieff, *My Life among the Deathworks* (Charlottesville: University of Virginia Press, 2006), 1.

Chapter 3: Quantitative vs. Qualitative Perspectives of Science, Reason, and Culture

1. More recently released as Erwin Panofsky, *Perspective as Symbolic Form*, translated by Christopher S. Wood (New York: Zone Books, 1997).

2. Philip Rieff, *My Life among the Deathworks: Illustrations of the Aesthetics of Authority* (Charlottesville: University of Virginia Press, 2006), 5–6.

3. Wayne Craven, *American Art* (Boston: McGraw-Hill, 2003), 143. The painting is a portrait of Bishop Bossuet.

4. Barry Bergdoll, *European Architecture 1750–1890* (Oxford: Oxford University Press, 2000), 30.

5. Wolfgang Herrmann, *Laugier and Eighteenth Century French Theory* (London: A. Zwemmer Ltd. 1962), 38.

6. The association of Puritan scholarship with mystical emotionalism will be discussed shortly in reference to the Reverend Ezra Stiles. For a discussion of Pascal's role in the shift away from

ontological reason, please see Baruch Spinoza, *Principles of Cartesian Philosophy*, translated by Harry E. Wedeck (New York: Philosophical Library, 1961).

7. For some, this incoherent subjective-objectivity is easily glossed over. Herrmann writes, "Evidently this generation still belonged to an age for which the limitations imposed by a dogma of universal consent, because of the strength and support it provided, were preferable to the fascinating rewards to be gained through the complete emancipation of the individual." Herrmann, 40. As the Puritans recognized, the complete emancipation of the individual is only good if we are as perfect as God. Otherwise, it is rightly understood to be dangerous.

8. See Thomas Molnar, *God and Knowledge of Reality* (New Brunswick, NJ: Transaction Publishers, 1993).

9. Nonetheless, it should be noted that the Augustinian paradigm differs from the Aristotelian-Scholastic by its methodological focus on seeking degrees of objective wisdom rather than a conceptualist-constructivist complementarity of mind and matter. Via the Doctrine of the Incarnation, the Augustinian also avoids a neo-Platonist mysticism.

10. An example of postmodern Christian theology attempting to do so is found in, Jean-Luc Marion, *God Without Being*, Thomas A. Carlson, translator (Chicago: University of Chicago Press, 1995). He does so by privileging and reinterpreting the First Letter of John, 4:8, over Exodus, 3:14, by concluding that since love precedes knowledge truth is actually grounded in feeling. This reinterpretation requires a redefining of the Logos of John 1:1. However, to understand love as feeling is to deny understanding love as meaningful completion. It is to understand the text from a postmodernist rather than orthodox perspective. The attempt to escape a rigid neo-Scholasticism is admirable but this attempt to reduce our understanding of God to an experiential relationship concludes in a violent existentialism, and to be a Christian existentialist is to be an apostate. To argue that knowledge of God or Being requires limiting the Logos of God to the realm of fact, feeling, and rationalization is true only if we proceed from a post-Newtonian perspective. From an Augustinian perspective (a perspective shared by Abraham Lincoln), we do not limit God to fact, feeling, and human rationality, but use rationality in the attempt to gain some degree of meaningful completion, some glimpse of His Being, and thus attempt to achieve better but never totally complete wisdom.

11. Voltaire began his discussion of beauty with the question: "Ask a toad what beauty is, the *to kalon*?" Given his empiricist and positivist foundations, he then proceeds to reduce beauty to opinion and sentiment. See *Voltaire's Philosophical Dictionary*, H. I. Woolf, translator (New York: Alfred A. Knopf, 1924), 53.

12. Devotion House, Brookline Historical Society, Brookline, MA.

13. See Edwin Burtt, *The Metaphysical Foundations of Modern Physical Science* (Garden City: Doubleday Books, 1954).

14. Rembrandt's great yet tragic painting of the prodigal son comes to mind. See John Carroll, *The Wreck of Western Civilization* (Wilmington, DE: ISI Books, 2008), 102ff.

15. A God of Becoming (that is, a God without Being) is a central concern of postmodern theory. Conflating Being with becoming is to conflate reason with feeling, truth with willful power. This results in God as unpredictable cosmic tyrant, and the rejection of scientific rationalism, since predictability is necessary for both science and reason to be real. Aquinas rightly observed that intuitive reason is a type of feeling; the problem is one of distinguishing intuition from nonsense, the suprarational from the subrational. The traditional response

is that genuine intuitive insight can only be obtained by those who rise from ignorance to structural knowledge and from structural knowledge to wisdom. This is transubstantiation, not a denial of reason. As such there is much valuable knowledge to be sought and learned. Mundanely, by way of analogy, the chef does not rely upon recipes, but is distinguished from the bad cook by rising above—not against—those recipes.

16. The point is the difference between the positions of Augustine and Heidegger in the role of the subjective in the pursuit of knowledge. Augustine argues for the subjective seeking the objective and thus rising to a transcendental realm, whereas Heidegger assumes that the subjective is the objective, limited within a positivist willful existentialism. In agreement with Augustine's position, Rieff observes that what the reader agrees with, the reader becomes. As he puts it: "True readings are always self-readings or readings of self . . . The reader is inseparable from what is read . . . World words and world pictures always have ourselves in them."

17. See Thomas Molnar, *God and the Knowledge of Reality*.

18. This position is discussed and astonishingly praised in Jeffrey J. Kripal, "Brave New Worldview," *The Chronicle of Higher Education* (Dec 12, 2008).

19. James R. Newman, ed., *The World of Mathematics*, vol. 1 (New York: Simon and Schuster, 1956), 277. The quote is from Aldous Huxley.

20. One is reminded of Socrates' warning, here paraphrased by Babbitt: "We are told that the aim of Socrates in his training of the young was not to make them efficient, but to inspire them in reverence and restraint; for to make them efficient, said Socrates, without reverence and restraint, was simply to equip them with ampler means for harm." Irving Babbitt, *Literature and the American College: Essays in Defense of the Humanities* (Boston: Houghton-Mifflin & Co., 1908), 71.

21. See Montague Brown, *Restoration of Reason: The Eclipse and Recovery of Truth, Goodness, and Beauty* (Grand Rapids: Baker Academic, 2006), 66.

22. Irving Babbitt, *Rousseau and Romanticism* (New Brunswick, NJ: Transaction Publishers, 2004), 111.

23. Russell Kirk, *The Roots of American Order* (Wilmington, DE: ISI Books, 2003), 340ff.

24. Traditional theology also argues that such indecorous behavior is grounded in a willful resistance to reality. According to the pseudo-Dionysius Areopagite, sin is a willful resistance to reality. It is not just a deprivation of reality, but its perversion.

25. Étienne-Louis Boullée, "Architecture, Essay on Art," translated by Helen Rosenau, *Boullée and Visionary Architecture* (London: Academy Editions, 1976), 107.

26. Barry Bergdoll, *European Architecture 1750–1890* (Oxford: Oxford University Press, 2000), 86–88.

27. Roy W. Battenhouse, *Companion to the Study of Augustine* (Ada, MI: Baker Book House, 1979), 292.

28. Harry Francis Mallgrave, *Modern Architectural Theory: A Historical Survey, 1673–1968* (New York: Cambridge University Press, 2005), 5.

29. Wolfgang Herrmann, *The Theory of Claude Perrault*. (London: A. Zwemmer, 1973), 31 and 38. This is analogous to saying that bad doctors disprove medical science.

30. Claude Perrault, *Ordonnance for the Five Kinds of Columns After the Method of the Ancients*, trans. by Kagis McEwen (Santa Monica, CA: Getty Center, 1993). Quote is from the introduction by Alberto Pérez-Gómez, 3.

31. Herschell B. Chipp, *Theories of Modern Art* (Berkeley: University of California Press, 1984), 214.

32. Battenhouse, *Companion to the Study of Augustine*, 292ff.

33. "An author should never conceive himself as bringing into existence beauty or wisdom which did not exist before, but simply and solely as trying to embody in terms of his own art some reflection of eternal Beauty and Wisdom . . . And always, of every idea and of every method the Christian will ask not 'Is it mine?' but 'Is it good?'" C. S. Lewis, *Christianity and Literature: Essay Collection and Other Short Pieces*, Lesley Walmsley, ed. (London: Harper Collins, 2000), 416–18.

Chapter 4: Scientific Rationalism and the Problem of Nature

1. Nelson Goodman, *Ways of Worldmaking* (Indianapolis: Hackett Publishing Company, 1988), 18. As noted earlier, the Baroque scholar Giambastista Vico (1668–1744) marked the shift from Truth to Fact. *Factum* is that which is done, made, accomplished, and that which is manufactured is that which is manually done, made, accomplished. So the shift from truth to fact is a shift from truth found to facts made.

2. For example, an Augustinian understanding of evolution as grounded in seminal reasons (as discussed in his text *On the Trinity*), of change leading to the fulfillment of God's plan, differs fundamentally from Darwinian evolution, in which there is no ultimate purpose to realize.

3. Burtt, *The Metaphysical Foundations of Modern Physical Science*, 234.

4. Ibid., 208.

5. Ibid., 294. This Anglosphere focus on the will and process spans the ages from Pelagius to Darwin.

6. Paul K. Conkin, *Puritans and Pragmatists* (Waco: Baylor University Press, 2005), 51.

7. David Hume's assertion lacks merit: it is a fact that humans possess self-consciousness, therefore they ought not be denied freedom of conscience.

8. Burtt, 294.

9. Ibid., 259ff.

10. The attempt to absolve God of the responsibility for evil is part of the impulse behind romanticism, as discussed shortly. Interest in the problem of evil in modernist culture has recently been renewed. See, for example, Susan Neiman, *Evil in Modern Thought: An Alternative History of Philosophy* (Princeton: Princeton University Press, 2002).

11. Burtt, 238ff.

12. Ibid., 256ff.

13. This attempt to round the square within a deistic worldview is characteristic of numerous modernist-postmodernist oxymorons, such as transcendent-aesthetic, qualitative-phenomenology, synthetic a priori, and many more.

14. Burtt, 259–60. To equate the Doctrines of the Trinity, the Incarnation, and Transubstantiation with the "mystery" of Newton's deistic Christianity is to confuse a transcendent cosmology with self-contradictory folly. Transubstantiation marks the shift from material fact to intellectual meaning, a shift that demonstrably occurs in human consciousness but is difficult to explain.

15. This will further be discussed in reference to William James's incoherent notion of a pluralistic universe.

16. John Patrick Diggins, *Ronald Reagan: Fate, Freedom, and the Making of History* (New York: W. W. Norton and Company, 2007), 3.

17. Conkin, 45–47.

18. Ibid., 49ff.

19. Nietzsche cannot fully be called a nihilist because he believes in the will to power and authenticity. He is, however, an ontological nihilist in that he denies any objective meaning in reality and life beyond existence.

20. Toward the end of his career, the premier *American Pragmatist*, Richard Rorty, concluded that the ultimate purpose of philosophy is entertainment.

21. This cosmology is evidenced in architecture by the Pantheon.

22. A valuable discussion of Boethius and early Christian philosophy is found in Edward Kennard Rand, *Founders of the Middle Ages* (New York: Dover Publications, 1957), 150ff.

23. Aristotle, *On Parts of Animals*, 1.640b30–36.

24. See Kenneth Clark, *Civilisation* (New York: Harper, 1969), 52.

25. For a discussion, see Stuart Peterfreund, *William Blake in a Newtonian World: Essays on Literature as Art and Science* (Norman: University of Oklahoma Press, 1998).

26. Burtt, 293–95.

27. Ibid., 214ff.

28. Ibid.,128.

Chapter 5: Paradigm Shifts and Transcendent Choice

1. The positive affirmation that the pursuit of truth is possible and practical is central to the Western tradition, advocated by figures such as Socrates, Plato, and Augustine. It is also characteristic, albeit in a variety of forms, of a variety of traditions around the world and through time.

2. For a discussion, see Neiman, *Evil in Modern Thought*.

3. In *Principles of Art History* (1915), the neo-Kantian art historian Heinrich Wolfflin posited five pairs of stylistic composition informing all visual art.

4. A third option, pantheism, will be discussed in chapter below. A recent advocate of this position is James Lovelock, who proposed a Gaia Hypothesis in a series of books.

5. Conkin, 52.

6. Ibid., 72.

7. Karl Popper argues for Plato being an enemy of freedom because of his confidence in obtaining a final vision of the true, good, and beautiful. See Karl Popper, *The Open Society and Its Enemies* (Princeton: Princeton University Press, 1971). The present argument is that it is the perennial pursuit of the true, good, and beautiful that marks the crowning achievement of Western tradition. That perennial pursuit is grounded in Augustinian theology, where we seek a glimpse of an ultimately ineffable Truth or God.

8. The economic application of this analysis is found in Reuven and Gabrielle A. Brenner with Aaron Brown, *A World of Chance: Betting on Religion, Games, Wall Street* (Cambridge: Cambridge University Press, 2008).

9. Ernst Cassirer, *The Philosophy of the Enlightenment* (Boston: Beacon Press, 1955), 37.

10. Thomas Kuhn, *The Structure of Scientific Revolutions* (Chicago: University of Chicago Press, 1996), 92.

11. Ibid., 171.

12. See Daniel Henninger, "21st Century Art Makes Its Escape from the Toilet," *Wall Street Journal*, February 18, 2005.

13. In the modernist-postmodernist academy it is viewed as prejudicial and beyond scholarly discourse to consider that sexuality might be teleological or that a nonteleological view is filled with dangerous pitfalls.

14. For a discussion, see *Vladimir Florensky, The Aesthetic Fact of Being*, translated by Viktor Bychkov (Scarsdale: St. Vladimir's Seminary Press, 1993).

15. Alan Sokol, "Transgressing the Boundaries: Towards a Transformative Hermeneutics of Quantum Gravity." *Social Text*, Spring/Summer 1996.

16. For example, the photographer Andres Serrano, whose previous claim to fame was photographing a Crucifix in urine, currently exhibits pictures of human and animal feces.

17. It is important to recognize that Ptolemaic, Copernican, Newtonian, and Einsteinian cosmologies are all empirically evidenced; it is the selection and interpretation of that empirical evidence that differs. Therefore it is an act of foolish hubris to assume that current interpretations are necessarily permanent and as qualitatively profound as those of the past—or of those that will occur in the future.

Chapter 6: Qualitative Differences among Paradigms of Science, Ethics, and Art

1. Charles Harrison, Paul J. Wood, and Jason Gaiger, eds., *Art in Theory, 1648–1815: An Anthology of Changing Ideas* (Hoboken: Wiley Blackwell, 1991), 654ff.

2. Peter Singer, *Animal Liberation* (New York: Avon Books, 1975). To deny the qualitative distinction of human from animal is to deny the importance of sophisticated rationality.

3. Postmodernist identity incoherently can celebrate the authenticity of the powerful as well as the weak. As discussed below in the context of the Armory Show, it can celebrate cultural minorities or revile them.

4. See Gregory R. Beabout, "Liberty Is a Lady," *First Things* 46 (October 1994), 18ff.

5. As evidenced by Charles Ray, *Family Romance* (1993) exhibited at the Whitney Biennial Exhibition. The assault on the biological family is well documented. Marx, Foucault, and Brownmiller are major proponents of the postmodernist view. See also Christopher Lasch, *Haven in a Heartless World* (1995).

6. William MacDonald, *The Pantheon* (Cambridge: Harvard University Press, 1976), 88ff.

7. Ibid., 89.

8. Ibid., 88ff.

9. Burtt, 106.

10. Ibid.

11. Ibid.

12. David P. Handlin, *American Architecture* (London: Thames & Hudson, 2004), 54. One may also consider how strikingly similar to the cathedral is Latrobe's 1799 design for the Bank of Pennsylvania.

13. Rem B. Edwards, *A Return to Moral and Religious Philosophy in Early America* (Washington: University Press of America, 1982), 108.

14. Burtt, 294ff.

15. Ibid., 296.

16. Ibid., 297.

17. Ibid., 212. Newton's quote ("our business is with the causes of sensible effects") clearly echoes Aquinas's admonition that all knowledge is obtained via the senses.

18. Conkin, 63ff.

19. Cassirer, 161ff.

20. Romans 8:28.

21. Liebnitz coined this term, as Neiman discusses in *Evil in Modern Thought*, 18ff.

22. This marks a reversal of Wilhelm Worringer's 1914 advocacy of a new postmodern art history written from the viewpoint of aesthetics. He states that such an approach constitutes a paradigmatic shift in our understanding; we state here that this shift was disastrous to the fine arts and humanities. See Wilhelm Worringer, *Abstraction and Empathy* (Cleveland: Meridian Books, 1967).

23. Wilbur Fiske Gordy, *History of the United States* (New York: Charles Scribner's Sons, 1922), 270ff.

Chapter 7: From Neoclassicism to Romanticism

1. Hugh Honour, *Neoclassicism* (London: Penguin, 1991), 186.

2. See Irving Babbitt, *Rousseau and Romanticism* (New Brunswick: Transaction Publishers, 2004); and Allan Bloom, *The Closing of the American Mind* (New York: Simon and Schuster, 1988).

3. A discussion of the various trends within Newton's thinking is presented in Stephen D. Snobelen, "Isaac Newton, Heretic: the Strategies of a Nicodemite," *BJHS* 32 (1999), 381–419.

4. Snobelen (416) makes the argument that Newton was not strictly a deist.

5. Arianism and Socianism both believe it possible; at point in this current discussion is how such theological disputes are primary, not secondary, to disputes on the nature of science and reason.

6. Not surprisingly, quality as referring to the fulfillment of teleological or cosmological purpose has been redefined by the modernist-postmodernist tradition. For example, the notion of qualitative phenomenological research is now common but makes no sense.

7. The dogmatic relativism of modernism-postmodernism has been discussed in Pontynen, *For the Love of Beauty*. Karl Popper, *The Open Society and its Enemies* (Princeton: Princeton University Press, 1971) perceives in Platonism an authoritarianism; others (Robert E. Wood, *Placing Aesthetics: Reflections on the Philosophic Tradition*, (Athens: Ohio University Press, 1999), 43) take issue with Popper's conclusions. Any authoritarian streak in Platonism is made moot by its later association with the Judeo-Christian tradition as articulated by Augustine. The Doctrines of the Trinity and the Incarnation in Augustinian tradition deny political absolutism and are central to the political and social commitment to responsible freedom that is the core of the American and Western tradition.

8. The racist quality of Kant's *Pragmatic Approach to Anthropology* is foundational to the eugenics of Social Darwinism. Nonetheless, just as the Galilean critique of Scholastic physics was a dangerous act, today so too is a critique of Kantian/Hegelian/Marxist/Darwinist thought.

9. Thomas Molnar, *Utopia: The Perennial Heresy* (New York: Sherd and Walp, 1967). Within a Christian context Milton's Paradise Lost begins with the observation that it is better to be free in Hell than a slave in Heaven. The book's conclusion is that no one is free in Hell.

10. This is evidenced by the changing perspectives in response to Edvard Munch's painting *The Scream* (1893). As explained by Frederic Jameson, the painting has self-deconstructed from the expression of genuine anxiety to mere parody. See Charles Harrison and Paul Wood, *Art in Theory: 1900–1990* (Oxford: Blackwell Publishers, 1997), 1078–9.

11. Traditionally, this distinction between negative and positive knowledge is made by the Pseudo-Dionysius and Augustine.

12. Augustine, *On Free Will*.

13. Susan Neiman, *Evil in Modern Thought: An Alternative History of Philosophy* (Princeton: Princeton University Press, 2002), 120ff.

14. Ibid.

15. Ibid., 124.

16. Neiman, 238ff.

17. These positions apply to the founding of the National Endowment for the Arts (NEA). As established, the NEA is charged with the impartial selection of works of art by impartial experts. Neither postmodernists nor conservatives find plausible the contention that works of fine art can impartially be identified and selected.

18. Cassirer, 161ff.

19. Vernon J. Bourke, *The Essential Augustine* (New York: Hackett Publishing, 1974) , 303.

20. Burtt, 297.

21. Ibid. 119.

22. Neiman, 118.

23. Neiman, 157.

24. Ibid., 166.

25. Ibid., 61.

Chapter 8: Romanticism and Knowledge

1. Ibid., 188.
2. A discussion of Adorno, Horkheimer, and the *Dialectic of Enlightenment* is found in Neiman, 192.
3. Ibid., 190.
4. Arthur C. Danto, *Encounters and Reflections: Art in the Historical Present* (University of California Press, 1997), 142.
5. *James Fenimore Cooper: His Country and His Art* (No. 11), Papers from the 1997 Cooper Seminar, Hugh C. MacDougall, ed., State University of New York College at Oneonta, 7–13.
6. Quoted in Danto, *Encounters and Reflections*, 140.
7. John Wilmerding, *American Light: The Luminist Movement 1850–1875* (Washington: National Gallery of Art, 1980), 31.
8. Danto, *Encounters and Reflections*, 142.
9. Paul Elmer Moore, *Platonism* (New York: AMS Press, 1969), 277ff.
10. From "Early Theological Writings," 162–63; for reference, see Paul Edwards, ed., *Encyclopedia of Philosophy* (New York: Collier Macmillan Publishers), vol. 3–4, 437.

11. This idea of a hidden narrative is oddly central to the scholarship of Leo Strauss; it is also used by Snobelen in his previously cited article on Newton.

12. This results in the Marxist notion that humanity develops by transforming the natural world through labor; the existentialist Foucault develops the notion differently: that we make our own existence.

13. This Emersonian idea is cited as a major aspect of the political philosophy of Ronald Reagan. See Diggins, *Ronald Reagan*, 3.

14. Irving Babbitt, *Rousseau and Romanticism* (New Brunswick: Transaction Publishers, 2004), 122ff, 65ff, 225ff.

15. Ibid., 63, 119.

16. Milton Brown, *American Art* (New York: Prentice Hall, 1988), 195.

17. Babbitt, 42–43.

18. We are following, with additions, Alister E. McGrath, *Christian Theology* (Oxford: Blackwell Publishers, 2000), 121ff.

19. Kant's attempts to ground a deontological rationality on twelve assumed mental tendencies of the human mind can rightly be considered a latter-day example of the perennial association of empiricist-mysticist analysis. Commonly denied is the correspondence theory of truth, by which we rationally aspire to obtain a glimpse of some degree of objective understanding of the world and life.

20. Nietzsche's contempt for Kant is well established. As he states: "'Virtue,' 'Duty,' 'Goodness in itself,' goodness stamped with the character of impersonality and universal validity—these things are mere mental hallucinations, in which decline the final devitalization of life and Koenigsbergian Chinadom find expression. The most fundamental laws of preservation and growth demand precisely the reverse, namely, that each should discover his own virtue, his own Categorical Imperative. . . . German decadence made into philosophy—that is Kant!" Friedrich Nietzsche, *The Birth of Tragedy and the Genealogy of Morals*, translated by Francis Golffing (Garden City: Doubleday & Company, 1956), 10ff.

21. Conkin, 46.

22. Ibid., 51, 52, 58, 62. The so-called American transcendentalists were philosophical immanentists. For that reason they rejected Trinitarianism.

23. David C. Huntington, "Church and Luminism: Light for America's Elect," in Wilmerding, *American Light*.

24. Ibid., 183, 154.

25. Barbara Novak, "On Defining Luminism," in Wilmerding, *American Light*, 23ff.

26. This painting can nonetheless be viewed via a Trinitarian Christian perspective, just as (discussed previously) St. Paul's Chapel can be.

27. Huntington, 185.

28. Harry Francis Mallgrave, *Modern Architectural Theory: A Historical Survey, 1673–1968* (Cambridge: Cambridge University Press, 2005), 85. Mallgrave suggests that these three are not only examples of picturesque theory built but also the roots of the nineteenth-century Gothic movement.

29. The association of the Gothic with emotion rather than intellect, or with emotion as intellect, is clear in Wilhelm Worringer, *Form in Gothic* (New York: Schocken Books, 1967).

30. David Watkin, *A History of Western Architecture* (New York: Waston-Guptill, 2000), 449. Watkin notes that the Saint-Simonistes aspired to have scientists and industrialists run the government.

31. William J. R. Curtis, *Modern Architecture Since 1900* (London: Phaidon Press, 1996), 27.

32. For a particularly bizarre example, see Minard Lafever's First Presbyterian Church (Old Whaler's Church), Sag Harbor (1844), featuring a facade based on the Egyptian pylon temple, a neoclassical interior, and a (now missing) English Baroque tower.

33. Hugh Morrison, *Early American Architecture: From the First Colonial Settlements to the National Period* (Oxford: Oxford University Press, 1952), 571.

34. Notably, Richardson's theological considerations were, at best, minimal. Brooks was the driving force behind the concepts of Trinity Church. See Kathleen Curran, "The Romanesque Revival, Mural Painting, and Protestant Patronage in America," *Art Bulletin*, vol. 81, 1999.

35. As designed, there was to be no altar at the front of the church. Rather, a large communion table was centered in the apse. On the chancel steps was the pulpit. Behind and to either side were the baptismal font and a reading desk.

36. Gillis J. Harp, *Brahmin Prophet: Phillips Brooks and the Path of Liberal Protestantism* (New York: Rowman & Littlefield, 2003), 88.

37. Harp comments about Brooks's private writings during his seminary years: "What stands out most is an amalgam of liberal Romantic Evangelicalism and literary Romanticism" (Harp, *Brahmin Prophet*, 28). Harp also notes the conspicuous absence of any typically evangelical references.

Chapter 9: From Puritan and Romantic to Pragmatist

1. Quoted in Roger Kimball, "The End of Art," *First Things*, June/July 2008. Kimball references Panofsky's comments published in *Life and Art of Albrecht Durer*, originally published in 1943.

2. The association of Heidegger's philosophy with Adolf Hitler's National Socialism is often noted. Both Hannah Arendt and Thomas Mann associated the rise of Hitler with German Romanticism. See: Richard Wolin, *Heidegger's Children: Hannah Arendt, Karl Lowith, Hans Jonas, and Herbert Marcuse* (Princeton: Princeton University Press, 2001. Heidegger's infamous Rectorial Address of 1933 prompted Karl Lowith to state that "it was not quite clear whether one should now study the pre-Socratic philosophers or join the SA brownshirts." See Rüdiger Safranski, *Martin Heidegger: Between Good and Evil*, translated by Ewald Osers (Cambridge, MA: Harvard University Press, 1998), 249.

3. Burtt, 109ff.

4. For example, a heart on a table occupies a space; a heart within the chest of a human being has a place; a healthy heart within a human being in a purposeful world occupies a sacred place.

5. Heidegger agrees with this notion of place but differs from tradition in assuming place to be subjectively determined and affected by our reasoning, will, and passions.

6. Paul K Conkin, *Puritans and Pragmatists* (Waco: Baylor University Press, 2005), 51ff.

7. Ibid.

8. Conkin, 59.

9. Alexander Pope, "An Essay on Man," Epistle i, I, 289 (1773).

10. Conkin, 50.

11. This is in radical disagreement with Heidegger's assertion that reality attains meaning by our acts of will.

12. Conkin, 69.

13. Ibid., 70.

14. In summary, according to Genesis 22 Abraham is commanded to prepare a sacrifice to God. Abraham and his son go to Mount Moriah, where Abraham prepares to sacrifice his son on an altar. At the last moment an angel of God stops him. So Abraham is prepared to sacrifice his son when he hears God's voice speaking in his head; for Kant, the content of Abraham's faith is revealed by his ability to emotionally respond to and obey the divine voices in his head. His willingness to kill in the name of God is judged a testament of his faith—but for Kant this action, this event, this willingness evidences not a successful testing of Abraham's faith but rather a manifestation of his bad faith. To kill a son by the alleged command of God is viewed as irrational and barbaric.

Søren Kierkegaard rejects Kant's position. Kierkegaard, a postmodernist, has deeply affected our thinking and understanding of faith. Kierkegaard opposes Kant's attempt to evaluate faith via human reason; indeed, he goes to the extreme opposite position: that faith and reason are separate. In his 1843 text, *Fear and Trembling*, Kierkegaard declares that if there is an apparent conflict between ethics and divine direction, between human reason and divine will, then the latter must prevail. For the postmodern Christian, there is a conflation of divine reason and divine will. We are to experience God as a supra—or is it a sub?—rational experience. The problem is distinguishing between the two, since failure to do so is to confuse the human will with the divine. But such knowledge is now denied.

So Kant the modernist declares that human reason is God, and Kierkegaard declares the experiencing of God to be beyond human reason. One pursues a rational fetish, the other a fetish of the will. What they share is a subjective objectivity that leads to self-deification. Scientific rational understanding of cause and effect is denied.

Both deny the possibility or importance of some degree of objective knowledge of transcendent Logos and Being, of purpose, idea, and matter; Kant pursues a secular rationalization, and Kierkegaard a religious irrationality in which there is no way to distinguish between divine and human will. Both deny the Logos as knowledge of Being. But when the transcendent object is denied, and the Logos is separated from the will, then a self-deification results.

15. For a discussion see Jean-Luc Marion, *God without Being*, translated by Thomas A. Carlson (Chicago: University of Chicago Press, 1995).

16. Conkin, 164ff.

17. Baruch Spinoza, *Principles of Cartesian Philosophy*, translated by Harry Wedeck (New York Philosophical Library, 1961), 3ff.

18. David Bjelajac, *American Art: A Cultural History* (Upper Saddle River, NJ: Prentice Hall, 2000), 45.

19. H. P. Blavatsky, *The Key to Theosophy* (Pasadena: Theosophical University Press, 1972 edition), 23ff.

20. Ibid., 62.

21. Ibid., 29.

22. Conkin, 182.

23. Ibid., 188.

24. A corresponding redefinition of a critical term is found in the case of realism. For Plato, realism refers to Being, to those ideals that are perennially true; for the positivist and materialist, realism refers to the realm of material becoming, descriptive fact.

25. As Freud discussed, should the narcissistic subject identify with an object, then the object no longer exists as such; therefore, love lacks an object and collapses. So narcissism involves a pathological obsession with and hatred of the self.

Chapter 10: American Pragmatism

1. Philip P. Wiener, ed., *Values in a Universe of Chance: Selected Writings of Charles S. Peirce* (Garden City, NY: Doubleday Anchor Books, 1958), 140

2. Ibid., xxiii.

3. Ibid., 400.

4. Ibid., 181.

5. Ibid., 140.

6. Conkin, 235ff.

7. For the following series of quotes by Peirce, see Wiener, ed., *Values in a Universe of Chance*, 142ff.

8. Just as Intelligent Design can be cited as proof of the ontological validity of a good or an evil god, Darwin's system can be cited as proof of the triumph of the good or the vicious.

9. Ibid., 152.

10. Harrison, 841.

11. Conkin, 334.

12. Bradley J. Birzer, *Sanctifying the World: The Augustinian Life and Mind of Christopher Dawson* (Front Royal, VA: Christendom Press, 2007), 106.

13. Ideologies—or paradigms—are today viewed via modernist and postmodernist perspectives. For Kantian modernists such as Panofsky, ideologies are meaningful fictions; for postmodernists such as Hegel or Marx, ideologies are deterministic. The alternative to ideology determining knowledge is traditional humility, which views ideology as a means to an end and not an end unto itself. Like logic, ideologies might provide glimpses of Truth rather than limit what Truth can be.

14. Conkin, 355.

15. See Richard Rorty, *Contingency, Irony, and Solidarity* (Cambridge: Cambridge University Press, 1989); and *Philosophy as Cultural Politics* (Cambridge: Cambridged University Press, 2007).

16. Cecil E. Greek, *The Religious Roots of American Sociology* (New York: Garland Publishing, 1992), 21.

17. Washington Gladden, *The Church and Modern Life* (New York: Houghton Mifflin Co., 1908), 27.

18. Walter Rauschenbusch, *A Theology for the Social Gospel* (Nashville: Abington Press, 1987/1917), 202.

19. John A. Battle, "A Brief History of the Social Gospel," *Western Reformed Seminary Journal* 6/1 (February 1999), 5–11.

20. Rauschenbusch, 13.

21. Gladden, 15.

22. Greek, 51.

23. Greek, 68. Greek is quoting from George Herron, another supporter of the Social Gospel movement.

24. See Jane Addams, *Twenty Years at Hull House*, Victoria Bissell Brown, ed. (New York: Bedford, 1999/1910).

25. Greek, 194. Greek continues, "It can be argued that much of American sociology has remained a fundamentally religious endeavor up to the present day."

26. See Jeanne Halgren Kilde *When Church Became Theatre* (Oxford: Oxford University Press, 2002). Kilde compares First Church of Christ, New Haven (Ithel Town, 1814) to First Baptist Church, Minneapolis (Frederick Kees, 1886).

27. Malgrave, 188.

28. This obscure but significant quote is in Malgrave, 189. Malgrave cites David A. Hanks, *The Decorative Designs of Frank Lloyd Wright* (New York: E. P. Dutton, 1979), 67. Hanks is quoting the travel journal of Charles Robert Ashbee, an architect who came to Chicago to lecture at Hull House to the local Arts and Crafts chapter.

29. Robert Twombly and Narciso Menocal, *Louis Sullivan: The Poetry of Architecture* (New York: W. W. Norton, 2000), 75. Menocal notes: "For most of the rest of the century French architectural thought went on taking for granted that the elements of architecture were results of pragmatic solutions to discrete problems the profession had encountered throughout history. A building was to portray its individual essence instead of referring to an ideal, as Neo-Classical design did."

30. Ibid., 74.

31. Morrison, 230.

32. Malgrave, 163. Malgrave notes further use of this paper: "In 1887 Sullivan sent the American bard [Walt Whitman] a copy of his lyrical essay, "Inspiration" with the confession that 'I, too, have pried through the strata, analyzed to a hair, reaching for the basis of a virile and indigenous art.'"

33. Morrison, 242.

34. Ibid., 231.

35. In spite of the Transportation Building's winning praise, and three medals from the Union Centrale des Arts Decoratifs, Sullivan's later career took a downturn. His last commissions were mostly small banks.

36. Sullivan was a member of the architectural committee and later wrote in scathing terms of the predominant neoclassicism that it was a "virus" that would set American architecture back fifty years. See Morrison, 183.

37. David P. Handlin, *American Architecture* (London: Thames and Hudson, 1985), 128.

38. Morrison, 269.

39. Jan Michl, *Magazine of the Faculty of Architecture and Town Planning* 10 (Winter 1995), 20–31.

40. Twombly and Menocal, 74.

41. Morrison, 256. Quoted from Sullivan's, *The Young Man in Architecture*, 1900.

Chapter 11: Neither Medieval nor Modernist Scholasticism: American Exceptionalism

1. Milton Brown, *The Story of the Armory Show* (New York: Abbeville Press, 1988), 172.

2. Ibid., 212.

3. Discussed in Arthur Pontynen, *For the Love of Beauty: Art, History, and the Moral Foundations of Aesthetic Judgment* (New Brunswick: Transaction Publishers, 2006), 311.

4. Sam Hunter and John Jacobus, *Modern Art* (Englewood Cliffs, NJ: Prentice-Hall, Inc., 1985), 102.

5. Harrison, 72ff.

6. Hunter and Jacobus, 103.

7. Ibid., 250.

8. For reference to Picabia's comments and a comprehensive overview of the Armory Show, see http://xroads.virginia.edu/~MUSEUM/Armory/armoryshow.html.

9. Herschell B. Chipp, *Theories of Modern Art* (Berkeley: University of California Press, 1984), 214.

10. This is discussed in Daniel Henninger, "21st Century Art Makes Its Escape from the Toilet: We Don't Need Modernism and Post-Modernism Anymore," *Wall Street Journal*, February 18, 2005. "Depicted elsewhere in this column you will find Marcel Duchamp's 'Fountain,' a ready-made urinal he posited as art in 1917 and which a December 2004 poll of 500 arts specialists in Britain said was the single most important work of art in the 20th century. Since this assertion appeared, it has taken up residence in that part of my mind reserved for persistent obsessions."

11. Harrison, 116.

12. Haskell, 27.

13. The tragic consequences of an identity-based approach to art and culture are made large in the career of Adolf Hitler. In his speech for the inauguration of the Great Exhibit of German art published in 1937, Hitler condemns art based upon inner experience, meaningful empathy, and original primitivism as claptrap. However, the terrible irony and tragedy is that his grounding of morality on the identity of the German people, his holding that art is the expression of the essence of that *ethnographic being*, is itself grounded in that which he allegedly despised: a positivist and existentialist inner necessity. For his speech, see Harrison, 424.

14. For example, Buddhism is devoted to the free and responsible pursuit of wisdom. But it is substantively opposed to the classical-Judeo-Christian understanding of science and reason. Therefore, the Buddhist influence within the West as evidenced by Spinoza and others marks not cosmopolitanism, but transgression. Postmodernists can use Buddhism in their assault upon Western culture. But Buddhism in turn is intrinsically opposed to the Postmodernist denial of cause and effect and the transcendent,

15. The following section follows closely Arthur Pontynen, "The Beauty of Humanity, the Aesthetics of Race," *American Outlook*, 2002.

16. Augustine, *City of God*, XIX, 24.

17. Malgrave, 300.

18. Ibid., 302.

19. Malgrave suggests this sprang from numbers of architects out of work during the war years (see page 236). Perhaps, but this misses the issue at hand: the change in architecture reflects a change in theory. Was it a change for the better?

20. Malgrave, 303. Quote is from the Hitchcock and Johonson book, *The International Style*. Malgrave wishes to dismiss this as the passion of youth and suggests, "This particular invective in an odd way recalls that sense of American cultural inferiority that was so evident in the first half of the nineteenth century." Certainly their statement concerns issues of cultural inferiority and superiority.

21. David Watkin, *Morality and Architecture Revisited* (Chicago: University of Chicago Press, 2001), xix. Watkin is quoting Cowling from the latter's *The Nature and Limits of Political Science* (Cambridge: Cambridge University Press, 1963). Cowling was a political historian.

22. Watkin,14. Watkin sees the fallacies in the neo-Hegelian theory of history and architecture as expressed by his primary subject, the outrageous claims of historian Nicholas Pevsner and the inhumanity of modern architecture. Sadly, Watkin concludes (127) "that an art-historical belief in the all-dominating Zeitgeist, combined with a historicist emphasis on progress and the necessary superiority of novelty, has come dangerously close to undermining, on the one hand, our appreciation of the imaginative genius of the individual and, on the other, the importance of artistic tradition." How genius is understood, and how tradition is to be evaluated, are left unanswered.

23. Malgrave, 290. These lectures were republished in 1931 in *Modern Architecture*.

24. Narciso G. Menocal, "Frank Lloyd Wright's Concept of Democracy: An American Architectural Jeremiad," in Bruce Brook Pfeiffer and Gerald Nordland, eds., *Frank Lloyd Wright in the Realm of Ideas* (Carbondale: Southern Illinois University Press, 1988), 154.

25. Watkin, 95. Watkin continues: "One of the reasons why the blatant crudities that Wright wrote are in such great quantity have not been acknowledged for what they are, is that he happened to be an architect of great imagination. His houses were subtle, expensive, romantic: everything we would not expect from his writings." This rather misses one point and begs the question on another: Perhaps whoever was reading Wright found his writing and his buildings to have a unity? Where is it said that "subtle, expensive and romantic" are the criteria for good architecture?

26. So, too, sexuality was no longer numinous. See Watkin, 44–46.

27. E. Michael Jones, *Living Machines: Bauhaus Architecture as Sexual Ideology* (San Francisco: Ignatius Press, 1995), 26.

28. It is important to emphasize that a postmodern Nazism opposed modernist Kantianism because of the cultural damage resulting from the latter. This leads some to falsely associate critics of modernist liberalism with postmodern identity based politics. The alternative to both modernist and postmodernist paradigms is American Exceptionalism, in which social equals agree to freely and responsibly seek wisdom via a scientific rationalism.

29. Ibid., 18.

30. Ibid., 100. Jones is referring to one of Gropius's many dalliances, in this case, Alma Mahler.

31. Jones, 99.

Chapter 12: The American Critics

1. As noted, European or Anglosphere scholars such as John Carroll, G. K. Chesterton, F. R. Leavis, C. S. Lewis, Hans Sedlmayr, Osvald Spengler, Hans Rookmaaker, and Eric Voegelin voiced deep concern over the state of Western civilization; so, too, did some scholars of cosmopolitan background such as Edward Conze and Ananda Coomaraswamy.

2. See also Pontynen, *For the Love of Beauty: Art, History, and the Moral Foundations of Aesthetic Judgment.*

3. Arnold's poem suffers a transgressive response by the postmodernist poet Anthony Hecht, who wrote "Dover Bitch" in 1967.

4. H. Wayne Morgan, *Keepers of Culture: The Art-Thought of Kenyon Cox, Royal Cortissoz, and Frank Jewett Mather Jr.* (Kent, OH: Kent State University Press, 1989), 106.

5. Ibid., 111.

6. Ibid., 131.

7. Ibid., 129.

8. Ibid., 129.

9. Ibid., 45–6.

10. Ibid.

11. Helen Gardner, *A History of Art* (New York: Harcourt Brace Jovanovich, 1975), 176.

12. Morgan, 56.

13. According to Richard Wolin, *Heidegger's Children* (Princeton: Princeton University Press, 2001), 13: "Convinced that Nazism reflected a spiritual malaise afflicting not only Germany but the West as a whole, [Karl Lowith] sought out the intellectual roots of the crisis in the nineteenth century, when educated men and women abandoned the balance of German classicism (Goethe and Hegel [*sic*] for the extremes of existentialism, scientism, and nihilism. Both [Hans] Jonas and [Hannah] Arendt also perceived a Faustian-nihilistic strain in [modernist-postmodernist] Western humanism—a loss of a sense of proportion and 'limit'—that seemingly propelled the modern age headlong towards the abyss." Indeed, Arendt comes to the same conclusion that Babbitt had earlier about Romanticism (48): "When [Arendt] first tried to assess Heidegger's Nazism in the pages of *Partisan Review*, she tellingly observed that Heidegger's 'whole mode of behavior has exact parallels in German Romanticism'; he was 'the last (we hope) romantic' . . . Following the war, Thomas Mann also looked to the debilities of romanticism to account for Germany's descent into barbarism: above all, romanticism's fascination with 'a certain dark richness of soul that feels very close to the chthonian, irrational, and demonic forces of life.'"

14. Irving Babbitt, *Rousseau and Romanticism* (New Brunswick. NJ: Transaction Publishers, 1991), 65.

15. Ibid., xii.

16. Ibid., lxx.

17. Ibid., 115.

18. Ibid., lxx.

19. Ibid., 363.

20. Ibid., lxxvi.

21. Ibid., 121.

22. Ibid., 348.

23. Ibid., 116. Babbitt apparently accepts Kierkegaard's existentialist view of Christianity as a cultural system in which we abandon a scientific rationalism and live in fear and trembling before an omnipotent and ineffable God. This marks a failure on Babbitt's part to view Christianity via an Augustinian or non-scholastic (Gothic or Modern) perspective.

24. Ibid., 24.

25. Ibid., 23.

26. Ibid., 38.

27. We might recall that Karl Pearson (the winner of the Darwin Medal of 1898), discussed earlier in the context of theories of racial war, wrote a highly influential book, *The Grammar of Science* (1892) . That book deeply influenced Albert Einstein; it advocated a Kantian constructivist relativity for science. He held that there is an equivalence of matter and energy, that facts conform to how we think, and that we are in essence worldmakers. The logical conclusion of the multi-perspectivism of Kantianism is the romantic denial of all perspectives, a denial that concludes in a Nietzschean nihilism. Frederick Copleston explains: "If Nietzsche is prepared to apply his view of truth to alleged eternal truths, he must obviously apply it *a fortiori* to scientific hypotheses. The atomic theory, for example, is fictional in character; that is to say, it is a schema imposed on phenomena by the scientist with a view to master . . . the atom, considered as an entity, a seat of force, is a symbol invented by the scientist, a mental projection. However, if we presuppose the fictional character of the atomic theory, we can go on to say that every atom is a quantum of energy or, better, of the Will to Power." Frederick Copleston, *A History of Philosophy* (Garden City, NY: Image Books, 1985), Book Three, 411.

28. Babbitt, *Rousseau and Romanticism*, 65.

29. Ibid., lvi.

30. A. Philip McMahon, *Preface to an American Philosophy of Art* (Chicago: University of Chicago Press, 1945), 7.

31. On the other end of the political spectrum, it is necessary to keep in mind the Stalinist issues surrounding Sartre, and the Frankfurt School.

32. Such associations also afflict those on the opposite side of the argument. See Hans Sedlmayr, *Art in Crisis* (Chicago: Regnery, 1958).

33. McMahon, 93.

34. Ibid., 97.

35. Ibid., 99.

36. Ibid., 88.

37. Ibid., 14.

38. Ibid., 16.

39. Ibid., 19.

40. This is discussed via the topic of creativity by Allan Bloom, *The Closing of the American Mind*, 180ff.

41. McMahon, 43.

42. Ibid., 59.

43. Ibid., 60 ff.

44. Ibid., 61.

45. Ibid., 62.

46. Ibid., 79.

47. Ibid., 85.

48. Ibid., 153.

49. Ibid., 173.

50. Postmodern conservatives also fail to make this distinction. Professor David Gelernter, who was grievously injured by a bomb planted by a postmodernist fanatic, wrote *Americanism: The Fourth Great Western Religion* (New York: Doubleday, 2007). Richard Gamble, in a review ("The Allure of "Demonic Patriotism," *Modern Age*, Vol. 50, no. 1, Winter 2008, 83), writes: "Whether Gelernter realizes it or not, there is something more dangerous than secularism, and that is a nation-state masquerading as God incarnate. In *The Four Loves*, Lewis defended the goodness of a non-ideological patriotism rooted in the concreteness of a shared place and culture." That admonition rightly applies to a dangerous postmodernist type of patriotism. But Gelernter's reverence for the Second Inaugural Address of Lincoln should make clear that neither he nor Lincoln believes the state is divine, but that the state should try resolutely to do what is true and good. As the closing words of that address read: "With malice towards none, with charity for all, with firmness in the right as God gives us to see the right, let us strive on to finish the work we are in, to bind up the nation's wounds, to care for him who shall have borne the battle and for his widow and his orphan, to do all which may achieve and cherish a just and lasting peace among ourselves and with all nations."

51. That contention is the crux of the argument. For a study of the fallacies stemming from Bacon, Descartes, Hobbes, and Hume, see Montague Brown, *Restoration of Reason: The Eclipse and Recovery of Truth, Goodness, and Beauty* (Grand Rapids: Baker Academic, 2006).

Chapter 13: Sacred and Profane Science, Reason, and Culture

1. Michael Fazio, Marian Moffett, and Lawrence Wodehouse, *Buildings Across Time* (Boston, McGraw-Hill, 2009), 523.

2. The assault upon grammar is examined in David Mulroy, *The War Against Grammar* (Portsmouth: CrossCurrents, 2003).

3. Gothic architectural scholarship evidences the perspectivism addressed in the book. In 1951 Erwin Panofsky wrote *Gothic Architecture and Scholasticism*. He approaches the study of Gothic architecture from a Neo-Kantian perspective. He addresses the scholastic *mental habits* that inform not only faith and reason, but architecture as well. Panofsky observes that the scholastic reconciliation of opposites, so essential to the scholastic pursuit of clarity, was a cultural mental habit essential to and manifest in Gothic architecture. That Gothic mental habit was criticized by Roger Bacon as one of division, rhythm, and *concordiae violentes*. The scholastic process by which faith and reason were to be reconciled was seen by Bacon as substantively violent.

The violence that Bacon criticized as the core of the scholastic method is celebrated by the postmodernist art historian Wilhelm Worringer. In his 1917 book *Form in Gothic*, Worringer rejects the Neo-Kantian methodology of seeking knowledge of mental habits, of meaningful fictions. He also rejects the possibility of Gothic cathedrals revealing wisdom and beauty via a temporal and material glimpse of eternal Truth or Being. Instead, he embraces what Bacon lamented: the methodological assumption that reality is driven by a violent dialectic.

Echoing Hegel's formulaic hierarchy of the symbolic, the classical, and the romantic, Worringer declares that all art is the manifestation of the will unfolding in time. That unfolding occurs via primitive, classical, and oriental stages. The primitive stage is where humanity surrounded by chaos attempts to conceptualize experience and thus escape that chaos. The second stage is the classical in which an abstract rational cosmos is postulated. Finally is the oriental in which an intuitive mysticism prevails. It is the oriental stage which Worringer celebrates, dividing it into two facets: the passive Asian and the dynamic German. The German option was Christianized during the Gothic period, oppressed during the Renaissance, but then reasserts itself in the Reformation. Later yet it asserts itself in a non-Christian mode informed by the will of northern European peoples associated with Germanic blood.

A contemporary of Worringer is the American architectural historian, Ralph Adams Cram. His 1917 book, *The Substance of Gothic*, reflects upon the calamitous collapse of Western civilization. Cram sees the modernist-postmodernist tradition as the cause, not the result, of the death of civilization. That cause is the exaltation of change, of becoming, to the neglect or denial of being. He confronts the destructive fusion of 19th century positivism with an evolutionist philosophy dedicated to purposeless change. Change without wisdom is just another word for nihilism. Reflecting upon the barbaric carnage of World War I, Cram laments (111): "It is only now, in these last days, while our own chosen system of evolutionary philosophy is falling in ruins around us, that we are beginning to think back beyond Herbert Spencer, beyond Kant, beyond Descartes, beyond St. Thomas Aquinas himself."

4. The struggles the Greeks had working out the exact mathematical relationships between the triglyphs, the metopes, and the columns underneath ultimately led to frustration; perfect harmony could not be achieved without cheating distances or sizes. The later Ionic style eliminated the triglyphs and metopes in favor of a continuous frieze and so avoided the problem entirely.

5. Thomas Molnar, "Architecture and Puritanism," *New American Review*, February/March 1978, 30.

6. L. Michael Harrington, *Sacred Place in Early Medieval Neoplatonism* (New York: Palgrave Macmillan, 2004), 2ff. It should be noted that whereas Heidegger's involvement with Nazism is clear, charges of Eliade's association with them are refutable. Indeed, it should be noted that his eminent academic colleague, Thomas Molnar, was imprisoned in Dachau by the Nazis.

7. Ibid., 28.

8. Ibid., 7.

9. Paul Davies, "Taking Science on Faith," *New York Times*, November 24, 2007.

10. William James's assertion of a plurality of universes is to the point. However, it makes no sense to posit the existence of universes or a multiverse; for universes to exist they must exist somewhere, and that somewhere would be y a universe.

11. Gerald Smith and, Lottie H. Kendzierski, *The Philosophy of Being* (New York: Macmillan Company, 1961), 172.

12. Harrington, 7.

13. See Arthur Pontynen, "The Aesthetics of Race, the Beauty of Humanity,"*American Outlook* (2002), 37–40.

14. Aleksandr Solzhenitsyn, *The First Circle,* translated by Thomas P. Whitney (New York: Bantam Books, 1968), 375ff.

15. Ibid., 586.

16. Frederick Copleston, *A History of Philosophy* (Garden City, NY: Image Books, 1985), Book Three, 411.

17. Max Horkheimer and Theodor W. Adorno, *Dialectic of Enlightenment*, trans. John Cumming (New York: Continuum International Publishing Group, 1976).

18. This false assumption is central to the Scholastic tradition from Aquinas to Kant. In contrast is the Platonic and Augustinian acceptance that knowledge is not limited by sensory experience, but occurs as an act of remembrance.

19. For a discussion, see Jacques Derrida, *Writing and Difference,* trans. Alan Bass (Chicago: University of Chicago Press, 1978).

20. Similarly, see Jacques Derrida, *Archive Fever* (Chicago: University of Chicago Press, 1996).

21. Jacques Derrida, *Points . . . : Interviews, 1974–1994*, edited by Elisabeth Weber (Stanford: Stanford University Press, 1995).

22. As discussed by Gary Gutting, "Michel Foucault." *Stanford Encyclopedia of Philosophy* (http://plato.stanford.edu/entries/foucault/ 2003).

23. For example, a postmodern translation and analysis of a Christian classic can be found in J. D. Jones, *Pseudo-Dionysius Areopagite: The Divine Names and Mystical Theology* (Milwaukee: Marquette University Press, 1980).

24. Jean-Luc Marion, *God without Being*, trans. Thomas A. Carlson (Chicago: University of Chicago Press, 1991), xx.

25. For a discussion, see Thomas Molnar, *God and the Knowledge of Reality* (New Brunswick: Transaction Publishers, 1993).

26. Philip Rieff, *My Life among the Deathworks* (Charlottesville: University of Virginia Press, 2006), 198.

27. Ibid.

28. For a critical examination of Lewis's ideas in this regard, see Rod Miller, "Mirrors, Shadows, and the Muses: C. S. Lewis and the Value of Arts and Letters," *Chronicle of the Oxford University C. S. Lewis Society*, Vol. 6, Issue 2 (April 2009).

29. The differences between the Greek *sophia* and *dianoia* are to the point.

30. As discussed in Birzer, *Sanctifying the World*, 226. See also, James Walsh, *Thirteenth, the Greatest of Centuries* (Washington: Catholic Summer School Press, 1910).

31. Frederick Copleston, *A History of Philosophy*, vol. 2, 66ff.

32. Ibid.

33. Philip Rieff, *My Life among the Deathworks. Illustrations of the Aesthetics of Authority* (Charlottesville: University of Virginia Press, 2006), 5–6.

34. Solzhenitsyn, 415.

Conclusion: The Perspective of an Optimistic Ontology

1. Maritain's critical realism is a sophisticated attempt to escape scientism. However, his Aquinian Aristotelianism undermines his argument. By arguing that metaphysics is prior to epistemology, and that Being is first apprehended via sense experience, he embraces a circular argument. He accepts as first principle a conceptualist constructivism that concludes in the empirical constructivism of modernity that he wishes to escape, Christopher Dawson argues

that a true philosophy of culture cannot be a neo-Thomist absolutism nor a modernist relativism. Nor can it be monistic and organic as Teilhard de Chardin arguably suggests. Dawson offers that it ought to be a theological absolutism combined with a philosophical relativism. See Birzer, *Sanctifying the World*, 66. This position is also problematic in that the separation of theology, philosophy, and science cannot be reconstructed without succumbing to postmodernism. Stanley Jaki's analyses of the history of science are deeply informative.

2. See Peter Harrison, *The Bible, Protestantism, and the Rise of Natural Science* (Cambridge: Cambridge University Press, 2001), 273.

3. A qualitative Aristotelianism relies upon a teleological perspective that concludes in the objective ideal, called by Aristotle, *final causes* that are ultimately grounded in the Unmoved-mover.

4. Ludwig Wittgenstein, *Philosophical Investigations* (New York: Macmillan Company, 1958). See: section 84e.

5. J. H. S. Burleigh, *Augustine: Earlier Writings* (Philadelphia: Westminister Press, 1953), 130.

6. Conkin, 252

7. Both Augustinian and Darwinian evolution accept change in time but differ on the mechanism and goal of that change. For Augustine, evolution is informed by a cosmic drama (which Edward Hicks would immediately recognize) in which a once perfect nature is corrupted and is then granted a means of redemption. In contrast, Darwinian evolution is grounded in an ultimately purposeless violence.

8. Traditional marriage accepts the individuality and the unity of husband and wife, united by the transcendent purpose of family. Empathy provides a model for political and social nihilism and totalitarianism. It is not surprising then that postmodernists (particularly Nietzsche) despise sympathy and praise empathy. Wilhelm Worringer discusses aesthetic enjoyment as an *objectified self-enjoyment*. The link between postmodernism, empathy, and narcissism is evident. See Wilhelm Worringer, *Abstraction and Empathy*, trans. Michael Bullock (Cleveland: Meridian Books, 1967).

9. Edward Kennard Rank, *Founders of the Middle Ages* (New York: Dover Publications, 1957 edition), 92. Rank notes (96) that for Ambrose, moral evil was not hard to explain: it is a consequence of the misuse of freedom. The stumbling block was physical evil.

10. Iris Murdoch, *Metaphysics as a Guide to Morals* (Cambridge: Cambridge University Press, 1992).

11. Smith, 312.

12. Anna S. Benjamin and L. H. Hackstaff, *Saint Augustine: On Free Choice of the Will* (New York: Macmillan Publishing Company, 1964), 17, 42.

13. Roy Battenhouse, ed., *A Companion to the Study of St. Augustine* (Grand Rapids, MI: Baker Book House, 1979), 289ff.

14. Smith, 313.

15. Edward Kennard Rand, *Founders of the Middle Ages*, 150.

16. George Duby, *The Age of the Cathedrals: Art and Society, 980–1420* (Chicago: University of Chicago Press, 1981), 193.

17. Benjamin and Hackstaff, *Saint Augustine*, 17.

BIBLIOGRAPHY

Addams, Jane. *Twenty Years at Hull House*. Edited by Victoria Bissell Brown. New York: Bedford, 1999.

Babbitt, Irving. *Rousseau and Romanticism*. New Brunswick, NJ: Transaction Publishers, 2004.

_____. *Literature and the American College: essays in defense of the humanities*. Boston: Houghton-Mifflin & Co., 1908.

Battenhouse, Roy W. *A Companion to the Study of St. Augustine*. Ada, Michigan: Baker Book House, 1979.

Battle, John A. "A Brief History of the Social Gospel." *Western Reformed Seminary Journal* 6/1 (February 1999).

Baumer, Franklin LeVan. *Main Currents of Western Thought*. New Haven: Yale University Press, 1978.

Beabout, Gregory R. "Liberty Is a Lady." *First Things*. No. 46 (October 1994).

Benjamin, Anna S., and L. H. Hackstaff. *Saint Augustine: On Free Choice of the Will*. New York: Macmillan Publishing Company, 1964.

Bennett, James C. *The Anglosphere Challenge*. Lanham, MD: Rowman & Littlefield Publishers, 2004.

Bergdoll, Barry. *European Architecture 1750–1890*. Oxford: Oxford University Press, 2000.

Birzer, Bradley J. *Sanctifying the World: The Augustinian Life and Mind of Christopher Dawson*. Front Royal, VA: Christendom Press, 2007.

Blavatsky, H. P. *The Key to Theosophy*. Pasadena: Theosophical University Press, 1972 edition.

Bjelajac, David. *American Art: A Cultural History*. Upper Saddle River, NJ: Prentice Hall, 2004.

Bloom, Allan. *The Closing of the American Mind*. New York: Simon and Schuster, 1988.

Boullée, Étienne-Louis. "Architecture, Essay on Art." Translated by Helen Rosenau. *Boullée and Visionary Architecture*. London: Academy Editions, 1976.

Bourke, Vernon J. *The Essential Augustine*. New York: Hackett Publishing, 1974.

Brenner, Reuven and Gabrielle A., with Aaron Brown. *A World of Chance: Betting on Religion, Games, Wall Street*. Cambridge: Cambridge University Press, 2008.

Brown, Milton. *American Art*. New York: Prentice Hall, 1988.

———. *The Story of the Armory Show*. New York: Abbeville Press, 1988.

Brown, Montague. *Restoration of Reason: The Eclipse and Recovery of Truth, Goodness, and Beauty*. Grand Rapids, MI: Baker Academic, 2006.

Burleigh, J. H. S. *Augustine: Earlier Writings*. Philadelphia: Westminster Press, 1953.

Burtt, Edwin. *The Metaphysical Foundations of Modern Physical Science*. Garden City, NY: Doubleday Books, 1954.

———. *Types of Religious Philosophy*. New York: Harper and Brothers, 1951.

Carroll, John. *The Wreck of Western Civilization*. Wilmington, DE: ISI Books, 2008.

Cassirer, Ernst. *The Philosophy of the Enlightenment*. Boston: Beacon Press, 1955.

Chipp, Herschell B. *Theories of Modern Art*. Berkeley: University of California Press, 1984.

Clark, Kenneth. *Civilization*. New York: Harper, 1969.

Coomaraswamy, Ananda. *Christian and Oriental Philosophy of Art*. New York: Dover Publications, 1956.

Conkin, Paul K. *Puritans and Pragmatists*. Waco, TX: Baylor University Press, 2005.

Copleston, Frederick. *A History of Philosophy*. Garden City, NY: Image Books, 1985.

Cram, Ralph Adams. *The Substance of Gothic*. Boston: Marshall Jones, Company, 1925.

Craven, Wayne. *American Art*. Boston: McGraw-Hill, 2003.

Curran, Kathleen. "The Romanesque Revival, Mural Painting, and Protestant Patronage in America." *Art Bulletin*, 81 (1999).

Curtis, William J. R. *Modern Architecture Since 1900*. London: Phaidon Press, 1996.

Danto, Arthur C. *Encounters and Reflections: Art in the Historical Present*. Berkeley: University of California Press, 1997.

Davies, Paul. "Taking Science on Faith." *New York Times*, November 24, 2007.

Derrida, Jacques. *The Gift of Death*. Translated by David Wills. Chicago: University of Chicago Press, 1995.

———. *Writing and Difference*. Translated by Alan Bass. Chicago: University of Chicago Press, 1978.

———. *Archive Fever*. Translated by Eric Prenowitz. University of Chicago Press, 1996.

———. *Points . . . :Interviews, 1974–1994*. Edited by Elisabeth Weber. Stanford: Stanford University Press, 1995.

———. "Violence and Metaphysics." Edited by John Salis. *Deconstruction and Philosophy: The Texts of Jacques Derrida*. Chicago: University of Chicago Press, 1989.

Diggins, John Patrick. *Ronald Reagan: Fate, Freedom, and the Making of History*. New York: W. W. Norton and Company, 2007.

Duby, George. *The Age of the Cathedrals. Art and Society, 980-1420*. Chicago: University of Chicago Press, 1981.

Dubos, Abbé. *Reflections critiques sur la poésie et sur la peinture*. 1719.

Paul Edwards, editor, *Encyclopedia of Philosophy*. New York: Collier Macmillan Publishers, 1967.

Edwards, Rem B. *A Return to Moral and Religious Philosophy in Early America*. Washington, DC: University Press of America, 1982.

Fazio, Michael, Marian Moffett, and Lawrence Wodehouse. *Buildings Across Time*. Boston: McGraw-Hill, 2009.

Florensky, Vladimir. *The Aesthetic Fact of Being*. Translated by Viktor Bychkov. Scarsdale, NY: St. Vladimir's Seminary Press, 1993.

Freud, Sigmund. Translated by James Strachey. *Civilization and Its Discontents*. New York: W. W. Norton & Company; The Standard Edition edition, 1989 (1929).

Gardner, Helen. *A History of Art*. New York: Harcourt Brace Jovanovich, 1975.

Gelernter, David. *Americanism: The Fourth Great Western Religion*. New York: Doubleday, 2007.

Gladden, Washington. *The Church and Modern Life*. Boston: Houghton Mifflin Co., 1908.

Goethe, Johann Wolfgang von. *Faust*. Translated by George Madison Priest. New York: Alfred A. Knopf, 1941.

Goodman, Nelson. *Ways of Worldmaking*. Indianapolis: Hackett Publishing Company, 1988.

Gordy, Wilbur Fiske. *History of the United States*. New York: Charles Scribner's Sons, 1922.

Greek, Cecil E. *The Religious Roots of American Sociology*. New York: Garland Publishing, 1992.

Gutting, Gary. "Michel Foucault." *Stanford Encyclopedia of Philosophy* http://plato.stanford.edu/entries/foucault/ 2003.

Handlin, David P. *American Architecture*. London: Thames and Hudson, 1985.

Harp, Gillis J. *Brahmin Prophet: Phillips Brooks and the Path of Liberal Protestantism*. Lanham, Maryland: Rowman & Littlefield, 2003.

Harrison, Charles, and Paul Wood, editors. *Art in Theory: 1900–1990*. Oxford: Blackwell Publishers, 1997.

Harrison, Charles, Paul Wood, and Jason Gaiger, editors. *Art in Theory: 1648–1815*. Hoboken: Wiley Blackwell, 1991.

Harrison, Peter. *The Bible, Protestantism, and the Rise of Natural Science*. Cambridge: Cambridge University Press, 2001.

Harrington, L. Michael. *Sacred Place in Early Medieval Neoplatonism*. New York: Palgrave Macmillan, 2004.

Hegel, G. W. F. *Phenomenology of the Spirit*. 1807.

Heidegger, Martin. *Sein und Zeit*. Halle: Max Niemeyer Verlag, 1927.

Henninger, Daniel. "21st Century Art Makes Its Escape from the Toilet: We Don't Need Modernism and Post-Modernism Anymore." *Wall Street Journal*, February 18, 2005.

Herrmann, Wolfgang. *Laugier and Eighteenth-Century French Theory*. London: A. Zwemmer Ltd., 1962.

Honour, Hugh. *Neoclassicism*. London: Penguin, 1991.

Horkheimer, Max, and Theodor W. Adorno. *Dialectic of Enlightenment*. Translated by John Cumming. New York: Continuum International Publishing Group, 1976.

Hume, David. *A Treatise of Human Nature*. 1740.

_____. *Enquiries concerning the Principles of Morals.* 1751.

Hunter, Sam, and John Jacobus. *Modern Art.* Englewood Cliffs, NJ: Prentice-Hall, Inc., 1985.

Robert Maynard Hutchins, editor. *Great Books of the Western World.* Chicago: Encyclopedia Britannica Press, 1952. Volume 7: *The Dialogues of Plato*; Volume 8, 9: *Aristotle. On Parts of Animals, Nicomachean Ethics;* Volume 18: *Augustine. City of God, On Free Choice of the Will, On the Trinity.* Volume 42: *Kant, Immanuel. The Critique of Pure Reason. 1781, The Critique of Practical Reason. 1788, The Critique of Judgment. 1790.*

Jones, E. Michael. *Living Machines: Bauhaus Architecture as Sexual Ideology.* San Francisco: Ignatius Press, 1995.

Jones, J. D. *Pseudo-Dionysius Areopagite: The Divine Names and Mystical Theology.* Milwaukee: Marquette University Press, 1980.

Kierkegaard, Soren. *Fear and Trembling.* 1843.

Kilde, Jeanne Halgren. *When Church Became Theatre.* Oxford: Oxford University Press, 2002.

Kimball, Roger . "The End of Art," *First Things,* June/July 2008.

Kirk, Russell. *The Roots of American Order.* Wilmington, DE: ISI Books, 2003.

Alexandre Koyre, *From the Closed World to the Infinite Universe.* New York: Harper and Row, 1958.

Kripal, Jeffrey J. "Brave New Worldview." *Chronicle of Higher Education,* December 12, 2008.

Kronman, Anthony T. *Education's End: Why Our Colleges and Universities Have Given Up on the Meaning of Life.* New Haven: Yale University Press, 2007.

Kuhn, Thomas. *The Structure of Scientific Revolutions.* Chicago: University of Chicago Press, 1970.

Lasch, Christopher. *Haven in a Heartless World.* New York: W. W. Norton and Company, 1995.

Laugier, Antoine. *Essai sur l'Architecture.* 1753.

Lewis, C. S. *Christianity and Literature: Essay Collection and Other Short Pieces.* Edited by Lesley Walmsley. London: Harper Collins, 2000.

Louden, Robert B. Editor. *Kant: Anthropology from a Pragmatic Point of View. Cambridge Texts in the History of Philosophy.* Cambridge: Cambridge University Press, 2006 (1798).

MacDonald, William. *The Pantheon.* Cambridge: Harvard University Press, 1976.

MacDougall, Hugh C., ed. *James Fenimore Cooper: His Country and His Art* (No. 11). Papers from the 1997 Cooper Seminar, State University of New York College at Oneonta.

MacIntyre, Alasdair. *After Virtue.* South Bend, IN: University of Notre Dame Press, 1981.

_____. *Whose Justice? Which Rationality?* South Bend, IN: University of Notre Dame Press, 1988.

Mallgrave, Harry Francis. *Modern Architectural Theory: A Historical Survey, 1673–1968.* New York: Cambridge University Press, 2005.

Marion, Jean-Luc. *God without Being.* Translated by Thomas A. Carlson. Chicago: University of Chicago Press, 1995.

McGrath, Alister E. *Christian Theology.* Oxford: Blackwell Publishers, 2000.

McMahon, A. Philip. *Preface to an American Philosophy of Art*. Chicago: University of Chicago Press, 1945.

Menocal, Narciso G. "Frank Lloyd Wright's Concept of Democracy: An American Architectural Jeremiad." In *Frank Lloyd Wright in the Realm of Ideas*, edited by Bruce Brook Pfeiffer and Gerald Nordland. Carbondale: Southern Illinois University Press, 1988.

Michl, Jan. "Form Follows What? The modernist notion of function as a carte blanch" *1:50 - Magazine of the Faculty of Architecture & Town Planning*. Haifa: Technion, Israel Institute of Technology. No. 10 (Winter 1995).

Milbank, John. *Theology and Social Theory: Beyond Secular Reason*. Oxford: Blackwell Publishers, 1993.

Miles, Sara Joan. "From Being to Becoming: Science and Theology in the Eighteenth Century." *Perspectives on Science and Christian Faith*, December 1991.

Miller, Rod. "Mirrors, Shadows, and the Muses: C. S. Lewis and the Value of Arts and Letters." *Chronicle of the Oxford University C. S. Lewis Society*. 6: 2 (April 2009).

Milton, John. *Paradise Lost*. 1667.

Molnar, Thomas. *God and the Knowledge of Reality*. New Brunswick, NJ: Transaction Publishers, 1993.

_____. *Utopianism: The Perennial Heresy*. New York: Sherd and Walp, 1967.

_____. "Architecture and Puritanism." *New American Review*, February/March 1978.

More, Paul Elmer. *Platonism*. New York: AMS Press, 1969.

Morgan, H. Wayne. *Keepers of Culture: The Art-Thought of Kenyon Cox, Royal Cortissoz, and Frank Jewett Mather Jr*. Kent, OH: The Kent State University Press, 1989.

Morrison, Hugh. *Early American Architecture: From the First Colonial Settlements to the National Period*. Oxford: Oxford University Press, 1952.

Mulroy, David. *The War Against Grammar*. Portsmouth, NH: CrossCurrents, 2003.

Murdoch, Iris. *Metaphysics as a Guide to Morals*. Cambridge: Cambridge University Press, 1992.

Neiman, Susan. *Evil in Modern Thought. An Alternative History of Philosophy*. Princeton: Princeton University Press, 2002.

Newman, James R., ed. *The World of Mathematics*. Vol. 1. New York: Simon and Schuster, 1956.

Newton, Isaac. *Mathematical Principles of Natural Philosophy*. 1667.

_____. *Opticks*. 1704.

Nietzsche, Friedrich. *The Birth of Tragedy and the Genealogy of Morals*. Translated by Francis Golffing. Garden City, NY: Doubleday & Company, 1956.

Panofsky, Erwin. *Perspective as Symbolic Form*. Translated by Christopher S. Wood. New York: Zone Books, 1997.

Perrault, Claude. *Ordonnance des cinq espèces de colonnes selon la méthode des anciens (Ordonnance for the five kinds of columns after the method of the ancients)*. Translated by Kagis McEwen. Santa Monica: Getty Center, 1993 (1683).

Peterfreund, Stuart. *William Blake in a Newtonian World: Essays on Literature as Art and Science*. Norman: University of Oklahoma Press, 1998.

Pfeiffer, Bruce Brook and Nordland, Gerald, editors., *Frank Lloyd Wright in the Realm of Ideas*. Carbondale: Southern Illinois University Press, 1988.

Pieper, Josef. *Leisure: The Basis of Culture.* Indianapolis: Liberty Fund, 1999.

Pontynen, Arthur. *For the Love of Beauty: Art, History, and the Moral Foundations of Aesthetic Judgment.* New Brunswick, NJ: Transaction Publishers, 2006.

_____. "A Winter Landscape: Reflections on the Theory and Practice of Art History." *Art Bulletin,* LXVIII, no. 3 (September 1986).

_____. "The Aesthetics of Race, the Beauty of Humanity." *American Outlook Magazine,* 2002.

Popper, Karl. *The Open Society and Its Enemies.* Vols. 1 and 2. Princeton: Princeton University Press, 1971.

Rand, Edward Kennard. *Founders of the Middle Ages.* New York: Dover Publications, 1957.

Ratzinger, Joseph. Translated by J. R.Foster. *Introduction to Christianity.* New York: Herder and Herder, 1970.

Rauschenbusch, Walter. *A Theology for the Social Gospel.* Nashville: Abington Press, 1987.

Roberts, Andrew. *A History of the English Speaking Peoples Since 1900.* New York: Harper Collins, 2007.

Rieff, Philip. *My Life among the Deathworks: Illustrations of the Aesthetics of Authority.* Charlottesville: University of Virginia Press, 2006.

Rorty, Richard. *Contingency, Irony, and Solidarity.* Cambridge: Cambridge University Press, 1989.

_____. *Philosophy as Cultural Politics.* Cambridge: Cambridge University Press, 2007.

Safranski, Rüdiger. *Martin Heidegger: Between Good and Evil.* Translated by Ewald Osers. Cambridge: Harvard University Press, 1998.

Scully, Vincent. *Architecture: The Natural and the Manmade.* New York: St. Martin's Press, 1962.

Sedlmayr, Hans. *Art in Crisis.* New Brunswick, NJ: Transaction Publishers, 2006.

Singer, Peter. *Animal Liberation.* New York: Harper Perennial, 2001.

Smith Gerald, and Lottie H. Kendzierski. *The Philosophy of Being.* New York: Macmillan Company, 1961.

Snobelen, Stephen D. "Isaac Newton, Heretic: The Strategies of a Nicodemite." *BJHS* 32 (1999).

Sokol, Alan. "Transgressing the Boundaries: Towards a Transformative Hermeneutics of Quantum Gravity." *Social Text,* Spring/Summer 1996.

Solzhenitsyn, Aleksandr. *The First Circle.* Translated by Thomas P. Whitney. New York: Harper & Row, 1968.

Spinoza, Baruch. *Principles of Cartesian Philosophy.* Translated by Harry E. Wedeck. New York: Philosophical Library, 1961 (1683).

Twombly, Robert, and Narciso Menocal. *Louis Sullivan: The Poetry of Architecture.* New York: W. W. Norton, 2000.

Francois-Marie Arouet Voltaire. Translated by H.I. Woolf. *Voltaire's Philosophical Dictionary.* New York: Alfred A. Knopf, 1924 (1764).

Walsh, James, *Thirteenth, the Greatest of Centuries.* Washington: Catholic Summer School Press, 1910.

Watkin, David. *A History of Western Architecture.* New York: Waston-Guptill, 2000.

_____. *Morality and Architecture Revisited.* Chicago: University of Chicago Press, 2001.

Wiener, Philip P., ed. *Values in a Universe of Chance: Selected Writings of Charles S. Peirce*. Garden City, NY: Doubleday Books, 1958.

Wilmerding, John, ed. *American Light: The Luminist Movement 1850–1875*. Washington, DC: National Gallery of Art, 1980.

Ludwig Wittgenstein, *Philosophical Investigations*. New York: Macmillan Company, 1958.

Wölfflin, Heinrich. *Principles of Art History*. New York: Dover Publications, 1950.

Wolin, Richard. *Heidegger's Children. Hannah Arendt, Karl Lowith, Hans Jonas, and Herbert Marcuse*. Princeton: Princeton University Press, 2001.

Wood, Robert E. *Placing Aesthetics: Reflections on the Philosophic Tradition*. Athens, OH: Ohio University Press, 2000.

Woolf, H. I., trans. *Voltaire's Philosophical Dictionary*. New York: Alfred A. Knopf, 1924.

Worringer, Wilhelm. *Abstraction and Empathy*. Translated by Michael Bullock. Cleveland: Meridian Books, 1967.

_____. *Form in Gothic*. New York: Schocken Books, 1967.

INDEX

Illustrations indicated in **bold**.